UNIVERSITY COLLEGE WINCHESTER

Martial Rose Library
Tel: 01962 827306

1 6 MAR 2006

-2 MAY 2006

1 2 MAY 2008

2 5 JAN 2010

1 8 FEB 2010

To be returned on or before the day marked above, subject to recall.

To all my students

Marina Abramović

Student Body

Workshops
1979-2003

Performances
1993-2003

Conceiving
Marina Abramović
Antje Müller

Design
Gabriele Nason
Daniela Meda

Editorial Coordination
Emanuela Belloni
Elena Carotti

Proof Reading
Harlow Tighe
Cecilia Bagnoli

Copywriting and Press Office
Silvia Palombi Arte&Mostre, Milano

Web Design and Online Promotion
Barbara Bonacina

Cover
Video still from: Franz Gerald Krumpl,
The Partisan, 2001

Back Cover
Iris Selke, *Narcissus*, 1997
photo TheMalher.com

This book has been published on the occasion
of the workshop *Cleaning the House* organised
by Centro Galego de Arte Contemporánea,
Santiago de Compostela.

Centro Galego de Arte Contemporánea

Project Coordinator
Silvia García

Editorial Staff
Elena Expósito
Elena Fabeiro
Isabel Méndez

The images are courtesy Marina Abramović Archives,
Amsterdam

Edizioni Charta
via della Moscova, 27
20121 Milano
Tel. +39-026598098/026598200
Fax +39-026598577
e-mail: edcharta@tin.it
www.chartaartbooks.it

Printed in Italy

I would like to thank Antje Müller, Snežana Golubović and Declan Rooney: without their collaboration and help the book would not be possible.

I would also like to thank Michael Schwarz, Director of the Hochschule für Bildende Kunste, Braunschweig, Birgit Hein and Raimond Kummer; Viola Yesiltać, Alessia Bulgari, Hannes Malte Mahler, Sarah Braun, Sonia Biard and all those who helped research the workshop materials and who provided us with diaries and photographs from their archives. There was much more material than could be included in this book. Many thanks also to all the known and unknown photographers and workshop participants over the years.

Special thanks for their participation in this project and for their valuable contribution:
Beatriz Albuquerque, Frank Begemann, Anna Berndtson, Oliver Blomeier, Vera Bourgeois, Sarah Braun, Maria Chenut, Ivan Čivić, Amanda Coogan, Yingmei Duan, Nezaket Ekici, Félix Fernández, Regina Frank, Marica Gojević, Pascale Grau, Katrin Herbel, Eun-Hye Hwang, Julie Jaffrenou, Tellervo Kalleinen, Oliver Kotcha & Frank Lüsing, Franz Gerald Krumpl, Lotte Lindner, Antón Lopo, Hannes Malte Mahler, Monali Meher, Marta Montes Canteli, Frau Müller, Daniel Müller-Friedrichsen, Llúcia Mundet Pallí, Hayley Newman, Ana Pol, Rubén Ramos Balsa, Barak Reiser, Declan Rooney, Andrea Saemann, Iris Selke, Chiharu Shiota, Christian Sievers, Anton Soloveitchik, Till Steinbrenner, Dorte Strehlow, Melati Suryodarmo, Irina Thorman, Ewjenia Tsanana, Frank Werner, Susanne Winterling, Herma Wittstock and Viola Yesiltać.

Contents

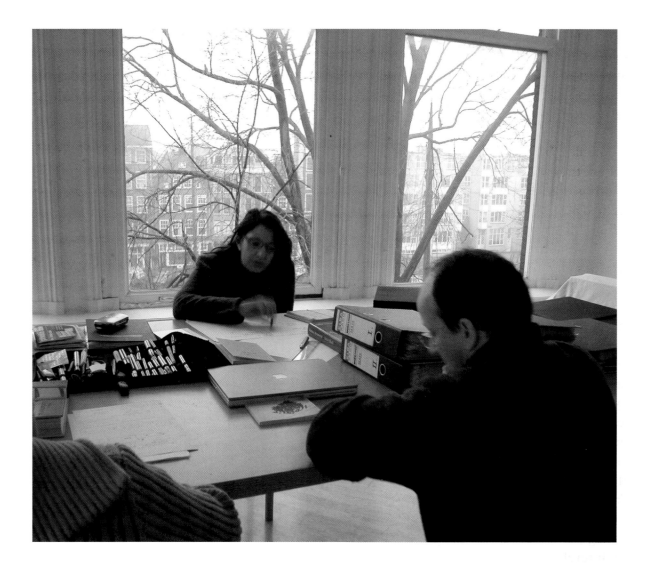

Meeting of Marina Abramović
with Miguel Fernández-Cid,
Amsterdam, The Netherlands, 2003

Questions and Answers
Marina Abramović and Miguel Fernández-Cid

Among all the possible prefaces to *Marina Abramović. Student Body* we finally chose the most unusual one: that I, as director of the centre that triggered the publication, should answer the questions created by Marina and her pupils. I suppose it is no coincidence that she should have formulated ten questions and they, thirteen. Marina's questions test the limits of the museum; her pupils are concerned about the attention paid to recent art. While I hope to have answered them all, I trust I have not allowed myself to come up with recipes for salvation.

I

Marina Abramović: As director of a museum of modern art, could you please explain the obligations entailed by your position?

Miguel Fernández-Cid: Being an art centre financed chiefly with public funds, we have a clear economic responsibility. In addition to this, in my view running an institution such as CGAC implies an intellectual commitment, the results of which can only be judged in hindsight. Upon my arrival five years ago I planned a programme of activities and interventions, a working philosophy. Personally, I am suspicious of interchangeable centres and programmes, for I believe it is necessary to make an effort to integrate museums and art centres in their surroundings, while it is also advisable to design their profiles and, in particular, their differences. In our case, being located in a city of less than 100,000 inhabitants with a significant student population yet with no other centres presenting continuous contemporary art programmes in the region, we felt it was advisable to launch a publishing programme to disseminate the image of the centre, an active educational service and a complete programme of activities. Examples of our work in these areas are your workshop and the present publication. Other priorities included opening a library and a bookshop specialised in contemporary art, for such services are non-existent in Galicia, and equipping the centre with the most advanced technical resources, as well as defining and promoting the museum's permanent collection. The architectural characteristics of the building by Álvaro Siza rounded out our project, for its irregular galleries encourage the development of our own exhibition programme (an option we prefer to the welcoming of travelling shows), and our determination that artists should relate to the museum's spaces through specifically designed interventions. Naturally, the public nature of our budget reminds us of the need to establish ties between local art and the outside world, yet free of quotas and impositions, defending quality, plurality and an unequivocal commitment to the contemporary.

MA: Do you have a right to veto the decisions of your curators?

MF-C: There are no regulations on this matter; curators are either chosen by us or by the artists on show, and usually belong to the museum's team of young professionals. We always discuss and compare our opinions, and my rule is to respect the criteria of each curator. If I disagree on some point, I explain the grounds for upholding my theses; I don't always win, but I do set out my reasons. Whoever we choose must have our support.

MA: What is your approach to the use of ephemeral materials in the work of many

contemporary artists? How do you preserve such works if they are to be kept as a part of a museum collection?

MF-C: I truly believe that all materials are ephemeral, and I think that all those working in museums and art centres should be intellectually engaged, bearing in mind that they also belong to the public "cultural" service sector. The former leads me to reject exhibitions, proposals and installations that are excessively theatrical; the latter encourages me to meet the requirements made by each artist.

I can't deny that we are generally more permissive with the materials of the works in exhibitions than in those entering the permanent collection, yet we are delighted to have Penone's first wall made of bay leaves, Alberto Carneiro's installation with an orange tree, and Schlosser's palm tree sculpture. I am aware that these works pose preservation difficulties, but I'm not so sure that they will last longer than a photograph or a traditional painting or sculpture. As soon as the work belongs in the collection, the problem falls on our restorer, who does an excellent job in which she must administer tolerance and exigency.

Personally, the privileged treatment afforded to works once they cross the threshold of our collection – works which I recall piled up in dark studio corners – amuses me. I don't think the situation is as dramatic as it seems, although we should dwell a little on the possibilities, the limits and the meaning of each collection. The "waiting lists" and the grounds for "retirement" of works could be a wonderful source of inspiration for a good novelist.

MA: Are the museum's preferences affected by the art market?

The reasonable answer would be no, but given that our objectives include elucidating the present, it is inevitable to become involved with commercial trends, and I am not referring to economic issues, which also have a bearing, of course. For instance, when attempting to define the guidelines of the CGAC collection we decided it should be a review of the voices and echoes defining its trajectory. We envisaged a metaphor – the spider's web – in order to afford it a physical image. Our intention is not to tell the history of a certain period, providing names and tendencies, but to point out behaviours and to establish connections. One thing is for sure, and that is that we don't want a collection of names. In the case of young artists, we often purchase a series or a group of works; in that of artists enjoying a wide reputation, we do not settle for minor works. When Marina Abramović enters the CGAC collection she will do so with a substantial meaningful work, however long that may take. If it doesn't happen while I'm the director, then someone else will make it happen…

MA: Do you maintain long-lasting relationships with artists who have exhibited at the museum?

MF-C: To tell you the truth, I think that one of CGAC's strong points is the human relationship established between its team and the artists we have presented. I personally like to follow the careers of those who have exhibited at the museum, and of those whose work I would like to see on display in our halls, although this rapport is almost secret. It's obvious when people see eye to eye, there is really no need to make public announcements. I have more faith in silent work than in an excess of social relations, although that's just a personal option.

MA: Do you visit the studios of younger artists? Do you follow the careers of those you are interested in?

MF-C: I visit studios less than I would like to, but I do follow the paths of young artists as I said before. I'm always open to enthusiasm, in the same way as I rebel against those who believe that one's sympathies should last a lifetime. I prefer critical following on both parts.

MA: Do you follow your intuition in making your choices?

MF-C: I'd be lying if I denied it, but public office and the responsibilities it entails call for serious reflection when important decisions have to be made.

MA: In my view, museums still base their functioning on nineteenth-century rules that present specific relationships between the artworks and their public. Do you think that time is ripe for changes in this structure, changes that will promote greater interactivity between works and visitors?

MF-C: I have my doubts about this. We are all familiar with contemporary art centres that have extremely conservative ways of functioning, and with small-scale museums that are quite dynamic. I think traditional museums are still valid proposals, albeit the relationships between works and spectators should be as compelling as possible. What I *am* sure of is the need to create dynamic centres and uncompromising spaces, the need for social systems to open up and welcome art without creating ghettos or marginal situations.

MA: Which museum of modern art presents, in your opinion, the ideal conditions and architectonic flexibility for exhibiting contemporary works?

MF-C: I find it impossible to give a firm reply or to come up with names, but I like moderate museums and exhibitions. On paper, I am either bored or overwhelmed by huge centres and never-ending exhibitions, although I do occasionally enjoy them. I have confidence in the memory, in the impression that continues to accompany us after our visit, for it bears witness to the interest aroused and to the questions elicited.

MA: How do you see the future of contemporary art museums?

MF-C: I would love them to be spaces where things happen, plural spaces of disquiet and tension. Be as they may, we will always have to strive to introduce the margins, what remains on the fringes, into their discourse.

II

Anna Berndtson: If artists make extreme political statements in their work, which may contradict your own beliefs, how would you approach the works in question? Would you exhibit them, would you voice your opinion or would you be objective and neutral?

MF-C: I have exhibited works and given artists my opinion, just to contrast their own views. When such works were displayed, I strove to appreciate their positive features in order to defend them. I must confess that I have not succeeded, but I don't think that makes me less objective or less neutral.

Ivan Čivić: What particular requirements are needed in order to become a museum director?

MF-C: Until recently there was no specific training for such a post in Spain. I belong to a generation of directors that comes from the academic world – universities – and from the spheres of art criticism, literature and curatorial work. Familiarity with the milieu is important, as is the recognition provided by one's previous professional trajectory.

Melati Suryodarmo: When the museum invites external curators to organise exhibitions, do you exert any influence upon their decision making?

MF-C: We discuss their objectives, the possibilities, budgets and technical conditions. I like clarifying our limits, particularly our technical limits. Then I request a follow-up of their work.

Anton Soloveitchik: When deciding upon the artworks that will be shown, do you choose works you particularly like or do you base your decisions on trends of the moment?

MF-C: It depends upon the intentions of each individual show. If the idea is to review an artist's work, we may include works that while not being perhaps the most successful are meaningful in his or her development. We take care over our installations, a fact which sometimes entails readjusting the selection of

works. I suppose personal taste does come into it, and certain visual tendencies occasionally surface, even unconsciously, especially in group shows and in our reviews of the permanent collection.

Declan Rooney: Where and when did you first become involved in art? Did you start as a practitioner, an administrator or a critic? What steps did you take in your career?

MF-C: I studied art history, but my first connection to art came through my writing; I have always considered literature and art to be very close. I never intended to be an artist, though after visiting a Philip Guston exhibition some years ago I was so excited that I felt like picking up pencil and paper; fortunately I went and had a few beers instead. I lectured on art criticism and aesthetics at various colleges of fine arts, I curated exhibitions and I worked as a critic for a number of newspapers and magazines. I edited a few art reviews, then launched one of my own and even ran a small publishing house. I never thought I'd end up working for a public institution but I'm glad to have had the experience. This was the path I followed. When it's over I'll go back home, to my library, to writing, to exhibitions…

Declan Rooney: What is the museum's official policy regarding the acquisition of works for the collection? Is it a balance between acquiring key examples from the history of modern art and more contemporary, cutting-edge works? Who decides how the money for acquisitions should be spent?

MF-C: Our budget is really quite low; therefore we have no access to the key works you mention. However we are able to acquire significant works by artists from the past thirty years. Nonetheless, the collection's forte are the works by young artists we usually acquire in groups, ensuring these works have close links to one another. Acquisitions are proposed by the director to the board of directors.

Declan Rooney: Does the museum have an outreach policy? Does it have its own educational programme? If so, which educational needs do you think the contemporary art museum should address first and foremost?

MF-C: In Spain it is essential for contemporary art centres to establish critical bonds with their surroundings, otherwise their permanence is difficult to uphold. The existence of educational programmes is vital, and these must devise specific activities related to each exhibition, including workshops and guided tours. CGAC publishes a magazine informing of its exhibitions and activities, a magazine we regard as pedagogical material in itself. We endeavour to relate more popular disciplines such as literature and film to contemporary art. Our intention is not to explain these links, merely to insinuate them, to set up dialogues, to teach new ways of seeing while respecting personal visions.

Herma Auguste Wittstock: What are your favourite questions for younger artists?

MF-C: I don't ask many questions; I let them talk and when I visit a studio. I try not to miss anything. Lou Reed once said that our responsibilities begin with our choices, and I always felt it was a good saying. I let them show what they choose and how they choose. I look, I listen and I draw my conclusions; it usually works. I don't give "redeeming" advice; decisions must be personal.

Herma Auguste Wittstock: How do you approach new works? Do you prefer to study artists' proposals viewing the actual works, or speaking to the artists personally? What procedure should young artists follow in order to get in touch with you?

MF-C: I like the first contact to be with the work; the work must lead to the artist and not vice versa. That's the best connection, the most efficacious – right in the eye. There are other reliable and speedy ways of course, such as sending information via e-mail.

Till Steinbrenner: Do you think a contemporary art museum has the responsibility and the flexibility to react spontaneously to things as they happen in the world, i.e., the war on Iraq?

MF-C: I'd be delighted if it did, but in my view the responsibility lies more on an individual level, and I'm afraid that flexibility can be extremely relative.

Viola Yesiltać: Most group exhibitions in museums show the most renowned works by well-known artists. Do you think curators are afraid to show the work of younger anonymous artists?

MF-C: I don't think it's fair to make generalisations. Each generation of artists has its counterpart in critics and curators. Some prefer not to take any risks and prefer to champion what has already been established, while others find it more stimulating to seek out new values. I think everyone lives the life they choose... I prefer to include young artists in my projects, but I can't bear the typical curator who declares having discovered the eighth wonder of the world, which is generally what they would love to achieve yet never manage to do so.

Lotte Lindner: What do you think of the sacred aura of museums?

MF-C: As background music, I prefer the sound of coffee cups and teaspoons!

Lotte Lindner: What is your idea of a utopian museum?

MF-C: As a place in which to work, a museum free of the monotonous burden of day-to-day routine. As a visitor, empty galleries and a busy café. I'm afraid I'm quite relentless and selfish about that.

Tadeusz Kantor:
*Panoranic Sea
Happening*, 1967

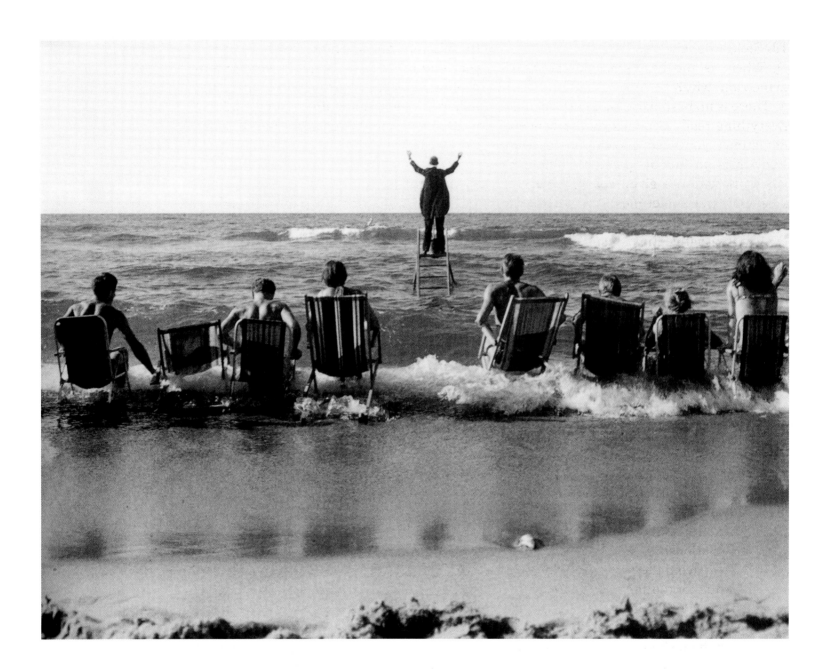

Questions and Answers
Marina Abramović and Students

Till Steinbrenner

Q: Where is the best place for a performance and why?

A: There is no best place for a performance. Everything really depends on the concept. Sometimes you need an outdoor location, sometimes an indoor location, sometimes you work within a given space (gallery or museum) and sometimes you are free to choose your own location.

Q: As a non-native English speaker, how do you feel about the use of English (in spoken word) in performance art?

A: In my opinion there are no limits. If you are a performance artist, you have absolute freedom to express yourself in any language you choose. If this language happens to be bad English, you are free to speak this bad English.

Q: Should the professor be able to do all that he expects from his students?

A: Relations between professor and students are very fragile. The professor should have enough experience, feeling and intuition to understand how much he can demand from his students without damaging their relationship. The professor has to know how to avoid the power game of pushing the students too far and expecting too much. If you do this, it will actually create the opposite effect.

Q: What is the task of the artist in society?

A: To answer this question I cannot generalise. The answer is very subjective and differs depending on each artist. Joseph Beuys saw his role in society as a shaman, Mondrian referred to his task being to present a true reality and Marcel Duchamp wanted to change the way society thinks. As for myself, my task is to be a bridge between the Western and Eastern worlds. This is a very natural thing for me; it is almost autobiographical in a way. I come from the Balkans, which is literally the geographical bridge between the Eastern and Western worlds.

Viola Yesiltać

Q: Do you think there is a point at which an artist should stop making artwork? If so, when?

A: I really like this question; I have been thinking about this for a long time. When I look around at what artists are producing today, I feel many should stop right now because they are repeating themselves, facilitating the art market and producing work that is easy to sell. The alternative is that they are just bad artists and their work makes no sense whatsoever. To me the most difficult thing is when I see artists who I highly respect for the work they have created in the past, repeating those works, as a result of which the works lose their meaning and become dull. But who am I to say when an artist should stop working? The only thing I can judge is myself. I will stop working and making art when I can't say anything new, when I stop taking risks, when I no longer have any new ideas and when I lose my passion, enthusiasm and the element of surprise. If I ever realise I am repeating myself it is especially pertinent for me to quit.

Q: The first time you were asked to become a professor, were you afraid?

A: No, I was not afraid. I have a feeling for teaching. Actually, I really love teaching. I think that at one point in your life, within your career as an artist and when you col-

lect enough experience, you have to transmit this knowledge to the next generation of artists. This never happened to me when I was a student; only one of my professors told me what I really wanted to know. I was almost at the end of my studies when this professor told me two truths that I still believe in today. The first was that if you make a drawing with your right hand and become better and better at it to the point of virtuosity and to the point where you can make the drawing with your eyes closed, you should immediately switch to your left hand. The second truth was that, in your whole life as an artist, if you are very lucky, you will have one good idea. If you are a genius, you may have even two! All the rest is merely a variation on that one good idea, but you must be careful with it.

Q: Do you think professors should express their real opinions of their students' work?

A: Yes and no. It depends on which state the student is in at the moment. If the student is about to develop something new and interesting but at the point of presentation it appears immature, naïve and not good enough, the professor should be able to see the bigger picture and understand where this idea could lead. The professor should encourage the student to continue the research rather than give immediate bad criticism, which can have catastrophic consequences on the student's ego and stop him or her progressing with their work completely, making them confused and lost.

Q: Do you think it is appropriate that a professor should tell a student to stop making art if it is really bad art?

A: This is a more complicated question than it seems, there are no black and white answers; both the professor and the student have to work it out together. The professor has to give the student enough chances. If all the chances end up as failures, an interval should be suggested. This break should be used to reflect upon the work, on students' motivations to become artists and to question the reasons behind their inability to make art. The decision to stop making art should not come from the professor. The professor should initiate the thinking process but it is the students who should be aware of their own positions and decide what they should do. In my experience as a professor, I have had some experiences like that with different outcomes. Some students truly realised they would not become artists and left, but for others this break in their studies served as a push towards a kind of creative frenzy, and they re-emerged with really good works.

Q: You are a professor of performance; do you want your students to work only with performance? If one student is working with the performative in video or photography, do you want them to transform this work into live performance?

A: Yes. I teach performance and that means I will accept students who are interested in learning and making performances. If the same students use other media such as video and photography as well as live performance this is perfectly acceptable. However, I am completely against pushing students to create performances just because they are in the performance class. I accept students into the class because they have a potential talent to become performance artists. I don't like pushing anybody into anything. It is not up to me. The desire to perform has to come from within the students. Sometimes I can see great potential in a student, but the student can't free himself to perform because he has to overcome shyness, self-consciousness or a fear of the audience. This is where my exact role as a professor arises – leading the student step-by-step towards overcoming these obstacles, which I know so well and which are recognisable by their symptoms. I was so shy before I started as a performance artist that I could not walk down the street if I heard footsteps behind me, thinking someone was observing me. I would immediately stop and look into a shop window until

they had passed. In the beginning, before every performance I was physically sick, and even today after a thirty-year career, I am still extremely nervous before I perform. When the performance begins this fear disappears and another energy replaces it. My role as a professor is to teach students to trust themselves and to learn to understand how to enter into this other energy.

Q: Do you accept other media in your class or only for documentation purposes?

A: There are different ways of approaching this question. In the beginning of performance art many artists even decided not to make photographs and videos of the event, to make it radical and pure and to preserve it as a time-based art. There is a fixed location, time and date when the performance takes place. If you are not there at that particular time you will miss it. All that exists is word of mouth with viewers talking about what they saw. These stories get distorted and exaggerated and become very different from the actual reality of the event, and there is no documentation to prove otherwise. In the early seventies, when performance art began to be documented, most of the video material was grainy and had low-quality sound and image. The black and white photographs show a sequence of events, which actually exist as a real document. Now with new changes in technology, working with professional digital video and still cameras, the documentation is far better and provides sharper and clearer images. The question is, when is this material from the performance just documentation, and when is it the artwork? In my opinion, there have to be one or two photographs from the performance which can work as singular images, which contain all of the elements of the work existing on their own, independently from the performance. This photograph or video then becomes an artwork. The performance is the basis or source material for this new work.

Q: Do you have a formula for working with your students? For instance, I see we often reduce the components in the work to just one element; is this a formula?

A: I am really sorry if you have this impression. I try very hard not to have one single recipe for everybody – all of you are so different with different needs, different ideas and different personalities. What I try to

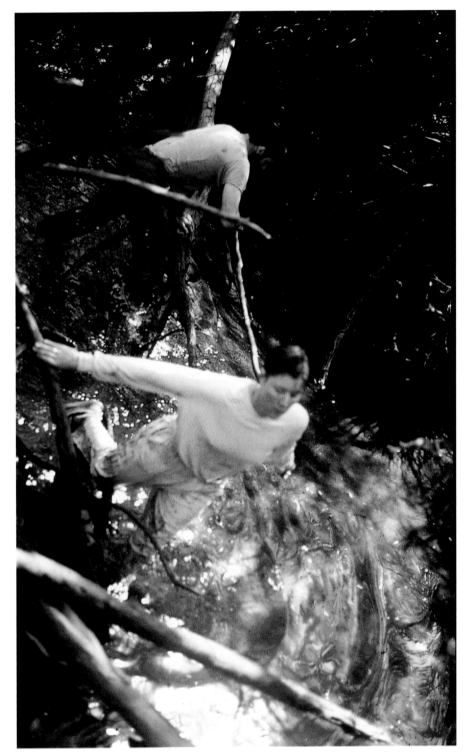

Kim March: performance, workshop with Ulay, Australia, 1979

show you is that sometimes when you present one work there could be three, four or even five performances all contained within that one piece. An intention common to many students is to overcomplicate works with unnecessary elements, thinking that more is better. You always have to bear in mind the idea of the work and how many elements are essential in the work, without sacrificing meaning.

Q: I feel some students in our class are producing only clear catchy images. Do you think that with this strategy we can be successful?

A: When you say "clear catchy images" and "with this strategy we can be successful," it places my whole idea of teaching on a very low level. This is not my intention. Let's analyse success first. For a true artist, success is not the aim; it is only the side effect. If the motivation of the work is only to be successful, you have to seriously question your reasons for making art at all. Art is about communicating something to people, pressing on and opening new boundaries. It is about a heightening of awareness. If you succeed in this, you may or may not be successful; sometimes artworks have to wait for a long time to be accepted. Society is not always ready for the works artists create and history is full

of such examples. El Greco had to wait one century to be discovered. "Catchy images" sounds so cheap and immediate, like advertising, very different from what we are trying to do here. Art is a visual thing and over centuries, people have been busy with painting and sculpture and more recently with video, installations and performance. If you stand in front of a good painting you'll find it contains everything: the clarity of the idea, the composition and the colour, all combined to create an image that works for you. It's the same with performance art. The performance has to create an emotional state within the viewer. What you call a "catchy image" I would call an "image with an impact." Let's talk about strategy; I do agree that artists have to have a strategy – I don't believe that artists should sit in their studios making work, ignoring the outside world and waiting for recognition. I believe in having the same amount of energy for making the work as for deciding where exactly the work will be placed in the world. In the right space and within the right time, the work becomes living and independent of the maker – this is our true responsibility as artists. This is the only strategy I agree with.

Q: Why do you prefer for all the class to participate in exhibitions and not just a selected few?

A: Maybe it's because I come from a communist country. This is a joke. Seriously though, for me the class is a family or a community and the balance within this family is very important to me. Of course people are more or less talented, and works are better or worse but I believe that everybody should have the same chances. It is only by actively participating in exhibitions that you can gain responsibility with regard to your work and to the audience context. I think you can learn more from these experiences than in any art academy. The moment I choose only some students from the group, I am creating an imbalance within the family. I prefer other external cura-

Melati Suryodarmo:
Alè Lino, 2003
Performance, *Recycling the Future*, 50. Esposizione Internazionale d'Arte La Biennale di Venezia, Venice, Italy, 2003

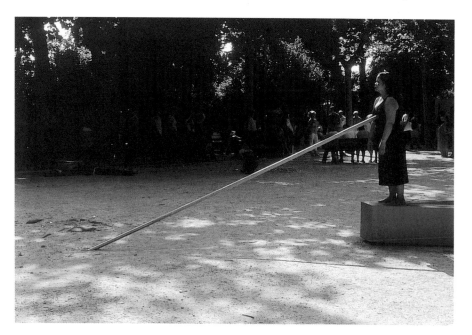

tors to make the choices about which students they want, though if I am asked I will always invite each and every one of them.

Q: Are you proud of your ex-students when you see them becoming successful in the art world?

A: Proud is not even the word, I am more than proud, I am excited and happy for them and I see that all the efforts of teaching do produce their fruits – this is a wonderful feeling for me.

Q: How long will you continue to be a professor?

A: This is a very important question. I am horrified at the idea of being a professor for twenty or thirty years. I am afraid that if I am a professor that long, I may slip into complacency or develop routine habits and lose my enthusiasm. I know I will have to stop before that happens.

Antón Lopo

Q: Do you take advantage of the extreme physical state of your students during the workshops, induced by fasting and abstaining from sex and smoking, etc. in order to face situations of weakness?

A: I don't think so.

Q: Do you feel any level of cruelty in your workshops?

A: I don't think so, but I think it's possible that a student, upon reflection, realises that what may be called cruelty is just another necessary step in the learning experience.

Q: Is there a significant degree of mysticism in your workshops?

A: No, I don't think so but there are definitely spiritual ingredients.

Q: Do you consider the creation of a performance having a relationship to Buddhism?

A: Some practices in the workshops and performances have applied Buddhist learnings.

Q: What did you feel during the days of intimate contact with Antas de Ulla during your 2002 Spanish workshop?

A: The landscape and nature of Antas de Ulla was very beautiful and moving. I would refer to this place as a place of power.

Ivan Čivić

Q: Why did you decide to become a teacher?

A: I think I decided to become a teacher because when I was a student I had so many questions to ask and nobody was there to answer them.

Q: When did you decide to become a teacher?

A: I decided to become a teacher almost immediately after doing my workshop with Ulay with a group of students in Australia in 1979. I felt then that I had something to contribute to students, and I felt that I could establish a level of trust between my students and myself. This trust is the basis for the development of a working relationship.

Q: Where were you at the moment you decided to become a teacher?

A: As I said previously, I was in the Blue Mountain region of New South Wales in Australia.

Q: Are you more of a public teacher or a private teacher?

A: Private teacher reminds me of the song *Private Dancer*! I am not a public teacher, nor am I a private teacher; I am everything that I need to be at a given moment. There are moments when the student needs private communication and then other moments when it is important to talk to a larger number of students at the same time. For me the group context is very important. Artists are generally very attached to their egos and they can pretend to be the centre of the world. In a group situation you learn interdependency with one another. You acquire patience in order to understand the concepts of others and not just your own. You learn to be constructively critical towards your own work as well as towards the work of others.

Q: How far will you go with your students and where are the psychological and physical boundaries?

A: I would never ask my students to do what I do in my performances. I could not request my students to visit the unsafe territories that I visit. It is my own responsibility, if I choose to do this myself. During the period of study, I am responsible for the works being created in my class. Once the students leave the academy and they become independent artists, they can push their psychological and physical boundaries as far as they deem necessary for their work. Only once in my career as a professor was I unaware of what one of my students was planning to perform and it really could have ended in the death of this student. One student, Llúcia Mundet Pallí, told me that she would do a performance in a 1970s style without telling me exactly what it would be. This was for an event held in the art academy called *Our Seventies*. The professors were asked to remember the 1970s and to create work or repeat work from that period. The students were asked to express how they saw the 1970s. This Spanish student produced a T-shirt with a photograph of one of my performances (where I lose consciousness in front of the public) printed on the front. She went to the bathroom and drank a whole bottle of whisky, then went back to the exhibition space and lay on the floor. A long time later in the evening someone noticed foam coming out of her mouth. At this point, nobody was aware that she had drunk a whole bottle of whisky. She was in a coma. We took her to the hospital; she stayed in a coma until the next morning. I remained by her bed all night long, in agony, thinking that I would never forgive myself or ever teach again if anything serious happened to her. After this incident I decided that if I ever saw anyone in my class doing something psychologically or physically unsafe, I would stop it immediately.

Q: Would you kill for a student?

A: After the war in Yugoslavia, I asked myself this question: could I ever kill a human being? If I look deep down within myself, the real answer is yes. I think that all of us in certain extreme circumstances, beyond our control, could actually kill. There was a friend of mine in Bosnia, a very talented graphic designer, whose two children, aged two and seven, were killed by snipers. It was too much pain for her to bear and she herself became a sniper, fighting against the opposite side. I love my students and would go very far to protect them. If their lives were threatened in a certain situation, I would kill for them. However, I do not think solely in terms of students, I think in terms of all human beings. In my recent installation/performance *The House with Ocean View* I had very direct contact with the public for twelve days. During this period, I realised I generated a great level of love towards the public, not specific to the people I know but for all those in the room. To trigger the feelings of killing there would have to be violence, injustice and cruelty. Killing is only justified in self-defence and in the defence of another human being whose life is threatened. We have the example of Rwanda where 900,000 people were killed and no political help was offered. If the number of the attackers, say 50, were to have been killed at the beginning of the massacre, the other 900,000 would have been saved; therefore the killing of the smaller number would have been justified.

Q: When you retire can you imagine an ex-student continuing to teach in the Abramović tradition?

A: Yes, I could imagine that, but with only one condition: that he or she should truly believe that my methods for teaching are the right ones. I wouldn't like to have Abramović clones without personalities of their own. I like students taking only the parts they need from my teachings and building on them with their own methods and experiences.

Q: Are you satisfied with your achievements as a teacher, to date?

A: Yes and no, it's very difficult to work and

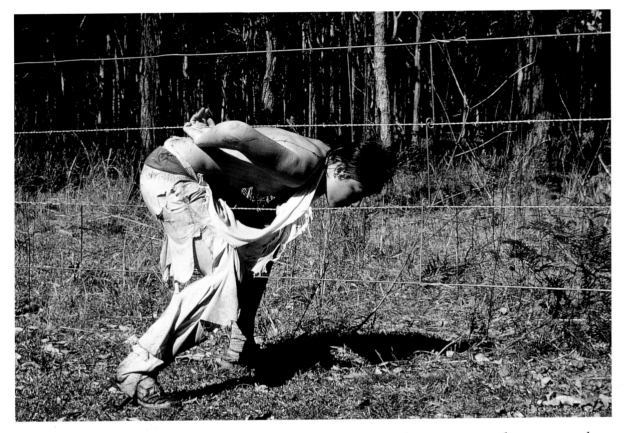

realise all your ideas in the framework of an art academy that operates within a bureaucratic system. My dream is to have my own academy. I would not mean to continually teach there but at least I could create the concept of one.

Rubén Ramos Balsa

Q: In comparison with the value of cleansing and purification in Eastern philosophies, do you believe that dirtiness, catastrophe and the corruption of the body, much pursued by the early avant-garde, can also give rise to an optimum state of creation? And secondly, what is your opinion of the extreme situations that may arise during the creative process, such as alcohol and drug abuse?

A: This is a good question. How one creates is a totally individual experience. Throughout the history of art there have been many controversial examples, which teach us to understand that there is no one rule. It depends entirely on the artist himself. There is the image of the artist as a drunk, taking drugs and who is physically unkempt. This image can be presented as some kind of expression of freedom. Personally, I don't agree with such an image but I don't argue that it's not possible to be creative under such circumstances.

The artist is a very complex being and is torn apart inside with contradictions. The creative act is like giving birth, and this birth is in many cases very painful and sometimes even destructive. Personally and not being able to generalise, I have to learn to understand my own contradictions and find a balance within these. I can only do that with a pure state of mind, that's why the *Cleaning the House* workshops act as a preparatory state in which to prepare for the creative act.

Q: We are progressively less and less aware of the most basic acts and of our own physique, yet at the same time we are increasingly concerned about our own bodies and our own body image. What's your opinion of society's current concept of the body?

A: What you say is really true. We are very concerned about our body image, fashion

and the exterior presentation of the body. At the same time we understand less and less how the body and the mind function. We do not stop to reflect. The increase in the speed of our lifestyles and the extra demands on ourselves unbalances the body completely. There are now more and more cases of eating disorders such an anorexia and bulimia. We are not feeling good but we want to look good.

Group portrait, workshop in Giessen, 2001

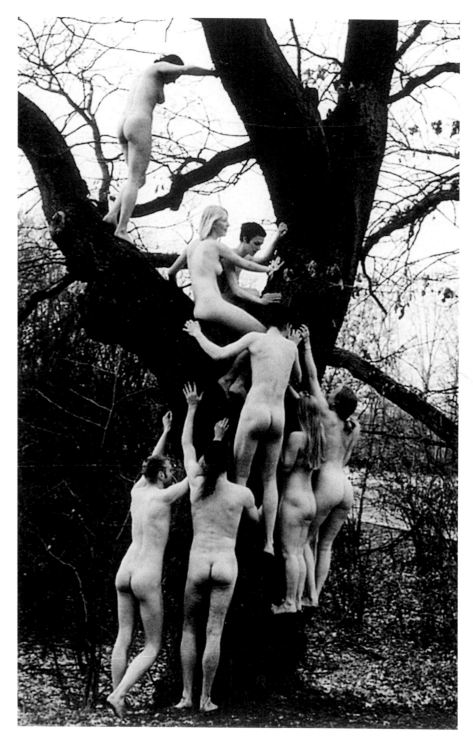

Q: Do you think that performance acts therapeutically on the viewer, or is this effect confined to the personal experience of the performer?

A: Good performances should affect both the audience and the performer, with one result being therapeutic but not exclusively so.

Q: I would like to know how the concepts of perception of time and body are related. Do our vital organs condition our perception of time to the same degree as our mind does?

A: I don't really know the right answer to this question. From my own experience during my performances, time sometimes passes very slowly in my mind, so a performance could actually last only a few minutes. Sometimes it feels as if it has passed very quickly, and yet it has lasted hours. The difference is based on activity. There is a point at which time ceases to exist and this is the most important moment for me: the moment of the here and now.

Q: How should science introduce ways of knowledge that are not based on the cause-effect relationship?

A: Please ask a scientist this question, I am just an artist.

Brais Fernandes Álvares

Q: What is *déjà-vu* and how important is it in our lives?

A: *Déjà vu* is a phenomenon that some people experience more than others. For an artist it depends on whether he can use this for his own work or not. I don't think it's so important.

Q: In the age of global madness, which would be most preferable: a process of introspection or collective action?

A: I think the process of introspection is more beneficial in understanding why things happen when they happen.

Félix Fernández

Q: How do your workshops enrich your artwork?

A: The workshops are very important for one's own work. They help me to focus and

they help me to open part of myself that is normally closed. They make me vulnerable and strong at the same time. I very often get many new ideas during the workshop time.

Q: Is "more and more of less and less" also applicable to feelings?

A: Absolutely not. Feelings do not come into this category.

Q: What happens when we empty ourselves?

A: We are free.

Sarah Braun

Q: How do you estimate your effect on your students?

A: It is very difficult and really depends on the students. In my current class, there are some students on whom I have no effect at all. Even if I try very hard, and when certain things have to be changed, they continue to work in the same way. Some students take parts of my criticism and develop the work farther, while other elements of my criticism are dismissed. The third group are those who absorb the criticism and change their work immediately without asking any questions. I recommend students to take the middle road. The best is to take the advice which you think you can use and refuse the rest. For me, the most frightening experience in which to teach was in Japan, within a very hierarchical system where the professor is treated like God. The students always bow their heads lower than the professor and never have eye contact. Whatever I said was accepted, unquestioned, and the work was adapted and changed immediately. Literally, if you tell your student to open the window and jump, he will open the window and jump. In Holland, it's complete chaos – nobody will listen to your advice. In Germany, students will ask many questions. In France, there is such a relaxed atmosphere that there is not enough tension in which good work can be created. In Italy, students are really hungry for advice, for the art education system is still very classical there.

Q: What do you expect from your students and from yourself?

A: I expect myself to be completely open to the students: to be equal, democratic and at the same time, I demand discipline from them. I also expect students to work very hard, developing and trying out ideas, making mistakes and learning from them. I ask students for complete trust and honesty.

Q: Have you changed personally through teaching?

A: Yes, I have learned that I am not always the centre of attention. When I am teaching, my students are of utmost importance. I learn to step back and give them space. I also learn that when they are ready to go, I have to let them go and this is the hardest part for me.

Q: What do you get from your students?

A: A sense of the spirit of the times we live in. They keep me in the present tense; they give me lots of energy. Their work can also inspire me sometimes too.

Q: Do you learn from your students?

A: Yes, as I said, I am not afraid to say that they often inspire me. I even put an example of the work of one of my students (Katrin Herbel: *Metrunk-me-edges,* 1998) alongside my other major influences in my *Public Body* book. As far as I know, this has never been done before.

Q: Are you honest with your students?

A: Yes, I don't play games with my students.

Q: Are you led by emotion or reason?

A: By emotion, I must admit.

Q: What are your feelings about the future?

A: I don't think that art can change the future as Joseph Beuys said. I hope that it can help to reflect our state in the world right now. I think that we are damaging our planet in a way that is irreversible. I also think that the future is going to be very difficult for us all. The development of technology has taken all our time from us. The cloning of human beings has started, the hole in the ozone is getting bigger, pollution is increasing, the rainforests are dying and war is everywhere. But I am

optimistic that we ourselves still have time to change.

Q: How important is the art business for you?

A: If you invite a plumber to work in your home, you pay him by the hour. If you go to the bakery to buy bread, you have to pay for it. If you ask an architect to make drawings for a house, you have to pay for the drawings. As an artist you should be able to make a living on your own work. The art business should be seen as any other business: nothing more and nothing less. Even now, there is this old-fashioned idea of the moneyless artist, living in poverty. We should not forget that Rembrandt van Rijn, Leonardo da Vinci, Joseph Beuys and Andy Warhol were good artists who successfully sold their works. This does not make their work any less important or relevant. You need to learn to be able to survive on your artwork, uncompromising to the needs of the market at any given moment.

Dorte Strehlow

Q: How many hours do you sleep at night?

A: Nothing is regular in my life and this includes sleeping too. In periods when I have a lot of work to do, I sleep only four hours. Seven hours is about normal. Ten is the most preferable. There was a period when I did all that I could in bed: reading, eating, writing, etc. I would spend all day in bed. I look back at that period nostalgically but I could never do it now.

Q: How many things are you able to do at any one time?

A: Quite a lot. Once I was working on thirty-six projects at the same time. Each project was at a different stage of development. I was so stressed that I decided to never do that again. I have decided to reduce the number of projects to between five and seven things at any one time. Right now it's about fifteen, though.

Q: What is art: the product you can sell or the process that leads you to create this product?

A: Neither: this way of looking at art is oversimplified and banal. Art is much more than that. Art is a tool to communicate to the world and to move the viewer to a higher level of consciousness. To create art is a necessity, it is like breathing; you never question your breathing, you just breathe.

Q: What do you prefer, quality or quantity?

A: Quality.

Q: Do you ever perform in everyday life?

A: Never.

Q: What is the connection between everyday life and art?

A: There is a strong connection. It is impossible to separate them. Ideas from life transform themselves into art and experiences in your art can change your life. There is a constant evolution and movement.

Q: How much time do you spend making and managing art – which of the two requires more time?

A: For me, making art doesn't need any time. The idea can come at any time; you just have to be ready for it. Once I know with my whole body that the idea is right, then I start the preparations for its realisation. The management involves finding the materials, the spaces to exhibit the work and the sponsors to realise the idea. Managing the idea usually takes more time than getting the idea.

Q. What do you think of students who don't become famous?

A: Let's analyse the word famous first. What does it mean to be famous? Is it to be in every newspaper and magazine, on TV or having people whisper your name? What about the artwork? Does this work play any part in your becoming famous? I think that the work is the only thing that you have to focus on here. The work has to be so strong that it lives on its own and that it becomes known everywhere. As I said earlier, fame and success are not the aims; they are just the side effects. Artists just have to focus on the works. The students who don't become famous should analyse why that didn't happen. Maybe they didn't give 100%; maybe family life took over, etc. Becoming famous or not becoming famous is secondary. For

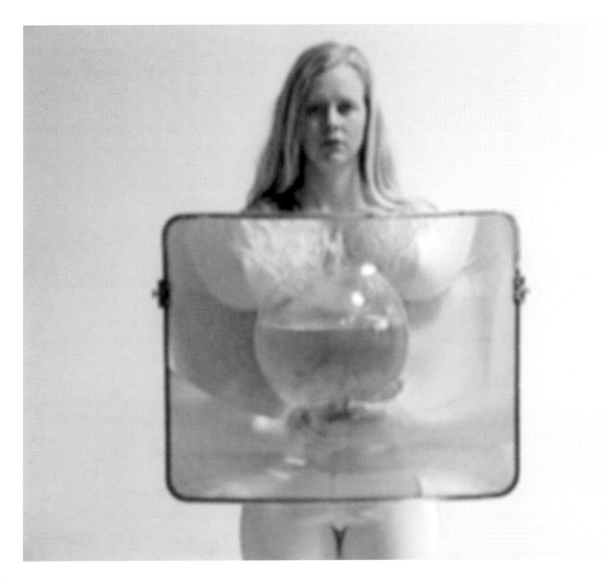

Hanna Linn Wiegel: *Fish*
Performance, workshop
in Giessen, 2001

me, what is essential is that the artists believe in their work.

Q: How many years do you have to work in regular jobs before you can make money from your own art to live from?

A: After I finished at the art academy, I took many different jobs for one year. I worked for the post-office in England, I restored mosaics in Yugoslavia, painted walls at technical fairs and even designed menus for a French restaurant. After that I decided to just live off art. To do that, I had to cut all my spending to the minimum and live as simply as possible. I lived in a car for five years: a simple Citroen with no facilities. I wore wooden shoes, knitted all my pullovers myself and milked goats in the mountains in exchange for food. I made performances for virtually no money.

Of course I did not have many expenses like electricity, rent, etc. I reduced my spending to meet my income and I succeeded in living from my art even with these sacrifices.

Q: What would you do if money were not a concern?

A: First of all I don't think about money and I do exactly what I want without compromising, always. I would still be performing, teaching and helping with just causes if I could. Ever since I was a child I was sure that I wanted to be an artist.

Maria Chenut

Q: What are the sources for your teachings: books, art history, experience, nature or feelings?

A: My source is experience.

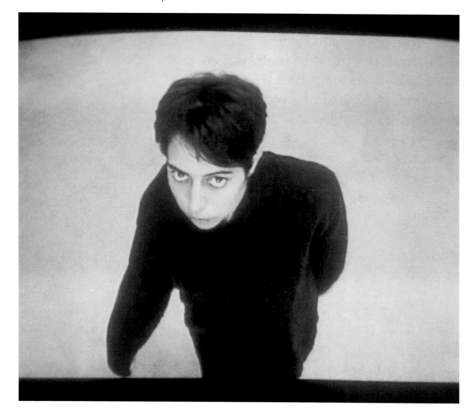

Katrin Herbel: *Exstatik*
Video installation, Irish
Museum of Modern Art,
Dublin, Ireland, 2001

Frau Müller

Q: How do you see the relationship between a spiritual teacher and an art teacher?

A: There is a big difference. To be a spiritual teacher you have to develop your mind in a certain way, within spiritual practices that can help and influence changes in other people's lives. An art teacher can only do this in relation to art.

Q: From whom or from which experiences did you get the deepest support in following your attitude as an artist?

A: There have been a few people who have had a profound effect on me, produced upon meeting them. I can't say they influenced me but I felt a deep level of support from them. This support meant a lot to me at the time. These people were John Cage, Joseph Beuys and Susan Sontag.

Yingmei Duan

Q: You have so much energy, where does it come from?

A: I have been asked this question many times and do not have an answer. I know that for as long as I can remember I have been this way. Maybe it comes from the fact that I really believe in what I'm doing.

Q: How can students continue to make performances after completing their studies at the art academy?

A: This is a universal question, what happens after students finish their studies and how can they become independent artists? How is it possible to be included in important group shows, how to have solo exhibitions and to be represented by art galleries? The preparation for all this has to begin during the time of study. Many students have a passive and lazy attitude at the school. They feel protected by the institution, making them passive and noncompetitive. That is why many want to stay for as long as possible, because in this position they are not forced to make decisions. They don't need to be faced with real situations of being artists in the real world. This is why I organise exhibitions for the students to participate in, for them to experience real situations outside the walls of the academy.

Q: How can performance artists live from performance work alone?

A: This is very difficult but not impossible. Performance artists should generate different types of material which the collector, museum or gallery can buy: video documentation, video installations based on the performance, photographic documentation, photo works based on the performance, etc. If the performance has a more installation-based character, there could be a combination including the performance objects, etc. There is also the fee for the performance and many artists also give lectures. In the beginning of your career, the fee should cover the material costs and the honoraria should be enough to survive on until the next performance. By developing ideas and exhibiting more works the young artist can slowly reach recognition and the price for works will increase. As always, there are no easy answers for this.

Q: You are different from other professors insofar as you organise many exhibitions in

which your students can take part, can you tell us why?

A: Every year I provide my students with different international exhibition possibilities in which to participate, generally between three and five venues a year. I do this so they can experience real stress and deadlines while taking responsibility for their work in front of the public. At the same time they will learn how to work within the infrastructure of an institution. After they finish in the academy they will be more equipped to deal with being artists in the professional world.

Q: What is your main wish for your future life?

A: That my work as an artist should produce some difference in the world.

Q: How did you create your study programme?

A: When I decided to become a professor I collected lots of material and gathered all the experiences I had been through, all of which enabled me to design a programme that is very flexible and adaptable to the many different personalities of my students. The programme is based completely on my own personal experiences. During my work with my students, I also go through a process of learning every day; they lead me to add and subtract from my methods constantly.

Q: Why do you like the opinions of your students?

A: I don't see teaching as a monologue, I see it only as a dialogue.

Q: Do you have a lot of time to rest?

A: I don't have much time to rest, which is why I have to create long performances where I make time for myself.

Q: What do you do in your free time?

A: If I had a job from nine to five, I could consider after five to be my free time but being an artist is no such job. An idea can come at any time, at any place; you have to be alert and prepared for it. My only true free time is when the performance is finished; the day after I feel empty, quiet and at ease.

Q: You are very nice to your students. Have they ever disappointed you?

A: Firstly, I hope the other students share the same opinion. Looking back, I don't think I am always nice. I can be very hard on students if they lie to me or if they are dishonest, if they don't finish their work and if they don't keep their promises. Regarding being disappointed in my students, yes, [I have been] many times. Not only disappointed but also hurt by their behaviour. Sometimes I show it, sometimes I don't. I try to understand the real reasons for such behaviour.

Q: After finishing their studies, some students continue to use your name. Do you think this is a misuse of your name?

A: If the student uses my name in order to get an exhibition, it's fine by me. It can be just the first step, opening the first door, but after that the content of the work has to develop independently of anybody's name. The relationship can be like that of mother and child, but the umbilical cord has to be cut eventually.

Daniel Müller-Friedrichsen: *Blast from the Past*, 2003
Performance, *Recycling the Future*, 50. Esposizione Internazionale d'Arte La Biennale di Venezia, Venice, Italy, 2003

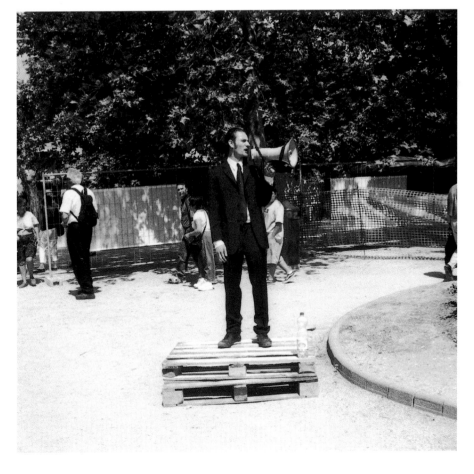

Irina Thorman

Q: What kind of role does religion have in your performances?

A: I am not particularly religious; I dislike religion because it is like an institution to me. What I do believe in is spirituality. I also believe that one of the components of a work of art should be spiritual, and this aspect is very clear in my performances.

Q: Which idols did you have when you were young?

A: It is very strange but when I was a young girl I never played with toys. I never had a favourite toy or doll. As I grew up, the same happened with idols. I didn't get attached to the idea of idols. When I look back in retrospect, I like some of the artists I have met, but I have never idolised them. These artists were Yves Klein, John Cage, Joseph Beuys, Tadeusz Kantor, Chris Burden and Vito Acconci.

Franz Gerald Krumpl:
Honkytonk
Performance, Irish
Museum of Modern Art,
Dublin, Ireland, 2001
video still: Susanne
Winterling

Q: Is there any painter whom you adore?

A: I always loved the work of Zurbarán. I love his still lifes, which were simple and minimal.

Q: Which painting would you hang on the wall in your house?

A: Any painting of a chair by Van Gogh, *Vincent's Chair with Pipe* from 1888, for instance.

Declan Rooney

Q: Can art really be taught? Is it possible to acquire or is it an inherent ability, whether channelled or otherwise?

A: Only to a certain extent can art be taught. I would like to give an example. In the past, hundreds and hundreds of artists used the same visual motif of the Madonna and Child. The Madonna was usually presented in a blue dress with one breast exposed, the child on her lap and two Apostles, one on her left and one on her right. It was the traditional way in which the scene was to be presented and fixed. Once in a while an artist would add something else or render the scene in a truly unique way within these controlled circumstances. It is essentially that little extra which makes an artwork great. This cannot be taught. In any one medium of expression and within certain existing rules, there is always an area in which to add that unique and sometimes radical extra element.

Q: "Theory is the lamp which sheds light on the petrified ideas of yesterday and of the more distant past (...) it does not precede practice, but follows it." Wassily Kandinsky, 1912. What is your opinion of this quote?

A: It is totally true. To answer this question I would add one other quote: "Well, I keep telling everybody this, and it's actually kept me in good stead because I was the son of an inventor. The fact that people weren't accepting what I was doing indicated that I was inventing something. In fact, I developed the opinion, which may be right or wrong but I still have it somewhat, that if

my work is accepted, I must move on to the point where it isn't." John Cage, 1982.

Q: What are the key lessons of experience, which you can now relate to your students?

A: - Lesson No. 1: The worst is the best. (Sufi saying)

- Lesson No. 2: More and more of less and less.

- Lesson No. 3: What you're doing is not important, what is important is the state of mind in which you are doing it. (Brancusi)

- Lesson No. 4: Don't be afraid to make mistakes.

Q: Do you approach teaching as a kind of "two-way flow", with students teaching professor and vice versa, a kind of mutual education?

A: It is a very nice way of saying it, teaching as a two-way flow. That is exactly what I believe in. There has to be chemistry and mutual understanding between professor and students.

Q: Who were or are your most valuable teachers?

A: The medicine man from the Central Australian desert, the Dalai Lama, the poetry of Marina Swevtia and the work of the scientist Nicola Tesla. As you can see, I don't mention any artists.

Q: What do you consider to be the main differences in how art is taught in academies today and when you were a student?

A: There are three main differences in how art is taught in academies today. Firstly, there are differences in current teaching methods; secondly, there are differences within educational systems; and finally there is a huge difference between Eastern and Western models of education. My studies in the art academy started every morning at 7:15 a.m. The professor was at the door to let students in, but after then you couldn't enter the building. If you didn't attend a lecture you couldn't pass the semester. It was a very strict military sort of discipline. We had fourteen theoretical and seven practical exams every year. I would study from morning till evening, and there

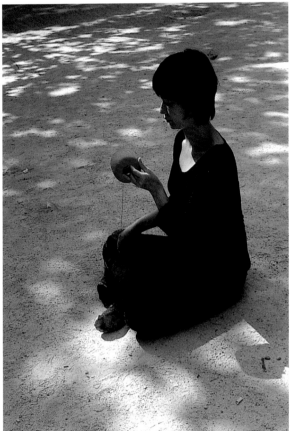

Heejung Um:
Disintegration II, 2003
Performance, *Recycling
the Future*, 50. Esposizione
Internazionale d'Arte
La Biennale di Venezia,
Venice, Italy, 2003

was never any time to play. I felt I got a solid education but I also had to forget and unlearn many things I was taught in order to find my own way. When I came here to the Western academy system I found a complete lack of discipline, a feeling of apathy, laziness and disinterest, and serious gaps in the knowledge of the history of art. I also found many students had difficulties in explaining what their work was about. I think the academy system has to be changed and several different possible models should be examined.

Q: How do you feel about the Black Mountain College as an interdisciplinary education complex? Is this model still relevant today?

A: This was a revolutionary concept at the time and also a visionary concept. I still think it is very relevant. Even today, all over the world, at the different symposia and discussions between artists, scientists and physicians, spiritual leaders and economists, people are looking for new models in which our society can function.

Q: What is your approach to students who possess radically different views on art from you, both conceptually and aesthetically?

A: An artist is a very subjective being, but if an artist is also a professor he or she has to learn to be objective and to accept opposite views. The professor has to evaluate these different views and establish a dialogue with the students. Sometimes when a student produces work that is conceptually and aesthetically opposed to something I believe in, I have to step back from my own beliefs and understand the reasons and ideas behind the work.

Q: Why is it important for you to teach?

A: As I have answered a variation of this question earlier, I merely wish to add that I find deep satisfaction in helping students to become artists.

Q: What about the element of chance or pure luck in acquiring possibilities to present artwork and in furthering one's career?

A: I must admit that for every biography written about an artist there is an element of chance and luck in their lives. This is very subjective and each artist will come up with different examples of it.

Q: Can the personality of the artist have a positive or detrimental effect on the artwork when it comes to the artist representing the work in a formal or public situation?

A: Yes, I agree. There are often situations in which the personality of the artist is so charismatic in presenting the ideas behind their work, that this pervades the actual work and postpones judgement until after the artist has left. The work remains, yet it seems as if something were missing. We have to learn that art has to be autonomous and that it should separate itself from the artist's personality. After all, one day we shall die and then we shall be unable to represent our own work. In other cases artists have difficult personalities, and this prevents them from presenting their works. The reasons can vary from shyness to intimidation, self-consciousness, lack of communication, etc. Artists should be aware of their own limits and find someone to mediate, like an agent, another artist or a critic. To a certain extent it is possible to be trained, even within the limitations of one's character, to learn to be able to talk about one's work. I place emphasis on this in my class; having the students write artistic statements about their work, learning to criticise other students work and learning to articulate ideas better. Another good learning process consists of giving lectures on one's own work as often as possible. At times, if a student is unable to express himself and the professor does not realise this, the student can close in on himself more and more, becoming almost impossible to

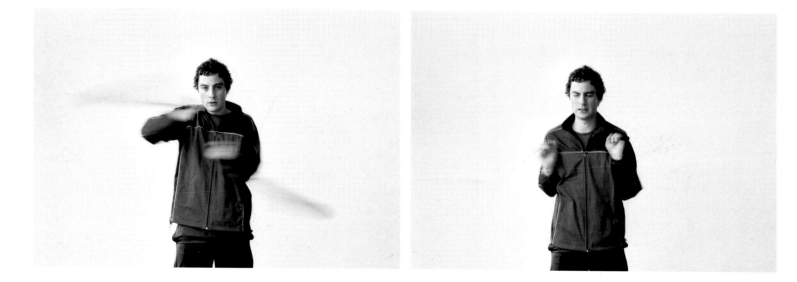

correct. In my experience, some excellent contemporaries of mine have this problem, projecting some very awkward public presences. Having a gallery take care of all the communications can sometimes solve this, although another problem can arise if dependency on the gallery system increases, eventually leading to the loss of artistic freedom.

Q: Should all artists manage their own work?

A: My answer is yes, I think artists should be able to follow the process of making and placing the work in the right context and within the right conditions. There is a long list of sad stories where artists have been misused and misrepresented. The artist should really know how the art business works, by visiting art fairs and auctions and learning from these events. So many artists, including myself, hate this part of the work and try to avoid it as much as possible. There is also the old-fashioned opinion that artists should not deal with money and business affairs, and that money is a dirty thing. I think the younger generation has a much better relationship with money than mine had. I remember my first show in Italy where my entire exhibition was never returned to me and when the works sold, I never received any money. I was even embarrassed to ask for the Belgrade to Milan return ticket. Even

now this gallery is making fake works, forging my signature. This would never have happened if I had been familiar with the mechanics of the art business when I was younger.

Q: If you could only give one more piece of advice to all of your students past and present, what would it be?

A: Take a risk!

Marica Gojević

Q: What is your next destination?

A: My next destination is another airport, another city and another country. There is always somewhere to go. I have been travelling constantly over the past thirty years and have never been in any place long enough to build up habits.

Q: What do you expect from yourself as a teacher?

A: As a teacher I expect myself to point my students in the right direction their work needs to develop. I hope to help my students fully realise themselves as artists.

Q: How important is money?

A: I place no importance on money but obviously it is necessary for the realisation of any new project.

Q: Do you like country music?

A: Yes, very much so.

Q: What do you expect from your students?

A: A lot.

Q: Are you scared at times?

Declan Rooney: *Beatific Performance*, 2002

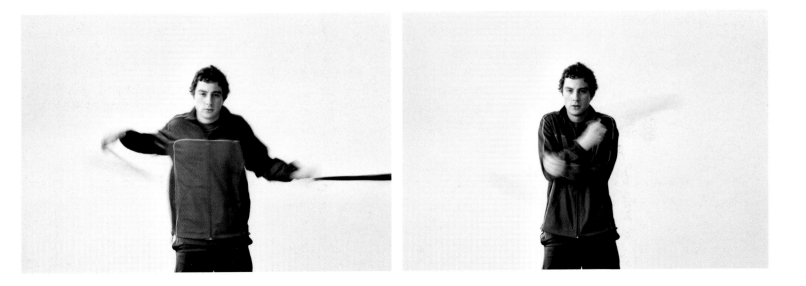

A: Yes.

Q: What are you scared of?

A: Failure.

Q: How important is success?

A: We should not be attached to the idea of success, but of course it is nice to have it.

Q: Do you have a question?

A: Yes. What is behind the universe? This is the same question that I have had since I was a young child.

Iris Selke

Q: Do you see art as the purpose of living?

A: Yes, it is the only purpose in life.

Q: Why did you choose art as your medium of expression?

A: I didn't choose art; art chose me. From a very early age I had no interest in doing anything else.

Q: How can you recognise a good work of art?

A: I cannot do this intellectually; it is entirely a question of intuition, not of the intellect for me. I get a strange physical sensation in an area above my navel. The intellect and understanding come later. First comes sensation and then understanding.

Q: What are the criteria for making good artwork?

A: The idea and the message should be clear and recognisable in the work. This is not the only thing but, as I have said previously, it is not something that can be explained rationally.

Q: What are the important guidelines to help younger artists further their work?

A: It is impossible to answer this. Each artist needs to be advised individually. All artists have to examine their relationship with their own work. There is no existing formula or recipe for this.

Q: Is it possible to judge a work objectively or subjectively?

A: I may think that I am completely objective, but if I am pushed to analyse this, it may not be entirely true. We all start from our own subjective opinion.

Daniel Müller-Friedrichsen

Q: When is an artwork finished?

A: There are many artists who are not able to complete the work and even when it has been completed, they continue to work on the same piece for many years. Sometimes the problem is not about finishing the work but about the fear of being separated from the work. It is up to the artist entirely to decide when the work is finished.

Q: Is competition useful for art?

A: My opinion is that competition is a very healthy thing. It is useful in making you work harder, making you become clearer and more focused.

Q: Which is a better working situation, harmony or contradiction?

A: This depends entirely on the individuals. In my case I prefer to start with contradiction, and then to bring the work to a more harmonic level.

Q: How important is destiny?

A: When we are born, we have a sort of blueprint or genetic code in which our destiny lies. Artists have to find a way to be in touch with themselves constantly in order to understand their mission and destiny.

Q: Which is more dangerous during the working process: self-censorship or repeating oneself?

A: During the working process both self-censorship and repetition can be very dangerous. When you are creating work you have to be completely free and unpredictable. Not think about the end result but completely enjoy the process.

Q: Is good work the key to success?

A: I believe that a good work of art is the key to inner transformation in which the artist is no longer concerned with succeeding or not succeeding.

Andrea Saemann

Q: Which spaces do you call your personal private spaces?

A: My toilet, the bus stop and the space under the pillow.

Q: At what moments are you struck by

doubts and fears?

A: At the end of a relationship.

Q: How do you imagine your own death?

A: I have a few ideas about that. One idea is the heroic death for an honourable cause, where I sacrifice my life in saving humanity. The second idea is death as a performance act. The third is getting very, very old, dying in a seated position at will, fully conscious. Quiet and peacefully, without being filmed. If I could, I would like to die three times and explore each of these deaths individually.

Hayley Newman

Q: What kinds or dialogues were you having with artists in the seventies compared to the dialogues you are now having with artists?

A: I have to say there is a big difference between these two periods. I feel there is now a total lack of enthusiasm, openness and readiness to take risks and explore new possibilities. I miss long nights in feverish discussions, talking about different ideas and concepts. These days, everything is more focused on strategies, politics and money.

Q: How did you find your tenor as a solo artist again after working as a collaborative artist with Ulay for so long?

A: I found it very difficult. For a long time the public didn't accept that I was working alone again. I have for years been asked to show collaboration works and being forced somehow to live in the past. I had to make an enormous effort to establish my new work and to start living in the present.

Q: Can you talk about the importance of both performer and viewer experiencing shame in performance?

A: This is a very good question. There are not many artists who think about the idea of shame, which I think is very important, only a few artists work with this idea. One of the most disturbing and interesting performers to deal with this subject of shame was Leigh Bowery. He managed to create a shameful situation where he put himself in front of the public and created a complete feeling of embarrassment and shame. When you experience this as a performer or an audience, the emotions are so strong and profound that during the process you feel an opening of a new door in yourself that you were not aware existed.

Q: You proposed once that you wanted to re-perform classic performance works. If you did this, how would you represent yourself?

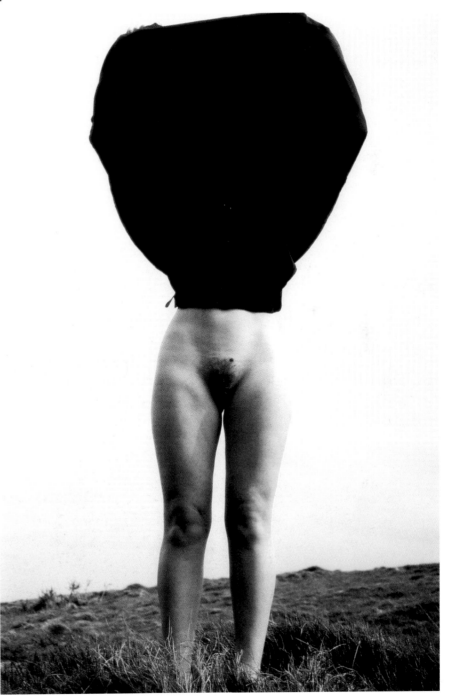

Amanda Coogan: *Athena* Photograph, Ireland, 2002

A: I would be represented as myself, giving my own interpretations of performances that I liked in the past. At the same time I would correspondingly show the original concept and the documentation of the original material.

Q: At which point in history do you believe that performance art established its own canon?

A: In the seventies.

Q: You have maintained an ongoing, extended dialogue with performance. Latterly, you seem to have sustained your practice by reviewing both your own work and that of others. Is this correct? If so, what are you implying?

A: I think it is very important to see artwork in context. That's why when I give lectures I like to show different works that I like and that I can relate to. By doing that, my work becomes clearer to me.

Q: The School of Abramović appears to be modelled on the European (classic) atelier system. Is this a conscious decision and does it produce any particular benefits in relation to more impersonal academic pedagogy?

A: The Abramović class is part of an already existing structure, the art academy, and this is where I teach. That is why it appears to be part of the traditional atelier system, but personally I don't believe in the benefits of an impersonal pedagogy.

Q: Can you describe some of the energy

transformations you have experienced? I am particularly interested in distinguishing different kinds of exchanges you have had between yourself and the audience. Are such exchanges controlled or not?

A: I control the energy that is established between myself and the audience during the performance.

Masha and Anton Soloveitchik

Q: Are your inner problems reflected in your performances?

A: My work includes very many elements related to my life: ups and downs, depression, sickness, insecurities, separations, deaths in the family, happy moments, love, misunderstandings, etc. I put them all into a cooking pot, adding all kinds of ingredients to make an artwork. I hope to produce good soup in the end.

Q: Is it possible to be an artist and also keep to social traditions (having children, etc.)?

A: Personally, I don't believe in this possibility but I speak only from my own subjective experience. I couldn't manage it in my life. I didn't have enough energy to divide between family, children and my art. I chose art. However, throughout history there have been plenty of examples of artists who could manage both. There are no set rules.

Q: Where would you like to live? By this, I mean a place you feel strongly about and could stay forever.

Oliver Blomeier: *In the Shell (1980-1992)* Performance, Hochschule für Bildende Künste, Braunschweig, 2002

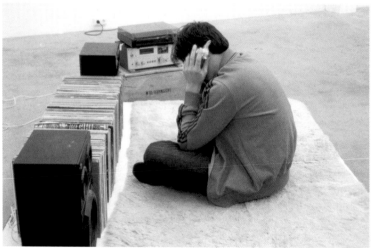

A: There is no such a place; the only place I really know is within myself. It doesn't matter where I am at any given point.

Herma Auguste Wittstock

Q: Do you love yourself?

A: Sometimes I do, but very rarely. Most of the time I really don't.

Q: What would you prefer to be doing at this moment instead of answering these questions?

A: I'll answer this with a quote from Roni Horn: "I don't want to do anything but be here. Doing something will take me away from here. I want to make being here enough. Maybe it's already enough. I won't have to invent any more."

Q: If you had a chance to change one thing in your life, what would it be?

A: My age.

Q: If you could choose one person you would like to meet, living or dead, who would this person be?

A: Ling Rinpoche.

Melati Suryodarmo

Q: Do you think artists have to search for their own spirituality?

A: I think spirituality is just one of the elements that an artist should search for. Artists also have to find out who they are and what their function is exactly.

Q: Do you think artists should compare themselves with pop icons?

A: I don't think so, this should be left for others to do if they wish; it is not an artist's job.

Q: Do you think the position of performance art is clear within fine art traditions, or is it still an independent art sector?

A: There is no such a thing as an independent art sector, or performance art having a clear position within fine art. Performance is just a tool or a medium which artists can use to express themselves.

Q: How do you recover your aura after the rush of day-to-day work?

A: If one wants to be balanced, centred, in tune with one's surroundings and to have a

Feun Hye Hwang: *No*, 2003 Performance, *Recycling the Future*, 50. Esposizione Internazionale d'Arte La Biennale di Venezia, Venice, Italy, 2003

clear aura, one has to renounce the life one lives in this society and go to a monastery where it is more easy to achieve such balance. For an artist this is not a realistic way to live. We have to find this balance amidst the rush of everyday life and our work. In my case, I get the right balance during my performances. When I return to real life, I lose this balance, but then I go back into a performance again, and so on and so forth.

Q: What do you hope to do in the next ten years?

A: Exactly the same I am doing now, doing the best I can do at any one moment.

Q: What do you do with your old clothes?

A: Every few years, I put whatever I don't use anymore into plastic bags and leave them on the street during Queen's Day, when everyone in Holland does the same. You leave the clothes out and people can take the things they like. I should say that I do actually wear my clothes for a very long time.

Q: In the supermarket, do you ever pay with little coins?

A: Actually I love to collect little coins. I love to exchange them for notes at the airport *bureau de change* and enjoy looking at the impatient faces behind the glass counting the many little coins. I don't remember having any specific pleasure in paying with little coins though.

Q: Have you ever thought you wanted to give up the artist's life?

A: Never, not even once!

Q: Do you think that younger artists today have less interest in political situations, compared to artists from your generation?

A: I don't think so, every generation has a different relationship with the political situation that exists in their times. Artists should generate their own responsibility.

Beatriz Albuquerque

Q: Solitude is a human trait, why is it so present in the workshops you organise?

A: Solitude is very important during the time of the workshop. We spend too much energy communicating verbally. During the workshop the idea is to change from being extroverted to becoming more introverted. It is an interesting contradiction because you are in a group yet at the same time you are very much alone.

Q: Does the community stand above the individual?

A: Absolutely, yes. I believe in interdependency and the fact that everything is related. As an individual you have to be aware that you are part of a community.

Q: Is abstinence necessary to acquire balance?

A: Practising temporary abstinence is very beneficial in acquiring mental and physical balance.

Q: Is love important?

A: I consider love to be the most important feeling that a human being can experience.

Carmen María Julián Molina

Q: How often do you feel the need to stop and "clean the house"?

A: The *Cleaning the House* workshop should be done at least once a year but the ideal would be to do it twice a year, in early spring and at the beginning of winter.

Q: What do you hope to teach your students through the workshop?

A: I hope to teach students different ways to understand themselves, to learn self-control and to understand their own boundaries.

Q: What do you think we learn as a group?

A: As a group, I hope my students understand interdependency, tolerance and self-control.

Q: As individuals, what do you think we learn?

A: To face hardship and then to understand the functions of the mind and the body.

Q: What do you think we learn as artists?

A: To learn how to listen to your intuition.

Q: How can we apply what we have learned to our everyday lives?

A: This is completely up to each individual. Some of the participants go on with their own lives after the workshop, with no changes. For some, it is a turning point at which to decide to apply the workshop experiences in order to change their lives.

Q: What do you learn from us as a group?

A: I can't really specify. Each workshop is a deeply emotional experience. With each group I go through difficult periods and this brings me very close to each participant, almost in the sense of family. It's not really what I learn, it's more the feeling that stays with me.

Q: What do you learn from each specific place, culture and climate?

A: I have been giving workshops in different cultures, continents and climates, and each workshop has to be adapted to suit the circumstances. There are certain rules that each country imposes and which have to be respected. For example, in Muslim countries we cannot work with the naked body. We have to be open and sensitive to religious, cultural and social limitations.

Anna Berndtson

Q: How do you decide which exercises you choose to use in the *Cleaning the House* workshops?

A: All the exercises I use in the workshop I have tried myself. I use different exercises during different workshops, reducing them or adding new ones. It depends on the group and their mental and physical abilities to deal with the exercises. There is always an unbalance between the physical endurance levels of the individuals I choose for every workshop, the exercises that all can take part in.

Q: Have you gathered the exercises from workshops you have participated in or are they your own?

A: Some of the exercises come from different workshops made around the world. Others I have adapted and modified, and many I have completely invented myself. For example, there is a ceremony in the Central Australian desert in which before men start to make a painting on the ground

the women will stamp the ground with both feet, until the earth becomes very flat. After doing this for a long time, all the men from the tribe arrive at the area and cut the veins in their hands. Once the blood has dried into the ground they will sit and paint images from their dreams on the surface. I took the first part of this exercise and excluded the rest. In Vipassana meditation practice, a retreat takes twenty-one days of walking, eating, etc. in extreme slow motion. For my workshop, I shortened and adapted this to last only one day. Another of my exercises is to look at the three primary colours, red, yellow and blue for one hour each. I also have an exercise where one has to hold a tree and complain for fifteen minutes.

Q: What do you expect your students to get out of the workshops and what do you get out of them?

A: I expect the participants to benefit from the workshop as regards the concerns of their own work. What I have seen up to

Ivan Čivić: *Naturally Sexual*
Performance, Centro Galego de Arte Contemporánea, Santiago de Compostela, Spain, 2002

Iris Selke: *Maria et Luigi*
Performance, Irish
Museum of Modern Art,
Dublin, Ireland, 2001

Q: What is the connection between meditation, fasting and performance?

A: For me there is a strong connection, it's like one thing divided into two parts. The first part is the preparation which comes in the form of meditation, fasting and physical and mental exercises. Secondly, there is the moment you enter into the performance in front of the public at a precise time and within a precise space.

Q: During the workshop you are not allowed to communicate, so what do you feel about participants who communicate through sign language or through facial expression for example?

A: This is difficult to stop. I notice that for my students it is harder not to talk than not to eat, and so they find other possible ways in which to communicate. I try to minimise this, but it's impossible to keep my eye on twenty people at any given moment. The need to communicate comes from the inability to focus entirely on oneself during the workshop.

Q: How important is it not to communicate, and what do you intend to achieve by this?

A: Walking around the lake twelve times takes nine hours, on empty stomachs and with only water afterwards it is an extremely difficult thing to do. Communicating is essentially using large amounts of unnecessary energy. The main idea of the workshops is not to use the group energy but to use the energy of each individual.

now is that after the workshops, most participants get a flow of new ideas and their work becomes clearer. They undergo a form of self-transformation. The participants and I get a burst of energy and become positive after the workshop. The general feeling is that the hardship was worth it. For me, a strong sense of unity is created between those who have taken part in the workshop.

Only once have I had a bad experience with the participants of a workshop. This was in Denmark, when after the second day of the workshop two students left the house by night to get a beer at the nearest town, which was 7 km away. It was late at night and they thought I hadn't seen them leave. When they returned later, I locked the door and refused to let them in. They were thus excluded from taking any further part in the workshop. The following year, those particular students were the first to sign the list to join.

Q: How important is it for the audience to fully understand the concept behind any one performance?

A: Before the piece is performed with an audience the students perform it for the class. Together, we discuss what we have seen, ask questions and criticise elements that the students or I think are unnecessary and which hinder the clarity of the work. Then it is performed again and again, until we all think it is ready to be presented to an audience.

Q: If the image works, is the idea behind the performance less important?

A: There is sometimes a very big gap between the idea of the artist and what the public perceives. The work should be open and not completely hermetic so that the audience can project its own feeling into it. If the artist can create an image that has a strong idea behind it, the public will react to this image, and there will be as many interpretations as viewers seeing it.

Vera Bourgeois

Q: Do you think that it is a female concept to put all your efforts into teaching and yet give up teaching when you want to concentrate on your own work? And how does this compare with male professors who hold a teaching position for over ten years, without wanting to leave? Do you think that women go about teaching differently?

A: I do not like establishing any form of classification between male and female teachers. I don't think it matters whether the teacher is male, female, gay or straight. You only have to look at the work to see if it is good or bad work. In my point of view, most artists who have long term teaching positions usually cease to be internationally active. They remain local artists, and this is one way of finding security and recognition in society – being a professor. Somehow progress stops and the work becomes a habit, and I am very much against habit.

Q: What is the symbolic meaning of teaching for you? Is it a symbol of a political or social process?

A: Politically it is totally irrelevant. For me, teaching is transmitting my own experiences and what I have learned. In my career I have found that the younger generation can really learn things and use these teachings in their own way.

You are at the base of a large mountain and you don't know how to get to the top because there are many different roads to take. You may choose one road, but it may take you a very long time to get to the top. However, if you find a guide who can take you to the top straight away because he knows the right road, this would be a much better way. The function of the artist as a teacher is to be this guide.

Nezaket Ekici

Q: Is it important for students to continually make new works, or can they continue to work on older pieces, placing them in new contexts?

A: I prefer students to be constantly producing new works, to experiment and to create many new possibilities. It is very important to try things out, even if these things don't work. Departing from a body of work, choices can be made regarding placement in new contexts. I disagree with this if it happens too often, because of the danger of repetition.

Q: What is the optimum lesson or plenum for your class?

A: I like it when students get passionate about the subjects they are discussing and when the discussion is constructive but at the same time it has clashing opposite opinions. I like the feeling when the class gets together, creating a feeling of unity. It is in such discussions that we can best clarify our different points of view.

Q: In the plenum/class situation you give a

Tellervo Kalleinen:
Take It
Performance, Irish Museum of Modern Art, Dublin, Ireland, 2001

Isabella Gresser: *Sad Tropics* Installation, Hebbel Theater-Berlin, Germany, 2000

lot of positive energy; do you get the same from your students?

A: I do not judge it in terms of receiving or giving energy. Sometimes the students give energy but sometimes they exhaust me. I understand that it takes a long time to create a balanced class structure. Ideally, the harmony between the class should be full of positive criticism and healthy conflict, which should not be based on feelings of anger or jealousy, etc. Before I come to the class I try to put away my own problems

and my own work, to be open and to be completely there for them. It is exhausting, but when I see the good work emerge, it is rewarding.

Q: Can you imagine giving a one-day lesson each week like many other professors, or is it essential for you to give only one intense lesson, lasting a week long, every month?

A: For me it would be impossible to give lessons every week. I work with extremes and I need complete concentration from my students and from myself in order to achieve results, which is more likely over a longer period of time. I always prefer intensity over routine.

Q: Do you have a big dream to fulfil with the class?

A: My big dream is to take my students around the world and to show them all of the geographically important places where energy is highly concentrated and where I have been before. These are places where I would like to go again, this time with my students. My dream is to share this knowledge and experience with the class.

Q: Do you maintain contact with your ex-students?

A: This depends very much on the ex-students themselves. If they want to remain in touch with me, I will be there for them. Personally, I am always interested in following them and seeing their development.

Q: You speak a lot about slow motion and practice, what does this mean for you?

A: In some of the exercises in my workshops I like to experiment with slowing time down by practising with slow motion. Our pace of life is so fast that we never seem to have any time. Within the framework of the workshop, we can finally practice slow-motion movement, self-control, will power, perception-heightening exercises, etc. This practice is very valuable for use later on in performances.

Q: In one of your recent works you fasted for twelve days; can you imagine this happening in your workshops with students?

A: Absolutely not. Special mental preparation is required for such a period of fasting, otherwise it could be dangerous. I do not want to expose my students to any kind of risk. If I fast for twelve days, I do this at my own risk. In the workshops the minimum number of days for fasting is three, and the maximum is five. Before the workshops, students sign a certificate stating that they don't have any mental or physical problems and only those who sign this certificate can participate. If fasting is important for you, once you have completed your studies at the academy you can practice on your own, adding one extra day to each of the fasting periods you do.

Q: The workshops usually end with an exhibition of artworks by participants. Is this important for the concept of the workshop?

A: Yes it is true, most workshops end with an exhibition of performance works, but it is also possible that the workshops finish before that. The reason I end with performances is that during the workshop the students' mental and physical states are intensified. Not speaking during the period of the workshop makes concentration travel inwards instead of outwards. This leads one to the right state of mind in which to create a performance, which is why after the workshop the students carry out performances in order to experience this state, and to understand why the preparation is so crucial.

Q: How did you arrive at the idea of this workshop book?

A: I have been wanting to make a book dedicated to all my students for a long time now. This book will have two parts: the first part will contain the exercises and echo a cookery book, to be used at any time. The second part will be selections from students' own works, which they can also use as a catalogue for their own needs. Artists can often be very selfish and possess big egos, and that goes for myself as well. Yet through teaching and constant

contact with my students, I realise that I don't always need to be the centre of attention. The students teach me. I have an immense pleasure in making this book. It takes the form of a gift to all of my students, past and present.

Viola Yesiltać, Ivan Čivić, Susanne Winterling, Daniel Müller-Friedrichsen:
Psycho Civilize
Group performance, 2002

1979-2003

Cleaning the House

Workshops

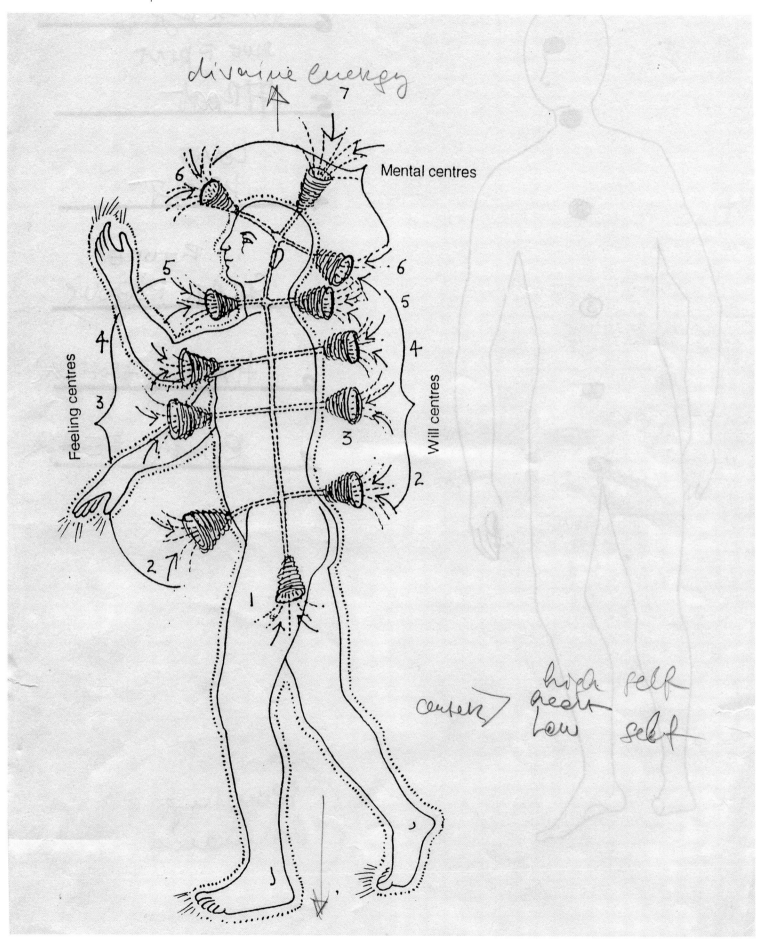

divine energy 7

Mental centres

6

6

5

5

4

4

Feeling centres

3

3

Will centres

2

2

1

centres high self
heart
Low self

Reflection on the Mental and Physical Condition
of the Artist

In ancient times, the artist, poet, philosopher, builder would climb silently
to the top of the mountain and there, in solitude, would be confronted
with what the Chinese refer to as Chi'j energy. This would condition their body
and their mind to one single point of concentration.

As a result of that particular state would come for the poet one line of poetry,
for the philosopher new thoughts, for the builder new solutions,
for the artist new work.

In the Renaissance, one could read in a book by Cennino Cennini how
to prepare the artist to paint the cupola of a church. He said three months
before starting work, the artist should stop eating meat, two months before
starting work, he should stop drinking wine, one month before starting work,
restrain from sexual desires. Three weeks before starting work, the artist
should put his right arm into plaster, the day he starts work, he should break
the plaster, take a brush and be able to make a perfect circle with a free hand.

Brancusi said:
"What you're doing is not important, what is really important is the state
of mind from which you do it."

That state of mind was essential for me in the moment of performing.
That fragile passage between one reality and another, when you take a step
towards your own mental and physical construction. In my extensive trips into
other cultures, I found different ways of achieving that conditioning.
I made my own symbiosis based on personal experience.
The function of the artist is the function of the servant.
At this particular point of my life, I feel that I can transmit my knowledge.
My field of action is restricted to art academies.
This is the place where the new generation of artists is emerging.
This generation of artists needs to be assisted.

Certificate

I hereby state that I am in a good condition of health and I am not suffering
from any kind of mental, physical or genetic disorder, anorexia, bulimia;
I am not pregnant and I am not using any prescribed medication
or drugs at the present time.

I assume full responsibility for my participation in the workshop.

I hereby declare that I will be in attendance for the entire duration
of the workshop and that I shall not leave at any moment, except in case
of physical or mental problems. If such an occasion should arise, this would
have to be discussed personally with Marina Abramović, who is the only person
who is able to decide whether a participant can leave the workshop.

Consumption of alcohol, drugs (in any form) and cigarettes is strictly forbidden
from beginning to end of the workshop, as is engaging in sex, reading
and talking. Consumption of any kind of food is also forbidden during the
advised period, with the exception of large amounts of water and herbal teas.

I hereby state that I will not issue any financial claims before,
during or after the workshop to Marina Abramović.

I hereby state that I agree to give Marina Abramović permission to publish
any material I may produce during the workshop.

I hereby state that I have read, understood and fully agree with the contents
of the certificate, and hereby sign accordingly.

Date:

Participant:

Signature:

Conditions of the Workshop

Cleaning the House - Workshop Concept

A maximum of 25 students should arrive at a given location, chosen
for the purpose. Everyone must be equipped with a sleeping bag,
one pair of heavy walking shoes, and one pair of light sneakers.
Clothes should be uniform – similar to factory clothes – e.g. dark blue overalls.
Under the overalls, students may wear their own clothes.
Personal possessions: one bar of non-perfumed soap, one bottle of pure
almond oil. Men only: razor blades. No kind of perfumes or make-up.

Duration of workshop: Seven days.

During the first three to five days, the exercises involve not eating
and not talking. The conditions of each exercise will be explained
at the moment of execution. It is also extremely important
for each participant to drink 2-3 litres of fluid per day.

Throughout the period of the workshop we shall need herbal tea,
one booklet of 24-carat gold leaf (this can be purchased in an artist's supply
store), 33 black peppercorns, 100 grams of unpeeled almonds, a small pot
of honey and 21 coriander seeds. These ingredients are required in order
to make gold balls for the last part of the workshop.

After the period of abstaining from eating and talking, participants will be
asked to produce work in this newly achieved state of mind using
the minimum material.

The Workshop Will Teach Participants

Endurance

Concentration

Perception

Self-control

Willpower

Confrontation with their Limits
Mental and Physical

The Workshop Exercises

After my long process of research and personal visits to workshops,
I came up with many exercises that I find very useful while working with my body
as a performance artist.

Each exercise is designed to help further understanding of how our body
and mind function. Walking backwards holding a mirror before our face
for orientation helps us see reality as a reflection.

Writing our own name during one hour, with a pen poised continuously on the paper,
helps us expand our levels of concentration.

Taking a bath in the ice-cold water of the river or sea, helps us reinforce
our physical strength. Looking at the primary colours helps us to sharpen
our perception, etc.

Location

Finding the right location for the workshops is very important. I prefer they be outside of art academies and cities. It is best to bring the participants to a different country; I like to think the participants cannot relate to their new environment. Their own environment is connected to certain habits and fixed ways of thinking, so being out of this environment, confronting different languages and cultures is much better. The best locations are those in nature, far from villages and even from other houses. I prefer simple and basic forms of accommodation with minimum facilities, such as toilets and warm water. Warm water is very important because when one doesn't eat, the body temperature drops. Water is also essential for purification, achieved through showering several times a day. The best location would be places next to the sea, waterfalls, volcanoes – spaces where the geographical location already contains a certain amount of energy.

Kerguéhennec, France, 1995

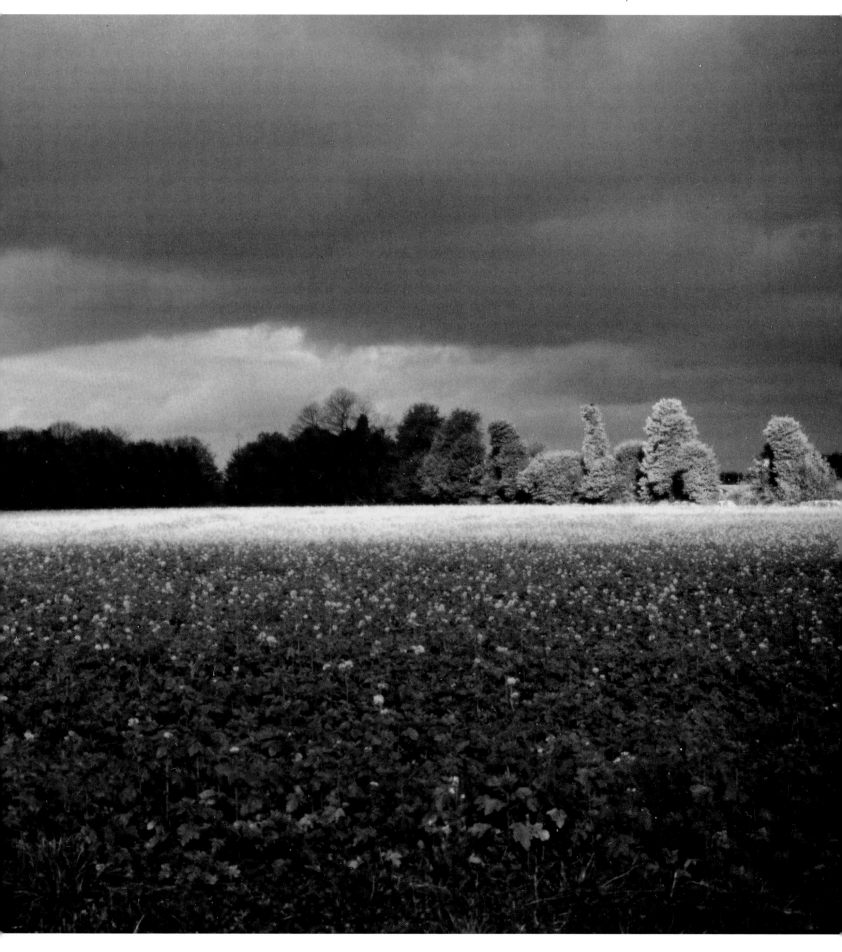

Food before Workshop

The day before the workshop begins, all participants arrive at the location. In the evening we all gather together and cook the last meal before the workshop starts. For the general spirit of the group, this is a very important time because it is also the last moment the participants have time to converse. The meal consists chiefly of vegetable soup, rice, boiled potatoes and salad. Participants usually eat large quantities in a state of panic at the thought of what is awaiting them the following day. The mood is very exhilarated and I am asked numerous questions about the conditions of the workshop.

Even if I suggest that the students go to bed early because of the hard days that lie ahead, they usually go to bed late and I can still hear them talking to one another in their rooms. Some of the participants have not met previously, so they feel they have to get to know each other as quickly as possible. As for myself, I go to bed early knowing that for the next week I must assume full responsibility for these participants.

Maastricht, The Netherlands, 1989

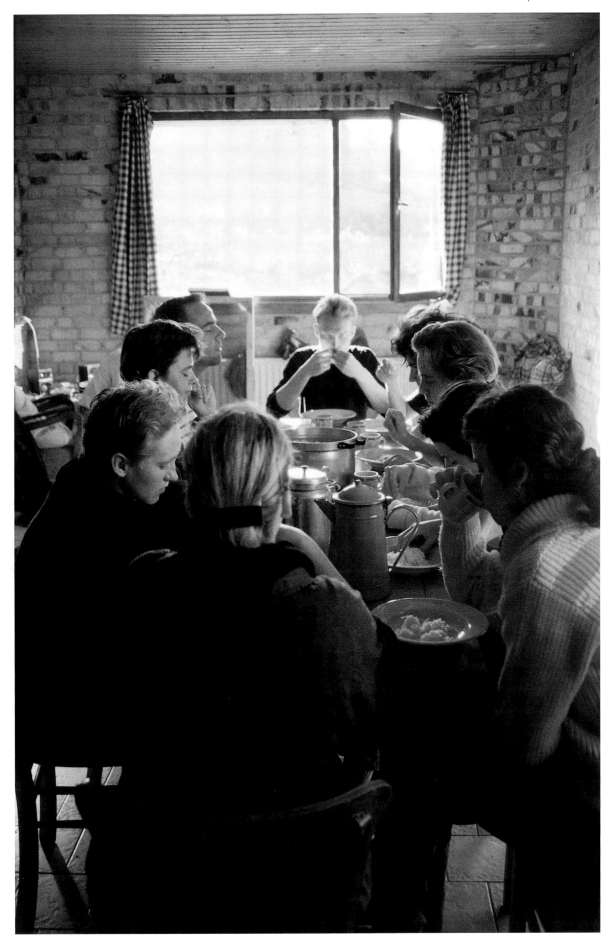

Different Morning Exercises

With the sound of the pan and spoon,
participants have to get out of bed inmediately.
Run outside of the house and start the morning
exercises.

30 minutes

Stepping on the Ground Exercise
In the early morning between 6 and 7,
naked, regardless of weather conditions,
go outside onto the land,
stepping on the ground and checking the body.

30 minutes

The Jump Exercise
With eyes closed,
wait for the call,
jump and use the entire energy of the body,
lifting both legs at the same time,
jump as high as possible
and at the same time release a scream.
Repeat three times.

Kerguéhennec, France,
1997

Kerguéhennec, France, 1997

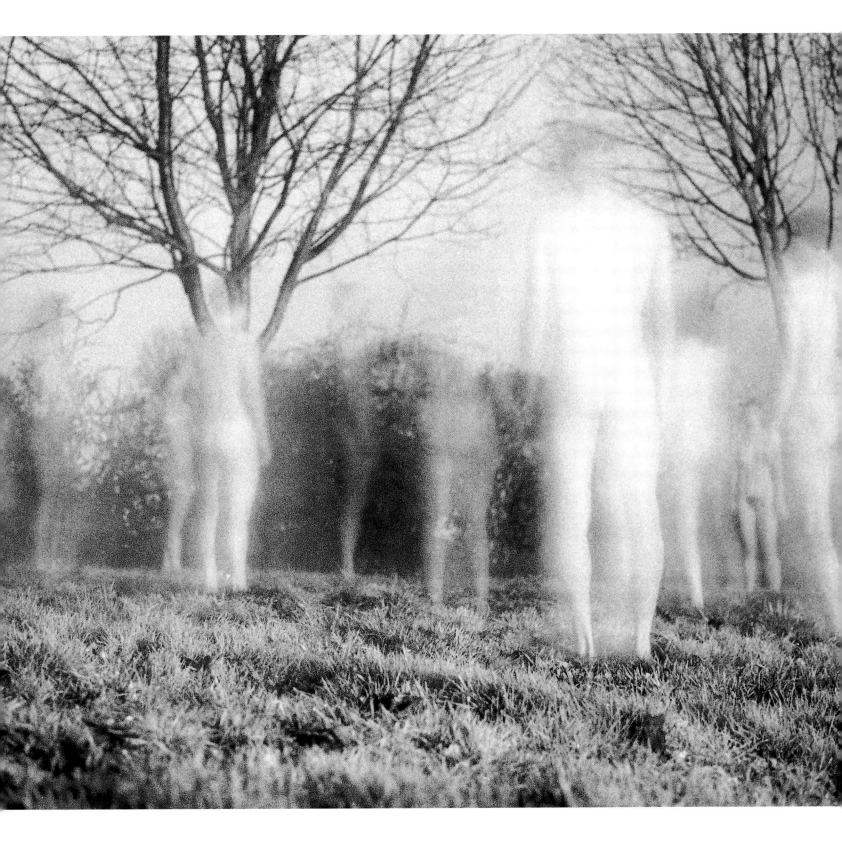

Running Exercise

In the morning after waking up
and still in night clothes
put on running shoes.
Run a fixed route around the house.

25 minutes

Antas de Ulla, Spain, 2002

Water Drinking Exercise

With your hand, hold a glass of pure water.
Wait and look at the water.
In slow motion, bring the glass to your lips.
Drink in small sips as long as you can.
Put the glass down and repeat this activity
throughout the day for a minimun of 21 times.

Kerguéhennec, France, 1995

Stop
with Mirror
Exercise

Participants are engaged in various activities in their free time between exercises. For example: drinking water, resting, writing in their diary, looking into the landscape.

Unpredictably, I will hold a mirror in front of a participant's face. He/she is not to change the facial expression of the moment. I demand that the participant look in the mirror.

5 minutes

Antas de Ulla, Spain, 2002

Breathing Exercises

No. 1
Sitting on the ground,
close the left nostril with a finger
and breathe in air deeply through the right
nostril nine times.
Repeat the same exercise with the left nostril,
and then breathe in air nine times
with both nostrils open.

No. 2
Lying on the ground,
press your body against the floor,
as forcefully as possible without breathing.
Keep this position as long as you can,
then breathe deeply and relax.

Repeat 12 times

No. 3
Standing,
breathe through your mouth only,
suck in the air as forcefully as possible.

1	time in	1	time out
2	times in	2	times out
3	times in	3	times out
4	times in	4	times out
5	times in	5	times out
6	times in	6	times out
7	times in	7	times out
8	times in	8	times out
9	times in	9	times out
10	times in	10	times out

Grenoble, France, 1992

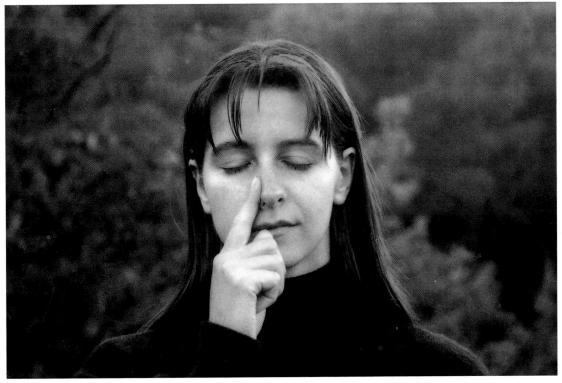

Kerguéhennec, France, 1992

North of Newcastle, England, 1996

Long Walk in Landscape Exercise

If the workshop is in the winter, bring warm clothes and comfortable walking shoes.
Start walking from the house in a straight line through the landscape. Walk in one direction for 4 hours, rest and return using the same route.

8 hours

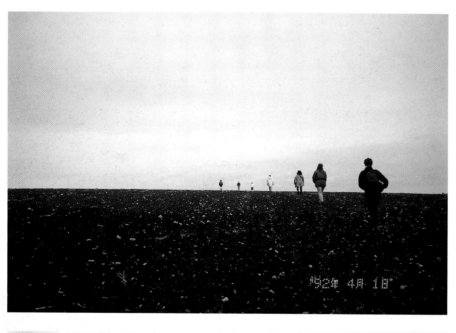

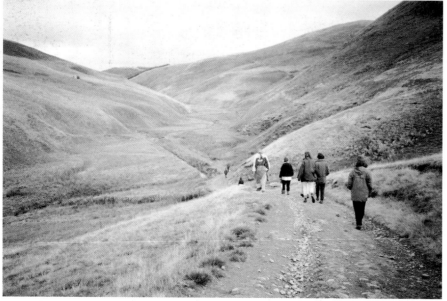

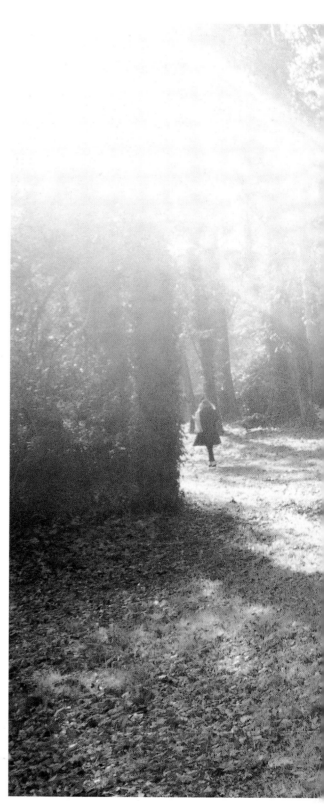

Kerguéhennec, France, 1992

North of Newcastle, England, 1996

Kerguéhennec, France, 1995

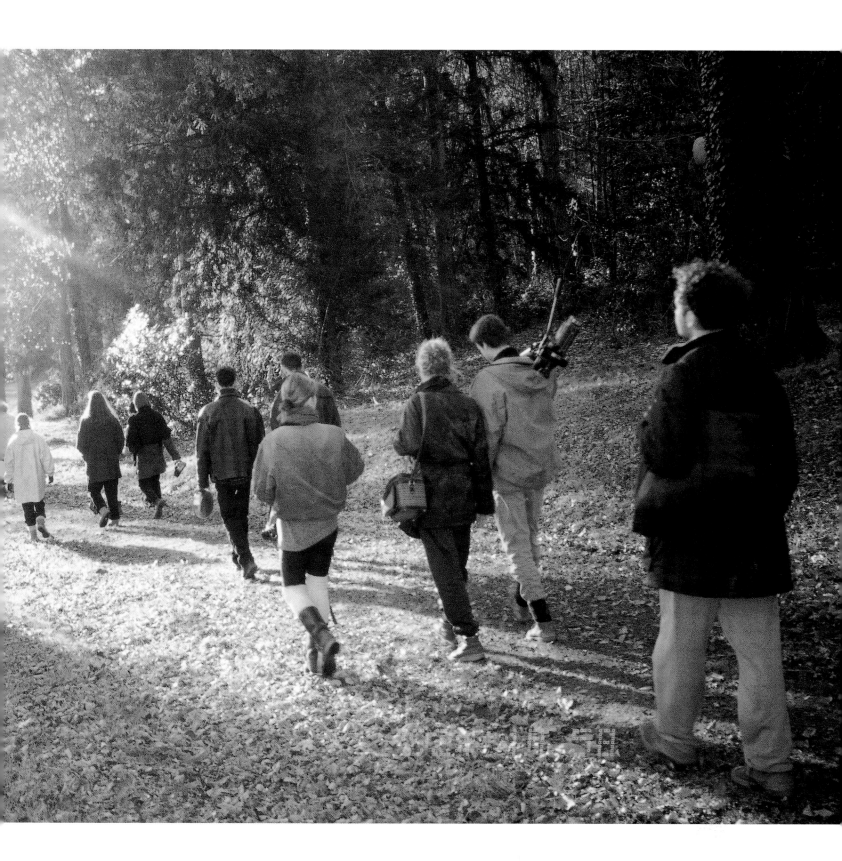

Blindfold Exercise

Walk far away from the house.
Stop, blindfold yourself.
Find the way back to the house.

Kerguéhennec, France,
2000

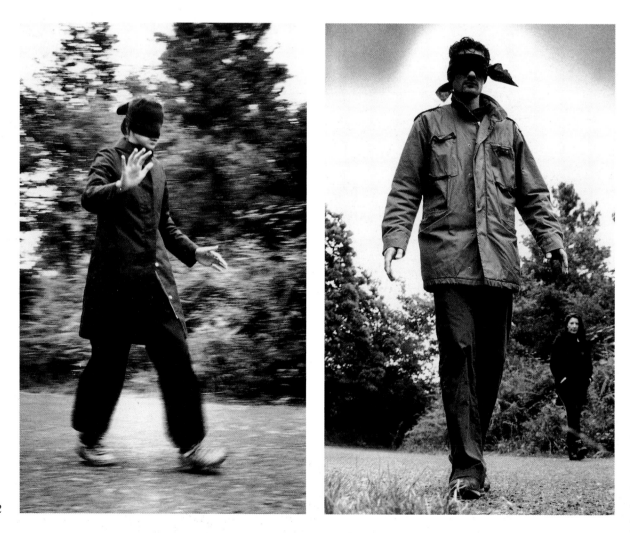

Antas de Ulla, Spain, 2002

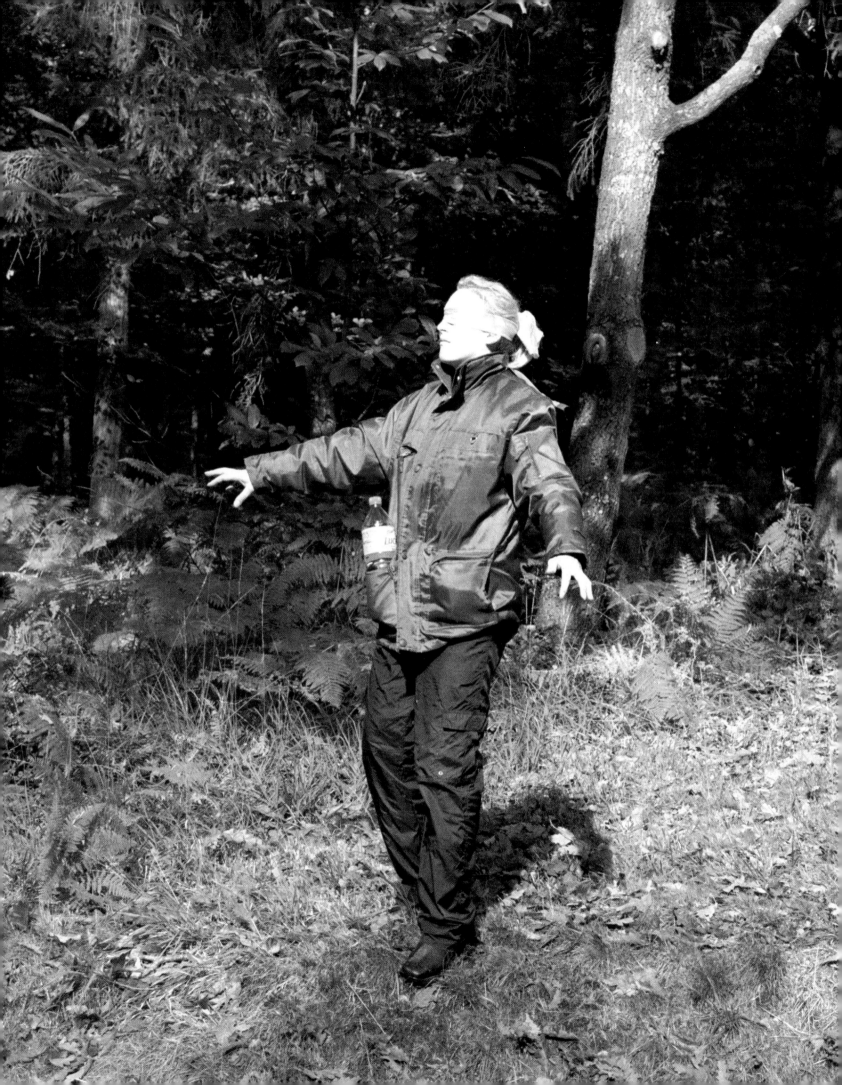

Mirror Exercise

Sitting on a chair,
facing a mirror.
Motionless.

1 hour

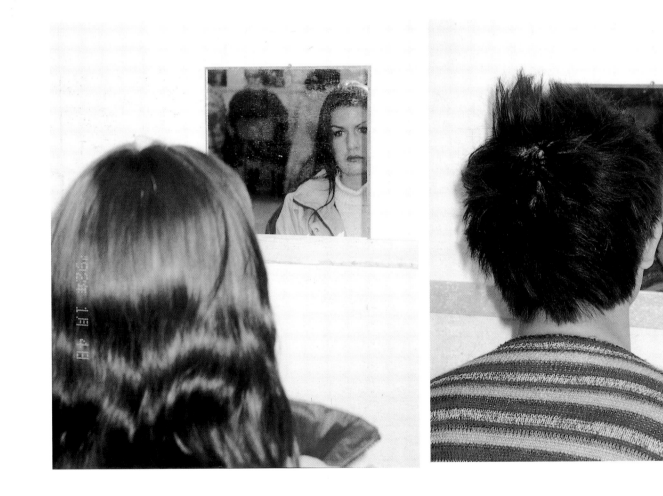

Holbæk, Denmark, 1996

Facing White Wall Exercise

No. 1
Sitting on a chair,
facing a white wall.
Motionless.

1 hour

No. 2
Sitting on a chair,
facing an empty wall.

7 hours

Kerguéhennec, France,
2000

The Lake Exercise

No. 1
Walk around the lake twelve times.

9 hours

No. 2
Walk around the lake one time blindfolded.

Kerguéhennec, France, 2000

Kerguéhennec, France, 1997

Colour Exercise

Sitting on a chair,
Looking at one of the primary colours –
yellow, blue or red.
Motionless.

1 hour each

Kerguéhennec, France,
2000

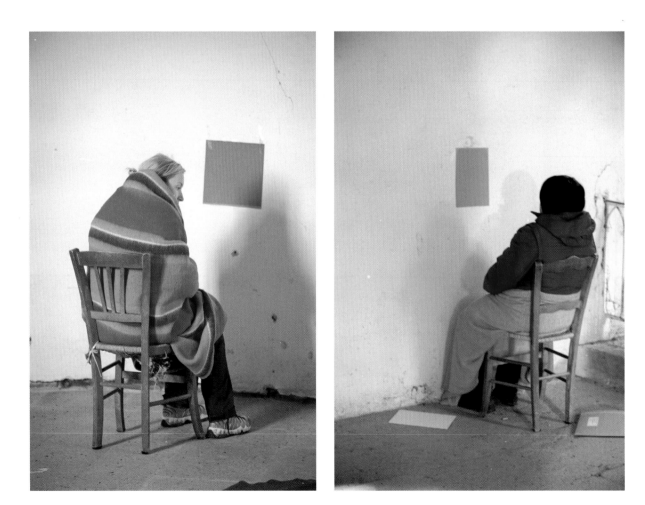

Como, Italy, 2001

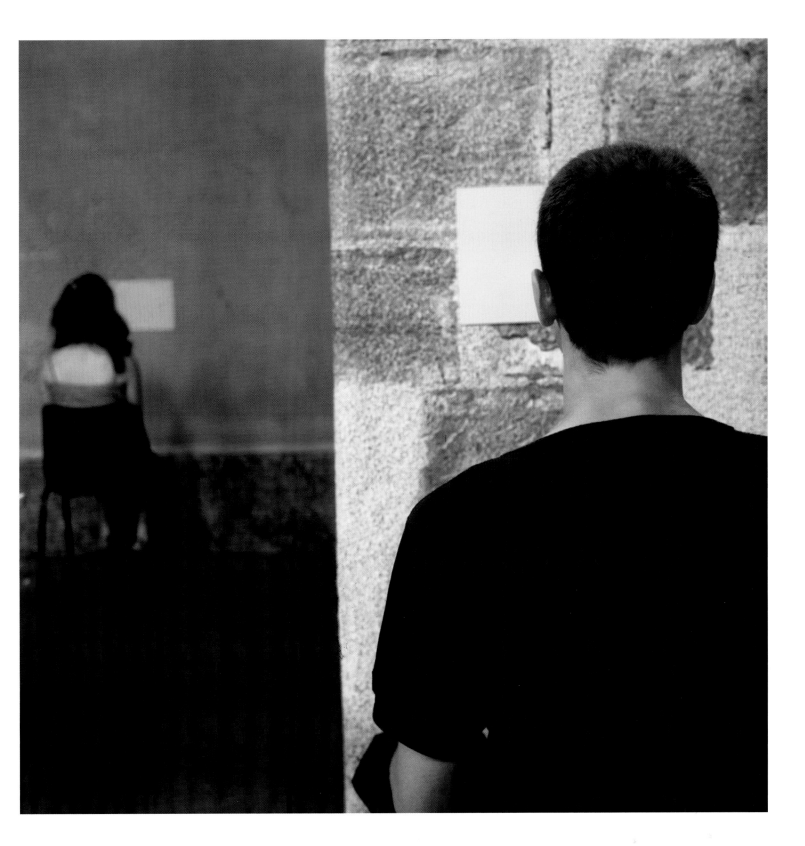

Water Exercise

Location: Sea or River
Season: Winter
Temperature of water: freezing or close to freezing
Take your clothes off.
Get into the water, swim and return to shore.

3 minutes

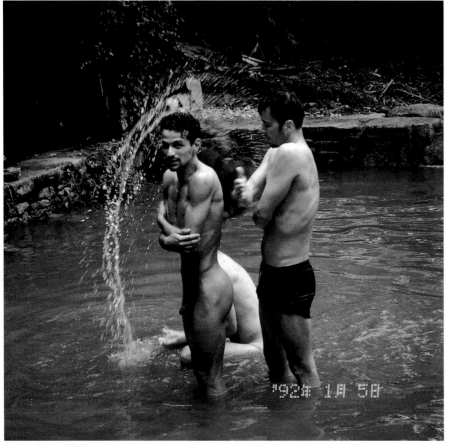

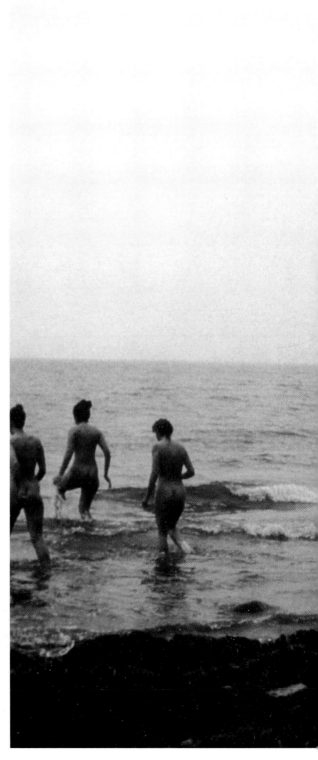

Kerguéhennec, France, 1992

Falster, Denmark, 1992

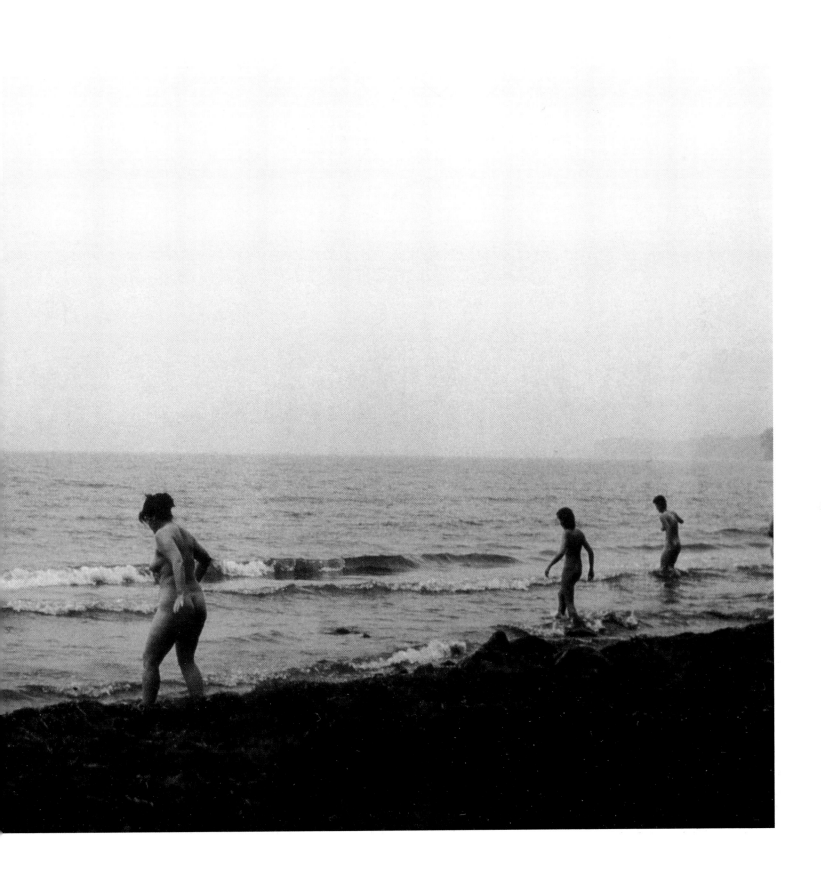

Walking Backwards with Mirror Exercise

Use a 30 cm diameter mirror.
Hold the mirror in front of your face.
Starting from the house, walk backwards,
looking constantly into the mirror to see the
route behind you.

4 hours each direction

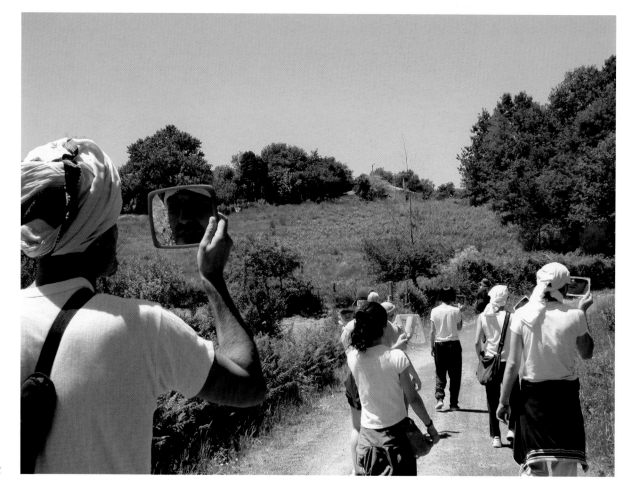

Antas de Ulla, Spain, 2002

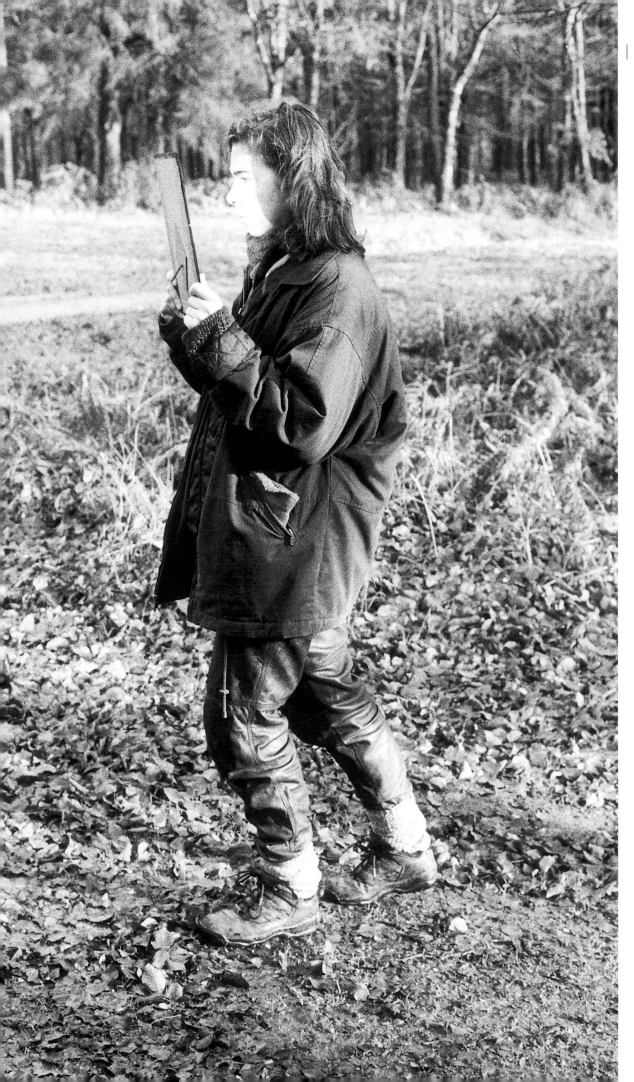

Kerguéhennec, France,
1997

The Bridge Exercise

The participants shall be divided into two groups. Each group shall sit on a different side of a bridge, one group looking at the river flowing up stream and the second group looks at the river flowing down stream.
Then the groups swap positions and repeat the exercise in the opposite location.

Upstream = Future
Downstream = Past

1 hour each side

Antas de Ulla, Spain, 2002

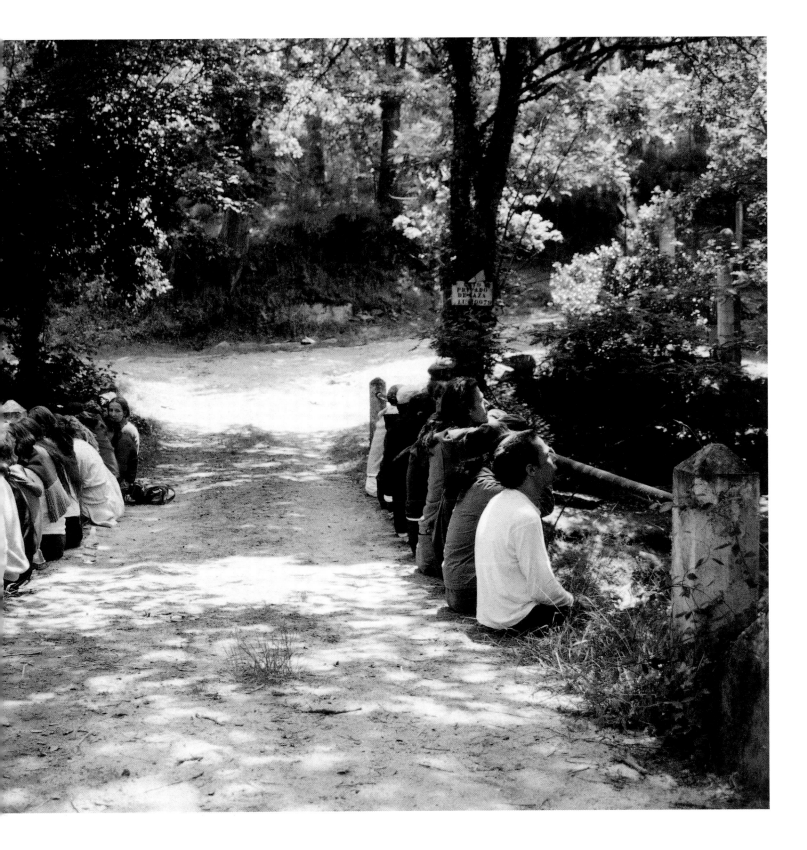

Smelling Exercise

Walk in the forest and choose three things whose smell you like and three things whose smell you do not like.
Describe the smells in writing.

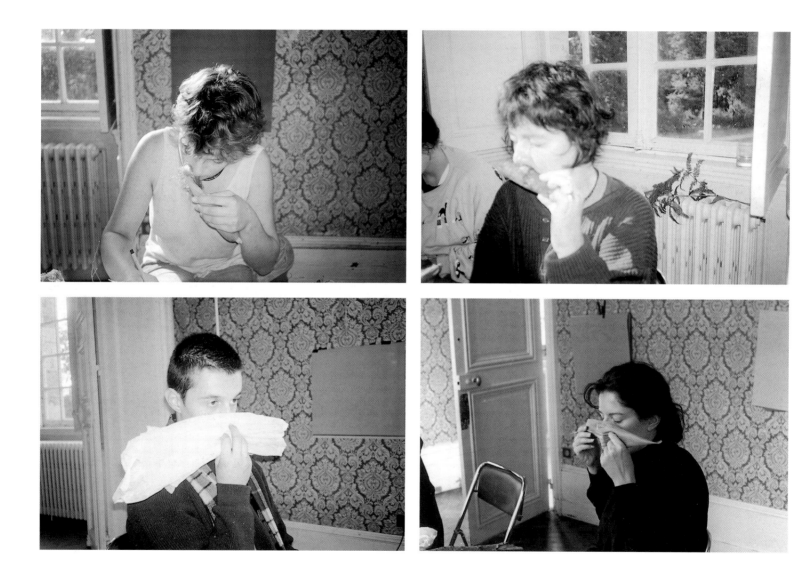

Kerguéhennec, France, 1992

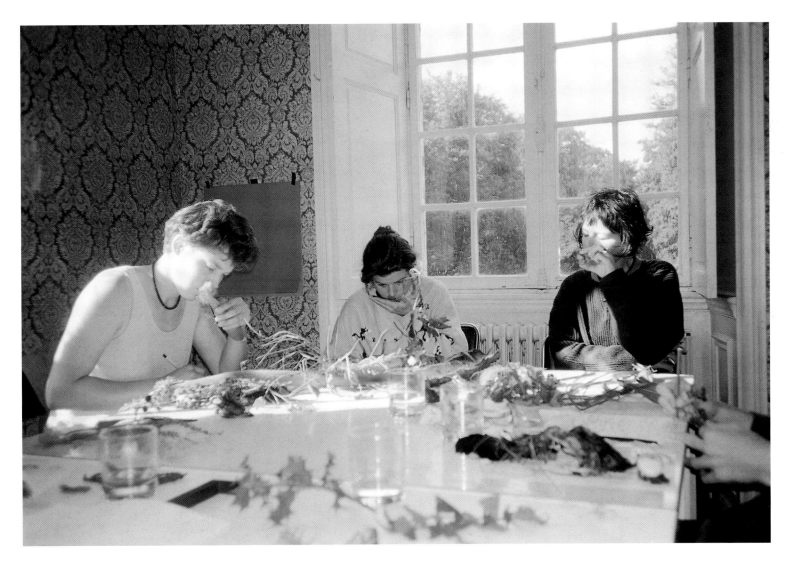

Feeling the Energy Exercise

Eyes closed,
extend your palms in front of you.
Place them 20 to 30 cm away from the body of
another participant.
Never touch the other partipant's body,
move your hands around the different areas of
the body,
feeling the energy.

1 hour

Paris, France, 1995

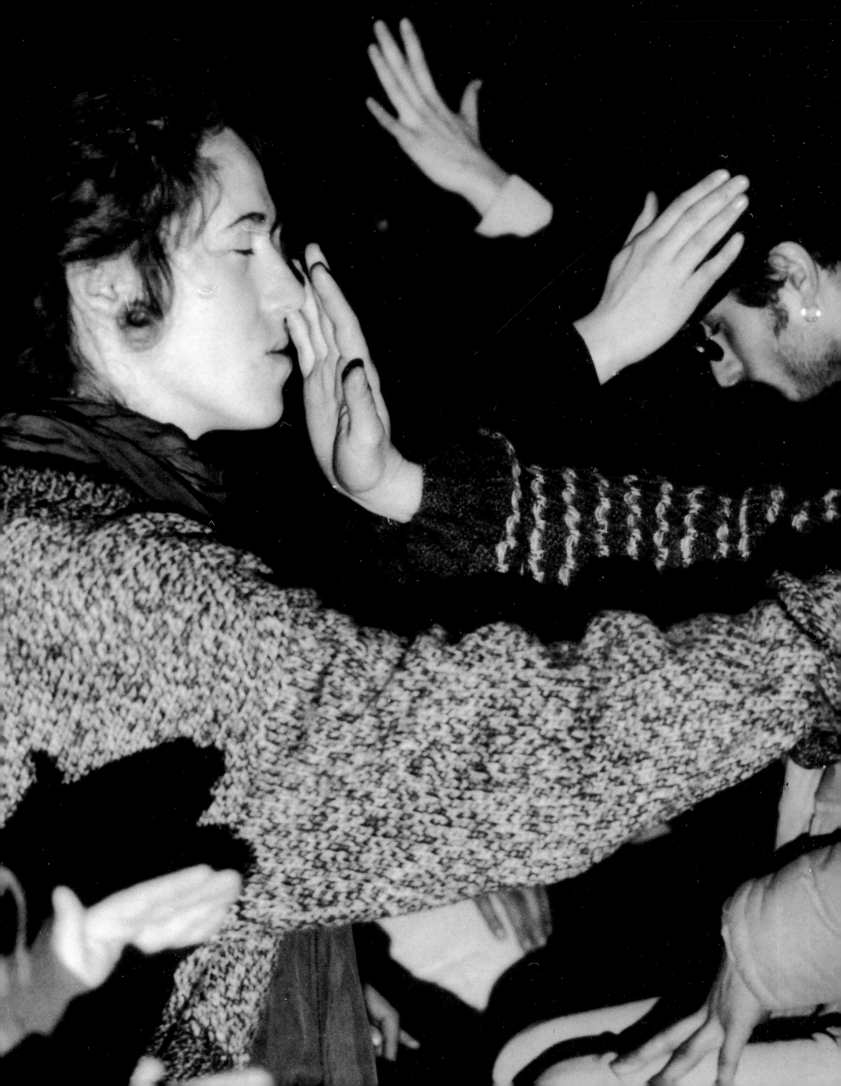

Stopping Anger Exercise

In a moment of anger,
stop breathing
and keep your breath until you reach your limit.

Holbæk, Denmark, 1996

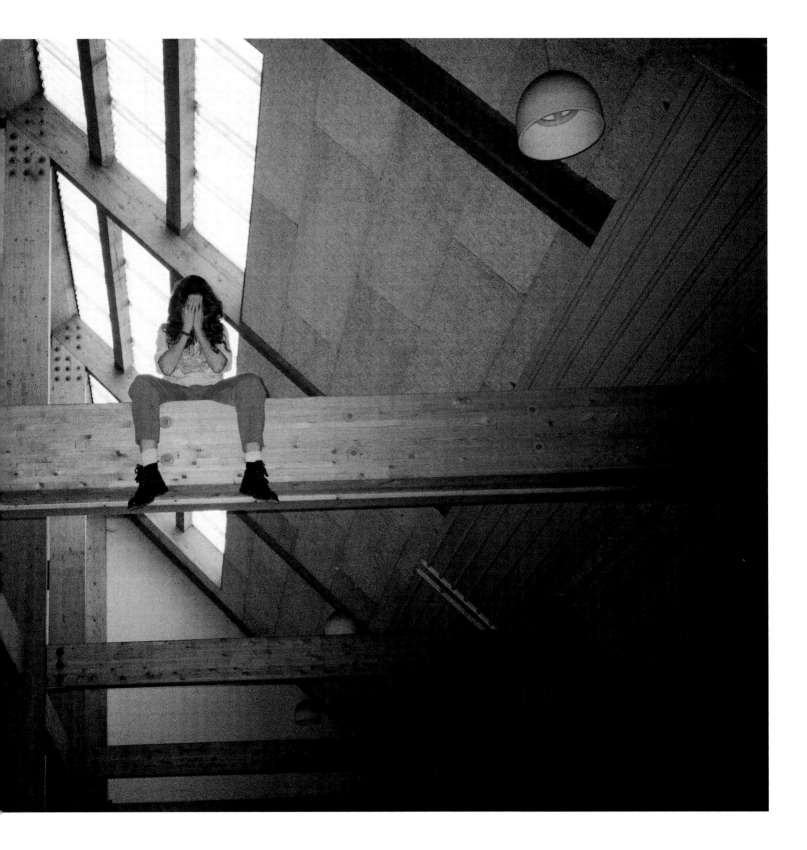

Listening to Sound

Close to the end of the workshop, I like the participants to be exposed to a certain type of music. As they reach the point of exhaustion, the mind becomes very sensitive and they become more open than usual to sound and music. The sounds we are listening to are mostly Eastern music, which is rich in overtones. I also ask participants to go next to the water and listen to the ambient sounds of nature and the flowing river.

Antas de Ulla, Spain, 2002

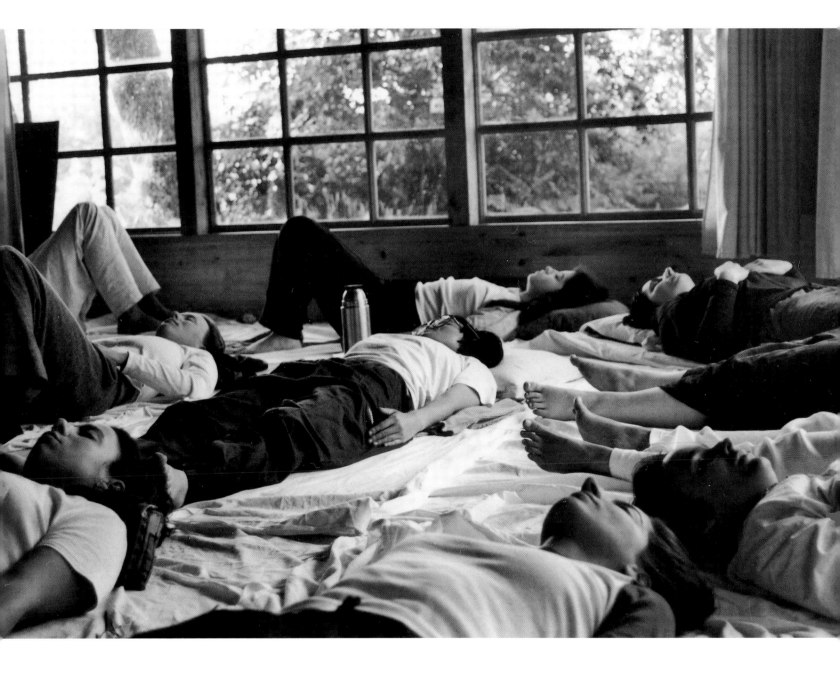

Making
Sound
Exercise

Sitting in a circle opposite to each other,
produce a sound,
concentrating on the different areas of the body.

U	for the sex.
O	for the stomach.
A	for the heart.
E	for the throat.
M	for the top of the head.

45 minutes

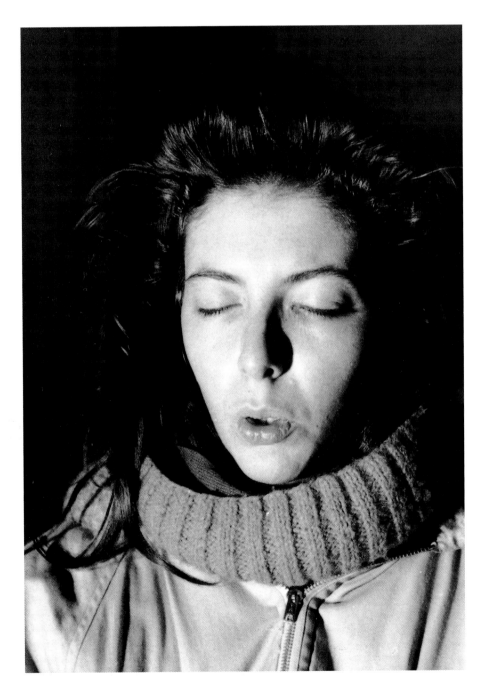

Paris, France, 1995

Releasing Static Electricity Exercise

Take a small piece of your hair in your fingers and pull as strongly as you can, releasing static electricity.

10 minutes

Amsterdam,
The Netherlands, 2003

Walking in a Circle Exercise

Walking in a field in circles as fast as possible.

3 hours

Drawing from Iris Selke's diary
Kerguéhennec, France, 1997

Complaining Exercise

Choose a tree you like.
Face the tree.
Complain.

Minimum 15 minutes

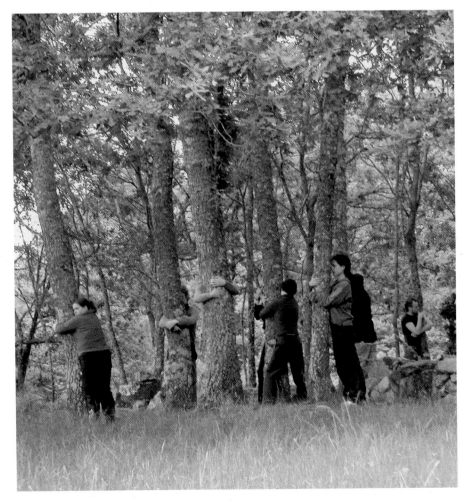

Antas de Ulla, Spain, 2002

Katrin Herbel: *Tree Sketch*
Kerguéhennec, France, 1997

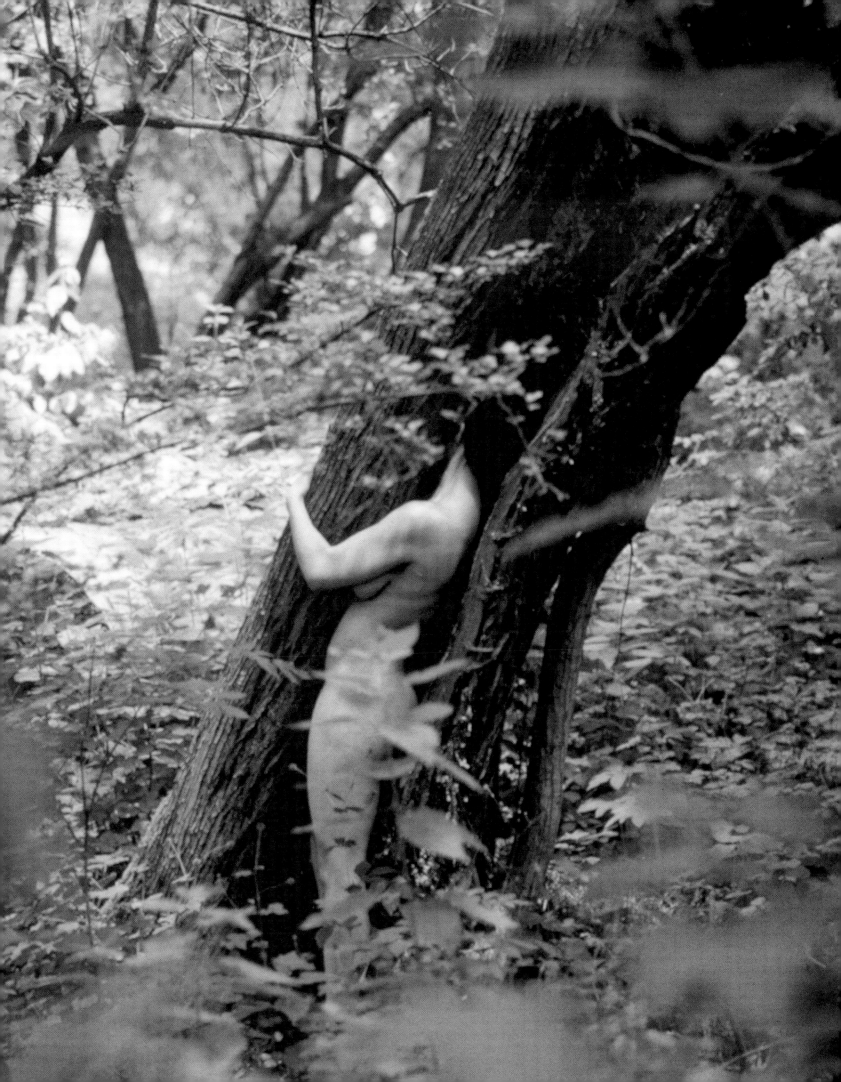

Writing the Name Exercise

Over a period of one hour,
write your name only once
with your pen poised on a white piece of paper.

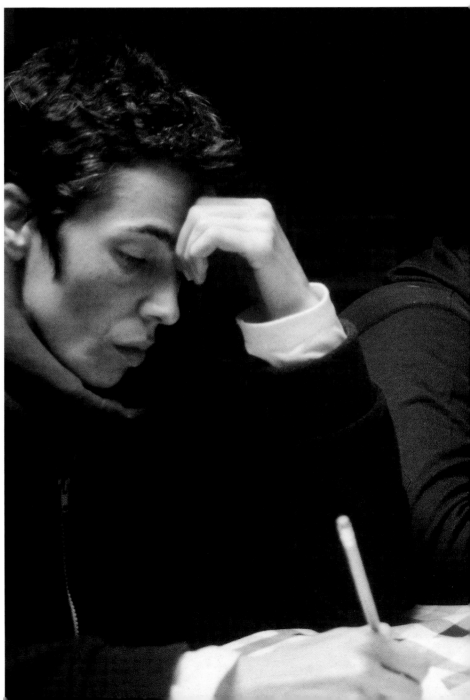

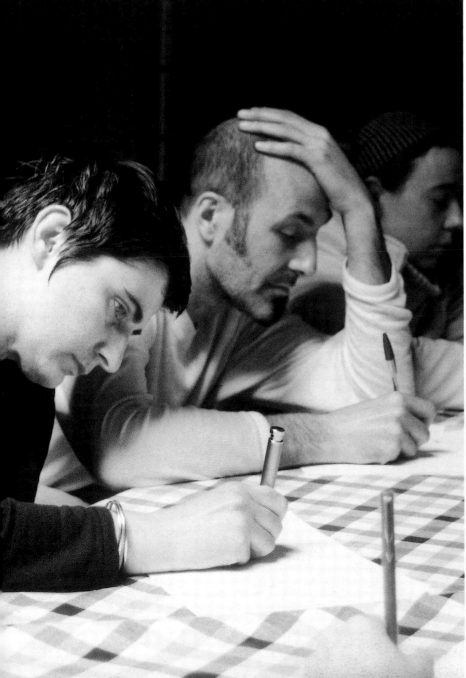

Antas de Ulla, Spain, 2002

Slow Motion Exercise

From the morning till the evening,
move as slowly as possible,
doing everyday actions:
getting up,
dressing,
washing,
drinking water,
sitting,
walking,
lying.

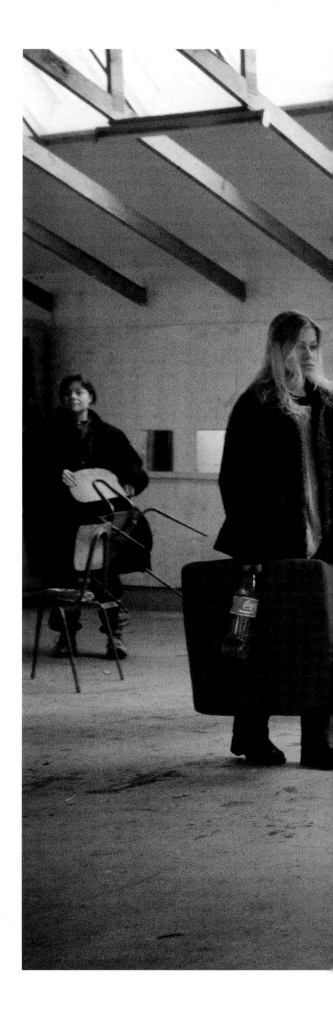

Holbæk, Denmark, 1996

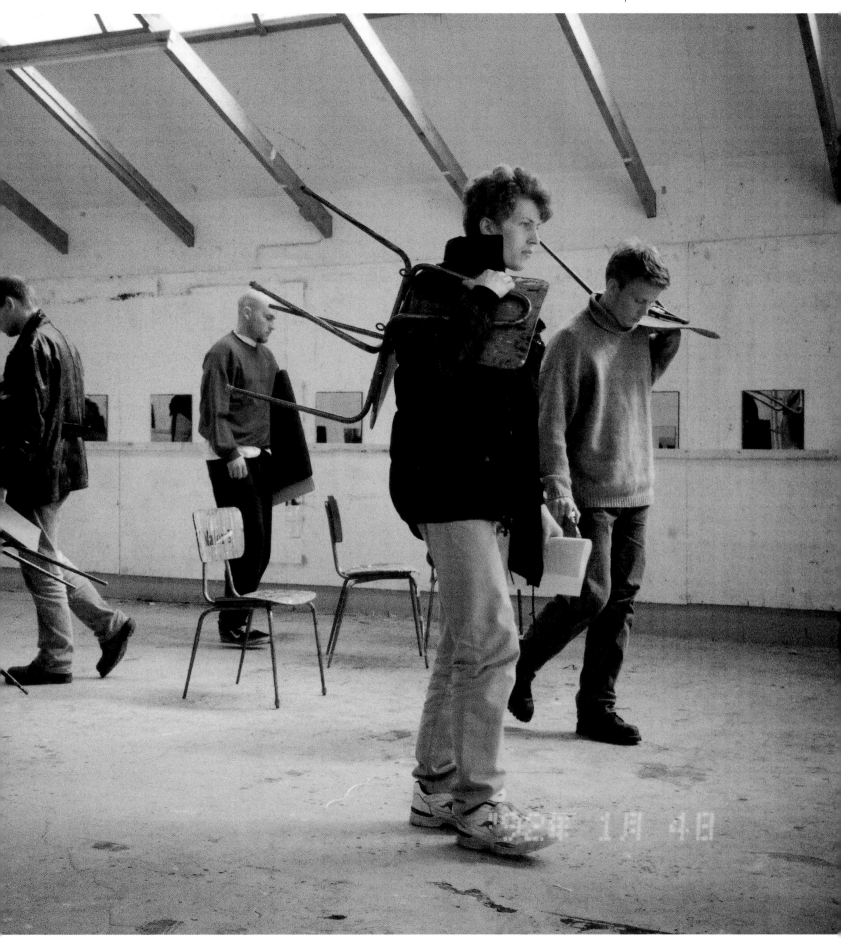

Making a Gold Ball

Ingredients
7 almonds
3 white peppercorns
4 black peppercorns
7 coriander seeds
3 drops of water
1/2 teaspoonful of honey
1 leaf of 24-carat gold

Recipe
The night before, place 7 almonds in a glass of water to soak. The following morning, peel the almonds and grind them with a stone on a stone plate. Mix in the white peppercorns, the black peppercorns and the coriander seeds and continue grinding until the mass acquires a compact consistency. With the middle finger of your right hand add 3 drops of fresh water and half a teaspoonful of honey. Continue mixing together and make the ball. Very carefully wrap the 24-carat gold leaf around the ball.
The ball should be eaten in solitude after 4 days of fasting and not talking. This recipe was given to me in a Tibetan monastery. The practice of eating a gold ball after a long period of fasting and seclusion dates back to the 6th century and helps to achieve a clear state of mind. In Indian, Indonesian and Chinese traditions, the mixture of gold leaf and honey is given to infants to stimulate their memory.

Antas de Ulla, Spain, 2002

Remembering Exercise

Try to remember the very moment between being awake and falling asleep.

Saché, France, 2001

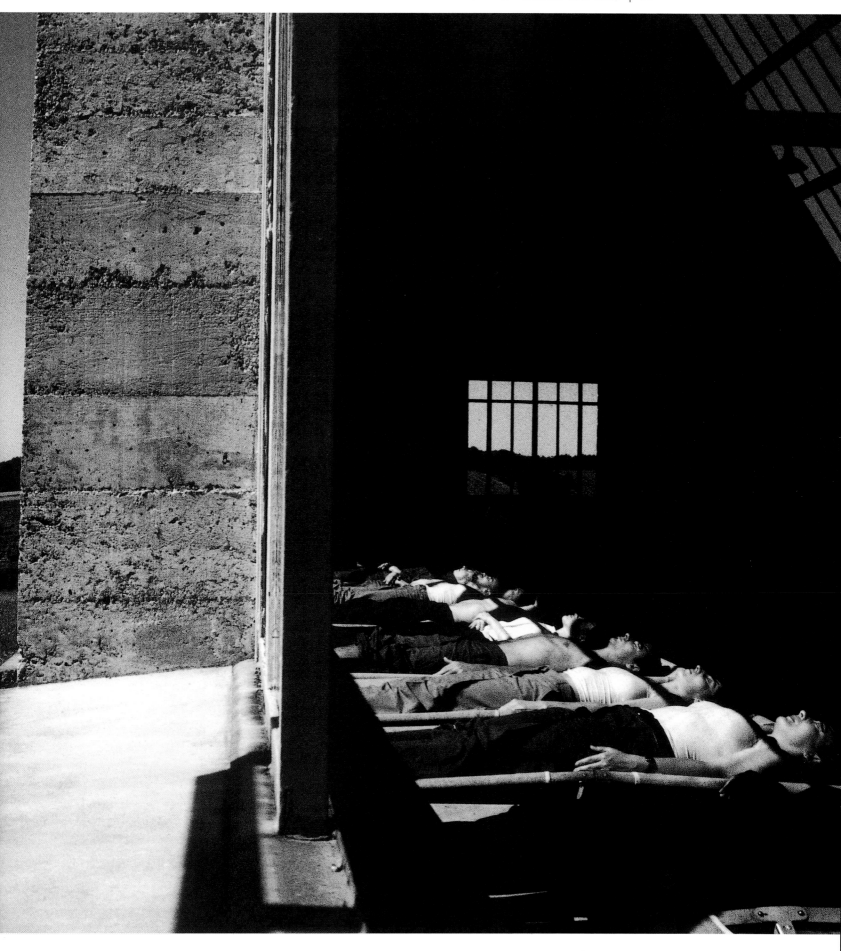

Looking at Each Other Exercise

Sitting on a chair opposite each other,
looking at the space between the eyes,
trying not to blink.
Motionless.

1 hour

Antas de Ulla, Spain, 2002

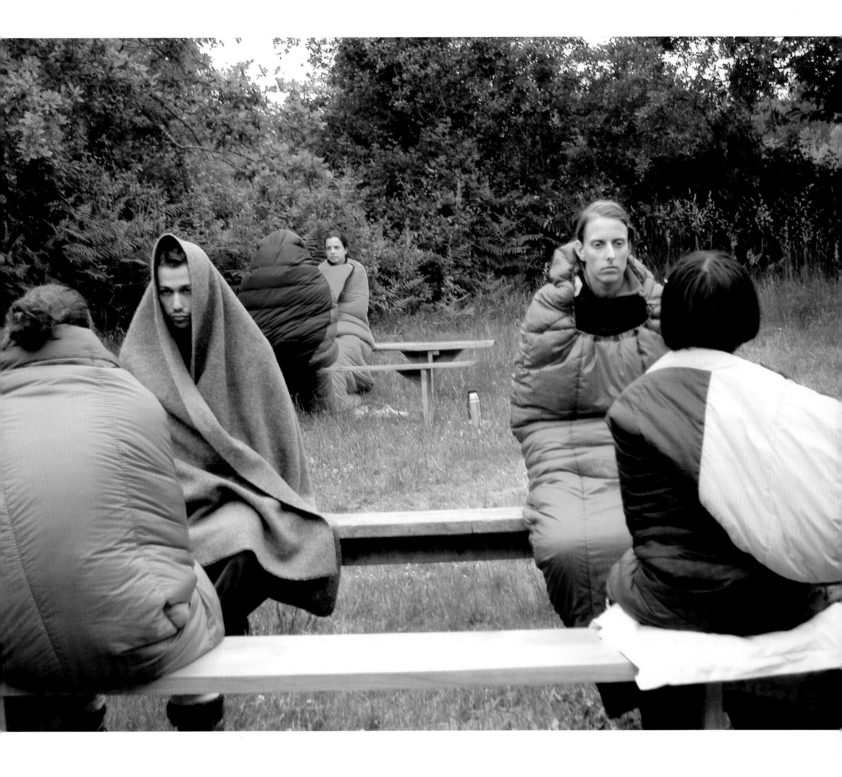

Opening the Door Exercise

In extreme slow motion, open and close the door then repeat this action.

3 hours

Maastricht, The Netherlands, 1991

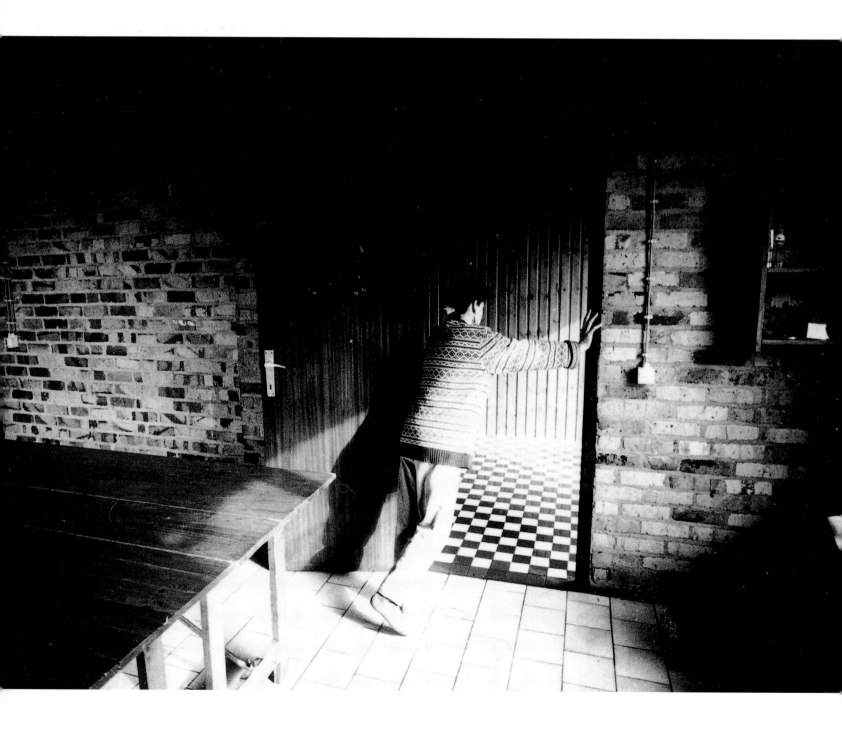

Cleaning the Floor Exercise

On your knees starting from one corner,
clean the floor with a scrubbing brush, water and
soap.
Slowly move backwards until the entire space is
totally clean.

As long as it takes.

Maastricht,
The Netherlands, 1991

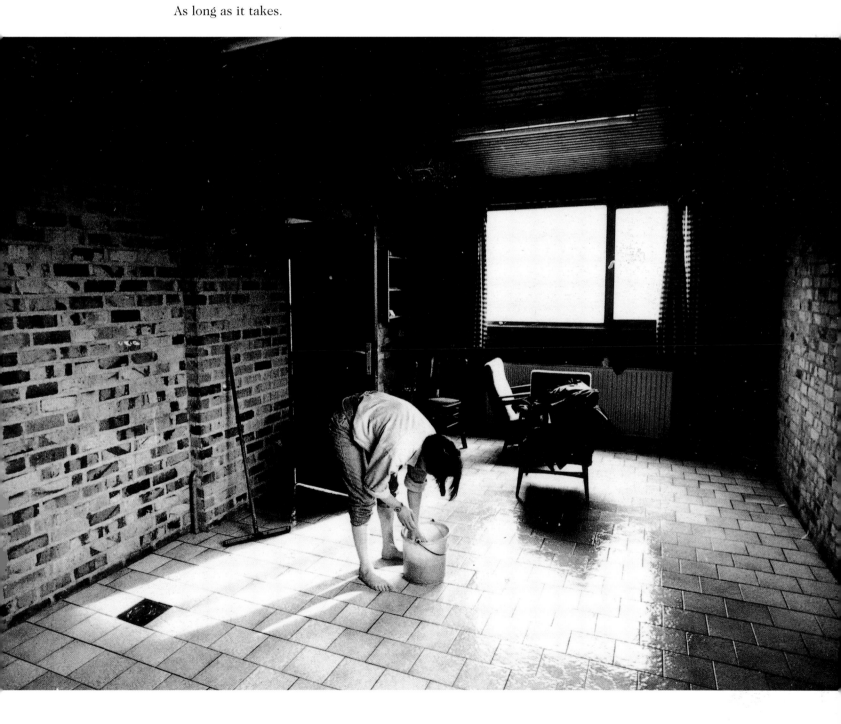

Word Giving Exercise

Between 4 and 5 a.m. in the morning, while the participants are asleep, I wake them up one by one, pointing a flashlight onto a white piece of paper. I give them a pen to write the first word that comes into their mind at that moment.

After this is done, they can go back to sleep.

The next day, while eating their first meal, they will find the piece of paper with the word they have written next to their dish. They will then be asked, on the basis of this word, to make a performance.

extrovert

going to buy meat

knowing

Amsterdam, The Netherlands, 2003

dreamer

aLeghria

I don't know

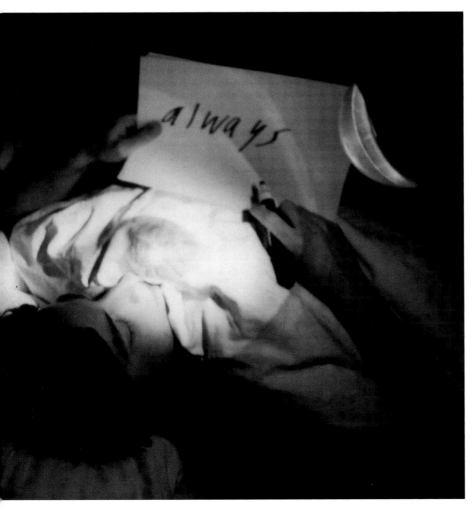

believe

what ?

First Food after Workshop

The fasting lasts between four and five days, therefore the first meal after the workshop is a very important event. Participants exchange notes and use gestures to describe the food they would like to eat. The atmosphere before the first meal is very tense. I wake up before dawn and prepare everything for the first meal myself. I usually look for a very beautiful place that hasn't been used previously for any of the exercises. Even if it is cold or raining, I prefer it to be outdoors. With the help of the organisers, I set the tables in the location and cover each one with a simple white tablecloth, plain glasses and plates. In front of each plate there is the piece of paper on which the participants wrote a word when they were awoken the previous morning. I then cook the plain white rice adding no salt. The smell of the rice spreads throughout the whole house and the participants slowly begin to wake up, aware that today I won't wake them up myself and that there will be no exercises. When the rice is ready, I bang loudly using the pan and spoon to indicate that the food is ready. Up until then, the same sound was connected to being woken up very early in the morning, but this time the sound means something else.

We go together to the location, which is usually close to the house, carrying the steaming pot of rice with us. Everyone will be seated at their allocated position, where their words have been placed. I will sit at the front of the table and

Kerguéhennec, France, 1997

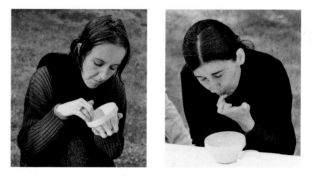

begin to share out the rice in silence. After the distribution, I will give my last instructions: the rice should be eaten using one hand, slowly, chewing well and with eyes closed, feeling its texture and smelling its aroma. In between eating, small sips of water should be taken. After eating, one may talk. This is the most powerful moment of the workshop – when it is over and all the participants are OK, with nobody ill or hurt, I personally feel a huge, incredible relief and get tears in my eyes. I usually open my eyes before they do, I look at the group in front of me, all participants have their eyes closed as they eat slowly and their faces show genuine concentration. They are absolutely rapt in this moment, here and now. It is an image of complete harmony, unity and beauty. I always feel that the hardship was worth it and that it has to be repeated, over and again.

Once the food has been eaten people generally remain seated, in silence, just looking at one another. The silence is often broken by laughter instead of words, transforming the intensity of the moment into total joy and pleasure. Later on in the day the level of energy becomes very high, almost euphoric, as participants create their works based on their personal experience of the workshop. In the evening there is a huge celebration, with music and dancing well into the night.

The following day, on our way home in the train, seated among other passengers, we all know that something has occurred over these past days, and everyone is well aware of the experiences and changes we have shared with each other.

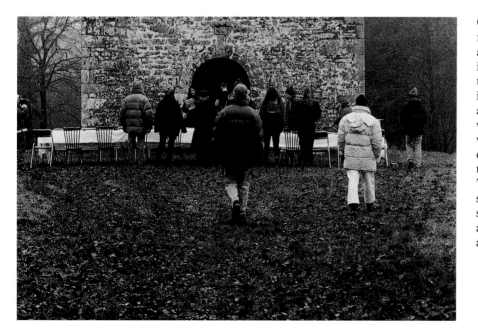

Antas de Ulla, Spain, 2002

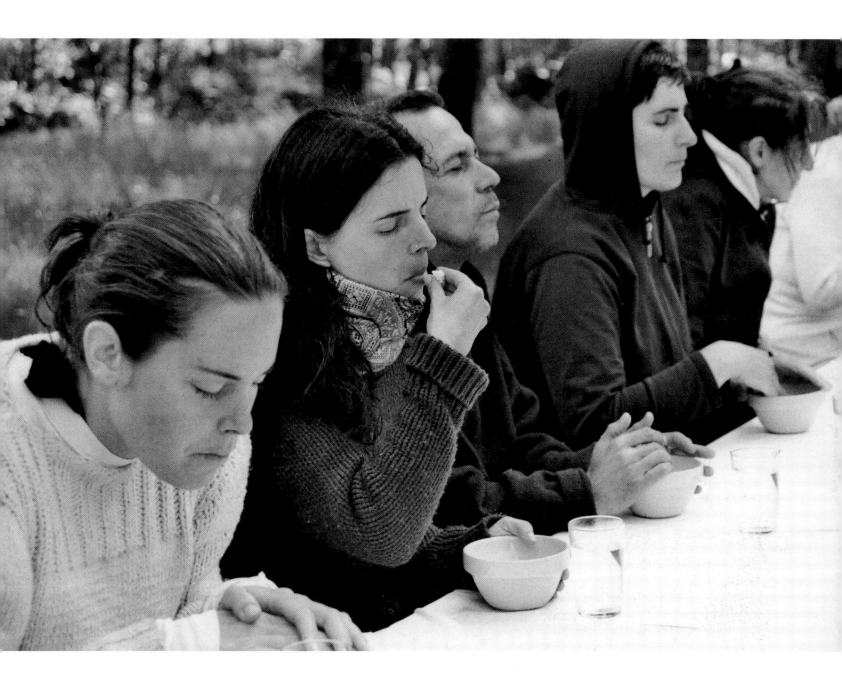

Writing the Diary

During the workshop, reading is not allowed but I encourage the participants to write in their diaries after every exercise or during their free time.

Maastricht, The Netherlands, 1993

Vera Bourgeois
Cleaning the House
Workshops 1990 and 1991-1992, Falster, Denmark

CREATIVITY
DYNAMICS
CONCENTRATION
CLEAR UP
INTENSITY
EXCHANGE
CONTACT

Ten years later, one long afternoon, I pour over the sketches of our workshop, schedules, key points in the course of events and personal notes… And next to them I read all the thoughts that were going through my head at the time: artistic matters, projects, ideas…

And the strength and energy of that time flooded back, the total dedication to art and life or life in art. The groundbreaking atmosphere of an evolving concept of art that was still struggling hard against personal confusion and, rather imprisoned by the various circumstances, attempting to break free. A wonderful period for me to get involved in Marina's workshops.

I was already familiar with many approaches stemming from Oriental meditation techniques and healing methods that I liked a great deal and had positive effects on me. Nevertheless, I still found a connection to art lacking. The workshops managed to provide that reasonably well. Marina had developed a technique to allow oriental experience to flow into the process of creating art, to allow open fractures to arise through "breaking off" of established habits. At these "open" edges, we/I could become aware of deeplying sediments of feelings as in a cross-section of earth. Those moments dealt with the existentialism of my own self, a base from which it was worthwhile to develop a work. An unbelievable value in a situation of uncertainties and confusion, and blurriness at the beginning of an artist's biography.

Thus I also tried letting go of habits that I had grown too fond of, entrusting myself instead to new and random ones, and reading from those that followed. And it came to a state of dizziness (*Himmel [Fall Into the Sky]*, 1991): the solidly established image began to totter and, as in the interactive performances of 1991, I assumed that a deeper view was possible. And new possibilities, subjects and meanings lit up (*When the Wind Blows the Heat*, 1992), generally finding a spacious future in which to unfold fineness, interaction, simplicity, the powerful image, the true-to-life motif.

Today I teach art, have children and nonetheless still have the energy to continue to develop my own artistic work. I am living life to the full, a life in art. This strength found its concentration also and particularly in workshops with Marina Abramović. She was an enormous catalyst for me.

Himmel (Fall Into the Sky)
Performance with a workshop group, Falster, Denmark, 1991
"Move your head and body in circles with eyes closed, until you fall down.
Open your eyes at that precise moment to see the sky."

When the Wind Blows the Heat
Performance with a workshop group, Falster, Denmark, 1992
The entire group sits in the twilight at an oval table, facing the double doors leading to the garden. On the table there are three shallow bowls with glimmering embers. It gets darker. After a while, I open the double doors. A breeze enters the room and makes the embers glow brightly.

Christian Sievers
Notes from the *Cleaning the House* workshop at Kerguéhennec, France, 2000

Day 1 – without food
Not great, rather a torture. Very angry. This Norwegian girl is really getting on my nerves with her *über-dedication*.

Day 2 – *without food*

Might just be mood swings, but I can very clearly see an enormous aggression building up. But I can as easily be disarmed, as with the massage earlier or by something nice. I was really, really pissed off today; the second day without food. I felt sick and my head was throbbing. At the warming up exercises I just beat and kicked around me. I sincerely regretted having come along to this and I still don't believe I will end up with some phenomenal new idea. However, if the outcome was predictable, one could save oneself the pain. There will be a result in one form or another, nevertheless I'm very sceptical about this whole enterprise now.

Day 3

Dreaming extremely vividly. I wake up every 2 or 3 hours, feeling very thirsty and having to pee. I have different dreams each time I go back to sleep. I was completely euphoric this morning.

I dream a lot about food, the really bad greasy stuff and lots of spices and salt. The worst is to get no sensory input like that, just disgusting horse piss herbal tea.

Some structures speak to me very clearly. Today the sods of earth on the fields: their whole story was written into them. Being dug up, lying in the sun, being washed up by rain. I am extremely sensitive to colour and form.

The last exercise, writing one's name in 1 hour – and then getting out, and suddenly it's full moon, clear sky and an owl starts to scream. You would believe anything anyone told you in that moment.

I'm doing astonishingly well, I feel strong and in a very good mood, like everyone else, I suppose. Tomorrow we will eat for the first time again. I'm always picturing how much and what I want to eat when I'm back. But actually I'd take anything!

Day 4 – *eating again*

Marina: "WE ARE DOING THE FAST FORWARD. DO ONLY THE FIRST PART OF THE EXERCISE, GOING OUTSIDE. NO STRETCHING, ETC... THEN YOU TAKE A SHOWER AND THEN YOU CLEAN UP THE WHOLE SPACE WHILE I COOK THE RICE."
I get goose bumps and *déjà-vues*.

Day 5 – *the day after*

It took a terribly strenuous and hard 3 1/2 days to bend the bow, but now I feel like an arrow being shot up into the sky. It had drained all the power from me, and now it's as if I will never get down again. This is worth ALL the pain.

Day 6 – *the way home*

I had some time before the train left so we walked around the city. The new Intifada had just broken out then (October 2000), and we were in no way prepared for the images in the newspaper that day. There was this guy proudly presenting his blood-soiled hands out of the window, where the

Drawing from Vanessa Briggs' diary Kerguéhennec, France, 1995

The most desired food before breaking the fasting Kerguéhennec, France, 1997

mob had just killed some imprisoned Israeli police officers with their bare hands. We had taken all our defence lines down in these few days, and I think several of us started crying, not being ready to get back to real life yet.

Rubén Ramos Balsa
Diary notes from Antas de Ulla, Spain, 2002

Meals

Meat:
Baked loin
Chops
Diced chicken with pineapple
Liver with cheese
Meat and cheese in breadcrumbs
Meatballs / rabbit
Chicken with vegetables
Ana's meat

Fish:
Baked hake
Octopus
Barbells

Pasta:
Spaghetti: alla carbonara, alla bolognesa, with garlic and olive oil sauce
Tagliatelle with meat

Rice:
Rice with vegetables / with salmon
Salad

The hardest thing is trying not to do anything; even when we do not move, we cannot stop thinking. There are only two moments in life when we stop thinking: when we sneeze and when we have an orgasm. When we do not think, time does not pass. These two endeavours are moments of absolute freedom. There is no brain activity recorded. Due to our culture, we have gotten used to doing things; we feel well and complete when we do something; we search for plenitude through activity, by surrounding us with millions and millions of things and information...

...There is something weird about my face. Sometimes I recognise myself, or parts of myself, I should actually say; some parts are familiar to me and I consider them part of me, but some others seem alien to me. I believe these are intermediate areas or joining areas between more ironic or designable parts such as the nose, mouth, eyes, eyebrows or cheeks. But the intermediate flesh, the linking and constituting matter seems alien to me and when I discover it, it is as if I could not feel it. They are "dead" zones. When you are looking at yourself for such a long time, I also believe that you begin to forget your own face and you start thinking about what surrounds you, since the only thing you have been looking at for an hour is yourself. When you finish, you do not remember yourself. My image does not remain in my memory and I cannot imagine it...

...The results I obtained were not new ideas or innovative knowledge about my work. On the contrary, the workshop actually broke my vital rhythm. I thought this was going to be a break, a trial that you enter and then leave, but I believe that nobody, or at least me, leaves the same as they entered. I was very interested by the alteration of daily temporal perception that our body and mind produces with meals and visual stim-

uli. I NEVER FELT SO VIVIDLY THAT THE PASSAGE OF TIME DEPENDED ON ALL OUR BODILY ORGANS.

The workshop did not give me anything that I expected but changed everything I already had. But this void the workshop has created in me is very hungry. I am satisfied by the new feeling that everything can be filled, even a breath of fresh air can be nutritive.

Llúcia Mundet Pallí

Five dreams

Workshop by Marina Abramović at Chateau du Kerguéhennec, France, December 1997 Five days of fasting / speaking forbidden / physical and contemplative exercises.

Dream, 14-15/12/1997

(Written in German, probably dreamt in the same language)

Every morning when I woke up at home I found out (either from the morning newspaper which had been left under my door, or through an acquaintance who knocked at the door and woke me up to inform me) that a crime had been committed near the casino where I had been playing the night before. One of my game partners had died. On the night before I could remember nothing – except for the game. At the beginning I tried to feel some sense of "guilt" in order to awaken the memory of the night before. Later, as the days went by, the same story happened again and again: the murder victim turned into "that" everyday happening free from any kind of memory or feeling.

The following morning, the news appeared again. I was asleep, sitting at the table reading the newspaper with my morning coffee. I was in my flat – a one-room flat. The table, next to the unmade bed, the still-warm sheets, and someone knocked at the door... – "Is it someone I know or are they coming for me?," I wondered.

"This time I hadn't won the night before. The game had been very messy and I hadn't been able to gain any ground... So I had decided to go home earlier. I had had this thought at about two in the morning and I had most probably carried it out. This time I had serious doubts as to whether I was the criminal or not."

The following morning I was told that I had won the game. I then knew that I had power, I had the strength you would need to kill someone.

But why? Just to win?

The absurdity of the situation made me nervous and I wasn't able to rest well for the remainder of the night.

The following morning I asked myself what I was doing in Brittany doing this workshop?

Dream, 15-16/12/1997

(Written in Catalan)

I remember nothing of what I dreamt that night.

Yesterday as it got dark I fell asleep during the concentration exercise and today I'm still tired.

Dream, 16-17/12/1997

(Written in Catalan)

I dreamt of a spot I had on my left ear... I squeezed it between my index fingers and... four white worms came out, three of them stuck together with a sticky substance and then the fourth, a large one came out slowly.

I carried on squeezing and more and more came out.... double or triple threads of white worms, longer and longer.

From somewhere else on my head – I think near my left ear – a bad-smelling, yellow liquid was coming out from the inside of my body. Afterwards I was able to observe the inside of my body and see how a sort of thick black skin had seeped out and was covering a soft white organ – it looked like a brain or the lining of a stomach.

I think I wasn't even frightened. Even so, I managed to control my feeling of disgust. Today everyone is smiling. Today everyone is communicating by signs or written notes.

Dream, 17-18/12/1997
(Written in Catalan)
After getting back from Germany I slept with my second eldest brother, Joan, in my grandparents' house in Palamós. It was day-time, we were lying on my parents' double bed, me on the left taking my mother's place. My brother and I apparently loved each other, desired each other; as we embraced I kissed him and before inter-course... it turned out I was sharing the bed with Joan and my younger brother, Narcís. Narcís was on my left at the time, with me in the middle and Joan on my right, waiting for me to finish making love to Narcís. Nar-cís was passive, loving was my job. Loving both at the same time would have been excessive... and Joan didn't want to go!

Then I said to myself that I didn't feel like it... and I went to my mother's house in Barcelona. It was night time and I was sur-prised to see her standing awake in her nightdress in the corridor. She was wearing a summer nightdress which was wide, worn and very light. She was her current age – 68 years old. She invited me to share her bed because she was alone. My father's side of the bed was empty (my father had died in 1996). Making love to my mother, I woke up during cunnilingus. I found it difficult, as though in the dream I was conscious of having crossed a taboo.

This morning I wished it had always been like that. I feel really good, I don't want to go back to my everyday life after the work-shop ends... work, worries....

Note: Both houses – the house in Barcelona and the country house in Abrera – had been used by the married couple in the past, and my mother had always slept on the right side of bed. In Palamós (seaside villa), on the other hand, she had slept on the left side of my father.

In Palamós we used to spend the summer at the home of my grandfather on my father's side, "L'ávia Lola". The home belonged, however, to my mother's parents – the Pal-lís who lived on the ground floor of the house. Now (2003), seven years after my father's death, my mother has bought her-self a new double bed and finally sleeps on the right-hand side.

Dream, 18-19/12/1997
Today, before we went to sleep, Marina agreed – our silence opposing no resistance – to wake us up quietly, one by one, at about four in the morning to draw a word out of our sleep. She would wake us up and put pen and paper in our hands and we must write down a word without thinking. We could then carry on sleeping until the gong at seven in the morning.

Today I dreamt that I had met a film pro-ducer who was starting up his own busi-ness.

"I might be able to work for him. But on the one hand, I didn't have much experience" – although I shouldn't really have to think about that now! On the other hand, I could prove my knowledge through my own video work. Also, my fellow-students at the Uni-versity were already young film directors. He did however need someone with real experience in the branch of "production."

I was still doubting as to whether to present him the scripts I hadn't yet carried out. "But most importantly, I am looking for a job... this isn't the time and place to make up my career as a film director." I was con-fused.

However, the reason why this job fascinat-ed me was because I wanted to learn two things from it: how to present myself in public and how to sell films. So, what I real-ly wanted to learn from this producer was how to treat important clients and how to trade with money.

At four in the morning I wrote down "Film-produzent" (film producer) on the paper.

After our first breakfast (boiled rice that had gotten cold) Marina told us that we had that day to create a performance based on the word in the dream. We would then pre-sent it in public. I presented the following script in "Spanglish": Filmproduzent.

Marta Montes Cantelli
Antas de Ulla, Spain, 2002

Suffocation is like cigarette smoke, slowly enveloping me, caressing me behind the ears. In my utter despair I have warped the rope gripping my soul. I've felt it for some time, closing in on me like the petals of a giant flower. I cannot fill my lungs and I realise that I can barely breathe. I'm like Juliette Binoche emerging from the swimming pool in *Blue,* or Nicole Kidman playing Virginia Woolf, sinking in an English river, her pockets filled with stones. The three of us are so pale that our faces could be the reflection of Death. This vision makes me laugh, in fact it makes me roar with laughter until I'm completely out of breath.

Drawing from Julie Jaffrennou's diary Kerguéhennec, France, 1997

Sarah Braun
Antas de Ulla, Spain, 2002

Walk Around the Lake Twelve Times
9 hours

The river was on the left at first, wasn't it? At the river, you went up a steep hill. When I continued, however, I came upon the village. But I'm afraid that I won't even find the river alone, as at first there were people in sight and I didn't pay much attention to the way. I realised that on the way back, I was so insecure and afraid.
A path that first leads up and to the right? But actually, in order to complete one lap, you have to always go left (in one direction), don't you?

Christine Hohenbüchler
Notes from the diary 3/10/1989

...Then you wonder, why you are doing all of these spiritual things. But people are beginning to look healthier. Their eyes are getting clearer. A clear blue, a clear brown, a clear green. You have to look into the other's eyes.
...You think of the end results which might be good for your body... for the arms... feet... joints... knees... everything. Perhaps they won't hurt anymore.
...So now I want another cup of tea, I hope there's one left.
You feel your calves and the head and the heart and the teeth and toes.
...Walking in the sun for hours, I don't remember what I was thinking all the time. It is just passing. You hear sounds a bit louder than normal. The tractor, the water, the vacuum cleaner. You have a rest of course. You see people and they seem to be much more of interest than before...
...Eating an apple had been nice, but also very normal. The apple sparkled like a cheek or like the red mouth of somebody you like and you see for the first time. (This is very poetic and perhaps very silly). But it had been like this anyway. The feeling of a big red mouth which you suckle inside your body, like a baby...
...Some people have really big eyes. Huge,

Drawing from Ana Pol's
diary
Antas de Ulla, Spain,
2002

Jean-Luc
The hands, feet and the rest of the body function. I grope, touch and scratch to recognize the space. I feel like an animal.

Michele Crozet

Being blindfolded and feeling your way along with the anxiety that comes from this forced blindness. I don't make any exalting discovery about space or about my body which is better at perceiving emptiness and noises. There are no pleasures of blind man's bluff. Only memories of what Gian, a friend of mine who is a Kurd, told me about his experiences in prison. I am impatient for this stage to end.

Susanne Winterling
Ideas for new works, Kerguéhennec, France, 1997

sparkling things in the middle of their face. I also love their hair, curly hair, straight hair, fair hair and dark hair. It is really nice to look at them all...

...And then the bodies, which are getting thinner and thinner. You can see it in the breasts. They are getting smaller, finer and thinner. You can't see it in the boys so much. I wonder why their faces are still round and not getting thinner...

...After your body feels so empty, it is the emptiest body you've ever had, it is all outside now. And the rest is just your health, feeling meat with blood. You smell and taste everything.

When you listen, the sound seems much louder than normal. When you brush your hair, even this has much more confidence and more body...

...I also love the disturbed things, otherwise the harmony might break you down...

...To jump into the lake, a dirty lake, but you can of course see the sky in it. Jumping in the cold water, paddling with your feet, with all your body, just enjoy to be for ever in the sky...

Fighting with myself; hitting my face each time. People jumping from above. Everybody is at least doubled in post-production.
The jumping ground is taken away.
A sculpture series of paper rows and pillars.
A film sequence: a single image widens with abstract changes. Slightly developing over time with bright colour contours.
A cleave that is a projection bowl in the floor: a grave: the sky in the ground.
A sundown installation: the position of the sun is projected on four walls which show the four perspectives and four states of the sundown according to the sky's direction.
A small room full of the strong, aggressive sound of horses.
A room full of death ropes.
A four wall installation with moving trees on each wall.

Franz Gerald Krumpl
Antas de Ulla, Spain, 2002

Since the time of non-talking and fasting in

Galicia, I started to listen to silence and this silence tells me the most beautiful stories. I've come to love it.

Patricia Venrechem

I become more silent within and more centered every day. There is a feeling of letting go, despite the tensions that are building up in my body. A greater harmony between my movements and my respiratory system is developing. My head and my mind are clearer. Everything is becoming more lucid. My conscience is sharpening up and my perceptions are more acute. This fasting is like self-sacrifice for me. I am very happy to be here. It is an enormous gift.

...I take great pleasure in the shouting exercise in the morning. I find it very violent, like something that we shouldn't ever dare to do. I would be very happy to be completely within the scream, freeing all of the bad things we have inside us.

The name writing exercise was very painful for me. I was in a cold sweat and weak. I felt prickles all over, nearly fainting, then wanting to be sick. There was like panic in me, doubt and struggle. What relief and feeling of well-being when the ordeal was over!

H.S.

...For most of the time I was thinking about lots of things, ordinary daily life and this workshop situation. It was sometimes disturbing doing this for the second time. This time I was also determined to go through it without moving and that was the most important for me. I got a very happy feeling when something happened. Sometimes I thought that I saw an aura of yellow, other times it was a green or purple colour...

...I think it is strange that the first time we did the sound exercise, I experienced a very good feeling which never came back to me when I did it later. It was the feeling of my body (head, chest and stomach) being hollow and full of light. It was incredibly good, so good I started to laugh and lose concentration. This came when I made the sounds myself and it harmonized with others...

...And now it's finally Friday. I've been waiting for this day all week. And I must say it was worth it. And the waiting days were good too. Today was the end of four days of fasting. It was absolutely wonderful to have a bowl of white rice, you felt so happy finally having something to eat.

Monica
Hamburg, November / December 1991 (?)

Once there was a very short moment in which I could see her future face wearing a more confident and quite energetic expression. Mostly her face shifted in between her real face and the face of a childish girl.

Till Steinbrenner
Antas de Ulla, Spain, 2002

Description of an object that I hate:
Plastic orange case, probably from a felt-tip pen.
Length = about 7 cm, diameter = about 8 mm, weight = about 3 g
The colour is faded neon orange, one end of the case is broken off, and the other is smooth, as if something had been in it which is now missing. The absence of a thread allows us to infer that it was a felt-tip pen. Near the broken end there are four small cracks. At the other end, a dirty, demolished sprue, which has caved in a bit. Inner agglomerations of dirt, above all up to the middle; presumably plant remains, some a bit larger. The very weak extruded cone is narrower at the broken end. The thickness of the walls are uneven, about 0.8-1.2 mm. At the smooth end, there is a groove inside that merges into the narrower rim at a 45-degree angle. The groove could not have had a hold-

ing function, as it could not be grasped from underneath. The object is smooth and shiny. No taste, no smell.

Sound: lighter than wooden, homogenous, hollow, thin.

Temperature: relatively warm.

The disagreeable object stands out in any setting, and will do so for a long time, as it does not rot. The energy used is quantitatively great and qualitatively negative. Negative, because from the development of the material through to the development of the product and its manufacture, we are dealing with negative, exploitative, reckless forms of energy. (The dye is probably cadmium.) The form, colour, etc. are artificially made and monotheistically goal-oriented.

The object is either new, or broken.

Place found: Casa da Terra, lying on the ground below the parking area, near the gutted skeleton of a car. The ink cartridge is probably in the car. Age = presumably 3-10 years.

Description of an object that I love:

Pebble, flat and egg-shaped to oval, height = about 5.5 cm, width = about 3.8 cm, depth = about 1.6 cm, weight = about 30 g

Colour dull grey, very light, with four irregular stripe-shaped deposits on one side – and five more on the other side. Each deposit has a crack-like plastic structure. On one side, on the slightly slanting end there is a brownish

discolouration of a diffuse, cloudy shape. The stripes here form radial to parallel patterns until they reach the fissure, of a grey colour and very fine. The other side also shows a brownish discolouration, but this one is shaped like a thin crescent and at the other end of the stone. The stripes here are more radial as well as diagonal, to some degree corresponding to those on the other side. This side is somewhat rounder than the other one, which is flat to convex, up to the middle.

The silhouette is nearly smooth, except for one slight dent leading to the larger fissure. The surface is overall matte, opaque and homogenous except for a few pores and the two fissures.

Taste is slightly salty. Smell: none.

Place found: on the beach (Atlantic) with Lotte. Age: presumably 10-100 million years. Intrinsic temperature: cool.

A pleasant object, as all the energy involved in its creation is of natural origin.

A difference cannot be observed between its creation and its destruction – the object is valuable from its first to its last day.

Nezaket Ekici
Antas de Ulla, Spain, 2002

Friday, 21/06/02
To be honest, I'm constantly hungry. In the

Till Steinbrenner
Things You Hate / Things You Love
Antas de Ulla, Spain, 2002

mean time, I don't like water anymore, never mind tea. My will-power perseveres – I want to manage this. Nevertheless, I can't conceal it. Delicious foods often appear in my thoughts. I'm not really hungry – it's more just an appetite for good things. So the delicious main courses alternate with sweets such as ice-cream, chocolate and fruit. Yes, above all, fruit. I need something fresh in my body, and tart.

Then I think of meat dishes. Poultry dishes. Vegetables. Pasta I can do without.

Saturday, 22/06/02

…The third lap was torture. My legs were already hurting and there was a painful pressure in my stomach. From time to time I got into stride, and then thoughts cropped up in my head. Naturally, food again, various dishes. But also family members, the past, my father and the rest of the family.

Sometimes, when I saw someone who was faster than me, the urge in me to overtake them was very great. And sometimes I managed to do so. I would observe their stride and imitate it. As there were some people who were smaller than me, I was able to overtake them by taking longer strides at the same pace as the person in question. After a time, my will-power would weaken, my body tire, so I would return to my own pace…

Sabine Ravn

The face is dissolving, changing into a monkey or a monster, then suddenly it is shining all over, as if it would consist only of light. Later, I could befriend myself. I actually try hard to like my face, which is not so very easy. I try to recognize every detail, even the smallest.

Vanesa Díaz Otero
Antas de Ulla, Spain, 2002

Siddhartha's breakfast.
A glass of hot water.

Marina is special – we trust her.
I like silence.
We will see hunger.
Feeling its presence is soothing, being there at the right time.
Tiny pupils. It was hard to recognise my expression before my aura.
Mouth of a furious heart.
Square mandible and toxic skin.
It depends on what you think.
Your expression changes.
These are not physical traits.
But existential principles that show in your face.
I believe that without talking everything is clearer.
Looks, approximations, each step, each position (physical position) are more valuable than any speech.
We will go to sleep although it is still not night.
For the time being, everything is all right.
Thinking of food is stupid.
Buried up to my knees like a tree.
With my arms stretched, with branches and leaves, in the nude.
This is seeing in a direct manner.
Daily things for real without the shield of pleasures.
A Casa da Terra is the place where butterflies meet.
How is it possible that purification and intoxication are so similar with regard to our state of consciousness, perception of reality, inner journey and astral body?
An object found that I do not like:
A dirty blue rope tied to a stick.
It involves a lack of freedom, repression, eagerness to possess.

Ivan Čivić
About my experience in the workshop
Antas de Ulla, Spain, 2002

June 2002…
This was the first time I willingly decided to disappear from this planet for five entire

days and starve, listening to the only person allowed to speak, that is to say Marina! She did speak indeed; giving us instructions about what to do and how to do it.

Not eating for five days was tough, but nothing compared to not talking for five days! Difficult stuff... and then waking up so early each morning... doing physical exercises, even if we had no more energy for jogging or sprinting naked into the freezing river at six each morning!

Abstract mental excercises like writing our names once and having to take one hour to do it without taking the point of the pencil off the sheet of paper.

It was tough. Thoughts started running through my mind very quickly. I had to begin with introvert personal mental games in order to achieve the missing "speech" our society donated us. Yes, I was indeed talking to myself. I was talking the whole time, laughing at my own jokes and crying at my miseries. Then a firm voice came; Marina's saying "Stop commiserating with yourself!" So I started thinking positive again and whenever I would start commiserating with myself again, she would be there, next to me, as if she had a radar built in, capturing your inner thoughts, making you know she was there and that all would turn out fine, somehow...

I must be sincere, I didn't like the physical excercises, I felt they were not professional and they were doing me more bad than good, but behind all that body experience, I noticed that for Marina it was more important to open other doors to us. We had to start forgetting the body in those few days which is an incredibly difficult task to achieve. I don't know if anybody really did achieve it but that is also not so important. What is important is that she made it clear to us that it is possible to escape the body. She made us feel how wonderful it is to be independent from this world, from our own limits, even if only for a fragment of a second, and fall or fly into our selves. Some got lost, or like me, the world tends to be very chaotic and I got a real need for order. With order I mean inner order.

And then the fifth day came and I was relieved, because I knew that if I had gone further, I probably wouldn't have been able to get back to society. Paradoxically, I needed civilization again, and soon, in order not to forget it. I wanted to forget it, but I knew that after those five days, it would have taken me back to its self anyway!

We got to eat our "golden ball," and were sent to spend some hours alone and think about a performance to present on the fifth day. This was the gate that took me slowly back into reality, the connection with the public. This is what performance is about, useless without society! The gate opened and I started my way back to the people, the ones I know, the ones I love and the ones I've never met before.

Beatrice

This unusual place was strange where we felt as if we were in a maze and every corner was a way out.

An out of time place...

...We notice that we cannot see well; we realise how "un-seeing" we are.

We learn how to look and memorize.

The hardest thing to do is to hold back your saliva, especially when you hear your neighbour swallowing. It was as if I was paralysed in the end, my body was heavy and my mind was still. Very soon, the image of our being dematerialized, moved and wore out. I saw much more the absence of image than the "real" image. I was only an illusion.

I was present, conscious and not there at the same time. My body was light. I felt as if I could walk for hours. I felt nature, wind, smells with immense pleasure. Just walking, released physical energy...

...When we went into the forest yesterday I got lost, whereas today, with my eyes blind-

folded, I found the way home much sooner than anticipated...

...This is a tremendous experience, as each part of the body vibrates according to the sound emitted; it calms you and does you so much good.

It is strange... I thought it was going to "traumatize" us much more, whereas my reactions are quite normal, if not more alert...

...Take the time to have time...

Frank Lüsing
Hamburg, 1992

I had already forgotten: for example – the way the constitution of the body influences concentration.

Myriam

Slowly writing my name, it takes on quite another "look." It becomes immense, unknown, dangerous, marvellous landscape. It takes form quickly but escapes me; mysterious. I am not able to follow it and discover everything it hides, like a dream.
I feel my name as antique and mythological.

Ana Pol
Antas de Ulla, Spain, 2002

It is strange to write when one cannot speak; it seems as if one could not communicate. Writing is almost the same as speaking, it stems from the same silence. Someone said that this is where history began...

...When there is no food and one cannot speak, you are the only one there to fill you; you are the only one to answer all of the questions and search for the damn answers. You realise how important it is to smile because people are nurtured by your smiles. There is a lot of peace and my stomach does not ask for food.
Crying before a cliff due to vertigo.

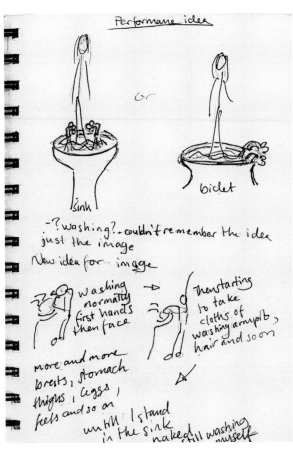

Drawing from Anna Berndtson's diary Antas de Ulla, Spain, 2002

Being quiet is strange, sometimes it is too easy. There are no mistakes in words, the only things left are our expressions, our looks, and our energy.
We have created a different form of relation. The feeling is different from being alone but everything is surrounded by silence. Silence with expressions; looks conveying even more, eyes are more expressive and everything moves you more...
...Looking into the mirror.
I get tired of myself. I am bored of my face and my expression.
I like the red veins in my eyes, they are more noticeable because I do not blink.
They draw maps, eyes covered with maps that rescue images from memories.
The background is black – grotto.

Lotte Lindner
Antas de Ulla, Spain, 2002

What I really don't like:
It is really hard to find something that I

don't like. When I begin to observe things more closely, I find something that I like about them. However, I do not like a heap of vomit. It's yellow-green, smells sour, you can still identify some of the food in it and partially smell it too. Part of it is chunky, another part liquid. Most probably someone vomited on the street and then someone else stepped in it. The walls are streaked with fine lines of it and I don't even know if I stepped on a streak that was too fine to see. The worse is to imagine touching vomit with your mouth. But there is no vomit here. There is only an old plastic brush, which is just moderately horrible. It is about 11 cm wide, its bristles some 8 cm long. The handle is pale red. A rather faded plastic red. The bristles are held in place by a metallic strip (copper?) having two bulges on the bristle edge that are 5 mm apart. One of these bulges lies directly along the edge, the other one under it. There is a third bulge that is 5 mm from the lower edge (the one that leads to the handle). The metallic strip has an overall width of 4 cm and is fastened to the plastic with two nails on the front side, and two on the back side. The nails are located just under the lower groove on the lower bulge, precisely the end of the strip leading to the handle. The nails on one side are already somewhat loose. One is about 4 mm high, the other 1-2 mm high. The metallic strip is tightened by overlap-

ping of its seams on the side. On this side of the metallic strip is the number 48. You can read it if you turn the brush with the bristle end towards you. The numbers are curved in a rather old-fashioned manner. The 4 is somewhat larger than the 8. The S-side of the 8 is thick, the opposite curves are thin. The numbers are in the middle of the strip and about 1 cm above the edge.

The handle is pale red, as mentioned. It looks a bit like a fish. On the wide end it runs flat against the shaft like a T, in any case connecting to the longer grip part with a shallow curve. The grip itself resembles a fish. At the lower end, it has a perforation/hole like an oval with straight sides. On the whole, the grip is flat and rounded at the edges, though somewhat thicker at the stem. In the sides, a mould or press seam is visible. On the grip there are specks and larger stains of black, matted tar. Some dust is stuck to it in some areas, in others it still shines a bit. The metallic strip has more tar on one side. It is the side with the number. On the other side, you can still see the shiny copper. In any case, stuck at its edge along the roots of the bristles are fine wooden splinters, sand and grass. The bristles are completely clotted and permeated with tar. They are slightly curved upwards from the position the brush was in and they thus taper and become flat at the tip. There they are also stuck together in groups, as opposed

to the roots, where they are clumped together in a single mass. On the back side, on which the brush was lying, some of the bristles are bent and stick out. There are also many more splinters and leaves of grass and sand here. On the front side, this is only the case along the left edge of the tip. On the right edge there is a thick blob of fresh tar, still deep black and shiny and moist/sticky. The bristles smell strongly of tar, whereby I don't find the smell itself horrible. It smells oily and somewhat spicy. What I find worse is that everything is sticky, that such a thing is old and can no longer be used, that the brush is hazardous waste and all the stains can only be removed with solvent. Every part of it is inorganic, even perhaps the tar? In any case, the dirt and the splinters are nearly pretty.

What I find beautiful:
Is a wheel. The wheel is made of wood. Oak. The wheel is no longer in use. It is leaning against a wall of natural stone. The wood is deeply weathered. It appears as if it had not been used for a long time. The wood is very cracked and worn. On the upper area you can see a fine crackle of hairline fissures. The wood has greyed even to the deepest cracks. You can no longer see the original wood colour even a centimetre deep. In some places, the younger wood is more washed out than the older wood, producing striped grooves in the direction of growth of the wood. The wood is highly snarled and has many knots. In these places it is more often torn and snagged than in others. In some areas it is black from mould or moss growth. In other places, nails have been driven in, apparently to reinforce or repair torn areas when it was still in use. The nails are rusty. The entire wheel is nearly solid. It has no spokes and consists of only three pieces of wood about 13-14 cm thick. Two parts are arched, not quite semicircular and about 20 cm wide. They lie above and below a crossbeam of the same width. It serves as a spoke and connects the semicircles through its

Drawing from Beatriz Albuquerque's diary Antas de Ulla, Spain, 2002

tips so that they form a circle. The crossbeam is about 24 cm wide inside the wheel space and at its ends has the thickness of the two other parts and is about 32 cm wide, forming a double T. In the middle it has a mortise that is 6 x 10 cm in size, lying lengthwise along the crossbeam. The wheel axle went into this hole and was perhaps wedged there. It is impossible to tell whether the three wooden parts are dovetailed to one another. The wheel is also reinforced with iron strips. One runs along the outer edge like a ring, protecting the wood from premature wear. Two encircle the crossbeam, one above and one below the axle mortise, in order to keep the wood from tearing. The axle brought the entire weight to bear on these areas. Then there are also two strips at front and back hammered onto the sides of the wheel. They are somehow adapted to the curve of the wheel, but are still slightly less curved. They reinforce the union between the crossbeam and the crescent parts. All iron parts have been set into the wood (approximately to the depth of the iron) and fastened with wrought-iron nails. These have square or nearly square heads. All iron parts are extremely rusted. The surfaces are stained in rust and therefore raw, as if they had been hammered. These rust stains are a variety of colours, from dark brown to rusty red. In some places, the strips are rusted through. Especially at the ends.

The entire wheel is heavy. I can only lift it with difficulty. It has a diameter of about 90 cm. At present it smells warm and like the sun, even though the sun has already set.

Oh, and I forgot that the insides of the crescents are profoundly worm-eaten, which produces a surface that I particularly like. It tapers at the ends.

Drawing from Fumi Ogasawara's diary Kerguéhennec, France, 1995

Unknown Participant

Slow motion... what about the arms, the legs, what about the muscles? Think at once, feel the feet and the toes all around the feet – one step is an adventure – slowly, slowly through time down to the ground and pick something up. Smell how many green smells there are, how many brown smells there are. Running as slowly as possible, head up! My feet feel the balance when I touch the ground. I try to catch the smell of the cows, they are afraid of this slow-motion person. Sun. Sleep, no sleep. The feeling of warmth and how my headache flows away! Blindfolded again but differently, now head up! Listen to the sound coming from, where is it coming from? I trust my ears absolutely, doves, crows, the murmuring of water,

tractors, a train, wind through poplars, footsteps all around. Sometimes we touch each other, I recognize Keli's jacket, Dean's smell, the twins giggling, the gong's sound is the most important thing in my life now. My hands meet a tree then I meet a tree. First its leaves, then the tree itself, like an old friend, soft but rough. Standing as if to say to me: you can trust me, you are welcome.

Carmen María Julián Molina
Antas de Ulla, Spain, 2002

Today I have learnt during the walk that we actually have the chance to see it all. It is only a matter of learning what to look at. Coming back to the house along the same path, I realised that there were many different things I had not noticed because I had been focusing my attention on the path.

Now we still have a slow-motion afternoon, cleaning the house. I do not like this at all. I do not feel like doing anything. I just want to have some custard. I want to take a hot shower and then go to sleep.

Oliver Blomeier
Diary, Kerguéhennec, France, 1997

14/12/1997
Now it is getting serious.
The last words were not so very moving: "Bye now, good night, take care, see you on Friday." Many of us had this urge to say goodbye to everyone personally. Susanne suffers the most, I think. She finds all of this esoteric stuff with stones and energy calculations really stupid. Now I'm lying here on my hammock, which at first glance appears to me like a bed. In addition, I share the room with a travel wardrobe – one of those foldable things with a zipper. The room measures four square metres and has a sloped ceiling. I can see myself in the window when I'm lying on the bed. Next door is one of the four toilets. I checked the noise level just in

case. It seems to be OK. I'm quite satisfied with the room and its drastic narrowness, but the bed could become a problem.
So much for the place. Too bad that I can't speak to you anymore. But what could I possibly tell you that is so moving that it can't wait till Saturday?
These are actually the first lines that I'm addressing to you – apart from postcards and messages on notepaper. And I myself don't even know how you write. We're lacking the time, or only the leisure.
So often it is musts instead of leisure.
– Dash
Mental leap.
Actually, what do you think of my handwriting?
I myself would describe it as legible but rather unstructured. Not very aesthetic. Now I'm not exactly writing a great deal. What I think stands out is the extremely different heights of the letters and the irregular spaces between lines. Everything seems to be fluttering.
Back in time to Braunschweig. I'm thinking of you and Schnuppi. You are most probably both still awake. Necessarily. Here it has suddenly become peaceful. For four days it will hopefully remain this tranquil. Heavenly. Everyone seems to have realised at once how pleasant it can be to record your thoughts on a white sheet of paper. Much remains unwritten. In any case, you can even chatter and prattle. You can, like me, write nearly automatically, just like I often speak. And when you don't like what you wrote, you can cross it out. That does ruin the aspect, though.
It really looks like shit when the flow of the text is ~~broe~~ broken and words are written above or below the lines. My dear Jeannine, today I'm not really getting through to you. I'm more on the paper in my thoughts too.
Brain – hand – pencil – paper.
Everything really close together.
Braunschweig – Constance – Paris, everything very far away. Saturday? Far away.
Time or distance? I thought today about my

perception of the world/reality and it struck me that I mostly...

Time or distance?

Do I organise my perception temporally or spatially?

Most certainly spatially/visually.

An idea pops up:

In ski races, there is a winning time. You could show the 2nd to 15th place skiers where they were, spatially, when the winner swished through the finish line. As if they had all started at the same time.

Darling. For the last 10 minutes I have again been rambling on and counting my eggs before they're hatched. I would now like to put away my pen and book and say good night to you, until tomorrow evening. Kisses, ***click***

15/12/1997 First morning

I dreamed that some people would speak; that they couldn't help it.

Lay awake in the middle of the night. Disoriented as to the time, as I have no watch. Survived the morning exercises. It was not as bad as I expected to hop around barefoot on the dew-filled grass. The first task is to check three times a day which nostril is open and which one is closed. This is supposed to be done at 7:00, 12:00 and 19:00. Feeling

Rationality

If you find a time when both nostrils are open, that is the right time to be creative.

around the lake

3267 steps

This is my fourth lap.

In the end it took twelve laps and seven hours of walking. I was quite tense most of the time and couldn't help comparing all the time who was relatively faster or slower than I was.

The path was beautiful. Despite the senselessness. My lap began each time at a fire where two workers with a tractor and a chainsaw were busy cutting shrubs and burning the twigs. At each lap I took a photo of this fire.

I doubt that only twelve laps would help to find the path better blindfolded.

That is yet to come.

When I arrived here at the house (it was already dark out) and had rested for a few minutes, I could hardly walk anymore from the pain, primarily in the shins. Furthermore, a long blister had appeared on my right toe.

I was disappointed/surprised that I was not able to mentally free myself from the others in the group during my walking. My thoughts were revolving the whole time around the question of whether I was making or losing ground. Nevertheless, it was fully clear to me that everyone had to cover exactly the same stretch. And furthermore, no one gained anything from getting there earlier (as long as they made it before total darkness). In any case, I have never walked so much without stopping in my entire life. Of the twenty walkers (Katrin only arrived today), sixteen went in a clockwise direction and four (myself included) went counter-clockwise. I wanted to walk longer with my face in the sun. Thus I crossed paths with these sixteen people twenty-four times each. That makes 384 meetings. Plus other walkers and the two workers. Each time a certain distraction of my concentration and restriction of my freely roaming gaze.

It was also impossible to calculate the entire time à la: still one lap and then you'll have managed two thirds of the way. And then at the same time Frank, who is lapping Kiki, comes at you from the other direction and has only one lap left. Kiki still has two and you still have 3 x 3,267 steps. That was what hurt the most.

But blindfolded...

Hopeless. And dangerous in addition. You would have to feel your way along the water's edge the entire time. Or have a long cane to feel the way.

At eight we all lay on our backs and made sounds and did breathing exercises: V-O-A-E-M, each time taking a deep breath and for about 5 minutes. V from the genitals, O

from the stomach, A from the heart, E from the throat and M from the fontanelle.

Subsequently, look at yourself in a mirror for one hour without blinking and then go to bed without eating. Excellent!

It's just a good thing there's no food at all in this house.

When looking in the mirror, it dawned on me that my sight was gradually growing duller and the image progressively more out of focus. It's a good method, though, to keep awake. Better than reading a book, which makes me fall asleep right away.

Yeah, but I don't have one right now. So I'll just think of you all and then I'll surely sleep well. One thing really gave me a headache though. I can't call at all on Thursday evening because we break our fast and our silence only on Friday morning. Oh well, maybe I can sneak away for a moment.

1-hour "Writing Your Name" Test.

Tuesday, 16/12/1997

I feel very calm.

This morning I jogged once around the lake clockwise. After that, I sneaked out to the telephone and called you. I would thus only be able to take the oil bath in KN. Then we can both relax in it. The Indian rope trick only entertained me for one minute, unfortunately. Not that I want to brag. In addition, there was something to read printed on it. Luckily, I don't take this so seriously.

Before me on the wall hangs a yellow square of paper, 30 x 30 cm. I will now stare at it for one hour. And then, this is what happens next:

Yellow: first a bright edge appears around the square. The wall becomes bluish-white. Eyes begin to hurt. Can't sit still. Later I fall asleep for a few seconds. Dream phases. Time appears to stand still. I become hungry. Stomach grumbles constantly... When I lean against something, I immediately fall asleep.

Sensations: nervous, tense, hungry.

Now comes one hour of

Red: I still have to add something about the yellow part. The colour faded quite quickly and withdrew from the edge of the square. Afterwards, I urgently needed to go to the toilet. Red also began fading at first – it became greyer. Then it began pulsating with my breathing rhythm. I concentrated thereafter very hard on my breathing and did not become sleepy at all. Also had to move much less than with yellow. In the end I was quite relaxed.

Sensations: relaxed, steady, vigorous in body: chest and back.

The last hour is

Blue: eyes, nose. Strong hallucinations. Tranquillise me and I finally fall asleep. Runny colours wander from the upper area to the lower area through the image.

Sensation: exhausted, tranquil.

Drawing from Marika Orenius' diary Kerguéhennec, France, 1995

Feeling in the skin was also sharper.

In the evening in bed:

My skylight is still just a white rectangle. No stars in sight. Instead there is snow on it. That means barefoot in the snow in the morning. My dearest... you already know.

After the colour studies, I ventured to take a walk with Anna and Anette. It was freezing cold and the wind blew strongly. Icy. There's a small church just behind the house. Curious because the windows were glazed, I wanted to go in – and it was open. Inside there were all sorts of foods on funny glass tables. Pumpkins and lemons, apples, onions, garlic, maize, etc., like a harvest festival. But what were the lemons doing there, and what about the garlic? A small sign informed us that it was a work of art with a French name by Mario Merz. (I can remember superfluous and unimportant names much better than those of interesting people, funny). We went on and it began to snow lightly but it soon became a real snowstorm. Along the path there were thorny bushes with yellow blossoms. Could it be broom? I took a bough. The flowers are very beautiful and smell like air fresheners (I think this one would be piña colada) – sweet and heavy. Perhaps it will keep until Paris.

Later I wrote my name in slow motion. For fifty-three minutes. My fingers became cramped. "You learn a lot about yourself". Yes, yes. In any case, my attempt was the smallest. Marina thought I could go into a monastery. Ben next to me sort of gave up and wrote BITCH. Then he scribbled on the dot of the i until he had gone through the notebook. Thereafter everyone was massaged by everyone. That is, 4-6 people massaged one person who lay on the table. I have never had such an experience. Total relaxation.

Sleep well, darling.

Muah.

M

E

A

O

U

Collected mobiles
Antas de Ulla, Spain, 2002

The elemental sounds and their relation to the body zones
Question: where is the "I"?

Wednesday, 17/12/1997
It is late in the evening (about 22:30 hours). My eyes are strongly smarting. No, it's actually somewhat better now.
I lie on my shitty bed and look around the room. Nothing happens.
Outside doors are slamming in the corridor, people are shuffling through to the toilets, to the showers. There is a great deal of groaning to be heard today. The "nervous breakdowns" are also mounting. Ben seems extremely apathetic and unmotivated. For many of us (myself included), the urge to communicate can only be suppressed with difficulty. If the matter is a burning question, then this is understandable. But it is mostly simply the need to show oneself.?
Is this true?
I don't want to ponder over this. How was the day?
In the morning, sports. Barefoot in the snow. Then abdominal gymnastics in order to burn off the "poisonous acids" in your stomach. Definitely ouch-ouch. Then a break. Drank some tea and then dozed off again. When I wanted to shower ("take a hot shower"), there was only cold water left. Then I went down to the stream and looked for stones, as we now had to build the golden ball. That was actually rather fun. Everyone sat in a circle on the ground. In the middle was a white cloth with pepper, cardamom and almonds. Then everything had to be finely ground, a ball was formed and packed in gold leaf, finished. Due to the spices, my throat burned for quite a long time, as it was already strained. At one it was the march to the lap of fear. Once around the lake blindfolded. Nonetheless, I first made a sharp blind-man's cane and felt very self-assured. As opposed to when I went around the lake twelve times, this time I departed in a clockwise direction and was soon alone, on through the meadows, tap, tap, tap – left, right, left, right, with

such a walking stick, not much can go wrong. Noises such as the murmuring of water and construction sites also helped to orient me. At some point in the middle of the lap, I was overtaken. I could not understand that. I lost my orientation and cheated. Had to lift the covers off my eyes. Not that I couldn't get back on track, but I simply had to know who had overtaken me. It was Anna, and she had no stick. Unbelievable. In the end, nearly all three of us (Anna, Iris and I) arrived at the finish/start point and fell into one another's arms. At that point we would all have enjoyed discussing our experiences. I can't wait to hear how it went for the others in this exercise. We then went off again, in order to see the others' progress. Many were completely disoriented and had left the path entirely. Yet they had already gone by twelve times. I then helped Sarah and Shiaru, who were far behind. I even led them by the hand for a good while. After two hours, everyone had reached the finish. At home I was finally able to take that hot shower that I didn't get in the morning. I lit a scented candle while drinking tea and dozed off until the next meeting. But now came another chore. Sitting for one hour across from someone without moving and without blinking. This is sup-

Drawing from Oliver Blomeier's diary Kerguéhennec, France, 1997

Then you sit on the opposite side and watch the ever flow away, thing of the past

after a while I unfortunately cost concentration — got to work on my concentration, I keep ready falling asleep — at the moment were all by

Drawing from Amanda
Coogan's diary
Antas de Ulla, Spain, 2002

posed to allow you to be able to see the other person well.

Luckily I had chosen Julie. Much better than Iris. Although in the end it's all the same. We're all victims here.

I soon noticed that a droplet of snot was building up under my nose. And then my left eye started watering. Then my right one. Then the other nostril started to drip. But: I only blinked three times. The first time at least after forty-five minutes. That's also why my eyes are stinging. Julie wasn't dripping or watery-eyed at all. (She sweated like crazy though). I did too, even more so. My eyes stung so badly at some point and were so full of tears that I couldn't see straight anymore, only schematically.

One thing neither of us could control was our swallowing reflex. About our aura I can only say that, in my opinion, everything gets a corona of light when you stare at it for a long time. You could already see that clearly with the colour square tests. I didn't notice any special aura. But perhaps I'm simply not "open" enough yet, ha, ha. Too occupied with myself. The others are only a scale for my achievements.

Marina then wanted to do the exercise with me again, because I intimated that I had not seen anything. Perhaps tomorrow!

Well then, goodnight.

Muah.

Sunday, 18/12/1997, 22:11 hours
Here I am again. I would actually be glad to fall asleep again immediately, but I can't. I found myself a clock for tonight, in case I wake up. It drives me nuts if I can't orient myself as to the time. But it is definitely still too early to go to sleep. I feel somehow exhausted after these four days. Time, my life, the future, all of that has somehow lost significance. I notice that I (and others) have a blank gaze more and more often. I just went down to the café to call you (in LU), but it was unfortunately already closed. On the way, we (Anna, Anette, I) were constantly breaking our vow. But one thing is certain. I am now much more aware of how often I make superfluous statements. Simply speaking in order to have said something. Whereas when you are silent, you seem to have a stronger charisma or emanation.

Emanation, the key word leads us back to this morning. Emanation is the same as "aura." And to see it, I stared at Marina for one hour after the morning exercises. I did not see any aura to speak of. There was a brief rosy brilliance above the shoulders,

but perhaps I only imagined it. Marina told me that I need more practice. She saw my aura radiating in light blue and yellow. I suspected that it was simply due to the lethargy of the eye, an after-image. But she held that it would not explain why she saw the most varied auras coming from different people. So it isn't an optical effect. Would you like to try it out with me once? I doubt it, but I would be willing to try it. At 11 o'clock we then marched off to the last exercise. The sun was shining, it was a beautiful day. We all took our mirrors and went into the park. The assignment was to do everything in extreme slow motion for the rest of the day until bedtime. And we were supposed to move backwards the entire time we were outside, and forwards when we were inside. At the same time, we were to look at our faces constantly in the mirror. Happy, etc.

So we started. I soon lost all notion of time. In the mirror you could also glimpse what the others were doing and how fast or slow they were going. Or simply look at their faces. During the course of the day, I found myself significantly more beautiful. Especially my eyes. The colour really appealed to me for the first time. I find they resemble my cat's eyes. (The rock crystal in the advent calendar was just as beautiful today – is it from Karstadt? Like a fossilised dewdrop. Now they are both lying next to me on the blue blanket [22:38 hours]).

Yes, the eyes. And then this spot in the left eye. It began to seriously get on my nerves. I mean, it didn't hurt or anything. But when you're looking at it the entire day. Ugly! I should probably go to the doctor's again.

First I went by my friend, the tree. There I took a short break and then went straight home. A total of approximately 800-1,000 meters. At 16:30 I arrived. Five hours of walking. Not bad. I was also completely exhausted and fell asleep in the chair over my mirror. Then I got into bed and broke off the experiment. But some people were still creeping through the house with their mirrors in front of their faces. Tomorrow there will be some food. Rice. But first I'll call you to see if everything went well for you three. And then we'll work in the morning. I still have no idea what I'm supposed to do. I greatly fear, however, that there will be a wild run on the material (specifically: cameras and DAT recorder). Hopefully I'll at least find someone who will help me (e. g., to take photos of me or the like). For the feast tomorrow evening, I would love to have roasted apples with

Drawing from Amanda Coogan's diary
Antas de Ulla, Spain, 2002

vanilla sauce and filled with nuts and raisins. Hmm, yum yum, from then on it will be all celebration and enjoyment. Until your birthday. And that we will celebrate just the three of us alone by cosy candle-light. I'll cook something, prepare everything. You can breast-feed Schnupp. Perfect or what?

Kisses, till tomorrow, Your Olli

Friday morning 0:09 hours
Since I've been trying to sleep for one hour now, I may just as well write down a couple of ideas that have been going through my head during the hour:

For the exhibition in Hanover I would finally like to carry out the installation/performance with the record player that always plays the same side of the Fitness through Movement record. I would furthermore need a chair to which arms and legs can be bound and a video camera. On the opening day, I will sit there, strapped in, the entire

day as a performance, and go to the bathroom in my pants if need be. The remainder of the time it will then be an installation.

The question that comes to mind is: what is the point of this crap? Difficult to say. I find that the work gains meaning when someone has really suffered on the chair. Everyone is allowed to sit in the chair for a while. I am still not sure, though, whether the performance should be with or without a public. Perhaps it should only be possible to observe everything through a one-way mirror. That would be even more perfidious. Naturally it would also be more difficult to carry out.

The second idea of the evening is one with an electrical typewriter, Robotron brand, that I have been wanting to operate by remote control for a long time now. It is supposed to become a "shining machine." On endless paper the same sentence is supposed to be typed: "All work and no play makes Jack a dull boy..." End.

Maybe tomorrow I'll do something of the sort. I mean with sayings and trees or with works of art. In the park there are all sorts of sculptures.

So, maybe now I can sleep – everything is written down, nothing can be forgotten.

Regina Frank

When I met Marina, I lived in a factory squat without heat, possessed a 28-year old Mercedes bus together with four other people, very little money, a great deal of political engagement. I have three hobbies: tango, tantra (meditation) and painting. The first two were strictly a secret and the third I made my profession. I painted images, studied painting intensively and some photography. I was deeply involved in student strikes, and participated in a student group called Interflugs. We organised presentations and workshops by artists who interested us. Some of them would then be invit-

Drawing from Oliver Blomeier's diary Kerguéhennec, France, 1997

ed by the school to remain as guest professor for a semester. I had just organised a "debate" with John Cage. This is where I experienced what a performance really was – John Cage swept me off my feet.

Marina was another one of those invited artists. I hadn't been on a stage since kindergarten. Marina said in her introductory presentation: "Do whatever you hate the most." I somehow felt attracted by this and I went to her class. I had never experienced this type of "teaching" before; I was much more used to having a sort of coffee circle where the latest works were discussed with the professors, whenever possible, that is, as our professors weren't necessarily present very often. In any case, never as present as Marina was, seven days a week, from ten in the morning onwards, open-ended. She asked us to jog to the school (around an hour and a half along the former wall from the depths of Kreuzberg 36, where I lived with several others) because of the energy implied by using the underground. She would close the door at ten and asked us all to be punctual. I expected nothing from Marina, except that she would have me do what I hated to do, and I think that was the only attitude that allowed this workshop to be so productive for me. Apart from that, I loved Marina, I could listen to her for hours without feeling the slightest impulse to leave. Her presence was very profound for me.

Until her workshop, not a single day had passed without my painting. Now I can't remember if I ever painted again afterwards. What struck me deeply then was how she said, "Artists produce so much trash, there is enough pollution on this earth..." It was like a total shock to me, a complete revolution in my thinking. It was as if she had thrown a burning match into my body and burned away all the painting in me, as if it were newspaper.

On the morning of the 14th of January 1991, I drove to the institute with my old bus to collect eight fellow students and Marina and drive to Sauen. I had bought sauerkraut juice, because I knew we were going to fast. For seven days I would neither eat nor speak. I had organised the house in Sauen and all the logistic details, primarily because I had the connections (through Interflugs and my link to the university administration). Even if I didn't carry out any performances, I knew that my presence had a reason, and furthermore, I liked fasting. The village was a place in the back of beyond. The house had curious rooms and buildings around it, as well as a small lake. It was very nice to encounter the others in this silence, for morning gymnastics, for tea... not eating or chatting with them, but instead a glance here and there, in the sauna, a walk around the lake, just being in the forest. In the morning, Marina woke us up as in Seshin, running from door to door and ringing a bell. Otherwise there was movement, nature, breathing and above all, peace, peace, peace.

For seven days, no news, no television, no discussions on important matters such as politics, war and peace, merely on what was to be organised for the day (with 22 housemates in a squat there is never tranquillity and always something to organise, even if it's only who goes to get the surplus vegetables and bread from the wholefood shop). I thought I was going to go crazy, but it was pleasant and everything seemed normal, 30 km away from the focal point of my life, the factory, and yet it felt like light years away.

On the last day, we were all supposed to do a performance. The time slot I had chosen for my performance was exactly five minutes to twelve at the bus stop. At exactly five minutes to twelve, I led my public to the "bunker" where I had installed a radio recorder in a small round bakery workshop. At exactly twelve, I intended to turn on the radio and tune in the news. At the same time I pressed the record key.

It was odd to share a space with a group, when before I had spent many hours alone

Drawing from Iris Selke's
diary
Kerguéhennec, France,
1997

and had been quiet. Suddenly, apart from my breathing, I could hear the throat clearing and breathing of the others, I could positively feel it. Then with a single click, someone is speaking from a couple of hundred kilometres away into your silence. This voice can sense nothing of where you are. It sounds neutral, objective, clear. You feel like you've just been catapulted down from the moon. But that was not all: the war had begun. I rewound the cassette and listened to it again. I rewound it again and heard it again. These abstract sound formations made of letters pressed like poison arrows under the skin. I read the lead article from the *Sauener Tagblatt* – in my own voice now, which I had not used for seven days... Then I led everyone back from the bunker to the house. I removed the tape from the recorder and developed the end of the performance, wrapping myself up in it... as a sort of development aid.

We rode the bus back to Berlin... without

Marina, who had already been picked up by someone earlier. The bus broke down underway and we were towed the remaining 10 km to our home. It never recovered. On the next day I was supposed to make a presentation in Jeannot Simmen's class. I still hadn't eaten anything except for a small ball of seven almonds, spices, honey and gold.

In the evening I photographed a live report by CNN on television about the Gulf War. In the morning, I got up at five and went to the press cafe at the zoo. I bought all the newspapers that had come out that day. I went to the Institute of Art and photographed all the photos in the newspapers. Weeks before, I had photographed Lecture Hall 110 in the Institute of Art building at Steinplatz. Lecture Hall 110 was often used as a conference room and was of great significance to the Faculty of Art, but general policy decisions for the entire Institute were also made here. I had everything from very detailed shots to photos of the entire hall.

I went to the photo lab and had all of the film developed. Having returned to the campus, I sorted the images into four slide cartridges. On the left, the slides of interiors, on the right those of the television and newspapers. Afterwards, I consciously tried not to do anything – I just sat there and the recently photographed images whirled in a jumble through my head, which threatened to explode. New rolls of film with the same images constantly popped up and then disappeared. I tried to make the moment between images longer, and this tranquillised me. For a time I fell into a quiet darkness and then suddenly, it was time for my "presentation."

Having no idea what was in store, Jeannot Simmen announced my project: *Sieh zu, dass Du nicht hinschaust* (Remember Not To Look). Otherwise, he also was uninformed.

I loaded the cartridges into the projectors. Then I turned out the lights at the two light switches by the door. Only the two projectors illuminated the room now with two

blank squares of light. I went forward to the lectern and stared at the public. The silence in the room was unbearable and when the first coughs started flitting through the room, I projected the first two photos onto the wall. On the left, a scratch in a green area (a door); on the right, a point of light in a dark blue area (the night sky), like a star, a lamp, a spark or a bomb just before exploding. Then on the right, four points of light; on the left, a long scratch in a door... Left, a wiped blackboard, chalk and sponge traces almost like an Abstract Expressionist painting in white-grey-green; Right, an explosion-like cloud of smoke in grey-white-black...

I projected all 2 x 120 images at the same speed on the wall. My trigger of horror remained steadily indolent. Alternately, my gaze plunged into the darkness or into the blinding light of the projectors. I heard nothing but the noise of the projectors when they loaded new slides. Then the last image, and then nothing. Again only two square fields of light like at the beginning. I took a green apple from the lectern and began to eat it. The sweetness of the apple mixed with the salt of my tears. I tasted my sorrow like a poison that was letting me die inside. The light of the projectors wiped out every other perception. No one said anything. Finally, I went to the projectors and turned them off. Then I left the room and left my rather shocked, angry or touched public sitting in darkness.

Silence has an intensity in the performance that I consider unrivalled. That is what I discovered during Marina's classes as an element for the performance. I later constantly experimented with my voice and yet always found my way back to silent performances. When no words are spoken, everything is said. The performance transforms silence into a perceptible sound. That is what is clear to me in Marina's work.

1993-2003
Performances

Beatriz Albuquerque

...The performer constantly mimics herself, transfigures herself, introduces and summons herself, to herself, to others, to things, ideas, images: she is "brought into existence" to herself and before the other. These processes may become painful exploratory voyages into unknown territories, conjuring up phantoms and incarnate memories that test the artist's ingenuity. Mythical forces summoned from the collective imagination are joined with evocations of the future as she seeks the almost ontological perplexities of an identity diluted before egoistic euphoria in order to gain access to the despoiled reaction, whose externality is a measure of its internality – ignored perhaps. Access to the austerity of the Ego, achieved during the performance, corresponds to a process of self-knowledge, which in some works tends towards the esoteric and hermetic. The power of concentration becomes a kind of expiation or exorcism; individuality – symbolic of humanity in a unique case – is redeemed by way of the body through an asceticism that brings together aesthetic voluptuousness and community ideology. Privacy thus shared does not exhaust its intimacy; it finds a sympathetic solution that presents "public" space as a collective route of dramatic affinities: deprivation, expansiveness, goals and paradoxes...

...The ephemeral nature of the action contrasts with the resonance of its mental and perceptual aftermath, which each person – artist and spectator / receiver – causes to echo within and without in a committed poetic act.

The moon is no door. It is a face in its own right,
White as a knuckle and terribly upset.
It drags the sea after it like a dark crime;
it is quiet
With the O-gape of complete despair. I live here.
Sylvia Plath

Erosão, 2002
Duration: 1 h. 20 min.
Cleaning the House, Centro Galego de Arte Contemporánea, Santiago de Compostela, Spain, 2002

The center of the Earth is the female body. The interior of the land is the cradle of mankind. Women and Earth are one. Feeding time in a complete erosion.

Frank Begemann

I want to put away my carpet.
It makes me sick.
I want to put away my books that I've read.
Under the carpet lies my courage.
My different moods sleep in old books.
With the things I'm doing, it's the same.
I've been doing a lot: selling insurance, caring for people, making art...
There's always a point in time, where I feel, I should go.
In this case I feel life; like a dance.
Cheek to cheek with death:
You don't have to stop, you have to move.
Don't leave yourself. Be awake.
And think about what makes you angry.

Master of Business *from the series* **Biography Works**, 2002
Duration: 20 min.
Galerie Medial, Berlin, Germany, 2002

Frank Begemann, Master of Business, offers the public a suitcase for sale. The wooden figures revolving on a turntable are introduced to the public with apparently personal biographical descriptions. The suitcase promises a variety of prospects for changing one's own biography. Encouragement to try out multiple personalities is the hidden message that the enthusiastic salesman is trying to transmit.

Take Energy – Leechy, 2000
Duration: 2 h.
Visible Differences, Hebbel Theater, Berlin, Germany, 2000

I bleed.
Art is blood-letting.
I use a leech to set me in motion.
To supply blood and receive renewed vigour, which strengthens me in the here and now.
Fresh blood does me good!

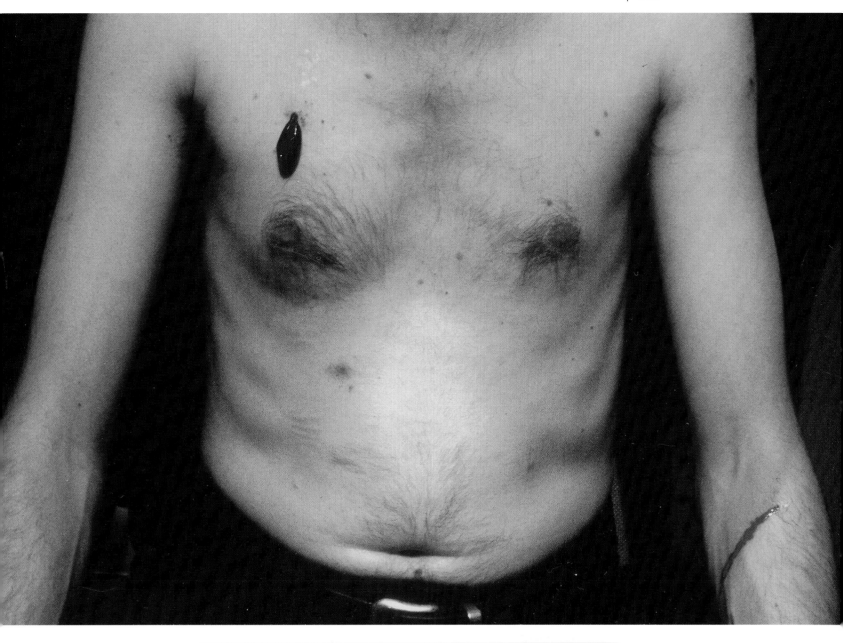

Anna Berndtson

My body and perception of space and surroundings is the essence of my work.
I concentrate on the formal, the structure and the precision; both of the visual image and of the movement.
I concern myself with human behaviour towards each other and with the engagement and interaction with the environment. My work derives from images and thoughts that are used as a vessel to reflect upon these concerns. The interdisciplinary character of my work, through the interaction between art, theater and dance performance, helps me to work on my own, as well as on collaborative projects.

Borg, 2002
Duration: 1 h. 45 min.
Tennis outfit, tennis balls, white stick
Body Power / Power Play, Württembergischer Kunstverein, Stuttgart, Germany, 2002

Borg is a durational piece that deals with always wanting to do the impossible. It works with images of tennis stars like Björn Borg as well as a personal frustration towards ball sports as a whole.
I am dealing with my own personal boundaries, as I walk though a landscape of tennis balls, with the help of my white stick.

Even if the white stick is my own, my present visual impairment does not require me to use it in my daily life. Although, in *Borg,* as I look straight ahead, I do not see the tennis balls on the ground.

RP, Retinitis Pigmentosa, is a progressive eye disease that causes, amongst other things, tunnel vision and night blindness. My field of vision at the moment (2002) consists of approximately 15° sight straight ahead, at 60% visual accuracy, which is of course reduced immensely in the dark.

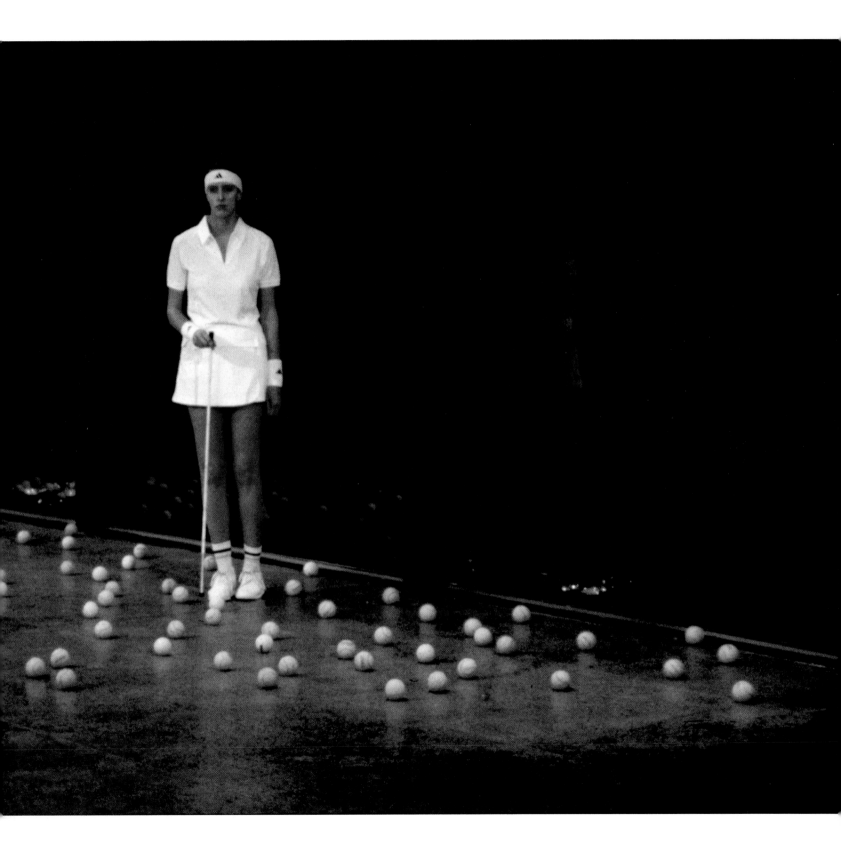

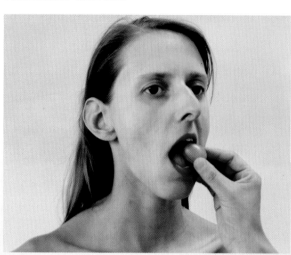

FOOD	Kcal/100g		FOOD	Kcal/100g
VEGETABLES			**SNACKS**	
New Potatoes, Boiled in Salted Water	53		Nutella	514
Cauliflower, Raw	34		Chocolat Cake	399
Red Peppers, Raw	32		Knoppers	528
Carrots, Raw	30		Snickers	580
Tomato, Raw	17		Mars Bar	452
Lettuce, Raw	14		Twix	496
Mushrooms, Raw	13		Kit Kat	508
Cucumber, Raw	10		Crisps	532
			Cashew Nuts, Roasted & Salted	610
FRUIT			Pistachio Nuts, Roasted & Salted	500
Banana	95			
Pear	40		**MISCELLANEOUS**	
Orange	36		Rape Oil	891
Apples	40		Grapefruit Juice	18
Kiwi Fruit	49			
Nectarines	4			
Peach	32			
Plums	36			
Grapes	17			
BREAD & RICE				
Basmati Rice, Boiled in Salted Water	352			
Spaghetti, Boiled in Salted Water	362			
Dark Bread	163			
With Bread	222			
Corn Flakes	368			
DAIRY				
Butter	595			
Edamer Cheese	310			
Tilsiter Cheese	335			
Brie	360			
Feta	267			
Yoghurt	73			
Milk, Full Fat	64			
MEAT				
Turkey Breast	133			
Boiled Ham	112			
Sausage	284			
Leberkäse	288			
FISH				
Herring Filets	224			

Not Scared, 2002
Duration: 2 h.
All kinds of food, scale, list
Hochschule für Bildende Künste, Braunschweig,
Germany, 2002
Body Basics I / Body Basics II, Transart 02,
Klangspuren Festival, Fortezza, Brixen, Italy, 2002

Not Scared is a durational performance dealing
with the thought of food as weight (or as a
weight gainer).
Not (Being) Scared is something that I try to
convince myself but maybe I am scared anyway.
I stand on a scale, on the wall a list, beside me a
table with a food-scale and lots of food. The
audience weighs the food and calculates how
many calories it has, feeds it to me and fills out
the following list:

Food
Weight - Food

Calories

Time
Weight - Anna

Sound-loop:
*The food on the table should be cut and weighed,
then you should calculate how many calories
there are in that piece and then feed it to me.
The list should then be filed out.*

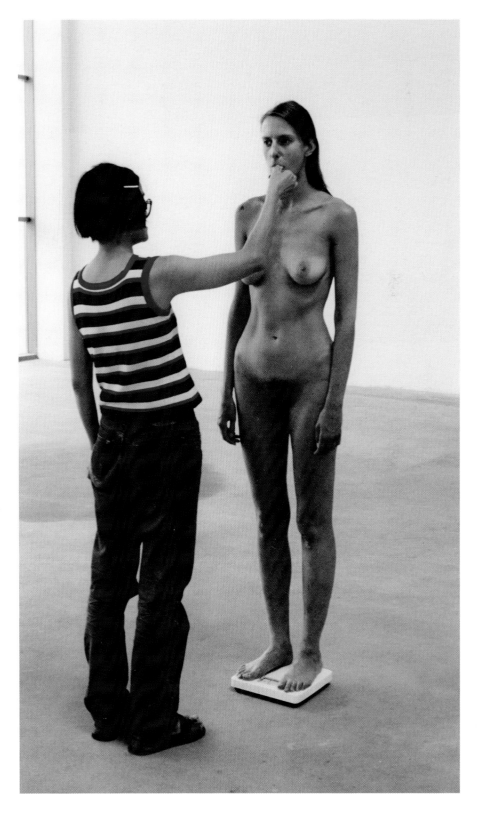

Earth – Rubbish, *2002*
Duration: 1 h. 30 min.
Plastic rubbish
Prêt-à-Perform, Viafarini, Milan, Italy, 2002
Hochschule für Bildende Künste, Braunschweig,
Germany, 2003
Recycling the Future, 50. Esposizione
Internazionale d'Arte La Biennale di
Venezia, Venice, Italy, 2003

Earth is composed of several performances with
the same focus. The original idea arose from an
engagement and interaction with the environment.
The durational piece *Earth – Rubbish,* concerns itself
with the effect of humans on their surroundings.

I am standing in the space, wearing a coat with
pockets full of rubbish.
I empty out my pockets, spreading the rubbish
around me until I am standing in a pile of rubbish.

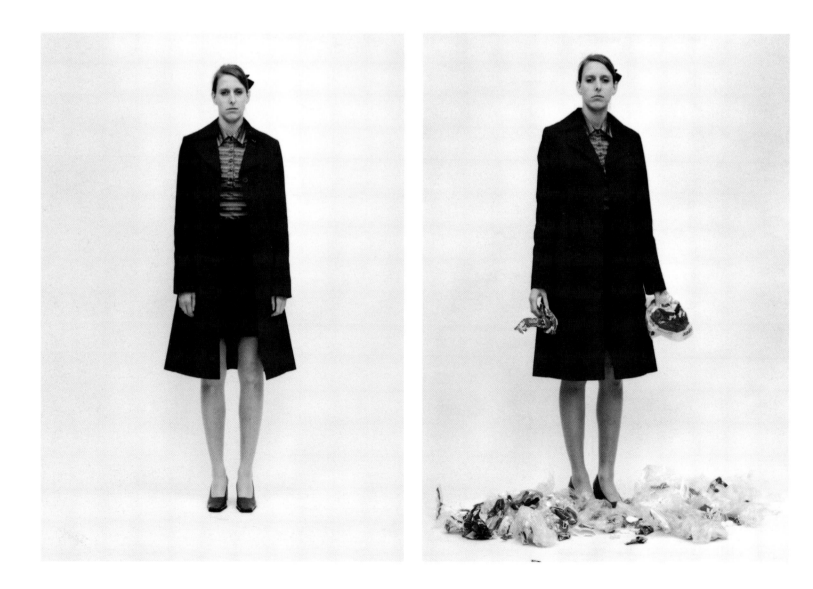

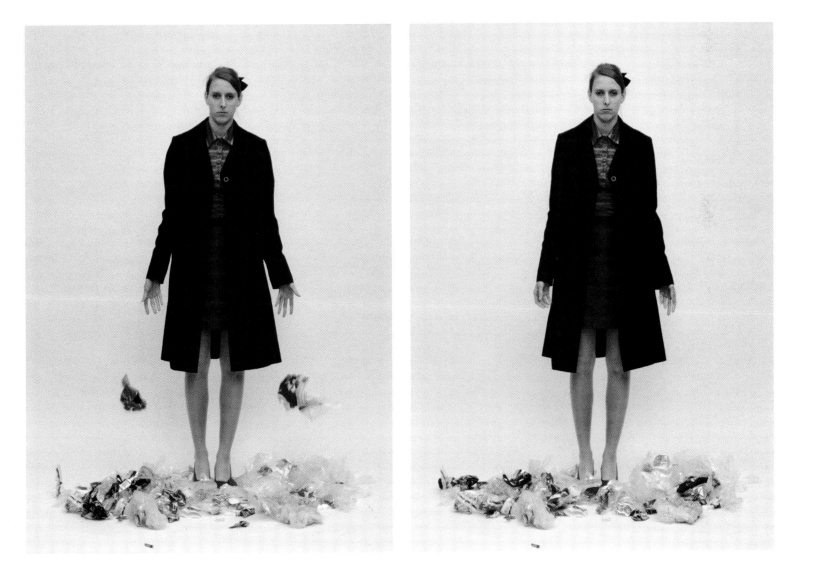

Oliver Blomeier

When I was a little boy I always wanted to be a farmer, later to be a researcher.
Being neither rooted in the soil nor systematical, I became a mechanic.

Based on correlations and patterns that derive from everyday impressions, I constantly develop ideas. These ideas come over and over again until they get fixed and realised.
I construct machines, objects and situations for spaces and audience.

I believe that art has to be free of the force of market principles and that the artist should only be responsible towards society. It's all in the idea. Form just follows the function.

flowtext.exe, 2002
Experiment / concert / performance / installation to be interpreted
28 typewriters, tables, chairs, paper, people, overhead projector
Hochschule für Bildende Künste, Braunschweig, Germany, 2002

To start with, each typewriter has a strip of paper measuring 1 metre placed in it. A line from Okwui Enwezor's text *Black Box* is already typed on each of them. An overhead projector shines the following text on the wall:

flowtext.exe
1) Go to the next line; in each space copy the character (or space) immediately above it.
2) Repeat 1 until the light fades
All visitors are welcome to join in!

All Work and No Play Makes Jack a..., 2002
Typewriter, paper, actor, other materials
Common Ground, Landesvertretung Niedersachsen and Schleswig-Holstein, Berlin, Germany, 2002

In this performance / installation, which gets slightly modified and adapted each time it gets presented, I bring together all of the diverse fields of my former work: installation, print, image treatment and performance.

A person (actor) sits in front of a mechanical typewriter and writes variations of the same sentence:
"All work and no play makes Jack a dull boy." This generates concrete poetry.

To create an acoustic and visual context for these actions, I use looping records, treated puzzles, video transmissions and speech.

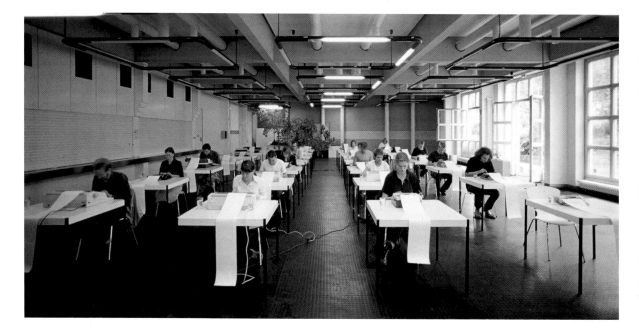

Frühling als Zustand (The State of Spring), 2002
A journey

For me, spring is the most beautiful time of the year. But it's always far too short. Botanists date "true spring" from the first apple blossom. And it wanders up northwards from Portugal. I found this very poetic and in the spring of 2002, I set out on an unusual journey – as a "passenger of spring," I travelled right across Portugal, Spain and part of France. And in order to keep pace with the onward march of spring, I did the 2,600 km by bicycle. My travelling speed averaged 60 kilometres a day.

Cycling in this case was like a mechanical way of lengthening my stride. Every metre of this trip was a personal experience. I saw how the horizon and the perspective changed slowly but constantly along with the landscape. My body became the pace setter, determining the length of each stretch and the places I stopped to rest. The route I followed was recorded by my body and the journey is engraved in my memory. Along the way, I took a picture of the road ahead every 20 seconds.

Meanwhile, more than 800 slides and 23 rolls of Super-8 film have captured my spring in thousands of individual pictures.

Spring stands still and Europe goes drifting by.

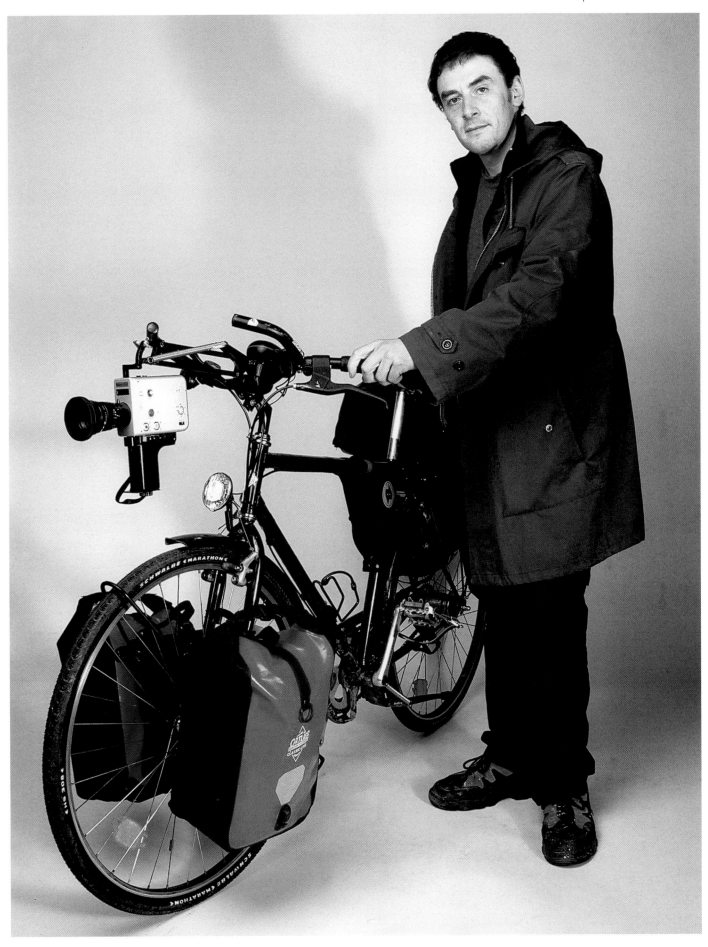

Immer weiter, 2002
Installation
Film-strip, Super-8 projector, bicycle, stand,
electrical switch

This installation consists of a bicycle with a
Super-8 projector attached to its front carrier.
A simple electric switch, triggered by the bike
generator, switches the projector on if a person
pedals. Thus a film loop is projected onto the
wall in front of the bicycle installation.

The film loop shows road surfaces with
interrupted white lines.

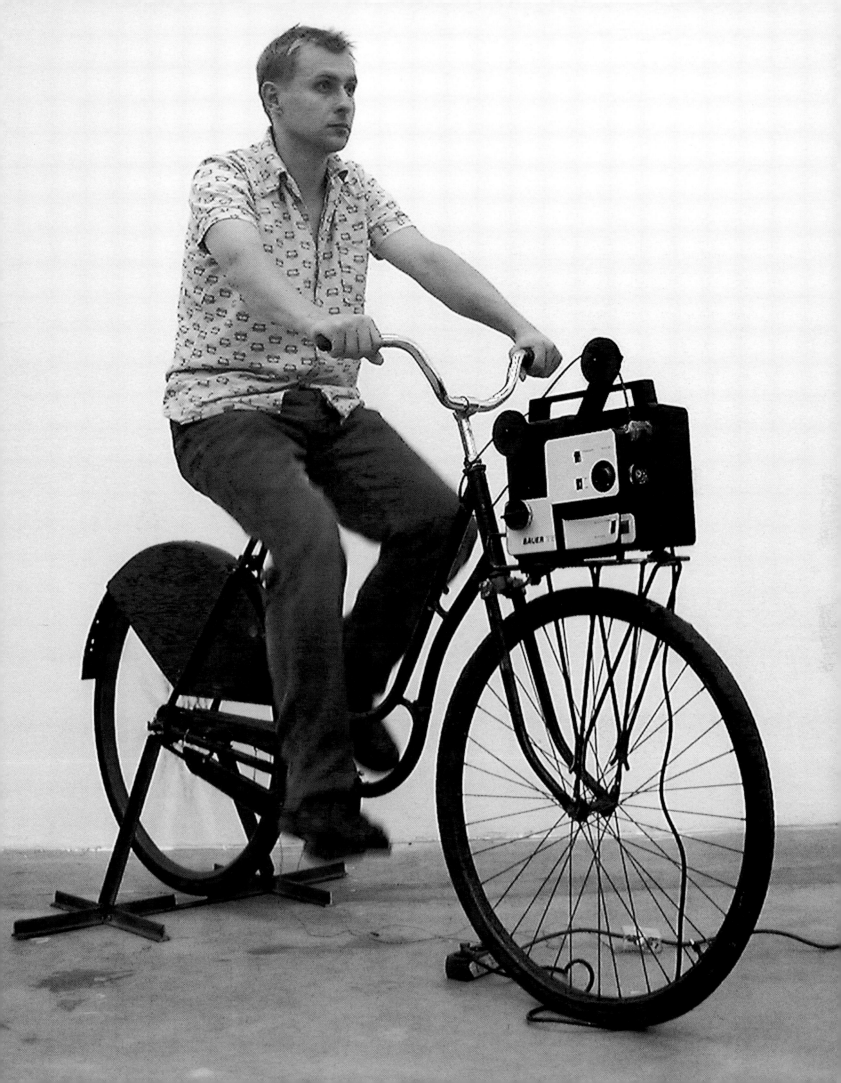

Vera Bourgeois

In my oeuvre, I produce interactive scenes and situations, in which visitors can enter into the works with me. Small everyday situations are contemplated intensively, taken out of their regular context and used in the works. Multi-polarity – the star – is the sign by which I am guided in doing this. I contemplate the radiation of a small particle and how it shines in many different directions. In recent years, themes have emerged which have become ever more fundamental. It is no longer the unseen by-products that are being brought into the limelight, but more crucial questions of being, which are finally being taken up and tackled.

Please Throw Your Most Loved Object..., 1999
2nd International Performance Festival,
Galerie Jespersen, Odense, Denmark, 1999

Sonnenbänke (Sun Benches), 1991-1995

A display of a total of eight park benches in
Berlin and Hamburg.
I placed brass-plated dedications to the
particular citizens of the respective cities on
each of the benches.

Sonderauswahl / Mangelware (Konservierung)
(Special selection / Scarce Commodity
[Conservation]), 1994-1998

My father is a chronic collector, accumulator and preserver of used articles. His collections take up four separate rooms in his house.
The collections are kept under lock and key. My intention was to get on my father's wavelength and understand his passion for collecting and then to persuade him to offer me these items to exhibit.

I spent a week in my parents' house and going on walks with my father, just as I had done 25 years earlier. This gave us time to talk about his collections. He then gave me selected boxes of items taken from the heaps of material he had accumulated as well as giving me a written explanation of his methods and the thought structures that lie behind this collection activity. With my father's help, I then arranged these boxes into a tower, as they are at home, and put this work into the exhibition context.

Sarah Braun

I am interested in the simpler forms of the complex languages we use.
I also deal with emotions, twisted and stretched.
I open the arena for the passing highlights of everyday life.
The grotesque aspect of life is also important for me.
It leads to a discharge of tension that I want to create in the room.

Sarah, 2001
Duration: approx. 7 min.
Marking the Territory, Irish Museum of Modern Art, Dublin, Ireland, 2001
video still: Barbara Klinker

Three people carry me into the space.
They put me down on the floor at a spot of red carpet.
Quitting my embryonic state, I begin – to die.
I enjoy the agony, executing myself in front of the audience.
I finish the show with slow hara-kiri.
Finally I whistle through my fingers, to call back my carriers.
They then come and take me out.

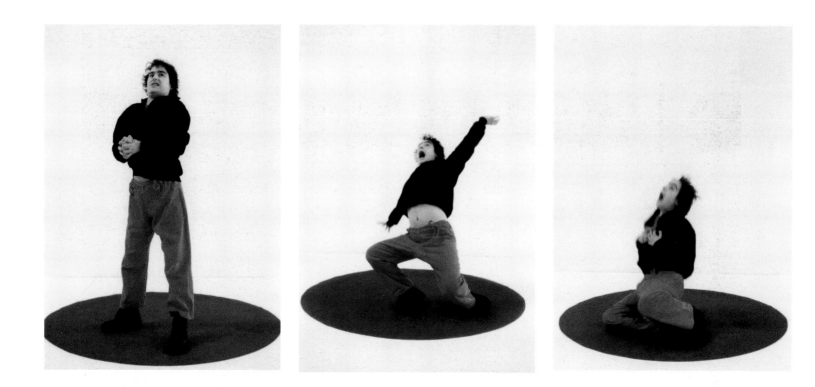

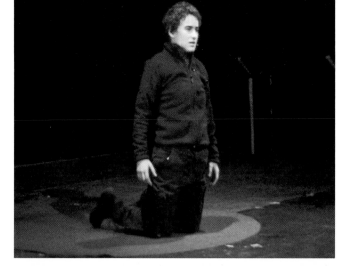

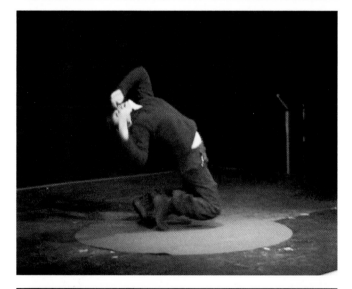

Euphorie, 2001
Duration: approx. 1 h.
Marking the Territory, Irish Museum of Modern
Art, Dublin, Ireland, 2001
video still: Daniel Müller-Friedrichsen

I climb up a ladder, checking the steps carefully.
Tense and uneasy, I finally reach the highest
point.
Even with vertigo, I manage the passage.
Touching the air, I scent the blossom of delight.
With every step down, I feel this glamourous
experience increase.
Every time I remove a hand, I risk falling.
I reach the ground and switch – to start it all again.

Muppet, 2002
Living installation
Duration: approx. 2 h. 30 min.
Klanspuren Festival, Fortezza, Brixen, Italy, 2002
Prêt-à-Perform, Viafarini, Milan, Italy, 2002
Body Power / Power Play, Württembergischer
Kunstverein, Stuttgart, Germany, 2002
video still: Oliver Blomeier

At my place in the room I sing and move without
using my voice. I wear little earphones, which
are connected to a CD player on a plinth beside
me. Another pair of earphones (which originate
from the same sound source) is hanging from the
ceiling in front of me. Passing by, you can see me
in action. By putting on the earphones you
become synchronised with the show of liquidly
changing interpreters within one person. In this
intimate space, cut from the surroundings, it
becomes the moment in which the actions are
only performed for you.

In the following pages:
Muppet, 2002
Performance
Duration: 3 min. 30 sec.
L.O.T. Theater, Braunschweig, Germany, 2002
video still: Daniel Müller-Friedrichsen and Carola
Schmidt

I am singing songs – with the voices of others.
Using playback; I morph from one interpretation
to another.
I become a medium – a "muppet"– medium.

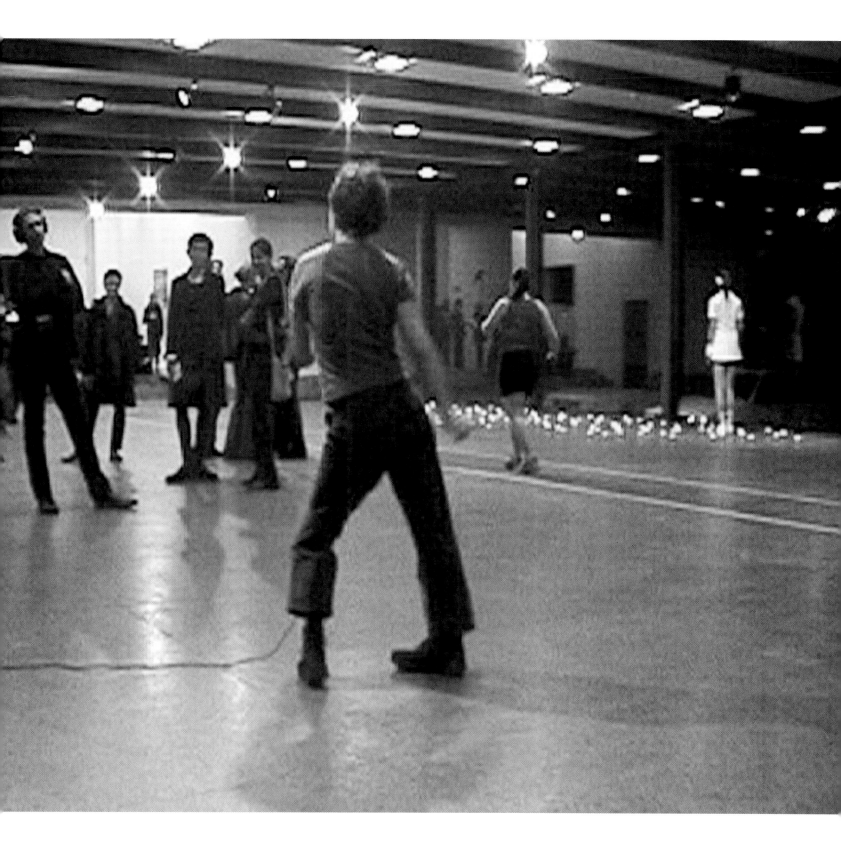

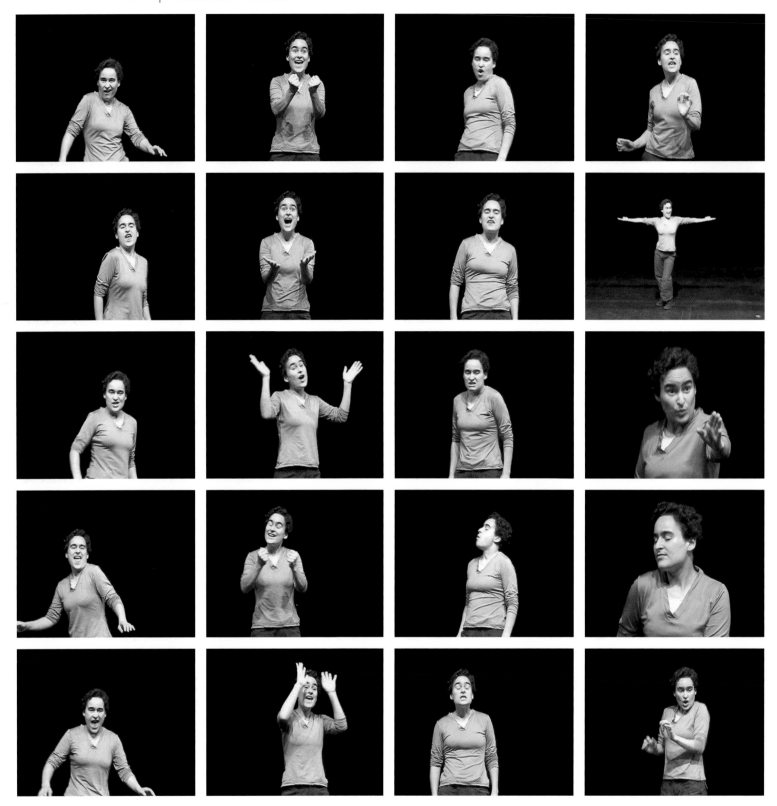

1. Elvis Presley
 I'm All Shook Up

2. Darinka / Karell Gott
 Fang das Licht

3. Leonard Cohen
 I'm Your Man

4. Brigitte Bardot
 Ça pourrait changer

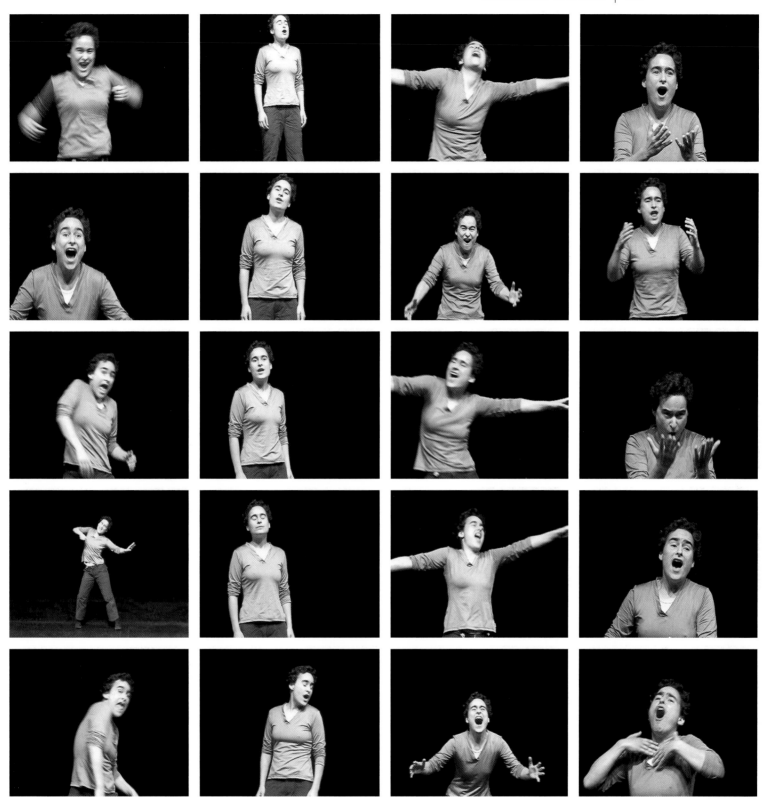

5. Stevie Wonder
Contract on Love

6. Amália Rodrigues
Rosa vermelha

7. James Brown
Bring It Up

8. Luciano Pavarotti
La mia letizia infondere

Maria Chenut

My work stems from contact and encounters between the body, materials and space. I collect all sorts of materials, ranging from raw materials like plaster and clay, to enlarged details of nature and marks on city walls, natural materials, found photographs and objects, fruits of city and country walks. Each with its own secrets and stories.
The tone is humorous and raw, as well as delicate and meditative. Through free play and poetic association the materials are coupled, joined, moulded, sometimes to the body itself, or else transformed to create an image, a scene, a text, a shape, a sound, a movement, a space, an action.

Besos (Kisses), 2002
Cleaning the House, Centro Galego de Arte Contemporánea, Santiago de Compostela, Spain, 2002

Giving.
Surprising and breaking the distance between strangers through the use of the body.
A welcoming gesture as well as setting a tone for the event, there is a transformation that occurs as one crosses a threshold.

Some people were surprised, some thought I worked in the museum and asked for directions, some went out again to repeat their entrance, some looked the other way, some asked if I would be there everyday, some thought maybe they knew me and that that was why I kissed them, some having waited in line to enter anticipated and gave themselves to be kissed. In the end I feel I received as many kisses and as much energy as I gave.

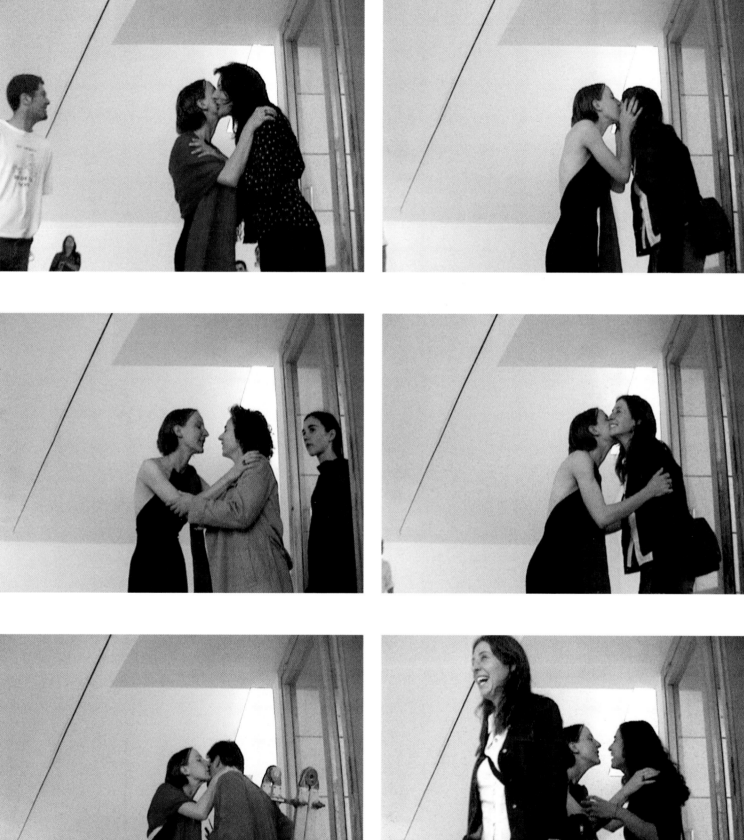

Ivan Čivić

I analise family structure... As a only child, growing up alone, I developed a more intimate relationship to my parents, which comes out through my work... My mother is almost always the central point... Showing myself and making the public show itself is also important. I have no limit, concerning the size or shape between me and my viewers... The type of comunication depends on my state of emotions and mind... It can be sexual, silent or almost non-existant. I need to be respected, hated and loved by the public... And I have to feel the same towards them, creating dependance through a total mix of emotions, so that they cannot leave the space until they have all exchanged their own fears and moral and personal restrictions...

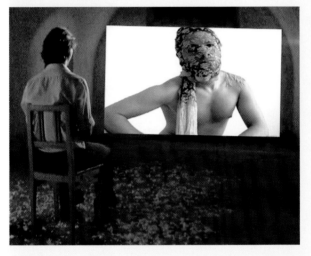

Il Signore delle Camelie, 2002
Duration: 2 h.
Body Basics I / Body Basics II, Transart 02, Klangspuren Festival, Fortezza, Brixen, Italy, 2002

For this performance I was given a space, which used to be a cannon chamber during the war. My idea was to fight against the cold room and the memories it holds. I thought to fill the room up with camellia petals. The George Cuckor movie The Camellia Mistress starring Greta Garbo in the main role inspired me.
Now in this context, it is I who sits in the empty room, surrounded by white camellia petals. I am looking at my own image, projected in front of me, during the entire duration of the performance.
A sound installation echoes in the room the whole time. It is my voice, whispering in five different languages sentences of remorse and anger.
I am trying to clean my own self up from inside. I testify to some of my deepest fears and thoughts in this space, which opens to the public as a sort of forgotten territory, where the smell of gunpowder is still present.

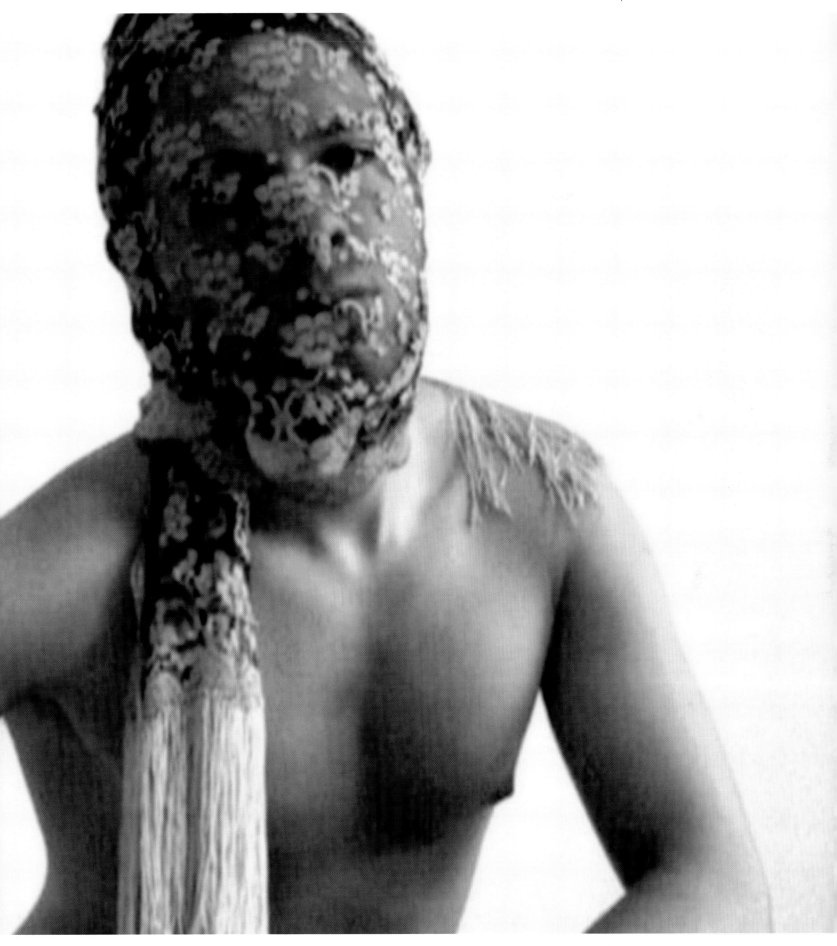

DIVA, 2001
Digital video
Duration: 5 min.
Transcription from the video
soundtrack

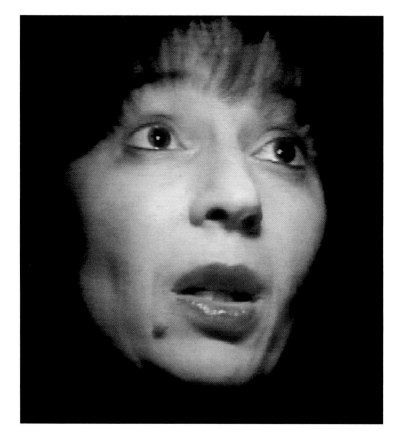

I am naming 100 important women
to my mother.
She decides if they're "YES", or "NO"...

IVAN:	ANNA MAGNANI
MOTHER:	NO!
IVAN:	LORETTA YOUNG
MOTHER:	NO!
IVAN:	BETTE MIDLER
MOTHER:	NO!
IVAN:	GRACE KELLY
MOTHER:	YES!
IVAN:	EDITH PIAF
MOTHER:	NO!
IVAN:	ANITA EKBERG
MOTHER:	NO!
IVAN:	SHELLY DUVALL
MOTHER:	NO!

IVAN:	MARLENE DIETRICH
MOTHER:	YES!
IVAN:	SILVA KOSCHINA
MOTHER:	NO!
IVAN:	JAQUELINE KENNEDY
MOTHER:	NO!
IVAN:	LANA TURNER
MOTHER:	NO!
IVAN:	EARTHA KITT
MOTHER:	NO!
IVAN:	DOLORES DEL RIO
MOTHER:	NO!
IVAN:	DORIS DAY
MOTHER:	NO!
IVAN:	KIM NOVAK
MOTHER:	NO!
IVAN:	FAYE DUNAWAY
MOTHER:	NO!
IVAN:	BRIGITTE BARDOT
MOTHER:	YES!
IVAN:	PRINCESS DIANA
MOTHER:	NO!
IVAN:	ANGELA LANDSBURY
MOTHER:	NO!
IVAN:	JAYNE MANSFIELD
MOTHER:	NO!
IVAN:	ZARAH LEANDER
MOTHER:	NO!
IVAN:	AUDREY HEPBURN
MOTHER:	YES!
IVAN:	SHARON STONE
MOTHER:	NO!
IVAN:	HELLY MILLS
MOTHER:	NO!
IVAN:	MARISA PAREDES
MOTHER:	NO!
IVAN:	SILVYE VARTAN
MOTHER:	NO!
IVAN:	NICOLE KIDMAN
MOTHER:	NO!
IVAN:	ELIZABETH TAYLOR
MOTHER:	YES!
IVAN:	DOLLY PARTON
MOTHER:	NO!
IVAN:	DEBRA WINGER
MOTHER:	NO!
IVAN:	JEANNE MOREAU
MOTHER:	YES!
IVAN:	INDIRA GANDHI
MOTHER:	NO!
IVAN:	GLENN CLOSE
MOTHER:	NO!
IVAN:	PAMELA ANDERSON LEE
MOTHER:	NO!
IVAN:	MILVA
MOTHER:	NO!
IVAN:	ORNELLA MUTI
MOTHER:	NO!
IVAN:	MICHELLE PFEIFFER
MOTHER:	NO!
IVAN:	KATHARINE HEPBURN
MOTHER:	NO!

IVAN:	URSULA ANDRESS		IVAN:	CHER
MOTHER:	NO!		MOTHER:	YES!
IVAN:	IVANA TRUMP		IVAN:	HANNA SCHYGULLA
MOTHER:	NO!		MOTHER:	NO!
IVAN:	SANDRA MILO		IVAN:	WINONA RYDER
MOTHER:	NO!		MOTHER:	NO!
IVAN:	MISS PIGGY		IVAN:	CATHERINE DENEUVE
MOTHER:	NO!		MOTHER:	NO!
IVAN:	MINA		IVAN:	ROSSY DE PALMA
MOTHER:	YES!		MOTHER:	NO!
IVAN:	GEENA DAVIS		IVAN:	EVA PERON
MOTHER:	NO!		MOTHER:	NO!
IVAN:	MARGARET THATCHER		IVAN:	JANE FONDA
MOTHER:	NO!		MOTHER:	NO!
IVAN:	GIULIETTA MASINA		IVAN:	BETTE DAVIS
MOTHER:	NO!		MOTHER:	YES!
IVAN:	SHIRLEY MACLAIN		IVAN:	MADONNA
MOTHER:	NO!		MOTHER:	YES!
IVAN:	BETTY BOOP		IVAN:	CLAUDIA CARDINALE
MOTHER:	YES!		MOTHER:	NO!
IVAN:	MARINA VLADY		IVAN:	SIGOURNEY WEAVER
MOTHER:	NO!		MOTHER:	NO!
IVAN:	BRIGITTE NIELSEN		IVAN:	MARIA CALLAS
MOTHER:	NO!		MOTHER:	YES!
IVAN:	MELANIE GRIFFITH		IVAN:	ANJELICA HUSTON
MOTHER:	NO!		MOTHER:	NO!
IVAN:	CARMEN MAURA		IVAN:	AVA GARDNER
MOTHER:	NO!		MOTHER:	YES!
IVAN:	MARY QUANT		IVAN:	MARGE SIMPSON
MOTHER:	NO!		MOTHER:	NO!
IVAN:	JESSICA TANDY		IVAN:	VIVIEN LEIGH
MOTHER:	NO!		MOTHER:	NO!
IVAN:	JODIE FOSTER		IVAN:	OPRAH WINFREY
MOTHER:	NO!		MOTHER:	NO!
IVAN:	DIANA ROSS		IVAN:	SOPHIA LOREN
MOTHER:	NO!		MOTHER:	YES!
IVAN:	GLORIA GAYNOR		IVAN:	ROMY SCHNEIDER
MOTHER:	NO!		MOTHER:	NO!
IVAN:	BEBA LONCAR		IVAN:	MONICA VITTI
MOTHER:	NO!		MOTHER:	NO!
IVAN:	VIVIENNE WESTWOOD		IVAN:	AMANDA LEAR
MOTHER:	NO!		MOTHER:	NO!
IVAN:	ROMINA POWER		IVAN:	GEENA ROWLANDS
MOTHER:	NO!		MOTHER:	NO!
IVAN:	YVETTE MIMIER		IVAN:	RITA HAYWORTH
MOTHER:	NO!		MOTHER:	YES!
IVAN:	KIM BASINGER		IVAN:	JESSICA RABBIT
MOTHER:	NO!		MOTHER:	NO!
IVAN:	ALI MACGRAW		IVAN:	ANNA KARINA
MOTHER:	NO!		MOTHER:	NO!
IVAN:	TINA TURNER		IVAN:	DUNJA REITER
MOTHER:	YES!		MOTHER:	NO!
IVAN:	GRETA GARBO		IVAN:	BARBRA STRAISAND
MOTHER:	YES!		MOTHER:	NO!
IVAN:	SUSAN SARANDON		IVAN:	LAUREN BACALL
MOTHER:	NO!		MOTHER:	NO!
IVAN:	VALERIA MARINI		IVAN:	BJÖRK
MOTHER:	NO!		MOTHER:	NO!
IVAN:	JULIA ROBERTS		IVAN:	GINA LOLLOBRIGIDA
MOTHER:	NO!		MOTHER:	NO!
IVAN:	COCO CHANEL		IVAN:	MARILYN MONROE
MOTHER:	YES!		MOTHER:	YES!

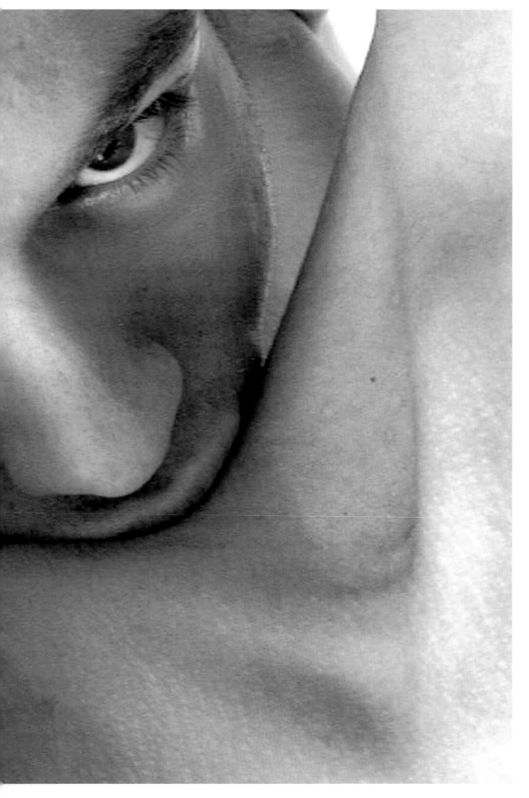

Family Parasite, *2002*
Video installation
Duration: 33 min. endlessly looped

Biting into a neck, as a vampire, for half an hour,
without ever letting go of the catch!
...And you can never have enough of it!

Back in Sarajevo... After 10 Years, 2003
Duration: 6 h.
As Soon as Possible, PAC, Padiglione d'Arte
Contemporanea, Milan, Italy, 2003

A video projection on the wall. The projection is
4 metres long and 3 metres high.
There are metal sticks fixed to the wall where
the video is projected.
I am continually moving between the metal
tubes: hanging, jumping and climbing up and
down, finding myself alive in the filmed city,
revisiting all the places and people from my
surroundings.
The video is 5 hours long and documents the
return to my home town, after 10 years of exile.
The remaining relatives can be seen, as well as
what has become of the town.
All video shots were made between the 9th and
15th of August 2002, in Sarajevo.
The performance is divided into 2 days, each day
lasting 3 hours, and ends when the video does.

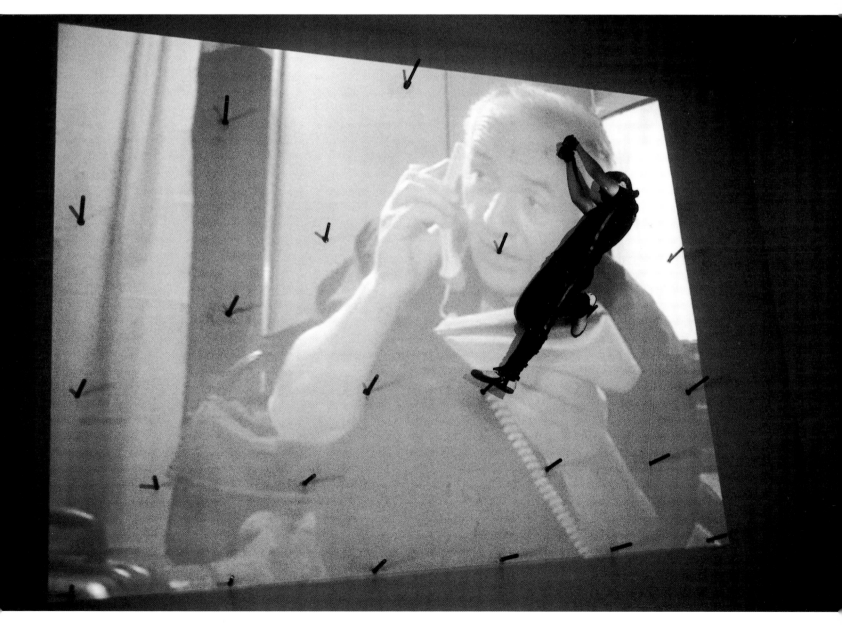

Put a Spell on Me..., 2002
Common Ground, Landesvertretung
Niedersachsen and Schleswig-Holstein, Berlin,
Germany, 2002

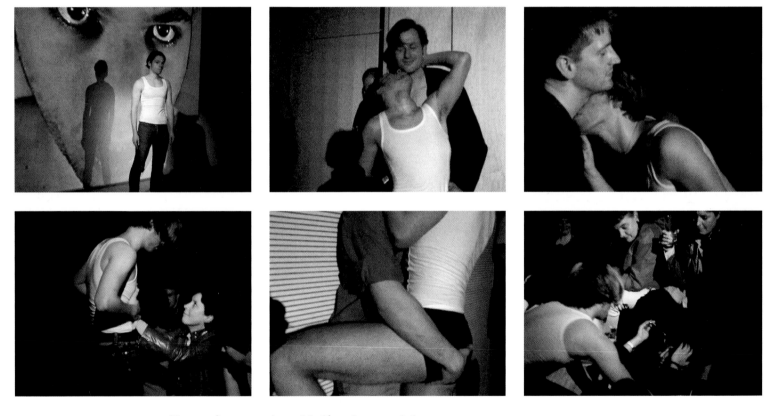

The performance lasted half an hour and the
public was limited to 35 people. Once they were
in, the door to the room I was in was locked.
Nobody could come in anymore nor go out
during the half hour. A big video projection was
showing my face while I am whispering in the
video... The words and sentences I say have all
to do with my obsessions, desires and
necessities... As a body, I materialize what my
image is "thinking out loud"...

... I'LL COME TO YOU... MISS ME... I'LL MISS YOU... TOUCH ME... I'LL TOUCH YOU... FIGHT FOR ME... I'LL FIGHT FOR YOU... BE MY FAMILY... I'LL BE YOUR FAMILY... KISS ME... I'LL KISS YOU... HUG ME... I'LL HUG YOU... COME TO ME... COME TO ME... COME TO ME... I'LL COME TO YOU... BE MINE FOREVER... I'LL BE YOURS FOREVER... ONCE... TWICE... THREE TIMES... FOUR TIMES... ENDLESS TIMES... FUCK ME... I'LL FUCK YOU... SLEEP WITH ME... I'LL SLEEP WITH YOU... FORGIVE ME... I'LL FORGIVE YOU... PLEASE FORGIVE ME... BEG ME TO FORGIVE YOU... BEG ME TO KISS YOU... I'LL BEG YOU TO KISS ME... I'LL BEG YOU TO MISS ME... BEG ME COME TO... I'LL COME TO YOU... FORGIVE ME... I'LL FORGIVE YOU... STAY WITH ME... I'LL STAY WITH YOU... COME TO... I'LL COME TO YOU... MISS ME... I'LL MISS YOU... TOUCH ME... I'LL TOUCH YOU... FIGHT FOR ME... I'LL FIGHT FOR YOU... BE MY FAMILY... I'LL BE YOUR FAMILY... KISS ME... I'LL KISS YOU... HUG ME... I'LL HUG YOU... COME TO ME... COME TO ME... COME TO ME... I'LL COME TO YOU... BE MINE FOREVER... I'LL BE YOURS FOREVER... ONCE... TWICE... THREE TIMES... FOUR TIMES... END LESS TIMES... FUCK ME... I'LL FUCK YOU... SLEEP WITH ME... I'LL SLEEP WITH YOU... FORGIVE ME... I'LL FORGIVE YOU... PLEASE FORGIVE ME... BEG ME TO FORGIVE YOU... BEG ME TO KISS YOU... I'LL BEG YOU TO KISS ME... I'LL BEG YOU TO MISS ME... BEG ME TO MISS YOU... TO MISS YOU... BE MY FAMILY... I'LL BE YOUR FAMILY... WALK WITH ME... I'LL WALK WITH YOU... TOUCH ME... TOUCH ME... TOUCH ME... STAY WITH ME... I'LL STAY WITH YOU... I'LL TOUCH YOU IF YOU TOUCH ME... RUN WITH ME... I'LL RUN WITH YOU... BE MINE... I'LL BE YOURS... MINE FOREVER... YOURS FOREVER... HUG ME... I'LL HUG YOU... BE MY FAMILY... I'LL BE YOUR FAMILY... RUN TO ME... I'LL RUN TO YOU... COME TO ME... I'LL COME TO YOU... TOUCH ME... I'LL TOUCH YOU... POSSESS ME... I'LL POSSESS YOU... BE MY FAMILY... I'LL BE YOUR FAMILY... LOVE ME... I'LL LOVE YOU... LOVE ME... LOVE ME... LOVE ME FOREVER... I'LL LOVE YOU FOREVER... TOUCH ME... I'LL TOUCH YOU... HUG ME... I'LL HUG YOU... RUN TO ME... I'LL RUN TO YOU... SLEEP WITH ME... I'LL SLEEP WITH YOU... POSSESS ME... I'LL POSSESS YOU... DO NOT FEAR ME... I WILL NOT FEAR YOU... SLEEP WITH ME... I'LL SLEEP WITH YOU... COME TO ME... TOUCH ME... TOUCH ME... TOUCH ME... DON'T TROUBLE ME... I WILL NOT TROUBLE YOU... MISS ME... I'LL MISS YOU... NEVER LEAVE ME... I'LL NEVER LEAVE YOU... FUCK ME... I'LL FUCK YOU... STAY WITH ME AFTER... I'LL STAY WITH YOU FOREVER AND EVER AND EVER... STAY WITH ME FOREVER AND EVER AND EVER... CRY WITH ME... I'LL CRY WITH YOU... LAUGH WITH ME... I'LL LAUGH WITH YOU... TOUCH ME... I'LL TOUCH YOU... WALK WITH ME... I'LL WALK WITH YOU... FLY TO ME... I'LL FLY TO YOU... REMEMBER ME... I'LL REMEMBER YOU... DON'T PRESS ME... I WILL NOT PRESS YOU... STAY WITH ME... I'LL STAY WITH YOU... FUCK ME... I'LL FUCK YOU... MISS ME... I'LL MISS YOU... I'LL LOVE YOU... LOVE ME...

Amanda Coogan

Since I was born I have had to communicate everything through my eyes and my body. I was brought up to follow the strict rules of visual communication:
Don't start communication until the person is looking at you.
Always look someone in the eye while communicating.
Bang hard on a vibrating surface (wooden floors, tables and some walls are good) for attention if eye contact is not forthcoming.
Everything was expressed through the body and received through the eyes: love, pain, happiness, sadness, hunger, satiation. I was born hearing to deaf parents. Irish Sign Language, a manual / visual language, is my first language. This informs my practice profoundly.

My work deals with the concept of otherness, and the outward manifestation of an interior state. The bedrock of my practice is the live event, followed directly, though equally, by still images, photography and video either taken from the live performance or produced in and around an action. I do not consider myself to be a performance artist solely but rather a performative practitioner.

The Fountain, 2000
Duration: 2 min. 30 sec.
Visible Differences, Hebbel Theater, Berlin, Germany, 2000

The Fountain is a tableau-vivant performance where over two and a half minutes the performer urinates copiously.

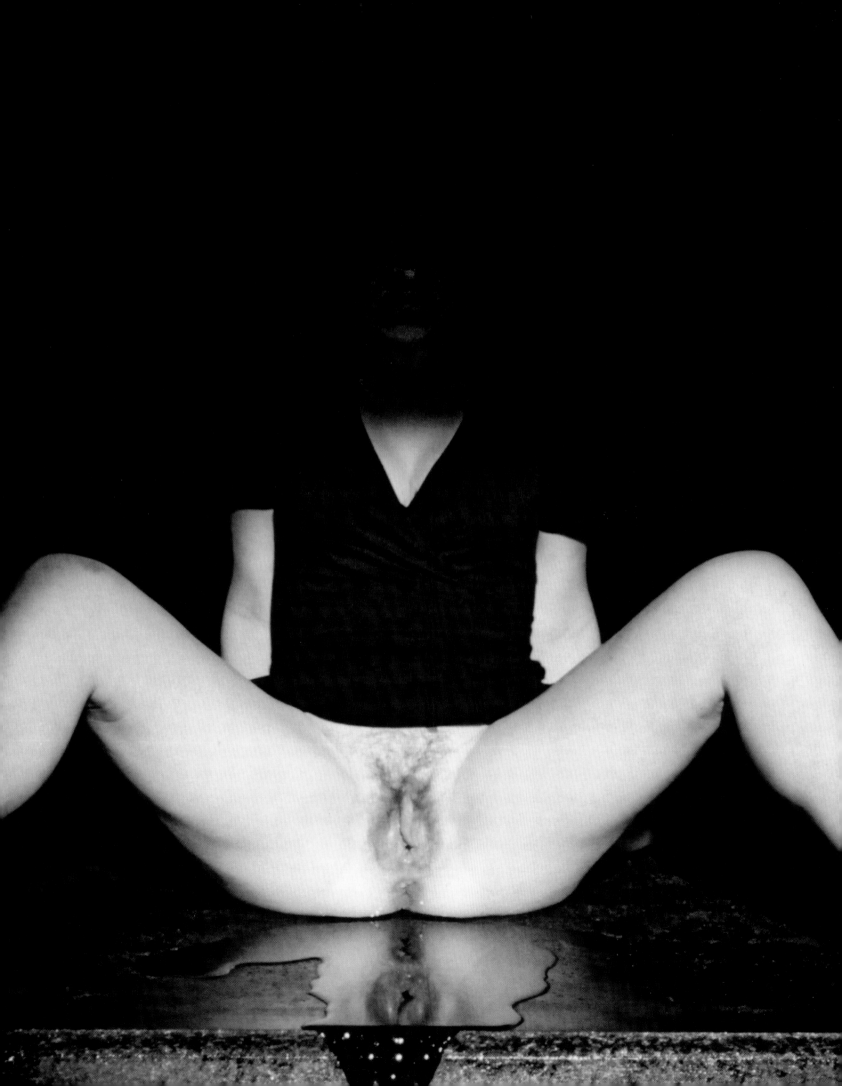

The Sacred Heart, 2002
Duration: 45 min.

The Sacred Heart is a still image from a tableau-vivant performance of the same title. Over 45 minutes a stain comes up on the performers chest. The performer is still; the action of the piece is the development of the stain. It is the outward manifestation of a broken heart.

Madonna in Blue, 2001
A photograph from the *Madonna* series

In this photo I wanted to make a religious / iconic image. A domestic-sized image that could be put in a purse along with one's prayer cards. This image blurs the line between religious prayer cards and sex line advertisements.

Madonna III, 2001
Duration: 1 h. 30 min.

This work is a still image from the performance *Madonna,* a living installation. The performer stands perfectly still for the duration of the performance holding her right breast.

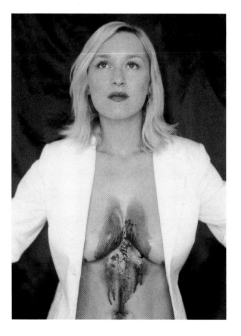

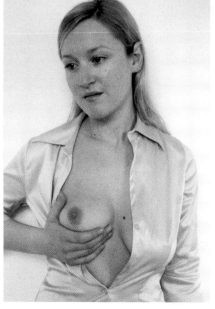

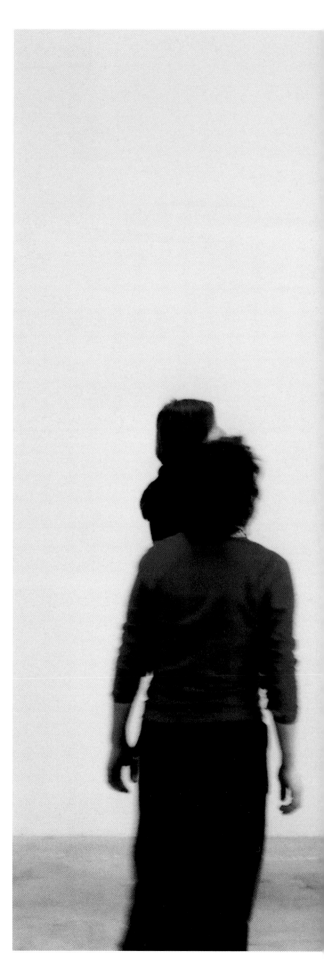

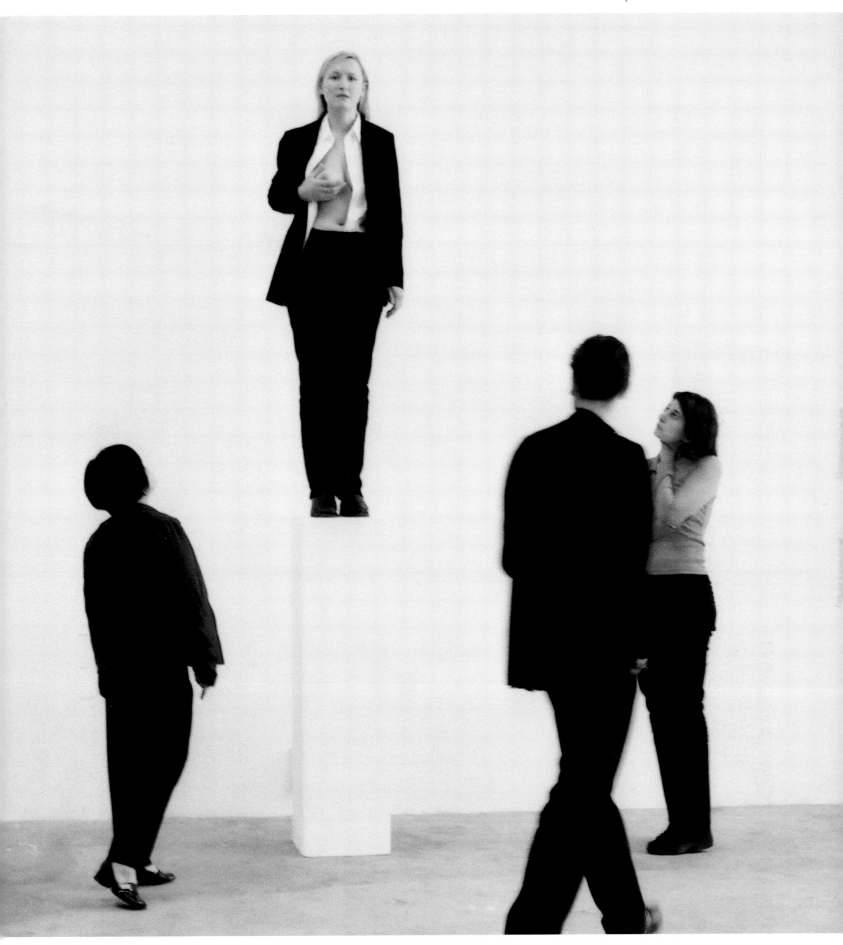

Medea, 2001
Marking the Territory, Irish Museum of Modern Art, Dublin, Ireland

This is a still photograph from the durational performance *Medea* taken in situ in the Irish Museum of Modern Art. The performance involves telling secrets of the Deaf community over a three-hour period, stories of oppression, and sexual and physical abuse at the hands of the clergy. These stories are told using Irish Sign Language, the language of the Deaf community and understood by a very small population.

After Manzoni, 2000
Photography

This image came to me in a dream after a *Cleaning the House* workshop. For the photograph I signed my own body. It is a reinvention of Manzoni's infamous action and a visual manifesto for my practice.

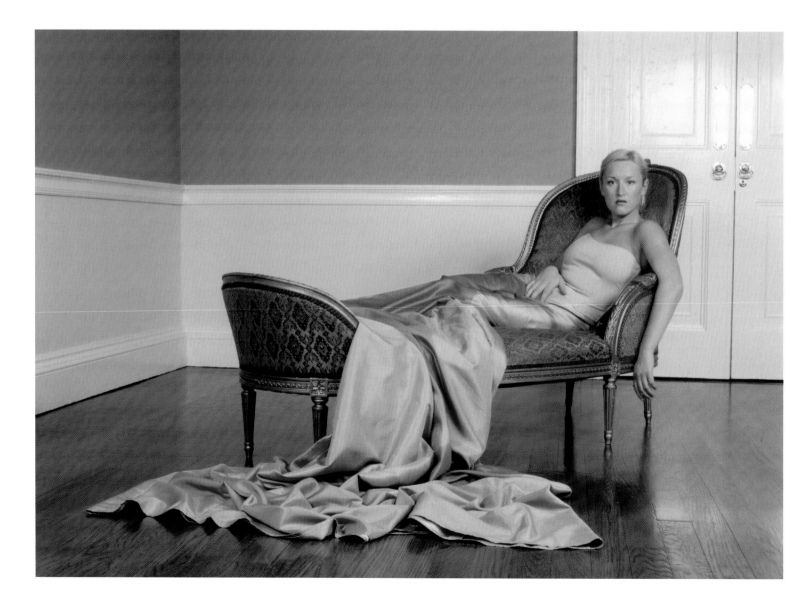

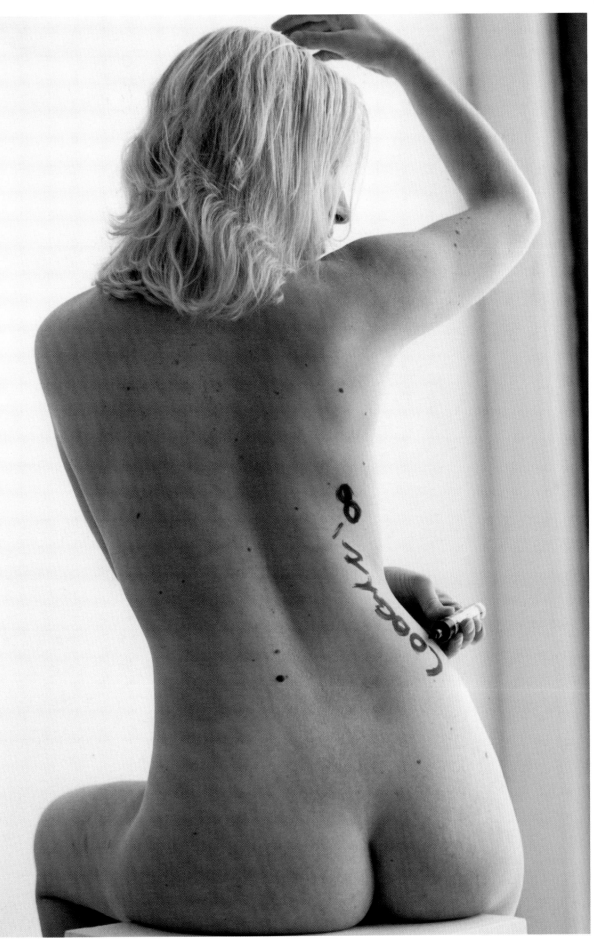

Reading Beethoven, 2003
Duration: 3 h. 15 min.
Recycling the Future, 50. Esposizione
Internazionale d'Arte La Biennale di
Venezia, Venice, Italy, 2003

Durational performance visually translating
Beethoven's Ninth Symphony, second movement;
molto vivace.
The sexy, dangerous performance *Reading
Beethoven* is a piece of headbanging to
Beethoven's Ninth Symphony. The performance
attempts to physically manifest Beethoven's call
to "jump over the edge of the cliff."

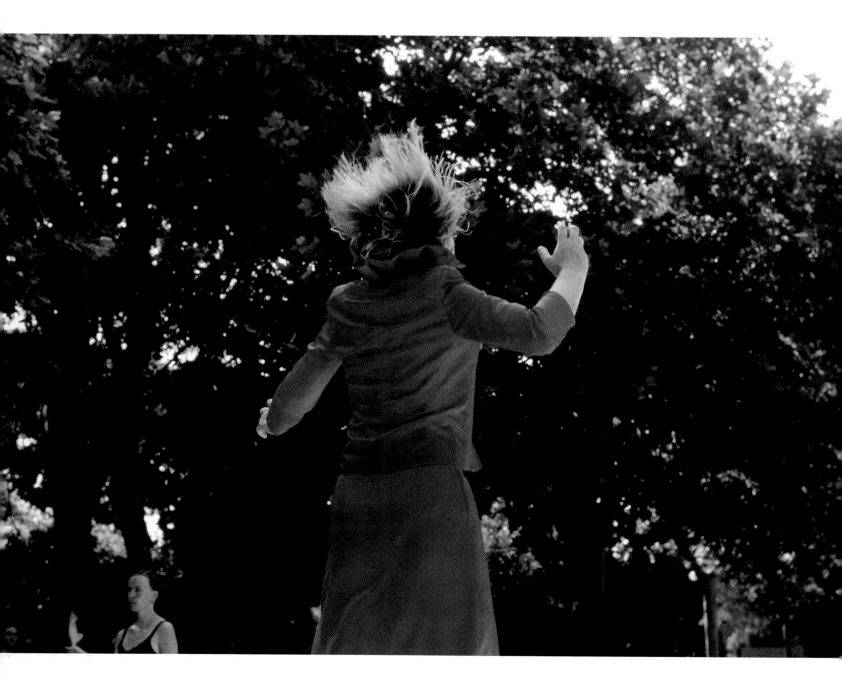

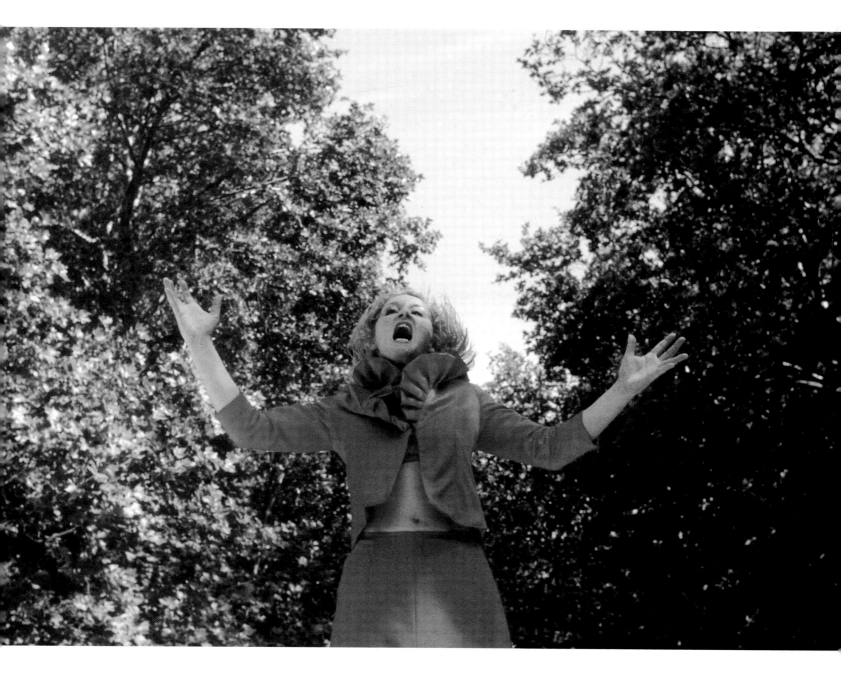

Yingmei Duan

Everything is vanity and a striving after the wind.
All things are wearisome.
What profit does a man have in all of his hard
work under the sun?
Everything is empty!

Tools, 2000
Duration: approx. 5 min.
Kerguéhennec, France, 2000
Hochschule für Bildende Künste, Braunschweig,
Germany, 2001

I am standing in front of the audience in ordinary
clothes, with my large pair of glasses on the floor
nearby. Slowly, I move towards somebody in the
audience and stop. When we are almost nose-to-
nose, I look the person straight in the eye.
Sometimes I have to stand on tiptoe if the person
is very tall. To look into the eyes of those who are
seated, I have to crouch down.
As soon as I have looked at everyone, I return to
my place. I look for my glasses, and then put
them on. I smile…

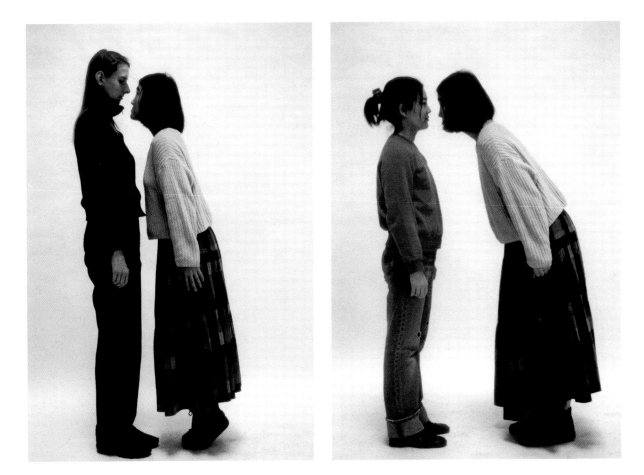

Clown, 2001
Duration: approx. 6 min.
Hochschule für Bildende Künste, Braunschweig,
Germany, 2001

I have made up my face like a clown. I am grinning
stiffly at the audience. With a contorted animal-like
voice, I laugh right into people's faces, moving past
them very slowly. The feeling conveyed is that the
situation is anything but funny.

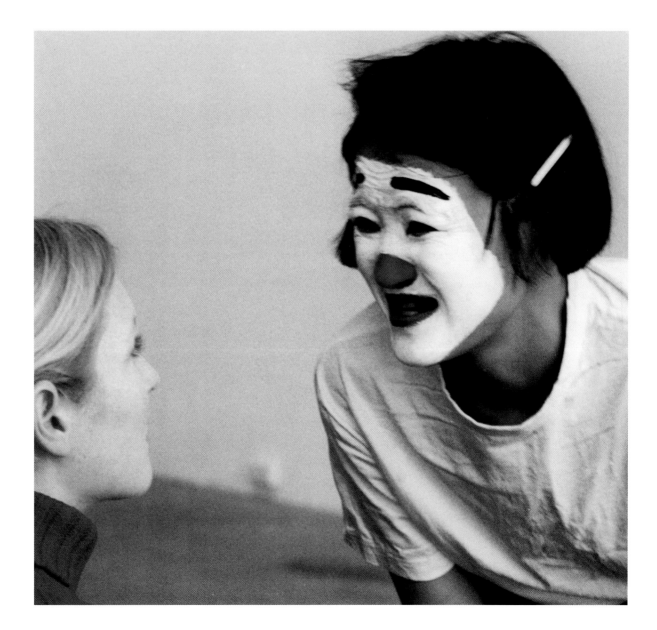

Corner, 2002
Duration: 1 h.
Cleaning the House, Centro Galego de Arte
Contemporánea, Santiago de Compostela, Spain,
2002

Corners are always my favourite place. I always
feel very good when I can stay in a corner. In
this performance, I crouch in the furthest corner
of a huge staircase set at a 45-degree angle, as if
I were carrying a huge mountain on my back. I
cannot lift up my head, but I can look at the
people from where I am crouched and I hear
their reactions. Whilst I was performing this, a
lot of people wanted to pull me out.

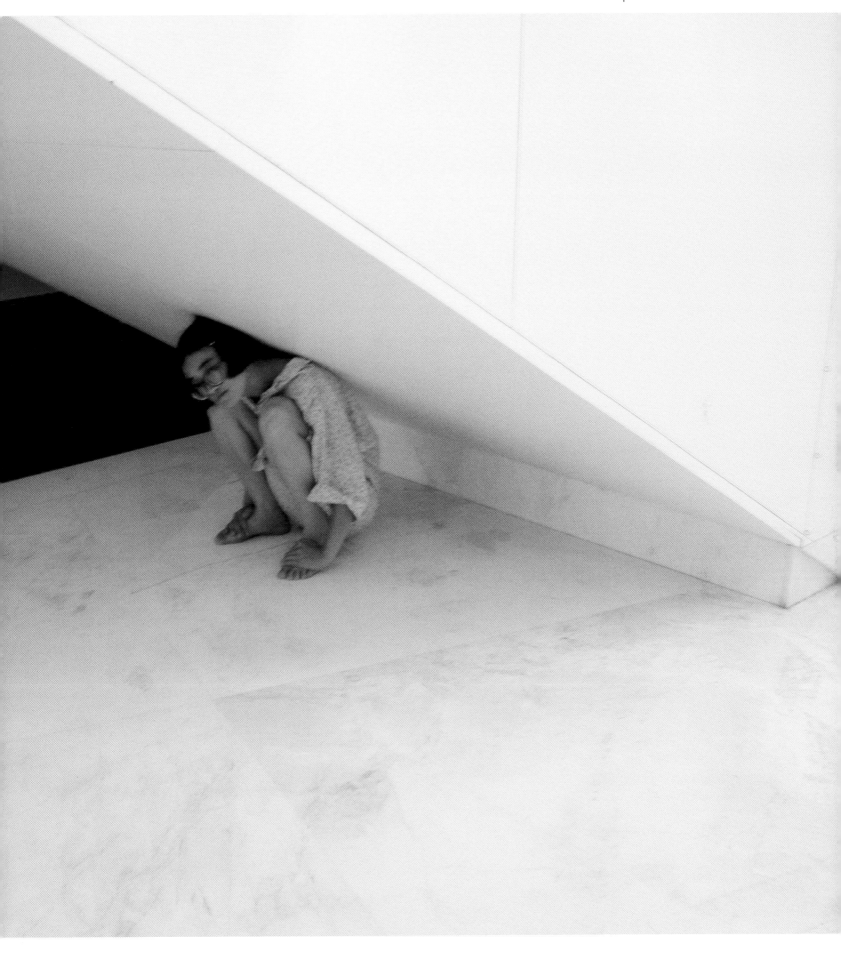

Help!, 2002
Duration: 2 h.
Common Ground, Landesvertretung
Niedersachsen and Schleswig-Holstein, Berlin,
Germany, 2002

In this performance, I am hanging right at the
top of a wooden partition. I am like a clown or a
child who cannot stop kicking her legs.

Friend, 2003
Performance with Mirko Winkel
Duration: 4 min.
Hochschule für Bildende Künste, Braunschweig, Germany, 2003

A naked man stands in the middle of the room. He looks in the direction of the public. There are bird sounds and I come into the space from one side of the room. I wear a pink dress and glasses. I am looking for something with a magnifying glass and go stealthily towards the man.

I am shy to see his penis. I am also very curious about the penis and check it thoroughly through the magnifying glass. After I have finished my intensive studies of the penis, I leave the room thoughtfully.

I come from China, which has a very different culture. There is no sexual education in the school system there. Before I was 21 years old, I really knew nothing about sex and I had never even spoken the word. I had a lot of questions in my mind at that time, for example: Why does a woman become pregnant? Where did I come from? Why do my parents have so many arguments? This was up until the day a girlfriend asked me what I knew about sex. I was very busy since that day.

Sexuality is very important in every society. Sexuality is similar to science and ritual. Each societal system instructs through different rituals. Sexuality is not only concerned with the family but also with religion, philosophy and psychology.

Nezaket Ekici

The idea, the thought and the draft are the basis for the execution of my artwork. Ideas come from everyday life situations, social and cultural atmospheres. Then the idea expresses itself in the performances and installation art. As well as this, I use the body as a means of expression.

The artistic idea is expressed using the body alone, as part of the installation and within the context of an audience.

The subjects I deal with are time, movement, space, material, body and action / interaction. I try to create works of art that leave the viewer free space for associations and new possibilities. I take a special situation from everyday life and place it into a new context.

I aim to create art where all of the elements are connected together to form a whole work of art.

180 Wishes, 2002
Duration: 3 min.
Alarm clock, 180 bunches, basket
Cleaning the House, Centro Galego de Arte Contemporánea, Santiago de Compostela, Spain, 2002
Hochschule für Bildende Künste, Rundgang, Braunschweig, Germany, 2002;
Braunschweiger Kulturnacht, L. O. T. Theater, Braunschweig, Germany, 2002
video still: Dorte Strehlow

This performance adapts a cultural peculiarity of Spain. During the stroke of midnight on New Year's Eve, 12 grapes are eaten, one for each stroke of the clock. Every grape stands for a wish. If one manages to eat all 12 grapes in the corresponding time, all wishes will come true.

In the performance *180 Wishes* this tradition is overtaken. Within 3 minutes 180 grapes are eaten one after another, to eat all 180 grapes within 3 minutes is an impossible task. The performance requires perseverance and concentration in order for all of the wishes to come true.

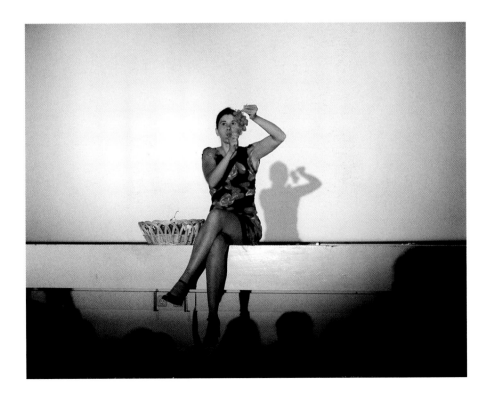

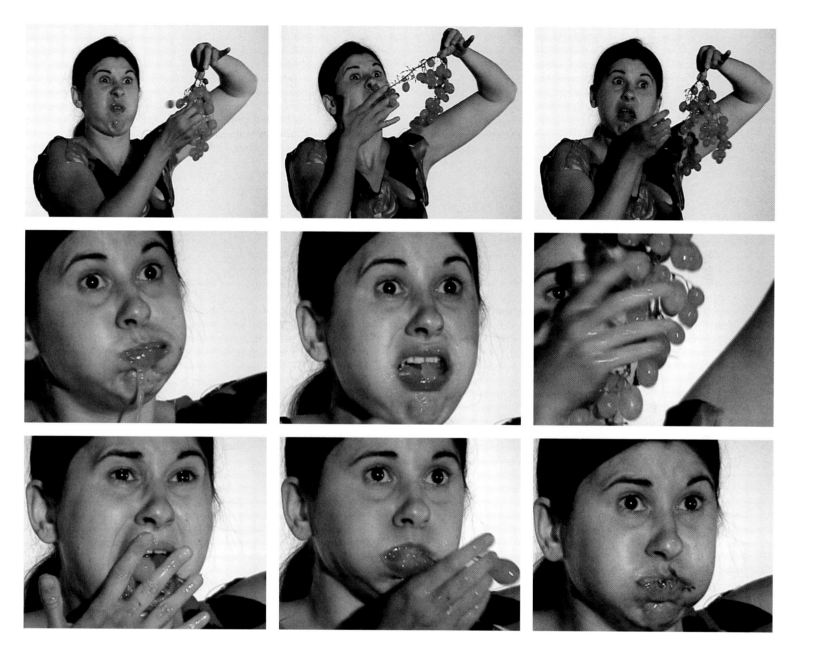

Emotion in Motion
Installation / performance
Duration: 24-26 September 2002 (performance) /
27 September – 19 October 2002 (installation)
15 lipsticks, personal belongings, furniture
Gallerie Valeria Belvedere, Milan, Italy, 2002
Marking the Territory, Irish Museum of Modern
Art, Dublin, Ireland, 2001
Galerie Unartig, Munich, Germany, 2000
video still: Francesca Santagata, Raoul Gazza,
Susanne Wagner and Yingmei Duan

The empty gallery space becomes a very private
room as I place my entire living room into it and
then propose to kiss every object within it. The
gallery space also gets kissed with red lipstick.
The actions end when everything is kissed. The
viewer has the possibility to follow the actions as
they happen. Afterwards, the installation stays
open for the public for some time.

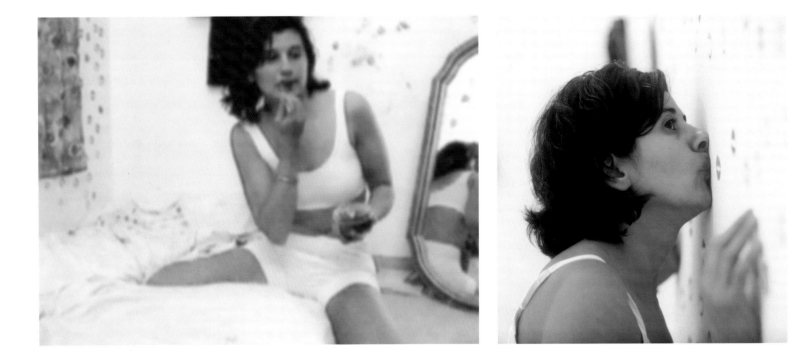

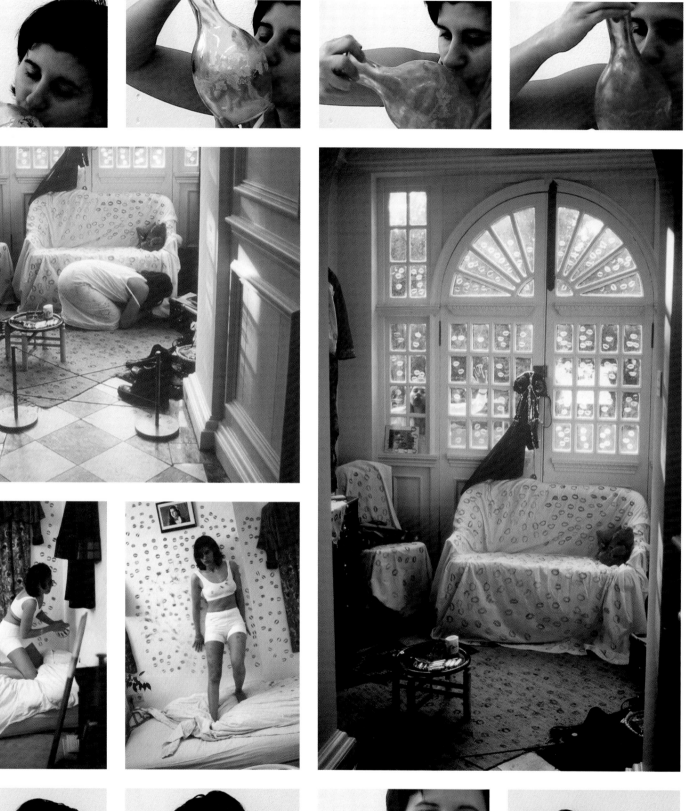

Hullabelly, 2003
Performance
Duration: 35 min.
Body Power / Body Play, Württembergischer
Kunstverein, Stuttgart, Germany, 2002

Video installation
Duration: 15 min. loop
Antalya, Turkey, 2003

This video installation consists of three video projections of twelve Turkish women of differences ages dancing with a hula-hoop to Oriental belly dance music. *Hullabelly* tries to overcome cultural barriers by combining Western and Eastern elements in a new aesthetic way.

The general wish of modern Western women is to become more beautiful, healthy and fit; this is also the secret and private wish of many religious Islamic women. The video installation shows this fight for personal freedom in a more symbolic way.

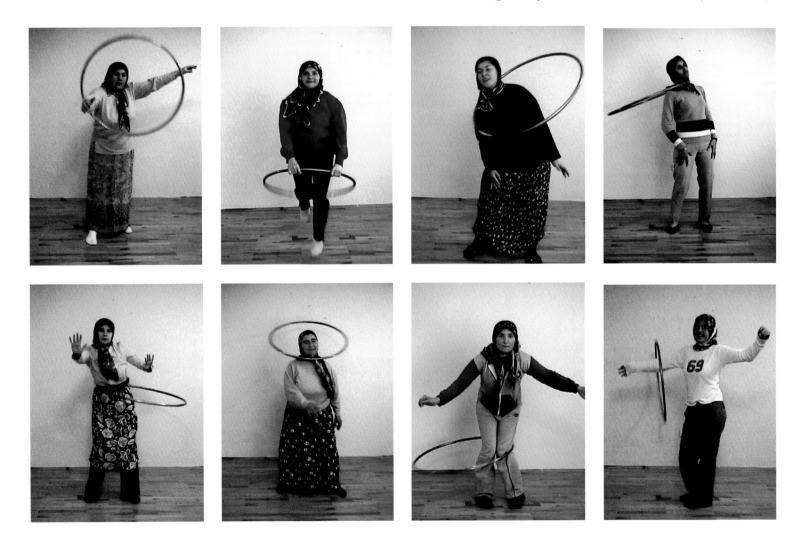

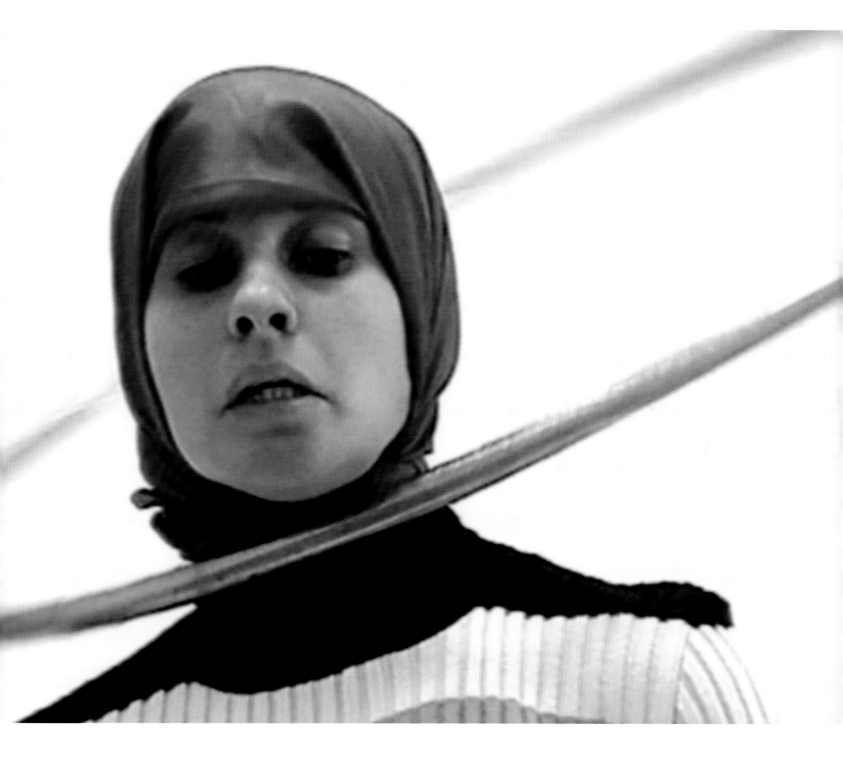

Berlin Version. Body of Silence, 2001
Collaborative work with Tania Bruguera
Duration: 3 h.
100 pieces of meat (no pic), string, food color
A Little Bit of History Repeated, Kunst Werke,
Berlin, Germany, 2001
No Place, Ifa Galerie, Bonn, Germany, 2002

The performance *Berlin Version* is based on
another performance work called
Body of Silence made by the Cuban artist Tania
Bruguera. This collaborative work is a translation
between cultures; from a Cuban work of art into
a Turkish / German context containing a new
historical meaning.

I am a living sculpture; my body is covered with
meat, upon which I have written thoughts about
my two cultures, Germany and Turkey.

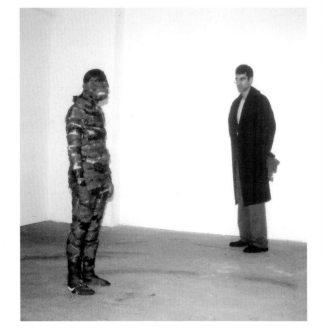

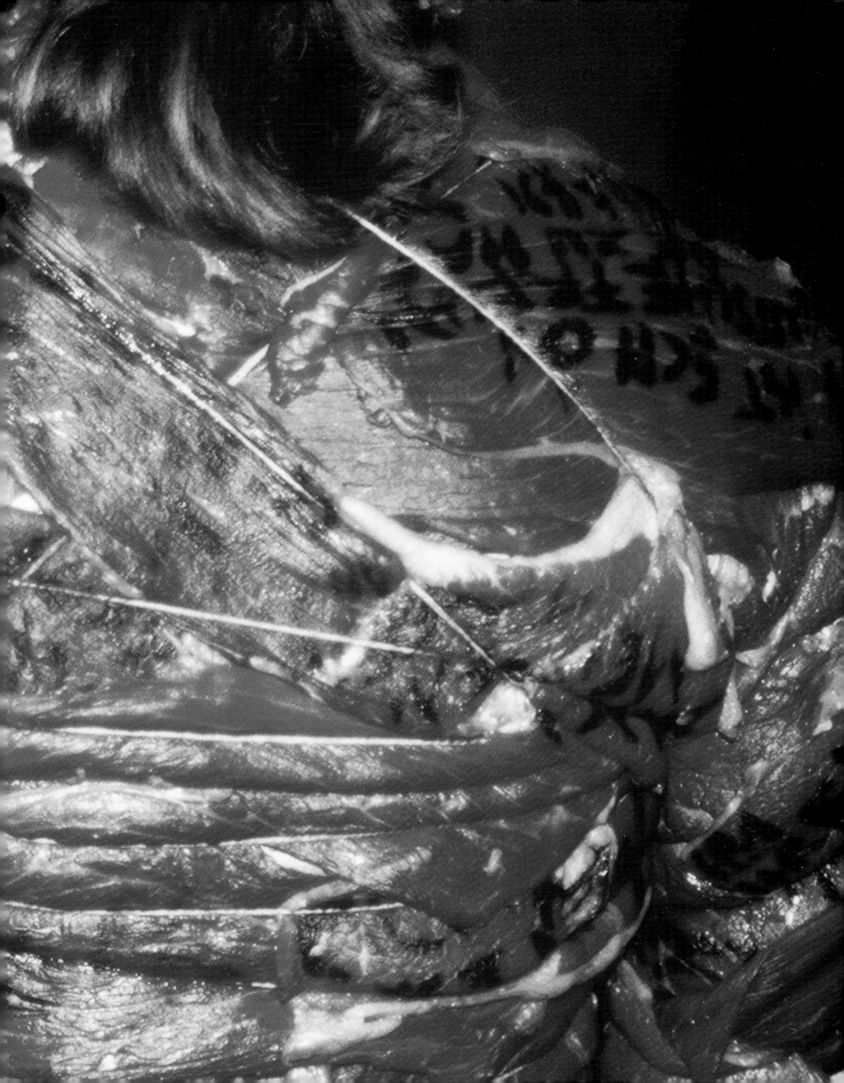

Félix Fernández

A return to the most radical intimacy, with all that it entails: liberation, but also unleashed violence. Assuming our responsibility for that hidden part: my work is closely linked to the body that has been mutilated by social restraints and the psychological consequences it entails. I cast a look at the inner ruins of a society that values the epidermal and conventional to the detriment of the unique and untransferable. I work with hybrid languages where interdisciplinary limits are blurry, but I feel at home with video performances or writing sounds that complement my visual pieces, creating a sound impression that penetrates the collective unconsciousness directly.

Untitled, 2002
Duration: approx. 5 min.
Chair and discman
Cleaning the House, Centro Galego de Arte Contemporánea, Santiago de Compostela, Spain, 2002

I'm singing a song by La Lupe, called "Puro teatro", completely off-key.

By means of an exacerbated exhibitionism of pain I question the role of the victim and of the executioner, which may coincide in the same person.

Puro teatro

Igual que en un escenario
finges tu dolor barato
tu drama no es necesario
ya conozco ese teatro
fingiendo qué bien te queda el papel
después de todo parece
que ésa es tu forma de ser.

Yo confiaba ciegamente
en la fiebre de tus besos,
mentiste serenamente
y el telón cayó por eso.

Teatro, lo tuyo es puro teatro,
falsedad bien ensayada
estudiado simulacro,
fue tu mejor actuación
destrozar mi corazón.

Y hoy que me lloras de veras
recuerdo tu simulacro
perdona que no te crea
me parece que es teatro.

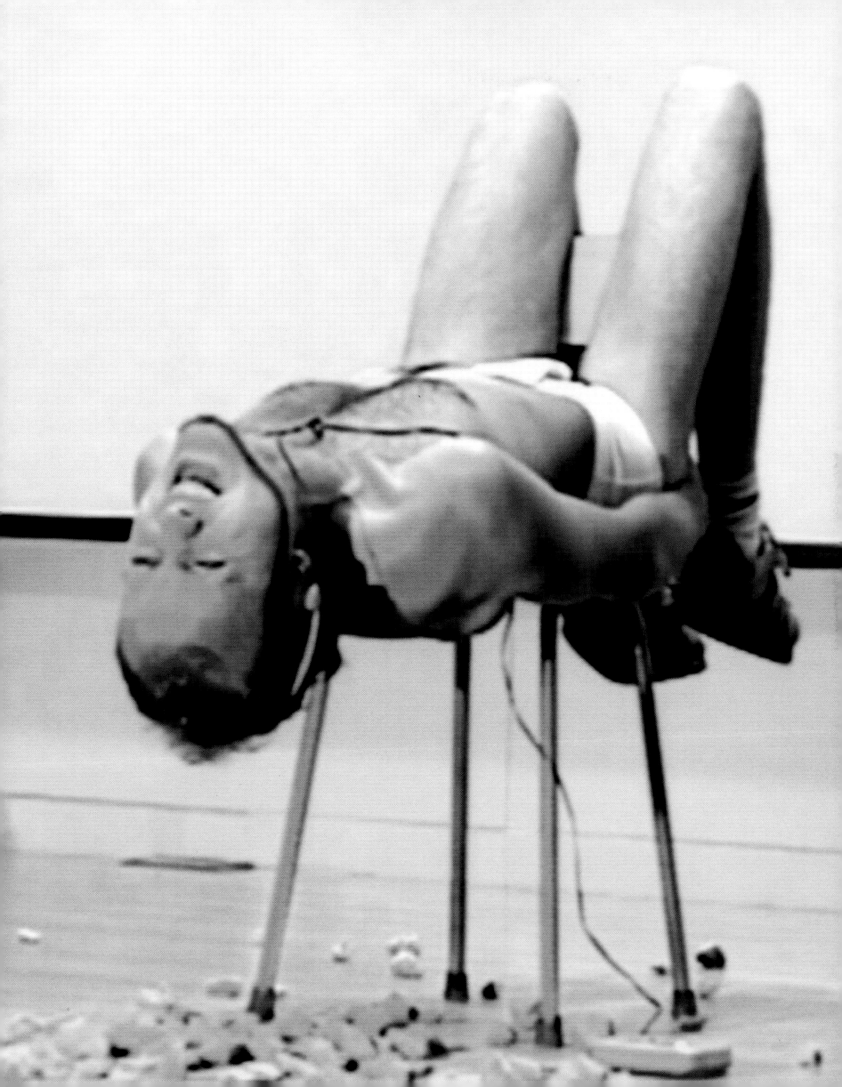

Regina Frank

Regina Frank has been working internationally as *The Artist Is Present* for the past decade in windows, museums and public spaces. Many of her works involve dresses that function as "addresses." The visual language, spoken mainly through text and textiles, reveals a meditative process of exploring inner and outer networks as well as political, cultural and spiritual issues. The works encompass a field of tension between virtual and real, analogue and digital. Most of the works are interactive installations, involving the viewer directly in the content and creation process.

L'Adieu – Pearls Before Gods, 1993
Performance / installation
Duration: 28 days
Pearls, bowls, silk dress, dress-maker's mannequin, bread, flowers, gold-leaf and seaweed tiles, surveillance camera and monitors, LED-display
Size: variable
Who Chooses Who, New Museum of Contemporary Art, New York, USA, 1993

As I worked daily, sewing pearls onto a white silk gown, I revealed the relationship of women's labor to global pay scales. My wage was calculated each day at the rate of a different country, and used for symbolic purchases of flowers and bread, as food for the soul and the body.

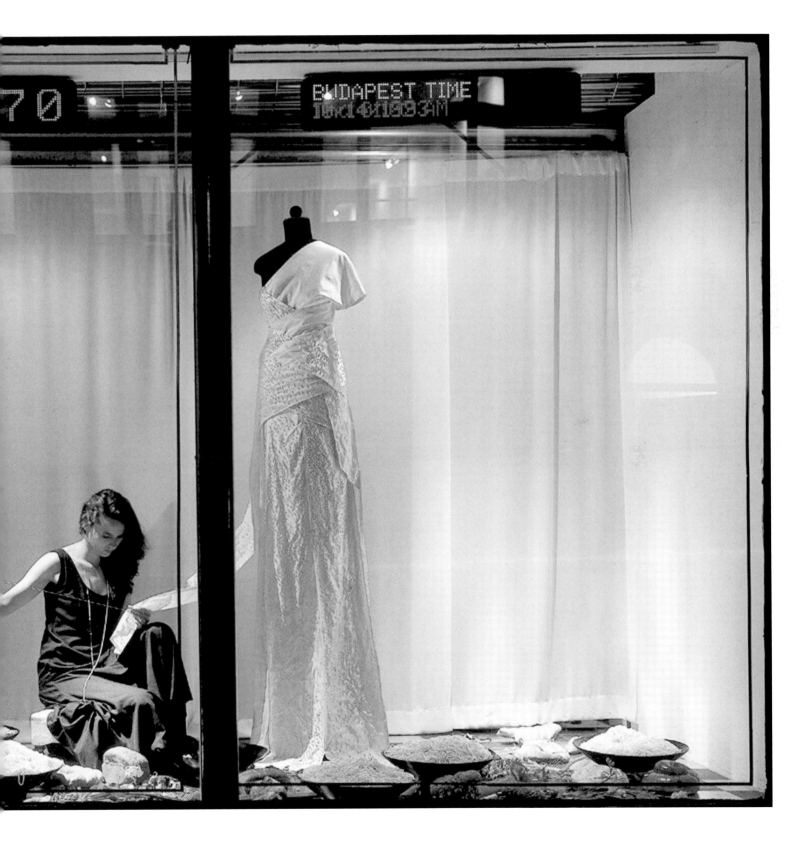

Hermes' Mistress, 1994-1999
Performance / installation
Duration: 157 days
Letter beads, silk dress, case, computer laptop,
shoes, VCR and monitors. Size: 4 x 4 x 1 m
Let the Artist Live, Exit Art, New York, USA, 1994
Fenster im Netz, Kunsthalle Berlin, Germany, 1994
Division of Labor, MOCA, Bronx Museum, Los
Angeles, New York, USA, 1995-1996
Museo Nacional Centro de Arte Reina Sofía,
Madrid, Spain, 1996
Die rote Königin, Frauenmuseum Bonn,
Germany, 1995
Eigen + Art in London, Independent Art Center,
London, United Kingdom, 1994
Spiral, Wacoal Art Center, Tokyo, Japan, 1996
Kampnagel, Hamburg, Germany, 1999

Hermes' Mistress bridges technology and
traditional handwork. In the middle of a huge,
expansive red dress, I sat with my portable
computer, embroidering a spiralling path of letter
beads that detailed information collected from
the Internet. It led me to rethink the concept of
home: home base as home page or ad-dress, and
dress as ad-dress.

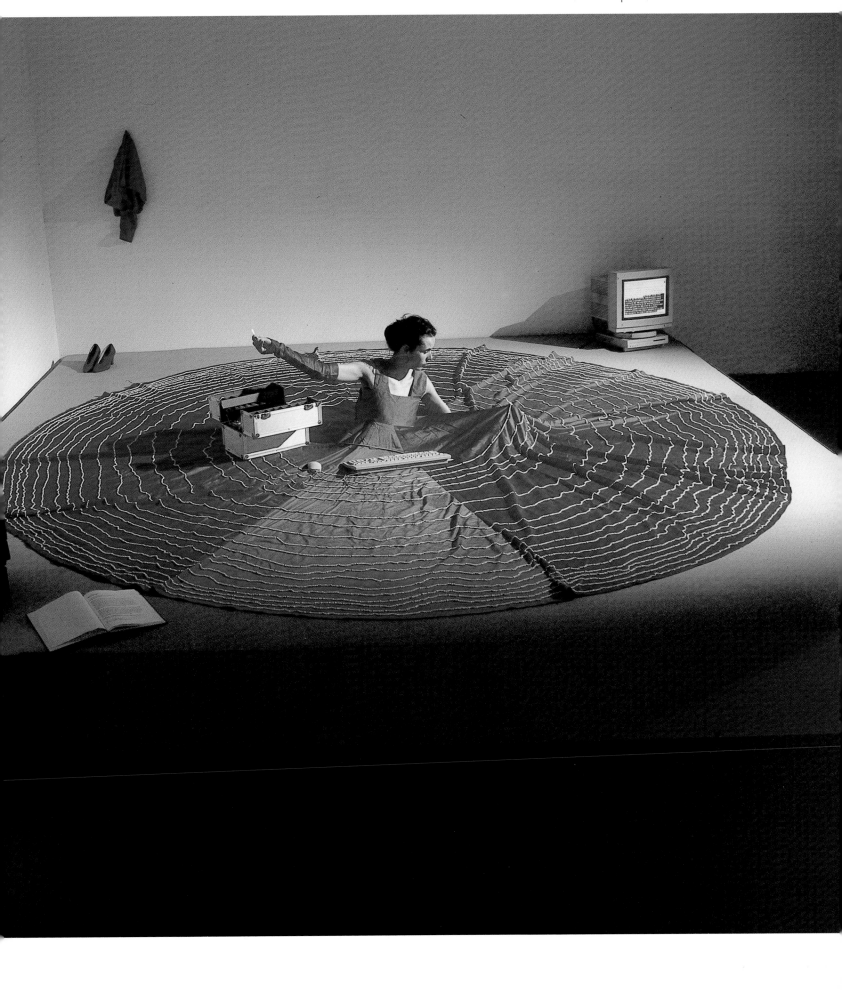

Marica Gojević

Meine Bänder sind wie Gedichte für mich.
(My tapes are like poems for me.)

Performance ist Erweiterung der Gedanken.
(Performance is an enlargement of thoughts.)

Propaganda, 2001
Installation
The words "Marica Gojević" measuring 750 x
100 cm, 30 min. videotape and video still

"'Who am I' is also a question asked by *Propaganda,*
a work about the identity of labels and meanings,
which takes a mischievous sideways glance at name-
dropping in the art circus. The artist's name is
resplendent on the wall in gigantic letters like an
advertising logo, while on the monitor underneath
we see alternating stills of her smiling face, ambiguously
cross-faded with various women's names, the
names of people who exhibit in the art business."

Andreas Baur, text published in the exhibition
catalogue *PIC UP #2. Marica Gojević. Hinter
dem Meer* (Marica Gojević. *Behind the Sea*).
Translation: Michael Robinson, London

In the following pages:
More, 2001
Single-channel video installation with sound,
DVD loop

In the work *More* I sing songs from my native
country. "More" is the Croatian word for sea.
This video installation shows a large projection
of my face. The whole room is filled with my
picture and my voice, which fades into an
atmosphere of yearning.
Yearning to get away, yearning to stay.

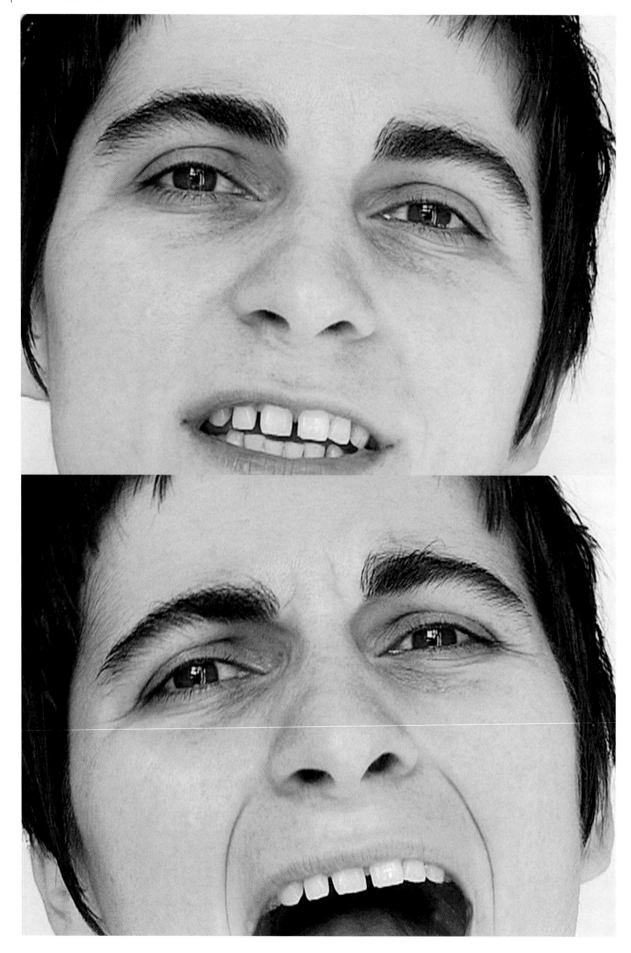

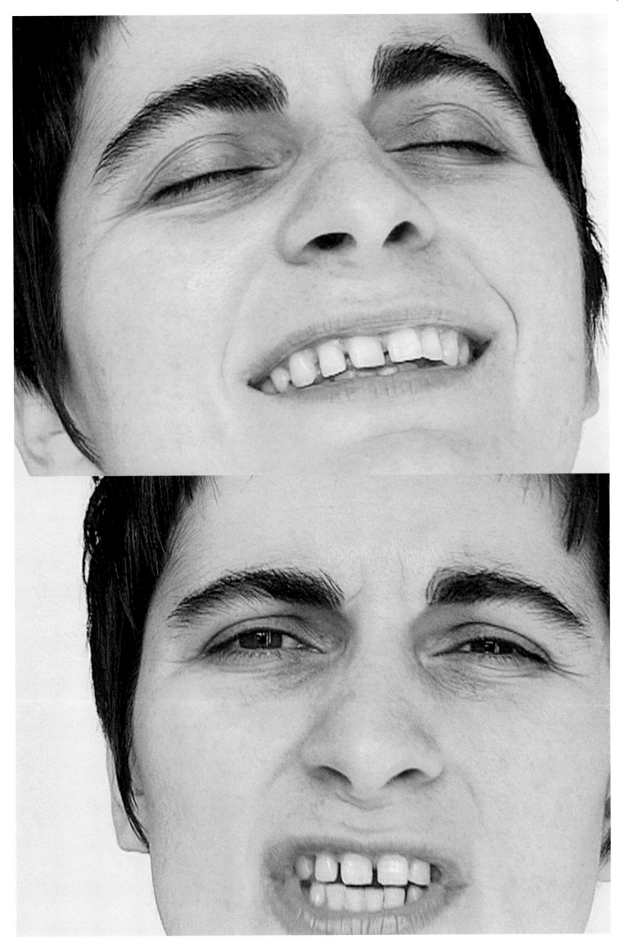

Miroir, 2000
Visible Differences, Hebbel Theater, Berlin,
Germany, 2000

In the performance *Miroir* I colour my body step
by step until I eventually stand there like
someone with dark skin. Then I get up on a
pedestal or a chair and sing a Croatian song. I
sing loud and long, in a full-throated way, and
my voice fills up the room until it almost breaks.
With this work, I once again raise the issues of
identity and belonging.

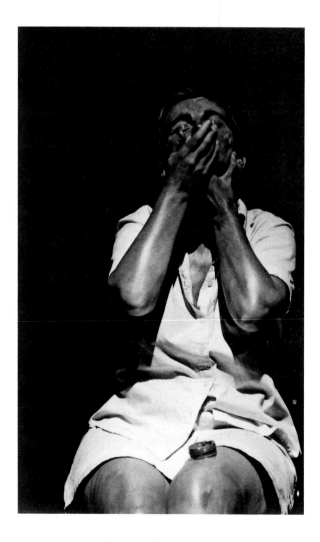

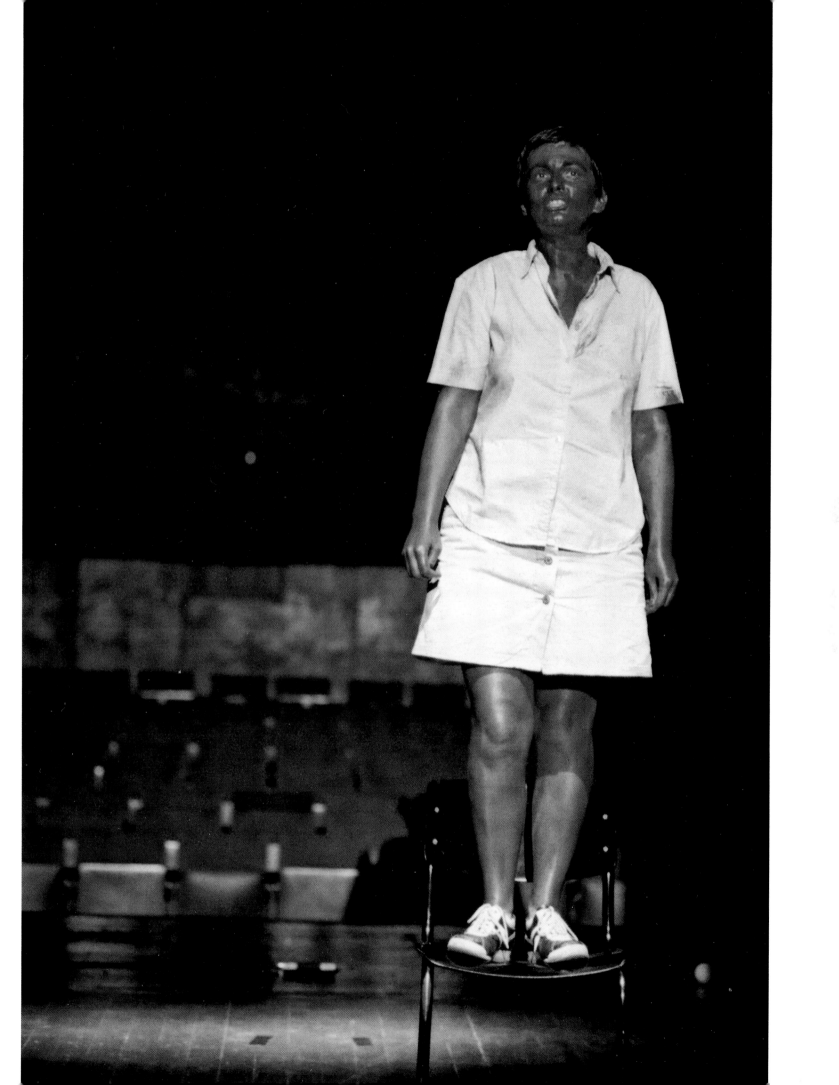

Pascale Grau

I work in the fields of performance art, (video) installations and video.

My instrument is the body, the pivot between my self and the world.

The world is all around my body. All around my home. I wander through the world. I grasp the world and let it flow in. I embody the world. By being portrayed, I am the picture library. The world becomes the body. My body becomes an image.

I contrast performances, role-playing and projections with my own physicality and that of others. In this way, I evoke conflicting feelings in the audience: horror and nobility, beauty and terror, and so on.

If performance is a non-linear language formation, the video of that performance is a repository in which the symbols of this language are stored. A visual vocabulary for a new reality.

Ei Sprung (Egg Leap), 1997-1999
Performance with video
3rd Performance Event, Seedamm Cultural Centre, Pfäffikon, Switzerland, 1997
Non Lieux. Poetry of the Non-Site, Kaskadenkondensator, Basel, Switzerland, 1998
Aufschnitt, Media Bodies, Mousonturm, Frankfurt, Germany, 1998
For Eyes and Ears, 2nd International Performance Festival, Odense, Denmark, 1999

The performance represents a portrayal of what is from the start "meaningless depletion."
The artist gives us a clue as to the double meaning of the words in the title: a leap into the water clad in eggs and ovulation.
With a costume made from 350 blown eggs, the artist stands by the edge of a swimming pool. She builds up the tension with a countdown to the leap from 38 to 0 (or whatever the present age of the artist is), in the course of which some of the eggs are knocked off, while others are smashed.
The action is filmed simultaneously by an underwater camera and projected live or else a fraction later. In a second part, the artist sings a song in front of the underwater projection.

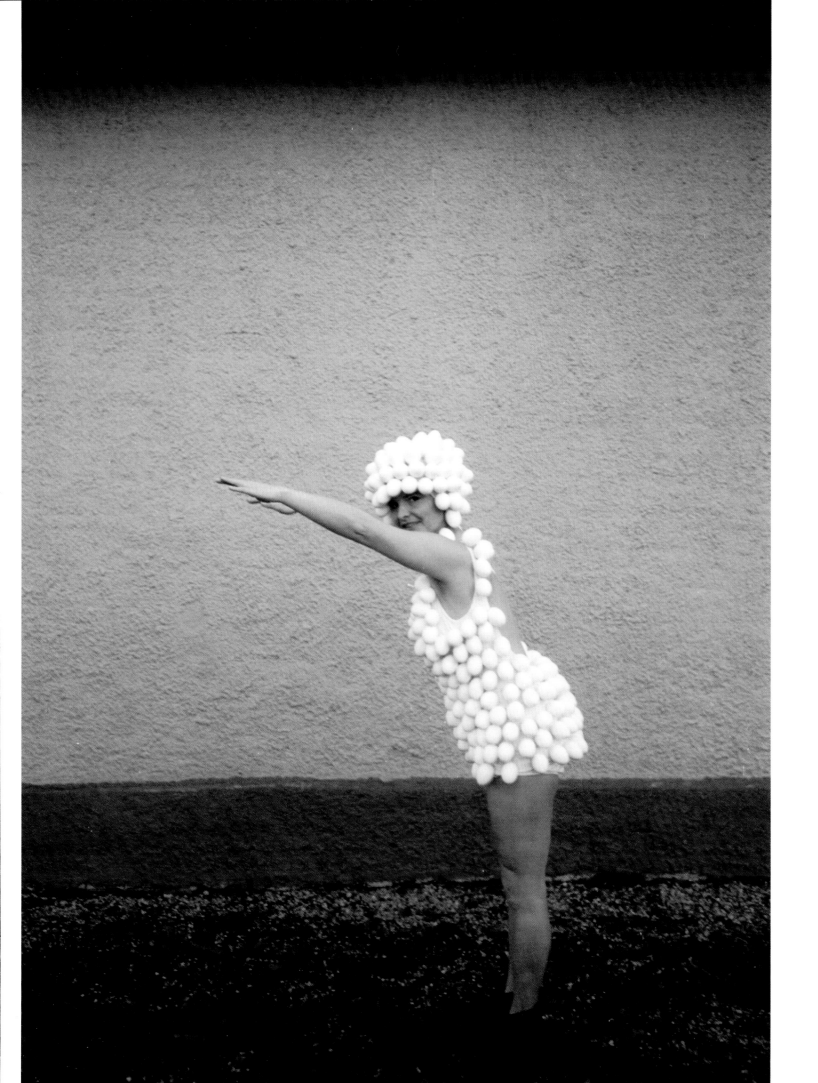

Mittwoch immer die Gummihose, 1996
Performance, 1994-1995
Video, 1996
ProT, Munich, Germany, 1996

A woman steps onto the stage and behind a microphone. She moves her mouth but produces no sounds. With her mouth wide open, she begins to stuff her fist into her mouth. Her entire fist is inside her mouth. Music plays to the woman's retching. She vomits her fist out after about 3 minutes. The woman smiles and leaves the stage to fading music.

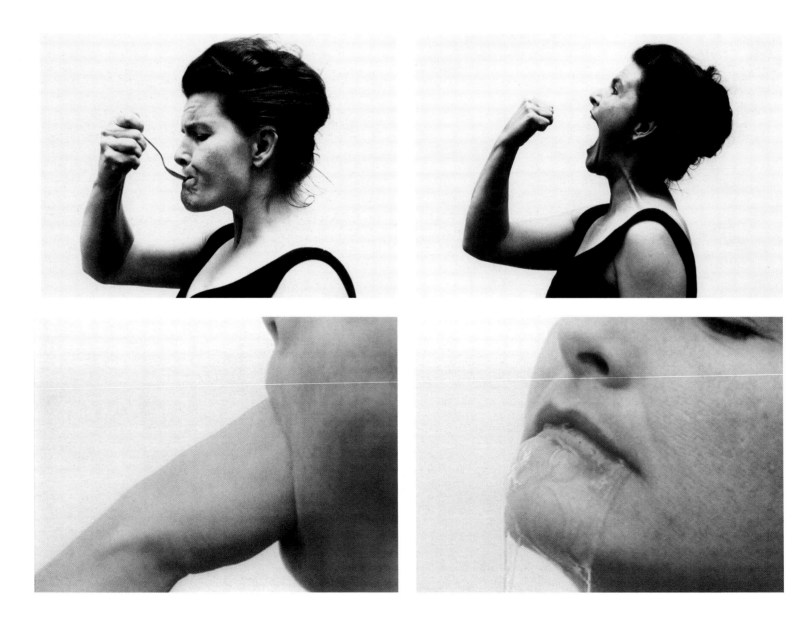

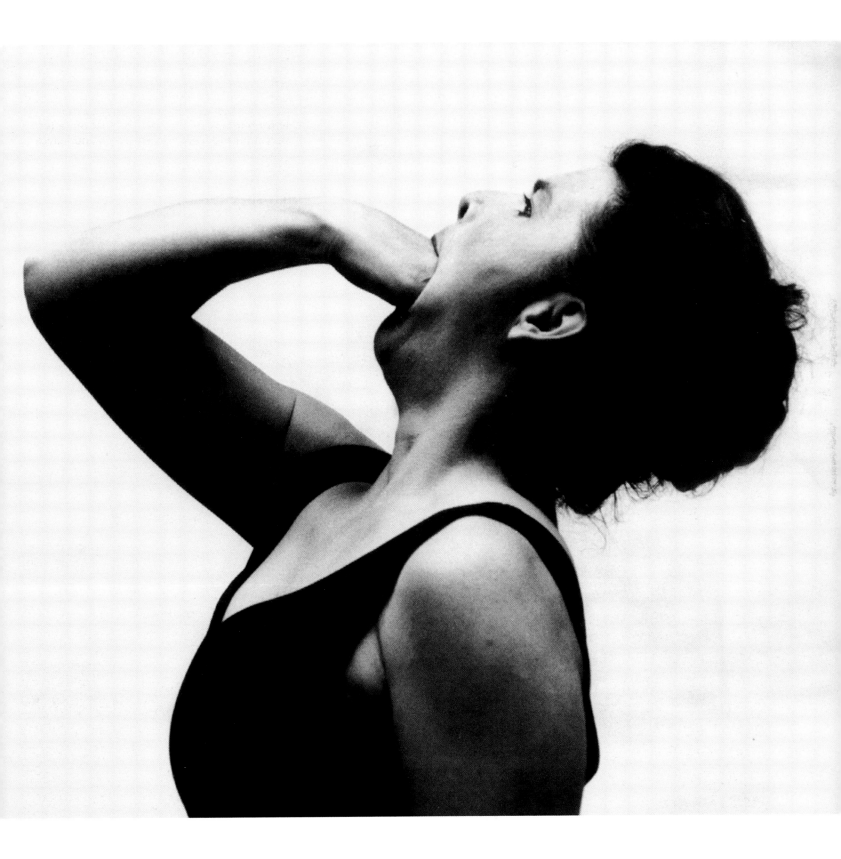

Endorphine (Endorphins), 1999
Performance, 1999
Video, 2000
Killing Me Softly Performance Event, Kunsthalle
Bern, Switzerland, 1999
International Performance Event, Giswil,
Switzerland, 1999
Fortpflanzung, KULE Performance Festival,
Berlin, Germany, 1999

I walk into the room wearing an elegant negligée.
In the background, a video is being projected:
two arms are reaching upwards towards the sky,
as if they wanted to capture it.
A hair-dryer lies on the floor.
Using the warm air of the hair-dryer, I wake the
ladybirds in the pockets of my dress from their
"wintry" torpor.
Forty thousand ladybirds begin to populate my
body. They swarm over my arms, my back, my
breasts, my head and they form patterns. Some
flock to the light or to the audience.
With my arms raised and turning in a circle, I
sing Roberta Flack's "Killing Me Softly." After
the song, I make my exit, leaving behind
hundreds of lucky ladybirds in the room. An
eerily beautiful picture.

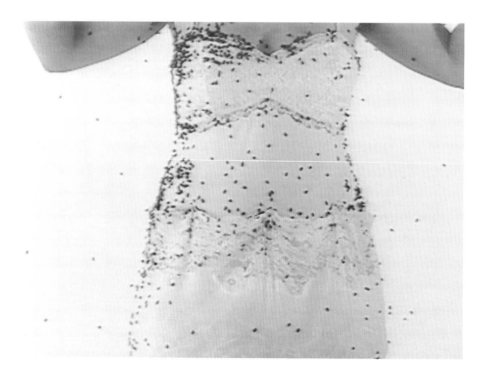

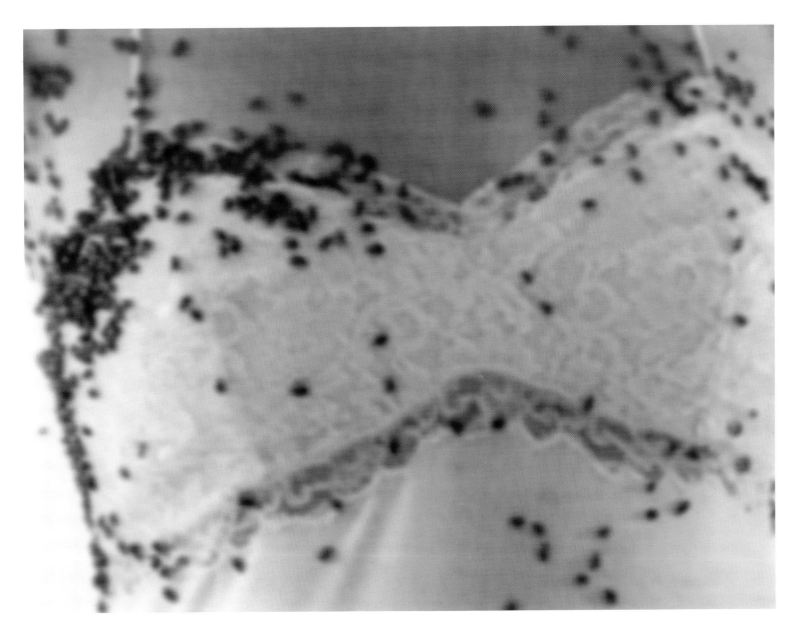

Katrin Herbel

The works move in the area of conflict between the person, the body and the in-between that binds time and space together.

Sides of myself are modified to reveal a new form on video, a being beyond "person" and "body," which seeks to make a momentary connection with the observer – albeit one that is at once bodily and highly personal...

**Veronica's Meditation Training
Part 7: The Head**, 1998
Video installation

Please take off your shoes.
Lie down comfortably on one of the couches.
Take one pair of headphones.
Close your eyes.
Relax.

If, due to your relaxation, you miss the video course or some exercises,
or if you fail to meet the course goal, never mind:

Take one of the folders home to read the exercises in peace,
in the English original or in German translation.
In addition, you can purchase a copy of Veronica's Meditation Training
directly from esotericvideos GoP; if you wish expressly, with German dubbing.
Please find the order address in your folder.

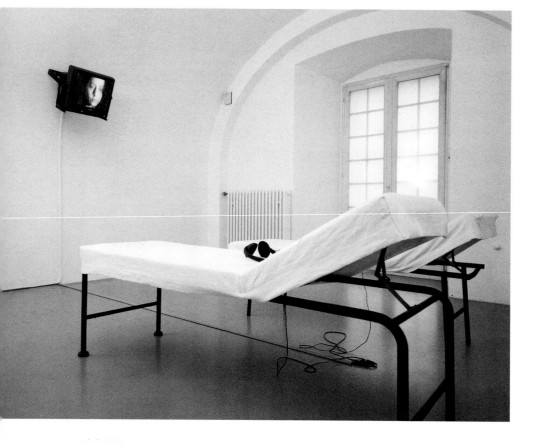

Esotericvideos presents:

*Veronica's Meditation Training
Part 7: The Head*
User's manual
English
1997 esotericvideos GoP

Hello to
*Veronica's Meditation Training Course
Part 7: The Head*

We remember having already released ourselves from our feet, knees, sex, our stomach, our breast and our throat. Today our exercises focus on the head.

Free your mind for 15 minutes.
Put nice, tender music on.
You know me already; I'm Veronica.
And these are my assistants Eva, Alex and Lea.

Let's start relaxing.
Take the flesh around your mouth with both hands and pull.
Don't let yourselves be disturbed by the phone – let it ring!
With both hands take the flesh around our mouths and pull as hard as you can.
There are various possibilities.
Never mind the expression on your faces: no one can see you
Concentrate on the material between your fingers – is there anything wrong?
Relax!

Feel your blood flowing, hear the sounds in your mouth from inside; just enjoy the feeling.
If you cannot enjoy yet – don't give up!
Try once more!
You shouldn't fail.

Recall the feelings of innocence and the sense of wonder, as the music slowly unfolds a tapestry of woven melodies, captured and expressed on piano and synthesizers, as we journey towards the brighter side.
Try hard – try again!

Till we come to the next exercise:
Now it is time to give an inside-massage to our lips.
Touch them all around: you'll experience that they are wet!
Pull the skin a little bit.
It'll make a sound. (...)
How moveable are your lips? You are not yet relaxed.
Widen up your mouth. Widen it up.
OK, Let's dry our big mouths.
The next exercise is smiling. Smiling against resistance.
The first try wasn't so good – now it is better – you see?
Next we concentrate on our nose: we take our nose as a bridge to our brain. But when we have crossed it, we reach our eyebrows instead. So we travel along them, encounter the gentle skin around our eyes.

We try to close our eyes. Pull.
It is not so easy, is it?
That's because your breath couldn't pass – breath can't pass the nose. It is not so easy...
Free your nose! Free it!

Now we are ready to practise the highly hypnotic Veronica-gaze.
By watching ourselves deeper and deeper into that unknown mind of your alter ego we get higher and higher. Roll your eyes to get more impressive. The expression gets higher – deeper and higher!

For the next step towards the brighter side you should free your nose again.
Try to move your mouth without help – as if you were kissing your alter ego.
Great. Fine!

Now it is getting difficult.
Relax your eyebrows – yes, relax; clean your face, yawn if you have to, relax everything you have.
We now start the big research:

We are looking for our brain.
Is it behind your eyes?
Might it be above you?

If you cannot find your brain, you really have to try hard and concentrate in a more complete way.

I did not yet give you any instruction about your ears; those funny little organs that have one ability the others don't:
They absorb waves from the air and lead them directly into your brain, which transforms those waves into sound – in other words: they make you hear!
We appreciate that and touch them gently, as they represent clearness.

When you carefully cover the holes of your ears, you will see what I mean.
Your hands let no wave come through, so that no sound will be produced anymore –
you will find that particular impression of emptiness that shows the presence of your brain:

This is your brain!
You have found it!
Empty as can be.
Enjoy not hearing my voice anymore, nor the soft music.

Enjoy your brain!

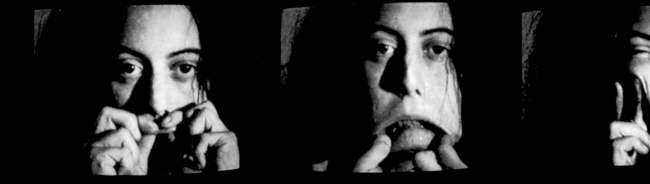

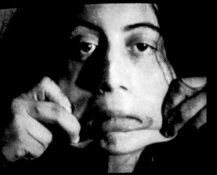

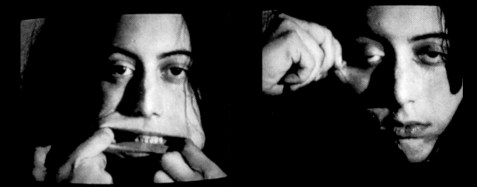

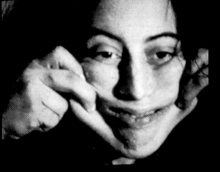
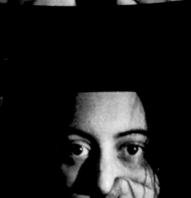

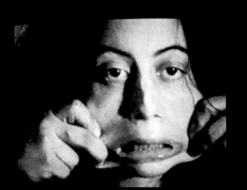

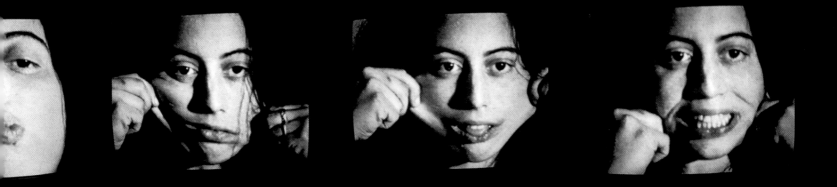

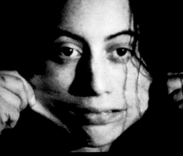
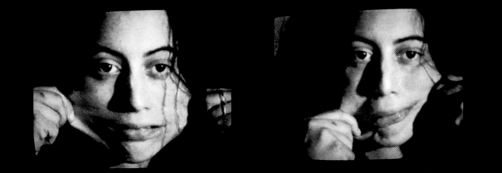
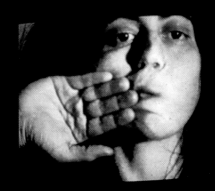
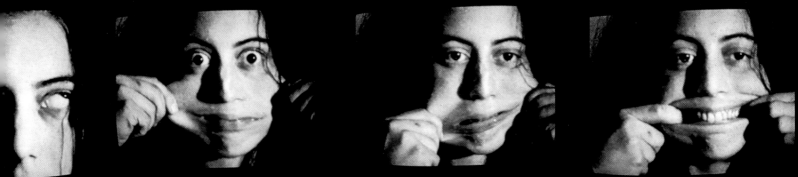
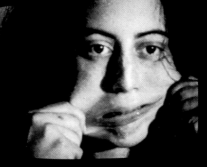
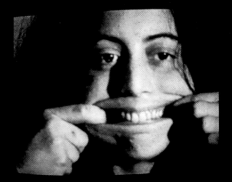

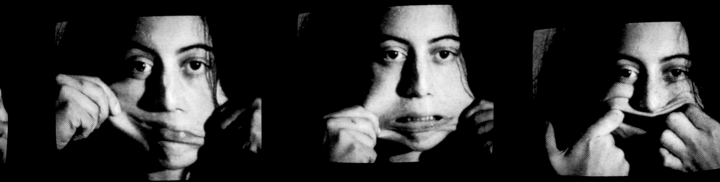

Looking for Some Body, 2003
Video installation

Exactly on the line between you and me, inside and outside, never and now: not so much a simple line but a space, a space of overlap. Living itself as the real space of life. In its very center: coincidence. Non-linear, non-dimensional: just and exactly one point of total concentration.

No edges, no beginnings, no ends. This point is the point of my interest: the instant of inter esse (being-in-between) as absolute interaction where everything coincides and nothing seems to be there.

"I" cannot be distinguished from "my body." There is no "my body," it is me – a liquid, incapable, immeasurably concrete me.

Metrunk – Me Edges, 1998-2002
Video installation

A space-filling projection onto a translucent, thin,
off-white curtain hanging from the ceiling in the
middle of the gallery room; through the screen,
the image is also projected onto the walls across
from the projector, lending the two-dimensional
image a certain plasticity. The curtain moves
gently in the slight breeze created by the people
passing it – adding life to the static video image,
in which only the leaves of the tree move.

Feeling my way along, rubbing along my own
skin, which is impenetrable only to me, in reality
the only commensurate resistance: the absolute
border, which I need not overcome,
which plain and simply cannot
be overcome

because my innermost border
is my outermost edge. Because
I need not be one
with my body, in order to
be inside of myself. Because
I myself am this
body. Because
I need not delve into it.

Because I myself am the background.
I find myself, see myself headless, but
with hands and feet – and everything in between.

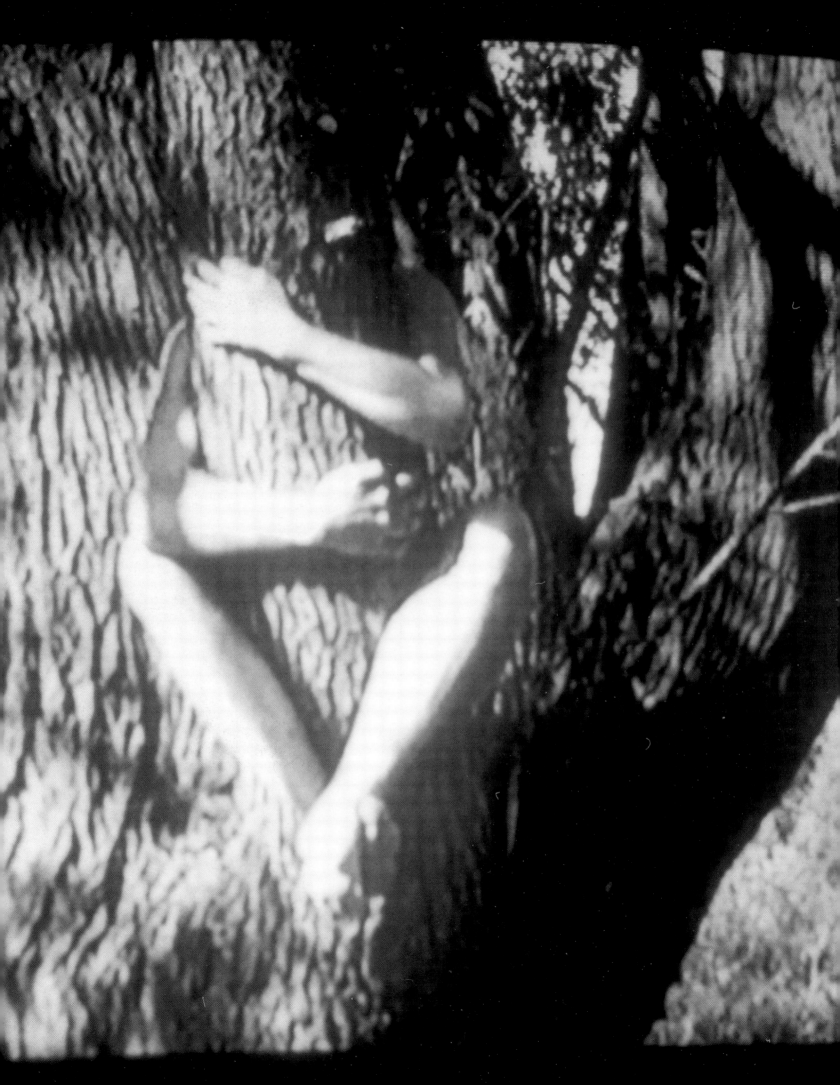

Eun-Hye Hwang

Mirror, 2002
Hochschule für Bildende Künste, Braunschweig,
Germany, 2002

They look at me.
They look at me up and down.
They stare at me.
They estimate me.

They become a mirror and…

I look at myself.
I look at myself up and down.
I stare at myself.
I estimate myself.

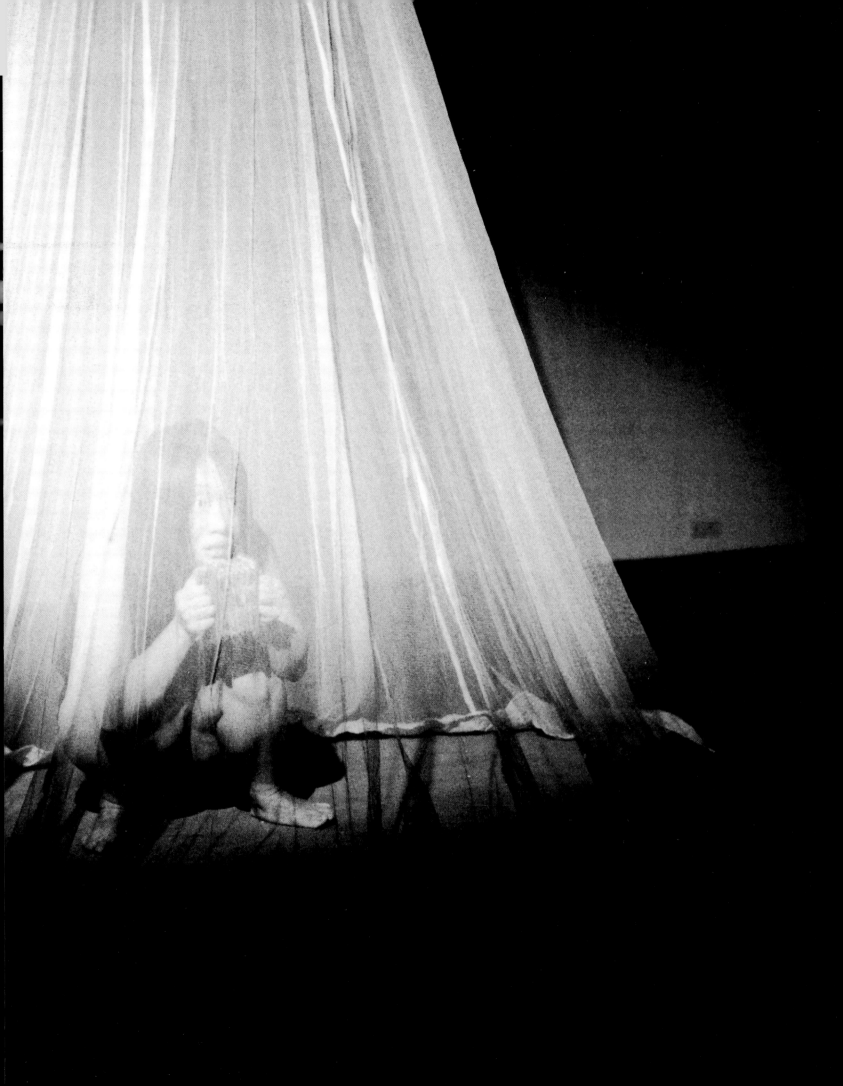

The Worship of Coffee, 2003
Duration: 10 min.
Olympia Park, Munich, Germany, 2003

Whenever the aroma of coffee wafts by me, I am
taken by it into a peaceful, friendly and mystical
space where I can have a feeling of being at home.

Breathe it in deeply.
Breathe out slowly.

Feel how the aroma of coffee goes into the body!
It transfers myself into an act of freedom
according to a shout of the aroma of coffee.

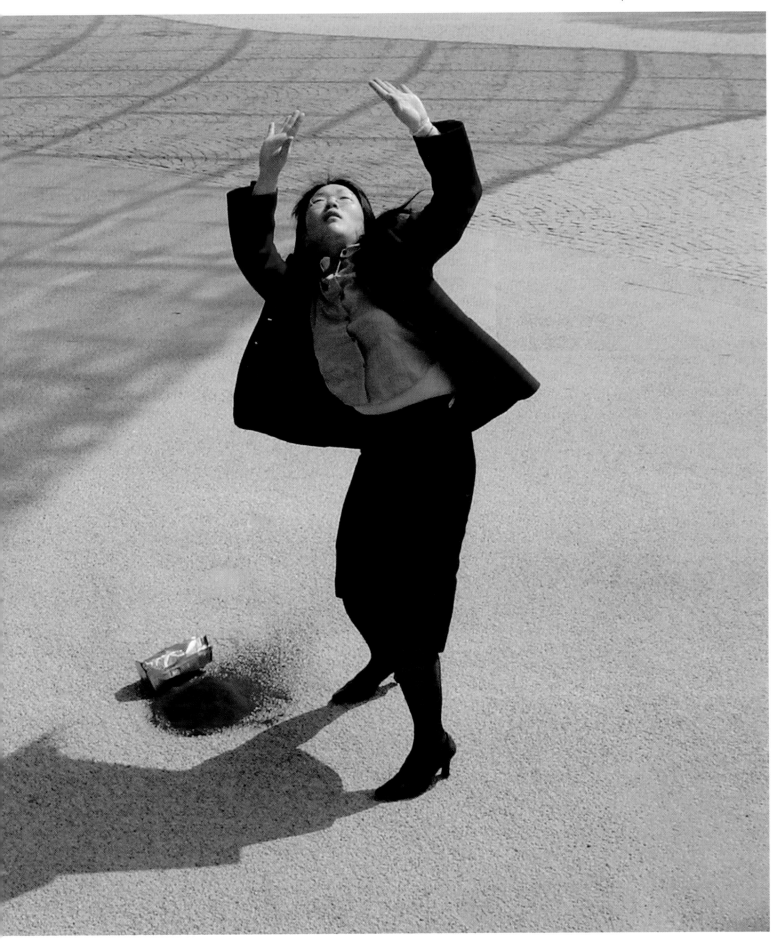

Julie Jaffrenou

Slips de Passage, 1998
This was a creation for the stairs of a museum during a preview.
Zwischenräume – Finally, Kunstverein Hannover, Hanover, Germany, 1998
video still: Iris Selke

Dressed in a classic way: a black dress, stiletto heels, a bun; a woman goes upstairs to an exhibition of video installations. Under her dress, she wears about twenty white pairs of panties, according to the number of exhibitors.

At the bottom of the stairs, the spectators observe her. One step after the other, she undresses, leaving after her the tracks of her intimacy. On the last step, the last pair of panties is removed. The public can go upstairs.

My body is not yours.
My body is my living substance.
My entity, my Identity.

I am a Performer.

I search for an own dialogue with a space, such as it is here and now.
I am attentive to its function, its architecture and its history.
Its own poetry and its own drama will be used as a part of the work.

In the performance, every element has a sense.
Video projections, objects, light and sounds have to fill in a chaos where each will find its place, or not.
Each one is loaded with codes, which will be exploited and broken.

The performer is the link between the various elements of the composition.
He is the receiver and the transmitter of data between the outside world and its internal world.
The medium of an ENERGIE exchange.
My intention is to invite the public into a scene or into a live picture, a space to be felt with the body as much as with all the senses, for another impregnation.

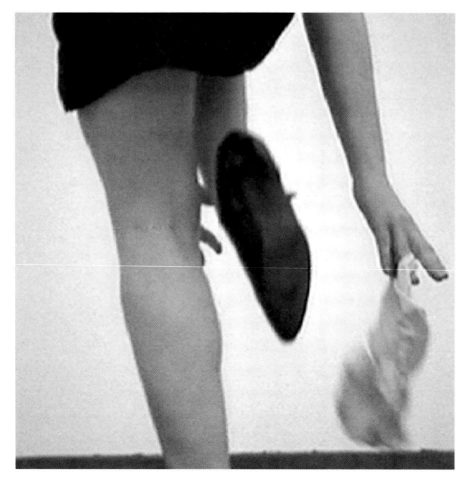

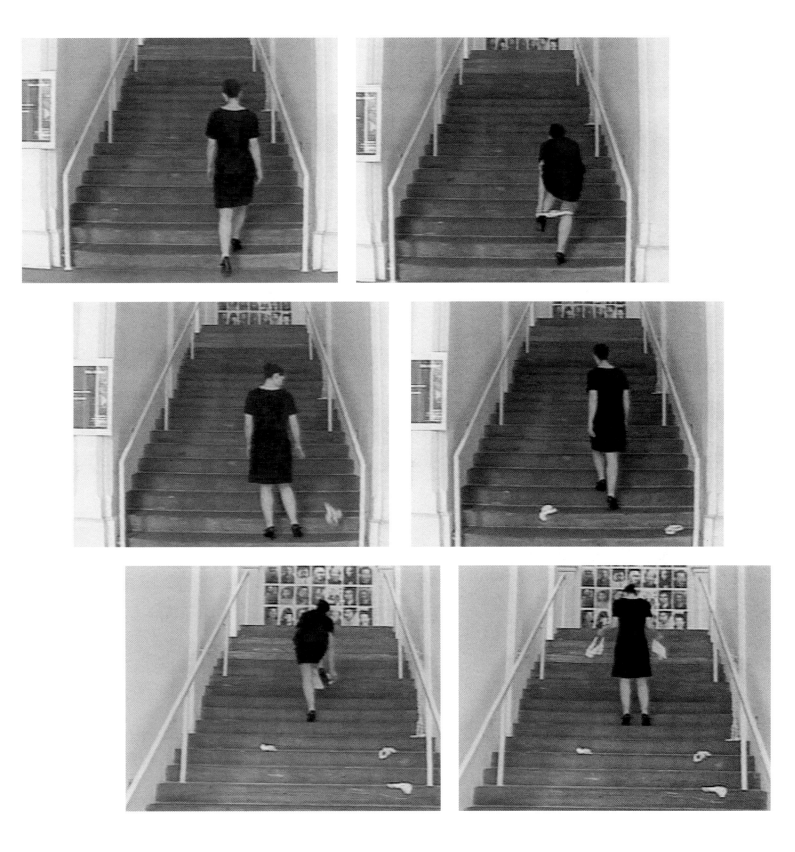

Tellervo Kalleinen

She hates performances but she loves to appear in front of an audience. She makes a fool of herself but she feels like a queen. She begins a performance by asking the audience to buy the clothes she is wearing, or she might call two different pizza services and ask the audience to make a bet on which of the pizzas will be delivered quicker to the performance area. She might give a lecture on her father's artistic ideas or make people wait in a line to buy an admiring whistle from her. Her interest in situations where people gather with a variety of expectations, brings her to the field of Performance Art.

Ylikier Roksilla, 2000
Guided city tours in Helsinki
A project planned, organised and curated by
Tellervo Kalleinen and Niina Lehtonen
Produced by Muury
Helsinki, Finland, 2000

We invited seven European artists to plan and guide a city tour in Helsinki.

The last one of the tours was made by our own performance group Voukkoset.

The tour by Voukkoset included for example the following ideas:

On a pedestrian street the audience got a chance to feel how it is to be a street musician. We taught them a simple rhythm and they had to clap their hands to it. Niina and I sang "Mikkihiiri merihädässä" ("A Mickey Mouse in Sea Distress") with great expression.

When our street performance was finished we collected money from those who had been watching us. With the money we bought ice-cream for everybody.

We brought the audience to a square in front of the main cathedral in Helsinki. The audience stayed in the square while I went up the high steps of the church carrying a bicycle. Niina told the audience that I would ride my bike down the steps. We let the excitement grow… and then I came all the way down! (Actually it was a stuntman who rode down the steps).

The tour ended so we brought the audience to our home. A legendary Finnish underground band Motelli Skronkle was playing. It was quite crowded in there because an audience five times greater than expected came to the tour!

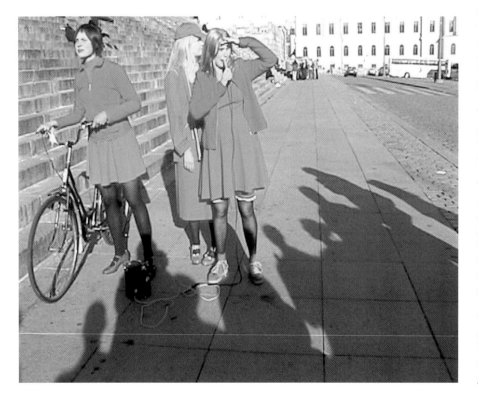

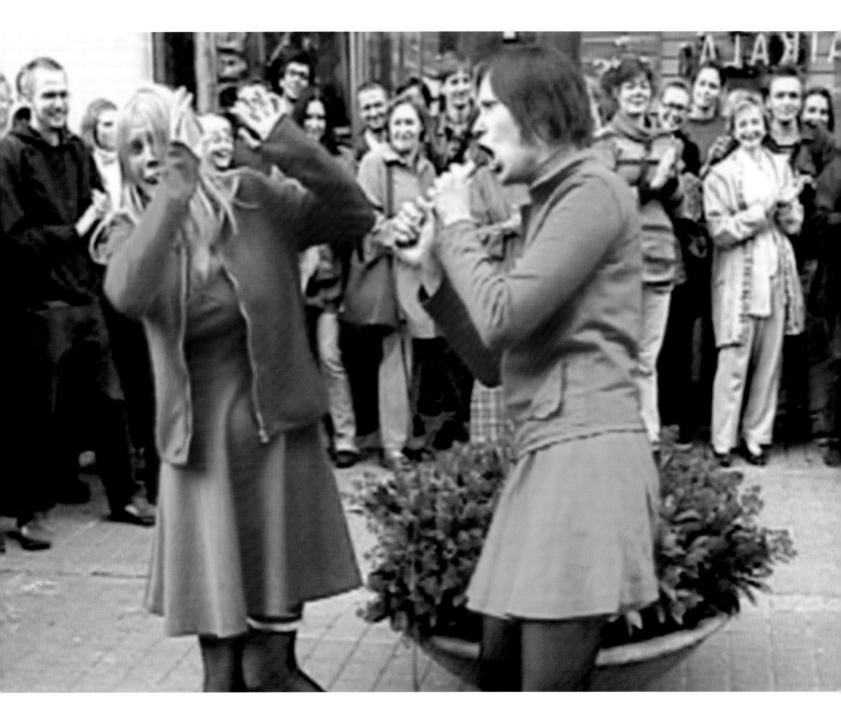

White Spot, 2002
I advertised in newspapers that anyone could come and direct a film scene in an empty white gallery space. I requested to have a role to act in the scenes. During the ten days I spent in a gallery in Helsinki there came sixteen strangers to realize their ideas.

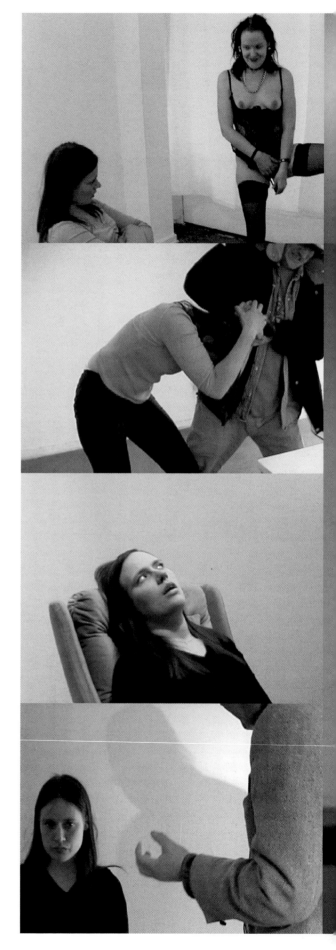

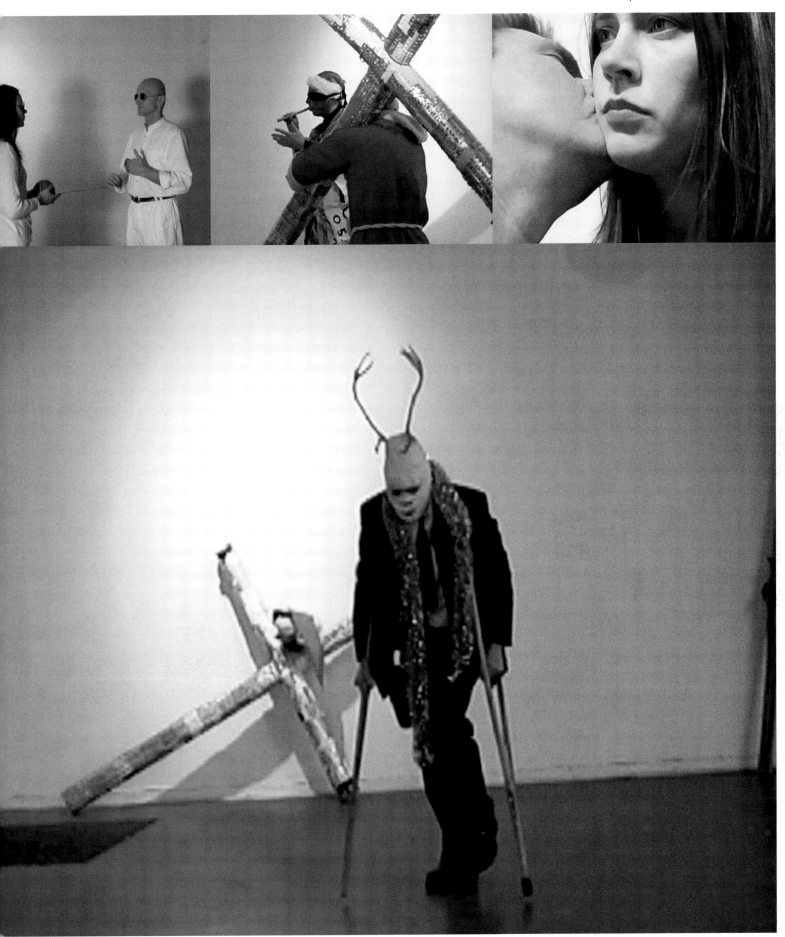

Hungry Amoeba, 2002
A project by Tellervo Kalleinen and Félix Kubin
Artgenda 02, Hamburg, Germany, 2002

We planned three performative city tours in Hamburg. Each of the tours lasted two hours. These are examples of the surprises that took place during the tours:
Disco of pseudo superstars: In the well-known Cafe Kese there were famous people were dancing together, for instance Madonna and Freddy Mercury.
Kidnapping: One of the guides was violently kidnapped during the tour. Later on she was found in a plastic bag which was lying in a road.
Russian poems: We planted the group of Russian poets "Drelikudapopado" in the earth and presented them as Russian meat flowers.
The guides were Tellervo Kalleinen, Félix Kubin, Niina Braun and Jacques Palminger.

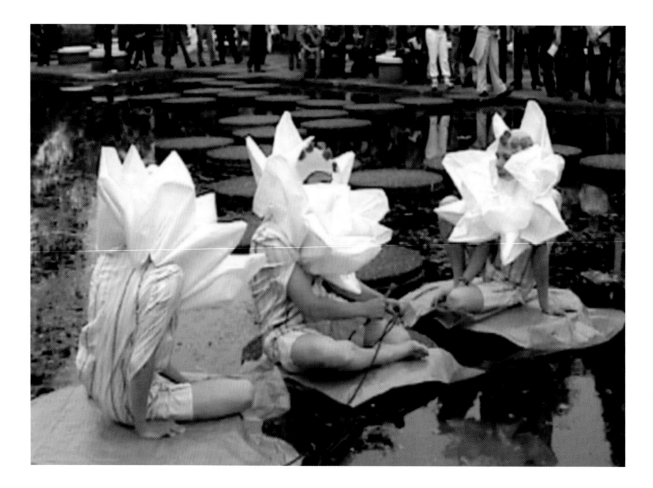

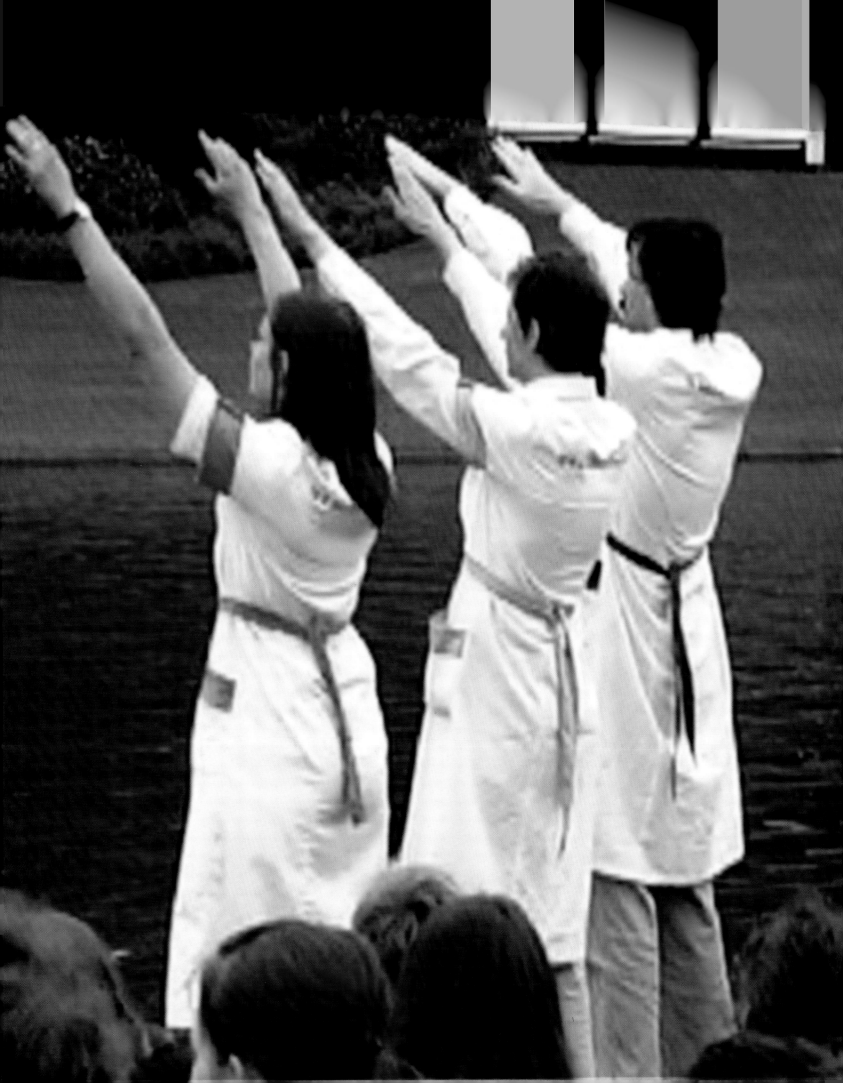

Oliver Kochta & Frank Lüsing

"The serpentine formed rise after Grignon – to my daily objective – pulls itself endlessly into the length. After each way turn a new zigzag emerges. I rest myself at a church, without to be particularly strengthened. Still there is a half hour foot march up to the farm. Clayde and I run here gasping one behind the other. Both we are tired and wet through. The rain gives way finally and a rainbow shows up before the Lure mountains. Only with trouble and emergency I reach the yard. The donkey breaks down on the place and throws itself into the grass. Even as it is freed from its luggage, remains it because of the soil being and has not even desire to eat. The farmer of the farm 'La Goutaille' amuses itself more about the exhausted donkey. I break my camp open at the gate beside the playground, cook a soup and drink large quantities of Whiskey. I confounded the valuable beverage before loud tiredness with my reserve water and poured it out-provided into the tea water. Since I do not lead a further lockable container with me, nothing different one remains than 1 litre of the Whiskey water mixture completely to drink up. In muzzily condition I see a white completely young cat to come from the darkness on me. It wants to begin a play. I take it to short hand also to the donkey on the pasture, which in the young cat is completely interested. It snuffles it gently and wants to kiss it. It behaves thereby very considerationful. Lucky moments between cat, donkey and human: the feeling, sudden entrance to the world of the animal find have, in it come up and there at home be."
Oliver Kochta / Frank Lüsing, *Travel with a Donkey*, 2001. Computer translation from German original.

The Queen of Hula Hoop, 1997-1998
Collaboration with Frank Lüsing
Duration: 12 min.
1st International Performance Festival, Odense, Denmark, 1997
Body Act, Malmö, Sweden, 1998

This performance was made in collaboration with Oliver Kochta and well-known hula-hoop artist Bernadette Deistler. The glamorous, apparently weightless world of acrobatics outshines the artists' intense efforts to overcome gravity.

"Since 1993, Lüsing and Kochta have used the hula-hoop dance form in performance art (including a charity show in aid of UNICEF in Africa). According to the artists, 'it is a marker in the history of Body Art whose main elements are nakedness, the expansion of bodily limits and repetition...' Interestingly, hula hoop was all the rage at virtually the same time as Body Art was an up-and-coming phenomenon in the USA of the fifties. The artists feel that the understandable conclusion of this to be that, as a universal form, hula-hoop dance is the essence of Performance Art."
Else Jespersen

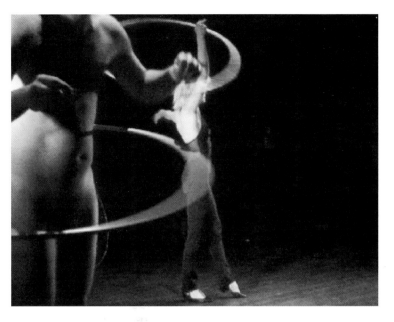
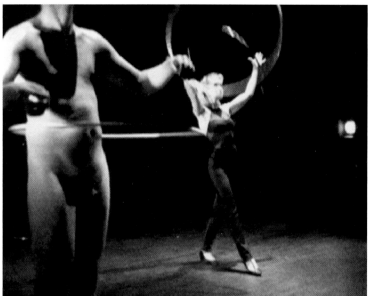
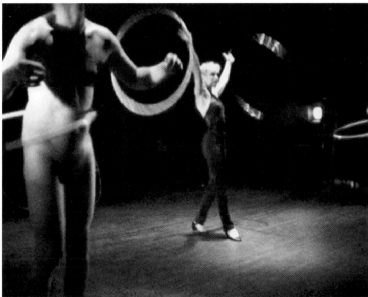
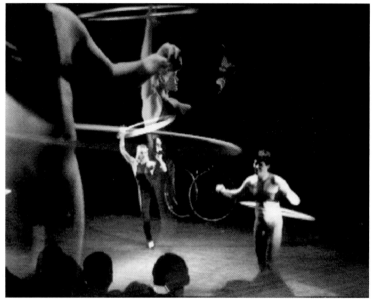
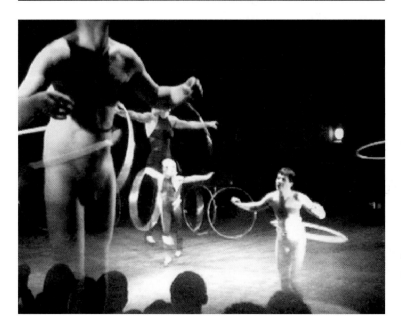
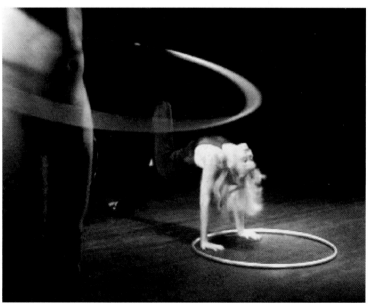

Nallo 2 – Tenting at Debris Mountain, 1997-1998
Collaboration with Oliver Kochta
Duration: 12 min.
1st International Performance Festival, Odense,
Denmark, 1997
Body Act, Malmö, Sweden, 1998

Nallo 2 is a choreographed work, which links 42
well-known performances from the golden age of
Performance Art. The only record of most of
these works are photographs, and in almost all
cases only one photo of each work is actually
documented in the literature on the subject and
stands out for its special talent for survival. It is
through these "self-propagating" pictures that
the history of Performance Art is written. In
Nallo 2, the observant spectator will be able to
recognise these long-lasting stills in a lavish
spectacle, albeit nestling in the midst of a
harmless camping scene, which depicts the
period from sunrise until darkness falls.

Theatrical performance. A short play built on
fragments of legendary performances from the
sixties, seventies and eighties. Whilst browsing
through all the different publications that cover
Performance Art,
we came up with the idea of tackling different
performances without bothering about their
context and time. We can't be sure that a
combination of fragments like these makes sense,
but it does at least make for great comedy!

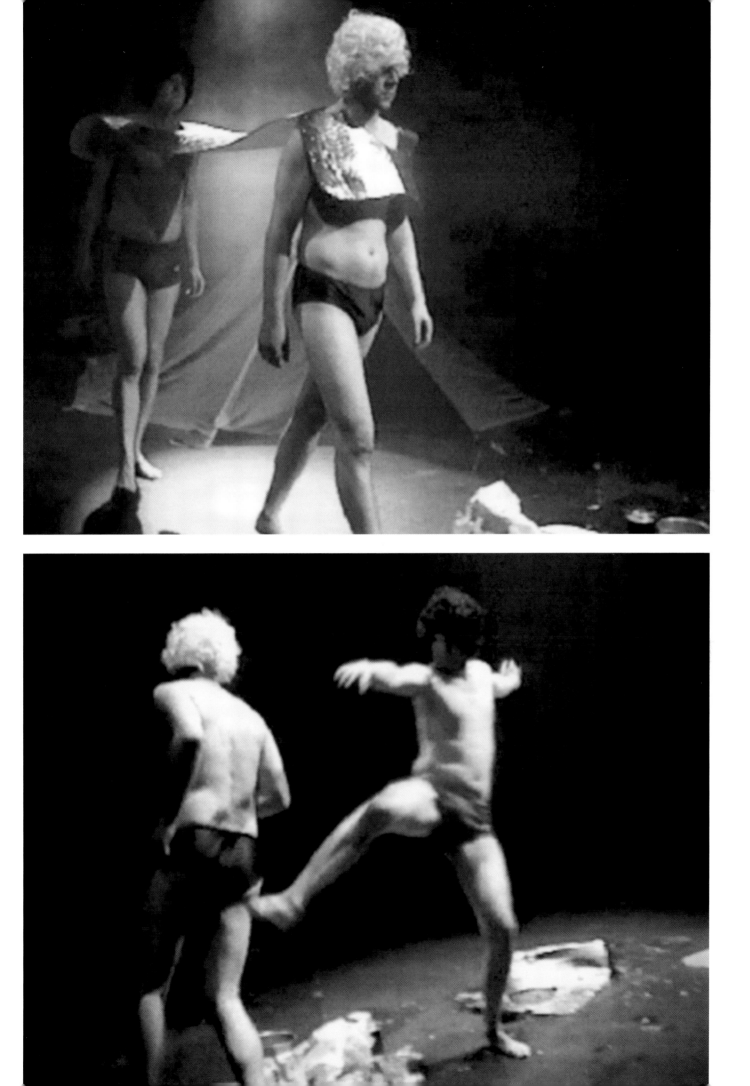

Travel with a Donkey, 2001
A project by Oliver Kochta and Frank Lüsing
DVD
Duration: 1 h.

Travel with a Donkey is documentation of a 10-day journey with the donkey Clayde through the mountains of southern France. The donkey is man's oldest working animal. Contrary to conventional wisdom, the donkey is actually a helpful, sensitive and highly intelligent travel companion. In the course of day-to-day contact and special situations, a very close relationship developed with the creature. The documentary video highlights key situations on the journey.

Travel with a Donkey | 78° North | 90° South | Revolution | Meditation on Violence

After receiving a grant for visual artists by the city of Hamburg in 2001, it was invested in a donkey. Taking the writings of Robert Louis Stevenson as our starting point, we embarked on a hiking trip together with the donkey, Clayde, in the spring of 2001 in southern France.
The film is both a documentation of the journey itself and a summary of the iconography of the donkey.

Franz Gerald Krumpl

Performance is the transformation of message, shape and time into sign language in space. It is my way of expression:

It is in controlling the loss of self-control, delighting audiences, creating atmospheres and in making stupid things.

Manifesto
Artists never eat prosciutto, artists prefer tiramisu!!!

The Portrait, 1999
Performance / photograph
Duration: 2 nights and 2 days
Silkscreen printing
70 x 100 cm
Fresh Air, Kulturhauptstadt, Weimar, Germany, 1999

The photographic print is advertised 400 times in town during the night-time, without further information. During the daytime, the reactions of the passers-by are filmed on video.

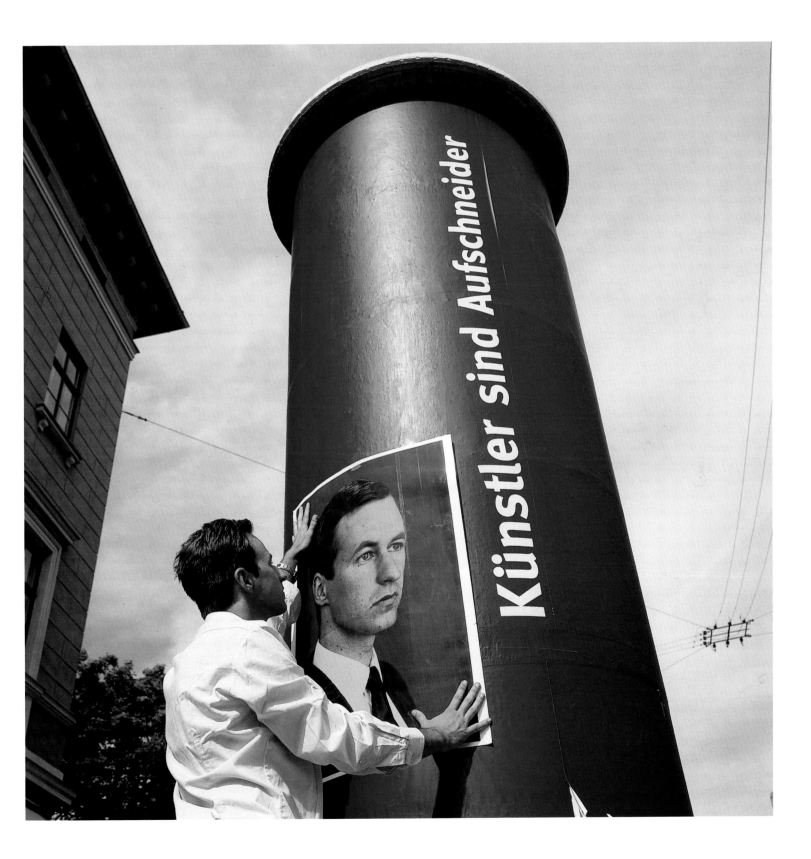

Mabumba, 2000
Duration: 3 sets of 12 min.
Visible Differences, Hebbel Theater, Berlin,
Germany, 2000

I wear a costume and mask of an African tribesman.
I "work out" with aerobic exercises instructed
by a Sydne Rome eighties aerobic record.

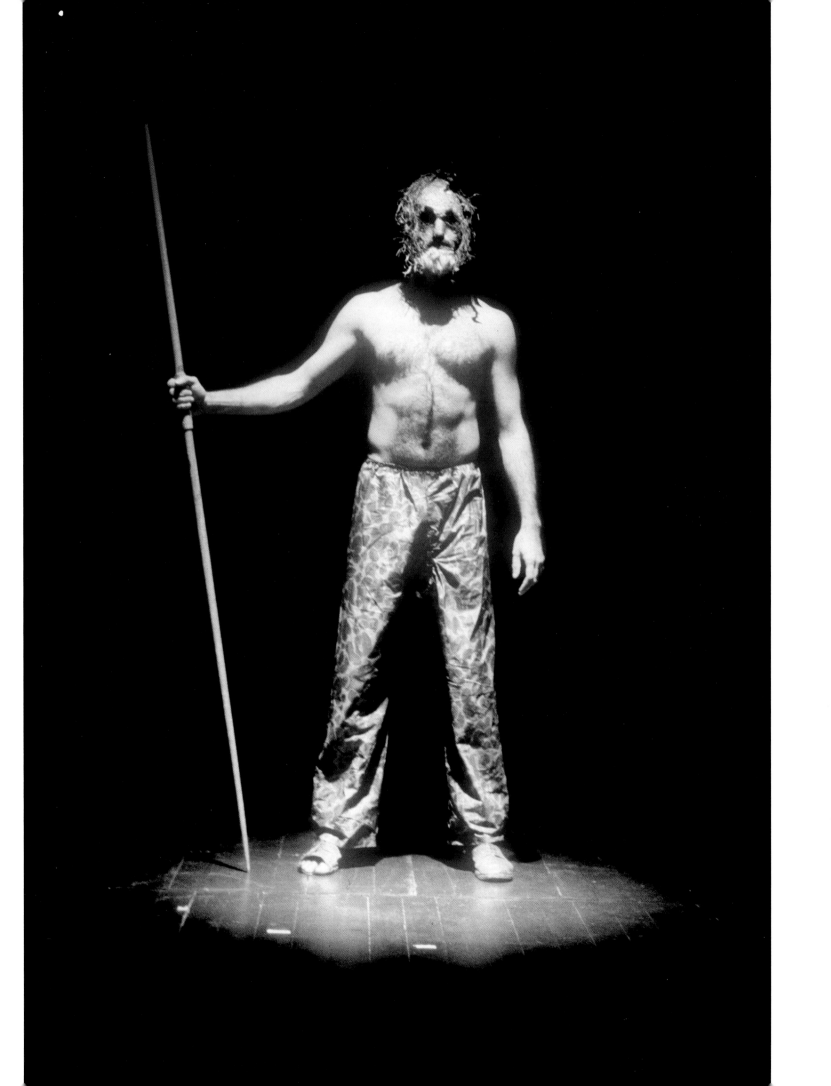

The Partisan, 2001
Duration: 14 min.
Marking the Territory, Irish Museum of Modern
Art, Dublin, Ireland, 2001

I fight against a fictive enemy. Instead of wearing
boxing gloves, I wear flowers on my hands.
There is no enemy, yet my own coaches in the
boxing ring knock me down with torturing
treatments.
The sound is of Serbian folk music.

Turbo Franz, 2002
Video
Duration: 4 min.
Belgrade, Serbia and Montenegro
Berlin, Germany
Basel, Switzerland
Barcelona, Spain
Body Basics I / Body Basics II, Transart 02,
Klanspuren Festival, Fortezza, Brixen, Italy, 2002
video still: Viola Yesiltać

Turbo Franz is an art character of mine, who interprets the Serbian so-called turbofolksong "crno pa, se ne vidi" in all the towns he travels to starting with the letter b.

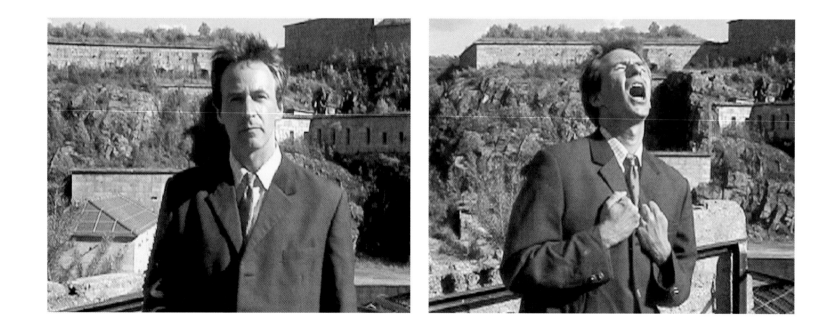

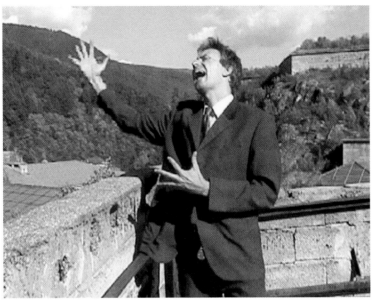
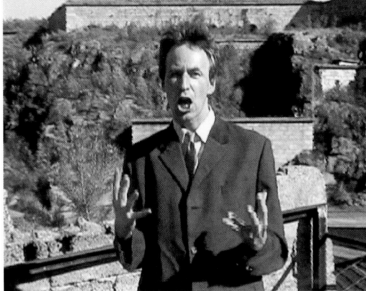

Changing the Habits, 2002
Cleaning the House, Centro Galego de Arte
Contemporánea, Santiago de Compostela,
Spain, 2002

1. Standing in front of the audience,
 I polish a chair.
2. Speaking the words "changing the habits,
 cambiar los hábitos" until I lose
 my mind.
3. Standing in front of the public, I polish
 the chair in a different way.

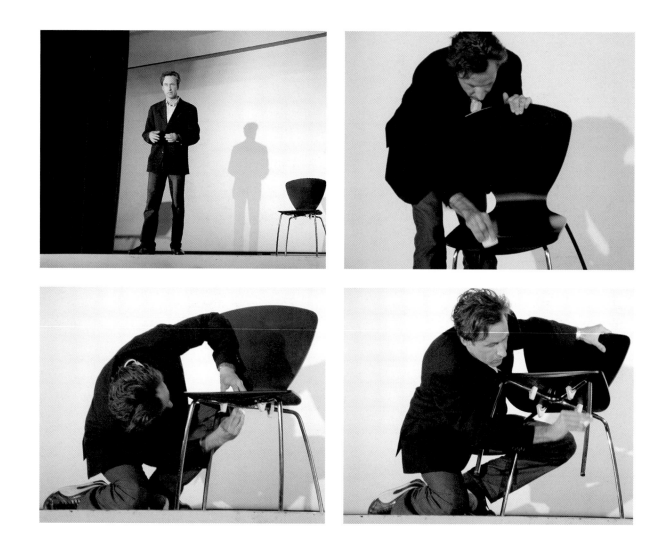

Un bacio piccolissimo!, 2003
Duration: 3 h. 15 min.
Recycling the Future, 50. Esposizione
Internazionale d'Arte La Biennale di
Venezia, Venice, Italy, 2003
Performed by Franz Gerald Krumpl and Jovana
Popic

After not having seen each other for more than
four months, Krumpl from Berlin, Germany, and
Popic from Belgrade, Serbia, meet for a
durational kiss lasting three hours in a *bacio*
box, constructed by Krumpl, in the Giardini di
Castello at the Biennale.

The creation of "private space" in public space
allows the audience to participate voyeuristically.
The performers are exposed to the audience and
at the same time are protected by intimate love.

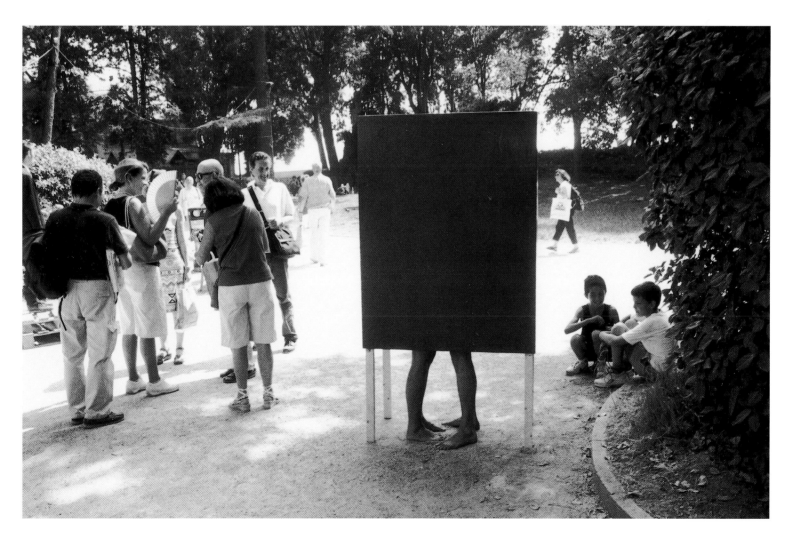

Lotte Lindner

I wake up, open my eyes and I start to collect.
I take in pictures. I observe things. I try to find
out why they are there and where they might go
afterwards. I keep them in my mind so that one
day I will put them together.

I like to combine things. I follow some molecular
logic. This is how I find images.

Mountain, 2002
Duration: variable
Hochschule für Bildende Künste, Braunschweig,
Germany, 2002

I have a tent.
I sleep in the tent.
From time to time I come out of the tent to take
the posture of an adventurer.

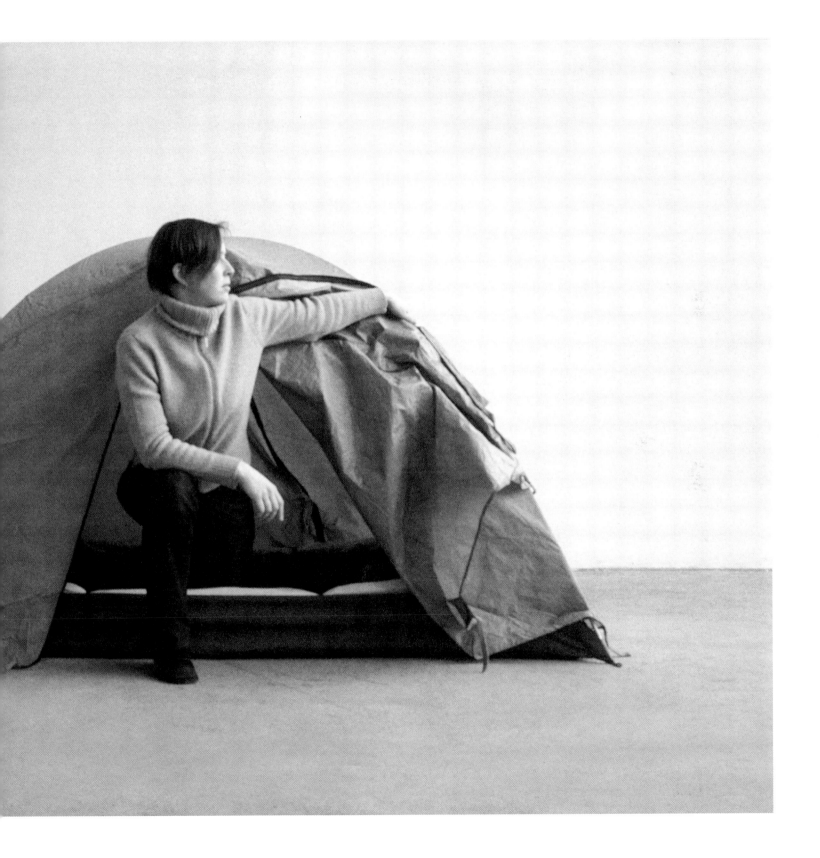

Embroidery, 1999
Duration: variable
Hochschule für Bildende Künste, Braunschweig,
Germany, 1999

I sit in hallways, staircases or corridors of public
buildings.
I fill in a piece of pre-printed stramin with
embroidery.

Chronicle, 2001
Duration: approx. 4 h.
Marking the Territory, Irish Museum of Modern
Art, Dublin, Ireland, 2001

I sit in hallways, stairways or corridors of public
buildings.
I reflect upon time, duration and procedure.
I embroider an endless sentence onto a 10-
metre-long canvas.

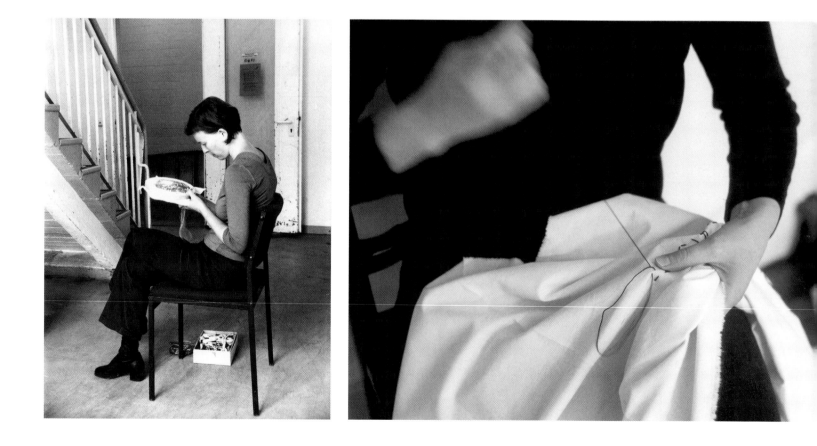

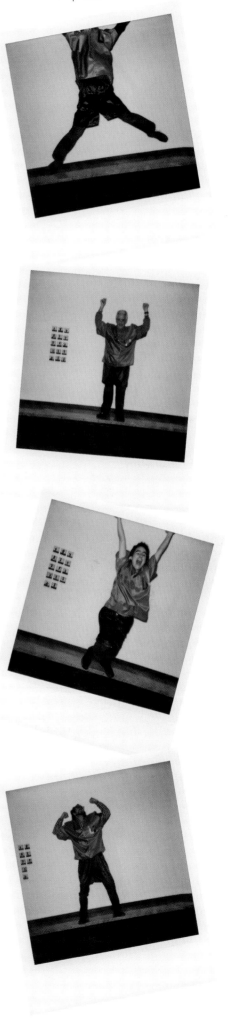

Goal II, 2002
Duration: 2 days
Body Power / Body Play, Württembergischer
Kunstverein, Stuttgart, Germany, 2002

I sew a football tricot. When the tricot is finished
I ask people to wear it and jump while screaming
"Goal!" I take a Polaroid picture of this moment
and collect the images on the wall.

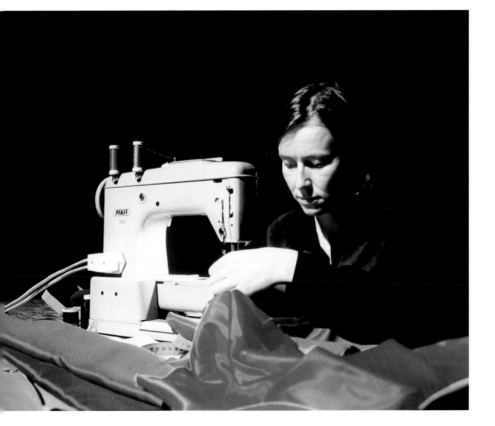

Questions, 2002
Duration: variable
Common Ground, Landesvertretung
Niedersachsen and Schleswig-Holstein, Berlin,
Germany, 2002

I chop and melt chocolate.
I have a book with all the questions from my
diaries since I was eight years old.
I start to rewrite these in layers with chocolate
on a glass wall.

Excerpts from the book *Fragen* which were used
in the work *Questions*:

How can you land a millionaire?
What is the weather like in Paris right now?
Do you like my role in life?
Is it dangerous?
Can you sing?
Who has the courage to watch over me?
Is there a limit for waiting?
What is a house?

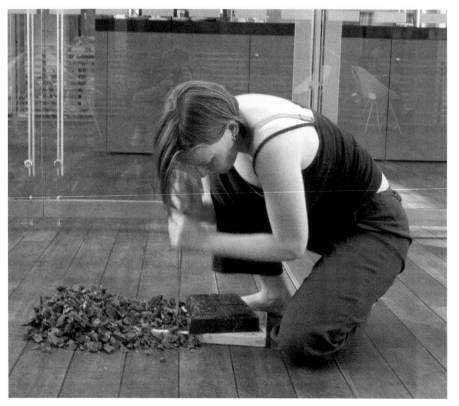

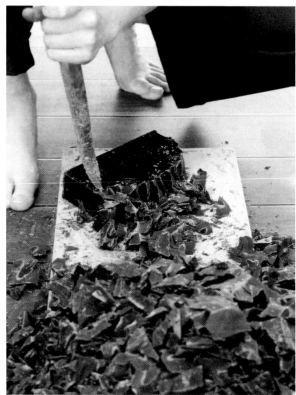

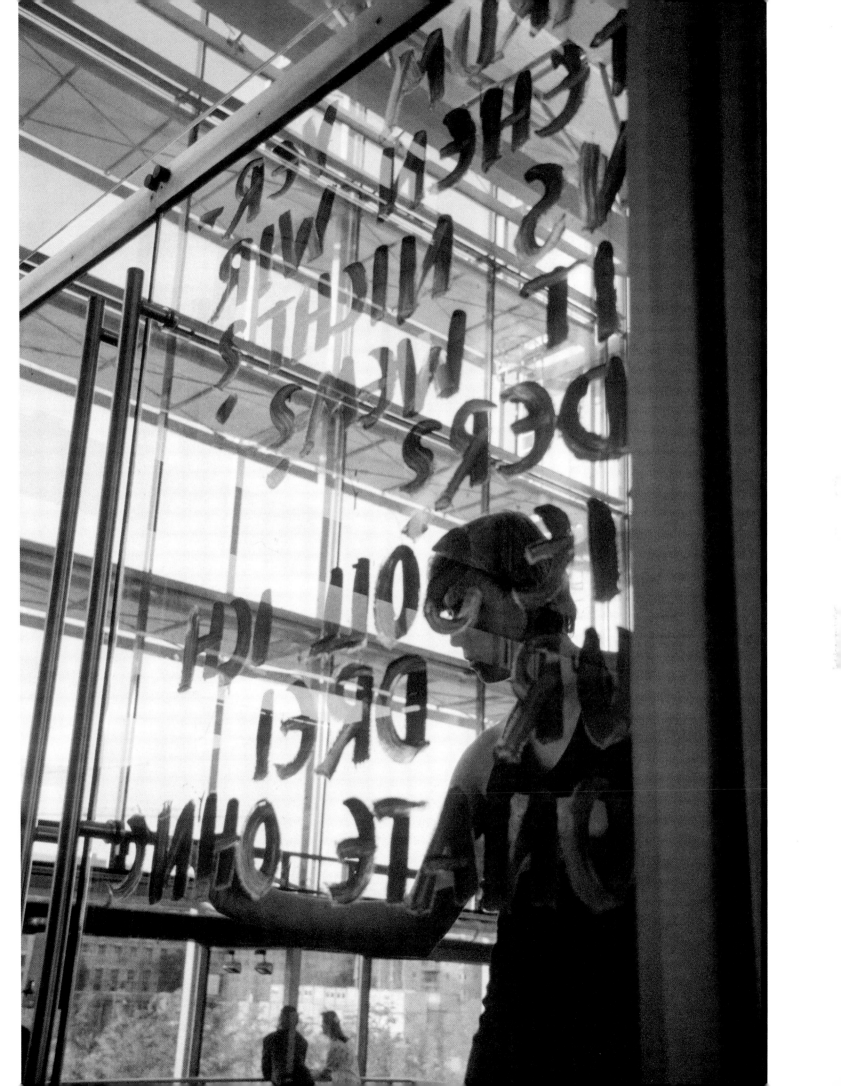

Chocolate Car, 2003
Installation
Hochschule für Bildende Künste, Braunschweig,
Germany, 2003

I melt an enormous amount of chocolate and try
to cover a car with it.

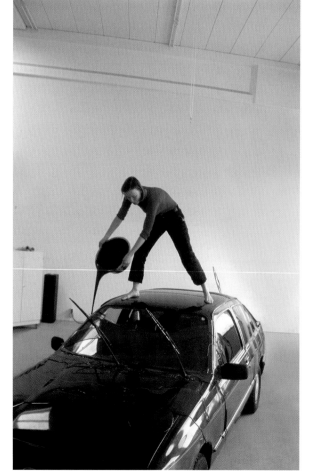

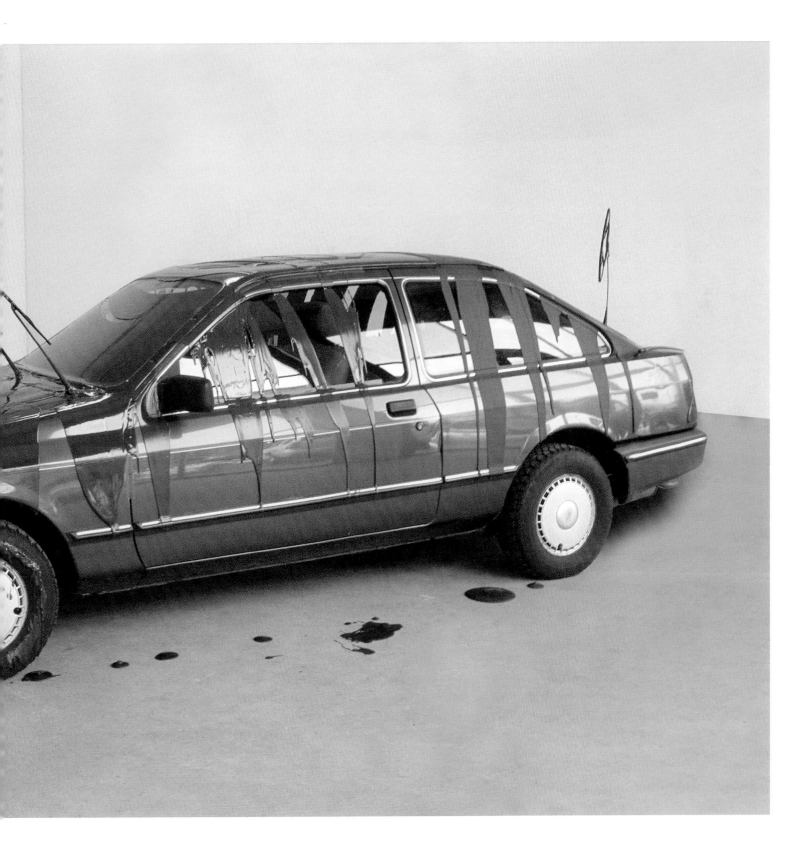

Comb, 2002
Duration: approx. 3 h.
Cleaning the House, Centro Galego de Arte
Contemporánea, Santiago de Compostela,
Spain, 2002

I comb the grass in a growing circle.
You can see the grass laying in one direction.

Fish, 2003
Duration: 3 h. 15 min.
Recycling the Future, 50. Esposizione
Internazionale d'Arte La Biennale di
Venezia, Venice, Italy, 2003

I hold up a shark with the gesture of a proud
hunter. The longer I hold it, the closer we come.
The victim becomes the victor.

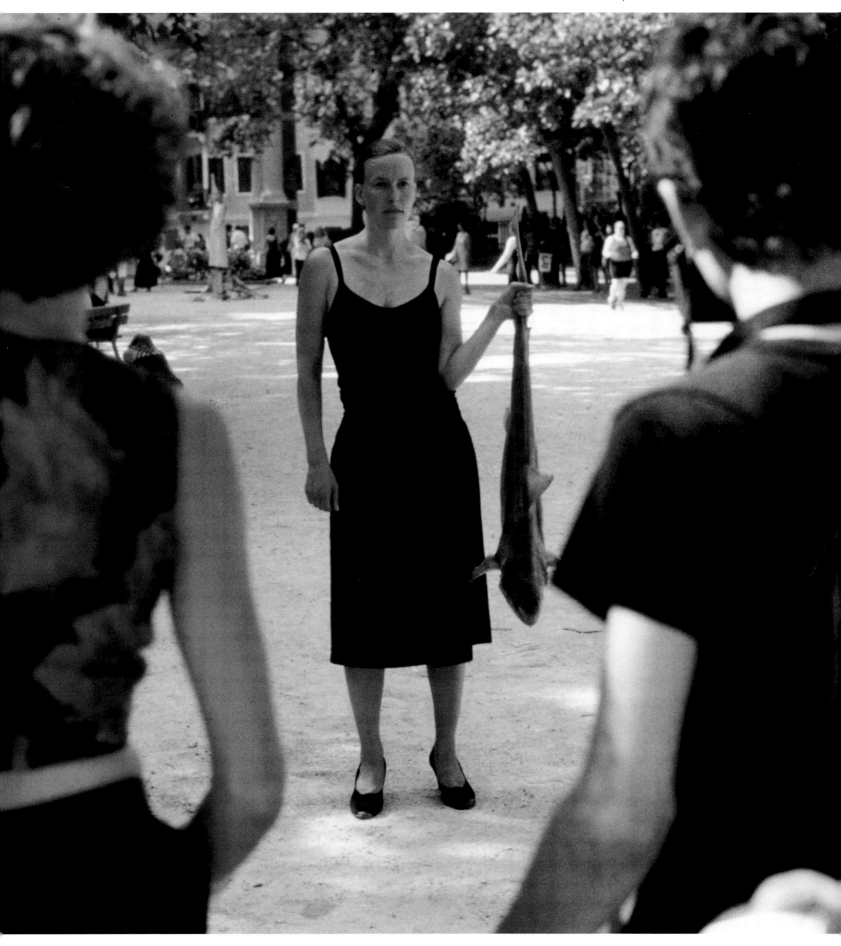




Antón Lopo

There is a place where edges and periphery turn into an axial point, occurring with logarithmic spirals. From this position, it is possible to describe the world without turning it into an object. The work is not as transcendent as the perturbations provoked by the creative process before and after this work exists. Creating is a shiver and its expansive waves shake the (emotional and physical) landscape beyond there, where that shiver can still be felt. The artist, as a seismographer, records turbulences and tensions, epicentres and aftershocks, so that the results of his work reflect the interdependency of matter, movement and time.

Three

We swam up the river and merged with the rust of its fountains,
With the tiny seaweed that are released by other seaweed into the turbulent waters
With the muddy embrace of the trees that, long ago, were trees and now are also part of the river.

She offered the vision of her bosom to the hermits.
He sometimes stops and waves his arms, like an awakening underwater faun.
I laugh.

Following the river up to the place where hundreds of dragonflies copulate looking at the sun,
On aquatic plants, so close to the solstice
That night never falls on that stretch of the river

when June arrives
And there is an explosion of chlorophyll and insects therein.
If you could spell the daisies,
They would always acquiesce.

The dragonflies bend their abdomen in pleasure
And the pleasure must be so intense that their contortions are impossible.

The frogs croak from one riverbank to the other,
Calling each other by the mellifluous name of frogs.
Butterflies fly into the sky
And let themselves plummet down.
There are crickets, water-striders skating their way up the river, flies we do not see but feel in the distance, like a beat box
There are birds making their nests on the alders while dotting the sky.
Two snakes caress us while swimming
And he sings
She shivers.

I plunge into the water
And lick them alternatively from their feet to their mouth.
I do not know if the saliva is mine or hers, the water or maybe him, who is sweating.
Neither do I know whose the tongue penetrating my mouth is,
Or who is asking if that is actually love,

Or who of the three replies,

"It is the river"

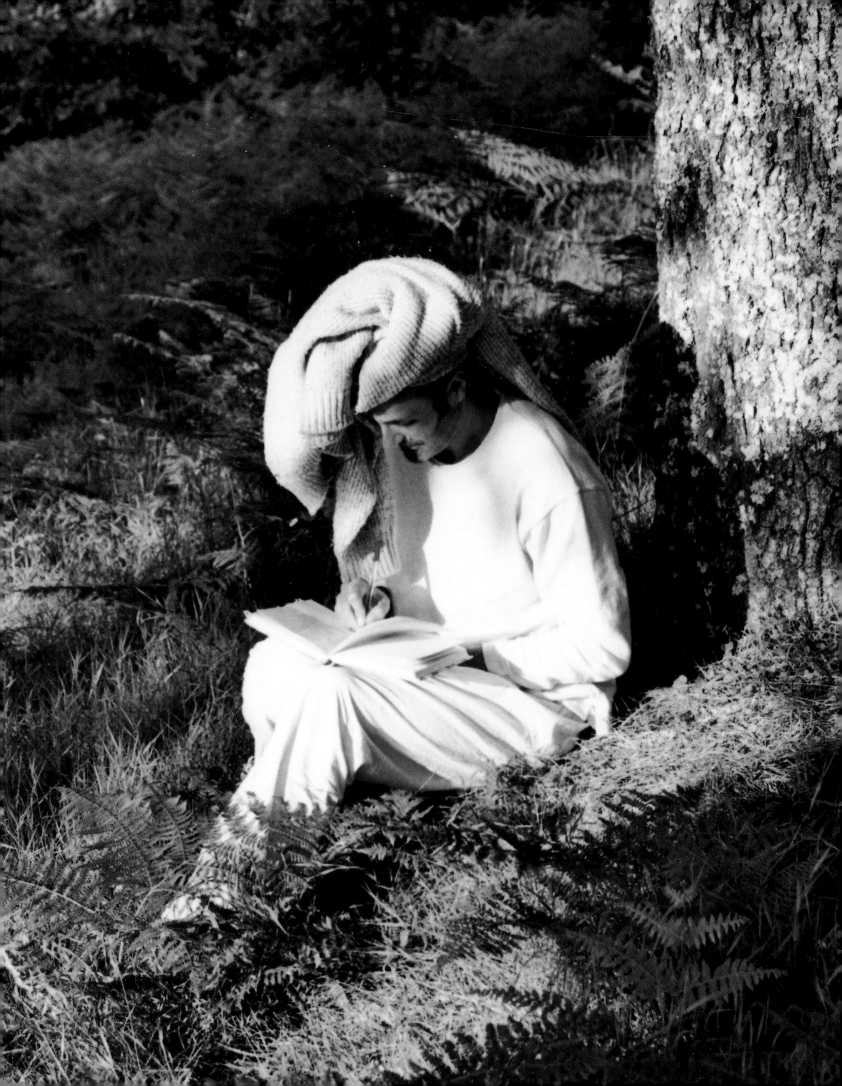

O instante infinito (The Infinite Instant), 2003
Duration: 1 min.
Performed by fifty people with cameras
Santiago de Compostela, Spain, 2003

Is it possible to build up a circular time and
therefore construct an infinite instant?

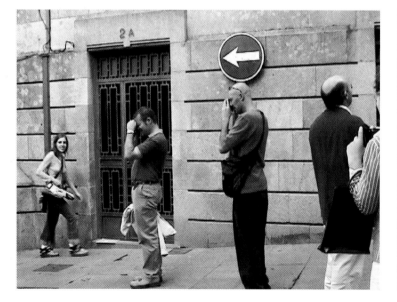
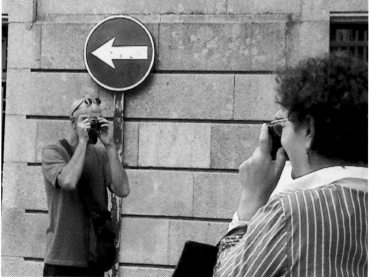

Hannes Malte Mahler

My work is about homes and houses, about territories and fences, about their proclamations and defence. I work with outer and inner places such as the one in front of and inside of the TV set. Then I switch channels. Focus on food. Landscapes. Drawing. Reading.[1] Computing. Music. Collecting too much. Throwing it all away again. Beginning. Organising. Merchandising. Drinking lots of coffee.

Painting a dog after two and a half years of not painting, acompanied by country and western and homoeopathic amounts of beer. (gebraut nach Deutschem Reinheitsgebot) / films.[2] Talking. Writing. Networking / Clustering. Formerly I performed all my activities alone. Now I like teams, support, help, tips.

My work is about life as a comic strip.[3] Complexity put in lines. The silver surfer never fails. He protects the world from Galactus. Black and white and colours in the empty fields. (A q u a rellieren)

Drawing one TV set next to the other, black screens, vibrating antennas, twenty on a sheet. (No. 49) Drawing a pavilion where T-shirts are sold with your own slogans to end the discussion. (Es ist ein weites Feld. Es gibt immer zwei Seiten. Über Geschmack läßt sich streiten.)

Drawing a digging pig, a jester with a cap, a car without wheels, the flying dutchman's suborbital routes, a plan for a sofa tower, a self-portrait with a red rubber nose, "a center in a table."[4] Inspirations – w o m e n, motorcycle riding, TV, newspapers, cultural studies and commenting on: – My work is about people's everyday life. The TV walls[5] to come. The spiritual homelessness to come. My work is (about) science fiction.[6] What might be an expression-of what might happen later-now? My work is about me being an artist – any question and any answer in the self-stylization and its medial representation. Printing a can cover, opened and closed, dissolved in dots. Black and bluish. Filming a meat cutter, rotating. Filming a rubber-spider, jumping up and down. Filming tomato juice being poured. Searching a sound of a frog choir concert in a swamp at dawn. Rebuilding the house (see above) because of uncontrolled cow invasion. Collecting ties for a new video work. Trying to find suitable speakers for the latest installation. Making up my mind about TV sets. Thinking about national anthems. Reflecting about canned beer. Importing wine from northern Italy and trying to stay at ease...

May the force be with you. Always.

1 Forsyth, Böhringer, Highsmith, Harris, R. Thomas, Frisch, Spillane.
2 Jack Arnold, Robert de Niro, Martin Scorsese, R. Scott, Bruce Willis, (Schießfilme vs. Sprechfilme).
3 Taking a bow – Don Lawrence, Hergé, Barks, Raymond, Franquin, Goscinny, Hal Foster, Edika.
4 Gertrude Stein – working directly with other people's art, things, work, ...
5 *Fahrenheit 451,* Ray Bradbury.
6 Tribute to Heinlein, John Brunner, Jack Vance, Philip K. Dick, AE van Vogt.

...ich weiß nicht... (...I don't know...), 2003

I am dressed in camouflage attire.
I brush the ground with a toothbrush.
I sing German folksongs such as:

"Es waren zwei Königskinder", "Lorelei", "Muss ich denn", "Hoch auf dem gelben Wagen", "Wenn die bunten Fahnen wehen", "Bolle reiste jüngst zu Pfingsten", "Heideröslein", "Wohlan", "Die Zeit ist kommen", usw.

1 minute, 1999
Collaboration with R. Gärtner
Video / performance
Duration: 1 min.

One minute
without
eating
drinking
doing drugs
or having sexual
intercourse.

Mopping Up Till the Floor Is Clean, 2000-2002
Performance / photography

I mop up the floor.

Firmitas IV, 2001
Uniform (grey, hand-made), rifle (carbine) 98
and German infantry arms since 1898 (Bj. 39)
with bayonet
Marking the Territory, Irish Museum of Modern
Art, Dublin, Ireland, 2001

Today, armed soldiers can be found in the
different trouble spots all over the world –
anywhere where strategic interests are at stake.

Firmitas IV turns the art space into an area of
strategic interest.
I wear a grey uniform.
I stand guard.
My guard position is frozen between an attitude
of aggression and one of defence.

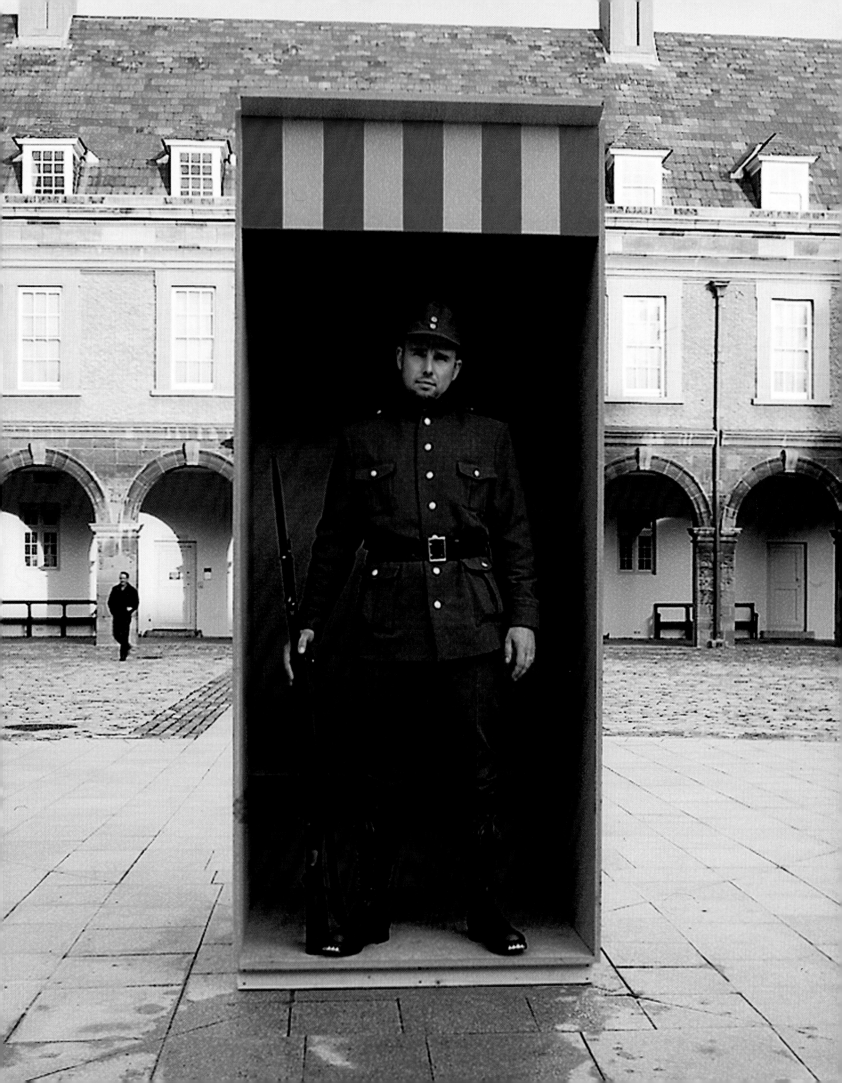

Monali Meher

A need to re-shape belongings and change the nature of substance, to have a dialogue between matter and memory, to create and animate, to give shape to memory and to evoke the past by enactment / performances; all of this constitutes the language of my work. It shows the hybridization of different cultural and social elements of a specific environment. My performances are atmospheric, ritualistic and show the cyclical circles of destruction and renewal. The formal and conceptual ideas within the framework of personal references inform the fragile divide between my life and art. The element of the past as a quantity of time is of significance. To record and replay time frames and juxtapose real time with mediated time is also a vital area of the work.

Miss Mask, 2001
Light box and computerized photo print
88 x 76,32 x 12 cm
Bollywood Has Arrived, P.T.A. (Passengers Terminal Amsterdam), Amsterdam, The Netherlands, 2001

This work shows the hybridization of different elements and very common, typically known things from both European surroundings and me in that situation from Indian background.

Specially in this photograph, Bollywood (the Indian Film Industry) as the main theme, I am playing different roles as the Bollywood actress: Glamorous, Integrated, Performative, Flamboyant, Confident and Nostalgic.

P.T.A. is a public space so I have treated this photograph as a poster of the film which is like an advertisement by fabricating into the light box.

There were five boxes altogether and this is one of them. These works were hanging on the same level, just outside the elevator. This space (P.T.A.) has a strong character and is very transparent, the work was very much site-specific.

coming soon.

miss mask

For the first time, playing different roles confidently!

Non-Repeating Loop, 2000
Performance / installation
Duration: 3 h.
Rijksakademie, Amsterdam, The Netherlands, 2000

Non-Repeating Loop was a three-hour performance. This loop or continuation of the movements of the human body in space was clearly not repetitious precisely because of the involvement of the human body.
I worked in this space for 15 days before the performance. There were 1,000 roses, which were drying and left the space filled with their organic smell. The sofa was suspended in the middle of the room and below the sofa was a plaster of Paris mould of my body, which I could not open. The negative and the positive moulds were stuck together. The rose petals were scattered all over the floor with white plaster of Paris powder.
As I was moving in the space and making drawings with my body, I became a part of the space as I had layers of petals and plaster powder on my body. Also the action of hammering the mould was like opening myself up. I was having a kind of dialogue with all these objects in the space. And to reach to these objects, I was stretching my body towards each of them in a specific manner as well as my voice without any words but a kind of sign language. The space had an acoustic quality. My intention was to use my voice, to reach every corner of the space, as it was not possible to do so using the body alone. This performance was atmospheric and had a theatre-like quality. All the things in the space were kept in an opposite order, like the hanging sofa or myself moving like a snake.
The smell of the drying roses was intense. And the time involved in this process was quite significant. I had to confront the situation in order to get adjusted to the new environment, which was created by myself and of which I had chosen to be a part.

Camouflage, 2001
Performance / video installation
The Nehru Centre, London, United Kingdom, 2001

My work is time-based and shows the hybridization of different cultural and social elements of the specific environment.

The Nehru Centre is a building that has its own character and history in the European context. It has a Victorian style architecture with classical interior furniture.

The performance addresses areas of the past and present by creating a fictional setting and persona within the context of the site.

By capturing the character of the space in my appearance, I have tried to become part of the space as much as possible. This extends to having a mask of certain facial expressions. The performance lasted for one hour.

The element of the past as a quantity of time is of significance. To be able to record and replay time frames and juxtapose real time with mediated time is a vital area of the work.

The link between the video in which my face is layered and un-layered by henna and the live performance of myself sitting on the sofa wearing a European costume with my hands dipped into the bowls of henna show the roots of my origin in spite of this new attire. The video alludes to an earlier time, recorded and re-played in the present.

The live performance was recorded and played for the duration of the exhibition, in the context of the recent past recorded and re-played. Each passing day added a dimension of the past to the work.

The two videos were playing on two monitors next to each other and the rest of the place had arranged furniture with henna bowls kept as it is for the rest of the show. The smell of henna was also a part of the atmosphere.

Marta Montes Canteli

Suffocation is like cigarette smoke, slowly enveloping me, caressing me behind the ears. In my utter despair I have warped the rope gripping my soul. I've felt it for some time, closing in on me like the petals of a giant flower. I cannot fill my lungs and I realise that I can barely breathe. I'm like Juliette Binoche emerging from the swimming-pool in *Blue*, or Nicole Kidman playing Virginia Woolf, sinking in an English river, her pockets filled with stones, The three of us are so pale that our faces could be the reflection of Death. This vision makes me laugh, in fact it makes me roar with laughter until I'm completely out of breath.

Panting, 2002
Duration: 1 h. 20 min.
Ladder, surgical tube, satin gown and wedding shoes
Cleaning the House, Centro Galego de Arte Contemporánea, Santiago de Compostela, Spain, 2002

Carrying a ladder I walk around in different exterior and interior CGAC spaces. I slowly climb up the ladder and choose a roof or wall section where I place a surgical tube, which I use to breathe heavily, with deep inspiration / expiration. Saliva droplets joyfully dance along the tube, while breathing gets gradually harder.

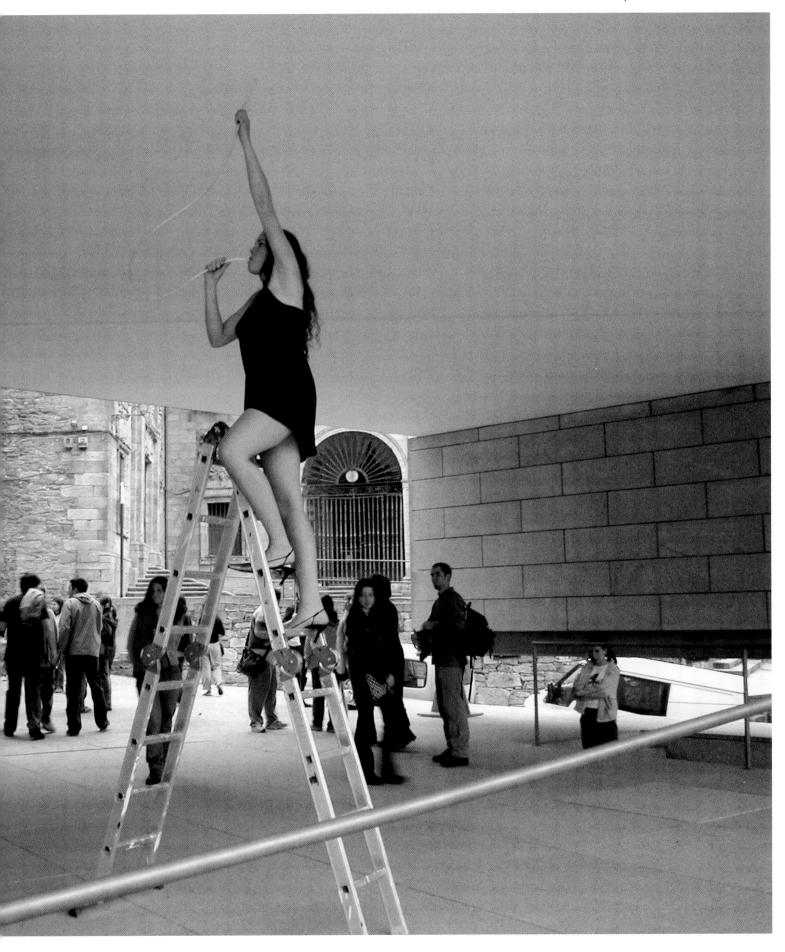

Mutual Choking, 2002
Duration: 20 min.
Surgical gloves and tube
Granada, Spain, 2002

Part 1
I introduce an inflated surgical glove in one of
my colleagues' mouth, preventing both of us
from breathing during 1 minute periods with
intermittent 30 second breaks.

Part 2
I introduce a surgical tube in one of my
colleagues' mouth through which we both expel
air simultaneously during 1 minute periods with
intermittent 30 second breaks.

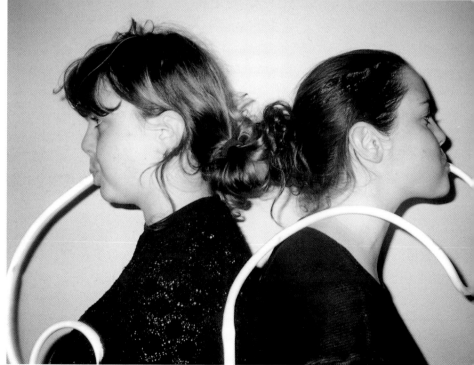

Patient Smile, 2003
Duration: 13 min.
Syringe, egg and coal dust
Granada, Spain, 2003

I stab a syringe into my gum and teeth until the viscous liquid pours out of my mouth.

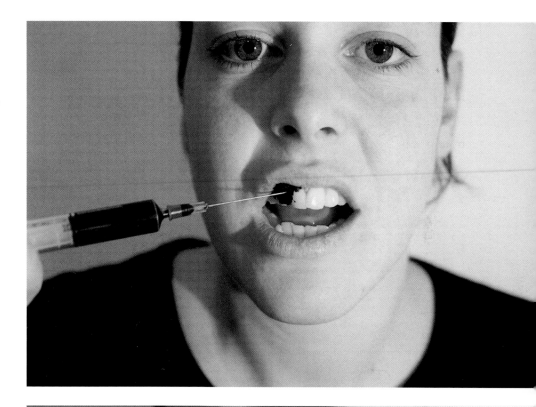

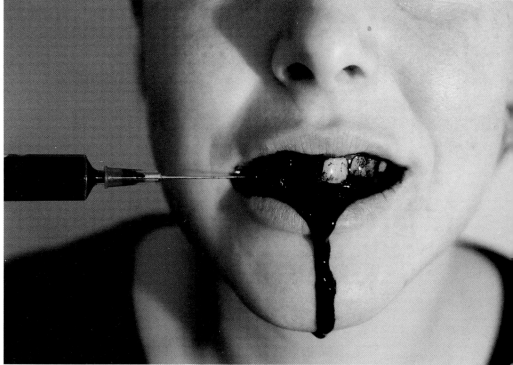

Frau Müller

I don't like either-ors.
So I'm doing my best to ignore the gaps between philosophical theory and earthly reality.
Suddenly spirituality and humor happen;
a kind of momentary zero-point.

Immaterial Cleaning, 1997
A new technology and its practical application
Performance and object
Dortmund, Germany, 1997

While cleaning the former office of the works manager Mr. Böker and the temporary offices of the Iron News Centre Mrs. Müller works swiftly and cautiously. This is the place where important telephone calls are made and documents are typed. The secretary concentrates on her work and barely notices Mrs. Müller. She doesn't want to disturb anyone. In any case, she has plenty to do herself and bears a lot more responsibility than you might at first assume.

Whilst the problem of material waste has long captured public awareness, the problem of immaterial data waste is still languishing in the wings. With the increase in television programmes and the spread of the Internet, the need to develop selection procedures for the

"Entstäubungspumpe",
a vacuum cleaner from
1906

immaterial areas of life is moving slowly but surely into the public arena. Beyond the information that has been recorded, arranged and many times processed, there is also, mostly unconsidered, an enormous quantity of historical hangovers. Swept into the depths of molecular structures, even the most minute facts survive any human life. This almost unbearable increase is a result not only of our cultural growth but is above all characteristic of temporal shifts and has quite its own justification. But in granting all information, even the most long forgotten, a right to exist, it does underestimate the effects of the disturbance fields, which become aware to us only diffusely as atmosphere. This is especially true when approaching the turn of the next millennium, there is an urgent requirement for action. This is what Mrs. Müller takes care of. After the removal of the rough – and fine – substantial contaminations, she turns her hand to the non-substantial deposits. The cleaning process requires patience and care. Nobody could predict what might happen to the data that is missed or have only been partially dragged away by an over-hasty move of the data vacuum cleaner. It is a responsible task. Of that she is well aware.

Already for some time now, the newly developed cleaning technology has been successfully applied in the fields of art history and criminological research. With its help, it is possible to read from the molecular structures of paintings the sounds that were heard while the painting was created. Just as possible is the foolproof detection of traces of blood that date back six hundred years. Encouraged by these successes, the new digital data vacuum cleaner is brought into service for the extensive redevelopment of inherited waste in the home and working environment. Now the floors at Am Remberg 6 in Dortmund-Hörde are to be most thoroughly cleaned to their deepest depths for the very first time. Wiping, polishing, sucking in, converting, printing out and eliminating: that would do Mrs. Müller's flat good one day too.

After a certain training period, the handling of the machine turned out to be quite uncomplicated. After suction, the data is converted into the hexadecimal system for data protection purposes. Mr. Böker doesn't need to worry. At the beginning, the caretaker would

Rough-substancial, fine-substancial
and now also immaterial!

Simply move the sucction-head over the area that should be cleaned and immediately the entire immaterial deposits are thoroughly, from the deepest depths of molecular structures, sucked out, coded, printed out and obliterated.

immaterial cleaning

Comfortable and reliable, nearly fully automatic!
Order today from: Frau Müller, Eisenbütteler Str.13, 38122 Braunschweig

Waste bags filled with data Eiserne Nachrichtenzentrale Dortmund, 1997

lean over the printer once in a while out of curiosity, in the hope that maybe a titbit of a scandal story might emerge. Eventually she gave that up. She just comes when technical problems appear. Mrs. Müller prefers it that way too. She doesn't approve of voyeuristic interests in the private stories of foreign persons. Yet there is another far more important reason for encoding the data and for completely refraining from its analysis: Even if information is only mentally reproduced, it triggers synaptic avalanches in the neuronal network, and gives rise to uncontrollable multiplications – and the data can be deposited in untraceable recesses and thus is evaded from being disposed.

The conversion of the recorded data into the hexadecimal system and in particular the printing out of this data that has to be proved, is up to now still a somewhat lengthy procedure. While the printer deposits the data into a dustbin bag, Mrs. Müller has time for a cup of coffee. This time of waiting is accompanied by the sound of the local radio station. She is particularly pleased when she hears Engelbert being played. Only the constant clatter of the printer disturbs her peace, although that at least is considerably better than the deafening noise of the vacuum cleaner. Then she can't even hear her own voice. Not to mention anyone else's. Only during the removal of the finest specks,

after the rough-substantial and before the non-substantial cleaning, a pleasant peace prevails. That's if the secretary doesn't in this moment, in a quite audible way, multiply and spread data with her typewriter or tape recorder. This will just create more pollutants, which have to be disposed of. It's in the nature of things. After all, the secretary is also only doing her job.

Soon, Mrs. Müller has heard, there will be a machine which can perform all three cleaning steps including conversion and printing, fully automatically. That would be quite convenient and practical. Though she would really miss the fine-substantial dusting, that careful polishing of the surfaces until they gleam and the precise look with an eagle eye that doesn't miss a thing (she only uses dusters with micro pores). Yet, as with all such refined technical innovations, one thing will only be able to change, when Einstein's theorem, $e=mc^2$ and with it the assumption of unavoidable mutual attachment and convertibility of energy and matter is proved wrong (Heinz Bogeslawski from Hamburg has been doing quite promising work in this field for some years now). As for thousands of years there is only one really reliable method for the definitive disposal or transformation into nothingness. It is fire. This is also known to Mrs. Müller. In spite of miserable weather, she personally takes the filled data bags the 32 km to the waste incineration plant of the city Hagen.

At least, as she occasionally says to herself, she has a job with future.

```
7D F7 DF 7D F7 DF 7D F7 DF 7D F7 DF 7D F7 DF 7D F7 DF 7D F7 DF 7D F7 DF 7D F7
DF 7D F7 DF 7D F7 DF 7D F7 DF 7D F7 DF 7D F7 DF 7D F7 DF 7D F7 DF 7D 00 00 7E
DF 7D F7 DF 7D F7 DF 7D F7 DF 7D F7 DF 7D F7 DF 7D F7 DF 7D F7 DF 7D F7 DF 7D
F7 DF 7D F7 DF 7D F7 DF 7D F7 DF 7D F7 DF 7D F7 DF 7D F7 DF 7D F7 DF 7D F7 DF
7D F7 DF 7D F7 DF 7D F7 DF 7D F7 DF 7D F7 DF 7D F7 DF 7D F7 DF 7D F7 DF 7D F7
DF 7D F7 DF 7D F7 DF 7D F7 DF 7D F7 DF 7D F7 DF 7D F7 DF 7D F7 DF 7D F7 DF 7D
F7 DF 7D F7 DF 7D F7 DF 7D F7 DF 7D FF DF 7D F7 DF 7D F7 DF 7D F7 DF 50 7D F7
DF 7D F7 DF 7D F7 DF 7D F7 DF FD F7 DF 7D F7 DF 7D F7 DF 7D F7 DF 7D F7 DF 7D
F7 DF 7D F7 DF 7D F7 DF 7D F7 DF 7F FF DF 7D F7 DF 7D F7 DF 7D F7 DF 7D F7 DF
7D FF DF 7D F7 DF 7D F7 DF 7D F7 DF 7D F7 DF 7D F7 DF 7D F7 DF 7D F7 DF 7D 00
00 EB FF 00 FD C4 FF 00 DF FA FF 00 F7 9E FF 00 DF F4 FF 01 00 00 BF FF 01 FE
7F F1 FF 00 DF 88 FF 01 00 00 BF FF 01 FC 1F F1 FF 01 FE 7F 89 FF 01 00 00 F5
FF 00 DF F8 FF 07 FD F7 FF FD F7 FF FF F7 FD FF 00 FD FD FF 00 DF F0 FF 00 DF
F9 FF 01 FE 3D F2 FF 02 F7 FF 7F F1 FF 00 DF E6 FF 00 7F F4 FF 00 DF DD FF 00
7F E9 FF 01 00 00 7E DF 7D F7 DF 7D F7 DF 7D F7 DF 7D F7 DF 7D F7 DF 7D F7 DF
7D F7 DF 7D F7 DF 7D F7 DF 7D F7 DF 7D F7 DF 7D F7 DF 7D F7 DF 7D F7 DF 7D F7
DF 7D F7 DF 7D F7 DF 7D F7 DF 7D F7 DF 7D F7 DF 7D F7 DF 7D F7 DF 7D F7 DF 7D
F7 DF 7D F7 DF 7D F7 DF 7D F7 DF 7D F7 DF 7D F7 DF 7D F7 DF 7D F7 DF 7D F7 DF
7D F7 DF 7D F7 DF 7D F7 DF 7D F7 DF 7D F7 DF 7D F7 DF 7D F7 DF 7D F7 DF 7D F7
DF 7D F7 DF 50 7D F7 DF 7D F7 DF 7D F7 DF 7D F7 DF 7D F7 DF 7D F7 DF 7D F7 DF
7D F7 DF 7D F7 DF 7D F7 DF 7D F7 DF 7D F7 DF 7D F7 DF 7D F7 DF 7D F7 DF 7D F7
DF 7D F7 DF 7D F7 DF 7D F7 DF 7D F7 DF 7D F7 DF 7D F7 DF 7D F7 DF 7D F7 DF 7D
F7 DF 7D F7 DF 7D 00 00 7E DF 7D F7 DF 7D F7 DF 7D F7 DF 7D F7 DF 7D F7 DF 7D
F7 DF 7D F7 DF 7D F7 DF 7D F7 DF 7D F7 DF 7D F7 DF 7D F7 DF 7D F7 DF 7D F7 DF
7D F7 DF 7D F7 DF 7D F7 DF 7D F7 DF 7D F7 DF 7D F7 DF 7D F7 DF 7D F7 DF 7D F7
DF 7D F7 DF 7D F7 FF 7D F7 DF 7D F7 DF 7D F7 DF 7D FF DF 7D F7 DF 7D F7 DF 7D
F7 DF 7D F7 DF 7D F7 DF 7D F7 DF 7D F7 DF 7D F7 DF 7D F7 DF 7D F7 DF 7D F7 DF
7D F7 DF 7D F7 DF 50 7D F7 DF 7D F7 DF 7D F7 DF 7D F7 DF 7D F7 DF 7D F7 DF 7D
F7 DF FD F7 DF 7D F7 DF 7D F7 DF 7D F7 DF 7D F7 DF 7D F7 DF 7D F7 DF 7D F7 DF
7D F7 DF 7D F7 DF 7D F7 DF 7D F7 DF 7D F7 DF 7D F7 DF 7D F7 DF 7D F7 DF 7D F7
DF 7D F7 DF 7D F7 DF 7D 00 00 FE FF 00 DF F5 FF 00 7F DA FF 00 F7 AC FF 00 7F
C2 FF 01 00 00 81 FF B3 FF 01 00 00 81 FF B3 FF 01 00 00 03 DF FF FF DF FB FF
00 FD FE FF 03 F7 DF 7D F7 F7 FF 09 7D F7 DF 7F FF DF FF FF DF 7F FA FF 04 DF
FF FF DF 7F F1 FF 02 DF 7F F7 ED FF 01 F7 DF FE FF 03 7F FF DF FD F1 FF 00 DF
F9 FF 00 DF FA FF 02 F7 FF 7D ED FF 00 7F E6 FF 00 F7 F4 FF 00 FD F9 FF 02 FD
00 00 7E DF 7D F7 DF 7D F7 DF 7D F7 DF 7D F7 DF 7D F7 DF 7D F7 DF 7D F7 DF 7D
F7 DF 7D F7 DF 7D F7 DF 7D F7 DF 7D F7 DF 7D F7 DF 7D F7 DF 7D F7 DF 7D F7 DF
7D F7 DF 7D F7 DF 7D F7 DF 7D F7 DF 7D F7 DF 7D F7 DF 7D F7 DF 7D F7 DF 7D F7
DF 7D F7 DF 7D F7 DF 7D F7 DF 7D F7 DF 7D F7 DF 7D F7 DF 7D F7 DF 7D F7 DF 7D
F7 DF 7D F7 DF 7D F7 DF 7D F7 DF 7D F7 DF 7D F7 DF 7D F7 DF 7D F7 DF 7D F7 DF
50 7D F7 DF 7D F7 DF 7D F7 DF 7D F7 DF 7D F7 DF 7D F7 DF 7D F7 DF 7D F7 DF 7D
F7 DF 7D F7 DF 7D F7 DF 7D F7 DF 7D F7 DF 7D F7 DF 7D F7 DF 7D F7 DF 7D F7 DF
7D F7 DF 7D F7 DF 7D F7 DF 7D F7 DF 7D F7 DF 7D F7 DF 7D F7 DF 7D F7 DF 7D F7
DF 7D 00 00 7E DF 7D F7 DF 7D F7 DF 7D F7 DF 7D F7 DF 7D F7 DF 7D F7 DF 7D F7
DF 7D F7 DF 7D F7 DF 7D F7 DF 7D F7 DF 7D F7 DF 7D F7 DF 7D F7 DF 7D F7 DF 7D
F7 DF 7D F7 DF 7D F7 DF 7D F7 DF 7D F7 DF 7D F7 DF 7D F7 DF 7D F7 DF 7D F7 DF
7D F7 DF 7D F7 DF 7D F7 DF 7D F7 DF 7D F7 DF 7D F7 DF 7D F7 DF 7D F7 DF 7D F7
DF 7D F7 DF 7D F7 DF 7D F7 DF 7D F7 DF 7D F7 DF 7D F7 DF 7D F7 DF 7D F7 DF 7D
F7 DF 50 7D F7 DF 7D F7 DF 7D F7 DF 7D FF DF 7D F7 DF 7D F7 DF 7D F7 DF 7D F7
DF 7D F7 DF 7D F7 DF 7D F7 DF 7D F7 DF 7D F7 DF 7D F7 DF 7D F7 DF 7D F7 DF 7D
F7 DF 7F F7 DF 7D F7 DF 7D F7 DF FF FF F7 DF 7D F7 DF 7D F7 DF 7D F7 DF 7D F7 DF
7D F7 DF 7D 00 00 F8 FF 00 DF C7 FF 00 F7 81 FF F8 FF 01 00 00 81 FF B3 FF 01
00 00 81 FF B3 FF 01 00 00 04 FF 7F FF FF FD F9 FF 00 7F FC FF 06 FD FF FF 7F
FF DF 7F FC FF 00 7F FE FF 06 F7 FF FD F7 FF FF F7 F9 FF 00 F7 FD FF 00 FD F3
FF 00 FD F9 FF 00 FD FC FF 03 7D FF DF 7F F4 FF 02 DF FF F7 F3 FF 02 DF FF F7
```

Spaces Between, 1997
A slide show about empty spaces
80 slides
Duration: 12 min., endlessly looped

From a purely intellectual point of view, Frau Müller's flat is spick and span. In whichever direction she thinks, all superfluous and restrictive memories and associations are cleared away. A brand new feeling of being extends. "Everything will be different now," she thinks with relief. Yet the very attempt to use this freedom freely has forced Frau Müller to realise that she herself is (still) by no means exclusively intellectually existing. She is pretty sure of this because there is sometimes a slight ache in her back. The relationship between mind and matter had always been a puzzle for Frau Müller. They somehow seem to be connected and yet they are two different things. Intellectually you can go both into and through things. At the material level, however, this presents certain difficulties. Wouldn't it be nice to find a place where there was room for both at the same time?

Frau Müller reflects on this. This sought-after place would have to fulfil two conditions. Firstly, it must already have been cleaned immaterially. She has already taken care of that. Secondly, there must be nothing there. The place she seeks can therefore logically be found exclusively between things. So Frau Müller wants to check how it looks there and how much of it can be found in her flat. Equipped with a metre-stick, she begins her search and establishes the following: 0.4 - 2.8 - 5.5 - 5.8.

Gauge Zero since 1884, 2000
A map of the geographical gauge zero of the
Planet Earth on a scale of 1:300,000

In the face of the new millennium, Frau Müller is
not so much concerned with exactly when and
how things will change, as with how people will
be able to deal with these far-reaching changes,
about which nobody can be quite certain. How,
with which attitude, could we confront those
changes and make them possibly even fruitful for
our personal growth? What is it that helps us in
times of confusing and radical change, to pursue
the orientation and clarity necessary in order
not to lose our direction? Where is the clear
line? And where is the goal?

Frau Müller ponders intensely over this at
10°31'18.176' 'East, 52°14'59.338" North and
72.527 metres above sea level. She is not yet
content to simply sit around in the grid.

It occurred to her that where there is a number
there must be a zero. Old Buddhist rule. Where
there is something, there must also be nothing
because everything came out of this pre-creative
nothing. Only there is everything: origin,
eternity, universe. In any case, Frau Müller had
always wanted to go there.

With the help of her old school atlas, she
discovered that our global "nothing" is located
about 350 nautical miles south of Ghana in the
middle of the Atlantic Ocean. The global centre
is located in the middle of the infinite expanse of
the sea. Water and nothing but water as far as
the eye can see. And yet quite very central –
considered as zero.

Now Frau Müller is on her way to gauge zero. In
order not to miss it, she has a precise map of the
region for guidance in her luggage.

Daniel Müller-Friedrichsen

My work is a compact structure about my personal marking of a space or time in which I unpack myself, my own feelings, ideologies and prejudices, transforming them into a movement or image, to create a charismatic field. I mark a space through adding something and analysing its function. Everything could be a part of my work, responding to an entirely different set of influences: my environment, personal experience and historical positions, so that the work is a by-product of living. Strategies of actions and rules of language are proved by their motivation. I use language in a way like chewing gum with various possibilities and different meanings, which also includes an irrational potency and openness. It is about the difference between image and text and using words in a sculptural way.

The Answer, 2001
Performance / installation
Duration: 20 min.
Speakers desk, sound system, a small amount of unopened books titled: *The Answer, Scientific Romances, Two Glasses and a Bottle of Water*

Like a presentation of an author at a book fair, the work deals with the prospect of a speech. Instead of talking, the action involves pouring water from one glass to the other.
I present the sound and the various qualities of water with a meditative effect.

Starless Tour, 2000
Duration: 7 min.
Luna Park, Halle für Kunst Lüneburg, Germany,
2000
Expo 2000, Hanover, Germany, 2000
Marking the Territory, Irish Museum of Modern
Art, Dublin, Ireland, 2001

Appearing as if a star, I arrive in a limousine with
bodyguards and disappear into an entrance. I
throw gimmicks to the public, taking pictures
with a Polaroid camera and signing them while
the images are still developing. The piece calls
for public interaction in creating a charismatic
space. The work is intent on demonstrating that
there is no distinction between the sacrosanct
gallery space and the everyday contingency "out
there." The performance *Starless Tour* deals
with the language of mass-media and acts as a
study of mass hysteria and group dynamics.

Dublin, 2001, video still: Ivan Čivić

Righting, 2000
Visible Differences, Hebbel Theater, Berlin, Germany, 2000

The performance *Righting* is derived from a pun on the English words "writing" and "righting" – the concept of writing, and the related question as to whether what is "written" can really be written "right." The person who is described or "written about" and the body are the media and bearers of information. And yet the bearer does not always know what information (s)he actually carries or bears.

Righting involves interactive moments. It shows the human body as a carrier and bearer of information and poses the question of the nature and correctness of this information. It is a play on the confusion concerning the words "write" and "right."

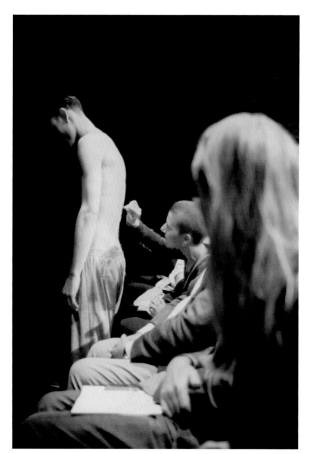

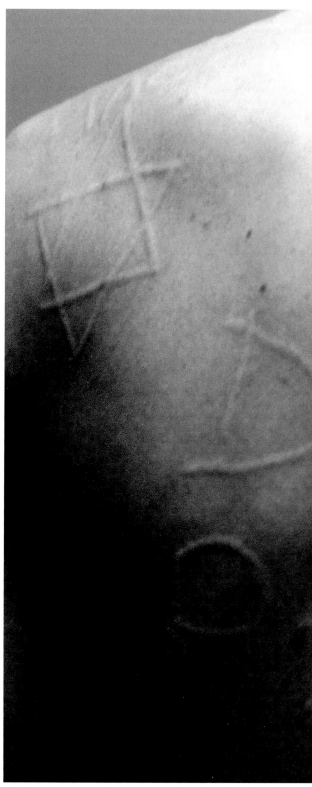

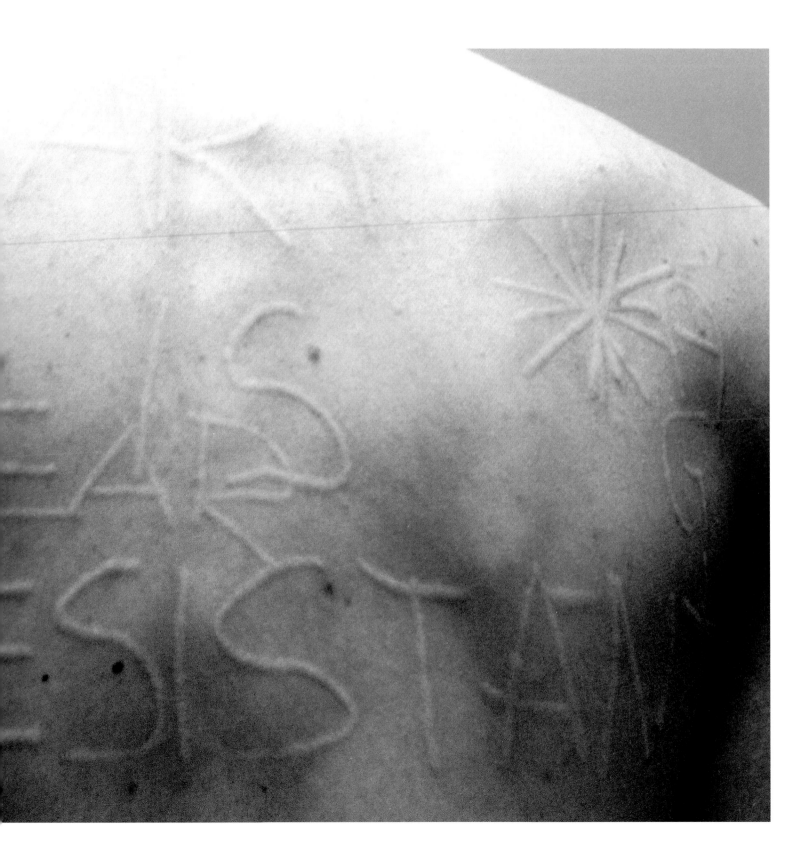

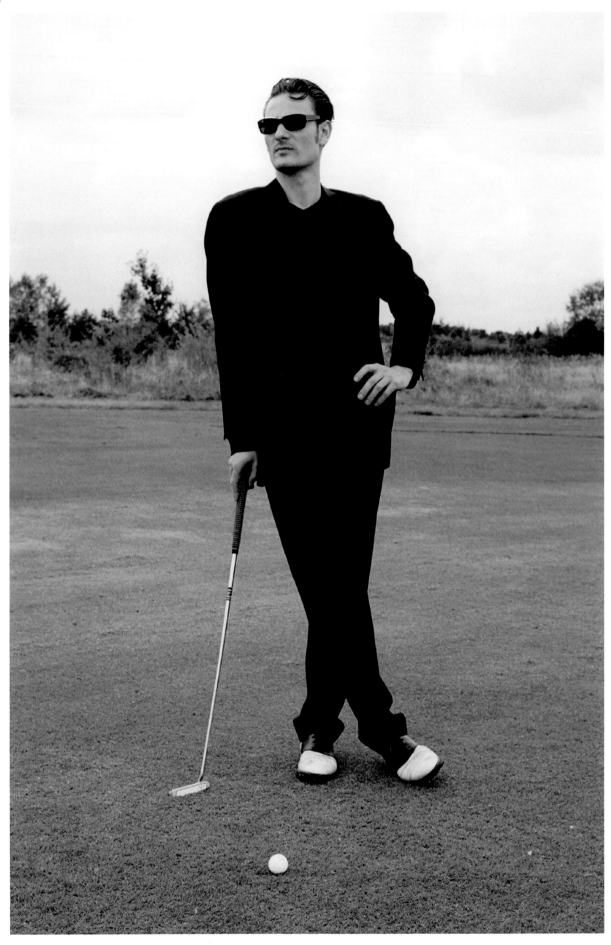

Starless Pin-Ups / At the Club, 2002
Photograph

Texas Tie, 2002
Performance / installation
Duration: 1 h. 30 min.
Rocking chair and gallows rope
Cleaning the House, Centro Galego de Arte
Contemporánea, Santiago de Compostela,
Spain, 2002

I'm sitting in a rocking chair disentangling
and knotting a gallows rope.

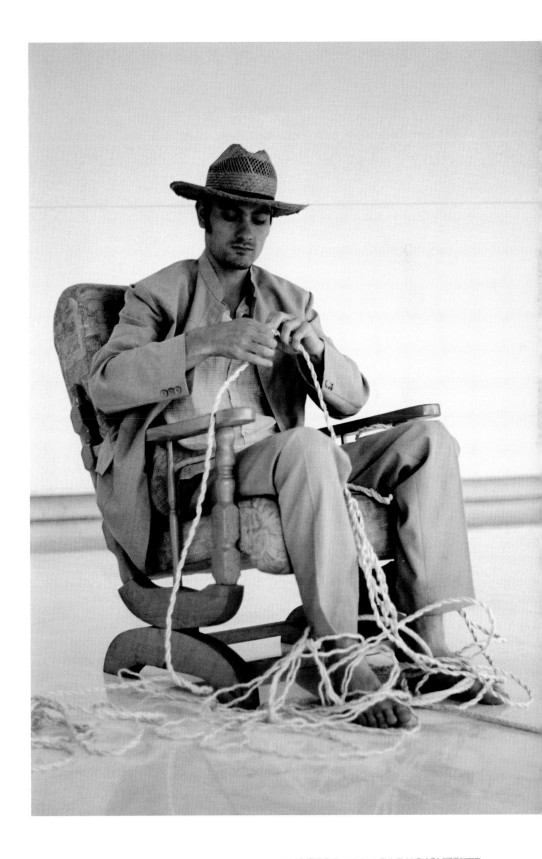

Llúcia Mundet Pallí

I am not a performance artist and I must confess that if I am included in this book it is only by chance.

Currently I try to offer "the reconstruction of people's own experiences." Since reflecting on identity has always been central to my work, the experiences are processed individually and each one is shown as an autonomous form, free from the experiences' original subject.

Unter Meninas: An Artist Portrait, 1998
Slide and video installation
Meisterhüler Austellung, Hochschule für Bildende Künste, Braunschweig, Germany, 1998

Professors
Marina Abramović
Dörte Eißfeld
Birgit Hein
Mara Mattuschka

Students
Sarah Braun
Llúcia Mundet Pallí
Frank Werner

Child
X Caluza

Dog
Joska

Director	Llúcia Mundet Pallí
Director's assistant	Maite X
Camera operator	Maurice Korbel
Sound technician	Christian Petersen
Light technician	Frank Werner
Make up	X Caluza
Dress helper 1	Julie Jafrennou
Dress helper 2	Constanze Westhofen
Dog trainer	Ralf X

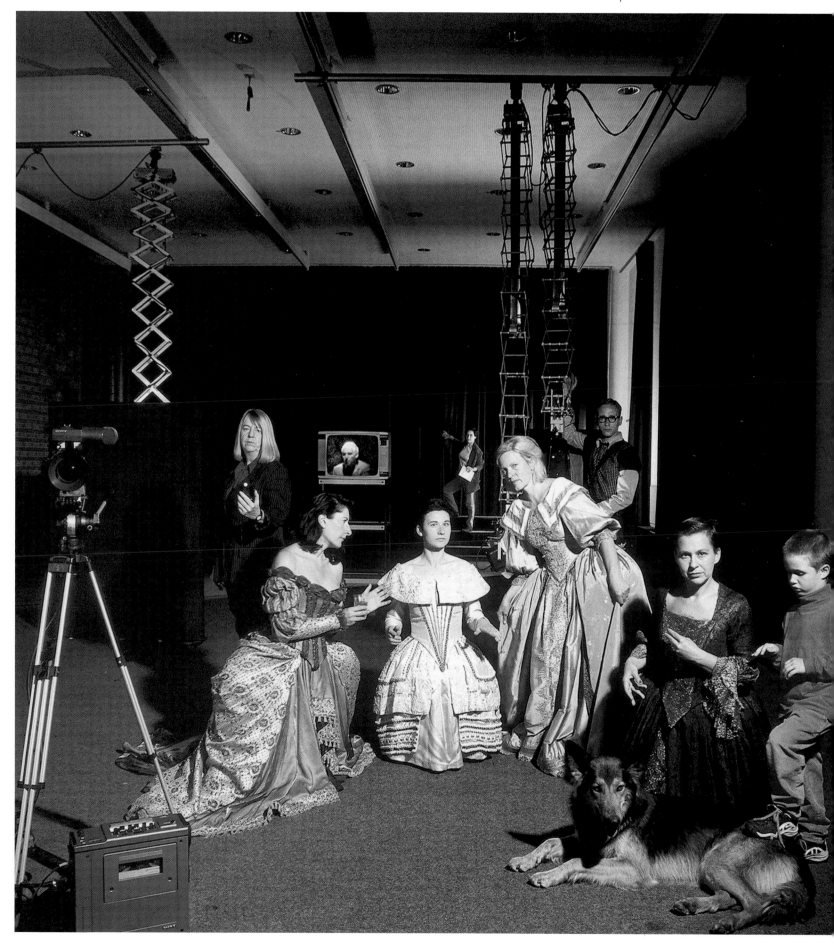

Still Alive, 1998
My 70's, Hochschule für Bildende Künste,
Braunschweig, Germany, 1998

Within the framework of the commemoration of
the 70s as experienced by different artists /
teachers at Hochschule für Bildende Künste in
Braunschweig, on the 13th of February 1998
Marina Abramović's 70s was celebrated.
Marina, the pupils in her class and her teacher
Michael Glasmeier organised a joint act of
simultaneous performances.

Above all I would like to state that I am not a
performance artist, and that the event of the
13th of February 1998, to which I subsequently
refer to as *Still Alive,* should not be considered
a performance. For personal reasons I took
advantage of the occasion – in view of the fact
that it provided me with favourable
circumstances – to celebrate a personal rite.
I regret the risk other people were unwillingly
involved on a professional level.

La Bilirrubina, 1997
Video-clip
Duration: 2 min. 14 sec.

With a seductive salsa-rhythm a love song by
Juan Luis Guerra describes the connections
between lover's grief and physical illnesses.

Absurdly extending the painful aspect of love,
leading to a dance of destruction: seduction until
death.

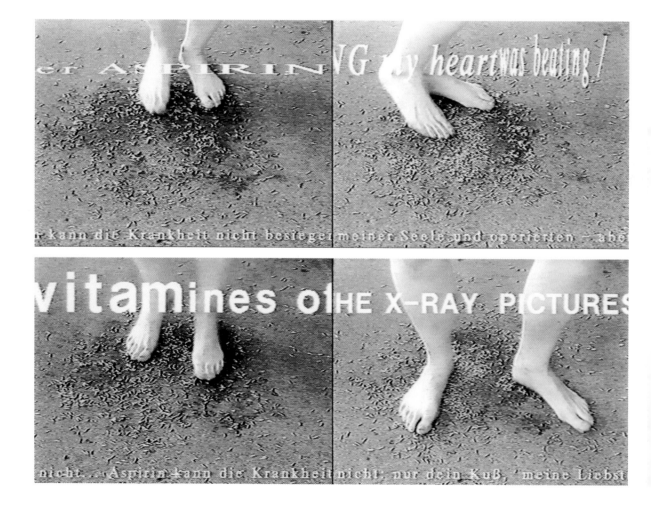

Self-Portrait, 1998
Video, stereo sound
Duration: 11 min. 30 sec., looped
Schlaglicht, Kunstmuseum Wolfsburg,
Germany, 1999

Patient and caretaker, videotape and nurse
Lucie, piece and author, smile and work,
sickness and catharsis, hand in hand coming out
of the operating room, continuing through the
hallways of Neurology centers 1 and 3 of
Salzdahlumer Straße hospital in Braunschweig.

In the following pages:
The Head, 1998
Video, silent
Duration: 56 sec., looped
Kunstpreis Landeskreis Gifhorn, Schloß,

Gifhorn, Germany, 1998
1st Biennal Niedersachsen, Kunstverein
Hannover, Hanover, Germany, 1999

Talking heads are familiar to us from television
and news programmes. In this case, contrary to
what is usual, the head lies still without opening
its mouth.

A smile is extending in slow motion, hardly
perceptible, playing forwards and backwards.
The eyes are motionless with a fixed look.

The head seems to be separated from the body;
it is represented as an autonomous sculptural
volume. It reminds us on the one hand of a skull,
and on the other of the permanent smile of the
Mona Lisa, which has as hypnotising an effect as
the face on the pillow.

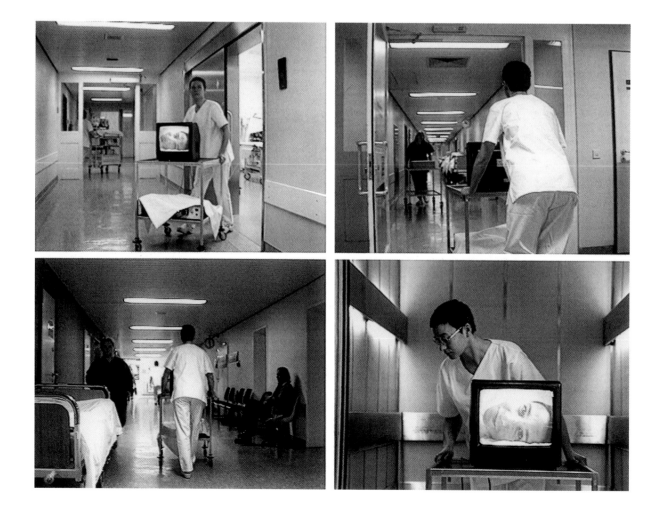

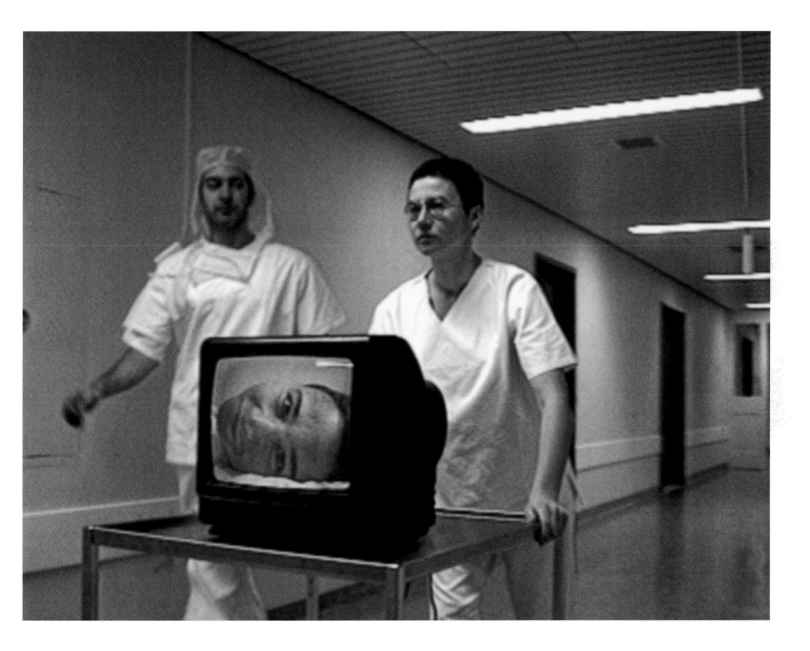

Hayley Newman

Since 1994 my practice has been a series of investigations into the nature of performance, its modality and methods in relation to the dominant historical context of 1970's Performance Art. More recently interest has been focused on performance and its representation as seen in the two photographic works; *Connotations – Performance Images 1994-1998* (1998) and *Connotations II* (2002). Comprising constructed images, these works intended to explore the role of documentation in performance. My current work has also included re-animating events in newspapers, presenting them as performances within the controlled environment of the gallery space and latterly investigating the nature of an "event" through the analysis of its own inherent performative qualities.

Tour, 1995
Hoschule für Bildende Künste, Hamburg, Germany, 1995
Rote Flora, Hamburg, Germany, 1995
The British Ambience, Podewill, Berlin, Germany, 1996

A portable performance made to be performed as many times as possible. In the performance I wear a microphone strapped around my waist with Cellotape, which I play with a plectrum like an air guitar. Each performance lasted the length of a track playing back on a CD player.

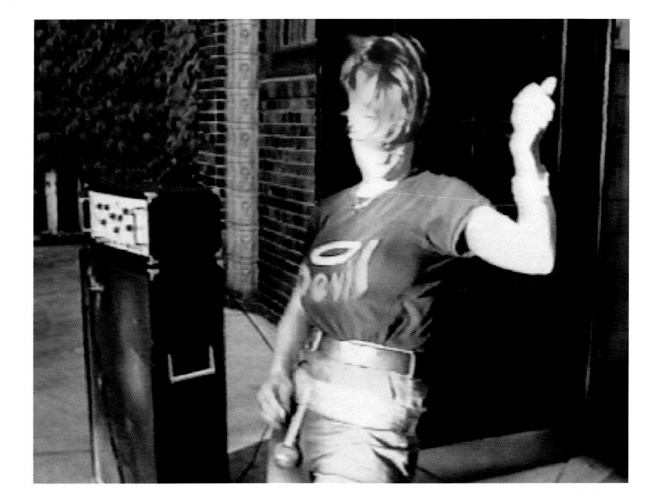

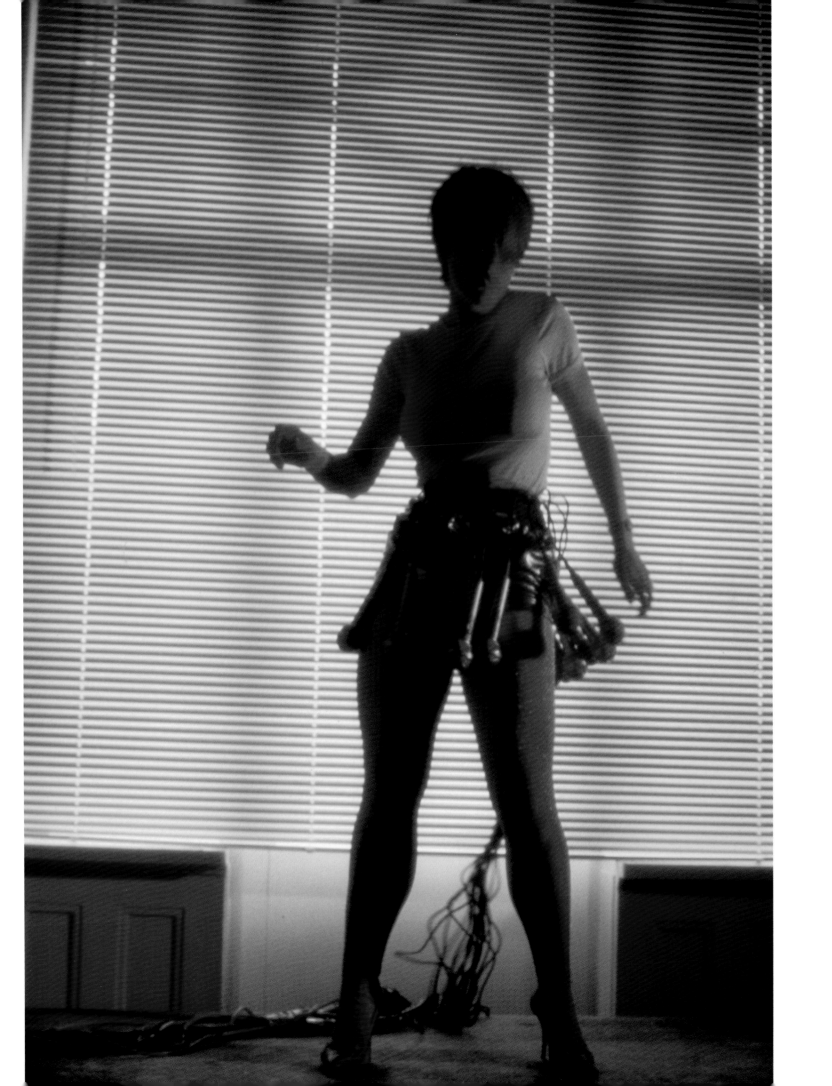

In the preceding page:
Microphone Skirt, 1995
I'm Pure, Osterwalder's Art Office, Hamburg,
Germany, 1995
The Tingle Factor, Hoog Huis, Arnhem,
The Netherlands, 1995
The Savage Club, Manchester, United Kingdom,
1996
The British Ambience, Tresor, Berlin, Germany, 1996
Rude Mechanic, Beaconsfield, London,
United Kingdom, 1996
Visionfest, The V-Club, Liverpool,
United Kingdom, 1996
Nacht-Schrange, Spiel Art '97, Munich, Germany,
1997

Erotic go-go dancing in a skirt made from 20 hi-
ball mikes. As I moved, the microphones hung
around my waist, jostled and knocked against each
other, tracing my physical movements with sound.

Kalte Schulter, 1995
Bild Me, Bild You, Gallerie KM25, Hamburg,
Germany, 1995

Delivered to the gallery wrapped in cellophane
and dressed as a polar bear, I carry a lollipop
with the message "Love Me" written on it. Once
unwrapped, I have my photo taken with people
before turning sexually aggressive towards them.

Ana Pol

My artistic work focuses on the idea of the ephemeral (disappearance / transformation). I am interested in the minimum changes produced daily in the realm of the commonplace, the small imperceptible "infra-slight" transformations that condition our personal construction. Chance is to be found in this terrain of minimums, in the minimum erosion that constructs / destructs our history.

I like voluble materials that suffer transformations. I try to map out a story of change. I work with perishable materials: food, fat, blood, etc. or those stemming from the sphere of the commonplace – sheets, tablecloths, clothes, etc.

The vanitas appeared as documents of the fleetingness of time, they are the vertigo sensed before the destruction of memory. What I am truly attracted to is the precise moment that relates to destruction or transformation – the moment in which presence becomes absence.

My oeuvre is arrested during the transformation that precedes disappearances and the paradoxical relations between weight and levity produced during this process. I do not wish to immortalise the bizarre, but to "mortalise" the usual.

The weight of memory and the weight of absence: the weight of oblivion.

The weight of levity.

Marcel Duchamp used to say that a full box of matches is lighter than one that has been started because it makes no noise.

My oeuvre is becoming a bit like that – the noise of my own matchbox.

VELAR, Staying Awake (Dreamer), 2002
Duration: 35 min.
Cleaning the House workshop, Antas de Ulla, Spain, 2002

I take the pulse of some of my colleagues and I add the figures up.
I take off my T-shirt and I spread some butter on my chest. I light a candle. I will stay like this for the time obtained by adding up the heartbeats.
Relationships produce changes in me.
Butter is the metaphor for my vunerability, it melts away, it fades, and it changes.
The fire is close to the grease. Even though the physical danger is almost non-existent, protection becomes a risk source: heat can be painful.
The candle light also goes away.
Exhaustion?

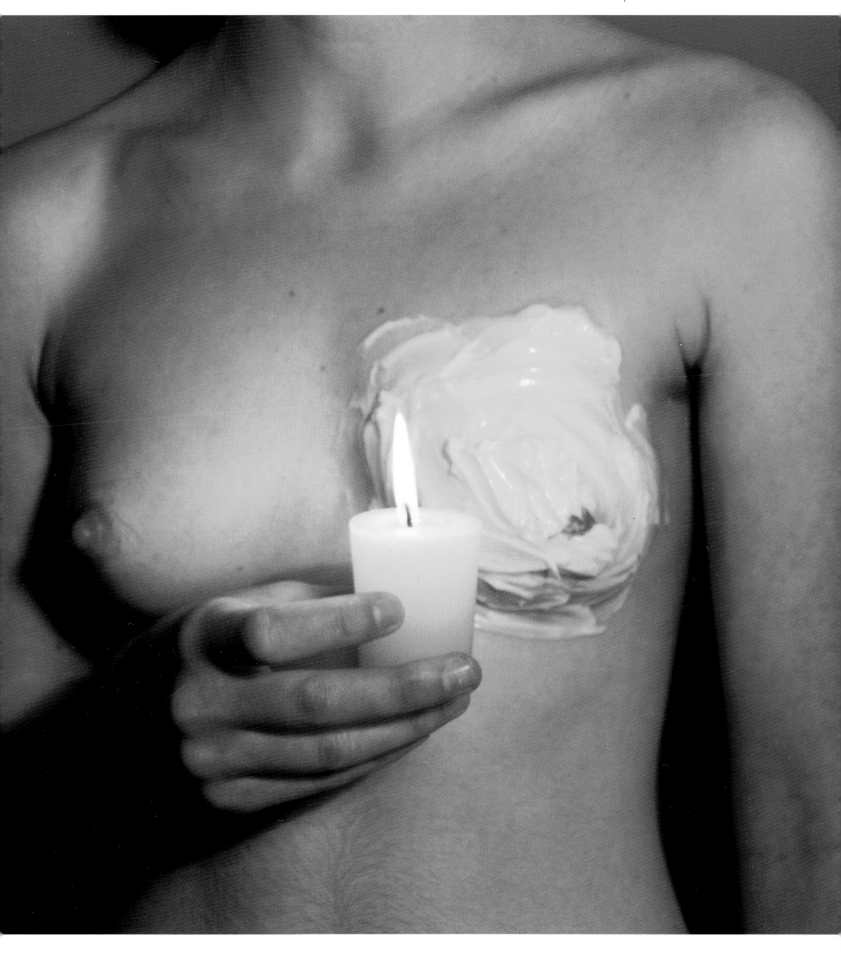

Rubén Ramos Balsa

The concept of duration is forever present in my work. The representation of duration is articulated in the binomial of before and after, by which we perceive change and movement and, consequently, the course of time. Yet somehow my work is closer to the representation of a static process in which not much is taking place. A process without any significant time progression, in which everything is static and objects and space establish a secret communion with the imminent action they themselves provoke. In my pieces, that is to say, at my pieces one never arrives at the right time, for they are records of an event one does not attend – the instant of representation is already too late, or else that of reception is too premature, as in a photo finish halfway through a race, where the position of runners cannot be determined.

With the diptychs, I seek the optical perversion of this before and after. I attempt to weaken this link, until the relationship with the time lapse becomes undecipherable. This explains why the installations are subject to the time of their viewers and to the interiorisation of the proposals, which are usually plays on approximation and recognition, evidence and absence – still lifes as systems of hidden relations in a highly unforeseeable pattern, or spaces as places where the spectacular consists of nothing happening.

I would like this static nature to benefit spectators as well, and lead to a levelling between the categories of object and subject. A mutual fascination. One must remain still in order to see how things move, in order to sense our evasive experience through the documents, and in this contemplation discover action as an absent driving force. My latest works are heading in this elliptic direction.

Untitled, 2002
Duration: variable
Cleaning the House, Centro Galego de Arte Contemporánea, Santiago de Compostela, Spain, 2002

Taking into account the distance from my feet to my mouth, my intention was to create a temporal structure of regular intervals divided by glasses. With these glasses I formed an action line on which I moved, transporting water in my mouth and then pouring it into the different glasses. During this process, the liquid I transported gradually became my own saliva.

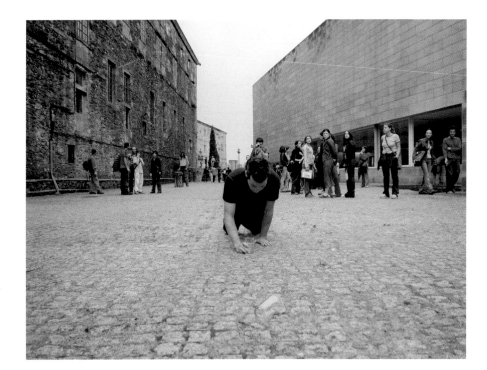

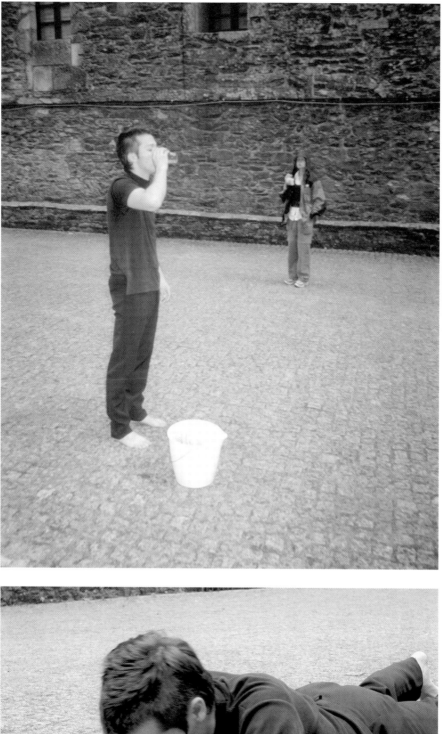

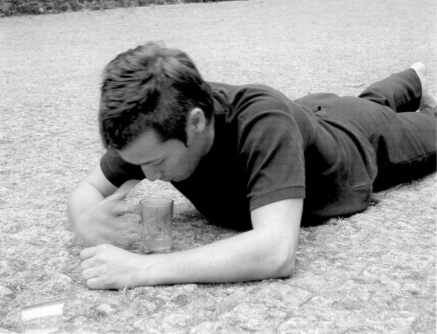

Orpheus, 2002
DVD, looped

Orpheus goes down to hell to rescue his wife Eurydice from the claws of death. Once there he manages to lure Hades and Persephone into bringing her back to life with the only condition that Orpheus walked towards the light followed by his wife without turning to look back before leaving the realm of darkness.

Orpheus walked all the time without looking back, but when the sun set he started to doubt if the demons had fooled him and if Eurydice actually followed him. As he could not resist anymore he turn around to look back and saw that she was actually there following him, but she immediately faded away because he had not met the condition imposed by the demons.

This video is the continuous image that Orpheus does not see while walking out of the realm of darkness. It is Eurydice's image, the bosom on which the sun projects Orpheus' shadowy silhouette walking before his beloved one.

Performance with Glasses of Water, 2001
Duration: 24 min.
Glasses, water, dressings and plastic bag
2nd Meeting on Action Art, Universidad
Politécnica de Valencia, Spain, 2001

In this performance my intention was to play
with temporal fragmentation. I decided – unlike
in previous performances – not to include any
technological element in order to focus my
attention on space and presence.
After having divided the space with different
glasses displayed equidistantly in line, I poured
water into them and then poured the water over
my head. After that, I wrapped the glass in
dressings and dropped it in order to break it; I
repeated the action on several occasions
increasing the amount of dressings and the
strength used to break the glass. The
performance concluded when the dressings
succeeded in protecting the glass with no
possibility whatsoever of breaking it.

Barak Reiser

Three or four years ago, I found a turning point in my work when I started to focus on public spaces. At the time I had doubts about the purpose and function of art objects and exhibition spaces.

I made impressions of objects on the street, casting and making rubbings of manholes, roadblocks, memorial stones and monuments. This was an application and extension of my studio practice.

These activities on the street invited dialogues and argument about art and politics with pedestrians. I came to understand that I was creating something like a show, and in the works that followed, the location was chosen to correspond with the central concept of the work. I found that in the activity of walking, I could explore the relationships between discipline and design – relationships concerning placing objects, movement and tempo.

At the end of 1999, when I moved to Germany, I had a better perspective about my homeland and the situation in Europe. Referring to this experience I understood that I'm dealing with time. I see time as an endless present, consisting of a repetition between past and present. What was here before? What will be here next? Memories from past moments. Maybe one must define the times, from a subjective and relative perspective.

At this point, I'm using photography and video, making simple photos of places. In the continuing project *Nachforschung* (Searching After) I use long night-time exposures, to "conserve" time.

I'm interested in an arena, a place where something happened. An object will be placed there, which will attract people or will create a movement. People spend some time in there, maybe in a situation of waiting, maybe knowing that they have to give some time away. An example of these arenas are the grounds of an airport, or open-air cinemas. A screen will be installed in an open space, and people will sit in front of it.

I like the idea of isolated air. Maybe empty space is empty, or maybe it is full of things and information, generous enough to let us be reflected in them.

Proposal No.1, Spinal Column, 2001
Video
Duration: 6 min.
Fondazione Antonio Ratti, Como, Italy, 2001

A found construction in the church, was lowered to the height of the knee.
The intention was to give a discipline to the way we usually proceed through the space.

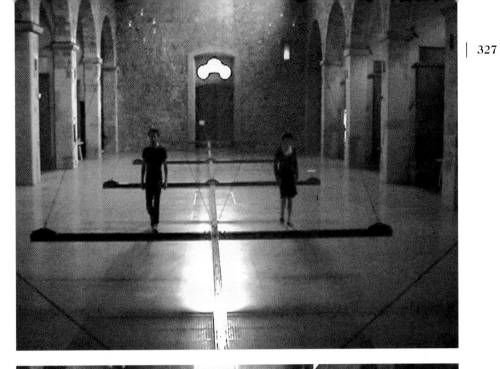

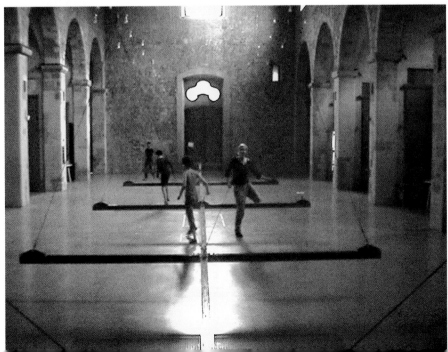

e, 2003
The Tel Aviv Artists' Studios, Tel Aviv, Israel,
2003

"E" is a syllable; the meaning in Hebrew would
be of an island, it's the extra "e" from the title of
text "three", which was part of the exhibition.

Within this exhibition a reduced "lexicon" of
objects and things was defined: an object of the
letter "e", a series of five photographs which
described a situation with people standing and
waiting on a platform in an underground station
(whose background was designed in the colours
of a sunset) and a ladder. With the help of these
elements two basic ideas were emphasized: one
of a free pass, and the thought of a feeling of a
déjà-vu. One of the strategic decisions in
composing this exhibition was that each element
would reappear in a different version once again.

Declan Rooney

In the performative aspect of my practice, I seek to re-inhabit the body through experience, memory, cultural history and tradition.

Ideas of imitation and falsity, passion and obsession, contrition and folly are demonstrated in works that are both ritualised and spontaneous.

I am interested in the communal and the collective, the public and the private and in creating a proactive and reactive dialogue with the audience.

Blood Shirt, 2003
Digital photograph

Pre-Mid-Post Trauma
Pre-Mid-Post Help
Pre-Mid-Post Attack
Pre-Mid-Post Salvation
Pre-Mid-Post Assistance
Pre-Mid-Post Tragedy
Pre-Mid-Post Violence
Pre-Mid-Post Distress
Pre-Mid-Post Shock
Pre-Mid-Post Redemption
Pre-Mid-Post Ordeal
Pre-Mid-Post Rescue
Pre-Mid-Post Aggression
Pre-Mid-Post Support
Pre-Mid-Post Disaster
Pre-Mid-Post Deliverance
Pre-Mid-Post Misfortune
Pre-Mid-Post Harassment
Pre-Mid-Post Recovery
Pre-Mid-Post Brutality
Pre-Mid-Post Hostility
Pre-Mid-Post Aid

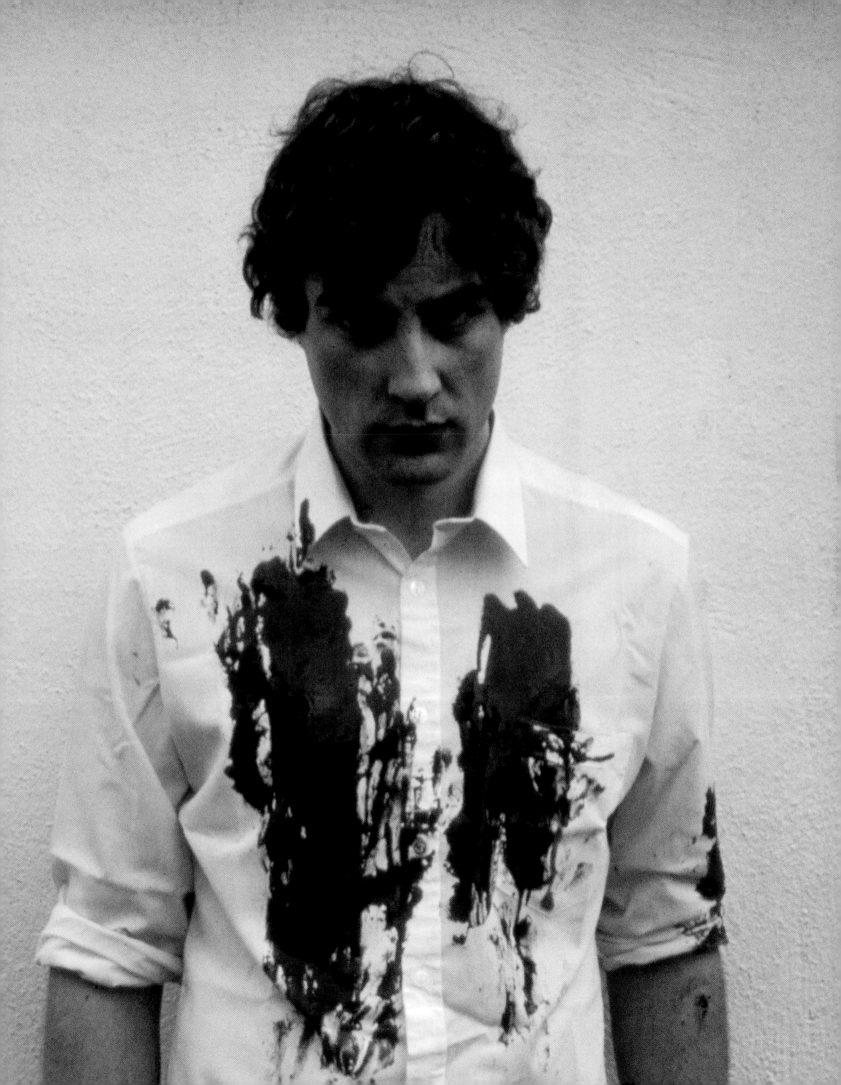

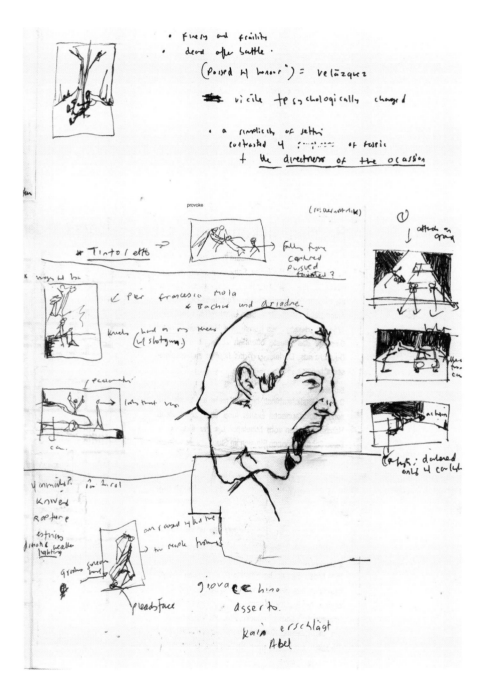

Pest, 2003
Video
Duration: 10 min., looped

Pest is one of a series of on-going works examining the idea of social nuisance and annoyance. The camera actions, aim to explore in humorous and tragic ways the play on an aggressive / passive dichotomy.

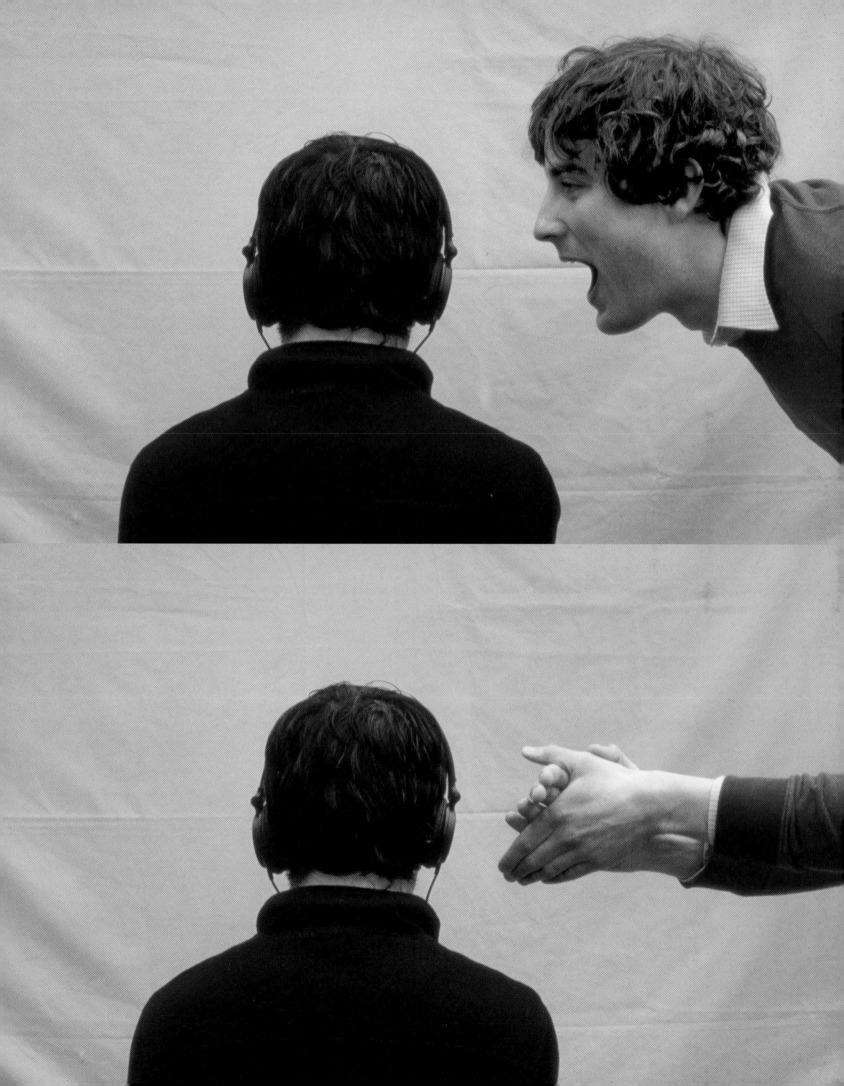

Mr. Grieves, 2002
Video
Duration: 1 h. 50 min.

Mr. Grieves is an extract from an untitled live improvisational sound performance. I present an audio work in a physical way within a particular working / performing environment. After reducing the aural components from a cacophony of sound to one basic element, my focused concentration becomes broken. My physical response to this results in a transformation of energy, changing the nature of my actions into a type of hysterical dance / trance movement.

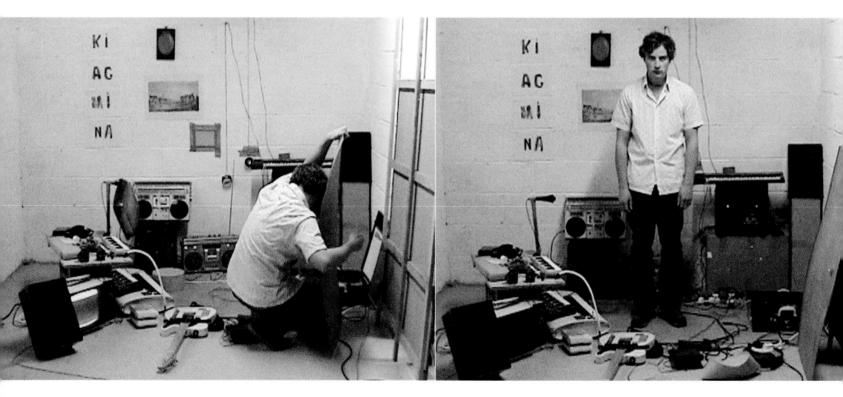

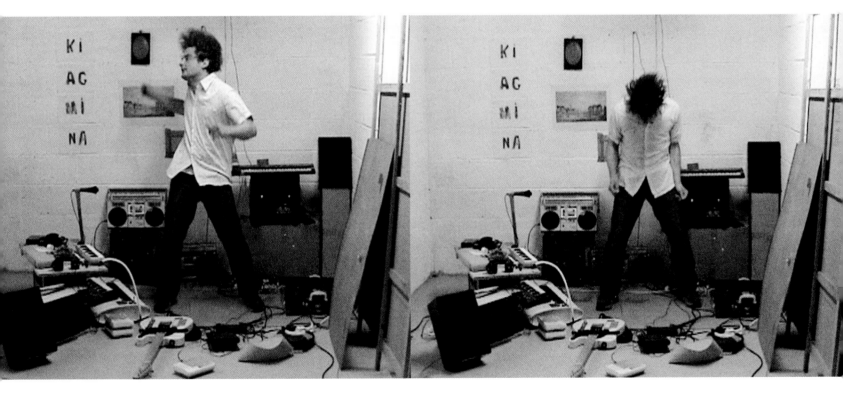

Parish Newsletter, 2003
Duration: 40 min.

Parish Newsletter is an exploration of a public and private persona and the frictions that exist between these two projected realities. The work also looks at the means of disseminating the moral and ethical viewpoints which make up these personas and the inherent responsibilities that exist in both a social and formal setting.

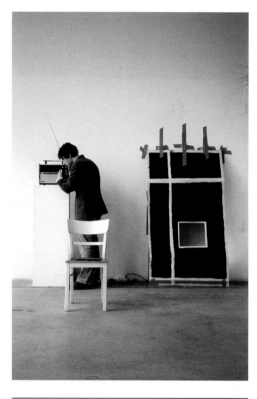

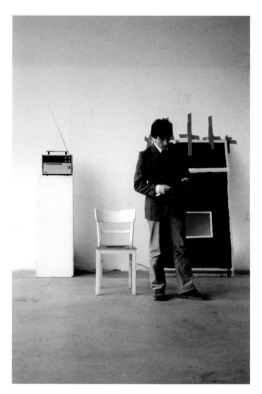

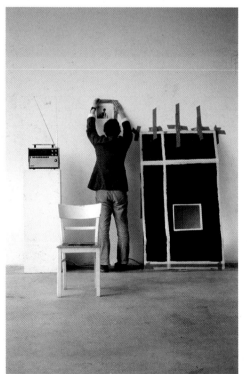

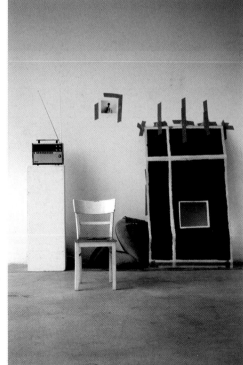

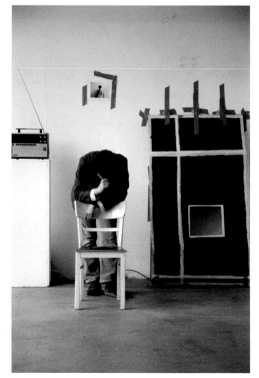

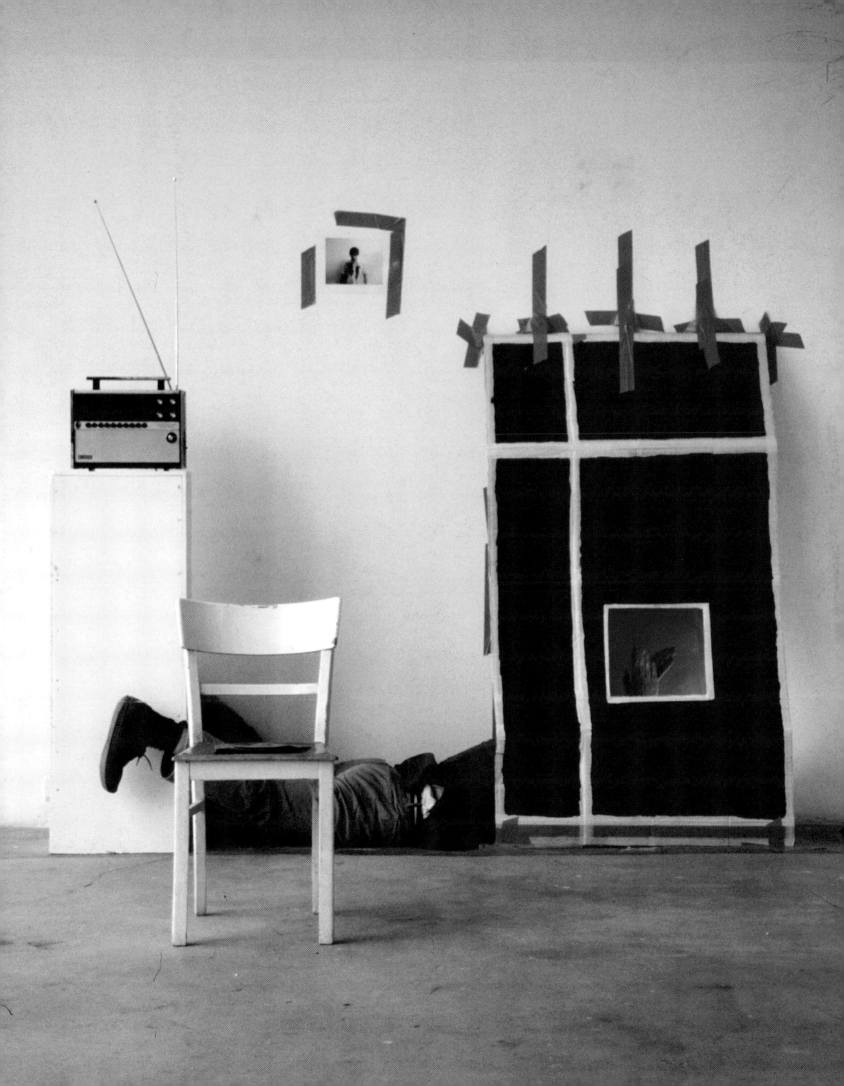

Homage, 2003
Duration: 2-3 h.

I stand beside a plinth with a CD player on top. On the ground in front of me are one pile of CDs and another pile of band T-shirts, brought to the space by the public, in advance of the performance. During the performance, I wear a selected T-shirt and play a pre-chosen song by that band. Using the "skip back" button on the CD player, I form new loops based on one-second sections of the song. The song (4-5 minutes approx.) becomes stretched over a one-hour period. In keeping with a fixed rhythm, I use the middle finger to dictate the soundscape. By choice or by natural error, the looped segments will change and another "movement" will begin. Upon the hour I remove the band T-shirt and pick another T-shirt from the pile. Then I pick up the corresponding CD by that band and continue this looping process.

Smirch No. II., 2003
Photograph

Andrea Saemann

The workshop and ways of working.
In the beginning we had to sign a commitment: no talking, no eating, no having sex. Marina set the rules and we had to follow. I recognised: authority is a performative achievement. I saw: it is the strict framing, which enabled me to experience the world in a new way.
I use this strategy for my own work. I am dealing with an older generation of women perfomance artists. In order to experience history, I start to copy singular performance pieces, different aspects of working. This process – I use my body for making copies – frees similar energies rising from the gap of self and foreign determination. It narrows my freedom of action and fills my mind with unforeseen perspectives and views of an unknown world.

In the best of cases, performance changes a human being.
 (Regula Huegli, 2002)
I work because I am oppressed.
 (Andrea Saemann, 1994)

Generation Gap, 2002
Video installation
Competition performance
In the photo: Marina Abramović, Andrea Saemann and B. J. Blume leaping over the threshold of the main entrance to the Hamburg School of Fine Arts – take role models by the hand

I am launching the *Generation Gap* project. In May 2002 I wrote the following: it would appear that depending on how well young artists are known, the clash with an older (still living) generation of artists is either not expressed at all, or tends to take place through publications, exhibitions or teaching. In the case of Performance Art, this (usually) implies a confrontation with frozen pictures.
Fantasies and wishes wrap themselves around these forerunners, operating as triggers and acting as role models, becoming effective in various places. Without Marina Abramović, a teacher at the time I was studying, how could I perform? Without Gertrude Stein, now gone but who has left us such a rich legacy, how could I write? Without the stories of Laurie Anderson, a star so often in the media, how could I speak? I understand identification to be a principle of learning.
I would like to be able to sit facing my gallery of forebears (photos leave behind an image, a faint idea of something) and to see these role models suddenly spring into movement. I would like to be able to encounter their aura, to feel their presence in a different way, to experience the immediacy of their breath, the dynamics of their thought and their speech. These, for me, are essential elements of Performance Art.
Generation Gap uses direct contact to establish a dialogue. *Generation Gap* visits the role models. First I interview them and record them on video. Then I invite performers to take these role models and use them to create a new, individual piece of performance work. I myself develop performances out of my perception of encounters with these role models.
As a first step I made contact with Basel-based Regula Huegli, the only artist from my own circle of acquaintances who belonged to a previous generation. I tried out my method with her, using video interviews to establish a dialogue, and subsequently created a performance out of the themes which came up in the conversation.

Partnerlook, 2002
Collaboration with Helga Broll
Duration: spread out over two weeks
Nette Homos Exhibition, Helga Broll Gallery at
the Kaskadenkondensator, Basel, Switzerland, 2002

For the duration of the exhibition I dress up as
gallery owner Helga Broll. I am present at the
exhibition and at the usual gallery opening times.

Terminator 1 + 2 – A Film Screening, 2000
Duration: 40-60 min.
Overhead projector, slide projector, screen and
markers
Basel Kunstkredit at the Movie Cinema, Basel,
Switzerland, 2000
North Rhine – Westphalia Performance Days:
Düsseldorf, Cologne, Münster, Essen, Germany
Bildwechsel at the Metropolis Cinema, Hamburg,
Germany
Theater an der Winkelwiese, Zurich, Switzerland
Neumarkt Theater, Zurich, Switzerland, 2001
Marking the Territory, Irish Museum of Modern
Art, Dublin, Ireland, 2001
Plug In, Basel, 2001
Bone 4, Performance Festival, Bern, Switzerland

I retell both films, *Terminator* and *Terminator 2.*
On an overhead projector I sketch the plot,
highlight references and pick out themes. My
thoughts take the following course:
How far can the mechanisation of the human
body progress? When will I meet my clone? Is
there a natural human core worth protecting?
Should I do something about it? Are the Olympic
Games the first step towards designer bodies?
And has the temporal anything to do with Plato's
cave wall? Why did Jean Paul call his woman-
machine Olympia? Why was that the name given
to the Parisian prostitute in Manet's time? What
does that have to do with Mr Universe and
Schwarzenegger as Terminator? How do I remain
as a body on a cinema seat, why do I usually
have a stomach ache after watching an action
film and what does all that have to do with
popcorn, ice-cream and Coca-Cola? And is
Terminator multidimensional?

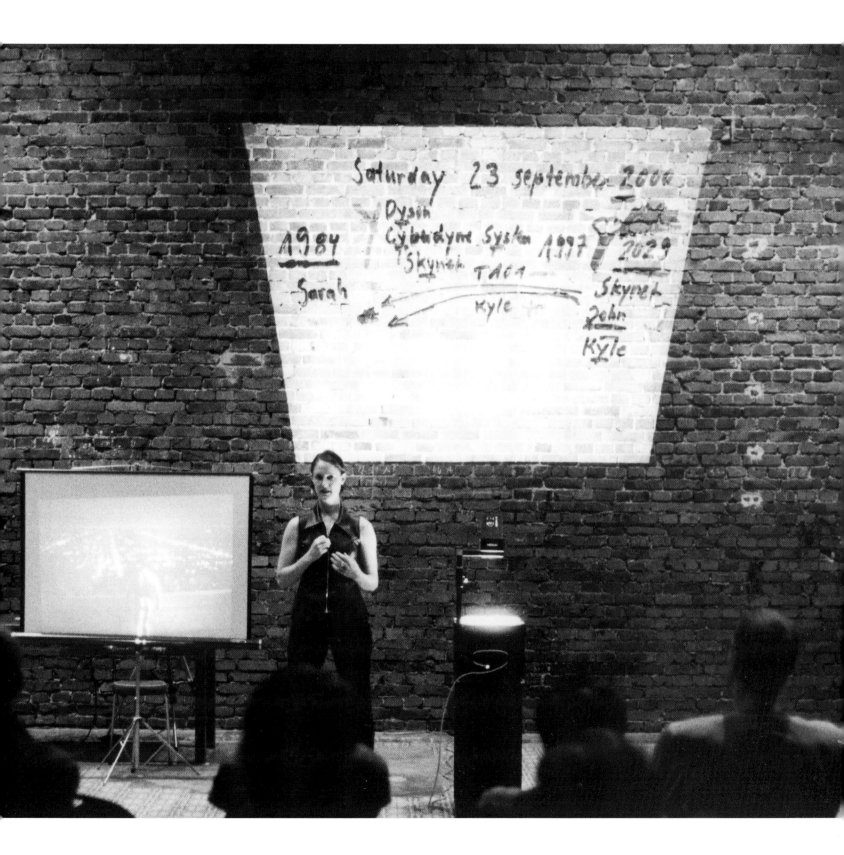

Iris Selke

The subjects in my work are gender, identity, history and politics. The work is based on my personal experience with a consideration of art criticism and art history. Within this context I try to find a way forward.

It is not not my intention to show either self destruction or torture in my performances. I intend to give a live impression of the physical and psychological traumas which are in our collective memories. The body is my tool to express what I cannot say. In order to communicate, I use the body as an object as well as transforming the body by using other objects.

Surface to Face, 2000
Duration: 10 min.
Visible Differences, Hebbel Theater, Berlin, Germany, 2000
Performance Event, Hochschule für Bildende Künste, Braunschweig, Germany
Performance Passing Through, Gedok, Stuttgart, Germany, 2000
Zustelle anders wo, Hannover Kunstraum 10, Hanover, Germany, 2000

I am standing in front of a tennis-ball machine. The naked body confronts the tennis-ball machine – a machine that was developed to replace a person.
The balls stand for situations and conditions which have to be faced in real life. Some of the balls hit me and elicit a reaction, whereas others miss their target. From experience I know that my body is able to call on my psyche to help it out in extreme situations, which means I work on this area and expose myself to other levels of consciousness against the rational functioning of the human body, so that I can go one step further. I am not interested in showing injury, self-destruction or violence. Rather, I am constructing a living picture. It is about the human being versus the machine. My body is my material, my tool and my means of expression. The body is obsolete in its limitations.

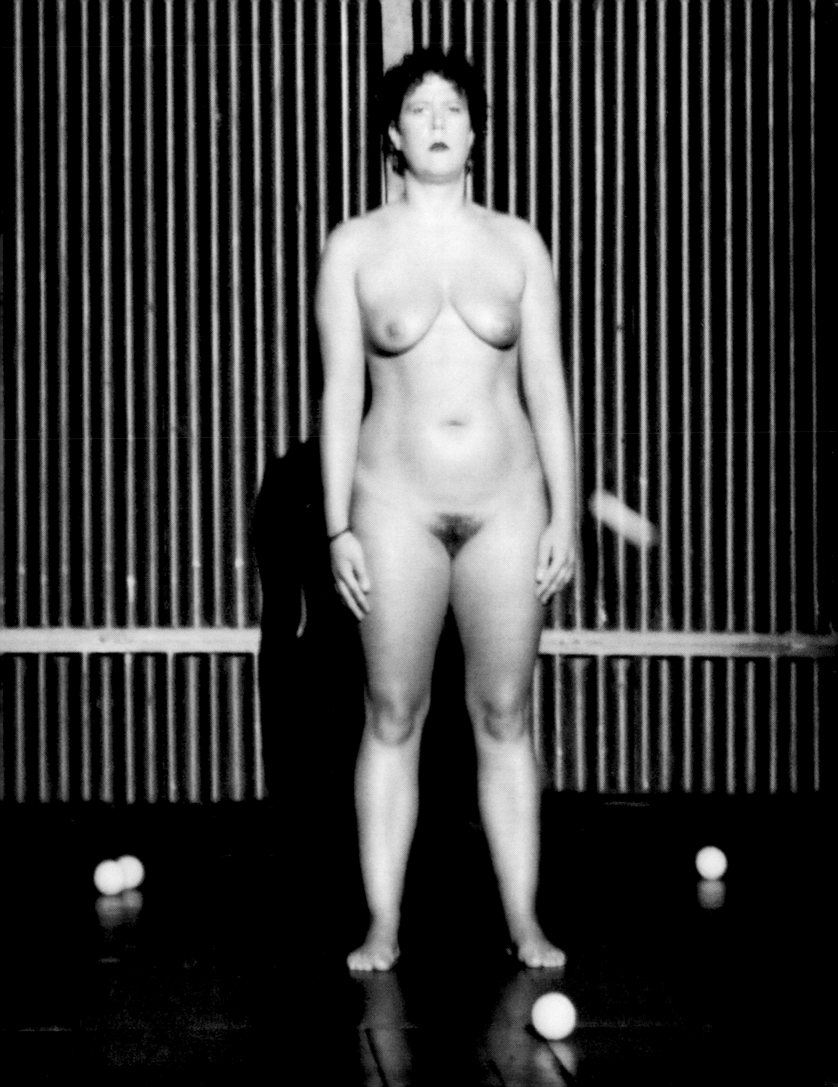

Splendid Isolation, 1998
The School of the Art Institute, Chicago, USA, 1998
Fresh Air, Kulturstadt Europa, E-Werk, Weimar, Germany, 1999
Braunschweiger Kulturnacht, Hochschule für Bildende Künste, Braunschweig, Germany, 1999
Real Presence – Generation 2001, The Balkans Trans / Border – Open Art Project, Belgrade, Serbia and Montenegro, 2001

The title is an expression from the British Empire. I have chosen it because of its aptness for this project. It also can be associated with the isolated beauty of masks of certain African tribes, or (politically isolated) masks used by extreme groups such as the Ku Klux Klan. In cutting the mask in the way I do, it should raise associations with borders and landmark lines on a map. It comments on the (almost) unbearable slowness of bureaucracy in the USA or Germany. The pieces I cut out of the paper will draw the spectator's attention to the form cut out of the mask. I am slowly cutting out pieces from the paper in front of my face with a razorblade, until you can see my whole face.

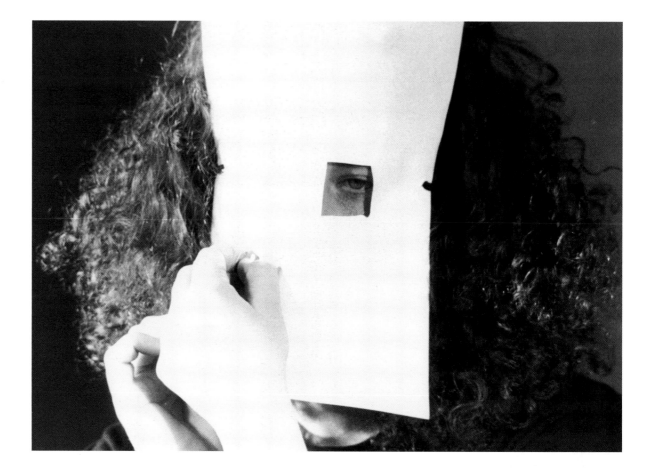

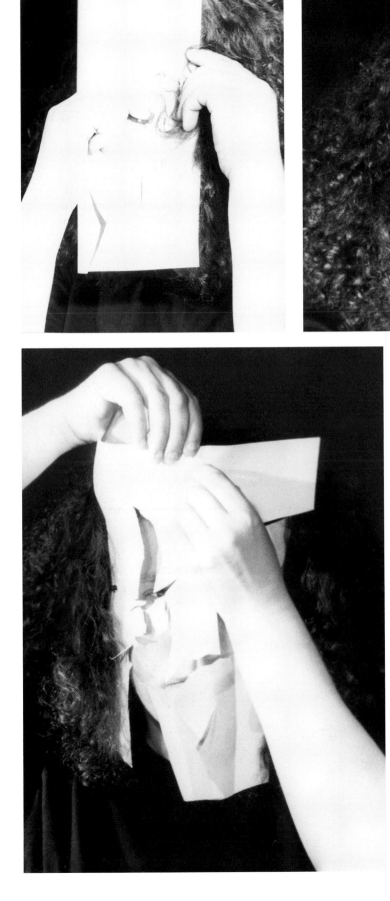

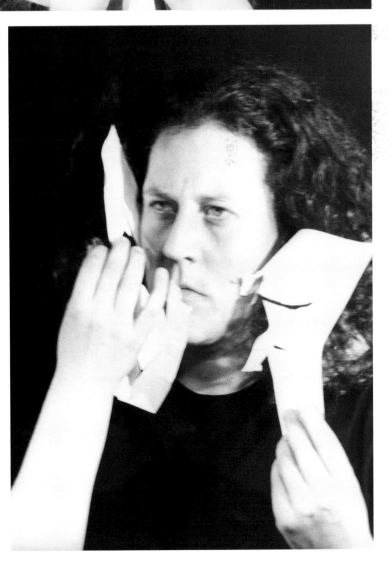

The Agreemement, 2002
Duration: 2 h. 30 min.
Common Ground, Landesvertretung
Niedersachsen and Schleswig-Holstein, Berlin,
Germany, 2002

How are political decisions made, what are the
effects of these decisions and is politics addicted
to democracy?

In this performance, I use a speech by Peter
Müller, Premier of the state of Saarland, after the
vote on the immigration law in the upper house
of the German Bundestag. My interview partners
shared my opinion unreservedly.

"Politics as State drama. Wasn't that the case on
Friday? On Friday, there were at least two
possible scripts and perhaps politics is
sometimes about conflict, such as which script is
ultimately going to be used and according to
which one will things ultimately proceed. There
were no journalists there. They should have
documented this indignation so that is what we
did. You may of course say that this is a piece of
drama. And yes, it is drama. So does that mean
politicians are actors? Well, yes, they are. And
yes, politics is drama. If you want to
communicate, you have to provide just a small
amount of information. And that being the case,
they have to make news. Without drama, there
can be no news and the more drama there is, the
greater the likelihood of news emerging.
The indignation that was expressed there did not
arise spontaneously. We orchestrated our
indignation. But even political theater that
begins in the best possible manner cannot
replace proper content in the long term. This is
something politics must bear in mind: even in
politics you can't go on selling a sleeping tablet
as a vitamin pill.
Thank you very much."

Peter Müller, quoted from the *Panorama programme*
broadcast on 28.03.2002

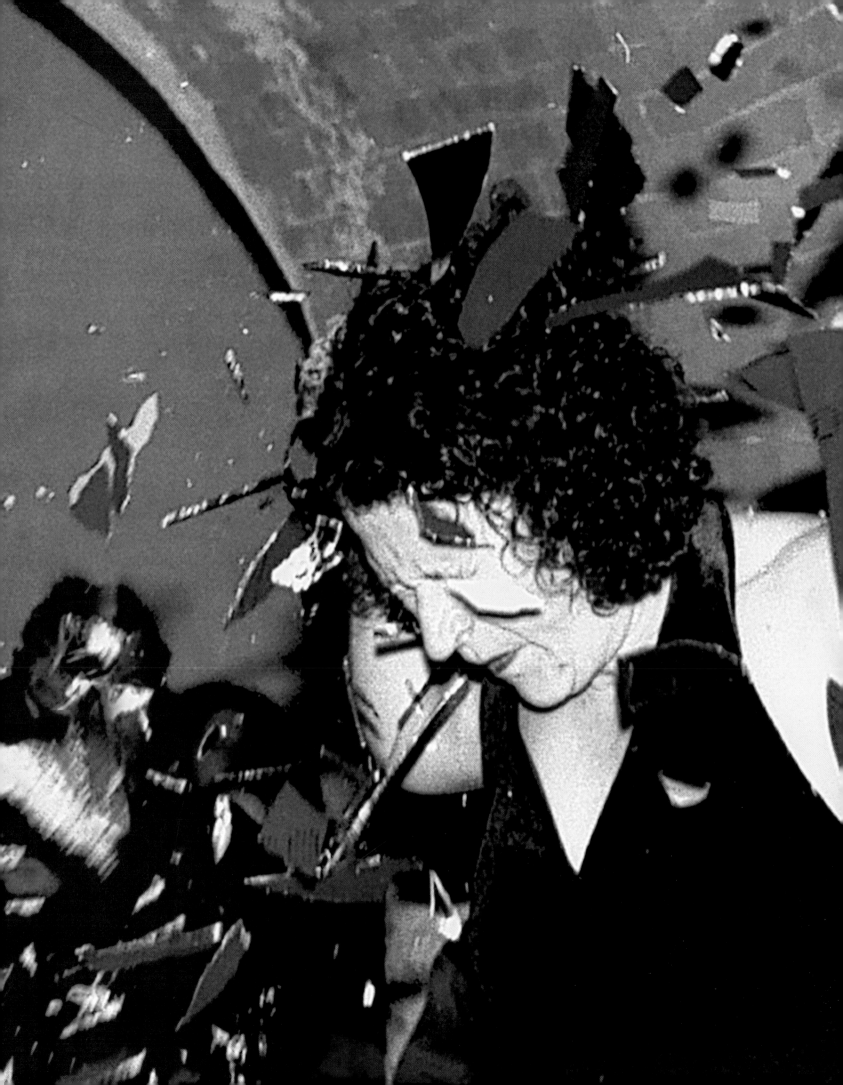

Narcissus, 1997
Duration: 30 min.
Zwischenräume – Finally, Kunstverein
Hannover, Hanover, Germany, 1998
*Real Presence – Generation 2001, The Balkans
Trans / Border – Open Art Project,* Belgrade,
Serbia and Montenegro, 2001
Marking the Territory, Irish Museum of Modern
Art, Dublin, Ireland, 2001
Prêt-à-Perform, Viafarini, Milan, Italy, 2002
Body Basics I / Body Basics II, Transart 02,
Klanspuren Festival, Fortezza, Brixen, Italy, 2002

I pick up a large mirror and look at myself and
my surroundings. After a while, once I have
reached my maximum point of concentration,
I smash the mirror with my forehead.
A face in a broken mirror. It is very symbollic:
first it is the symbol of narcissism. Breaking the
mirror with one's face means breaking the image
of narcissism and trying to look at what lies
behind it.

Chiharu Shiota

Me, myself, my emotion and the material are ritual, which becomes art.

Try and Go Home, 1997
Duration: approx. 20 min.
Cleaning the House workshop, Kerguéhennec, France, 1997

This work was made after the *Cleaning the House* workshop in Kerguéhennec, France, in 1997. On the fifth day, after four days of fasting, Marina came to my bed at 5.00 am and gave me a piece of paper and a pencil. She asked me to write down just one word. It was so difficult because I hadn't eaten for four days and was now completely weak and my consciousness was very blurred. Then I wrote down a word on the paper. The word was "Japan".
In my ordinary life, I am always running. I have something to do everyday: making telephone calls, going to the bank, shopping, meeting friends. In Kerguéhennec I had nothing to do except playing in nature. It reminded me of my childhood. It was a time when I thought about what is most important for us to stay alive and what do we need for living? Firstly, of course, oxygen, water and food, then money, having a house, a lover, etc. Then having a bigger house and more money is what many desire. However, free thinking is something no one and nothing can disturb.
This is a feeling I have had for a long time but couldn't explain; after France I could understand that this feeling was going to stay forever. It is similar to explaining death. When I explain it, it has no reality.
Free thinking is similar.

I want to present something unclear: my feelings after a performance.
I want to wash something unclear: a feeling without my body.
I want to find my missing piece, which I forgot in my time of growth.

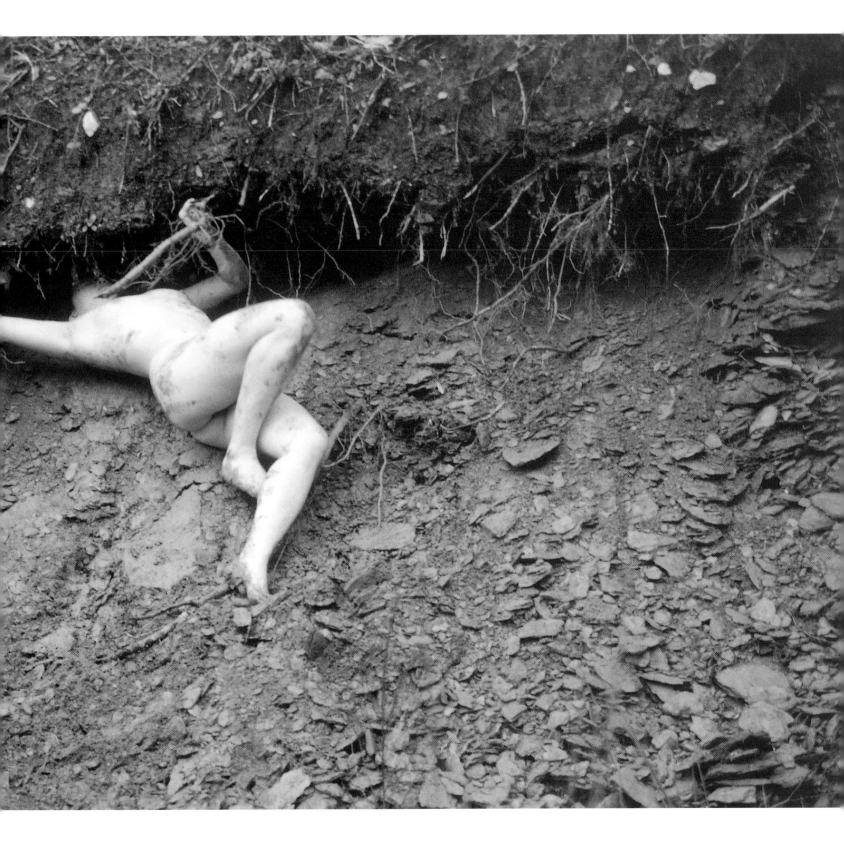

Bathroom, 1999
Water and earth
Berlin, Germany, 1999

After each performance, I washed my body. It was dirty everywhere. I would try to wash, but it either never become clean or else it was already clean but something had been left behind. Normally, I am extremely busy with my day-to-day life. When I have nothing to do or if I am at an ambiguous stage, I suddenly get a fear. I have a feeling that my body is going somewhere. This is neither a question nor an answer about death, just my body accepting everything, even death. When I see a blue sky or the ocean, I have the same feeling.

It is a similar feeling to the one I have after a performance. There is always something that couldn't be washed away. It is neither abandonment nor desire, but something that stays in my body and will never be cleared.

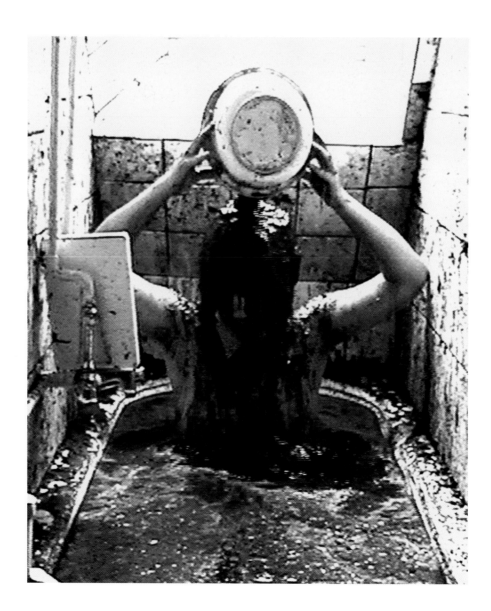

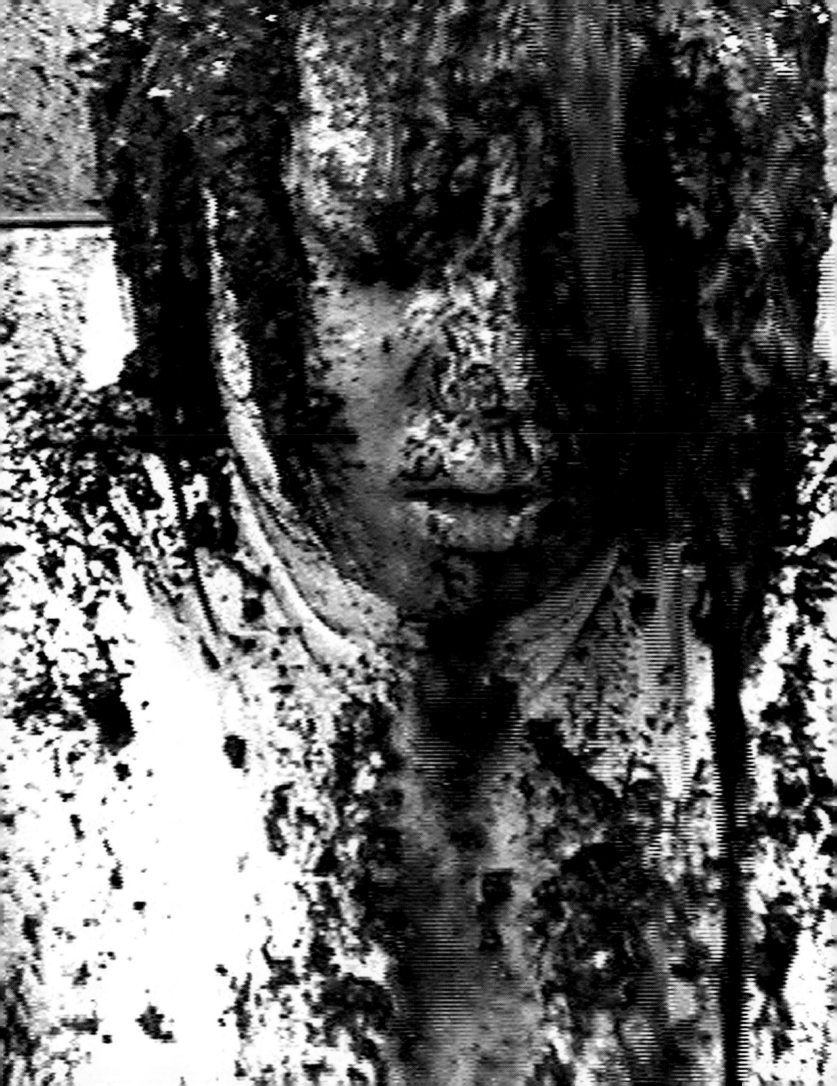

Breathing from Earth, 2000
Performance / installation
70 beds, thread
Maximiliansforum / Stadforum, Munich,
Germany, 2000

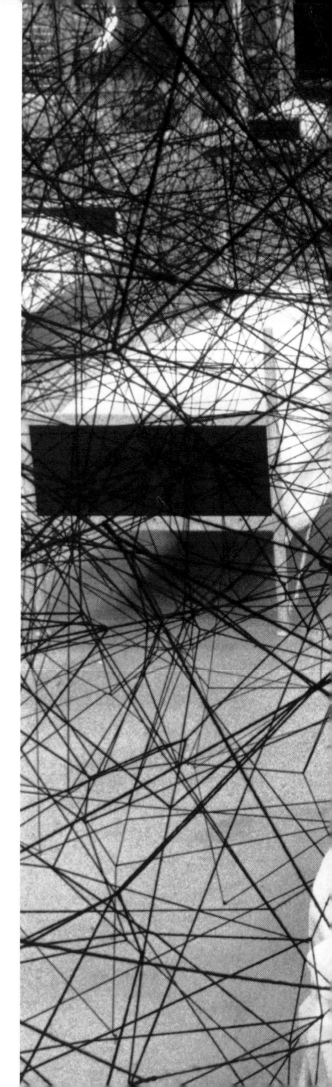

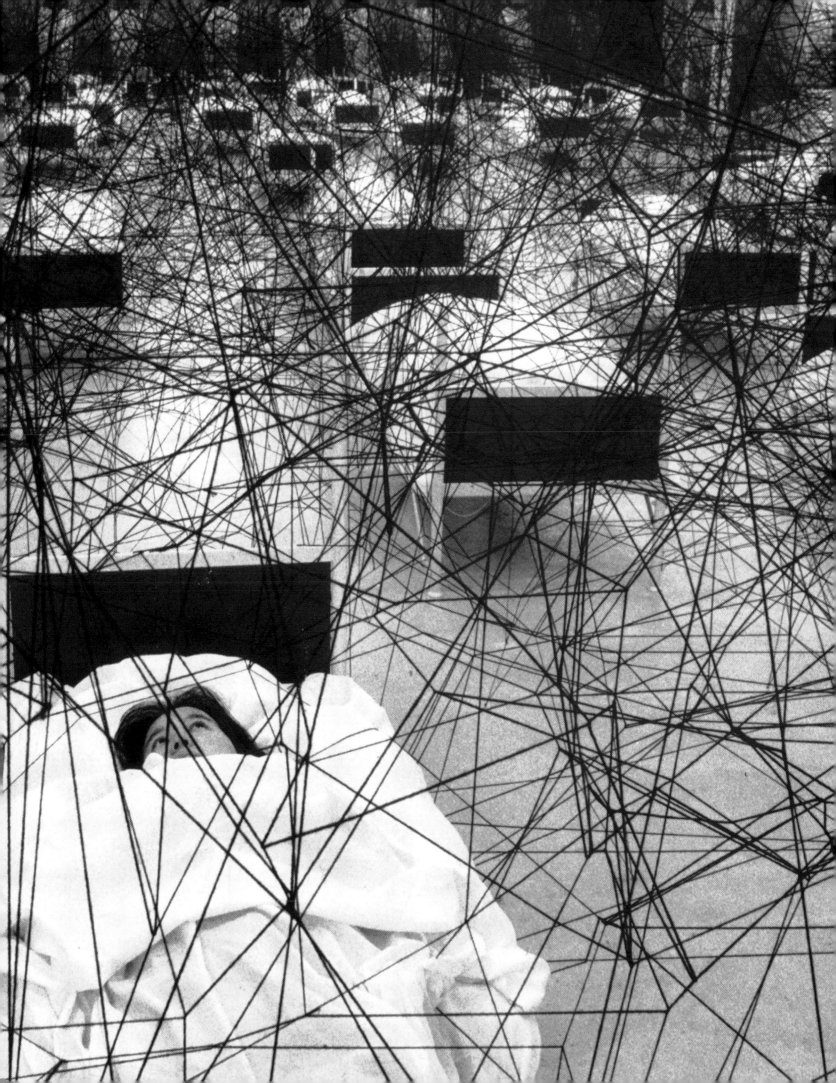

Where are you from?

Looking for home, where is my home? I came from Japan, stayed in Hamburg, Berlin, Australia but where is my home? Looking at myself, my black hair, my black eyes and yellow skin. People call me Asian, but where is my origin? Where is my home? I tie my body up with rope. The rope is not only the material for tying my body up, it is like a petrified organism, a muscle devoid of activity. The audience can throw dirt onto my body. I talk and ask questions to the earth. It is the fundamental contact with something that I have missed.

Untitled, 2001
Red thread
Courtesy Kenji Taki Gallery

Congregation
Earth and water
Hamburg, Germany

Christian Sievers

I'm not religious, but I believe in art's ability to save one's life.

Untitled (Mushrooms), 1999
R-type print
30 x 40 cm

About artist's needs and about having fun with art. About motivation, nurturing and growing from dissolution, as mushrooms exist on decomposing vegetable material like an animal, but they're not alive in the way animals are; they're neither animal nor vegetable, etc.

Orange Eater, *2002*
R-type print
20 x 30 cm

Rob has a henna tattoo tracing the bones of his right arm and hand. (After Baselitz, see *One More Time*)

One More Time, *2002*
R-type print
40 x 30 cm

Lilli has a henna tattoo tracing her collarbones, breastbone and ribs. (Part of the work was that she would have to wear the henna drawing around for as long as it lasts. Henna tattoos are semi-permanent and can last for up to 4 weeks).

Heart Shaped Explosives, 1998
Interactive objects
Cardboard, different types of ignition,
firecrackers and a playful audience
approx. 40 x 40 x 30 cm each
Hochschule für Bildende Künste, Braunschweig,
Germany, 1998

A rough reflection on "interactive art."
The audience is invited to blow up cardboard
hearts filled with small-scale explosives.
Different triggers make it increasingly difficult
not to get hurt.
Even for a very playful audience.

Special Effects (installation view), 1999-2001
Object / installation
Steel, wood, cloth, two mini-DV cameras,
polyester fittings, parachute and zippers
Hochschule für Bildende Künste, Braunschweig,
Germany, 2001

This device can be tilted along its middle axis,
turning it upside down. As the cameras move
along with the body, it seems as though it doesn't
change its position.

The resulting video shows a face that
mysteriously swells up and turns bright red,
when all the while the eyes are transfixed to a
higher point, as if something from above was
being revealed.

p. 367
Special Effects (detail),
1999-2001
The resulting video is
shown in the LCD screen
of the camera

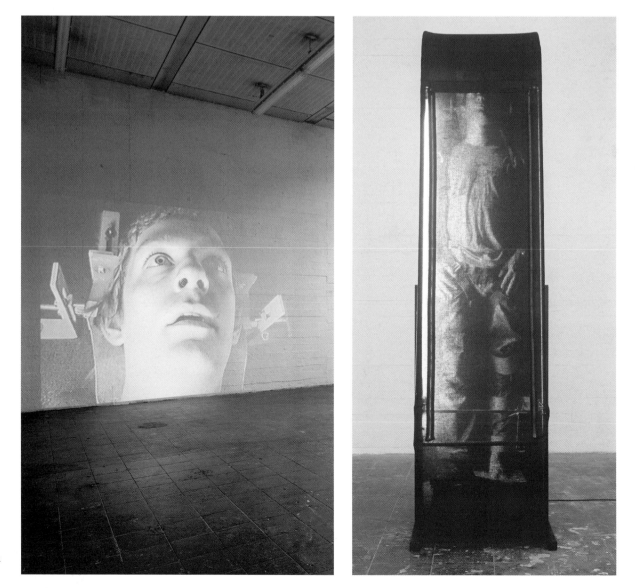

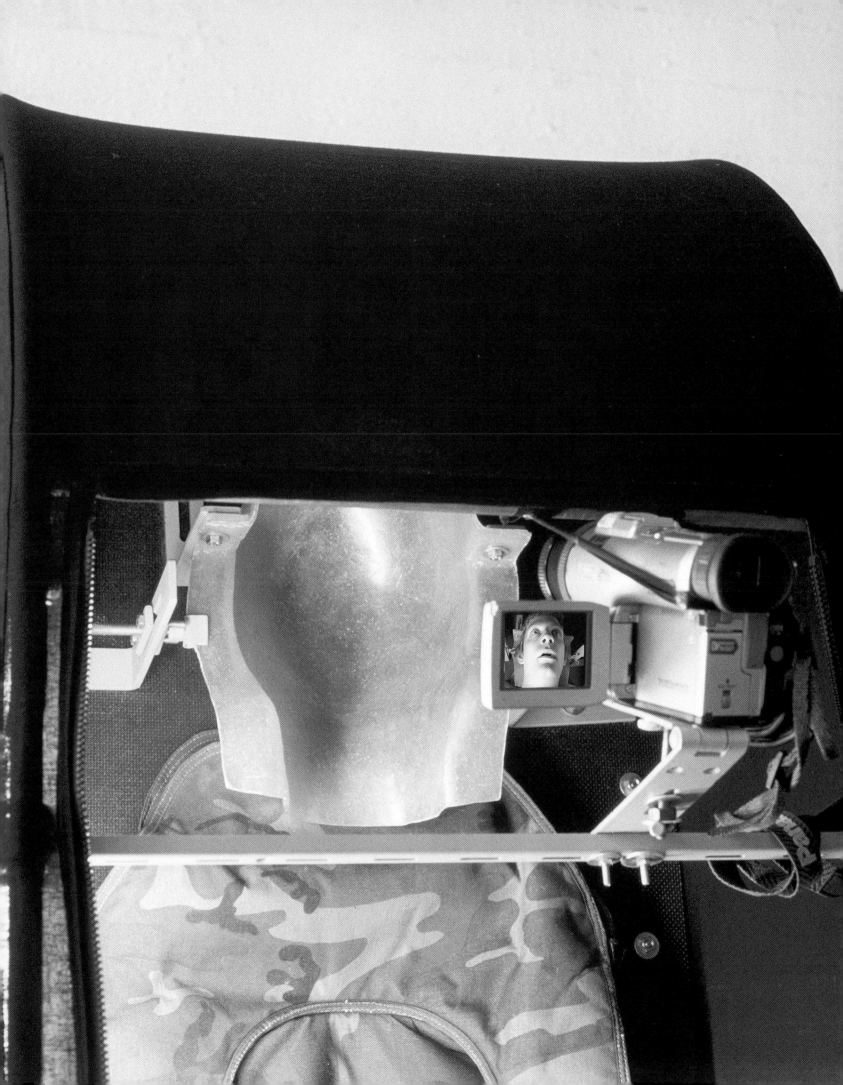

Lectures, 2003
On Weapons and Fun and *On Sleeping in Public and Being Cautious*
Lecture given at various locations including:
My Living Room, 2003
The Royal College of Art, London, United Kingdom, 2003
291 Gallery, London, United Kingdom, 2003
The Bargehouse, Oxo Tower Wharf, London, United Kingdom, 2003
VTO Gallery, London, United Kingdom, 2003

The term "lecture" is deliberately deceptive. I'm not teaching anyone at all. I am merely showing images, hinting at issues, telling anecdotes; employing the established form as a vehicle for my kind of performance. If the artist had an obligation to society, it would be to identify – to picture – its present condition.

On Weapons and Fun

Anton Soloveitchik

Forging links across the boundaries of individual artistic genres, taking the "interdisciplinary" path, building bridges between the separate spheres of music, poetry, literature, theatre and fine arts, inside the new terrain of one artistic space. Once again we are witnessing an attempt to create a new "total work of art."
Ilya Kabakov, 1995

We supplement each other not only in life but also in creation.

Untitled, 2003
Duration: 3 h. 15 min.
As Soon as Possible, PAC, Padiglione d'Arte Contemporanea, Milan, Italy, 2003
Recycling the Future, 50. Esposizione Internazionale d'Arte La Biennale di Venezia, Venice, Italy, 2003

I lay on the floor with a guitar behind my head. One by one, I tune each string extremely slowly until they violently snap.

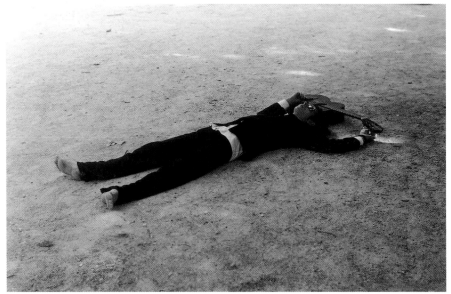

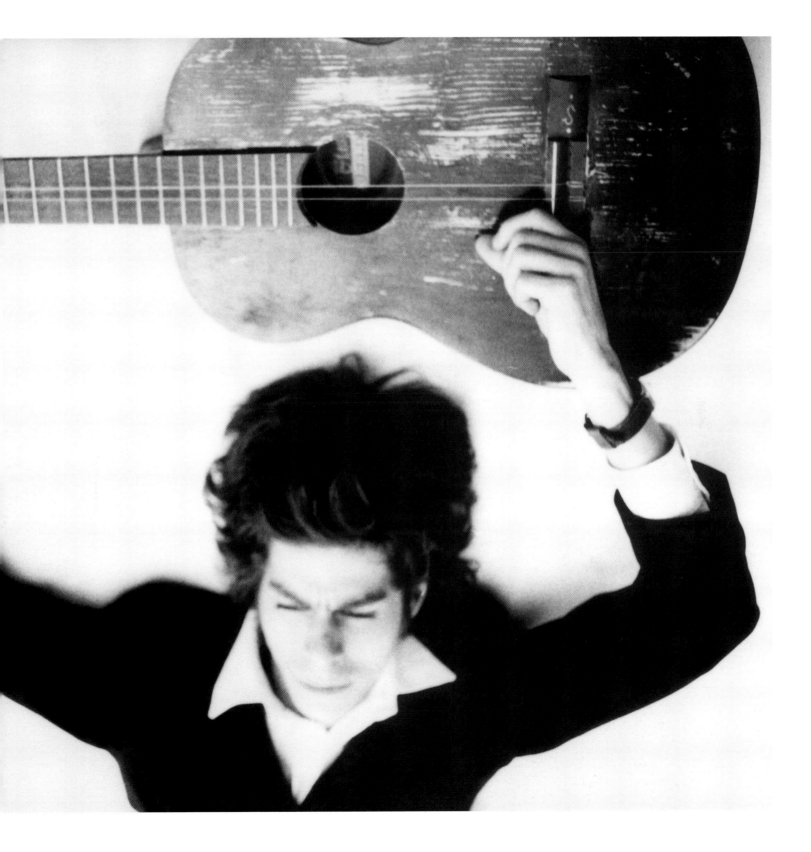

Bad News, 2003
Duration: 3 h.
As Soon as Possible, PAC, Padiglione d'Arte
Contemporanea, Milan, Italy, 2003

I am sitting on a chair. Beside me there is a small
table with an answering machine on top.
On this machine are recorded messages relating
to people who were killed in the war.
Occasionally I press the "play" button and listen
to these messages.

Extracts from the answering machine:

– "Anton, I have some bad news for you, Franz
was marching today and was shot dead."

– "Hello Anton, you know your brother was
killed in the war. It's not certain as to how he
was killed... I'm sorry..."

– "Herr Soloveitchik, hier spricht General
Blutberg. Ich muss Sie benachrichtigen, dass
Ihrer Vater bei Explosion einer Bombe starb."

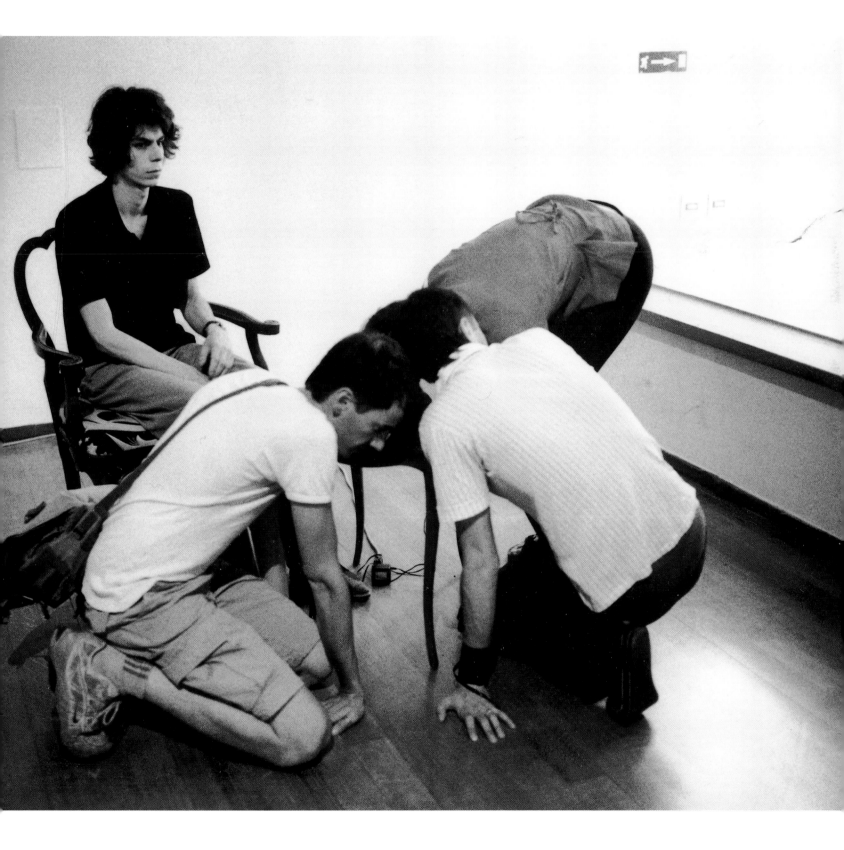

Till Steinbrenner

I do not believe in art.
I believe in life.
I believe in a kiss, in washing dishes, in hands building a house.
The more art becomes life, the more life becomes art.

Bread, 2001
Duration: 10 min.
Hochschule für Bildende Künste, Braunschweig, Germany, 2003
Marking the Territory, Irish Museum of Modern Art, Dublin, Ireland, 2001
Cork Opera House, Cork, Ireland, 2001

I enter a space with a huge knife and a loaf of bread. I cut the bread against my breast and share it with the public.

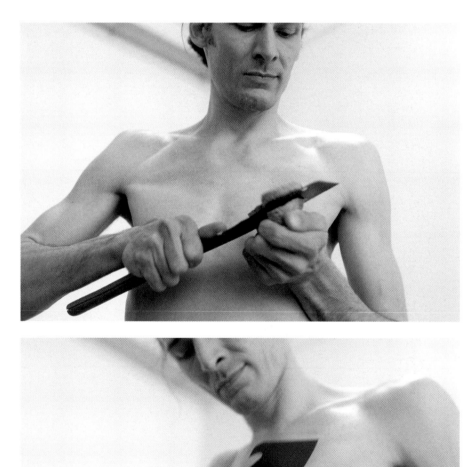

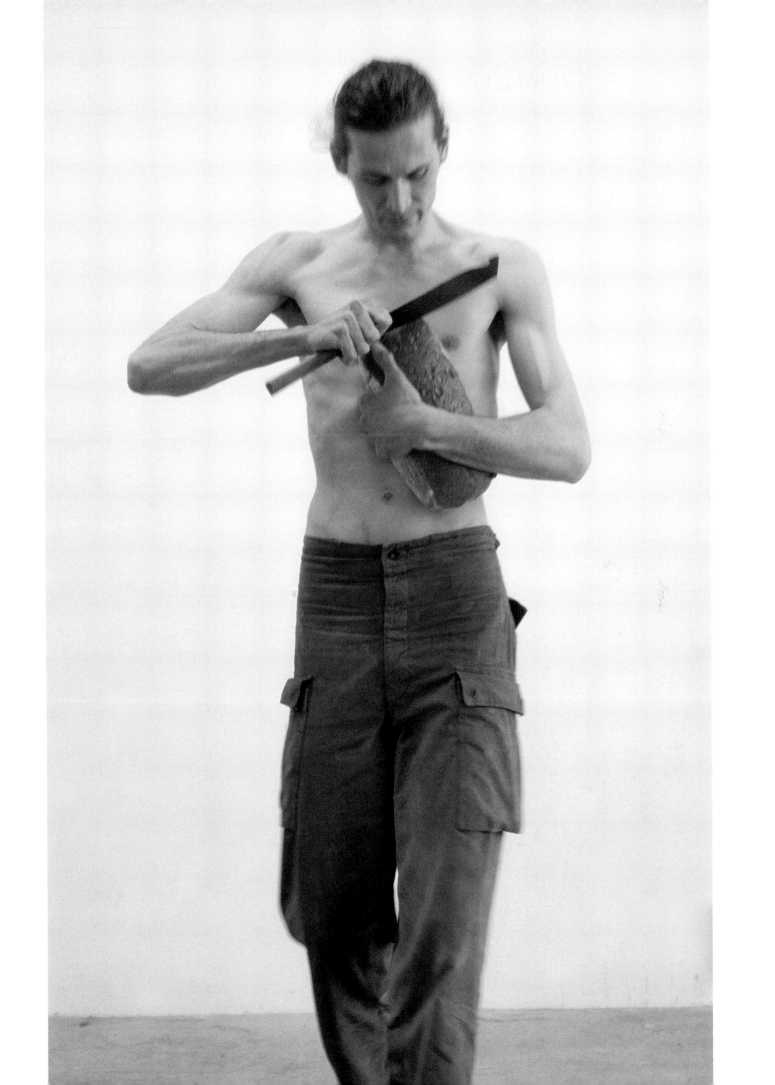

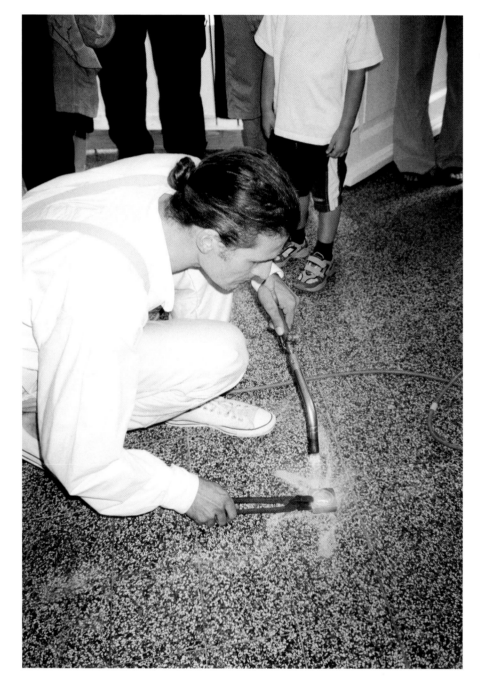

Silver, 2002
A virtual sculpture to mark a territory
Abgebrannt, Galerie Obornik, Hildesheim,
Germany, 2002

I enter a dark room with some tools; a gas bottle,
an electric drill, some pliers and a crucible. I
drill a hole into the floor. Then I light a gas flame
and start to melt pieces of silver in the crucible,
which I hold with the pliers. When the silver is
blazing hot and melted, I pour it into the hole.
The silver disappears. Nobody can find it there
unless they destroy the floor. It will stay a sign in
the minds of the spectators but others will never
notice whether it is there or not.

Tree, 2002
Duration: 20 min.
Cleaning the House workshop, Antas de Ulla,
Spain, 2002

I stand between trees with buried feet. I hum
with a very deep voice. The public can hear and
feel the vibrations of my body.

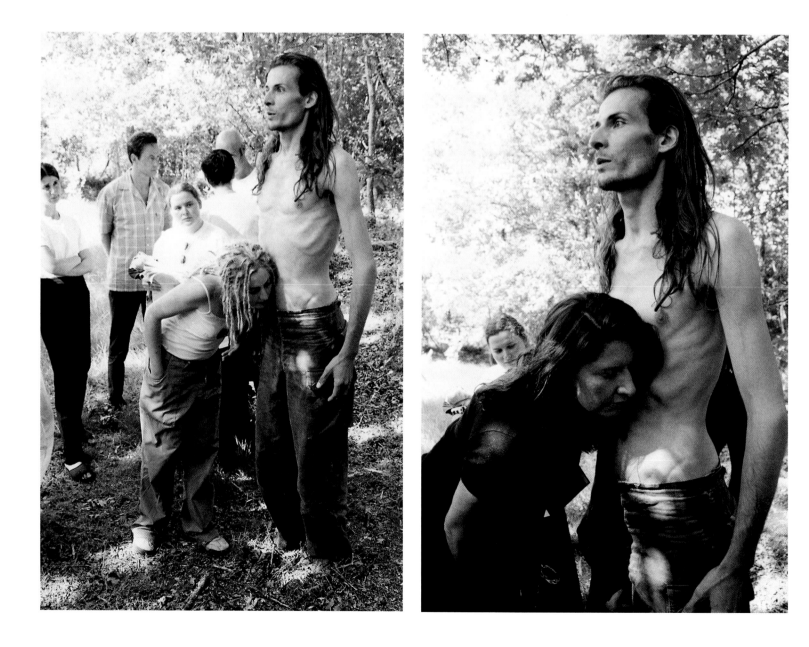

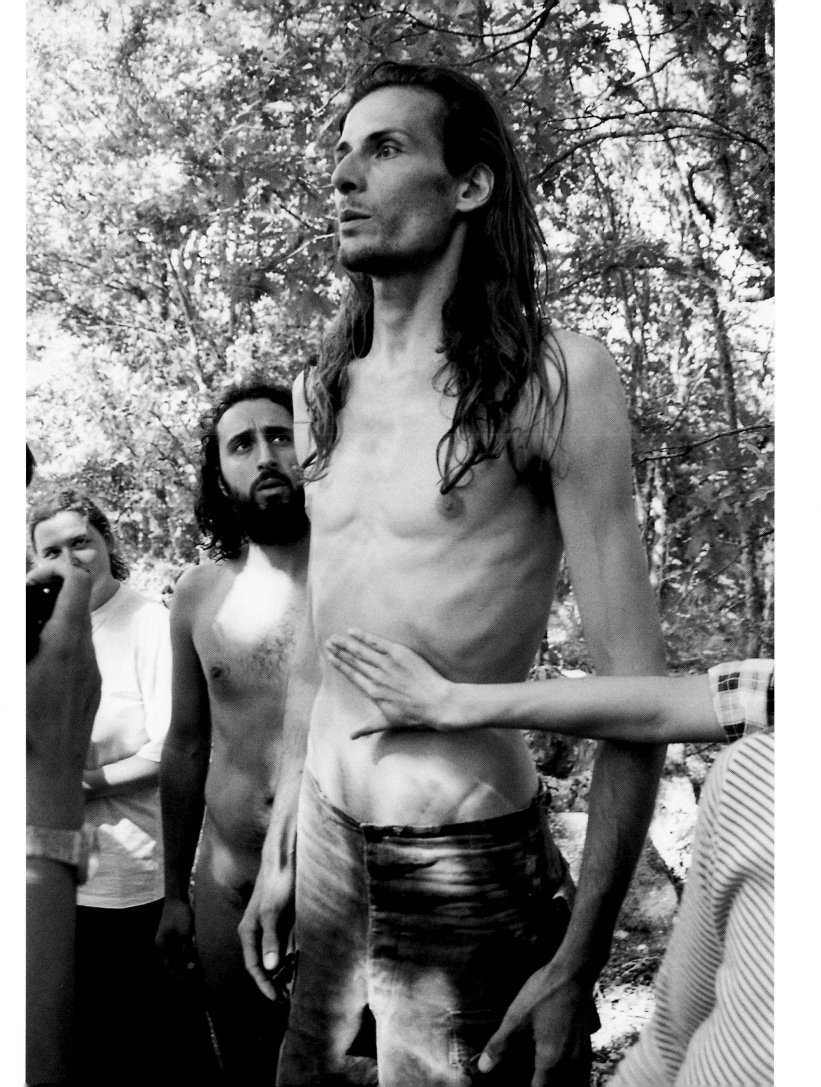

Bullets, 2003
Duration: unlimited
Hoschschule für Bildende Künste, Germany,
2003

Thirteen people aged between fifteen and
seventy-six are sitting on the floor around nine
camping stoves, which are placed randomly
within the room.
Using these stoves, the participants melt lead.
The lead is then poured into bullet moulds.
An old man collects and lubricates the bullets.
The performance is finished when there is no
more lead.

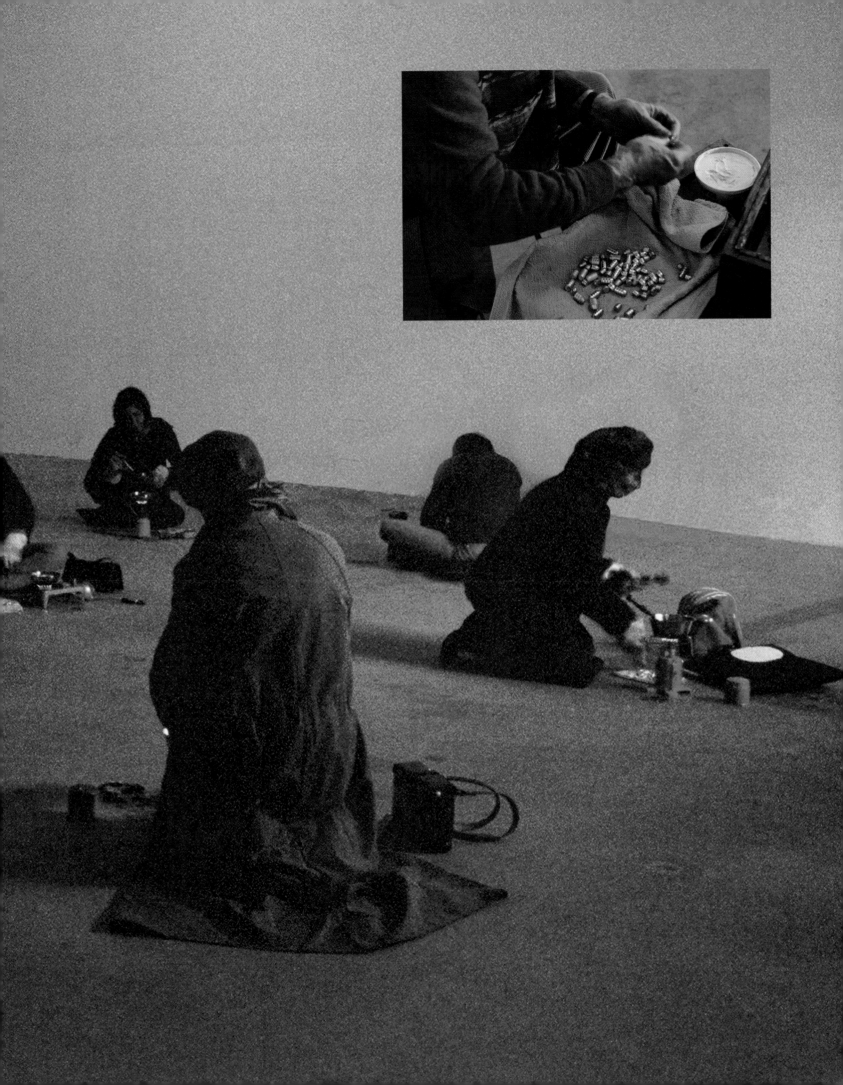

Dorte Strehlow

The biggest provocation today is silence.
Silence makes space.
Space for thoughts, interpretations, reactions.
This sensible occurrence is a kind of
interhumanity which is seldom today and for
which I am longing.
The aim of my work: levitation.

Levitation, Second Try, 2003
Duration: 2 h.
Pack of cards and carpet
Hochschule für Bildende Künste, Brauschweig,
Germany, 2003

I try to build up a house of cards, which is
collapsing all the time.
Patience. Timelessness. Never giving up.
Hopefully exercising. One day making the
carpet fly.

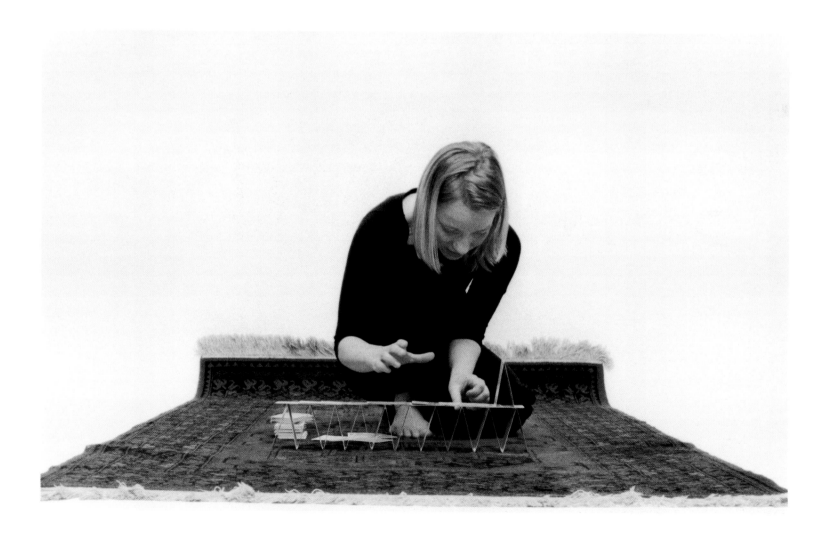

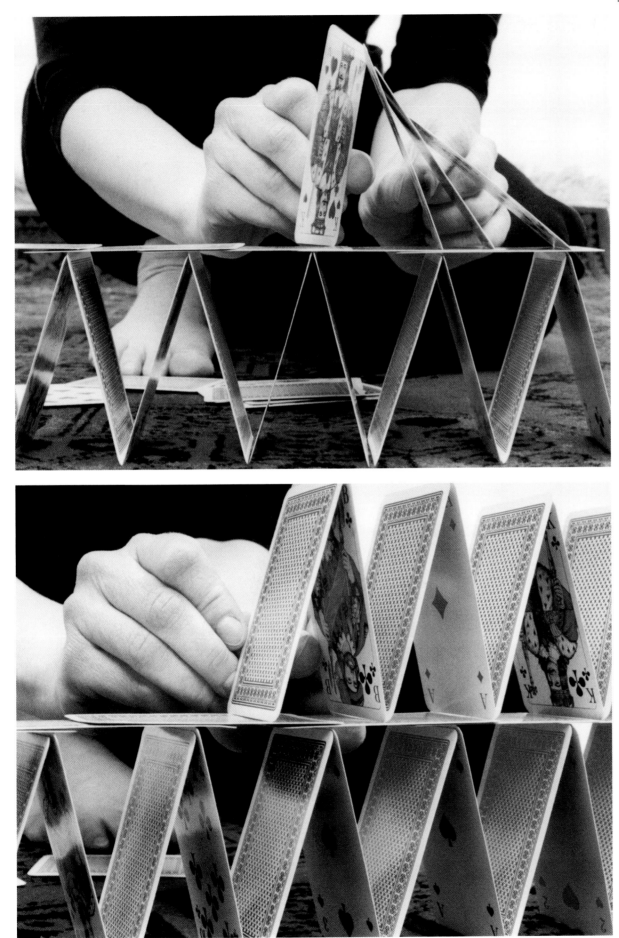

Diamant, 1999
Duration: 15 min.
50 kg flour of the brand Diamant
Hochschule für Bildende Künste, Braunschweig,
Germany, 1999

I try to carry 50 kg of flour from one place to another.

Fighting with absurdities. Making energy visible. Measuring power. Measuring energy. The weight of my body is the equivalent of two sacks of flour. Am I strong enough for myself?

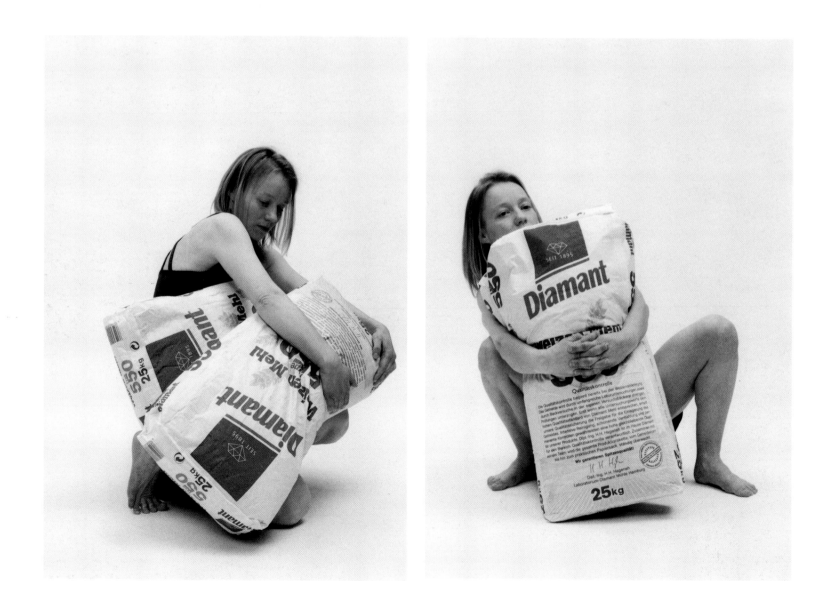

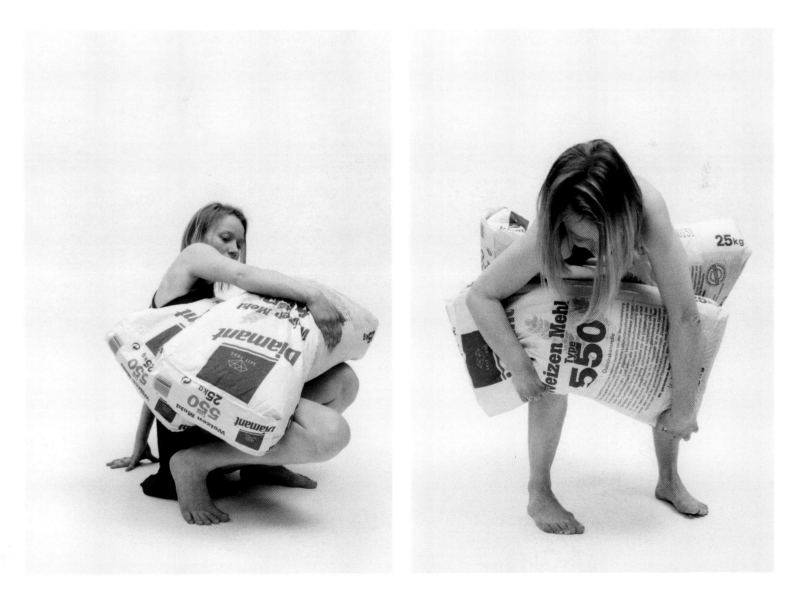

Queen Bee, 2002
Duration: 2 h.
Honey
Common Ground, Landesvertretung
Niedersachsen and Schleswig-Holstein, Berlin,
Germany, 2002

I lie on a table. Above my mouth hangs a glass
bottle filled with honey.
Honey flows from the bottle into my mouth
and from there onto the table and from there
further on the floor.

Empty and full.
Filling emptiness.
Full of emptiness.

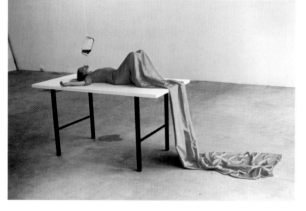

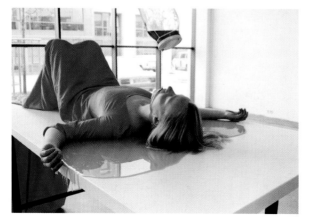

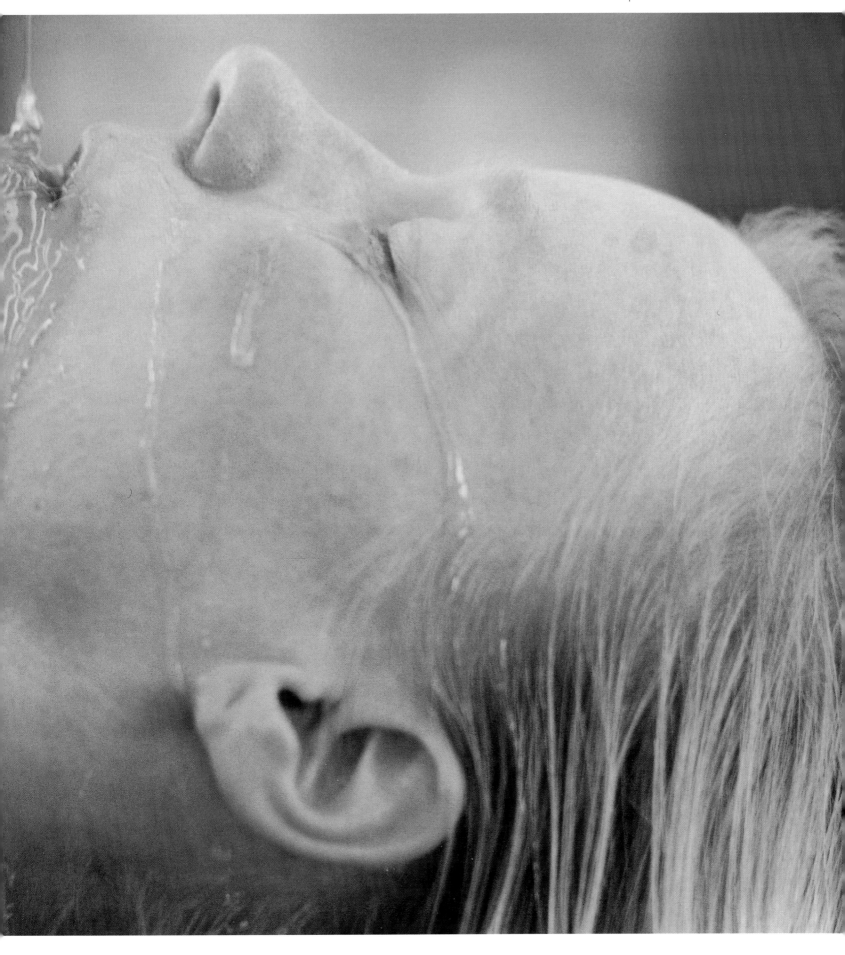

Crossing Energy, 2003
Duration: 3 h. 15 min.
As Soon as Possible, PAC, Padiglione d'Arte
Contemporanea, Milan, Italy, 2003
Recycling the Future, 50. Esposizione
Internazionale d'Arte La Biennale di
Venezia, Venice, Italy, 2003

I collect smashed glass. Every little fragment.

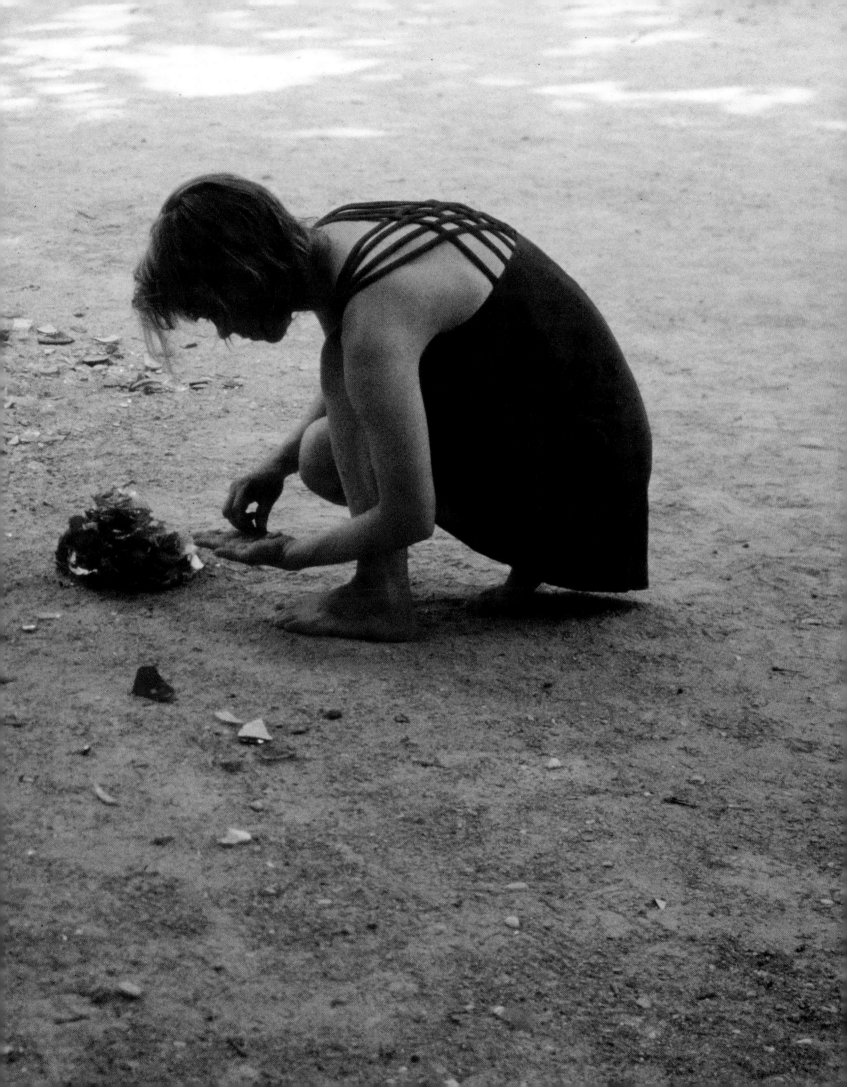

Melati Suryodarmo

I intend to touch the fluid border between the body and its environment through my artwork. In my performances, I aim to create a concentrated level of intensity without the use of any narrative structures.
I believe that the nerve system contains the capacity to absorb our particular environment. Talking about politics, society or psychology makes no sense to me if the nerves are not able to digest and understand the information.
I love it when a performance reaches a level of factual absurdity.

The Promise, 2002
Duration: 2 h. 20 min.
Galerie Gedok, Stuttgart, Germany, 2002
Prêt-à-Perform, Viafarini, Milan, Italy, 2002
Body Basics I / Body Basics II, Transart 02, Klanspuren Festival, Fortezza, Brixen, Italy, 2002
Common Ground, Landesvertretung Niedersachsen and Schleswig-Holstein, Berlin, Germany, 2002
Performance Art Nord Rhein Westfalen, Maschinenhaus, Essen, Germany, 2003

It is a distance far away, to get to the end of meaning and to become something else. Once I thought that I might be at the edge of this search. I was not. Then the situations changed, and made me sure that I had found it. But it was only my emotion.
When I decided to change my way of getting the meaning, it did not help me to get closer to it. Illusions figure out my points of view. Is it a dreamland where I am living?

In Java, we have a very famous idiom of "eat the liver!", which has always been translated as being introverted, having a problematic life and not speaking what he or she feels. Liver has its organic function, which conserves all the bad stuff of the body. Eating your own liver means bringing your own life into death.
Hair is the crown of a woman, which has a strong sexual attraction or seductive quality. I intend to prolong and spread out the meaning of beauty in women's hair, by using deconstructive actions and objects. As the hair has its extreme length, it destructs the border between all values of elegance and monstrosities. I mix up the images of female evilness and elegance. It is important for me, to experience the transformation of my personality as a female and as an evidence of cross-cultural experience.

In the performance, I hold a raw liver in my arms and change position, inspired by the icons and gestures from ancient depiction of women in sculpture and painting from the Renaissance time.

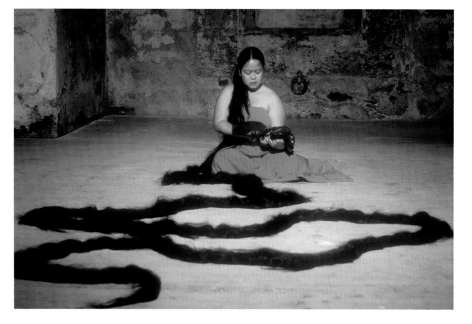

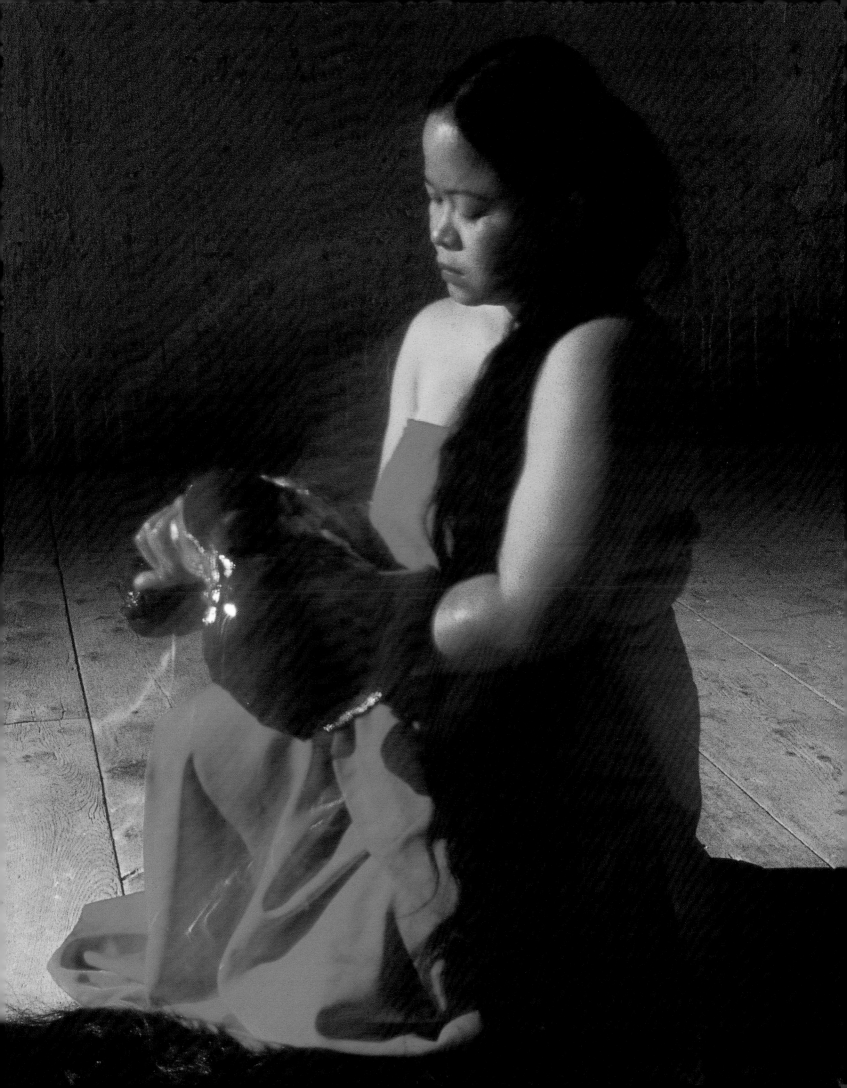

Der Sekundentraum, 1998
Duration: 1 h.
Hundreds of my own clothes
Zwischenräume – Finally, Kunstverein
Hannover, Hanover, Germany, 1998
2nd Performance Festival Odense, Odense,
Denmark, 1999
Healing Theater, Cologne, Germany, 1999
Indonesian Live Art, Gallerie Mein Blau, Berlin,
Germany, 2001
Music: "Bei mir bist du schön," Andrew Sisters

Hundreds of clothes of various colours are lying
on the floor. I pack and fold the clothes and pile
them up one after another. Then I mess them up.
I take off the white clothes I was wearing at the
start and begin to wear the clothes that are lying
on the floor. I put them on my body one after the
other until I become fat and inflated. This is the
transformation into grotesque.

There are stories, which I will never forget until
the end of my life. There are the paths of each
story, which I will never be able to erase. The
line of construction, the construction of a rule,
the rule of conjunction, the conjunction of
situations, the situation of stimulations, the
stimulation of destructions, the destruction of
constructions: all return to the beginning again.

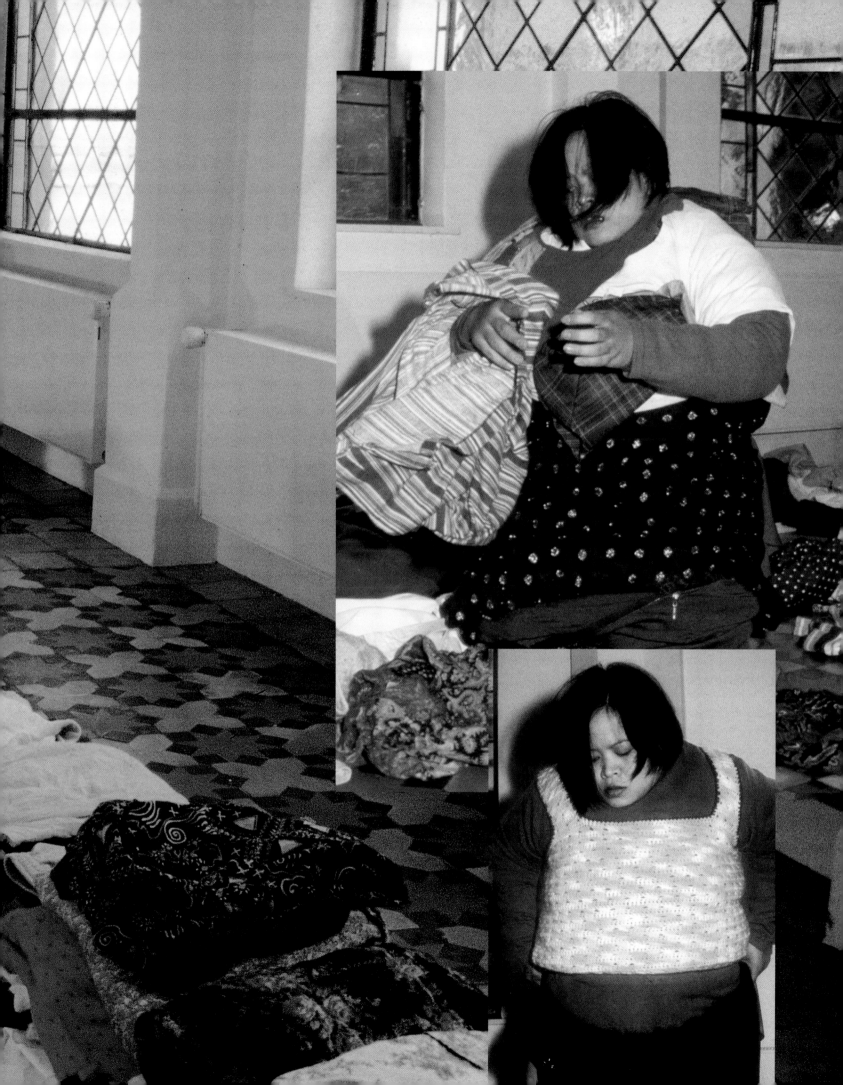

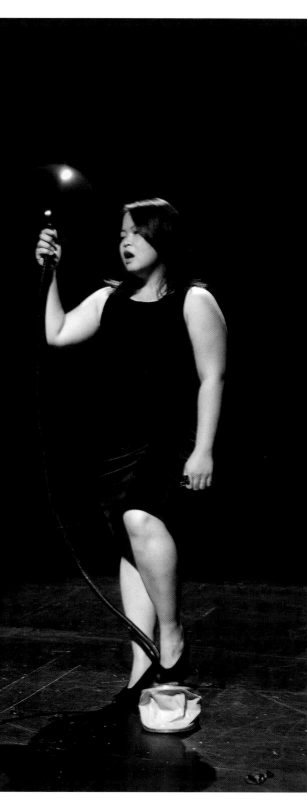

LOVE ME TENDER
LOVE ME SWEET,
NEVER LET ME GO
YOU HAVE MADE
MY LIFE
COMPLETE, AND I
LOVE YOU SO
LOVE ME TENDER
LOVE ME TRUE,
ALL MY DREAMS
FULFILLED
FOR MY DARLIN I
LOVE YOU, AND I
ALWAYS WILL

LOVE ME TENDER
LOVE ME LONG,
TAKE ME TO YOUR
HEART
FOR ITS PLACE
THAT I BELONG,
WE'LL NEVER BE
APART
LOVE ME TENDER
LOVE ME TRUE,
ALL MY DREAMS
FULLFILED
FOR MY DARLIN I
LOVE YOU, AND I
ALWAYS WILL

LOVE ME TENDER
LOVE ME DEAR,
TELL ME YOU ARE
MINE
I'LL BE YOURS
THROUGH ALL
THE YEARS, TILL
THE END OF TIME
LOVE ME TENDER
LOVE ME TRUE,
ALL MY DREAMS
FULLFILLED
FOR MY DARLIN I
LOVE YOU, AND I
ALWAYS WILL

ELVIS PRESLEY

Love Me Tender, 2001
Duration: 10 min.
Hochschule für Bildende Künste, Braunschweig, Germany, 2001
Get that Balance, National Sculpture Factory, Opera House / Half Moon Theater Cork, Cork, Ireland, 2001
Marking the Territory, Irish Museum of Modern Art, Dublin, Ireland, 2001
Body Basic I / Body Basics II, Transart 02, Klanspuren Festival, Fortezza, Brixen, Italy, 2002
Braunschweiger Kulturnacht, L.O.T. Theater, Braunschweig, Germany, 2002

This work articulates my contradictory feelings about love, on a private scale and on a general scale, pronounced through the perfect love song of Elvis Presley. As I can not articulate anymore what real love means, I am supported by the lyrics of this socially kitsch song, in expressing my feeling of love. As I lose my own understanding, I still feel secure because the common understanding can bring a bridge through its perfect articulation. This is a sign of disability in searching for the truth.

In the performance, I sit in the dark until a spotlight turns on. I hold twenty black balloons with my left hand. With my right hand, I hold the edge of a pump. I place a balloon on the pump nozzle and start pumping. I sing "Love Me Tender." I stand up and slowly move my hips. The balloon becomes bigger and bigger until it explodes. I place another balloon on the nozzle and continue the same action, until the song is finished. After the last explosion, I smash everything on the floor and leave the space.

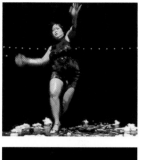

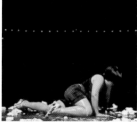

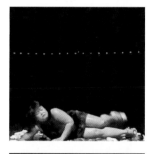

EXERGY – Butter Dance, 2000
Duration: 20 min.
Performance Passing Through, Gedok, Stuttgart,
Germany, 2000
Ins, Maximiliansforum, Munich, Germany, 2000
Visible Differences, Hebbel Theater, Berlin,
Germany, 2000
Spot + Places, Performance Congress, Healing
Theater, Cologne, Germany, 2000
Fingerspitzengefühle, Galerie der Stadt
Sindelfingen, Sindelfingen, Germany, 2001
Hochschule für Bildende Künste, Braunschweig,
Germany, 2001
Polysonneries, 2nd International Performance
Festival, Lyon, France, 2001
Von weiß-rosa zu rot, Luther Turm, Cologne,
Germany, 2001
Festa dell'arte, Aquario di Roma, Rome, Italy
2001
Marking the Territory, Irish Museum of Modern
Art, Dublin, Ireland, 2001
Live Art brr, Teatro Carlos Alberto / Teatro
Nacional de São João, Porto, Portugal, 2003
4th International Performance Festival Odense,
Odense, Denmark, 2003
Music: Daeng Basri Sila and Khaeruddin, drums
of Makassar
Video still: Kristian Petersen and Ruth Hutter

There are moments
Which I never expect to happen
Which exploded when I lose my view
Which remain empty when I want to fulfil

An accident is just one moment
Silence is just one moment
Happiness is just one moment
This is just one moment
Being caught by the moment
Melati dances on the butter

I walk into the space towards the butter blocks
prepared already on the dance carpet.
I stand with my back towards the public. I then
turn to the front and step on the butter. I start
dancing, letting myself fall down if it happens,
trying to stand up again. This action is repeated
until I lose my energy. I take off my shoes, stand
up slowly and leave the space.

Trauma, 2003
Installation 13 min
Body Power / Power Play, Württembergischer
Kunstverein, Stuttgart, Germany, 2002
Meisterschule 2002, Hochschule für Bildende
Künste, Braunschweig, Germany, 2003
Kunstverein Wolfenbüttel, Germany, 2003

The video projection of the cock-fight runs on
the projections wall.
I appear with the sword on the right hand and
chicken fulfilled with coins on the left hand. I
move very concentrated with the music at the
background.

This work is based on the energy of fight. I am
focusing on the animalistic attitude of human
beings. Life goes up and down as the layers of
the earth like the layers of the body. Combining
the aesthetics of a cock-fight with the slow
motion movements, gives an image of being a
winner and at the same time poverty of soul. I
sometimes like to be forced to fight with the
realities of winning the goal and at the same time
facing my own poverty of my soul.

Lullaby for the Ancestors, 2001
Duration: 20 min.
L.O.T. Theater, Braunschweig, Germany, 2001
Marking the Territory, Irish Museum of Modern
Art, Dublin, Ireland, 2001
As Soon as Possible, PAC, Padiglione d'Arte
Contemporanea, Milan, Italy, 2003
video still: Reinhard Lutz

I enter the space leading a horse and walking in a large circle. I give the horse to the horse guard. I go to the place where the bucket is. I place my head inside the water and hold my breath. As soon as I get up again I pick up a whip and move to the centre of the space. I start to crack the whip several times, according to my feeling. I go back to the bucket and repeat again the action several times. Parallel to this action, the guard keeps the horse running in a circle while I am whip cracking, and keeps the horse static while I put my head into the water. After the last whip cracking, I leave the whip in the middle of the space and return to the horse. I leave the space together with the horse.

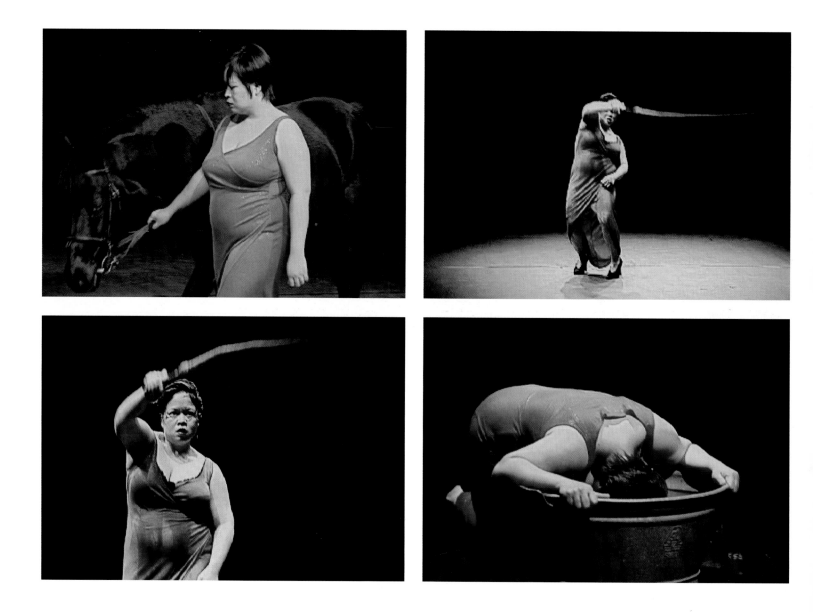

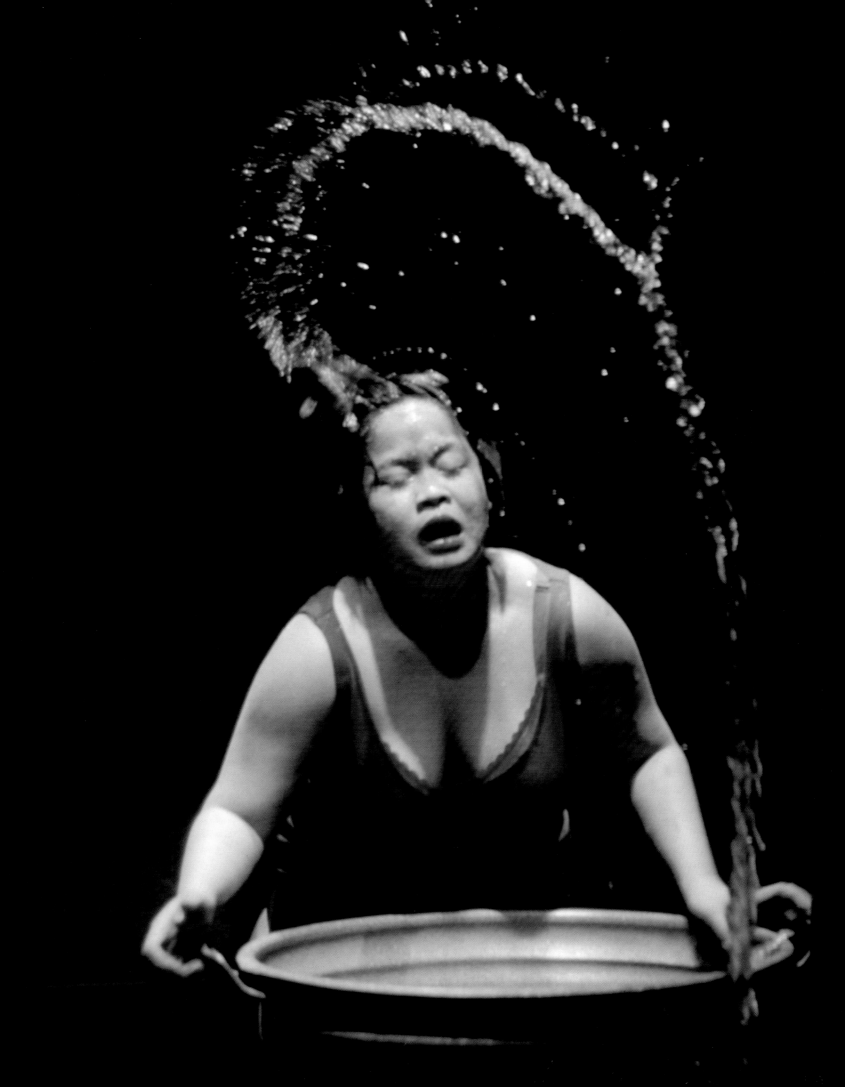

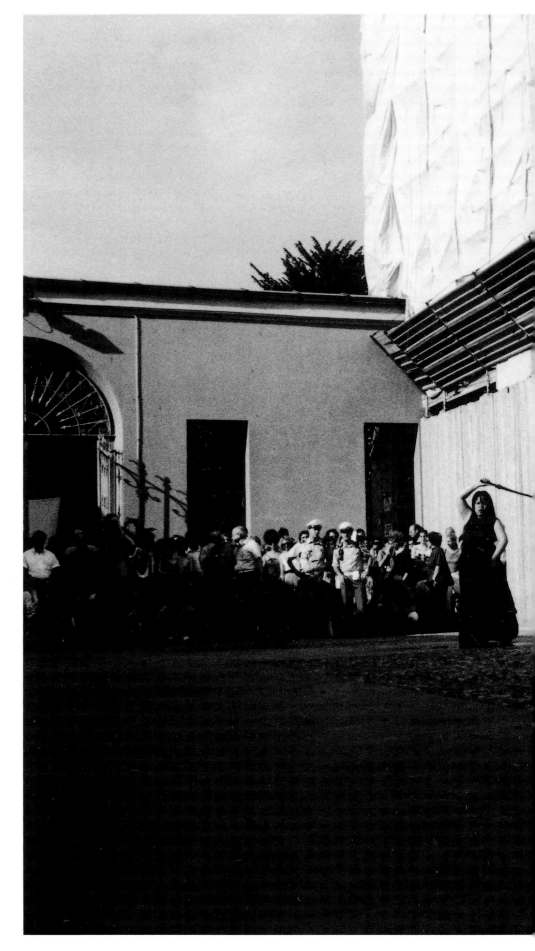

As Soon as Possible,
PAC, Padiglione d'Arte
Contemporanea,
Milan, Italy, 2003

Irina Thorman

In performance I work with moods. It is rarely the case that the acting person has a special proficiency. It is more that out of a meditative attitude an atmosphere can be built. The inner attitude is being turned inside out. Before I started performing I did a lot of drawing. Here it was not so much the outline that captured power, effort and pain, it was this search that turned me towards performance. Then as soon as I started performing, the body itself as a means of expression was no longer my interest. It was more the sociological and psychological states of being that grabbed me. I try to sense this through moving into or letting myself move into a certain attitude.

Red, yellow and blue built up the flag of *Join US Now*, a collaborative project with Roland P. Runge, questioning gestures of patriotism and nationality.
The longing for the fatherland awakens as a primary instinct. The outer staggers. The nation holds safety: it has no borders.

Collaborative statement Irina Thorman and Roland P. Runge.

Heitmatliebe III, 2001
Photograph

Before *Join Us Now* there was a series called *Heitmatliebe.* This series was the beginning of a debate with the idea of being bound to the construct of nationality. The work *Heitmatliebe III* is my statement in relation to the birth of a German human.

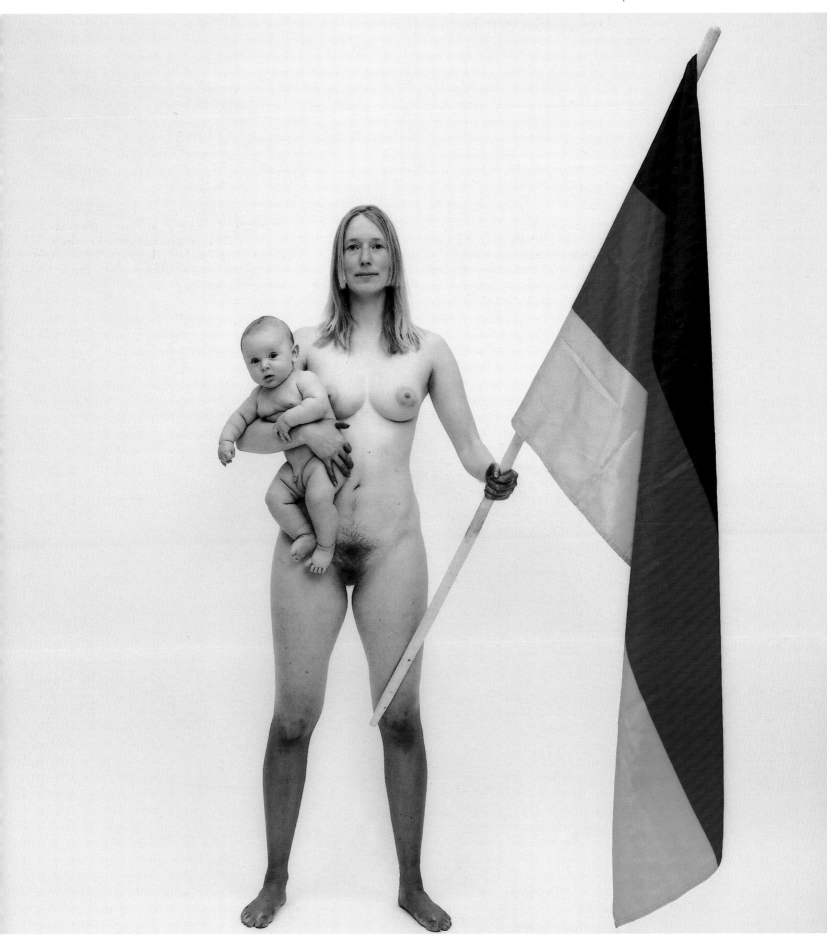

Join Us Now – Family, 2001
Collaboration with Roland P. Runge
Photograph with self-timer

Father, mother, child.
The stereotype of a family is standing in front of
the red, yellow and blue flag.

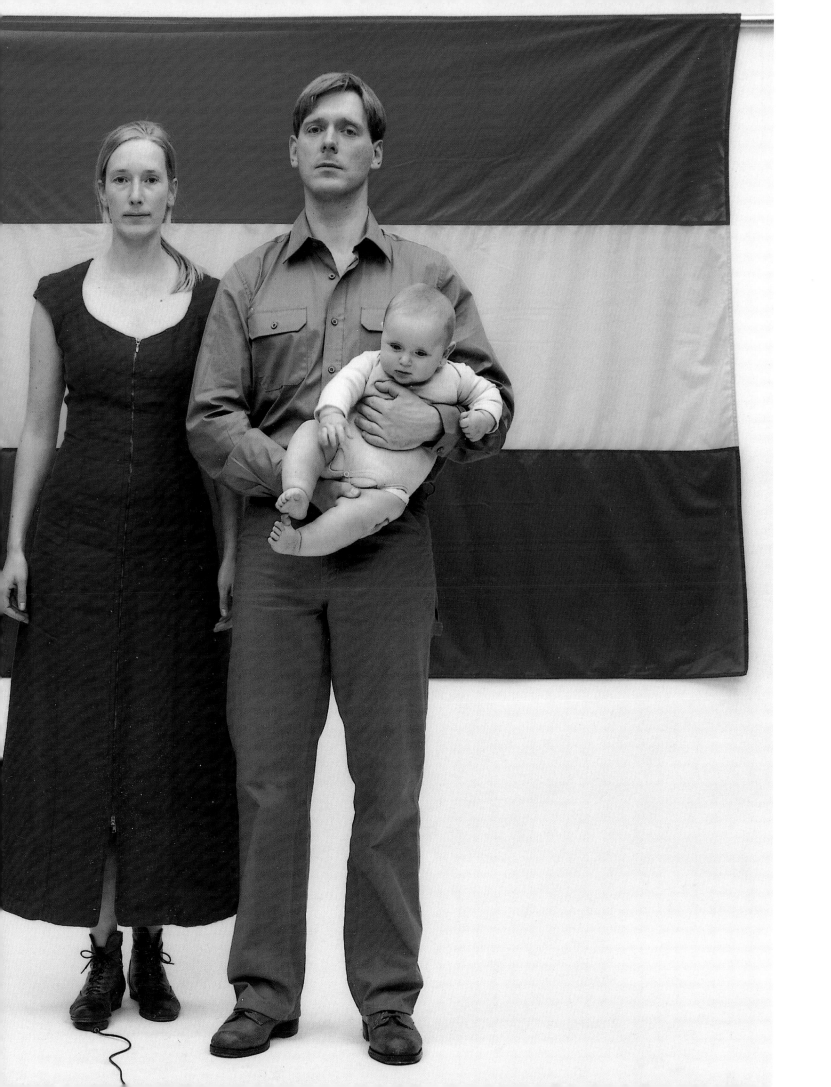

Join Us Now – Fatherland Has Burnt Down, 2002
Collaboration with Roland P. Runge
Duration: 1 h. 30 min.
Prêt-à-Perform, Viafarini, Milan, Italy, 2002

A woman in a dirty white dress is sitting on a
rocking-horse in front of a torn, wrecked and
burnt flag. The flag is sticking out of a heap of
burnt wood, ashes and coal. The woman is riding
on a floor covered with ashes and coal. The
woman is humming the children's song
"Cockchafer Fly".

Maikäfer flieg,
Dein Vater ist im Krieg,
Dein Vater ist in... land,
...land ist abgebrannt.
Maikäfer flieg.

Cockchafer, fly,
Your father's in the war,
Your father is in... land,
...land has burnt down.
Cockchafer, fly.

Join Us Now – Fatherland Song, 2003
Collaboration with Roland P. Runge
Living installation
Duration: 3 h.
As Soon as Possible, PAC, Padiglione d'Arte
Contemporanea, Milan, Italy, 2003

A woman in a long dress is standing in a big heap
of corn up to her knees. In her right hand she is
holding a flag.

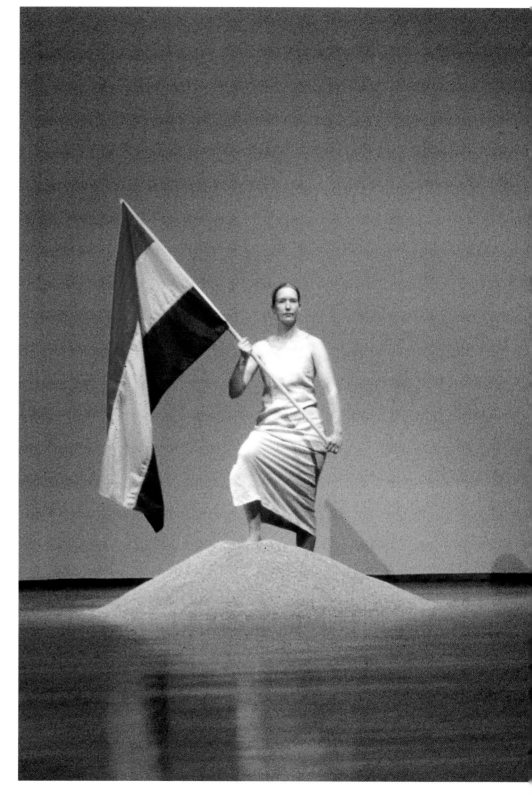

Ewjenia Tsanana

It's really worth it, to observe things as precisely as possible, and then talk about those things as simply as possible.

Weighted Body Parts, 1996-1999
An analysis of the theme of breasts and gravity. Slides, videos and an electronic piano

Since I cut my hair short, my breasts are the only parts of my body which are subject, unrestrained, to the forces of gravity. Hanging from my body, these weighted body parts constantly hamper me as I walk. They hit my upper body forcefully in a more or less rhythmic manner, reminding me of my materiality.

In the following pages:
Nana 1 and Nana 2, 1995
Photograph

A study in symmetry and identity.

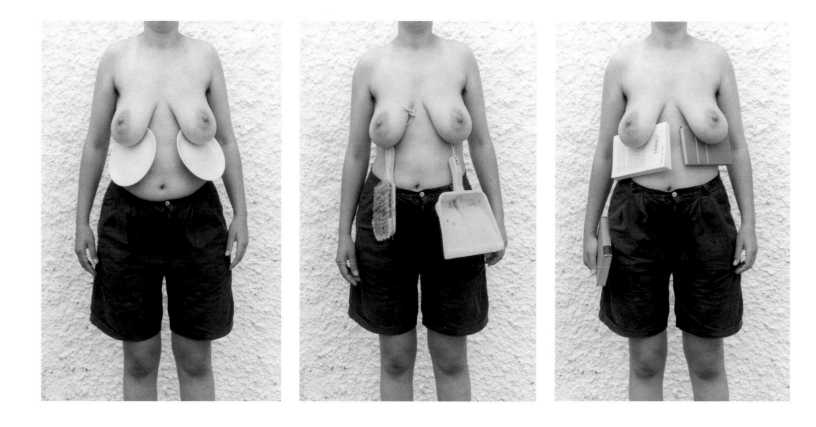

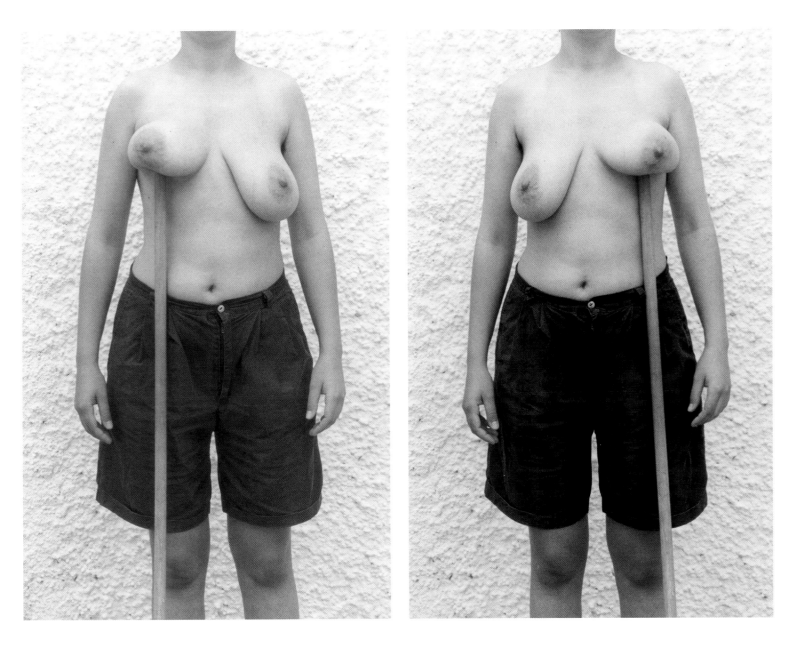

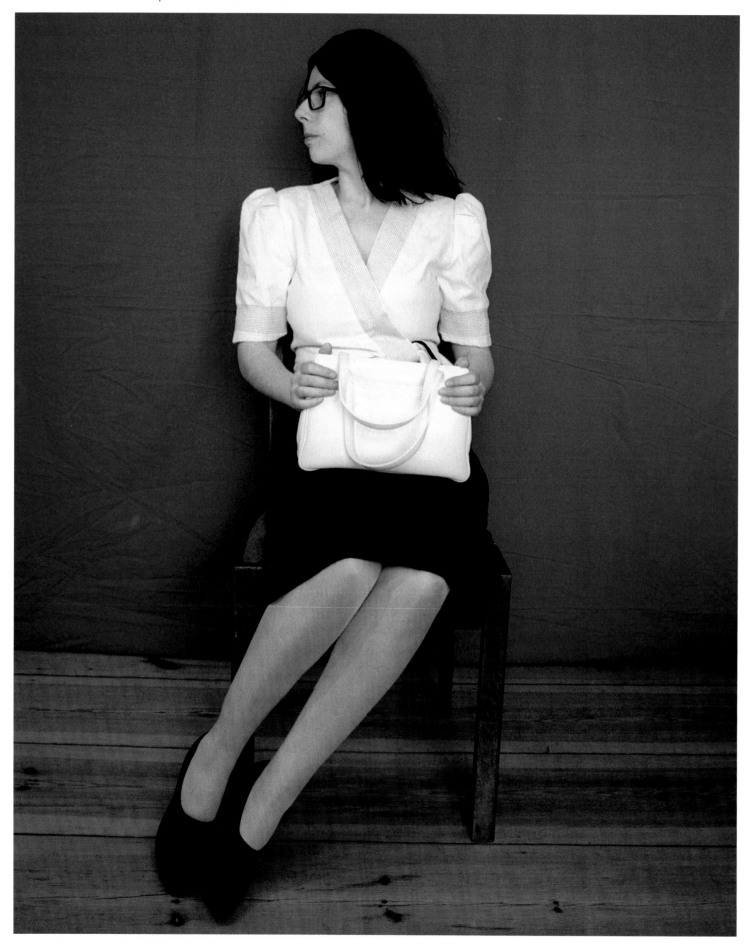

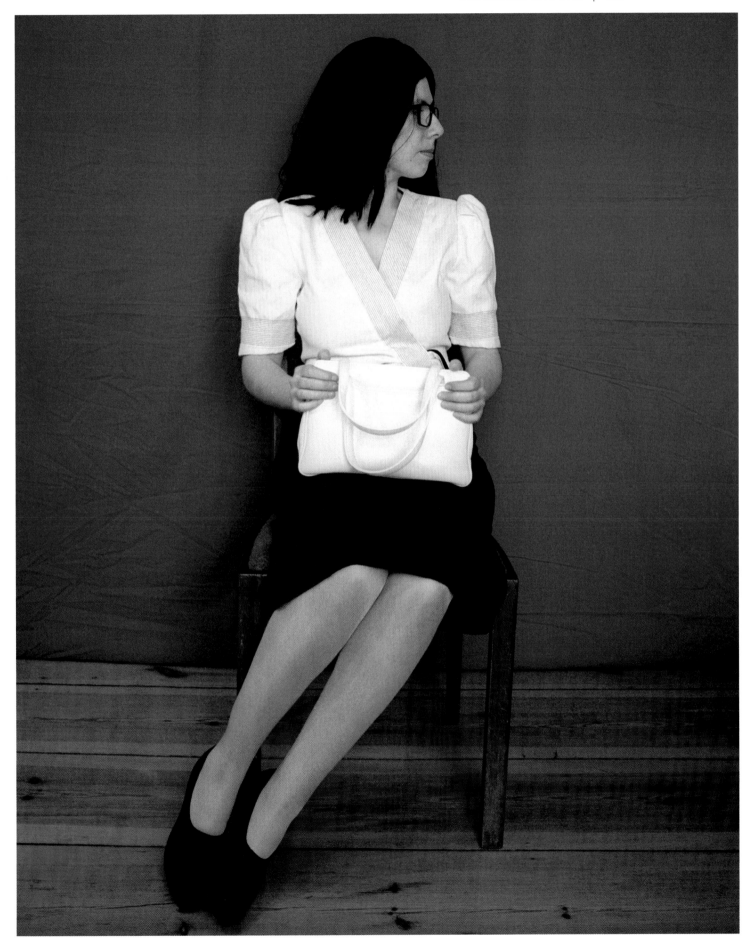

Frank Werner

For me "life" is a situation of endless work, where nothing allows us to rest in some sort of a fixed point of view or social philosophy. Out of this Western Protestant mentality I create performances, videos and room installations.
Using my relatives and aspects of my own story, I try to explain the big trap we are in as a single membership holder in this construction of social action.
The big trap is created out of our expectation of growing, exploring and developing, fed with traditions, fear and yearning.
Therefore my work often begins with an explosion or another sort of deconstruction,
to give a new point of structure and different behavior a chance. Even if it's useless, I try to give my best and do it again, do it again... do it again.
All of this is presented in some sort of glamorous way with pictures from spectacles and theatrical events, like we normally are used to deal with.

Interview, 2001
Video performance conceived as interview for a video catalogue
Digital video
Duration: 1 min.
Marking the Territory, Irish Museum of Modern Art, Dublin, Ireland, 2001

Text
Left Frank: Hello everybody. Hello Frank.
What are the most important aspects of your work?
Right Frank: Explosions.
Left Frank: What are you expecting from the audience?
Right Frank: Explosions.
Left Frank: What is the meaning of your performance?
Right Frank: Explosions.
Left Frank: OK, thank you very much, and bye.

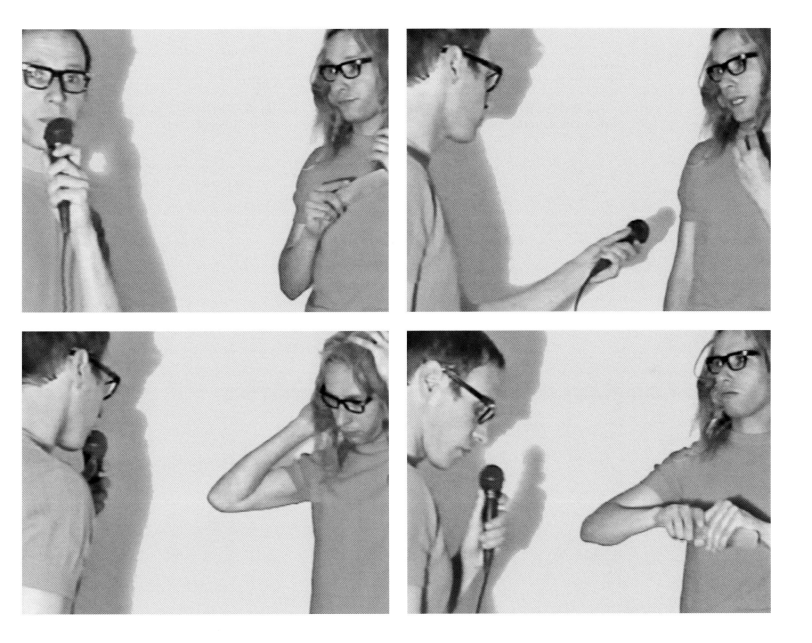

All About Nature
ALL ABOUT NATURE... sexy dance, 2002
Eisfabrik Hannover, Hanover, Germany, 2002
Me dancing on a metal bar under the condition
of a shooting graphic.
ALL ABOUT NATURE... opera, 1999-2002
Digital video
A study of a family under the condition of a
stage-based view.
ALL ABOUT NATURE... primary song, 1999
Digital video, looped
A staged study of a possible family background.
ALL ABOUT NATURE... gymnastic trainer, 1999
Digital video, looped
A lesson and study about schizophrenic
movements in relation to personal development.

Ingredients:

250 g butter
200 g sugar
1 sachet of vanilla sugar
some rum
salt
5 eggs
500 g flour
4 level teaspoons baking powder
milk
500 g currants
200 g candied peel

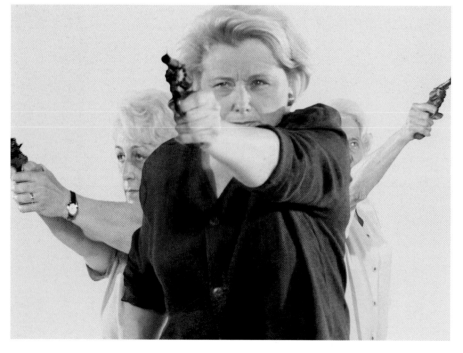

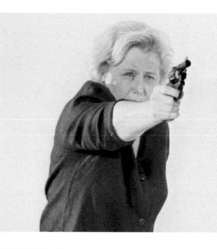

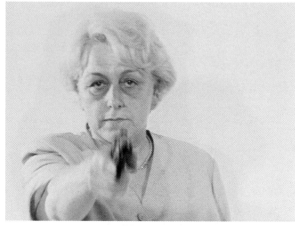

ALL ABOUT NATURE...
opera, 1999-2002

ALL ABOUT NATURE...
primary song, 1999

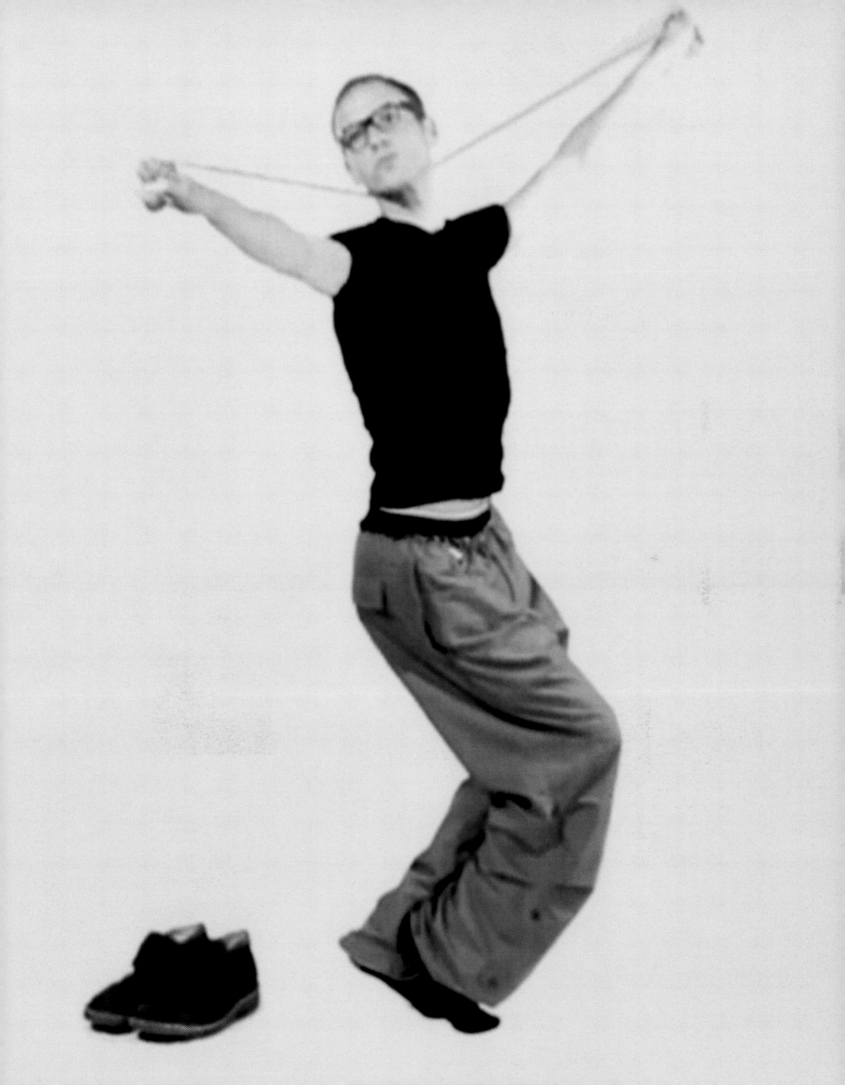

Cheerleaders, 2002
Video, looped

An endless video
screen as a portrait of
possible cheerleaders.
Female relatives waiting
and breathing with
pompons in their
hands.

Survival Training, 2001-2003

Various performances, installations and screens
under the conditions of survival training.

Over the past two years I have created
performances and video installations under the
conditions of never-ending survival training.
Survival training as some sort of live opera with
a singing choir, explosions, big-breasted women,
food, gun ballet, fireworks, video and live
effects... actually everything I need to make our
daily "live circle training" visible.

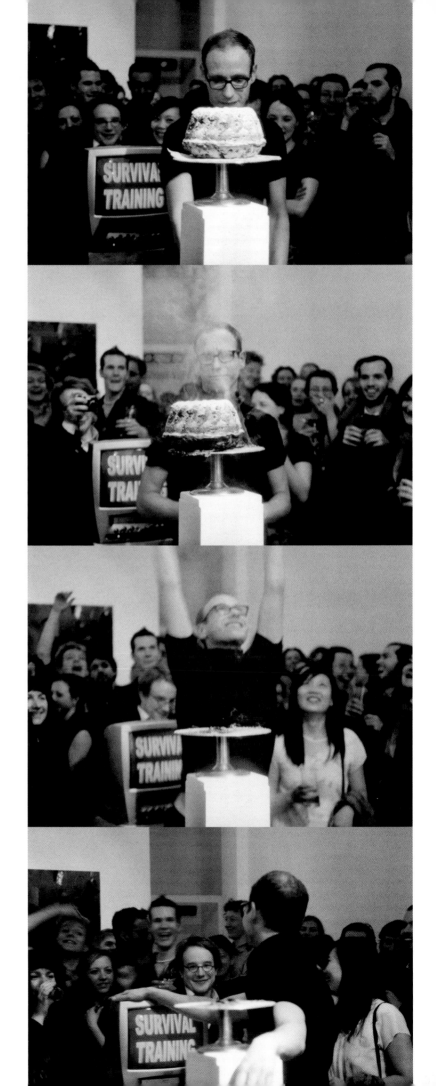

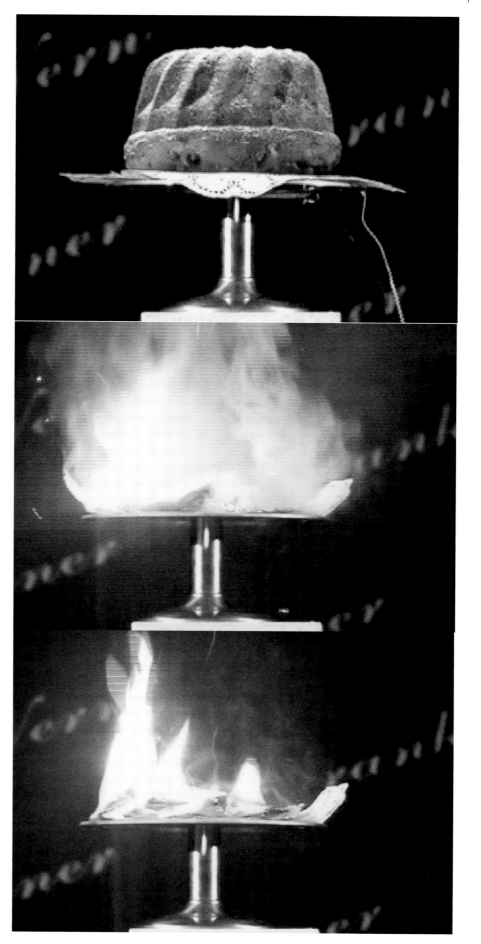

Susanne Winterling

My personal manifesto as an artist starts with the importance of creating, inventing and (maybe the simulation) of sensibilities. My work in video, film and performance images is based on movement in time and its possibilities. It aims to focus on moments of perceptual and sensual conscience. The minimal and moving images that I am composing live on the projection screen or as an experience in space want to open up the direct involvement of the viewer, even if it is contemplation. Usual ways of seeing and experiencing should be shifted. My work aims to find, select and put into a scene, the scenario which is usually very minimal and subtle. Then I choose and manipulate the way people should experience it. This abstract concern is realised in moments when the figure depicted is in a certain kind of dialogue with herself or the viewer or with a group of people. Documenting and putting those dialogues on stage or in a projection deck to bring these dialogues from an inner space to a form that can be experienced by everybody.

Drehen (Rotation), 2000
Installation / video projection, looped
photo: Susanne Winterling

The dream of flying. Using one's own body as a
propeller.
A movement study of the body machine.
Different moments of speed during a rotation,
longing to fly away.
Blue and white like the sky.
If we could only fly away, everything would be so
much easier.

A Swimmers's Doubt, 2002
Living sculpture
Body Power / Body Play, Württembergischer
Kunstverein, Stuttgart, Germany, 2002

This is a performance of a girl, (about 14-16
years old) in a swimming suit in front of a
projection on the floor. The projection shows a
swimming lane from a swimming pool. The girl
steps onto the jumping board overlooking the
projected lane. She does not jump in but turns
around after a few minutes and steps down to
repeat the same action as in a video loop.

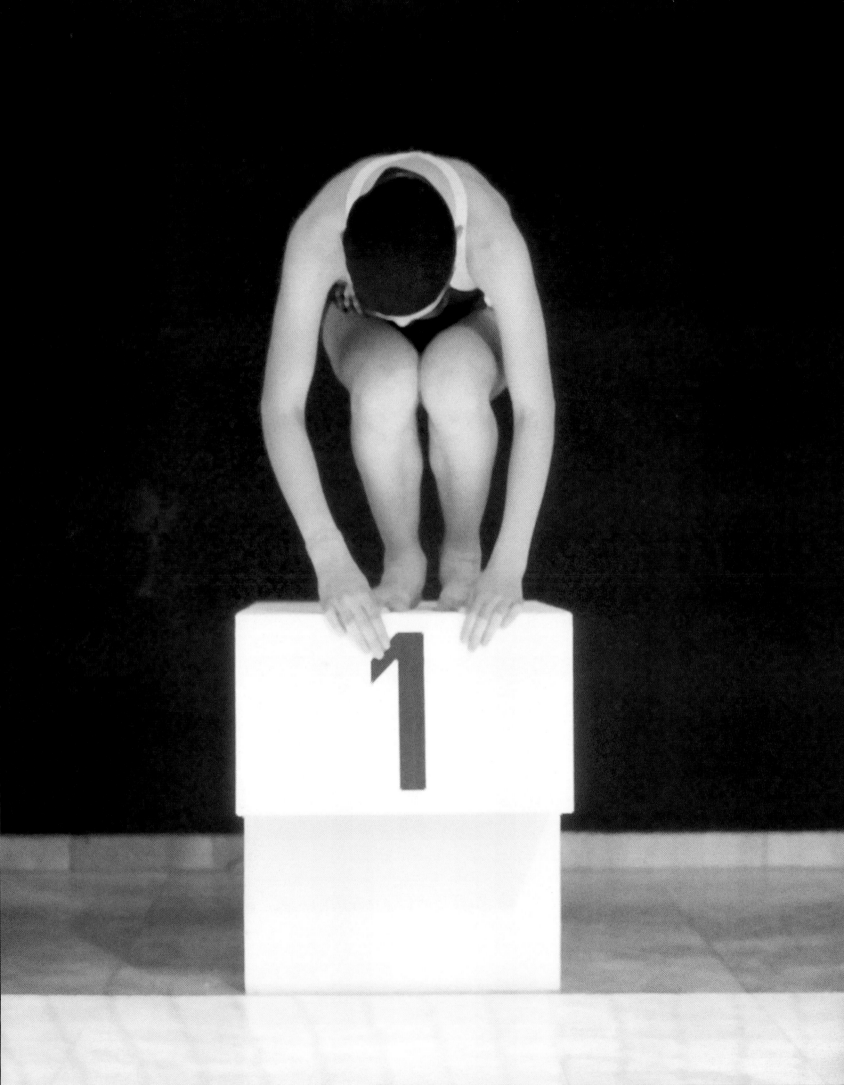

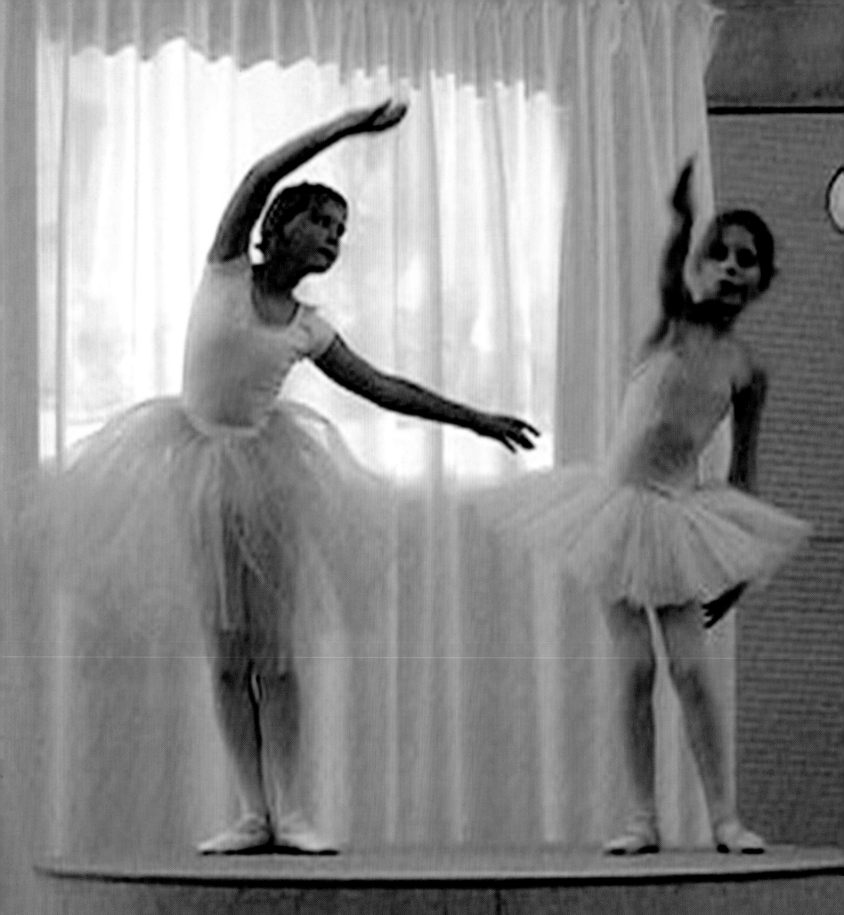

Girl's Dream, 2002
Living sculpture / video projection
Common Ground, Landesvertretung
Niedersachsen and Schleswig-Holstein, Berlin,
Germany, 2002

Girl's Dream is a performance of two ballet girls
dancing on a large circular plinth. Behind them
is a projection of dancing feet from *Romeo und
Julia.*
Staatsoper Berlin, Berlin, Germany, 2002

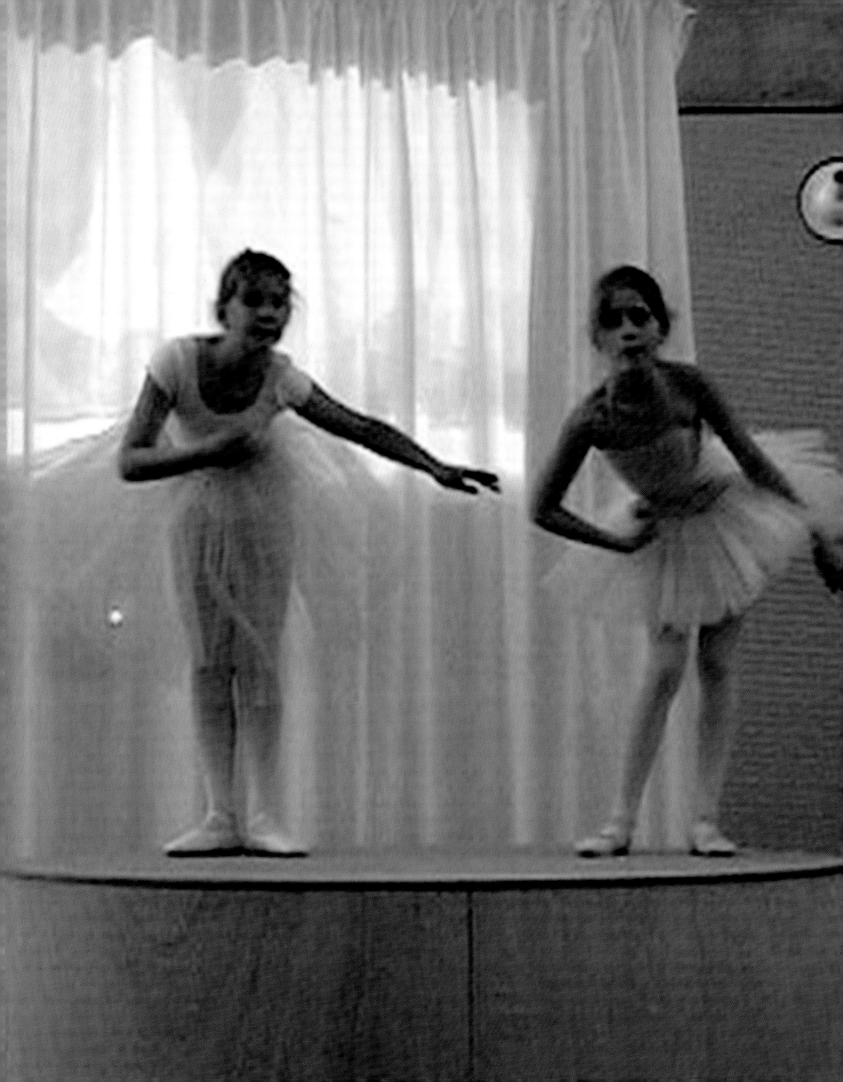

Straight Line, 2003
Performance / video projection
Rituale Adk, Berlin, Germany, 2003

Straight Line is a modern interpretation
of rituals. Our "new economy" society
invented new rituals. A performing young
woman kneels in front of an elegant table
on the floor.
On the shiny table is a projection of a white
line of powder. Using a credit card the woman
tries to make that line perfect. An endless
process because this is impossible.

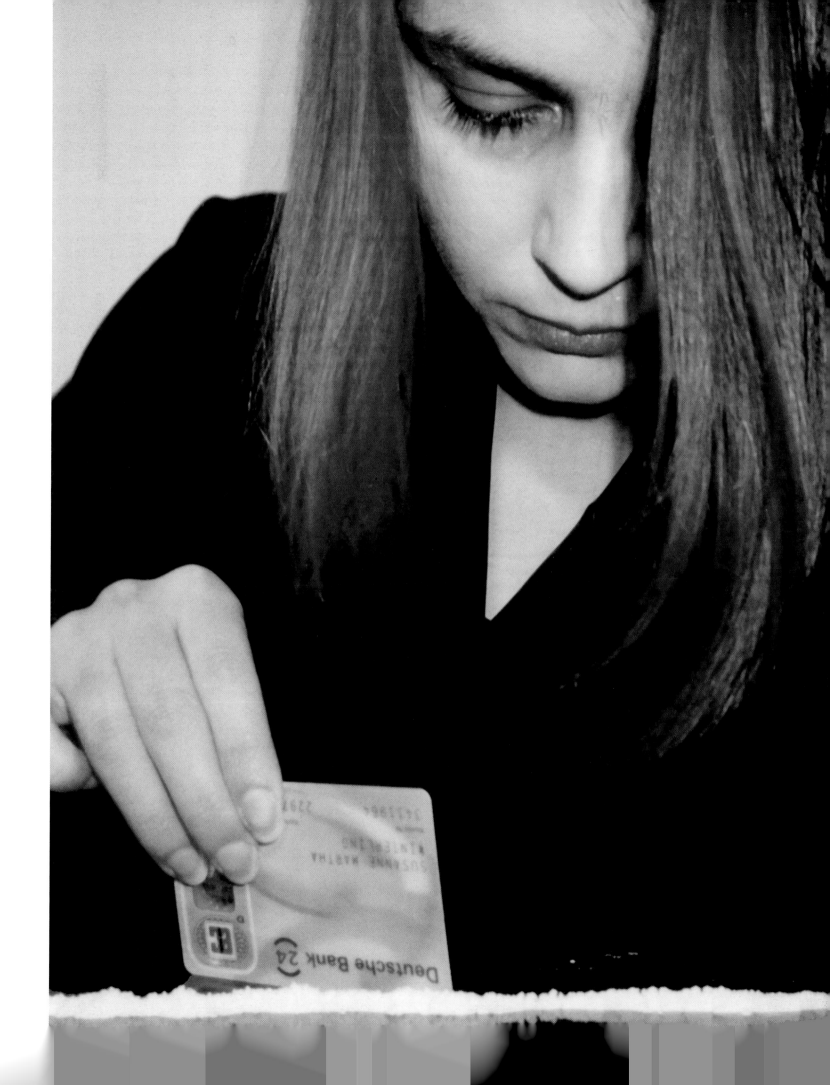

Global Players: You Raised Us to Riot – You Raised Us to Romance, 2003
As Soon as Possible, PAC, Padiglione d'Arte Contemporanea, Milan, Italy, 2003

Performers: twenty-five people dressed as seen in the image walk around the hall and the space in silent conspiracy. They have small stones and pieces of wood in their hands.
They suggest aggression but only in the viewers' mind.
They don't take any action apart from being around.

The performance uses the stereotypes and images of the protest culture, which is present especially in the anti-globalisation movement.
A group of people dressed in white and wearing a mask is among the audience of the opening. They have small pieces of wood and stones in their hands. Without talking or any kind of communication they walk around in silent conspiracy. Although they take no action, they represent the permanent possibility of aggression. But the expected violence and aggresion that might be perceived by the public is only imagined and triggered by former experiences.

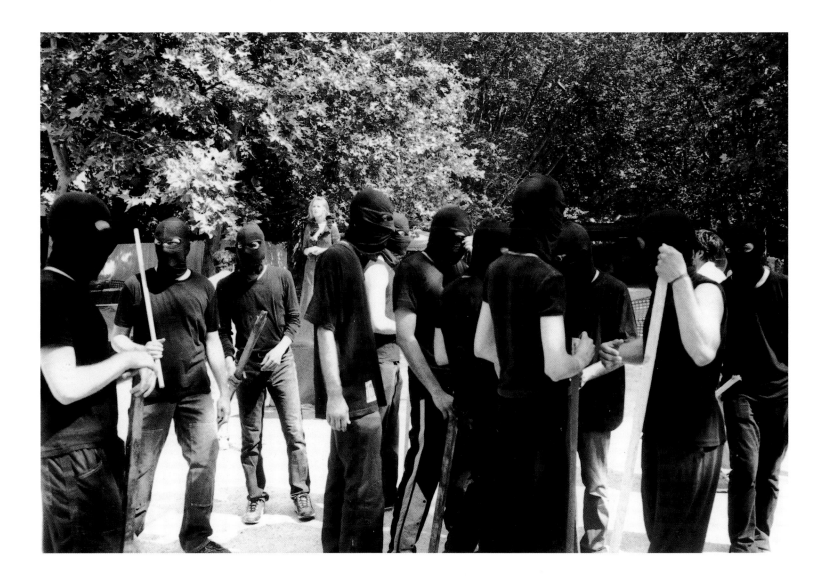

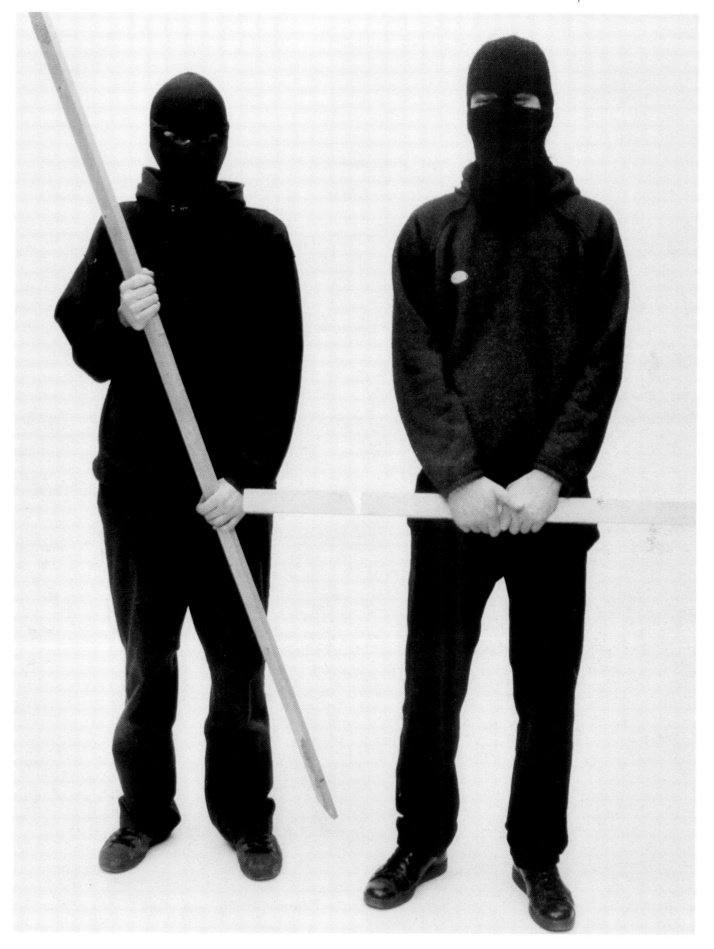

Herma Wittstock

The main focus of my work is to absorb energy and pass it on to the audience.
My body is my temple, it is at the centre of my work.
My work raises questions such as:
What basic needs do human beings really have and what are their / my limitations?
The body is put to the test. What interests me is the dividing line between strength and pain. For the most part, the audience is afforded a view of the dividing line. What they make of it is up to them. If they can find their own ideas and stimuli through the body, then so much the better.
An important question in most of my works concerns the kind of concentration that is required to prevent demanding or negative feelings from arising, and to be able to practise meditation instead, as well as how or whether I can achieve this.

Drink Ambrosia, 2001
Living installation
Duration: 2 h.
Marking the Territory, Irish Museum of Modern Art, Dublin, Ireland, 2001

In the living installation *Drink Ambrosia,* I wear a traditional German dirndl. I have my feet in a large bowl filled, according to the season, with oranges, strawberries, grapes and / or plums.
I sing Mozart's *Ave Maria* non-stop and use my feet to crush the fruit to juice.
Afterwards, I hand out the juice to the audience.
Drink Ambrosia is a work which appeals to the senses of the audience. An intense scent of fruit juice reaches the nose of the viewer.
The religious music makes the drink godly – ambrosia is the result.
In traditional clothing, traditional fruit pressing becomes a ritual. The audience is able to come and enjoy the sampling of the nectar of the gods, ambrosia.

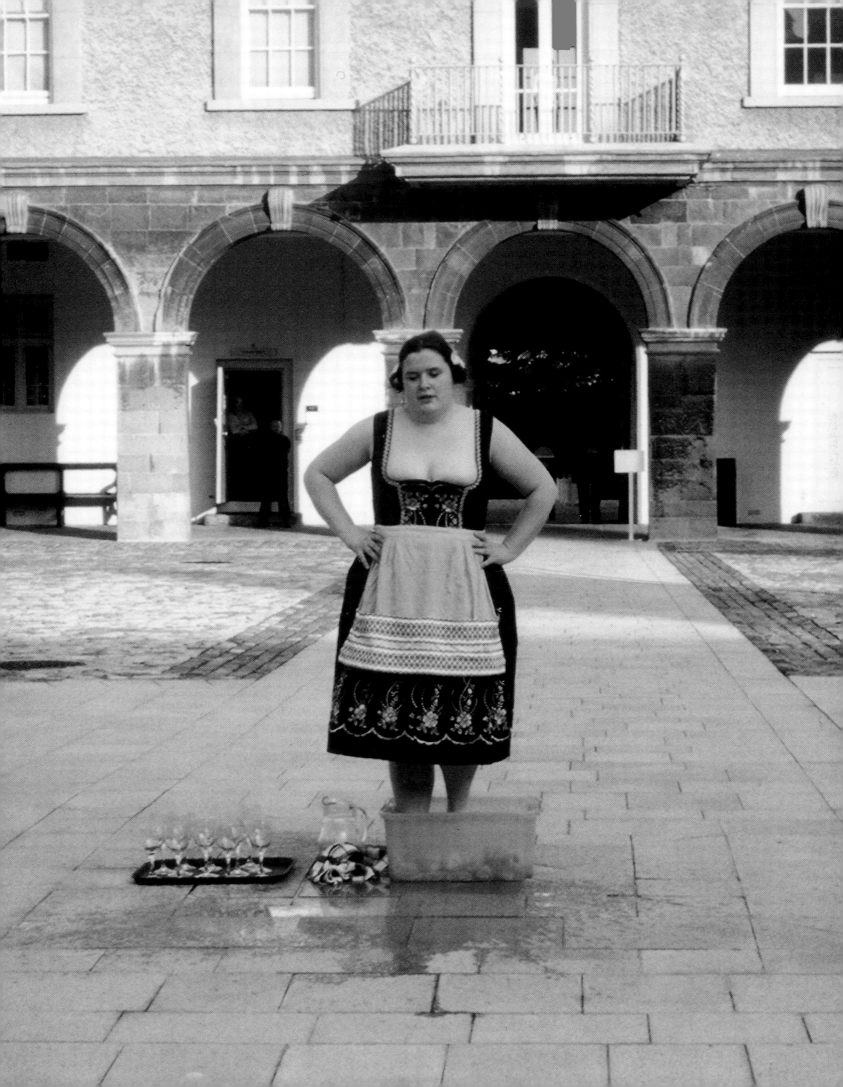

Sunday Bath, 1999
Duration: 20 min.
Scene: Brunswick
Zinc tub filled with water and nails
Hochschule für Bildende Künste, Braunschweig,
Germany, 1999

I gave the *Sunday Bath* performance on a
Sunday during the 2000 tour of the
Braunschweig School of Art. A zinc bath tub,
filled with water and containing many large nails
stands in the middle of the room. I am naked
and wash myself in the tub, which is too small,
using the nails and the water. My skin becomes
red with the scratching of the nails.
It is Sunday. We should cleanse ourselves, wash
the guilt away. And yet the crucifixion of Jesus
sticks in our minds. The nails cut my skin. I
want to wash myself, keep myself clean, but the
tub is too small.

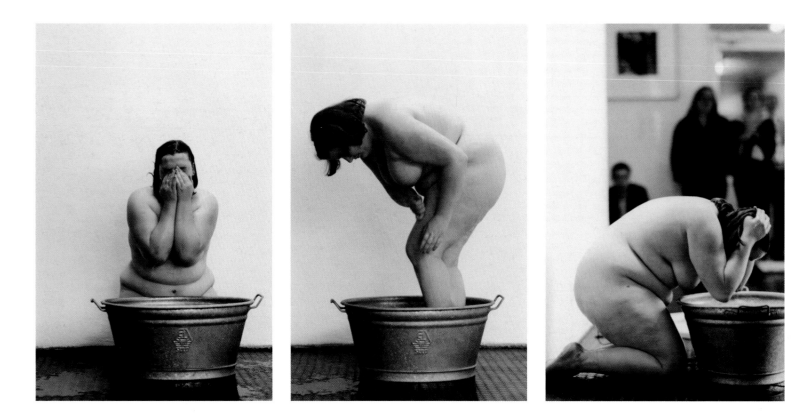

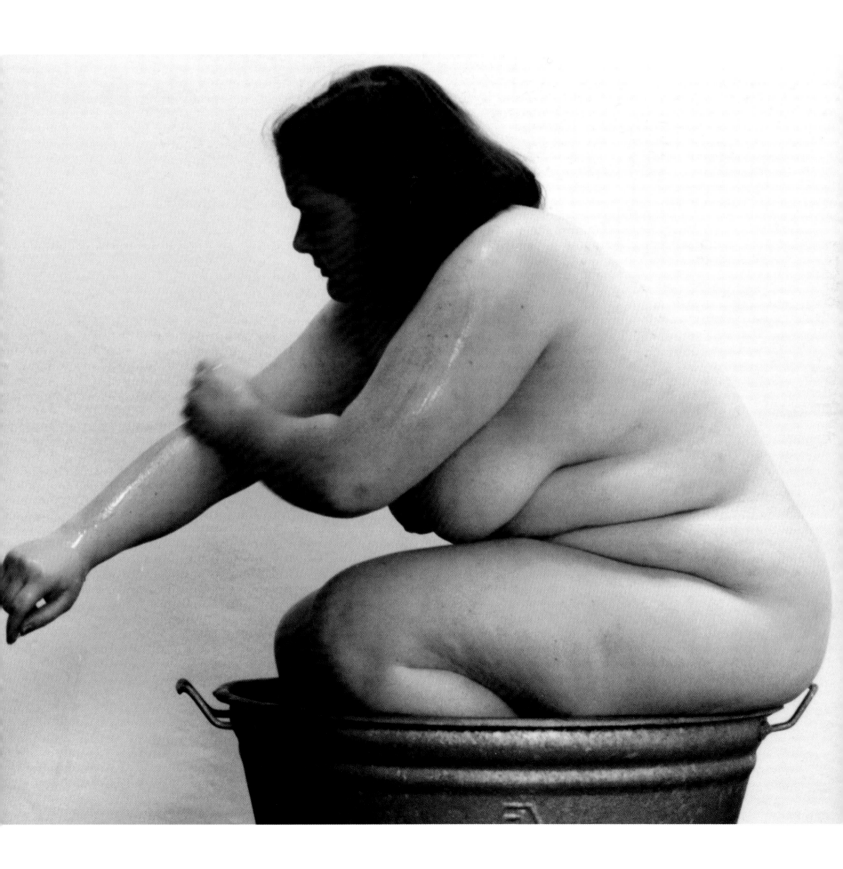

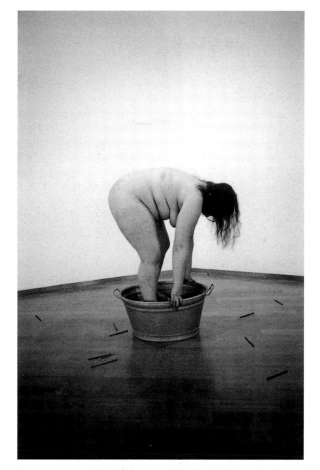

Sunday Bath, 2003
Living installation
Duration: 3 h.
As Soon as Possible, PAC, Padiglione d'Arte
Contemporanea, Milan, Italy, 2003

Sunday Bath is a durational performance.
(I can do it 2 hours, but I can do it longer)
In the middle of the room is a bath. The bath
is made of zinc. It is too small to sit inside.
This zinc bath is filled with big nails.
I am naked and wash myself with the nails.
After a while my skin is grey because of the iron
and red because of the scratching of the nails.

The work *Sunday Bath* rouse out of my feelings
towards the Church.
The first time when I showed was on a Sunday.
On Sundays one must wash oneself, one must
wash before you enter the church in order to
have a new clean soul.
But Jesus' death, his blood, the nails in his hands
is not clean. I must think about it.
I like to wash myself to be really clean, but the
bath is too small.
So I cannot really be clean.

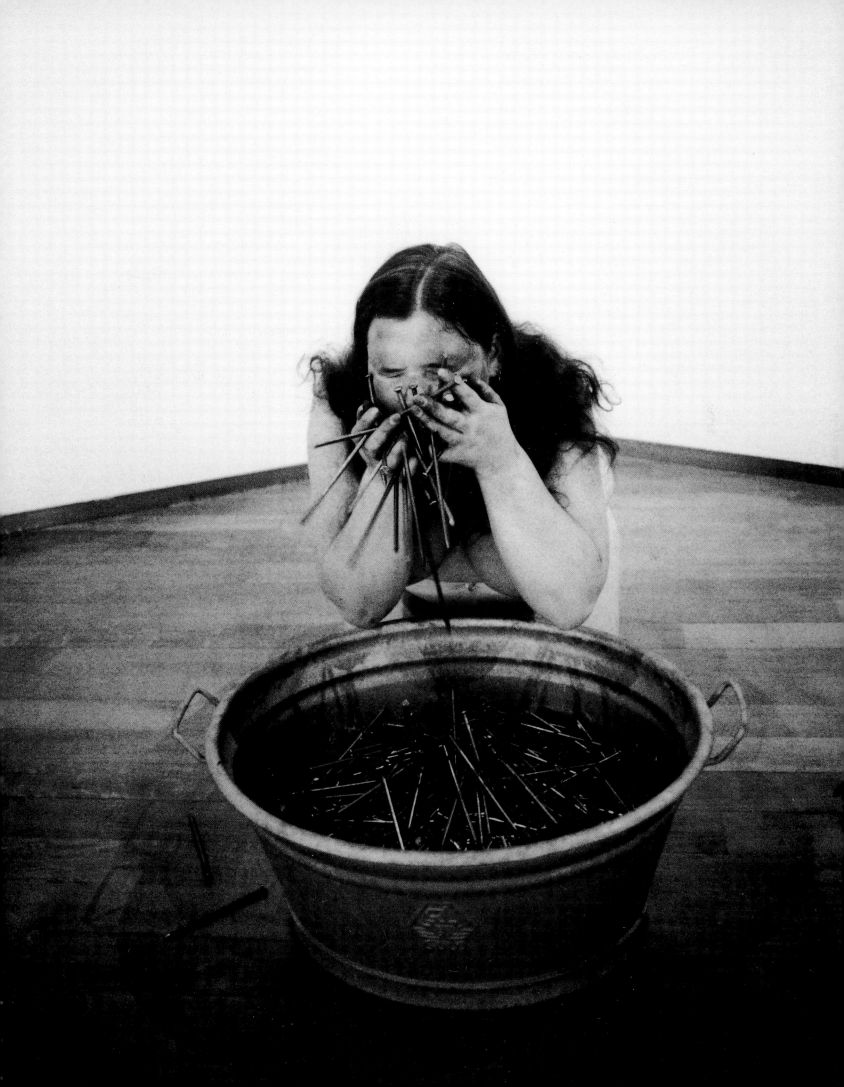

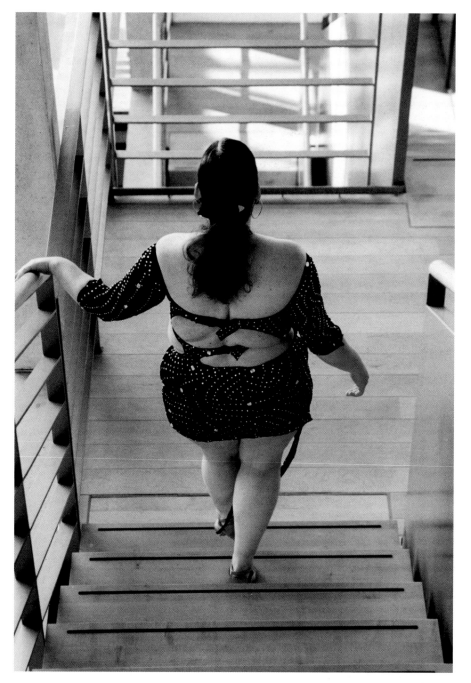

High-Way, 2003
Living installation
Duration: 3 h.
As Soon as Possible, PAC, Padiglione d'Arte
Contemporanea, Milan, Italy, 2003

Normally I need stairs, but I can do this piece
on the big ramp.
My body is fat. I am wearing a dress for Latin
dance competitions. The dress is very daring,
asymmetrical and with a lot of sequins.
Everybody can see that this dress is really too
tight, so my body looks fatter than it really is.
I proudly walk up and down the stairs and down
the ramp the whole time.

The work *High-Way* was prompted by the fatness
of my body and advertisements showing only
thin models.
I like my body and I'm proud enough to show it.
But sometimes I am not really sure whether I
like to show myself or not. I lot women share
these feelings no matter whether they are thin
or fat.
Am I walking like a diva on her "high" way, or
am I just an impossibly fat woman with no taste?
It doesn't matter which association is made. I'm
standing and walking proud... up and down with
no sense of direction.

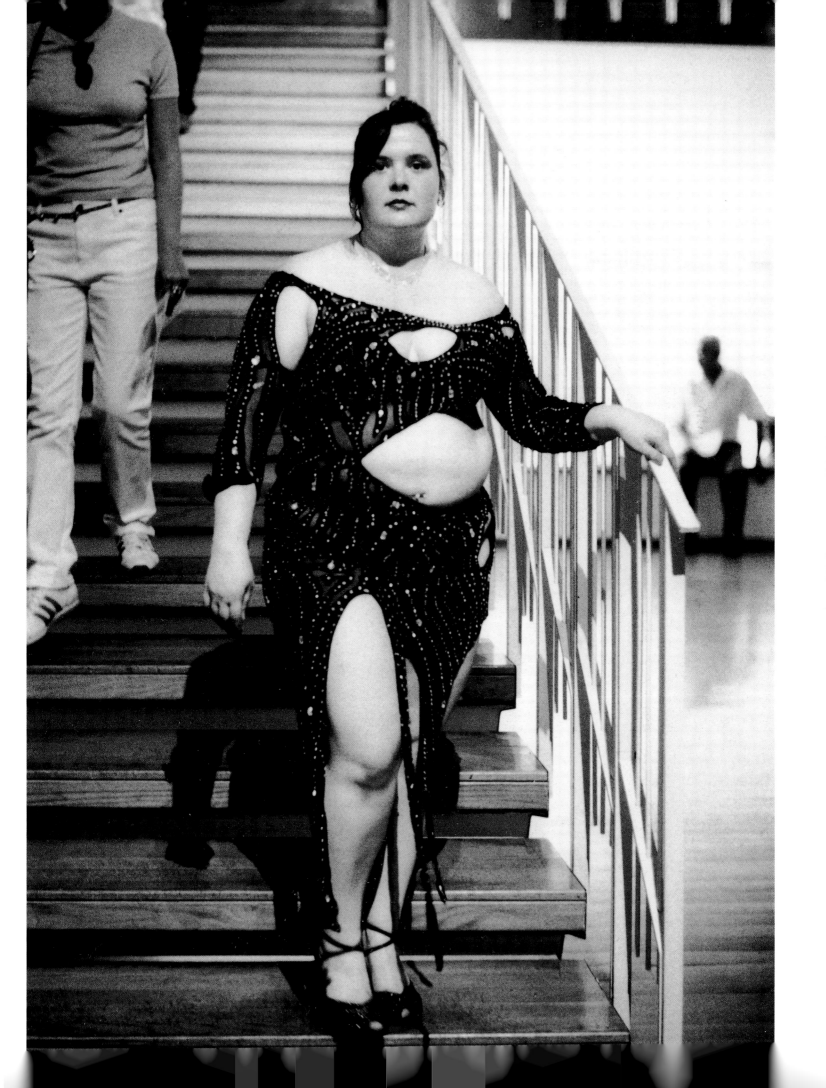

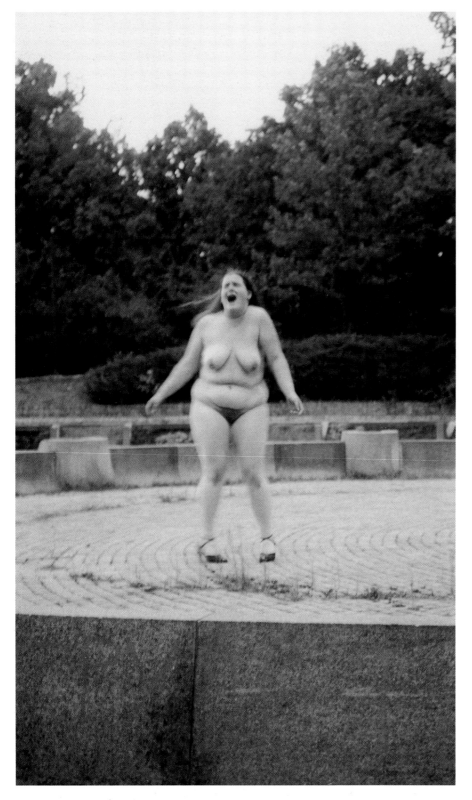

Turn Around, 2001
Duration: 30 min.
Real Presence – Generation 2001, The Balkans Trans / Border – Open Art Project, Belgrade, Serbia and Montenegro, 2001

In the *Turn Around* performance I stand in the middle of an amphitheatre. I am wearing only high-heeled shoes and am otherwise naked.
I am continuously turning on my own axis until I can no longer keep it up. Intermittently and at irregular intervals, I give a loud and incessant scream.
This work plays with my body limits of concentration and co-ordination.
The amphitheatre amplifies my scream.
I try to find the centre of the centre.
The centre of the theater helps me in this.

Dance and Feel, 2001
Duration: 2 min.

In this performance, I wear a dance dress and Latin-dance shoes. I dance to a blend of samba and rumba without a partner. In the background a ghetto blaster is playing kitschy samba music. The music goes off intermittently, I go over, switch it back on and dance some more. This sequence is repeated several times until I simply carry on dancing without any music.
Feel the rhythm, feel the music. Once you have stored these up you can just dance on your own, without a partner and without any music.
This piece deals with the despair at technical failure combined with the loneliness of dancing by oneself. But the rhythm and beat of the music "conquers" all.

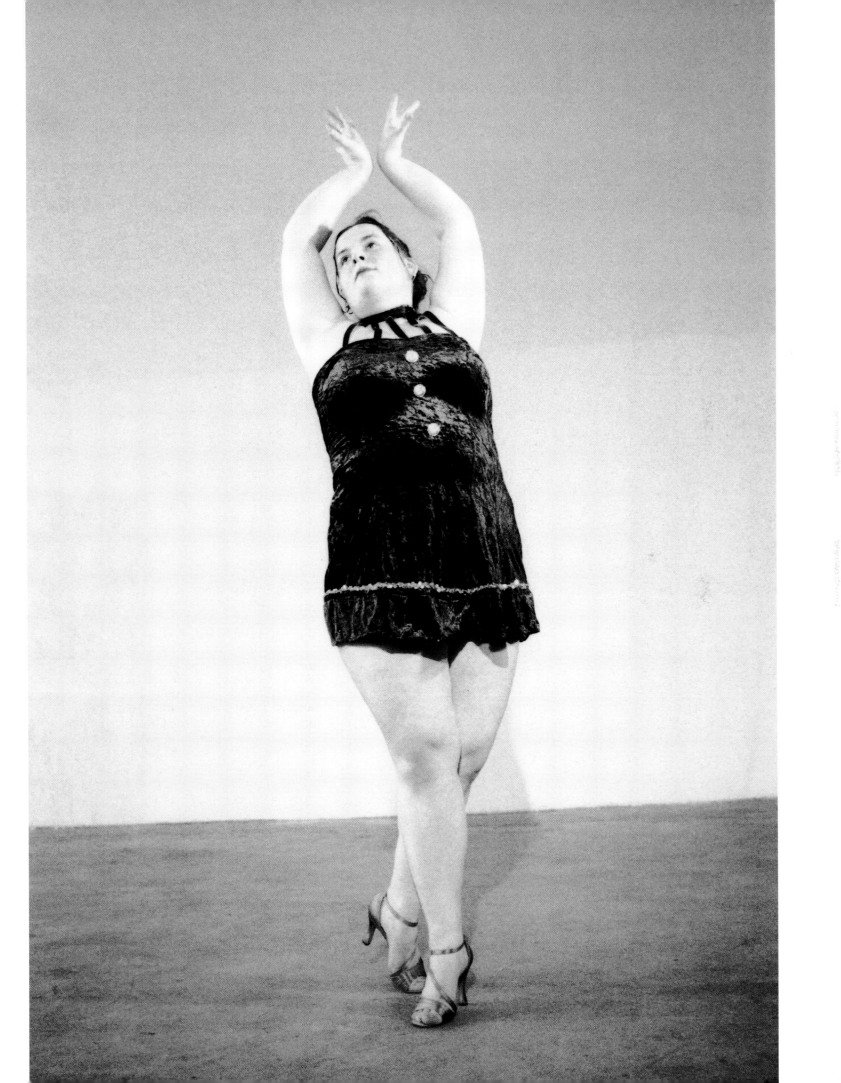

Viola Yesiltać

The work is mainly performative.
The performances and videos concetrate on the photographic image.
This level of scrutiny helps me to extract the tragic insecurities and defects from daily life.
The peculiar instant is the most interesting one for me.
I aim to make the public feel a mixture of shame and awe, I aim to make the public aware of this.

Untitled, 2002
Duration: 5 min.
Body Power / Body Play, Württembergischer Kunstverein, Stuttgart, Germany, 2002

The black wrap-around skirt is slowly peeled off to reveal a pair of yellow tights. The skirt is turned into a headscarf, and the three colours of the German flag – black, red and yellow – are displayed in the correct order.

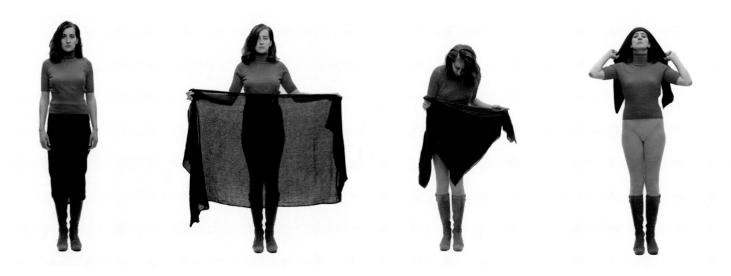

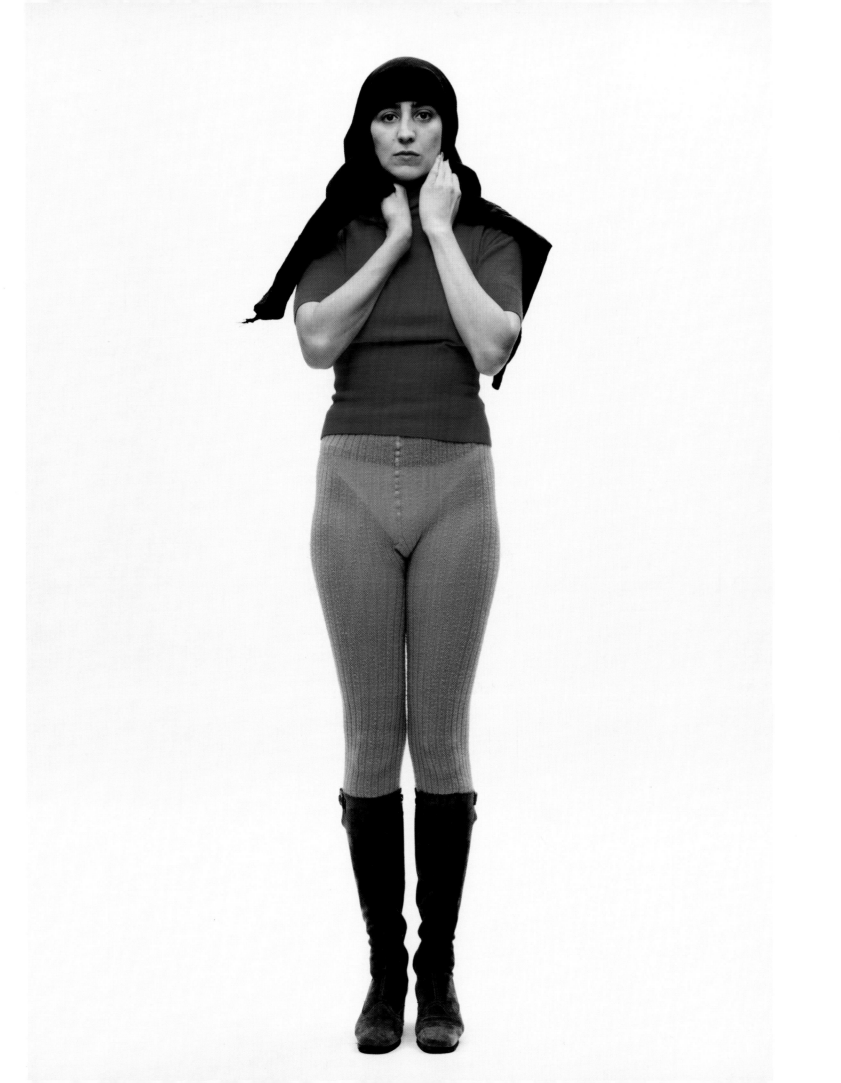

3.5% Fat, 2001
Duration: variable
Marking the Territory, Irish Museum of Modern
Art, Dublin, Ireland, 2001

Crossing a room with 15 litres of milk in bags.
This picks up on moments from everyday life
that are laden with associations and which
provide a perspective on femininity as a
reference point for locating one's own position.

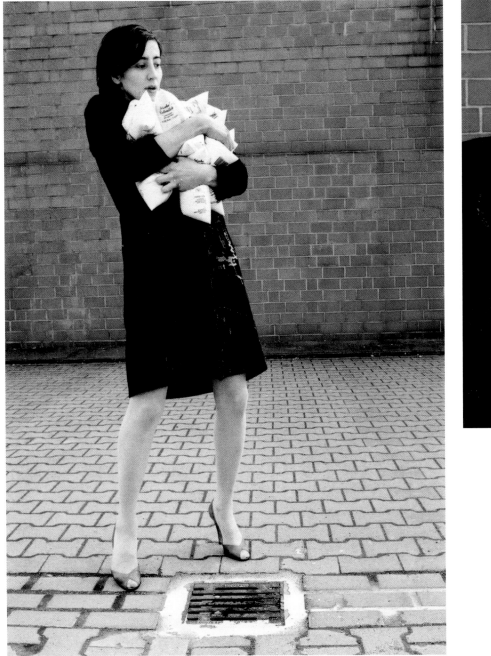

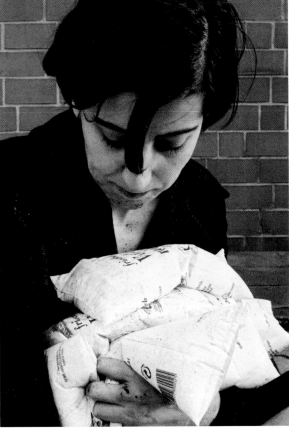

Untitled, 2001
Duration: 1 h.
Get that Balance, National Sculpture Factory,
Opera House / Half Moon Theater, Cork,
Ireland, 2001

In *Untitled,* I use the notion of dual functionality
as both the subject and object of my own work.
As I spin around, I wind up a musical box
playing the theme tune of *Love Story,* thereby
evoking associations with the female figures
inside these boxes.

In deep concentration, it is the artist who is the
central focus here.

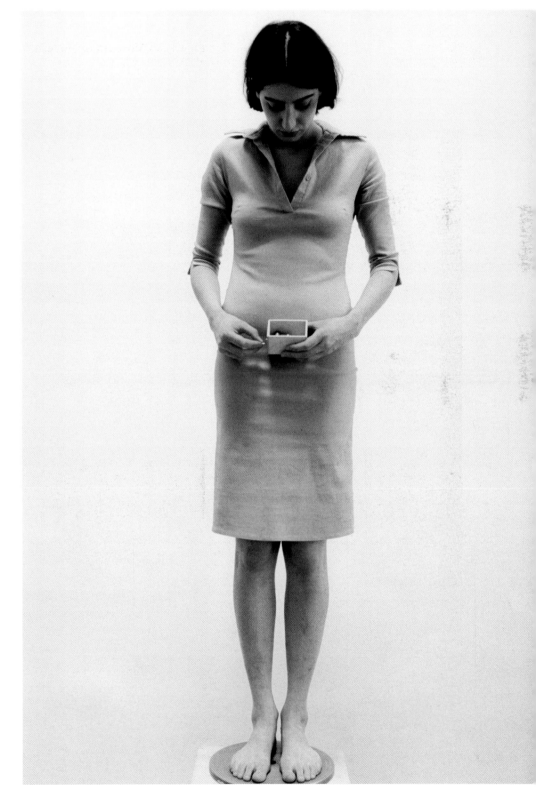

Regional Express, 2001
Video installation
Duration: 6 min. 25 sec., looped
Tempo Reale, Acquario Romano, Rome, Italy,
2001

As she crosses the forest over and again, the
question is raised as to whether she is moving
towards something or away from it. This shows
the constant repetition of an action (loop),
in which beginning and end flow continuously
into one another.

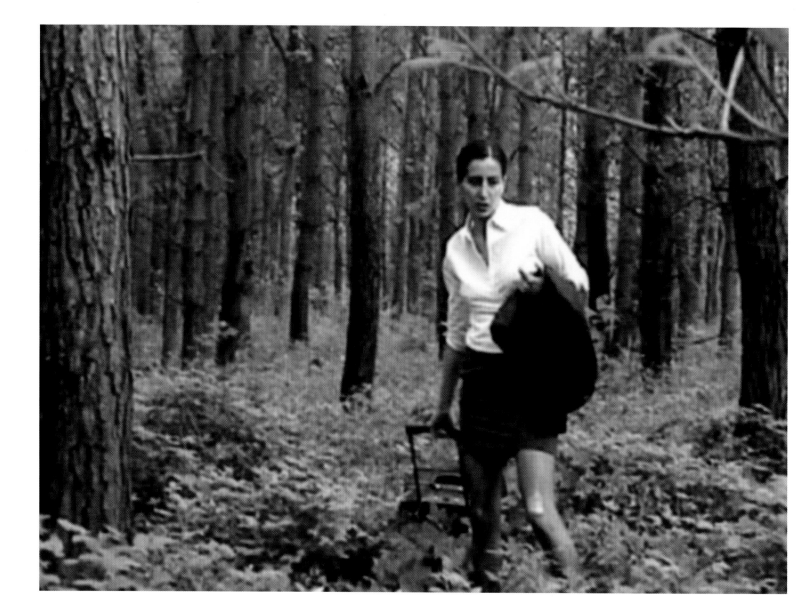

Die Gelegenheit (The Opportunity), 2002
Duration: 1 h.
Cleaning the House, Centro Galego de Arte
Contemporánea, Santiago de Compostela,
Spain, 2002

Sitting in front of a collection of clover leaves,
looking for the ones with four leaves.

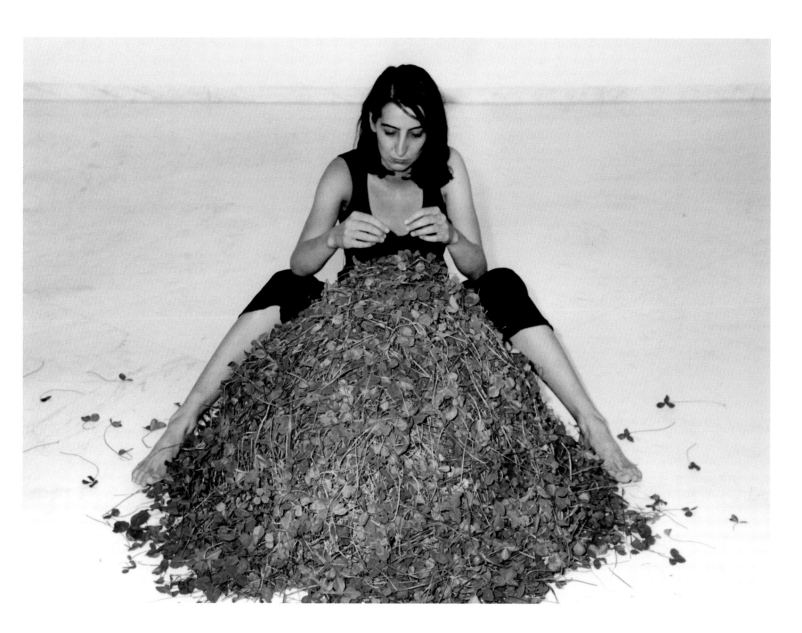

Untitled, 2002-2003
Photo series
12 photographs, 60 x 80 cm each

In the constructed reality of nature, objects are
isolated as ready-mades or as circumstantial
evidence, and people appear as perpetrators.

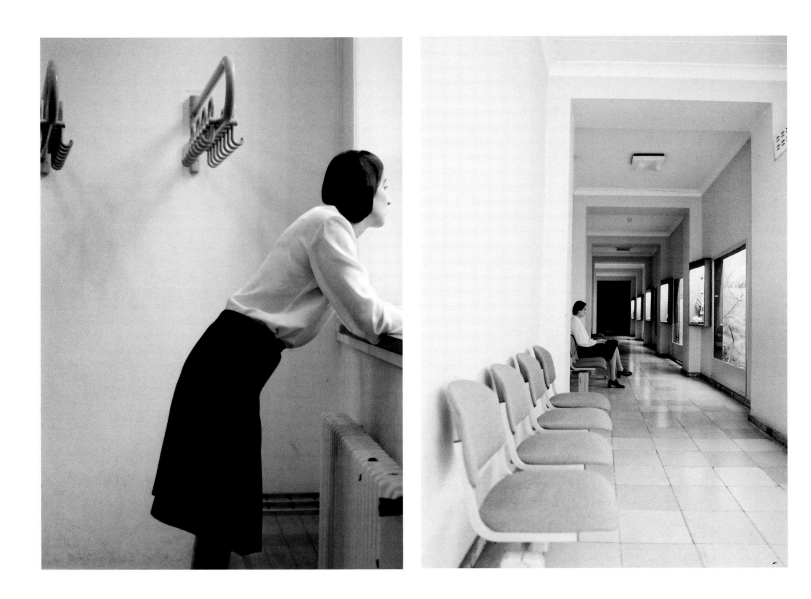

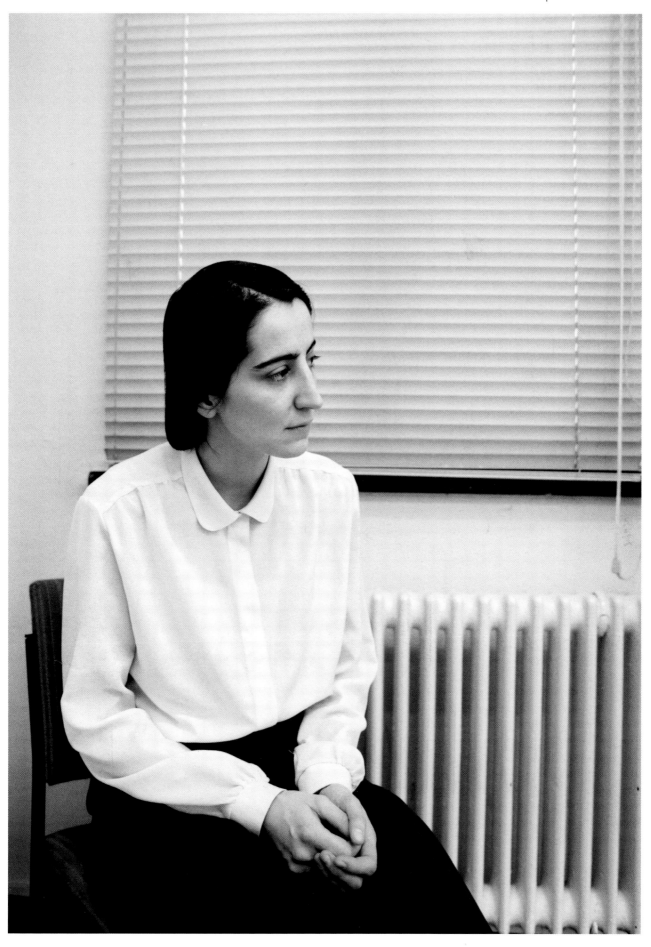

Blue Box World, 2003
Duration: 3 h.
As Soon as Possible, PAC, Padiglione d'Arte
Contemporanea, Milan, Italy, 2003

The performance is based on a photograph,
placed against an ocean-blue photographic
background. The performer adopts different
positions, changing these from time to time.

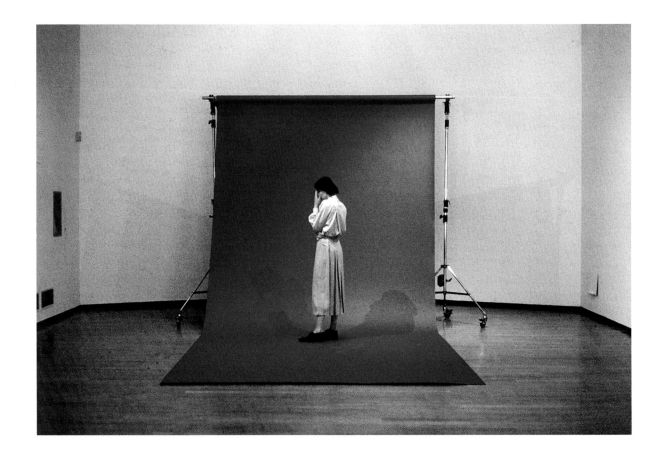

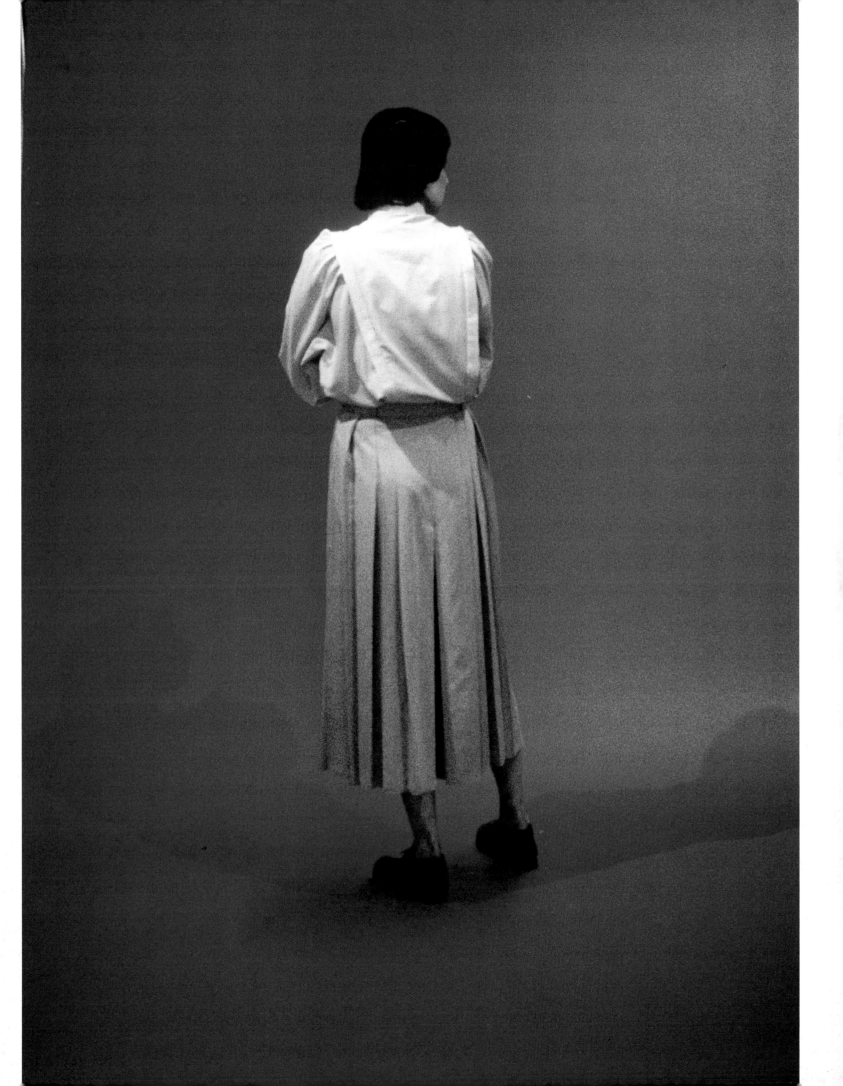

1993-2003
Collaboration
Performances

Melati Suryodarmo, Julia Kami & Julie Jaffrenou

Zeit Wind, 1997
Duration: 25 min.
Braunschweiger Kulturnacht, FBZ
Braunschweig, Germany, 1997

This is a collaboration between three women from different cultures. The performance is based on a narrative story about the process of birth and self-fulfillment, in different ways. The work is placed within the context of feminism today.

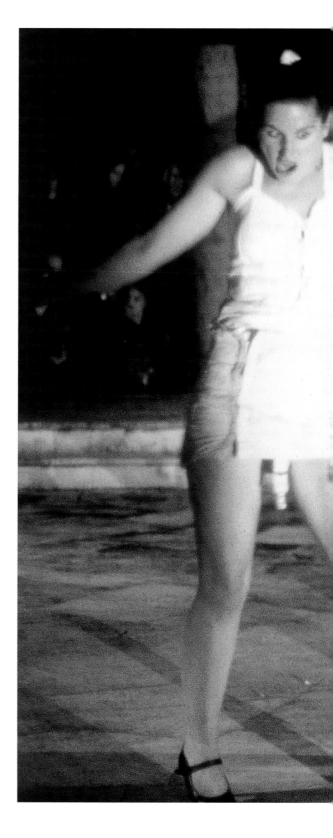

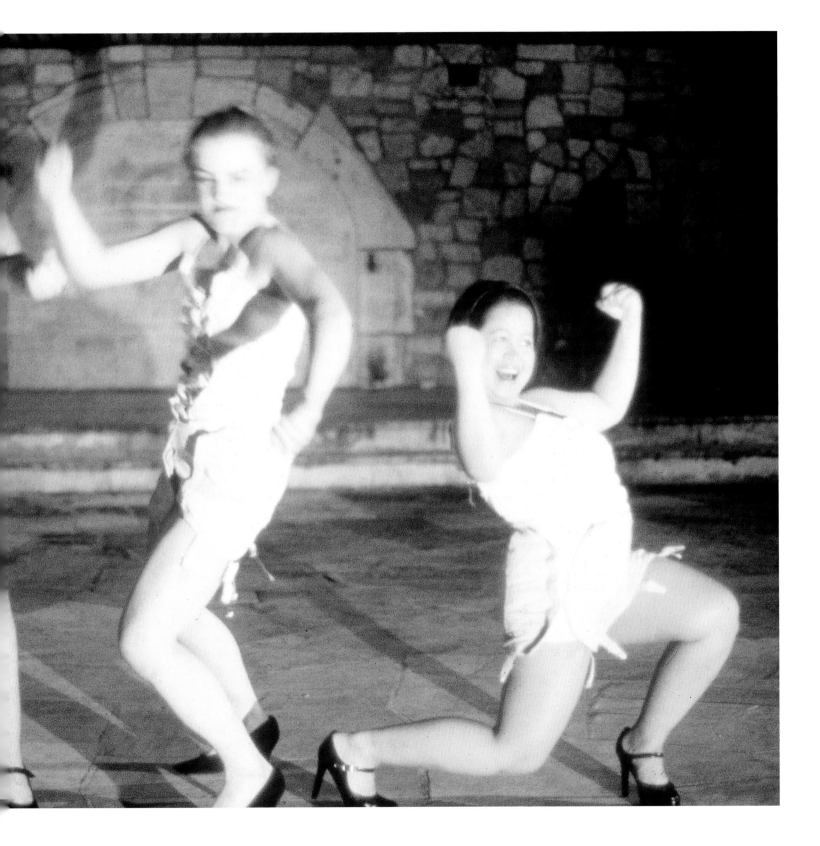

Sarah Braun & Barbara Klinker

Videomasters, 1998
Duration: approx. 10 min.
Zwischenräume – Finally,
Kunstverein Hannover,
Hanover, Germany, 1998

Disguised in cardboard boxes,
wearing shiny clothes and
cables, we appear as two video
players: Beta (the tall one)
and VHS (the small one).
We produce futuristic sounds
using keyboards and toy-
instruments, which are taped
to our "heads" and breasts.

The plot:
VHS and Beta enter the space
and collide in the middle.
VHS immediately falls in love
with Beta.
But to his admiring
compliments Beta reacts
condescendingly.
To impress the poor VHS she
even starts to demonstrate her
perfect technical functions.
VHS inserts a tape (made from
foam-rubber) in Beta's slot.
Suddenly her system gets
disturbed.
VHS tries to repair the broken
connection with technical first-
aid, but fails.
Beta collapses and ejects the
tape.
They both call the big U-Matic
for deliverance but there is no
response.
Finally, VHS takes a deep breath
and pulls out a red cape.
VHS changes into Super-VHS!
He rescues Beta, who
completely delighted, regains
her functions.
Playing joyfully, they leave the
space.

VHS: "Beta!"
Beta: "VHS!"
VHS: "Superloop color gain box load!"
Beta: "Delete local dropout chip."
VHS: "Disc scroll digital jog-shuttle!"
Beta: "Out reverse score local drop."
VHS: "Reverse!"
Beta: "Sync, sync.....!"
VHS: Advanced disc-desk!"
Beta: "Default right modus."
VHS: "Disc size, disc correct."
Beta: "Channel one, channel one..... audio mark
into trigger point – framer inter database!"
VHS: "Clear enter station loft!"
Beta: "....."

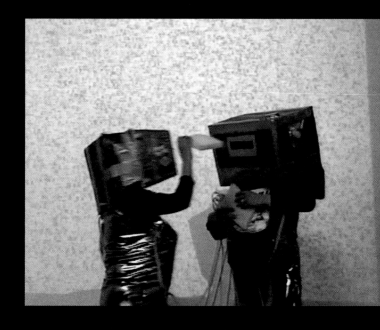

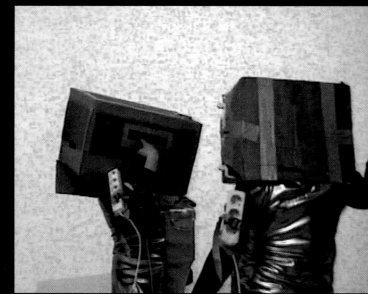

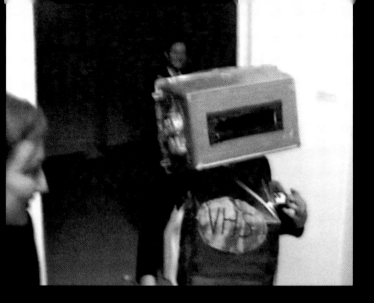

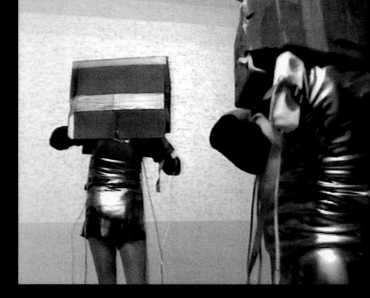

VHS: "Play!"
Beta: "Play..... eject."
VHS: "Pal in ?"
Beta: "Trigger, trigger, trigger!"
VHS: "Channel O.K.?"
Beta: "Audio split, audio split!"
VHS: "Local!"
Beta: "Power..... off."
VHS: "U-Matic, U-Matic,..... U-Maaaatic!"
Beta: "U-Maaaaaaatic!"
VHS: ".....?"
Beta: "Color kill."
VHS: "Uuuuuuuuuuuuh!" (VHS changes into
Super-VHS, drops out a red cloth).
Beta: "Super-VHS!!!"

Anton & Masha Soloveitchik

Family, 2002
Duration: 1-3 h.
Cleaning the House, Centro Galego de Arte
Contemporánea, Santiago de Compostela,
Spain, 2002

They are a family.
Him and Her.
The staircase is their way and their development.
Embraced, laying on the steps, they move up the
stairs very slowly, step by step, from a low level
to a high level.
Pushing and pulling, they help each other.
They are completely relaxed, concentrated on
their interaction and on the feeling of each other.

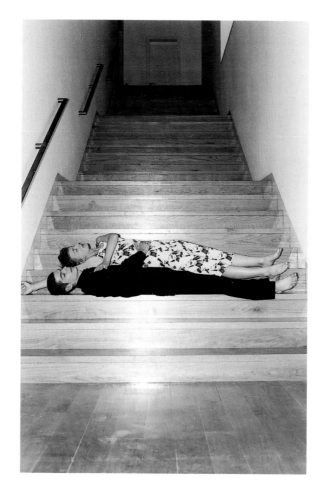

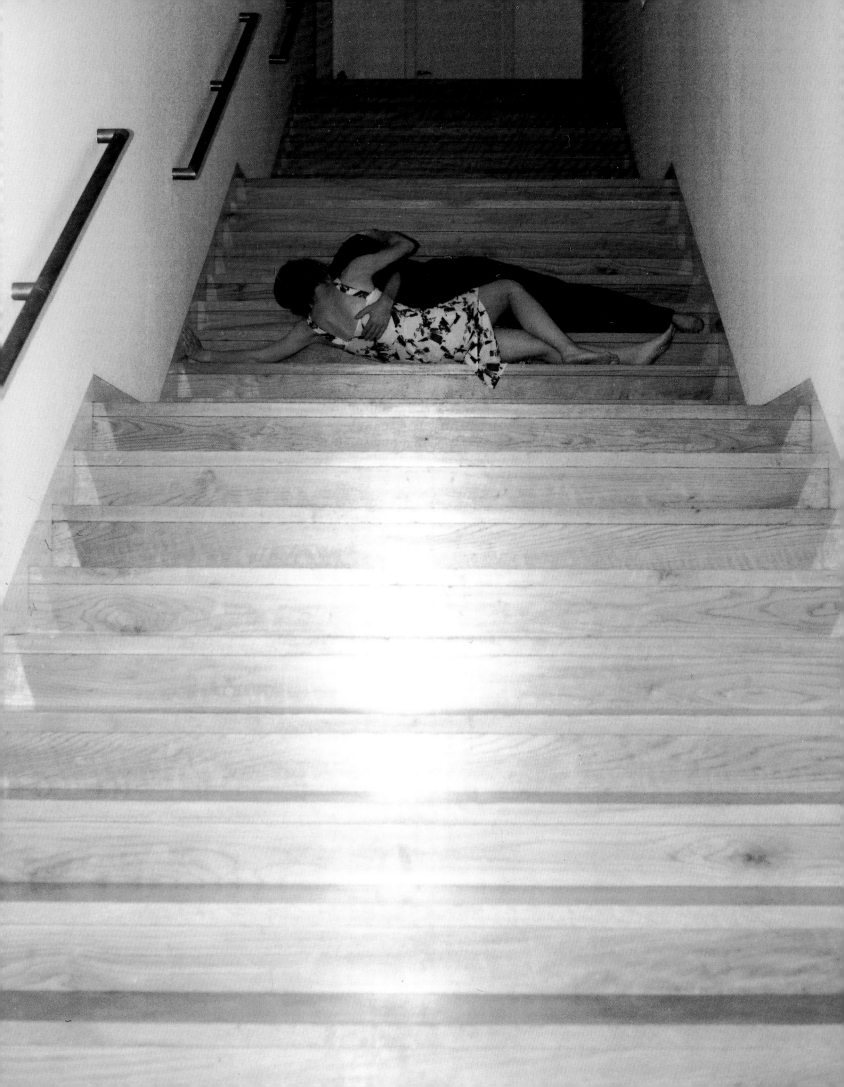

Amanda Coogan
& Declan Rooney

The Bridge, 2000
Photograph

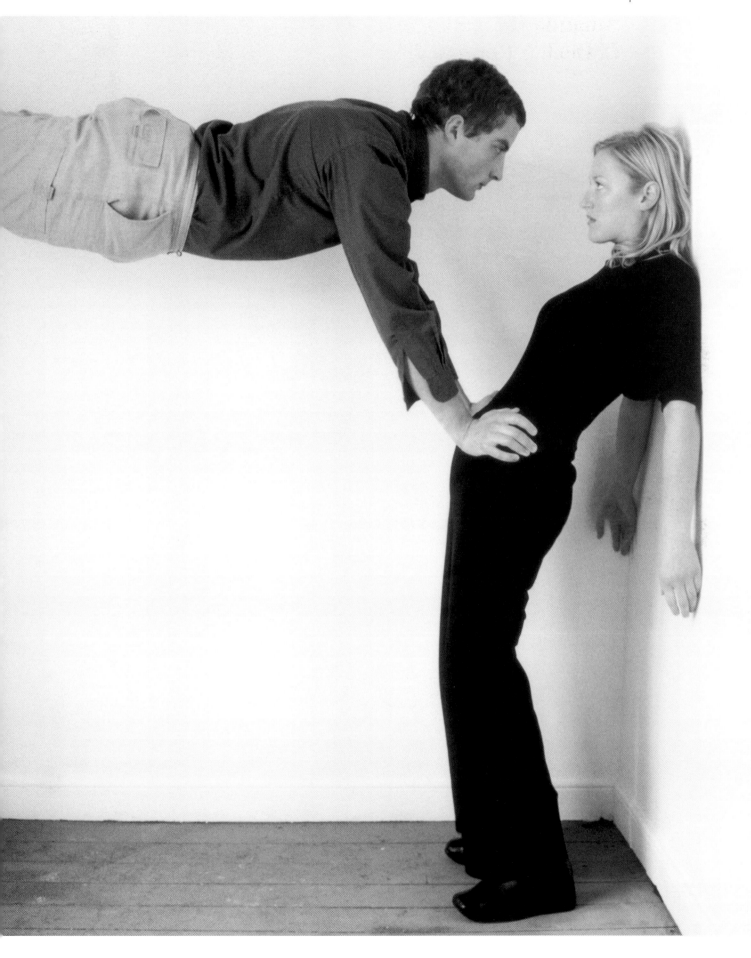

Susanne Winterling &
Daniel Müller-Friedrichsen

Steady State, 2002
Duration: variable
Body Basics I / Body Basics II, Transart 02,
Klanspuren Festival, Fortezza, Brixen, Italy, 2002

A finger on the trigger.
Both parts of this possible fight are unable
to shoot or act.
One threads the other but neither can make
the next move.
Each gun is target and aggressor.
No movement is possible.

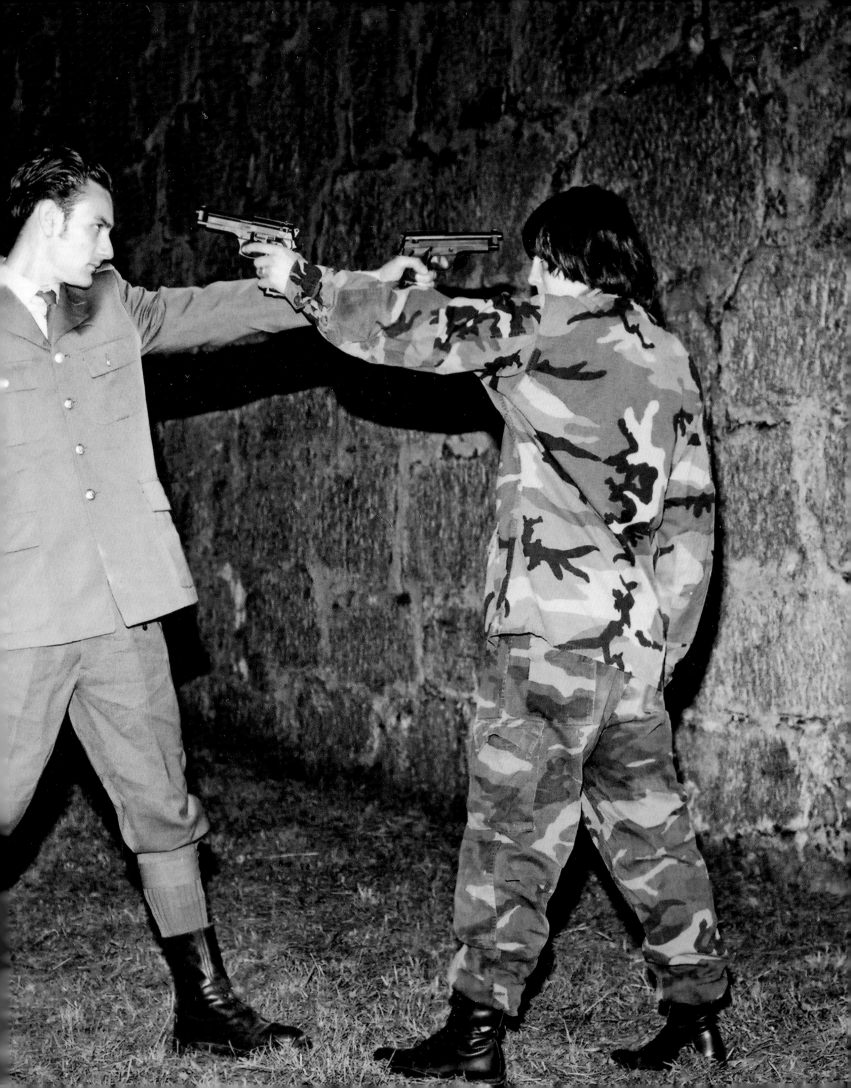

Lotte Lindner
& Till Steinbrenner

Family III, 2002
Video installation
Hochschule für Bildende Künste, Braunschweig,
Germany, 2002

The video shows two hands, each from a
different person, peeling potatoes continuously.

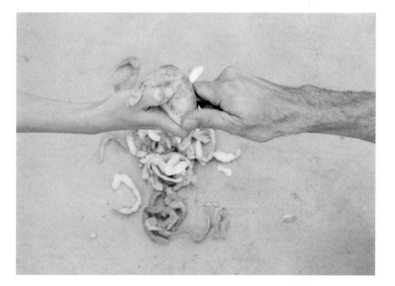

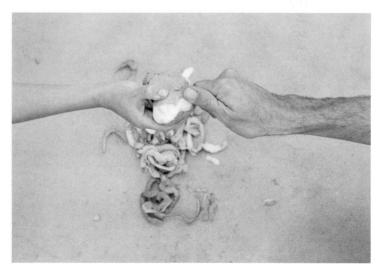

Family II, 2002
Duration: unlimited
Hochschule für Bildende Künste, Braunschweig,
Germany, 2002
L.O.T. Theater, Braunschweig, Germany, 2002

We peel an enormous pile of potatoes.
He holds the knife and she holds the potatoes.

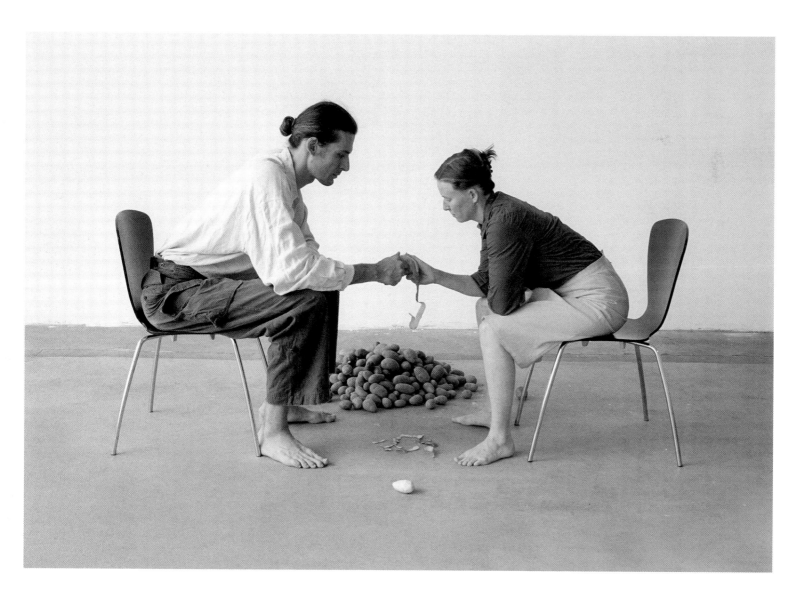

Viola Yesiltać,
Susanne Winterling,
Daniel Müller-Friedrichsen
& Ivan Čivić

s.o. p.o.o.r.e / s.o.p.o.u.r. / s.o. p.u.r.e, 2003
Performance, living sculpture
Duration: 2 h. 15 min.
Recycling the Future, 50. Esposizione
Internazionale d'Arte La Biennale di Venezia,
Venice, Italy, 2003

Four people sitting next to each other crying
on a bench. This emphatic image
shows the sorrow for no reason and all reasons.
S.o.p.u.r is S.o.p.u.r.

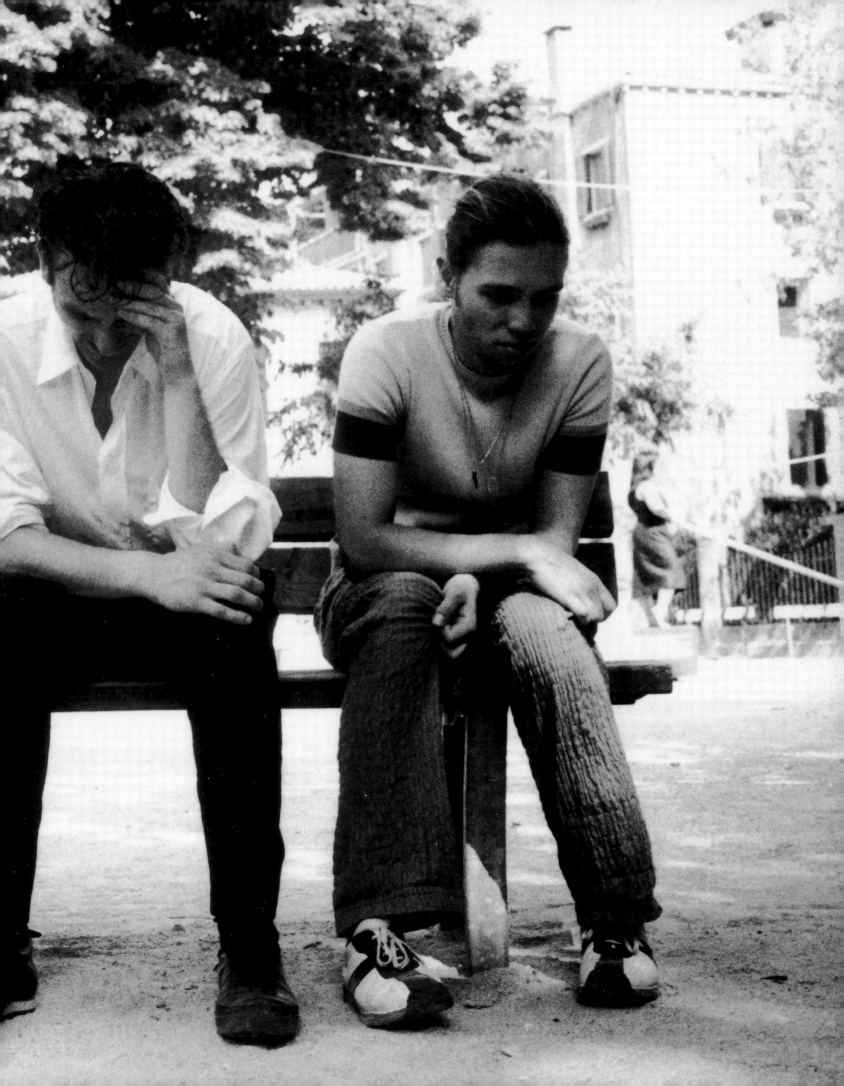

Photo Album

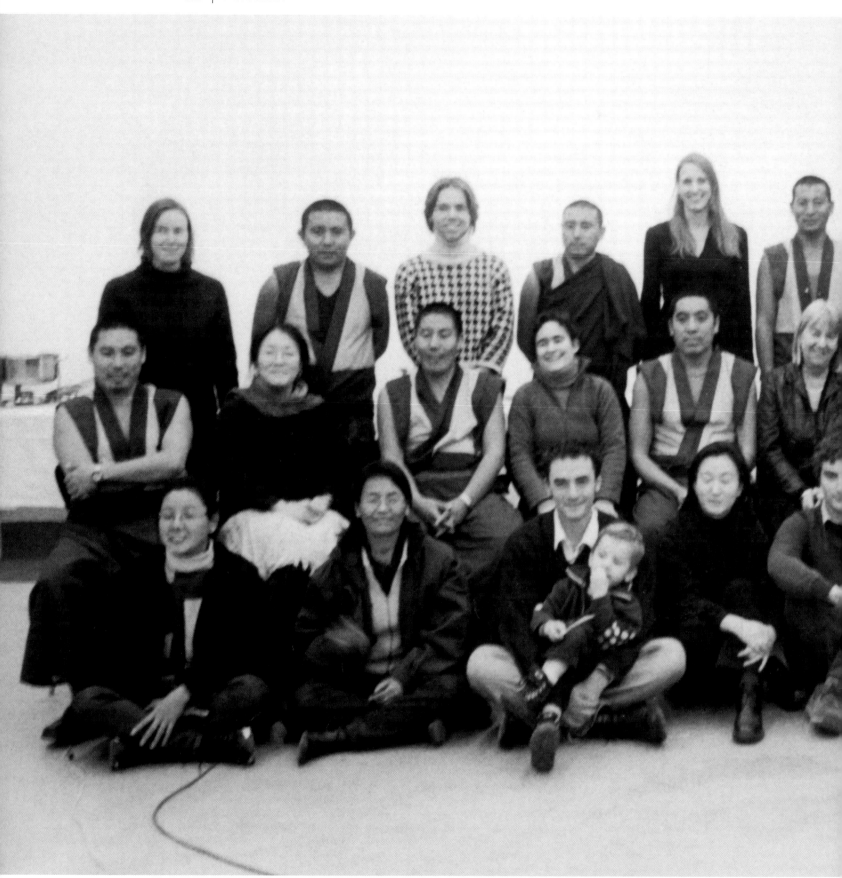

Lama Dobom Tulku and monks with students and professors (from left to right and back to front: Lotte Lindner, Ivan Čivić, Anna Berndtson, Till Steinbrenner, Uli Planck, Anton Soloveitchik, Yingmei Duan, Eun-Hye Hwang, Sarah Braun, Birgit Hein, Marina Abramović, Susanne Winterling, Nezaket Ekici, Oliver Blomeier and son, Heejung Um, Declan Rooney, Herma Wittstock, Daniel Müller-Friedrichsen, Melati Suryodarmo) at the HBK Braunschweig, Germany, 2002
photo: Alessia Bulgari

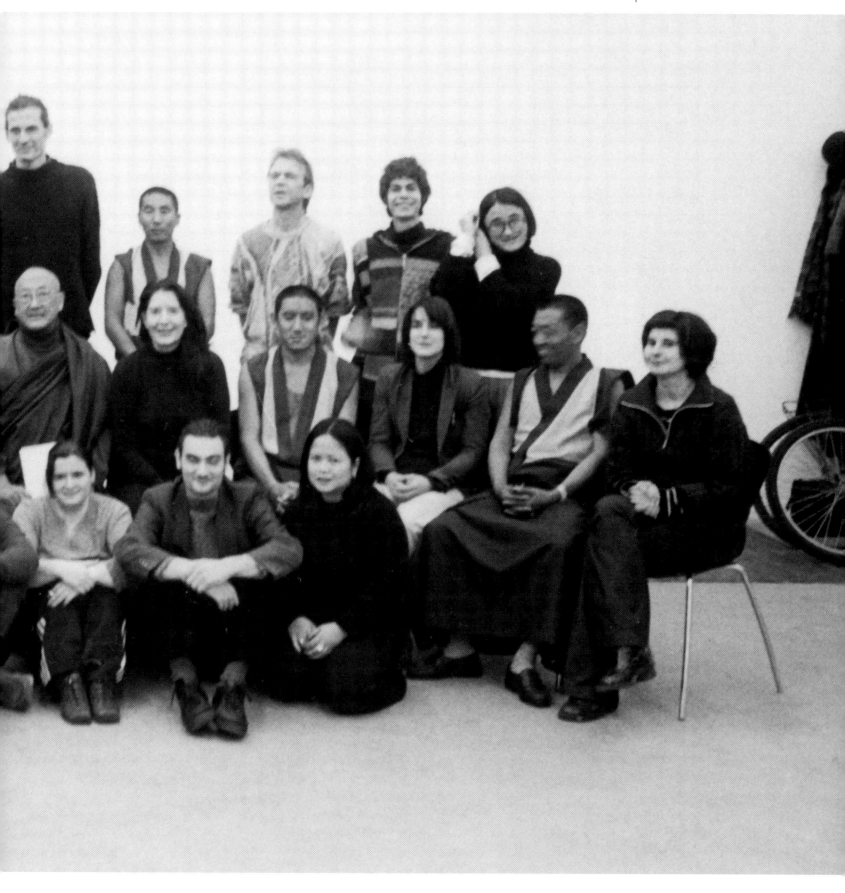

Workshop in Maastricht,
The Netherlands, 1993

Sarah Braun in Antas de Ulla, Spain,
2002
photo: Viola Yesiltać

Marica Gojević in Antas de Ulla,
Spain, 2002
photo: Viola Yesiltać

Till Steinbrenner
Workshop in Antas de Ulla, Spain, 2002
photo: Anton Soloveitchik

Susanne Winterling and Viola Yesiltać, House of the Cultures of the World,
Berlin, Germany, 2002
photo: Alessia Bulgari

Adrianne Goehler, Director of the Hochschule für Bildende Künste, Hamburg,
Germany, 1999

Workshop at the Fondazione Antonio Ratti, Como, Italy, 2001
photo: Luca Bianco

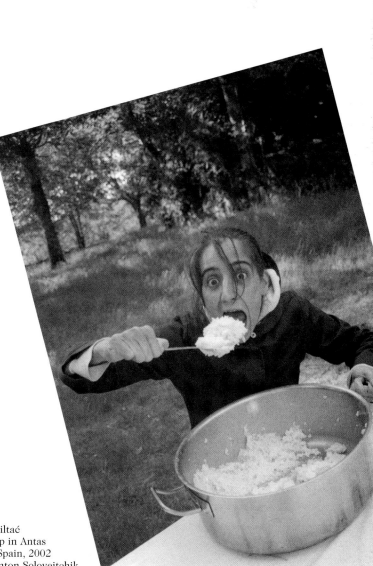

Viola Yesiltać
Workshop in Antas
de Ulla, Spain, 2002
photo: Anton Soloveitchik

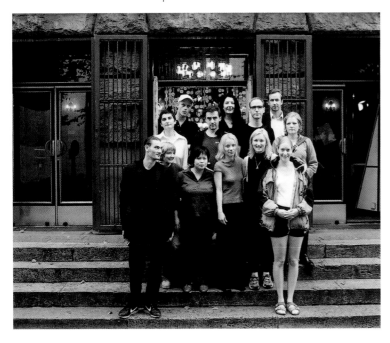

Visible Differences at the Hebbel
Theater, Berlin, Germany, 2000
photo: Viola Yesiltać

Class-plenum at the HBK Braunschweig (Frank Begemann, Amanda Coogan, Franz
Gerald Krumpl, Marina Abramović, Christian Sievers, Daniel Müller-Friedrichsen,
an unknown guest, Sarah Braun, Lotte Lindner, Dorte Strehlow), 2001

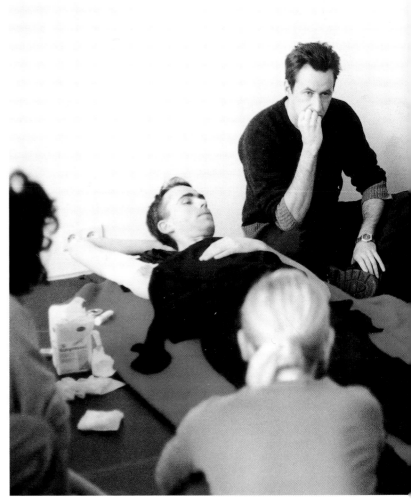

Marina Abramović, Ruth Hutter,
Frank Werner, Julie Jaffrenou, Ben
Stone, Julia Kami, Llúcia Mundet
Pallí and Isabella Gresser at the
workshop in Kerguéhennec, France,
1997
photo: Maurice Korbel

North of Newcastle, United Kingdom,
1996
photo: E. Bates

Marina Abramović with Dennis
Zacharopoulos at Kerguéhennec,
France, 1994

Workshop in Antas de Ulla, Spain,
2002
photo: Anton Soloveitchik

Workshop in Grenoble, France

Workshop with Hamish Fulton in
Japan, 1994

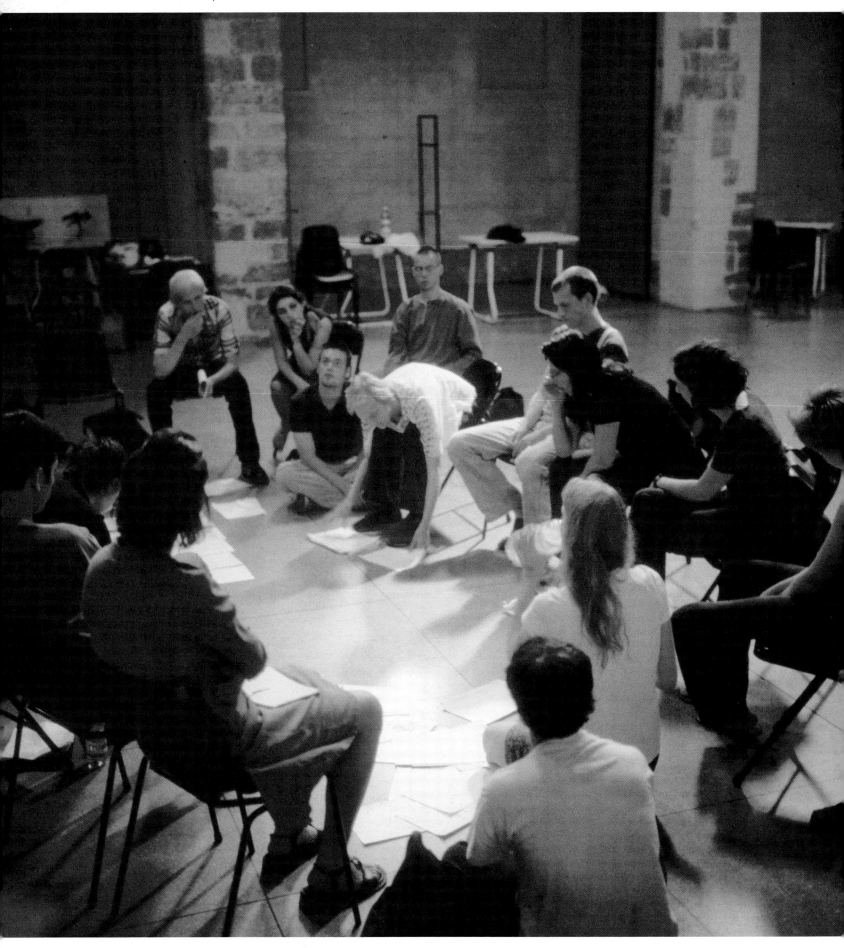

Anton Soloveitchik in Antas de Ulla,
Spain, 2002
photo: Viola Yesiltać

Daniel Müller-Friedrichsen and Ivan
Čivić in Antas de Ulla, Spain, 2002
photo: Viola Yesiltać

Irina Thorman, Amanda Coogan and
Iris Selke, 2000
photo: Viola Yesiltać

Workshop at the Fondazione Antonio
Ratti, Como, Italy, 2001
photo: Luca Bianco

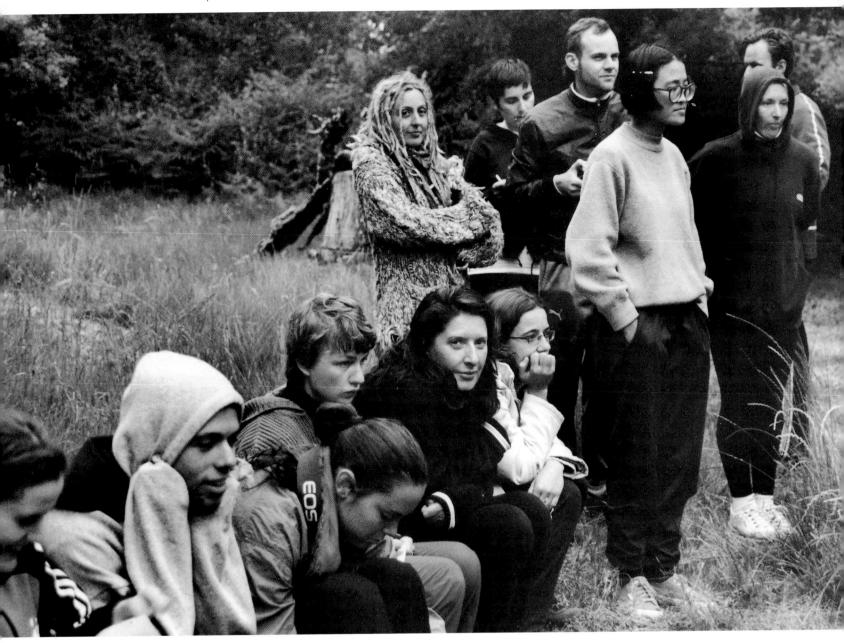

Herma Wittstock, Ivan Čivić, Marta
Montes Canteli, Mascha Soloveitchik,
Ana Pol, Marina Abramović, Carmen
Julián Molina, Marica Gojević, Félix
Fernández, Yingmei Duan, Amanda
Coogan and Franz Gerald Krumpl at
the workshop at Antas de Ulla,
Spain, 2002
photo: Silvia García

Plenum in the HBK Braunschweig,
Germany, 2002
photo: Alessia Bulgari

Iris Selke, Julie Jaffrenou, Ruth Hutter and Maurice Korbel at the workshop in Kerguéhennec, France, 1997
photo: Frau Müller

Kristian Petersen in Kerguéhennec, France, 1997
photo: Frau Müller

Luca Malgheri and Hannes Malte
Mahler, Calder Studio, France, 2001
photo: Viola Yesiltać

Frank Lüsing, Oliver Kochta and
Hayley Newman at the HBK
Hamburg, Germany, 1995

The class at the HBK Hamburg,
Germany, 1995

Maurice Korbel during the preparation of the exhibition *Fresh Air* in Weimar, 1999

Barbara Klinker, Frank Werner, Ruth Hutter, Julie Jaffrenou, Kristian Petersen and Iris Selke at the HBK Braunschweig, Germany, 1998
photo: Maurice Korbel

Ready for the blind-folded walk during the workshop in Kerguéhennec, France, 1998
photo: Maurice Korbel

Workshop in Denmark, 1996

At the exhibition *Finally* in Hanover
photo: Frau Müller

HBK Braunschweig, Germany, 2002
photo: Viola Yesiltać

Workshop in Kerguéhennec, 1992

Franz Gerald Krumpl and Marina
Abramović on their way to the
workshop in Spain, 2002
photo: Viola Yesiltać

Get that Balance, exhibition in Cork,
Ireland, 2001
photo: Oliver Blomeier

Yingmei Duan in Braunschweig, Germany, 2001
photo: Viola Yesiltać

Yingmei Duan in Antas de Ulla, Spain, 2002
photo: Viola Yesiltać

Snežana Golubović right after the
deadline in Amsterdam,
The Netherlands, 2003
photo: Alessia Bulgari

Frank Werner and Kristian Petersen
during the workshop in
Kerguéhennec, France, 1997
photo: Maurice Korbel

Ivan Čivić, Hungary, 2000
photo: Viola Yesiltać

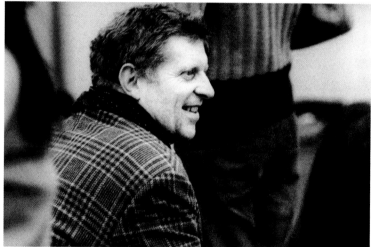

Yingmei Duan and Sarah Braun
preparing a performance in
Braunschweig, Germany, 2001
photo: Viola Yesiltać

Raimund Kummer at the HBK
Braunschweig, Germany, 2002
photo: Alessia Bulgari

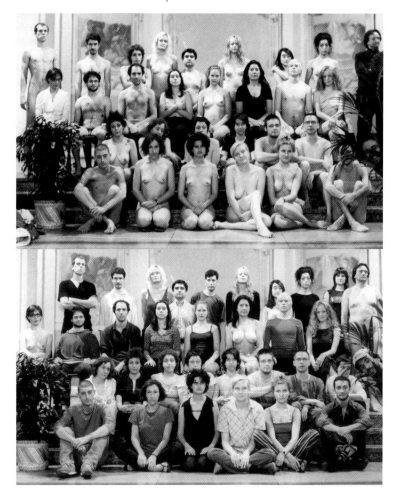

Workshop at the Fondazione Antonio
Ratti, Como, Italy, 2001
photo: Gianluca Malgheri

Summer Academy in Wolfenbüttel,
Germany, 2002

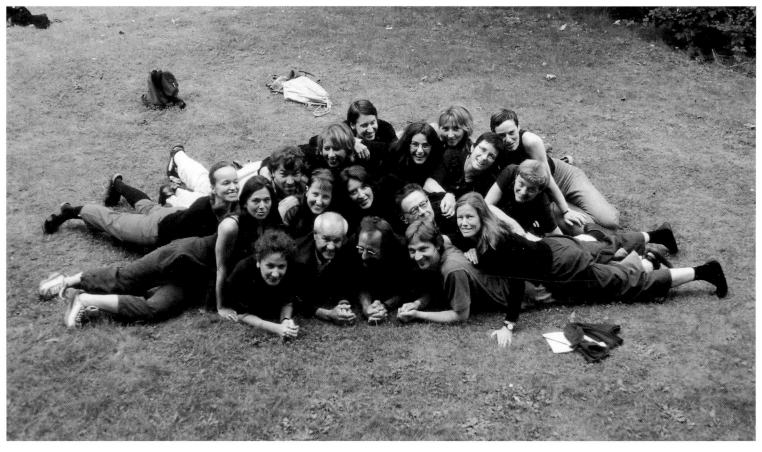

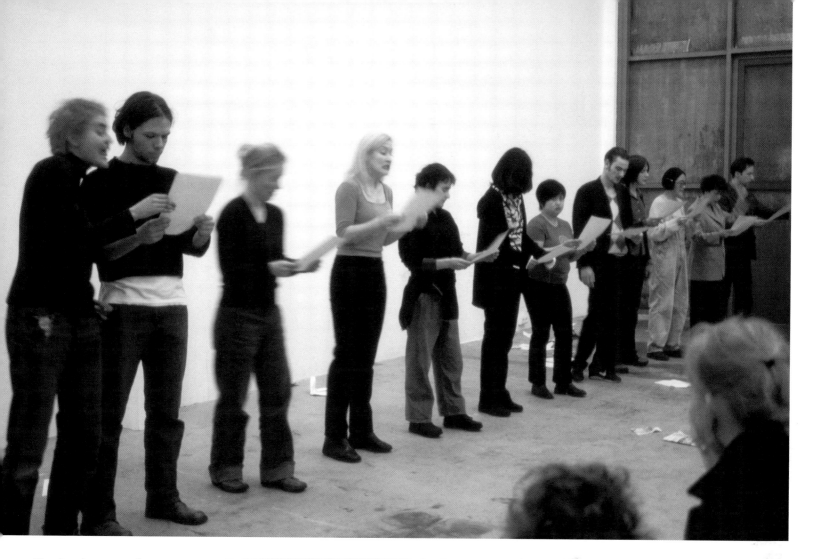

The class during a performance-
evening in the atelier, HBK
Braunschweig, 2001
photo: Frau Müller

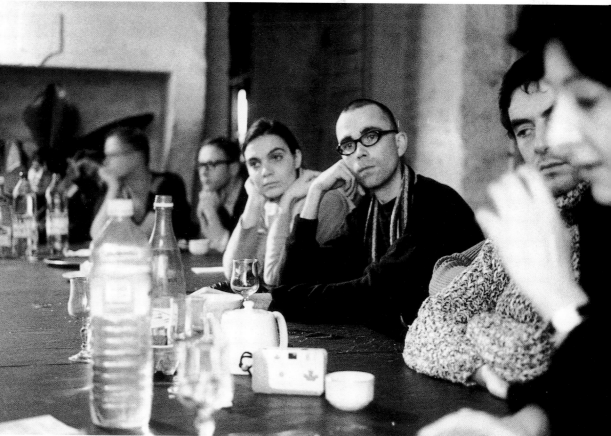

Susanne Winterling, Kristian
Petersen, Frank Werner, Anna
Gollwitzer, Frank Begemann, Oliver
Blomeier and Marina Abramović at
the workshop in Kerguéhennec,
France, 1997
photo: Maurice Korbel

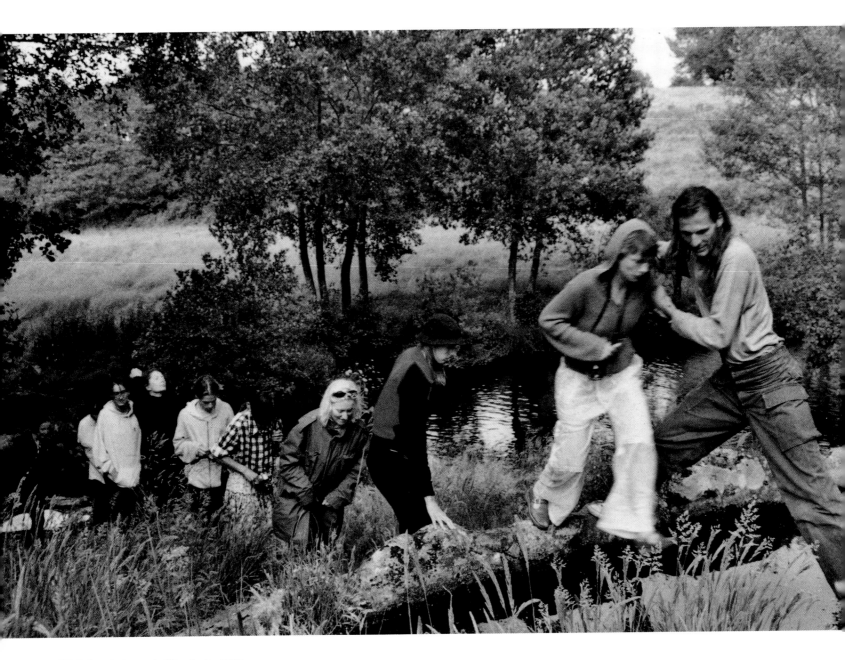

Workshop in Antas de Ulla, Spain, 2002
photo: Silvia García

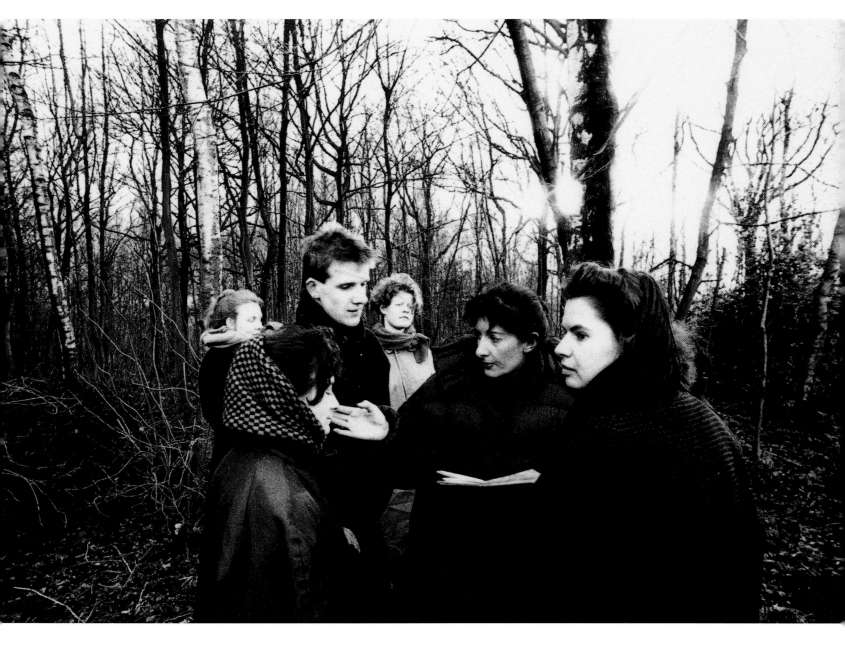

Workshop in Maastricht,
The Netherlands, 1991

Lama Dobom Tulku and monks
visiting and performing at the HBK
Braunschweig, Germany, 2002
photo: Alessia Bulgari

Oliver Blomeier and Marina
Abramović at the Haus am
Lützowplatz, Berlin, preparing the
exhibition *Unfinished Business*, 1999
photo: Alfred Raschke

Marina Abramović and Alessia
Bulgari in Amsterdam,
The Netherlands, 2003
photo: Alessia Bulgari

Barbara Klinker in Kerguéhennec, 1997
photo: Frau Müller

Preparing this book
photo: Alessia Bulgari

p. 490
Lama Dobom Tulku and monks
visiting and performing at the HBK
Braunschweig, Germany, 2002
photo: Alessia Bulgari

p. 491
Kristian Petersen, Frank Werner and
Ivan Čivić in Weimar, Germany,
1999

p. 492-493
Marina Abramović (right) watching the performance *Alè Lino* by Melati
Suryodarmo, PAC, Padiglione d'Arte Contemporanea, Milan, Italy, 2003
photo: Alessia Bulgari

Sabine Baumann and Marina
Abramović in Wolfenbüttel,
Germany, 2002

Birgit Hein, Mara Mattuschka and
Marina Abramović at the HBK
Braunschweig, Germany, 2001

Marina Abramović and Daniel Müller-
Friedrichsen, Braunschweig,
Germany, 2003
photo: Alessia Bulgari

Declan Rooney working on the texts
for this book in Amsterdam,
The Netherlands, 2003
photo: Alessia Bulgari

Declan Rooney and Snežana
Golubović in Amsterdam, The
Netherlands, 2003
photo: Alessia Bulgari

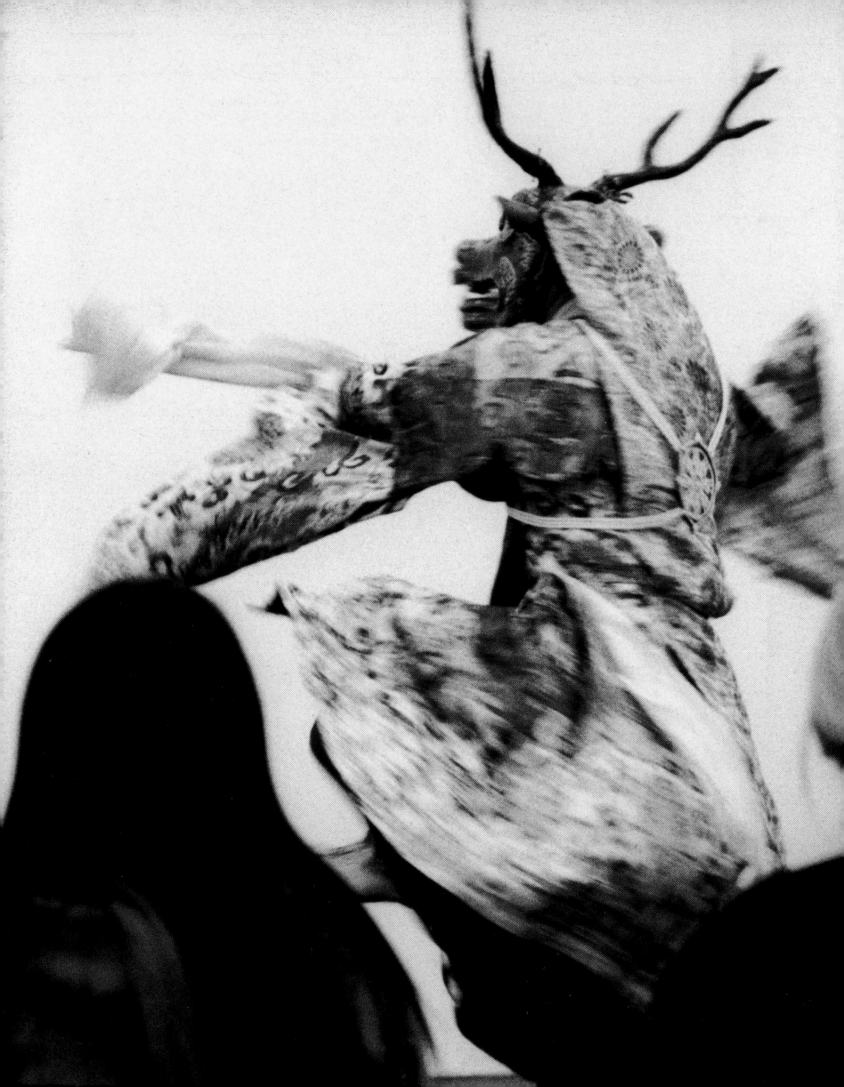

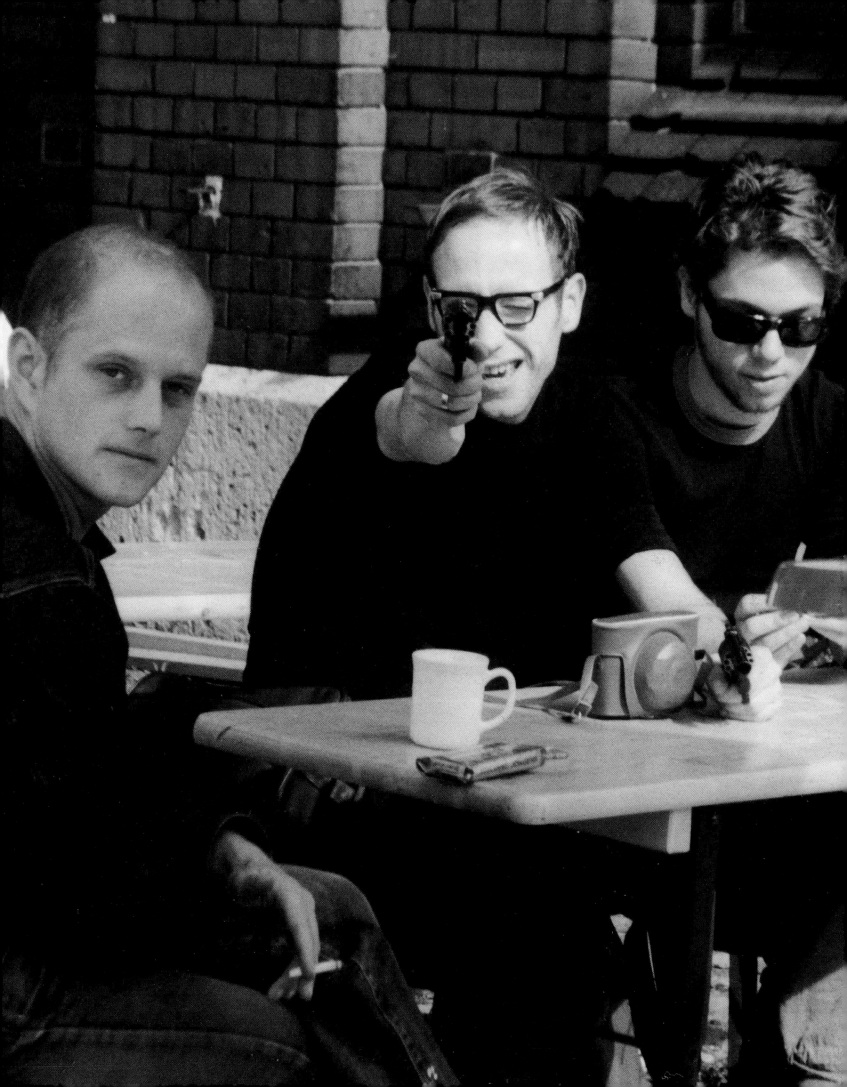

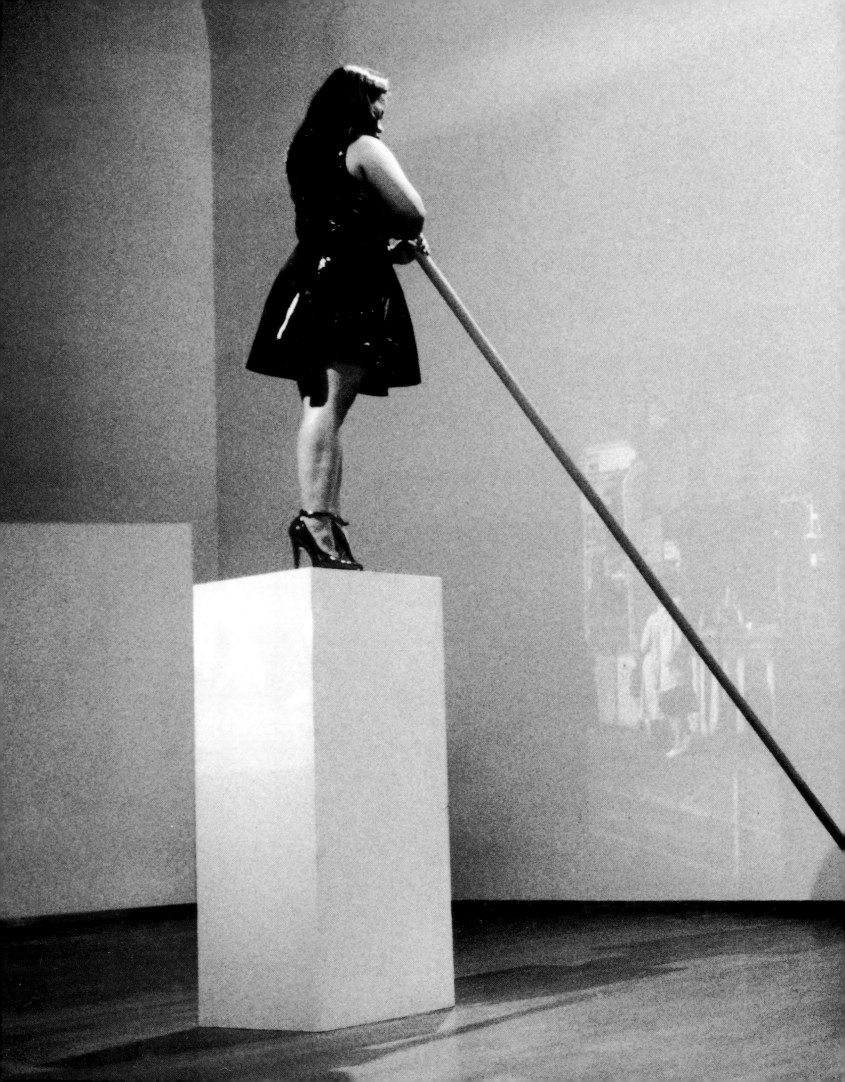

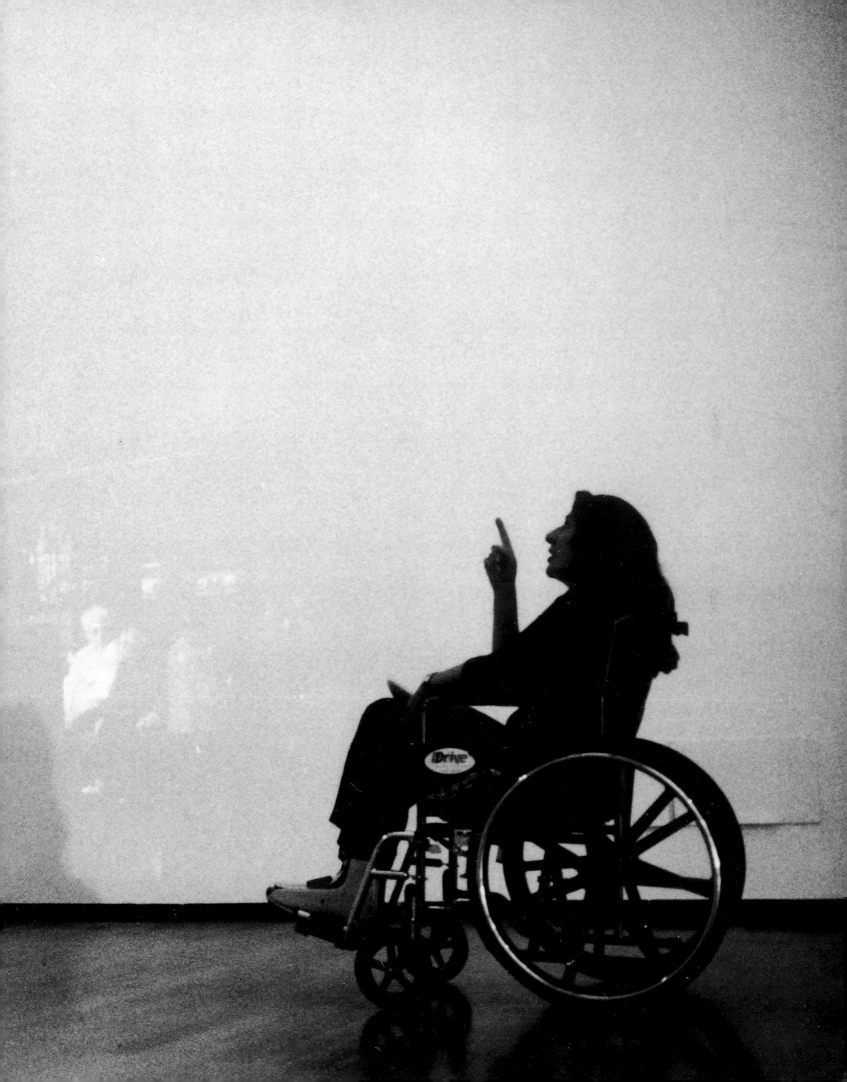

Appendix

Students' Biographies

Beatriz Albuquerque
Born 1978 in Porto, Portugal

Education
Faculdade de Belas Artes da Universidade do Porto,
Porto, Portugal, 1998-2003

Selected Solo Exhibitions and Projects
Mutatis Mutandis, Maus Hábitos, Porto, Portugal,
2002
47ème Salon de Montrouge, Salon de Montrouge,
Montrouge, France; Monestir de Sant Cugat, Sant
Cugat, Spain; Museu de Arte de Amarante, Amarante,
Portugal, 2002

Selected Group Exhibitions and Projects
21Porto2001, Galeria João Lagoa, Porto, Portugal,
2001
Punto a punto, Centro Cultural Palacio de la
Audiencia, Soria, Spain, 2002
HumaniArte, Mercado Ferreira Borges, Porto,
Portugal, 2003

Bibliography (selection)
Nicole Ginoux, Mario Pasqualotto and Fátima
Lambert, *47ème Salon de Montrouge: Salon européen
des jeunes créateurs,* Ecoprint, France / Spain /
Portugal, p. 16, 50, 82

www.beatrizalbuquerque.web.pt
e-mail: beatriz_albuquerque@hotmail.com

Frank Begemann
Born 1967 in Dannenberg / Elbe, Germany

Education
Insurance agent, Magdeburger-Versicherungsgruppe,
Magdeburg, Germany, 1985-1987
Degree in Social Pedagogy, Fachhochschule
Braunschweig-Wolfenbüttel, Germany, 1990-1994
Degree in Visual Arts, Hochschule für Bildende
Künste, Braunschweig, Germany, 1996-2002

Selected Group Exhibitions and Projects
Cleaning the House workshop, Domaine de
Kerguéhennec, France, 1997
Zwischenräume – Finally, Kunstverein Hannover,
Hanover, Germany, 1998
Windscreen Movie, Kottbusser Tor, Hochschule der
Künste, Berlin, Germany, 1999
Fresh Air, Kulturstadt Europa, E-Werk, Weimar,
Germany, 1999
Kontext / Kunst / Vermittlung Januar 01 Neue
Gesellschaft für Bildende Kunst e.V., Berlin, Germany,
2001

Visible Differences, Hebbel Theater, Berlin, Germany,
2000
Performances Klasse Abramović,
Kaskadenkondensator, Basel, Switzerland, 2001
Städelschule / Manifesta 4, Projekt 1004, Frankfurt
am Main, Germany, 2002

Bibliography (selection)
Karla Götz, "Frischer Wind im Straßenbahndepot",
Braunschweiger Zeitung, Braunschweig, 20/09/1999
Marina Abramović, *Fresh Air,* ed. Hannes Malte
Mahler, Salon Verlag, Cologne, 1999
Florian Klebs, "Das muss doch weh tun", *Unicum,*
Bochum, April 2000, p. 16
"Humour et ironie en action", *ETC Montreal,*
Montreal, May 2001, p. 30-31

www.fuzzy-kids.de

Anna Berndtson
Born 1972 in Malmö, Sweden

Education
City of Bath College, Bath, United Kingdom, 1994-
1996
Dartington College of Arts, Dartington, United
Kingdom, 1996-1999
Hochschule für Bildende Künste, Braunschweig,
Germany, 2001

Prizes and / or Awards
The Lydia and Charles Thompson Award for
Performing Arts, City of Bath College, Bath, United
Kingdom, 1996
Francois Berliner Performance Preis, Gesellschaft für
Gegenwart und Kultur e.V., Berlin, Germany, 2001

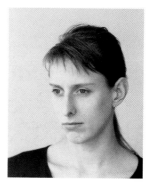

Selected Group Exhibitions and Projects
Satellit, Z 2000, Berlin-Pavillon, Berlin, Germany,
2000
Kontakt Räume – Junger Schmuck – Zweiter Teil,
Kunsthalle Rodstock, Rodstock, Germany, 2001
Body Power / Power Play, Württembergischer
Kunstverein, Stuttgart, Germany, 2002
Prêt-à-Perform, Viafarini, Milan, Italy, 2002
Body Basics I / Body Basics II, Transart 02,
Klanspuren Festival, Fortezza, Brixen, Italy, 2002
Common Ground, Landesvertretung Niedersachsen
and Schleswig-Holstein, Berlin, Germany, 2002
Cleaning the House workshop, Centro Galego de Arte
Contemporánea, Santiago de Compostela, Spain,
2002
Tanztage, Sophiensaele, Berlin, Germany, 2003
Westend Unfinished, Lindenauer Markt and
Schaubühne Lindenfels, Leipzig, Germany, 2003

Bibliography (selection)
Hartmut Fischer, *Theaterperipherien*,
Konkursbuchverlag, Tubingen, 2001,
p. 107-109
Ulrich Amling, "Die Geschichte vom blutigen
Ende der Liebe", *Tages Spiegel*, Berlin, 04/01/2003,
p. 21

www.berndtson-art.net
www.hbk-bs/abramovic-class

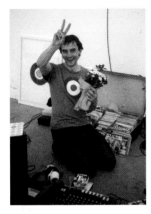

Oliver Blomeier
Born 1967 in Karlsruhe, Germany

Education
Hochschule für Bildende Künste, Braunschweig,
Germany, 1994-2002

Selected Solo Exhibitions and Projects
Spur der Kohlen, Bauhaus Dessau, Dessau, 1993
Immer Weiter. Frühling als zustand, CargoBat, Basel,
Switzerland, 2003

Selected Group Exhibitions and Projects
OSTranenie'93, Bauhaus Dessau, Dessau, Germany,
1993
Materia Troïka, Halle Dessau Schönebeck, Dessau,
Germany, 1995
Wiedersehen, Herbstausstellung des Kunstverein
Hannover, Hanover, Germany, 1996
Pandaemonium, London Festival of Moving Images,
London, United Kingdom, 1997
European Media Art Festival, Osnabrück, Germany,
1998
Zwischenräume – Finally, Kunstverein Hannover,
Hanover, Germany, 1998
Unfinished Business, Haus am Lützowplatz, Berlin,
Germany, 1999
Marking the Territory, Irish Museum of Modern Art,
Dublin, Ireland, 2001
Body Power / Power Play, Württembergischer
Kunstverein, Stuttgart, Germany, 2002
As Soon as Possible, PAC, Padiglione d'Arte
Contemporanea, Milan, Italy, 2003

Bibliography (selection)
Hermann Pfütze, "Unfinished Business",
Kunstforum, Ruppichteroth, no. 145, June / July
1999, p. 357-358
Marina Abramović, *Fresh Air*, ed. Hannes Malte
Mahler, Salon Verlag, Cologne, 1999, p. 56-59
Kunstpreis 2000, Landkreis Gifhorn, Gifhorn, 2000,
p. 20-21

e-mail: o.blomeier@gmx.net

Vera Bourgeois
Born 1961 in Saarbrücken, Germany

Education
Hochschule der Künste, Berlin, Germany
Hochschule für Bildende Künste, Hamburg,
Germany

Städelschule, Frankfurt am Main, Germany

Scholarships
Institut für Bildung und Kultur Remscheid,
Remscheid, Germany, 1989
Erasmus, Vienna, Austria, 1995
Ministerium für Wissenschaft und Kunst, Wiesbaden,
Germany, 1999
Kulturministerium Hamburg, Germany

Prizes and / or Awards
1st Prize, Bildende Künstler stellen dar, Munich,
Germany, 1995

Selected Solo Exhibitions and Projects
Soil and Mineral, Galerie Delta, Moscow,
1992
Willst du mal mein Kästchen sehen?,
Galerie Vaalserberg, Rotterdam, The Netherlands,
1995
Sonderauswahl, Mangelware, Kaskadenkondensator,
Basel, Switzerland, 1997
Handwerk-atelier Bourgeois, Forum 1822, Frankfurt
am Main, Germany, 1999
My Own House, Kunstverein Hannover, Hanover,
Germany, 2002

Selected Group Exhibitions and Projects
Gefühlsort München, Black Box and Gasteig,
Munich, Germany, 1998
8 x 8 x 8, Kunstverein Frankfurt, Frankfurt,
Germany, 1998
Kunstfragen, Kunsthaus Glarus, Glarus, Germany,
1999
Home-Summit Meeting, Migros Museum, Zürich,
Switzerland, 1999
Bitte werfen Sie jetzt..., Performance Festival Odense,
Odense, Denmark, 1999
HiFa, National Gallery Harare, Harare, Zimbabwe,
2000

Bibliography (selection)
Konservierung, Hamburg, 1995
T. Erdelmeier, B. Franzen and M. Schneider (ed.),
Etwas besseres als den Tod findest du überall,
Verlag Walter König, Cologne, 1997
Vera Bourgeois, Forum 1822, Frankfurt am Main,
1999
Vera Bourgeois, Frankfurt, 2000

e-mail: vera.bourgeois@gmx.net

Sarah Braun
Born 1972 in Gießen, Germany

Education
Hochschule für Bildende Künste, Braunschweig,
Germany, since 1995

Selected Group Exhibitions and Projects
Zwischenräume – Finally, Kunstverein Hannover,
Hanover, Germany, 1998
Grand Prix d'Amour, KuLe, Berlin, Germany,
Germany, 1999
Visible Differences, Hebbel Theater, Berlin, Germany,
2000

Real Presence – Generation 2001, The Balkans Trans /
Border – Open Art Project, Belgrade, Serbia and
Montenegro, 2001
Get that Balance, National Sculpture Factory, Opera
House / Half Moon Theater, Cork, Ireland, 2001
Marking the Territory, Irish Museum of Modern Art,
Dublin, Ireland, 2001
Cleaning the House workshop, Centro Galego de Arte
Contemporánea, Santiago de Compostela, Spain, 2002
Body Basics I / Body Basics II, Transart 02,
Klanspuren Festival, Fortezza, Brixen, Italy, 2002
Prêt-à-Perform, Viafarini, Milan, Italy, 2002
Body Power / Body Play, Württembergischer
Kunstverein, Stuttgart, Germany, 2002

Bibliography (selection)
Marina Abramović, *Fresh Air,* ed. Hannes Malte
Mahler, Salon Verlag, Cologne, 1999
Wer hat Angst vor Roger Whittaker? (CD-Rom),
Freunde Aktueller Kunst, Zwickau, 2000
Marking the Territory (video catalogue), Irish Museum
of Modern Art, Dublin, 2001

e-mail: sarahlacht@hotmail.com

Maria Chenut
Born 1976 in Paris, France

Education
Career Discovery Program in Architecture, Harvard,
USA
Graduate School of Design, Cambridge, Massachusetts,
USA, 1993
Gallatin School of Individualized Studies, New York
University, New York, USA, 1994-1998
Studio Art Center International, Florence, Italy, 1996-
1997
Contemporary Dance with Beatriz Fuentes, Santiago
de Compostela, Spain, 2002-2003

Selected Solo Exhibitions and Projects
Sala Wootelo, Lugo, Spain, 2002

Selected Group Exhibitions and Projects
Loaded, 873 Broadway, New York, USA, 1996
Liquidation Show, Gallery 128, New York, USA, 1998
Set design and construction of *The Artificial Nigger,*
The American Living Room, Here, New York, USA,
1998
Installation in the Library Miguel González Garcés, A
Coruña, Spain, 1999
Set design and construction of *Madras la nuit où...,*
Art Studio Teatre, Paris, France, 1999
Set design of *Lembranzas,* Ballet Galego Rey de Viana,
A Coruña, Spain, 2001
Poetic acts and installations with Espacio and
Iniciativa Curva, Fundación Eugenio Granell, Santiago
de Compostela, Spain, 2001-2002
Cleaning the House workshop, Centro Galego de Arte
Contemporánea, Santiago de Compostela, Spain, 2002
Festival IFI (collective installation), Palacio de
Congresos de Pontevedra, Pontevedra, Spain, 2003
Vibración espacial (performance with Pablo Orza),
Maus Hábitos, Porto, Portugal, 2003

e-mail: mariachenut@yahoo.com

Ivan Čivić
Born 1979 in Sarajevo, Bosnia & Herzegovina

Education
Liceo scientifico Giorgio Dal Piaz, Feltre, Italy,
1995-1999
Hochschule für Bildende Künste, Braunschweig,
Germany, since 1999

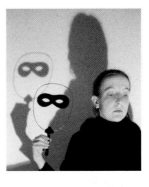

Selected Group Exhibitions and Projects
A Little Bit of History Repeated, Kunst Werke, Berlin,
Germany, 2001
Marking the Territory, Irish Museum of Modern Art,
Dublin, Ireland, 2001
12th Impakt Filmfestival, Central Museum, Utrecht,
The Netherlands, 2001
Cleaning the House workshop, Centro Galego de Arte
Contemporánea, Santiago de Compostela, Spain, 2002
Body Basics I / Body Basics II, Transart 02,
Klanspuren Festival, Fortezza, Brixen, Italy, 2002
Prêt-à-Perform, Viafarini, Milan, Italy, 2002
13th Impakt Filmfestival, Voormalige Rechtbank,
Utrecht, The Netherlands, 2002
Body Power / Power Play, Württembergischer
Kunstverein, Stuttgart, Germany, 2002
As Soon as Possible, PAC, Padiglione d'Arte
Contemporanea, Milan, Italy, 2003
Recycling the Future, 50. Esposizione Internazionale
d'Arte La Biennale di Venezia, Venice, Italy, 2003

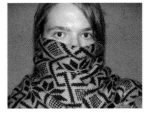

Bibliography (selection)
Frank Werner, "Summercollection", *Filmklasse,* Salon
Verlag, Cologne, 2000, p. 156
Melissa de Raaf, "Stardom", *Impakt guide bulletin,*
Utrecht, no. 13, November 2002, p. 11
"Arti performative, Una nuova avanguardia?", *Flash
Art,* Milan, no. 232, February / March 2002, p. 56

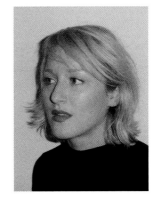

Amanda Coogan
Born 1971 in Dublin, Ireland

Education
Limerick School of Art and Design, Limerick, Ireland,
1989-1992
Athens School of Fine Arts, Athens, Greece, 1994-
1995
National College of Art and Design, Dublin, Ireland,
1997-1998
Hochschule für Bildende Künste, Braunschweig,
Germany, 1999-2001

Scholarships
Greek Government Scholarship, Athens School of Fine
Arts, Athens, Greece, 1994

Prizes and / or Awards
Artist Bursary, Arts Council of Ireland, Dublin,
Ireland, 2002
Prize winner, *EV+A 02,* Limerick, Ireland, 2002

Selected Group Exhibitions and Projects
Marking the Territory, Irish Museum of Modern Art,
Dublin, Ireland, 2001
EV+A 02, Limerick City Gallery, Limerick, Ireland,
2002
Intermedia, Triskel Arts Centre, Cork, Ireland, 2002

Eisge Arts Festival, CIT, Carlow, Ireland, 2002
Cleaning the House workshop, Centro Galego de Arte
Contemporánea, Santiago de Compostela, Spain, 2002
Eurojets Futures, Royal Hibernian Academy, Dublin,
Ireland, 2002
Reading Beethoven, Location, Playforum, Firestation
Artist Sudios, Dublin, Ireland, 2003
As Soon as Possible, PAC, Padiglione d'Arte
Contemporanea, Milan, Italy, 2003
Recycling the Future, 50. Esposizione Internazionale
d'Arte La Biennale di Venezia, Venice, Italy, 2003
New Additions, National Self Portrait Collection of
Ireland, Limerick, Ireland, 2003

Bibliography (selection)

Marking the Territory (video catalogue), Irish Museum
of Modern Art, Dublin, 2001
Patrick T. Murphy, *Eurojets Futures 02,* Royal
Hibernian Academy, Dublin, 2002, p. 16-19
Paul M. O'Reilly, *EV+A 2002 Heros + Holies,* Gandon
Editions, Limerick, 2002, p. 10, 54-55
Robert Ayers, "*Marking the Territory* at IMMA, a
review", *Contemporary,* London, January 2002
Declan Long, "Are you someone? Artists and the Art
of branding", *Circa 101,* Dublin, Autumn 2002
Medb Ruane, "Take-off for a new generation", *The
Sunday Times,* Dublin, 28/7/2002
Aidan Dunne, "Coming from a different perspective",
The Irish Times, Dublin, 23/5/2003, p. 16

www.firestation.ie/beethoven
e-mail: amandacoogan@hotmail.com

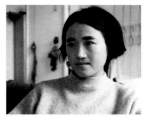
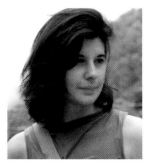

Yingmei Duan
Born 1970 in Shenyang, China

Education

The Northeast Petroleum University, Daqing, China,
1987-1989
The Central Academy of Fine Arts, Beijing, China,
1991-1993
The Central Academy of Applied Arts, Beijing, China,
1996-1997
Hochschule für Bildende Künste, Braunschweig,
Germany, since 1999

Scholarships
12.R.C.-Stipendium, Eichhofen, Germany, 1999

Selected Solo Exhibitions and Projects
Duan Yingmei – Peking, Kunsthaus Erfurt, Erfurt,
Germany, 1995
Duan Yingmei Bilder aus Peking, Galerie am Prater,
Berlin, Germany, 1996

Selected Group Exhibitions and Projects
100 Young Artists, National Art Museum, Beijing,
China, 1993
An Anonymous Mountain Increased One, The
collective works by artists of Beijing East Village,
Biennale di Venezia, Venice, Italy, 1999
Wer har Angst vor Roger Whittaker?, Städtisches
Museum, Zwickau, Germany, 2000
Ovalen den frie udsillings bygning, Copenhagen,
Denmark, 2001
Get that Balance, National Sculpture Factory, Opera

House / Half Moon Theater, Cork, Ireland, 2001
Marking the Territory, Irish Museum of Modern Art,
Dublin, Ireland, 2001
Common Ground, Landesvertretung Niedersachsen
and Schleswig-Holstein, Berlin, Germany, 2002
Cleaning the House workshop, Centro Galego de Arte
Contemporánea, Santiago de Compostela, Spain, 2002
Body Basics I / Body Basics II, Transart 02,
Klanspuren Festival, Fortezza, Brixen, Italy, 2002
Prêt-à-Perform, Viafarini, Milan, Italy, 2002

Bibliography (selection)

"Erotisches in dunklen Farben", *Erfurt,* Erfurt,
1/09/1995
Eike Küstner, "Die Frauen – frontal oder auch
unwirklich geisterhaft", *Erfurter Allgemeine,* Erfurt,
11/08/1995
Sara Thiel, "Gegen die Verflachung der Kultur
angestänkert", *Kulturseite,* Zwickau, 26/06/2001
Ulrike Winter, "Dickes Lob für schräges Zwickau",
Zwickauer Zeitung, Zwickau, 26/06/2001
Alexander Huber, "Kunst mit Ohrfeige nach dem
Prinzip Kurzfilm", *Braunschweig Kultur,*
Braunschweig, 5/06/2002

e-mail: yingmei@gmx.de

Nezaket Ekici
Born 1970 in Kirsehir, Turkey

Education
Education as print / layout operator, Duisburg,
Germany, 1990-1993
Studies of History of Art and Art Pedagogy at the
Ludwig Maximilians University, Munich, Germany,
1994-2000
Akademie der Bildenden Künste, Munich, Germany,
1996-2000
Hochschule für Bildende Künste, Braunschweig,
Germany, since 2001

Scholarships
Stipendium des Bayerischen Staatsministeriums für
ausländische Studierende, Munich, Germany, 1998
Class of Ilya Kabakov, Fondazione Antonio Ratti,
Como, Italy, 2000
Brazier's International Artist Workshop, Oxfordshire,
United Kingdom, 2001
Else-Heiliger-Stipendiums der Konrad-
Adenauerstiftung, Berlin, Germany, 2002
Stipendium Stiftung Künstlerdorf Schöppingen,
Germany, 2003

Prizes and / or Awards
Kulturreferat der Stadt München, BMW Group,
Munich, Germany, 1999
Kulturreferat der Stadt München, MVV und Dresdner
Bank, Munich, Germany, 2001
Goethe Institut Inter Nationes, Milan, Italy, 2002
Goethe Institut Inter Nationes, Damaskus, Syria, 2003

Selected Solo Exhibitions and Projects
Lab Control, Akademie Galerie, Munich, Germany, 1999
Emotion in Motion, Kaskadenkondensator, Basel,
Switzerland, 2000
Lee(h)rstellen – Beauty Lies in the Eye of the

Beholder, Akademie Galerie, Munich, Germany, 2002
Werkschau, Galerie Weisser Elefant, Berlin, Germany, 2002
Emotion in Motion, Galleria Valeria Belvedere, Milan, Italy, 2002

Selected Group Exhibitions and Projects
Marking the Territory, Irish Museum of Modern Art, Dublin, Ireland, 2001
Random Ize Film and Video Festival, London, United Kingdom, 2002
Cleaning the House workshop, Centro Galego de Arte Contemporánea, Santiago de Compostela, Spain, 2002
Prêt-à-Perform, Viafarini, Milan, Italy, 2002
Rituale in der zeitgenössischen Kunst, Akademie der Künste, Berlin, Germany, 2003
5th International Women's Art Festival, Aleppo, Syria, 2003

Bibliography (selection)
Laura Frigerio, "Interno a una bottiglia vuota", *Corriere della Sera,* Milan, 3/7/2000, p. 55
Ilya Kabakov / Public Projects or the Spirit of a Place, Fondazione Antonio Ratti, Advanced Course in Visual Arts Publication, Milan, 2001, p. 297
base.ment, 13 Installationen im Zwischengeschoß der U6, Munich, 2001, p. 42-45
Astrid Mayerle, "Überschall im Untergrund", *Die Welt (Kultur & Gesellschaft),* Munich, 6/7/2001
Rituale in der zeitgenössischen Kunst, Akademie der Künste, Berlin, 2003, p. 58-59
Nisrine Maktabi, "Women's arts festival turns heads with daring performances"
"Aleppo hosts international event that challenges ideas on sexuality, space and expression", *Special to The Daily Star,* Jordan, 20/5/2003

www.ekici-art.de
e-mail: nekici@yahoo.de

Félix Fernández
Born 1977 in Celeiro, Viveiro, Spain

Education
Degree in Fine Arts, University of Vigo, Pontevedra, Spain, 2001

Prizes
VIII Certame de Artes Plásticas Cidade de Lugo, Círculo de Belas Artes, Lugo, Spain, 2001

Selected Solo Exhibitions and Projects
Miradas Vírgenes, Centro Torrente Ballester, Ferrol, Spain, 2003

Selected Group Exhibitions and Projects
Plugged, Unplugged, Centro de Arte Joven, Madrid; Facultade de Belas Artes, Pontevedra, Spain, 2002
R-Visiones (de lo doméstico), Salón de los Relojes, Colegio de Fonseca, Salamanca, Spain, 2002
Festival IFI (sound installation), Facultade de Belas Artes, Pontevedra, Spain, 2002
III Festival Internacional d'Investigació Artística de Valencia OBSERVATORI 2002, Museu Valencià de la Il·lustració i la Modernitat, Valencia, Spain, 2002
Muestra audiovisual INJUVE, Sala Amadís, Madrid,

Spain; Centro Cultural Montehermoso, Vitoria, Spain, 2003
Doméstico 02, Delicias 143, Madrid, Spain, 2003
Operario de ideas, stand 9.5-D, Arco '03, Madrid, Spain, 2003
Emergencias, Casa Encendida, Madrid, Spain, 2003
Photoespaña, Plaza de Santa Ana, Madrid, Spain, 2003

Regina Frank
Born 1965 in Meßkirch, Germany

Education
Hochschule der Künste, Berlin, Germany, 1989-1994

Scholarships
Senatsverwaltung für Wissenschaft und Forschung, Berlin, Germany, 1993
Institute for Foreign Exchange, IFA, Germany, 1994
Arts International, USA, 1996
Kade Collaborative Works Program, USA, 1996
IBM Interactive Media, Atlanta, USA, 1996
Goethe Institute Atlanta, Atlanta, USA, 1996
Stiftung Kulturfond, Berlin, Germany, 1997
Senatsverwaltung für Wissenschaft und Forschung, Berlin, Germany, 1998
Canbox Technology, 1999
SAIR Sapporo Artist in Residency Program, Sapporo, Japan, 2003

Selected Solo Exhibitions and Projects
L'Adieu – Pearls Before Gods, Broadway Window, New Museum of Contemporary Art, New York, USA, 1993
Fenster im Netz, Hermes' Mistress, Kunsthalle Berlin, Berlin, Germany, 1994
Positionen, Gallery Wewerka, Berlin, Germany, 1994
Hermes' Mistress, Spiral Wacoal Art Center, Tokyo, Japan, 1996
The Artist Is Present – 1992-1998, Kunst auf Kampnagel KX, Hamburg, Germany, 1998
The Artist Is Present – 1992-1999, Städtische Galerie Drei Eich, Frankfurt, Germany, 1999
Mother of Pearl, Clifford Smith Gallery, Boston, USA, 1999
Zwischen Zeilen, Haus der Presse, Berlin, Germany, 2001
Zwischen Zeilen, Henrike Höhn Kunstprojekte, Berlin, Germany, 2001
Whiteness in Decay, San Diego Museum of Art, San Diego, USA, 2003

Selected Group Exhibitions and Projects
Let the Artist Live, Exit Art – The First World, New York, USA, 1994
Divisions of Labor, Museum of Contemporary Art, Los Angeles; Bronx Museum, New York, USA, 1995-1996
Conversations at the Castle, Arts Festival of Atlanta, Centennial Olympic Games, Atlanta, USA, 1996
Join Me, Spiral Wacoal Art Center, Tokyo, Japan 1996
Blurrr, Biennale for Performance Art, Center for Performing Arts – The Opera, Tel-Aviv, Israel, 1997
Loose Threads, Serpentine Gallery, London, United Kingdom, 1998
Biennale di Venezia, Italian Pavilion, Giardini di Castello, Venice, Italy, 1999
EXPO 2000, IFU – Pavilion, Hanover, Germany, 2000

Intermediale, PS7 Performance Studies Conference, Mainz, Germany, 2001
Digital Crossover, Muffathalle, Munich, Germany, 2002

Bibliography (selection)

Elisabeth Hess, "No Exit Art", *The Village Voice,* 11/10/1994, p. 1, 103
Yuko Hasegawa, "Regina Frank – Hermes' Mistress", *Studio Voice,* Tokyo, July 1996, p. 62-67
Arnd Weseman, "Datenfaden im Seidenkleid", *Screen Multimedia,* Hamburg, February 1996, p. 131-133
Miki Miyatake, "Knotting Threads of Friendship", *Japan Times,* Tokyo, 29/06/1996, p. 21
Regina Frank, *Being on Line,* Lusitania Press, New York, p. 150-156
Regina Frank, "De Arte y Moda", *Arte y Parte,* no. 14, Madrid, April / May 1998, p. 18-23
Homi K. Bhabha and Regina Frank, *Conversations at the Castle,* Mary Jane Jacob and Michael Brenson (ed.), MIT Press, Cambridge, Massachusetts, 1998, p. 20-25, p. 26-36
Richard Vince, Cathy Byrd and Ute Ritschel, *Regina Frank: The Artist is Present – 1992-1999,* Sentsverwaltung für Wissenschaft und Forschung, Berlin, 1999, p. 1-169
Cathy Bird, "Regina Frank: Nurtuting a Sculptural Encounter", *Sculpture Magazine,* International Sculpture Center, Hamilton, vol. 20, no. 2, March 2001, p. 16-23
Robert L. Pincus, "Two for the Show", *The San Diego Union Tribune,* San Diego, 29/06/2003, p. 34-35

www.regina-frank.de
e-mail: regina@regina-frank.de

Marica Gojević
Born 1968 in Croatia

Education
Fine Arts, Split, Croatia, 1983-1988
Visual Communication, HfG, Basel, Switzerland, 1995-1996
Audiovisual Design, HfG, Basel, Switzerland, 1996-1999
Class of Marina Abramović, Hochschule für Bildende Künste, Braunschweig, Germany, 1999-2002

Prizes and / or Awards
Kunstreisepreis, Kunstverein Basel-Stadt, Basel, Switzerland, 1998
Support Fachausschuß für Film, Foto und Video, Basel-Stadt & Basel-Landschaft, Switzerland, 1999
Support Fachausschuß für Film, Foto und Video, Basel-Stadt & Basel-Landschaft, Switzerland, 2001
Swiss Art Award, Switzerland, 2001
Kulturförderpreis Alexander Clavel Foundation, Switzerland, 2002
Swiss Art Award, Switzerland, 2002

Selected Solo Exhibitions and Projects
Miroir (performance), Kaskadenkondensator, Basel, Switzerland, 2000
Galerie im Tor, Emmendingen, Germany, 2001
Hinter dem Meer, Villa Merkel, Esslingen am Maim, Germany, 2001

Selected Group Exhibitions and Projects
Insight Out, Kunsthaus Baselland, Basel, Switzerland, 1999
Visible Differences, Hebbel Theater, Berlin, Germany, 2000
Communicationfront, International Festival for New Media, Plovdiv, Bulgary, 2000
Quand l'art se met à rimer avec départ, Galerie Gisèle Linder, Basel, Switzerland, 2001
Marking the Territory, Irish Museum of Modern Art, Dublin, Ireland, 2001
Cleaning the House workshop, Centro Galego de Arte Contemporánea, Santiago de Compostela, Spain, 2002
Prêt-à-Perform, Viafarini, Milan, Italy, 2002
Hanoi Art Goes New Media, Vietnam Fine Art Association, Hanoi, Vietnam, 2002
Miss.You, Museum für Neue Kunst, Freiburg i.Br., Freiburg, Germany, 2002
Appendix 2, Caucasian Institute for Cultural Development, Tiblisi, Georgia, 2003

Bibliography (selection)

Wonder Red Now, Bundesamt für Kultur, Bern, 2001
Hinter dem Meer, Bahnwärterhaus, Villa Merkel, Esslingen am Neckar, 2001
Swiss Art Awards, Bundesamt für Kultur, Bern, 2002
Miss.You, Museum für Neue Kunst, Freiburg i.Br., 2002

Pascale Grau
Born 1960 in St. Gallen, Switzerland

Education
Hochschule für Bildende Künste, Hamburg, Germany, 1986-1994

Scholarships
Corti – Aeschlimann Stipendium, Bern, Switzerland, 1997
BINZ 39: Scuol – Nariz, Switzerland, 1998

Prizes and / or Awards
Werkbeitrag Kanton und Stadt Bern, Switzerland, 1996
Foto / Film / Videokredit, Basel, Switzerland, 2001

Selected Solo Exhibitions and Projects
Ei Sprung (performance), *Body Act,* Kunsthalle Malmö, Malmö, Sweden, 1998
Ei Sprung (performance), Neumarkt Theater, Zürich, Switzerland, 2000
Enhanced by King Kong (performance), *Intervention,* Centre Georges Pompidou, Paris, France, 2001
Die Welt mit Blumen schlagen, Galerie Werkstatt Reinach, Reinach, Germany, 2002
Ovation, Galerie Foth, Freiburg, Germany, 2003

Selected Group Exhibitions and Projects
Weihnachtsausstellung, Kunsthalle Bern, Bern, Switzerland, 1997
Body Act (with Andrea Saemann), Kunsthalle Malmö, Malmö, Sweden, 1998
In and Out (with Andrea Saemann), Barcelona / Madrid, Spain, 1998
Ostschweizer Kunstschaffen, Kunstmuseum St. Gallen, St. Gallen, Switzerland, 2000
Killing Me Softly, (performance: *Endorphine*),

Kunsthalle Bern, Bern, Switzerland, 2001
Come Back, Projektraum exex St. Gallen, St. Gallen, Switzerland, 2003

Bibliographie (selection)
Performance-Index, documentation catalogue, "Pascale Grau", PERFORMANCE-INDEX-Group, Basel, 1995
Monitor, Mediaskulptur96, newspaper with text contribution Pascale Grau and Andrea Saemann, Langenthal, 1996, p. 7
Isabel Morf, "Pascale Grau", *Frauen im kulturellen Leben in der Schweiz,* PRO Helvetia, Zürich, 1997, p. 43-44
"Pascale Grau", Kulturzentrum Scuol-Nairs Dokumentation 1997, Stiftung BINZ 39, Horgen, p. 37
Dr. Thomas Müller, "Pascale Grau", Berner Kunstmitteilungen, 1997, no. 311, p. 32
Fred Zaugg and Alexander Egger, "Pascale Grau", *Lokaltermin Atelier II ,* Bernische Kunstgesellschaft, Bern, 1998, p. 83
Regionale 2000, Kunsthalle Basel, Basel, 2000
In between, Bildmedien im Dialog, Kunsthaus Langenthal, Langenthal, 2002

www.xcult.org/pascalegrau
e-mail: pascalegrau@gmx.ch

René Block and Tobias Berger, *Rundgang 2 – Katrin Herbel, Henrik Hold, Catrine Val,* Museum Fridericianum, Kassel, 1998, p. 4-7
Jörg Worat, "Bandagierter Künstler Ben Stone legte sich nackt in Salz und Zucker – Extreme 24-Stunden-Aktion im Kunstverein", *Neue Presse,* Hanover, no. 103, 04/05/1998
Jörg Worat, "Extremkunst: Ein Nackter zwischen Salz und Zucker – HBK-Studenten performten 24 Stunden in Hannover", *Braunschweiger Zeitung,* Braunschweig, 06/05/1998
Kristina Tieke, "Mann in Windeln – 'Sommerfrische': Videoarbeiten in der Eisfabrik Hannover", *Hannoverische Allgemeine Zeitung,* Hanover, 24/07/1999
Hermann Pfütze, *Unfinished Business* – Marina Abramović and students, Haus am Lützowplatz, Berlin, 18.5. - 4.7.1999", *Kunstforum,* no. 147, September / November 1999, p. 357-358
Marina Abramović, *Public Body,* Edizioni Charta, Milan, 2001, p. 16
Wolfgang Seybold, "Ausstellung 'Lemon Fresh' bei den Gronauer Kulturtagen – Grafische Strukturen, lebhafte Kontraste", *Heilbronner Stimme,* Heilbronn, 12/09/2001

e-mail: absolutherbel@gmx.net

Katrin Herbel
Born 1972 in Heilbronn, Germany

Education
Hochschule für Bildende Künste, Braunschweig, Germany, 1994-2001

Scholarships
Arbeitsstipendium des Landes Niedersachsen, Braunschweig, Germany, 2000
Atelierstipendium Künstlerdorf Schöppingen, Schöppingen, 2000 / 2001

Selected Solo Exhibitions and Projects
Mit Händen & Füßen – Katrin Herbel, Kunstraum Alter Wiehrebahnhof, Freiburg, Germany, 2002

Selected Group Exhibitions and Projects
Zwischenräume – Finally, Kunstverein Hannover, Hanover, Germany, 1998
Rundgang 2, Museum Fridericianum, Kassel, Germany, 1998
Get Physical!, Galerie Gutleut 15, Frankfurt am Main, Germany, 1999
Unfinished Business, Galerie Haus am Lützowplatz, Berlin, Germany, 1999
Fresh Air, Kulturstadt Europa, E-Werk, Weimar, Germany, 1999
Scape, Eisfabrik Hannover, Hanover, Germany, 2000
Wer hat Angst vor Roger Whittacker?, Freunde Aktueller Kunst e.V. Sachen und Thüringen, Städtisches Museum Zwickau, Zwickau, Germany, 2001
Lemon Fresh, Kulturtage, Gronau, Germany, 2001
Marking the Territory, Irish Museum of Modern Art, Dublin, Ireland, 2001

Bibliography (selection)

Eun-Hye Hwang
Born 1978 in Seoul, Korea

Education
Studies of Painting (Major in Western Painting), Yong-In University, Yongin-Shi, Korea, 1997-2002
Graduation exhibition in Kyoung-Pyeng Art Center, Seoul, Korea, 2002
Class of Marina Abramović, Hochschule für Bildende Künste, Braunschweig, Germany, 2002

e-mail: eunhye0@hotmail.com

Julie Jaffrennou
Born 1973 in Angers, France

Education
Conservatoire d'Art Dramatique, Angers, France, 1990-1993
École des Beaux-Arts, Angers, France, 1992-1997
Hochschule für Bildende Künste, Braunschweig, Germany, 1995-1999

Scholarship
Bourse de l'Office Franco-Allemand pour la Jeunesse, 1995-1996

Selected Solo Exhibition and Projects
Curiosités lumineuses, Tour Saint-Aubin, Angers, France, 2001
Défloraison, Plage, Tréguennec, France, 2003

Selected Group Exhibitions and Projects
Kulturnacht, FBZ, Braunschweig, Germany, 1997
Cleaning the House workshop, Domaine de

Kerguéhennec, France, 1997
Zwischenräume – Finally, Kunstverein Hannover, Hanover, Germany, 1998
Festival Les Surréales, Berlin, Germany, 1998
Festival Art in Time, Cardiff, United Kingdom, 1999
Fresh Air, Kulturstadt Europa, E-Werk, Weimar, Germany, 1999
Unfinished Business, Haus am Lützowplatz, Berlin, Germany, 1999
Mediengalerie, Mannheim, Germany, 2002

Bibliography (selection)
Sorrento Aureliana, "Slip für Slip, Bild für Bild", *Hannoverische Allgemeinen Zeitung,* Hanover, 07/05/1998
Marina Abramović, *Fresh Air,* ed. Hannes Malte Mahler, Salon Verlag, Cologne, 1999
"Le cabinet de curiosités de Julie Jaffrennou", *Courrier de l'Ouest,* Angers, 09/06/2001

http://juliejaff.free.fr/
e-mail: juliejaff@voila.fr

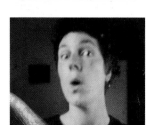

Tellervo Kalleinen
Born 1975 in Lohja, Finland

Education
Chinese Medicine, School of Oriental Medicine, Finland, 1996-2001
Academy of Fine Arts, Helsinki, Finland, 1997-2003
Class of Marina Abramović, Hochschule für Bildende Künste, Braunschweig, Germany, 2000-2001
Class of Cosima Von Bonin, Hochschule für Bildende Künste, Hamburg, Germany, 2001
MFA-Degree, Time and Space Department, Academy of Fine Arts, Helsinki, Finland, 2003

Prizes and / or Awards
Finnish Cultural Foundation, 2003

Selected Solo Exhibition and Projects
White Spot, Gallery of the Academy of Fine Arts, Helsinki, Finland, 2002

Selected Group Exhibitions and Projects
Ylikierroksilla (performance), *Feeling the City* (project by Muury), Helsinki, Finland, 2000
Marking the Territory, Irish Museum of Modern Art, Dublin, Ireland, 2001
Get that Balance, Kampagnel, Hamburg, Germany, 2001
Dr. Kalleinen Opens Her Heart - Performance, *Artgenda - 02,* Hamburg, Germany, 2002
Cosima What Have You Done (performance), Galerie Gabriele Senn, Vienna, Austria, 2002
Hossa, Centro Cultural Andraitx, Mallorca, Spain, 2002
Skaftafell Cultural Center, Skaftafell, Iceland, 2002
Let Me, International Performance Festival, Odense, Denmark, 2003
Exhibition, *Anti-festival,* Kuopio, Finland, 2003

Bibliography (selection)
Patricia Ellis, "Crime scene investigation", *Lab magazine,* London, no. 4, 2002, p. 224
Marja-Terttu Kivirinta, "Elokuvakohtauksia kuutiossa",

Helsingin sanomat, Helsinki, 21/12/2002, p. B5

e-mail: tellervo@kuva.fi

Julia Kami
Born 1972 in Berlin, Germany

Education
Class of C.E. Wolf and Johannes Brus, Sculpture, Painting and Graphic Art, Hochschule für Bildende Künste, Braunschweig, Germany, 1992
Baroda School of Fine Arts, Baroda, India, 1993
Theatre and Body Work, L.O.T. Theater, Braunschweig, Germany, 1994-1996
Class of Marina Abramović, Hochschule für Bildende Künste, Braunschweig, Germany, 1998

Solo Exhibitions and Projects
Lolaland (dance and objects), L.O.T. Theater, Braunschweig, Germany, 1997
Berlin – Brest – Dakar, Parkhaus Treptow, Berlin, Germany, 1999
Black Box Exercise, Hong Kong – Berlin, Haus der Kulturen der Welt, Berlin, 2000
Regenmanteltanz, Performance Salon, K77 studios, Berlin, Germany, 2001

Group Exhibitions and Projects
Sous le vent du temps (performance with Julie Jaffrennou and Melati Suryodarmo), *Kulturnacht,* FBZ, Braunschweig, Germany, 1997
Russian Piece (voices and object), *Cleaning the House* workshop, Domaine de Kerguéhennec, France, 1997
Unterwasserstadt (performance and video projection), *Zwischenräume – Finally,* Kunstverein Hannover, Hanover, Germany, 1998
Master Student's Exhibition, Kunshalle Frankfurterstraße, Braunschweig, Germany, 1998
Prozess, WEIS Herbstkollektion, Berlin, Germany, 2002

www.JuliaKami.de
e-mail: juliakami@web.de

Barbara Klinker
Born 1971 in Villingen, Germany

Education
Hochschule für Bildende Künste, Braunschweig, Germany, 1997-2003

Selected Solo Exhibitions and Projects
Ortwelt, Ausstellunsraum Kurzschluß, Bremen, Germany, 1998
Von Möbeln und Menschen, Projektraum Berlin, Germany, 2000
Funktionieren, Galerie Gruppe Grün, Bremen, Germany, 2000
Smelling and Telling, Barras Market, Glasgow, United Kingdom, 2001

Selected Group Exhibitions and Projects
Die Eiserne Nachrichtenzentrale, Dortmund, Germany, 1997

Zwischenräume – Finally, Kunstverein Hannover, Hanover, Germany, 1998
Fresh Air, Kulturstadt Europa, E-Werk, Weimar, Germany, 1999
Unfinished Business, Gallerie Haus am Lützowplatz, Berlin, Germany, 1999
Haus Köbberling, Guesthouse and Art Space, Kassel, Germany, 2002
Ausland, Cultural Space, Berlin, Germany, 1999-2003

Bibliography (selection)
Hermann Pfütze, "Unfinished Business", *Kunstforum,* p. 357-358
NY Arts Magazine, vol. 7, no. 6, 2002, p. 19
NY Arts Magazine, vol. 7, no. 7, 2002, p. 66-67

Oliver Kochta
Born 1971 in Dresden, Germany

Education
Hochschule für Bildende Künste, Hamburg, Germany, 1991-2000
Myndlista -og Handidaskola, Rekyjavík, Finland, 1996-1997
Academy of Fine Arts, Helsinki, Finland, 1998-1999

Scholarships
Hamburg Stipendium, Hamburg, Germany, 2001
DAAD Stipendium, Helsinki, Finland, 2002
Finnish Cultural Foundation, Helsinki, Finland, 2003
The Alfred Kordelin Foundation, Helsinki, Finland, 2003

Selected Solo Exhibitions and Projects
Skulturenprojekt Odense (with Frank Lüsing), Gallery DFKU, Odense, Denmark, 1998
Skulptuuri (with Frank Lüsing), Kuvataideakatemian Galleria, Helsinki, Finland, 1999
Public Polar Light Observatory (with Frank Lüsing), valon voimat, Tähtitorninmäki, Helsinki, Finland, 2000
New Discoveries, Harakka Telegraph Station Exhibition Center, Helsinki, Finland, 2003

Selected Group Exhibitions and Projects
The Queen of Hula Hoop (with Frank Lüsing), 1st International Performance Festival, Odense, Denmark, 1997
Group Show, Living Art Museum, Reykjavík, Finland, 1997
Visions du Nord, Musée d'Art Moderne de la Ville de Paris, France, 1998
Camp of Outlaws, Kuvataideakatemian Galleria, Helsinki, Finland, 1999
Circumnavigate (with Frank Lüsing), New Millenium Gallery, St. Ives, Cornwall, United Kingdom, 1999
Kullervo's Death (with Frank Lüsing), *Performance Index,* Basel, Switzerland, 1999
Nallo II (with Frank Lüsing), 2nd International Performance Festival, Odense, Denmark, 1999
Ylikierrokset (with Frank Lüsing), Guide City Tour's, Feeling the City, Helsinki, Finland, 2000
Travels with a Donkey at *Hamburg Stipendiaten* (with Frank Lüsing), Kunsthaus, Hamburg, Germany, 2002
Videoteque 2002 (with Frank Lüsing), Art Surgery, Cornwall, Denmark, 2002
Travels with a Donkey, Gessellschaft für Aktuelle Kunst, Bremen, Germany, 2003

Romantic Geographic Society, Annual Exhibition, Galleria Huuto, Helsinki, Finland, 2003

Bibliography (selection)
Finnland, Hamburg, 1996
10 Examples of Extraordinary Architecture in Reykjavík, Reykjavík, 1997
Vortrag zur Architektur, Hamburg, 1997
Bilderreise Island, Helsinki, 1999
Skulptuuri, Helsinki, 1999
The Straight Line (interviews with Lauri Anttila, Jussi Kivi and Yrjo Haila), Hamburg, 2001
Oliver Kochta and Frank Lüsing, *Travel with a Donkey* (travel report), Hamburg, 2001

e-mail: kochta@nexgo.de

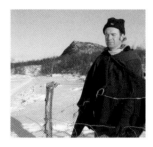

Franz Gerald Krumpl
Born 1970 in Carinthia, Austria

Education
Hochschule für Schauspielkunst "Ernst Busch", Berlin, Germany, 1994-1996
Hochschule für Bildende Künste, Braunschweig, Germany, 1997-2002

Grants and Scholarships
Hauptstadtkulturfond Berlin, Germany, 1996 and 2001
Arbeitsstipendium Akademie Graz, Austria, 1999
Ministry of Education and Culture of Austria, 2001
Goethe Inter-Nations, Germany, 2002

Selected Solo Exhibitions and Projects
Simply the Best, Scoescenypuszta, Hungary, 2001

Selected Group Exhibitions and Projects
Simply the Master (performance), Maus Hábitos, Porto, Portugal, 2002
Simply the Worst – Servus, Servus, Kunsthalle Fridericianum Kassel, Kassel, Germany, 2003

www.performfranz.de

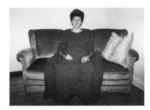

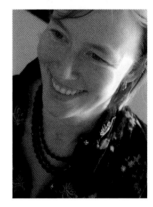

Lotte Lindner
Born 1971 in Bremen, Germany

Education
Werkkunstschule, Flensburg, Denmark, 1992-1995
Hochschule für Bildende Künste, Braunschweig, Germany, 1996-2003

Scholarships
Erasmus, Glasgow, United Kingdom, 2001

Prizes and / or Awards
Fotoprice, Internationale Umwelt Filmtage, Bremen, Germany, 2003

Selected Solo Exhibitions and Projects
Wood Objects, Kreissparkasse, Verden / Aller, Germany, 1996
Figure, Glasgow Botanic Gardens, Glasgow, United Kingdom, 2001

Tor I, Hochschule für Bildende Künste, Braunschweig, Germany, 2001
Sculptures and Sketches, Galerie Conny Kamp, Sylt, Germany, 2001

Selected Group Exhibitions and Projects
Wahlverwandtschaft, Projektraum, Berlin, Germany, 1999
Geparkt, Braunschweig, Germany, 1999
Text and Image, Glasgow School of Arts, Glasgow, United Kingdom, 2001
Marking the Territory, Irish Museum of Modern Art, Dublin, Ireland, 2001
Common Ground, Landesvertretung Niedersachsen and Schleswig-Holstein, Berlin, Germany, 2002
Cleaning the House workshop, Centro Galego de Arte Contemporánea, Santiago de Compostela, Spain, 2002
Konvergent, Eva Luna, Hildesheim, Germany, 2002
Body Basics I / Body Basics II, Transart 02, Klanspuren Festival, Fortezza, Brixen, Italy, 2002

Bibliography (selection)
Bernd Münster, *Durchblicke,* Werkkunstschule Flensburg, Flensburg, 1993, p. 11-12
Rolph Sperber, *Wurzeln und Freiheit,* Kunstwerkstatt Rote Laterne e.V., Flensburg, 1999, p. 44-47
Julia Neuenhausen, *Da,* Hochschule für Bildende Künste, Braunschweig, 2000, p. 8, 27-32
Marking the Territory (video catalogue), Irish Museum of Modern Art, Dublin, 2001

e-mail: post@lottelindner.de

Antón Lopo
Born in 1961 in Santiago de Compostela, Spain

Education
Degree in Spanish Philology, Facultade de Filoloxía, University of Santiago de Compostela, Santiago de Compostela, Spain, 1979-1995

Prizes and / or Awards
Leliadoura, Editorial Sotelo Blanco, Santiago de Compostela, Spain, 1987
Galicia de Comunicación, Xunta de Galicia, Santiago de Compostela, Spain, 1990
De catro a catro, Editorial Xerais and Café Catro a Catro, Vigo, Spain, 1991
Irmandade do libro, Federación de Libreiros de Galicia, Santiago de Compostela, Spain, 1992
Manuel Lueiro Rey, O Grove, Spain, 1999
Reimondez Portela, A Estrada, Spain, 2000
Esquío, Ferrol, Spain, 2002

Selected Solo Exhibitions and Projects
Bioloxismos (performance), Fundación Eugenio Granell, Santiago de Compostela, Spain, 2001
Prestidixitador (performance), Teatro Galán, Santiago de Compostela, Spain; El Canto de la Cabra, Madrid, Spain, 2001
Acción, Galería Trinta, Santiago de Compostela, Spain, 2002
One. In... Out... (video), 2002
O lugar (performance), Santiago de Compostela, Spain, 2002

O instante infinito (performance), Santiago de Compostela, Spain, 2002
A creación (performance), Galería Trinta, Santiago de Compostela, Spain, 2002

Selected Group Exhibitions and Projects
*Lob*s* (poetry show with Ana Romaní), Teatro Galán, Santiago de Compostela; Auditorio de Pontevedra; Ateneo de Ferrol; Instituto Rosalía de Castro, Noia, Spain, 1998
Todos sangran (graphic novel, slide show with Lupe Gómez), 2000
Lúa chea de agosto (performance with Braulio Vilariño e Luísa Iglesias), Ons, Spain, 2001
Cleaning the House workshop, Centro Galego de Arte Contemporánea, Santiago de Compostela, Spain, 2002
Palabras no vento (exhibition), Galería Noroeste, Santiago de Compostela; Centro Comarcal de Trives, Pobra de Trives; Centro Comarcal das Terras de Lemos, Monforte, Spain, 2002
Exercicio nº 1 (video, dance and performance with Branca Novoneyra), *IFI 2003,* Facultade de Belas Artes de Pontevedra / Pazo da Cultura de Pontevedra, Pontevedra, Spain, 2003
Batiscafo (poetry and action with Manolo Martínez, Alfonso Pato and Iris Cochón), 1ª Inmersión (gráfica), 2ª Inmersión (performance), Pub A Reixa, Santiago de Compostela, 3ª Inmersión (disco), 4ª Inmersión (performance), Palas de Rei, Spain, 2003
Scarlattina (action with Brais Fernandes), Pavillón itinerante das Redes Escarlata, 2003

Bibliography (selection)
Antón Lopo, *Pronomes,* Espiral Maior, A Coruña, 1998
Antón Lopo, *O riso de Isobel Hill,* Deputación de Pontevedra, Pontevedra, 2000
Antón Lopo, *Ganga,* Edicións Xerais, Vigo, 2001
Accións (exhibition catalogue), Galería Trinta, Santiago de Compostela, 2002
Oscar Wilde, *A balada do cárcere de Reading* (trans. Antón Lopo), Laiovento, Santiago de Compostela, 2003
Antón Lopo, *Fálame,* Fundación Caixa Galicia, A Coruña, 2003
Antón Lopo, *Xuro que nunca volverei pasar fame,* Editorial Linteo, Ourense, 2003

e-mail: lopo93@hotmail.com

Frank Lüsing
Born 1967 in Hamburg, Germany

Education
Hochschule für Bildende Künste, Hamburg, Germany, 1988-1998

Scholarships
Germinations Europe, Center for Polish Sculpture, Poland, 1995
Artists Work Programme, Irish Museum of Modern Art, Dublin, Ireland, 1998
Hamburger Arbeitsstipendium für Bildende Kunst, Hamburg, Germany, 2001

Prizes and / or Awards
Grenzgänge, Dance 95, Gasteig, Munich, Germany, 1995

Selected Solo Exhibitions and Projects
The Queen of Hula Hoop (with Oliver Kochta), International Performance Festival, Odense, Denmark, 1997
Skulpturenprojekte Odense (with Oliver Kochta), Odense, Denmark, 1998
The disqualified Round Towers of Ireland (with A. Rischer), Irish Museum of Modern Art, Dublin, Ireland, 1998
Skulptuuri Helsingissä (with Oliver Kotcha), Helsinki, Finland, 1999
Kullervos Tod (with Oliver Kochta), PerformanceIndex, Basel, Switzerland, 1999
Nallo 2 (with Oliver Kochta), International Performance Festival, Odense, Denmark, 1999
Circumnavigate (with Paul O'Neill & Oliver Kotcha), Art Surgery, Cornwall, United Kingdom, 1999
Public Polar Light Observatory (with Oliver Kochta), Forces of Light, Helsinki, Finalnd, 1999
Taumelnd vor Sham (with Cardiophon), Deutsches Schauspielhaus, Kantine, Hamburg, Germany, 2000
Die Hütte des Architekten (with Oliver Kochta), Odense, Denmark, 2000

Selected Group Exhibitions and Projects
Germinations 9, Prague, Czech Republic; Nice, France; Luxemburg, 1996-1997
Recent Acquisitions, BUND, London, United Kingdom, 1997
Wir, comawoche, Deutsche Bank, Hamburg, Germany, 2001
Printed Space, Londonprintstudio, London, United Kingdom, 2001
Stipendiaten, Kunsthaus Hamburg, Hamburg, Germany, 2002
Cluster, Dublin, Ireland, 2002
Fix02, Belfast, United Kingdom, 2002
Feine Ware, Kunstverein Hamburg, Hamburg, Germany, 2003
Romatic Geographie Society, Helsinki, Finland, 2003

Bibliography (selection)
Martin Pesch, Reviews, *Frieze*, no. 36, 1997, p. 97
Finnland (travel report), 1998
Cardiophon (disc), 1998
The Disqualified Round Towers of Ireland 1&2, 1998-2000
Oliver Kochta and Frank Lüsing, *Travel with a Donkey* (travel report), Hamburg, 2001
Travel with a Donkey (video), 2001
Cardiophon (disc), 2002

e-mail: luesing@gmx.de

Hannes Malte Mahler
Born 1968 in Hanover, Germany

Education
Hochschule für Bildende Künste, Braunschweig, Germany, 1993-1999

Scholarships
Jahresstipendium des Landes Niedersachsen, 2000

Prizes and / or Awards
Kunstpreis des Paritätischen, 1992

Selected Solo Exhibitions and Projects
Retail, Galerie Viktoria Hoffmann, Hanover, Germany, 1999
The China Room, Galerie Viktoria Hoffmann, Hanover, Germany, 1999
The Private Domain # Drawing, Södertälje, Stockholm, Norway, 2000
Mopping Up (performance), Kunstakademie München, Munich, Germany, 2000
Centrifuge, Foyer für junge Kunst, Braunschweig, Germany, 2001
Glitterballshooting, Galerie Drees, Hanover, Germany, 2002
Die Büxe knallt im Deutschen Wald, Kunstverein Hannover, Hanover, Germany, 2003

Selected Group Exhibitions and Projects
Triple Climax, Kunstverein Hildesheim, Hildesheim, Germany, 1999
Fresh Air, Kulturstadt Europa, E-Werk, Weimar, Germany, 1999
3rd International Performance Festival, Odense, Denmark, 2001
Marking the Territory, Irish Museum of Modern Art, Dublin, Ireland, 2001
Perspektiven, Kunstverein Hannover, Hanover, Germany, 2002
Don, Chinati Foundation, Marfa, Texas, USA, 2002

Bibliography (selection)
Hannes Malte, *Dipple* (artist's book), Salon Verlag, Cologne, 2000 (with texts by Michael Glasmeier, Mandy Mahler, Michael Schwarz, Beate Söntgem, Gregor Jansen, Marina Abramović et al)
Lokalzeit, 1. Biennale Niedersachsen, Kunstverein Hannover, Hanover, 1999
Perspektiven, Kunstverein Hannover, Hanover, 2002

www.theMahler.com
e-mail: Hannesmalte@themahler.com

Monali Meher
Born 1969 in Pune, India

Education
B.F.A. in Painting, Sir J.J. School of Arts, Bombay, India, 1985-1990
Workshop *Performer & Mediated Image*, Monte Video, Amsterdam, organized by Amsterdam-Maastrich Summer University, The Netherlands, 2001
Performance workshop with Marina Abramović, Rijksakademie, Amsterdam, The Netherlands, 2001

Grants and Scholarships
"Unesco-Aschberg" Residency in Vienna by the Federal Chancellery for the Arts and Science, 1998
Nuffic, Huygens Grant, Amsterdam, The Netherlands, 2001

Prizes and / or Awards
Fine Arts Award, Inlaks Foundation, New Delhi, India, 1997

Selected Group Exhibitions and Projects
Bio-Morphosis, Lakeeren Art Gallery, Bombay, India, 1996

Untitled, F.I.A. Gallery, Amsterdam, The Netherlands, 1998
Reflect (A Personal Window Display), Jehangir Art Gallery, Lakeeren Art Gallery, Bombay & Gallery Juttner, Vienna, Austria, 1998
Theatre of Memory, Lakeeren Art Gallery, Bombay, India, 1999
Protected Reflection (performance), Lakeeren Art Gallery, Bombay, India, 1999
Non-Repeating Loop (performance), Rijksakademie, Amsterdam, The Netherlands, 2000

Selected Group Exhibitions and Projects
Smell the Art, National Gallery of Modern Art, Bombay, India, 1999
New Territories (performance), International Festival of Live Art, Glasgow, United Kingdom, 2002
In My Accent (performance), Arti et Amicitiae Cafe, Amsterdam, The Netherlands, 2002
Camouflage (performance), The Nehru Centre, London, United Kingdom, 2001
Bollywood Has Arrived, P.T.A. (Passengers' Terminal), Amsterdam, The Netherlands, 2001
Labyrinths, Asian Art – Biennale d'Arte Contemporanea, Genoa, Italy, 2001
Moist, Art Asia Pacific, Multi Media Art Festival, Beijing, China, 2002
Old Fashioned (performance), Kunstrai (Artkitchen), Amsterdam, The Netherlands, 2003

Bibliography (selection)
MAAP (exhibition catalogue), Beijing, 2002, p. 76, 77
Third Text, Camouflage, Zeigam Azizov, 2002, p. 96, 97

e-mail: monalimeher@yahoo.com

Marta Montes Canteli
Born 1977 in Gijón, Spain

Education
Facultad de Bellas Artes de Granada, Granada, Spain, 1998-2003

Selected Solo Exhibitions and Projects
Una mirada hacia Rumania, Casa de Porras, Granada, Spain, 1998
Enterramiento, Facultad de Bellas Artes, Granada, Spain, 2001
Urna, El manchón, Granada, Spain, 2002
Polla o lengua, brothel in Sta. Gloria, Spain, 2003
Velor, Hospital San Juan de Dios, Granada, Spain, 2003

Selected Group Exhibitions and Projects
Y además, Facultad de Bellas Artes de Granada, Spain, 2000
Basta ya, Facultad de Bellas Artes de Granada, Spain, 2000
Sonríeme veneno, Lucena, Córdoba, Spain, 2002
Los centauros del desierto, Garage-Gallery, Granada, Spain, 2002
Premio Pintura, Gran Capitán, Granada, Spain, 2002
Viólame, Facultad de Bellas Artes, Granada, Spain, 2002
Cleaning the House workshop, Centro Galego de Arte Contemporánea, Santiago de Compostela, Spain, 2002

Hilaron solas IV, Castillo del Moral, Córdoba, Spain, 2003
Ateneo Libertario, CGT, Madrid, Spain, 2003
Cariño, seguro que tú sabes hacer algo, Círculo de Bellas Artes, Madrid, Spain, 2003

e-mail: marta@canteli.com / cantelli@mixmail.com

Frau Müller
Born 1968 in Cologne, Germany

Education
Bookseller training, Weinsberg, Germany, 1988-1990
Degree in History of Art and German, Ruhr University, Bochum, Germany, 1990-1995
Degree in Fine Arts, Hochschule für Bildende Künste, Braunschweig, Germany, 1995-2001

Selected Group Exhibitions and Projects
RotX, Kleinhüningerstrasse 165, Basel, Switzerland, 1993
GiGa, Waldheim Gaissberg, Stuttgart, Germany, 1993
Sonderart, Rhanania-Hallen, Cologne, Germany, 1993
Die eiserne Nachrichtenzentrale, Am Remberg 6, Dortmund, Germany, 1997
Zwischenräume – Finally, Kunstverein Hannover, Hanover, Germany, 1998
Unfinished Business, Haus am Lützowplatz, Berlin, Germany, 1999
Fresh Air, Kulturstadt Europa, E-Werk, Weimar, Germany, 1999
Transfer, Central Station, Braunschweig, Germany, 2000
Visible Differences, Hebbel Theater, Berlin, Germany, 2001
Kein Schöner Land, Kubus, Hanover, Germany, 2001

Bibliography (selection)
Frau Müller, *Bubblicious Delicious Orange* (privately published), Bochum, 1993
Projektgruppe Eisenhans & Engelbert, *Die eiserne Nachrichtenzentrale* (privately published), Braunschweig, Germany, 1997, p. 6-8, 25-27, 33
Frau Müller, *Die Braunschweiger Enzyklopädie* (privately published), Braunschweig, 1999
Marina Abramović, *Fresh Air*, ed. Hannes Malte Mahler, Salon Verlag, Cologne, 1999
Transfer Projekt (privately published), Braunschweig, 2000, p. 23
Da (privately published), Braunschweig, 2001, p. 7, 36-39
Kein Schöner Land (privately published), Hanover, 2001, p. 37-41

http://www.walk.to/fraumueller
e-mail: fraumueller@gmx.ch

Daniel Müller-Friedrichsen
Born 1975 in Hanover, Germany

Education
Hochschule für Bildende Künste, Braunschweig, Germany, since 1998

Lives and works in Berlin, Germany

Selected Group Exhibitions and Projects
Luna Park, Halle für Kunst, Lüneburg, Germany, 2000
Marking the Territory, Irish Museum of Modern Art, Dublin, Ireland, 2001
A Little Bit of History Repeated, Kunst Werke, Berlin, Germany, 2001
Festa dell'arte, Aquario Romano, Rome, Italy, 2001
Intermedia, Triskel Arts Center, Cork, Ireland, 2002
Prêt-à-Perform, Viafarini, Milan, Italy, 2002
Body Power / Power Play, Württembergischer Kunstverein, Stuttgart, Germany, 2002
As Soon as Possible, PAC, Padiglione d'Arte Contemporanea, Milan, Italy, 2003
Performance in der Kunsthalle, Kunsthalle Friedericianum, Kassel, Germany, 2003
Recycling the Future, 50. Esposizione Internazionale d'Arte La Biennale di Venezia, Venice, Italy, 2003

Bibliography (selection)
Filmklasse, Salon Verlag, Cologne, 2000, p. 159
Robert Ayers Contempory, January 2001, p. 90
"Arti performative, Una nuova avanguardia?", *Flash Art,* Milan, no. 232, February / March 2002, p. 56

www.mueller-friedrichsen.com

Llúcia Mundet Pallí
Born 1967 in Barcelona, Spain

Education
Degree in Fine Arts, Universitat de Barcelona, Barcelona, Spain, 1991
MA with Marina Abramović, Hochschule für Bildende Künste, Braunschweig, 1998

Scholarships
Erasmus, Hochschule für Bildende Künste, Braunschweig, Germany, 1991

Prizes and / or Awards
1. Kunstpreis, Landkreis Gifhorn, Gifhorn, Germany, 1998
Arbeitsstipendium, Landes Niedersachsen, Germany, 1999
Premio Lux, Asociación de Fotógrafos Profesionales de España, Spain, 2001

Selected Solo Exhibitions and Projects
Wort und Bild, Kunstverein, Gifhorn, Gifhorn, Germany, 2001
Mundets 01 (permanent exhibition), Passage Mundet, Barcelona, Spain, 2001

Selected Group Exhibitions and Projects
Kunst im Zweiten, Stadtsteather, Braunschweig, Germany, 1997
Schlaglicht, Kunstmuseum, Wolfsburg, Germany, 1998
Zwischenräume – Finally, Kunstverein Hannover, Hanover, Germany, 1998
Fresh Air, Kulturstadt Europa, E-Werk, Weimar, Germany, 1999
Unfinished Business, Haus am Lützowplatz, Berlin, Germany, 1999
Lokalzeit 1, Biennale Niedersachsen, Kunstverein

Hannover, Hanover, Germany, 1999
Schwarz-Weiß, Schloß Gifhorn, Gifhorn, Germany, 1999
Descubrimientos Photoespaña 02, Centro Cultural Conde Duque, Madrid, Spain, 2002
Primavera Fotográfica de Catalunya 02, Barcelona, Spain, 2002

Bibliography (selection)
Henrike Junge-Gent, "Schwarz und Weiss – ein bewährtes Thema", *Kunstpreis '98,* Landkreis Gifhorn, Gifhorn, 1998
Dirk Engelhardt and Holger Klemm, "Auf Maden tanzen", *Berliner Zeitung,* Berlin, 17/05/1999
Marina Abramović, *Fresh Air,* ed. Hannes Malte Mahler, Salon Verlag, Cologne, 1999
Martí Peran, "In the public name", *Mundets 01,* ed. Llúcia Mundet, Direcció General de Ports i Transports de la Generalitat de Catalunya, Barcelona, 2001
Rosa Olivares and Seve Penelas, "Índice de artistas", *Exit,* Madrid, no. 5, February / April 2002, p. 167, 171
Gustavo Marrone, "Dialogues with the environment", *B-guided,* Barcelona, no. 11, March / April 2002, p. 22-24

e-mail: mundet_art@web.de

Hayley Newman
Born 1969 in Guildford, United Kingdom

Education
Middlesex University, London, United Kingdom, 1989-1992
Slade School of Art, University College London, London, United Kingdom, 1992-1994
Hochschule für Bildende Künste, Hamburg, Germany, 1994-1995
University of Leeds, Leeds, United Kingdom, 1996-2001

Scholarships
DAAD Scholarship, Hamburg, Germany, 1994-1995
Stanley Burton Research Scholarship, University of Leeds, United Kingdom, 1996-1999

Prizes and / or Awards
Julian Sullivan Memorial Prize, Slade School of Art, London, United Kingdom, 1994
Artsadmin Bursary, Artsadmin, London, United Kingdom, 2001

Selected Solo Exhibitions and Projects
Rude Mechanic, Beaconsfield, London, United Kingdom, 1996
Invisible Crowds, The Western Front, Vancouver, Canada, 1996
Connotations – Performance Images 1994-1998, Beverley Library, Beverley, United Kingdom, 1998
Soundgaze, Ferens Art Gallery, Hull, United Kingdom, 1999
Smoke, Smoke, Smoke, Chapter Arts Centre, Cardiff, United Kingdom, 1999
The Daily Hayley, Matt's Gallery, London, United Kingdom, 2001
Ikon Gallery, Birmingham, United Kingdom, 2002
Centre d'Art Contemporain Genève, Geneva, Switzerland, 2003

Selected Group Exhibitions and Projects
Small Pleasures, Hamburger Bahnhoff, Berlin, Germany, 1999
Audible Light, Museum of Modern Art, Oxford, United Kingdom, 2000
Becks Futures, ICA, London; Cornerhouse, Manchester; CCA, Glasgow, United Kingdom, 2001
A Shot in the Head, The Lisson Gallery, London, United Kingdom, 2001
Performance Art in Nord Rhein Westphalen, Düsseldorf Kunstraum, Dusseldorf, 2001
Austellungshalle Münster, Munster; Maschinenhaus Essen, Essen, Germany, 2001
Century City, Tate Modern, London, United Kingdom, 2001
Marking the Territory, Irish Museum of Modern Art, Dublin, Ireland, 2001
Bandwagon Jumping, The International Three, Manchester, United Kingdom, 2002
Superhero Artstaaar: Beyond Good and Evil, Gertrude Contemporary Art Spaces, Melbourne, Australia, 2002
Live Culture, Tate Modern, London, United Kingdom, 2003

Bibliography (selection)
Hayley Newman, Pan Sonic and David Crawforth (piano), *Rude Mechanic* (CD), Beaconsfield, London, 1999
Hayley Newman and Kaffe Matthews, *Pointy Stunt* (CD), Lowlands, Belgium, 1999
Rachel Withers, "Openings: Hayley Newman", *Artforum,* New York, March 1999, p. 104-105
Dave Beech, "Profile Rattling art's cage", *Art Monthly,* London, no. 231, July / August 2000, p. 22
Hayley Newman and Aaron Williamson, *Performancemania* (monograph), Matt's Gallery, London, 2001
Martin Longley, "Whistle Concert", *The Wire,* London, no. 224, October 2002, p. 82-83
Michael Archer, "Hayley Newman", *Artforum,* New York, vol. XLI, no. 3, November 2002, p. 197-198
Peter Suchin, "Hayley Newman", *Frieze,* London, no. 71, November / December 2002, p. 108
Emma Safe, "Hayley Newman", *Art Monthly,* London, no. 261, October / November 2002, p. 25
Hayley Newman, *Roundabouts* (7 inch single), Work and Leisure International, Manchester, 2002

Ana Pol
Born 1979 in Lugo, Spain

Education
Degree in Fine Arts, Universidad de Salamanca, Spain, 1997-2002
Workshop with Esther Ferrer, Centro Galego de Arte Contemporánea, Santiago de Compostela, Spain, 2001
Workshop with Daniel Canogar, *Imago 2002,* Junta de Castilla y León, Spain, 2002
Workshop with Jordi Claramonte, *La obra de arte en el espacio público,* Gijón, Spain, 2002
Graduate Studies in Fine Arts, Universidad Complutense de Madrid, 2002-2003
Anthropology, Universidad Autónoma, Madrid, Spain, 2002-2003
Workshop with Javier Vallhonratt, *Imago 2001,* Junta

de Castilla y León, Spain, 2002-2003
Workshop with Félix Guisasola, Praxis Artística, Madrid, Spain, 2003

Scholarships
Erasmus, Academy Liège, Liege, Belgium, 1999-2000

Selected Solo Exhibitions and Projects
Dolor de ojos, Espacio Los Cadáveres Exquisitos, Madrid, Spain, 2003

Selected Group Exhibitions and Projects
Jóvenes Artistas de Castilla y León, 1999-2000
Les Brasseurs Gallery, Liège, Liege, Belgium, 2000
Cidade de Lugo (selection), Lugo, Spain, 2001
Maniquíes y Butter-fly-s, Espacio Panorama, Salamanca, Spain, 2002
Performance, Sala Unamuno, Salamanca, Spain, 2002
Casas y calles (project in artists' houses), Madrid, Spain, 2002
Cleaning the House workshop, Centro Galego de Arte Contemporánea, Santiago de Compostela, Spain, 2002
Comer o no Comer (performance vernissage), CASA, Salamanca, Spain, 2002
IFI 2003, Facultade de Belas Artes / Pazo da Cultura, Pontevedra, Spain, 2003

e-mail: anapoc@yahoo.es

Rubén Ramos Balsa
Born 1978 in Santiago de Compostela, Spain

Education
Degree in Fine Arts, Facultade de Belas Artes de Pontevedra, University of Vigo, Pontevedra, Spain, 2001
Graduate Studies at the Universidad de Vigo and Universidad Politécnica de Valencia, Spain, 2001-2003

Scholarships
Erasmus, Kuopio Academy of Design and Crafts, Kuopio, Finland, 2000

Selected Solo Exhibitions and Projects
Present-action, Kuopio Academy of Design and Crafts, Kuopio, Finland, 2000
Acontecimientos y registros, Ciclo *Miradas Virxes,* Centro Torrente Ballester, Ferrol, Spain, 2003

Selected Group Exhibitions and Projects
Recíproco (performance), Sala NASA, Santiago de Compostela, Spain, 1999
La acción y su huella, Centro Galego de Arte Contemporánea, Santiago de Compostela, Spain, 2000
Vacío Espeso, Galería Sargadelos, Pontevedra, Spain, 2001
Performance with glasses of water, 2ᵃˢ Jornadas de Performance y Arte de Acción de la Universidad Pública de Valencia, Spain, 2001
Cleaning the House workshop, Centro Galego de Arte Contemporánea, Santiago de Compostela, Spain, 2002
IFI 2002, Facultade de Belas Artes, Pontevedra, Spain, 2002
Plugged – Unplugged, Centro de Arte Joven, Madrid, Spain, 2002
Enciclopedia de sueños, 5 proyectos audiovisuales

becados por el INJUVE, Sala Amadís, Madrid, Spain, 2002
Trienal Nacional de Grabado, Centro Cajastur, Gijón, Spain, 2002
Una película de piel VIII, Galería Marisa Marimón, Ourense, Spain, 2002

e-mail: rrbalsa@hotmail.com

Barak Reiser
Born 1973 in Haifa, Israel

Education
Bezalel Academy of Art and Design, Jerusalem, Israel, 1994-1998
Städelschule, Frankfurt am Main, Germany, 2000

Scholarships
DAAD Grant for Study and Research in Germany, 1999, 2001

Prizes and / or Awards
The Schtrueck Award for the Best Achievement in the field of printmaking, Jerusalem, Israel

Selected Solo Exhibitions and Projects
Ring, Forum 1822, Frankfurt am Main, Germany, 2002
E, The Tel Aviv Artists' Studios, Tel Aviv, Israel, 2003

Selected Group Exhibitions and Projects
Idea Bank, Church of St. Fransisco, Fondazione Antonio Ratti, Como, Italy, 2001
Vasistas, Istambul Technical University, Istanbul, Turkey
Blickachse 3 (a sculpture-project in the park of Herrnsheim Castle), Worms, Germany, 2002
Say Something to the Audience (a project with Heike Bollig and Matti Blind), www.to-the-audience.de, Akademie-Galerie, Munich, Germany, 2002
Stars and Bright, Brigitte March Gallery, Stuttgart, Germany, 2002
Make It New, Portikus, Dresdener-Bank, Frankfurt am Main, Germany, 2003
The State of the Upper Floor / Panorama, Kunstverein München, Munich, Germany, 2003
Art – Focus 3, taking part in the exhibition *Alley Cats,* The Teddy Kollek Stadium, Jerusalem, Israel, 2003

Bibliography (selection)
Ring (exhibition catalogue), Forum 1822, Frankfurt am Main, 2002
Marina Abramović, Edizioni Charta, Milan / Fondazione Antonio Ratti, Como, 2002
E (exhibition catalogue), The TelAviv Artists' Studios, 2003
Alley Cats (exhibition catalogue), Art-Focus 3, Jerusalem, Israel, 2003
The State of the Upper Floor / Panorama, Kunstverein München, Munich, 2003

Declan Rooney
Born 1977 in Carlow, Ireland

Education
National College of Art and Design, Dublin, Ireland, 1994-1998
Academie Minerva, Groningen, The Netherlands, 1997
University College Dublin, Dublin, Ireland, 1999-2000
Hochschule für Bildende Künste, Braunschweig, Germany, 2002-2004

Prizes and / or Awards
Travel Award, Arts Council of Ireland, Dublin, Ireland, 1999
Art Flight, Arts Council of Ireland, Dublin, Ireland, 2000
Artists Award, Carlow County Council, Carlow, Ireland, 2001

Selected Group Exhibitions and Projects
EV+A 99 reduced, Belltable Arts Centre, Limerick, Ireland,1999
Intermedia '99, Triskel Arts Centre, Cork, Ireland, 1999
Typhoon York, Parkside Pacific Place, Hong Kong, 1999
Crawford Open 3, Crawford Municipal Art Gallery, Cork, Ireland, 2002
FLIX @ Rubicon, Rubicon Gallery, Dublin, Ireland, 2003
As Soon as Possible, PAC, Padiglione d'Arte Contemporanea, Milan, Italy, 2003
Performance in der Kunsthalle, Kunsthalle Fridericianum, Kassel, Germany, 2003
Recycling the Future, 50. Esposizione Internazionale d'Arte La Biennale di Venezia, Venice, Italy, 2003
Us Live, Fifth Gallery, Dublin, Ireland, 2003
Us Live, WAH Centre, New York, USA, 2003

Bibliography (selection)
Paul M. O'Reilly, "EV+A 99 reduced," *Gandon,* Cork, 1999, p. 56-57
Mark Ewart, "Sound Art Focus," *The Irish Times,* 04/06/1999, p. 12
Peter Murray, "The Crawford Open," *Gandon,* Cork, 2003, p. 130
Hugh Farrelly, "The Art of Bluff," *Irish Examiner,* 24/01/03, p. 15
Suzy O'Mullane, "Crawford Open 3," *Circa,* no. 103, Spring 2003, p. 78-79

e-mail: rooneydeclan@hotmail.com

Andrea Saemann
Born 1962 in Wilmington, USA

Education
Hochschule für Bildende Künste, Hamburg, Germany, 1989-1994

Prizes and / or Awards
Basler Künstlerstipendium, Basel, Switzerland, 1999
Büropreis, Maurus Gmür, Zürich, Switzerland, 2000
Otzenrath Stipendium, Haus Otzenrath, Otzenrath, Switzerland, 2000

Selected Solo Exhibitions and Projects
Terminator, Plug In, Basel, Switzerland, 2001

Liberty, Kunsthaus Baselland, Muttenz, Switzerland, 2003

Selected Group Exhibitions and Projects
Kongress für künstlerische Strategien, Sudhaus WWpp, Basel, Switzerland, 1999
Killing Me Softly, Kunsthalle Bern, Bern, Switzerland, 1999
Helle Nächte, Kunstvereine Binningen, Bottmingen, Reinach and Basel, Switzerland, 2001
Marking the Territory, Irish Museum of Modern Art, Dublin, Ireland, 2001
Weder verwandt noch verschwägert, Kaskadenkondensator, Basel, Switzerland, 2002
3rd Open Art Platform – Performance Art Festival, Xian, China, 2002
High Calibre, Kongresszentrum Rauchstrasse, Berlin, Germany, 2002
Eingreifen, Galerie Helga Broll in der Gesellschaft für aktuelle Kunst, Bremen, Germany, 2003

Bibliography (selection)
Andrea Saemann and Annina Zimmermann, *Helle Nächte,* Christoph Merian Verlag, Basel, Switzerland, 2002

e-mail: andreasae@bluewin.ch
www.xcult.ch/helle

Iris Selke
Born 1966 in Bielefeld, Germany

Education
The School of the Art Institute of Chicago, Chicago, USA, 1998
Degree in Fine Arts, Hochschule für Bildende Künste, Braunschweig, Germany, 2002
Class of Marina Abramović, Hochschule für Bildende Künste, Braunschweig, Germany, 2003

Selected Group Exhibitions and Projects
Cardiff Art in Time, UWIC, Cardiff, Wales, United Kingdom, 1998
Visible Differences, Hebbel Theater, Berlin, Germany, 2000
Real Presence – Generation 2001, The Balkans Trans / Border – Open Art Project, Belgrade, Serbia and Montenegro, 2001
Marking the Territory, Irish Museum of Modern Art, Dublin, Ireland, 2001
A Little Bit of History Repeated, Kunst Werke, Berlin, Germany, 2001
Body Basics I / Body Basics II, Transart 02, Klanspuren Festival, Fortezza, Brixen, Italy, 2002
Common Ground, Landesvertretung Niedersachsen and Schleswig-Holstein, Berlin, Germany, 2002
Recycling the Future, 50. Esposizione Internazionale d'Arte La Biennale di Venezia, Venice, Italy, 2003
Performance in der Kunsthalle, Kunsthalle Fridericianum, Kassel, Germany, 2003

Bibliography (selection)
IK Verein Internationale Bildende Künstler Bielefeld und Umgebung e.V., 1992
Filmfest Braunschweig (festival catalogue), 1997
Marina Abramović, *Fresh Air,* ed. Hannes Malte Mahler, Salon Verlag, Cologne, 1999

Birgit Hein and Gerhard Büttenbender, *Filmklasse,* Salon Verlag, Cologne, 2000
Filmfest Braunschweig (exhibition catalogue), 2001
Jens Hoffmann, *A Little Bit of History Repeated* (exhibition catalogue), Édition Valerio, Paris & Kunst Werke Berlin, Berlin, 2001, p. 36, 37
PHOTONEWS, Zeitung für Fotografie, March, 2002, 14 Jahrgang, p. 14

http://www.gmx.net

Chiharu Shiota
Born 1972 in Osaka, Japan

Education
Art School, Kyoto Seika University, Kyoto, Japan, 1992-1996
Semester Exchange to Canberra School of Art, Australian National University, Australia, 1993
Hochschule für Bildende Künste, Braunschweig, Germany, 1997-1999
Universität der Künste, Berlin, Germany, 1999-2002

Scholarships
Akademie Schloss Solitude Stipendiaten, Stuttgart, Germany, 2002
Pola Art Foundation, Tokyo, Japan, 2003

Prizes and / or Award
Kunstpreis 1998, Landkreis Gifhorn, Gifhorn, 1998
Dorothea von Stetten-Kunstpreis (shortlist), Bonn, Germany, 2000
Philip Morris K.K. Art Award, Tokyo, Japan and New York, USA, 2002

Selected Solo Exhibitions and Projects
My Existence as a Physical Extension, Houenin Temple, Kyoto, Japan, 1995
Breathing from Earth, Maximiliam Forum / Stadtforum, Munich, Germany, 2000
Chiharu Shiota, Kenji Taki Gallery, Nagoya, Japan, 2001
The Way into Silence, Württembergischer Kunstverein, Stuttgart, Germany, 2003

Selected Group Exhibitions and Projects
Continental Shift, Ludwig Forum für Internationale Kunst, Aachen, Germany, 2000
Strange Home, Kestner Museum & Historisches Museum, Hanover, Germany, 2000
Dorothea von Stetten-Kunstpreis, Kunstmuseum Bonn, Bonn, Germany, 2000
Mega – Wave, Yokohama 2001, International Triennale of Contemporary Art, Yokohama, Japan, 2001
Translated Acts, Queens Museum of Art, New York, USA, 2001
Another World, Twelve Bedroom Stories, Kunstmuseum Luzern, Lucerne, Switzerland, 2002
Miss You, Museum für Neue Kunst, Freiburg, Germany, 2002
A Need for Realism, Centre for Contemporary Art, Ujazdowski Castle, Warsaw, Poland, 2002
Rest in Space, Kunstnernes Hus, Oslo, Norway, 2002
First Step, P.S.1 Contemporary Art Center, New York, USA, 2003

Bibliography (selection)
The Way into Silence (exhibition catalogue),
Württembergischer Kunstverein, Stuttgart, 2003

www.chiharu-shiota.com

Christian Sievers
Born 1974 in Braunschweig, Germany

Education
Hochschule für Bildende Künste, Braunschweig,
Germany, 1996-2001
Royal College of Art, London, United Kingdom, 2001-2003

Scholarships
German National Merit Foundation, 1999-2002
DAAD scholarship for Great Britain, 2002

Prizes and / or Awards
Deutsche Bank Pyramid Award, 2003

Selected Solo Exhibitions and Projects
In Case I Hurt Myself, Hochschule für Bildende
Künste, Braunschweig, Germany, 2000
Nebenraum, Berlin, Germany, 2002
Monthly Update (lecture series in various locations),
London, United Kingdom, 2003

Selected Group Exhibitions and Projects
Cleaning the House workshop, Domaine de
Kerguéhennec, France, 2000
Dem deutscher Volk, Galerie auf Zeit, Dresden,
Germany, 2000
Visible Differences, Hebbel Theater, Berlin, Germany, 2000
Kunststudenten stellen aus, Kunst und
Ausstellungshalle der Bundesrepublik Deutschland,
Bonn, Germany, 2001
Real Presence – Generation 2001, The Balkans Trans /
Border – Open Art Project, Belgrade, Serbia and
Montenegro, 2001
Marking the Territory, Irish Museum of Modern Art,
Dublin, Ireland, 2001
Militant, Postfuhramt Berlin, Berlin, Germany, 2002
Minutes before It's Too Late (with Mike Cooter),
Hockney Gallery, Royal College of Art, London, United
Kingdom, 2003
Timeshare, The Bargehouse, London, United Kingdom,
2003
Stew, VTO Gallery, London, United Kingdom, 2003

Bibliography (selection)
Christian Sievers, *On Sleeping in Public and Being
Cautious* (artists' book, privately published), London,
2003

www.christiansievers.com

Anton Soloveitchik
Born 1973 in St. Petersburg, Russia

Education
Degree in Ecology, University of Saint Petersburg, St.
Petersburg, Russia, 1995

Hochschule für Bildende Künste, Braunschweig,
Germany, 1999

Selected Solo Exhibitions and Projects
Vertigo, Dostoewskij Museum Saint Petersburg, Saint
Petersburg, Russia, 1995
The Images of Saint Petersburg, Prague, Czech
Republic, 1997
Anders, Landesmuseum Braunschweig, Braunschweig,
Germany, 2001
Aktion Jackson Orchestra (sound performance),
Hochschule für Bildende Künste, Braunschweig,
Germany, 2001

Selected Group Exhibitions and Projects
Photobieniale 96, Moscow, Russia, 1996
Novie Osnovania (photography), Moscow, Russia,
2001
Common Ground, Landesvertretung Niedersachsen
and Schleswig-Holstein, Berlin, Germany, 2002
Body Basics I / Body Basics II, Transart 02,
Klanspuren Festival, Fortezza, Brixen, 2002
Cleaning the House workshop, Centro Galego de Arte
Contemporánea, Santiago de Compostela, Spain, 2002
As Soon as Possible, PAC, Padiglione d'Arte
Contemporanea, Milan, Italy, 2003
Recycling the Future, 50. Esposizione Internazionale
d'Arte La Biennale di Venezia, Venice, Italy, 2003

Bibliography (selection)
The New Alphabet (exhibition catalogue),
Photobieniale 96, Moscow, 1996
O. Listzova, "*Photobienniale 96 Festival* opens in
Moscow", The Moscow Tribune, Moscow, 16/04/1996
"Ein anderer Kunst-Blick", *Braunschweiger Zeitung,*
Braunschweig, November 2001
A. Huber, "Kunst mit Öhrenfeige nach dem Prinzip
Kurzfilm", *Braunschweiger Zeitung,* Braunschweig,
July 2002

Mascha Soloveitchik
Born 1973 in St. Petersburg, Russia

Education
International School of Psychology and
Psychotherapy, St. Petersburg, Russia, 1998-2001
Degree in General Medicine, University of St.
Petersburg, St. Petersburg, Russia, 1999

Selected Group Exhibitions and Projects
Bistrii Festival, Saint Petersburg, Russia, 2000
Novie Osnovania (photography), Moscow, Russia,
2001
Cleaning the House workshop, Centro Galego de Arte
Contemporánea, Santiago de Compostela, Spain, 2002

Till Steinbrenner
Born 1967 in Hildesheim, Germany

Education
Fachhochschule für Produktdesign, Hildesheim,
Germany, 1989-1993
Assistant of Rüdiger Höding (sculptor), Bad

Salzdetfurt, Germany, 1989-1995
Hochschule für Bildende Künste, Braunschweig,
Germany, 1996-2003

Selected Solo Exhibitions and Projects
O.T. 9 (workshop and exhibition), Hanover, Germany,
1996
Skulptur und Funktion (workshop and exhibition),
Hanover, Germany, 1997

Selected Group Exhibitions and Projects
Winter-Gärten, Gruppe 7, Hanover, Germany, 2000
Zeugen, Galerie Obornik, Hildesheim, Germany, 2001
Marking the Territory, Irish Museum of Modern Art,
Dublin, Ireland, 2001
Get that Balance, National Sculpture Factory, Opera
House / Half Moon Theater, Cork, Ireland, 2001
Finale Grande, Kommando Hasenpfuhlstrasse, Speyer,
Germany, 2001
Common Ground, Landesvertretung Niedersachsen
and Schleswig-Holstein, Berlin, Germany, 2002
Cleaning the House workshop, Centro Galego de Arte
Contemporánea, Santiago de Compostela, Spain, 2002
Konvergent, Eva Luna, Hildesheim, Germany, 2002
Abgebrannt, Galerie Obornik, Hildesheim, Germany,
2002
Body Basics I / Body Basics II, Transart 02,
Klanspuren Festival, Fortezza, Brixen, Italy, 2002

Bibliography (selection)
Winter-Gärten, Gruppe 7, Hanover, 2000, p. 116-117
Marking the Territory (video catalogue), Irish Museum
of Modern Art, Dublin, 2001

e-mail: till@steinbrennerxl.de
www.steinbrennerxl.de

Dorte Strehlow
Born 1965 in Hanover, Germany

Education
Annastift Hannover, Physiotherapist, 1987-1989
Contemporary Dance, Manja Chmiel Studio, Hanover,
1989-1993
Butoh Zentrum Mamu Göttingen, Göttingen, 1993-
1998
Class of Marina Abramović, Hochschule für Bildende
Künste, Braunschweig, Germany, since 1999

Prizes
International Audition of Choreography, 3rd with Hans
Fredeweß, Theater am Aegi, Hanover, Germany, 1995

Selected Group Exhibitions and Projects
Es zog mich an einen sonnigen Platz, Theater im
Künstlerhaus und Eisfabrik, Hanover, Germany, 1997
Spots & Places (congress of performance), Healing
Theater, Cologne, Germany, 2000
Visible Differences, Hebbel Theater, Berlin, Germany,
2000
Cleaning the House workshop, Domaine de
Kerguéhennec, France, 2000
Zur stelle anderswo, Kunstraum Zehn, Hanover,
Germany, 2001
Heim & Welt, Theater Healing, Cologne, Germany,
2001

Common Ground, Landesvertretung Niedersachsen
and Schleswig-Holstein, Berlin, Germany, 2002
Prêt-à-Perform, Viafarini, Milan, Italy, 2002

e-mail: Dorte-strehlow@gmx.de

Melati Suryodarmo
Born 1969 in Surakarta, Indonesia

Education
Degree International Relations, Faculty of Politics and
Social Sciences, Universitas Padjadjaran Bandung,
Indonesia, 1993
Degree in Fine Arts, Hochschule für Bildende Künste,
Braunschweig, Germany, 2001
Postgraduate, Hochschule für Bildende Künste,
Braunschweig, Germany, 2002

Scholarships
Graduiertem Stipendium, Hochschule für Bildende
Künste, Braunschweig, Germany, 2002-2003

Selected Solo Exhibitions and Projects
Der Sekundentraum (performance), Healing Theater,
Cologne, Germany, 1999
Lullaby for the Ancestors, L.O.T. Theater,
Braunschweig, Germany, 2001
The Promise, Gallerie Gedok, Stuttgart, Germany,
2002
*Transexuelles Schamanen in Süd Sulawesi
Indonesien*, Makassar, Indonesia, 2003

Selected Group Exhibitions and Projects
A Little Bit of History Repeated, Kunst Werke, Berlin,
Germany, 2001
Marking the Territory, Irish Museum of Modern Art,
Dublin, Ireland, 2001
Festa dell'Arte, Aquario di Roma, Roma, Italy, 2001
Prêt-à-Perform, Viafarini, Milan, Italy, 2002
Body Power / Power Play, Württembergischer
Kunstverein, Stuttgart, Germany, 2002
Performance, Kunsthalle Fridericianum, Kassel,
Germany, 2003
Live Art brrr, Teatro Carlos Alberto / Teatro Nacional
de São João, Porto, Portugal, 2003
4th International Performance Festival, Odense,
Denmark, 2003
Recycling the Future, 50. Esposizione Internazionale
d'Arte La Biennale di Venezia, Venice, Italy, 2003

Bibliography (selection)
Marina Abramović, *Fresh Air*, ed. Hannes Malte
Mahler, Salon Verlag, Cologne, 1999
Else Jespersen, *International Performance Festival
1999* (exhibition catalogue), 2nd International
Performance Festival, Odense, 1999, p. 44
Mario Candia and Stefania Miscetti, *ANAPBLEPS*
(exhibition catalogue), Galleria Stefania Miscetti,
Rome, 2000, p. 38, 116
"Humour et ironie en action", *Etc Montreal, Revue de
l'art actuel*, Montreal, no. 53, March / April / May
2000, p. 30-33
Jens Hoffmann, *A Little Bit of History Repeated*
(exhibition catalogue), Kunst Werke Berlin e.V., Berlin,
2001, p. 36, 37
Marie-Claire Cordat, "Polysonneries ou Quand l'Art

vivant 'ici et maintenant' remet la pendule culturelle a l'heure", *Block Notes*, no. 192, September 2001, p. 24
Adan Dunne, "The art of living dangerously", *The Irish Times*, 28/11/01, p. 14
Robert Ayres, "Marking the Territory", *Contemporary*, Dublin, 1/01/02, p. 90
50. Esposizione Internazionale d'Arte La Biennale di Venezia (exhibition catalogue), Marsilio, 2003, p. 497

http://www.sylvie.ferre.com/melati
http://www.performance-festival-odense.dk
http://www.iapao.net/frame.html
http://www.maschinenhaus-essen.de/Presse.html

Irina Thorman
Born 1971 in Ratzeburg, Germany

Education
Artherapist (diploma), Fachhoschule Ottersberg, Ottersberg, Germany, 1994-1998
Hochschule für Bildende Künste, Braunschweig, Germany, since 1998

Selected Solo Exhibitions and Projects
Kerze, Aktion im öffentlichen Raum, Alexanderplatz, Berlin, Germany, since 1999
Rasur I, Forum der Frauen Kunst, Lilienthal, Germany, 1999
Rasur II, Projektraum, Berlin, Germany, 1999

Selected Group Exhibitions and Projects
Die Geschichte vom Soldaten, Kulturufer Friedrichshafen, 1998
Projektraum, www.projektraum-berlin.de, Berlin, Germany, 1999-2001
Virus, Theaterprojekt, Theater am Halleschen Ufer, Berlin; Pumpenhaus, Munster, Germany, 2000
Visible Differences, Hebbel Theater, Berlin, Germany, 2000
BrotZeit, Zagreus Projekt, Berlin, Germany, 2000
Art Migration, Nationalmuseum, Stettin, Germany, 2000
Join Us Now (project with R. P. Runge), www.joinusnow.org, since 2001
Raumtrieb 2000, Projektraum, Berlin, Germany, 2001
Common Ground, Landesvertretung Niedersachsen and Schleswig-Holstein, Berlin, Germany, 2002
Prêt-à-Perform, Viafarini, Milan, Italy, 2002

Bibliography (selection)
Marta Poszumska, *Art Migration*, Nationalmuseum Stettin, Stettin, 2000, p. 20-21

Ewjenia Tsanana
Born 1964 in Thessaloniki, Greece

Education
Hochschule für Bildende Künste, Hamburg, Germany, 1989-1998

Prizes and / or Awards
2ⁿᵈ Short-Film Prize, *8. Lesbisch-Schwule Filmtage*, Hamburg, Germany, 1997

Selected Solo Exhibitions and Projects
Gewässer des Grauens (solo slide-show evening), Lichtmeß Kino, Hamburg, Germany, 1999
Meine andere Hälfte (lecture), Kaskadenkondensator, Basel, Switzerland, 2002

Selected Group Exhibitions and Projects
Von woanders – kenn' ich nicht, Haus 3, Hamburg, Germany, 1990
13ᵗʰ International Hamburg Short-Film Festival, Germany, 1997
8. Lesbisch-Schwule Filmtage, Hamburg, Germany, 1997
22nd San Francisco International Lesbian & Gay Film Festival, San Francisco, USA, 1998
28ᵗʰ Molodist – Kyiv International Film Festival, Kiev, Ukraine, 1998
Performance Index, Basel, Switzerland, 1999
FEMINALE 2000 – 10ᵗʰ International Women's Film Festival, Cologne, Germany, 2000

Bibliography (selection)
Marianne Pitzen and Gudrun Angelis, *Brust-Lust-Frust*, Verlag Frauen Museum, Bonn, 1999, p. 88
Urs Grether, "Beziehungsmittelkörper", *Basellandschaftliche Zeitung*, Basel, 27/04/2002, p. 6

e-mail: tsanana@gmx.de

Frank Werner
Born 1968 in St. Ingbert, Germany

Education
Hochschule für Bildende Künste, Braunschweig, Germany, 1995-2001
Graduate Studies / Master Year, Goldsmiths College, London, United Kingdom, 2001-2002

Scholarships
New York Traveler Grant from The German Academic Exchange Service, DAAD, 1997
Postgraduate Studies scholarship for London from DAAD, 2001

Prizes and / or Awards
Video Art Award of the Saarlorlux Festival, Saarbrücken, Germany, 1998
Award at Milano Filmfestival, Milan, Italy, 1998
Prize at the Video Art Press, Marl, Germany, 2000
Nominated for "The Observer / The Guardian Art Award", London, United Kingdom, 2002

Selected Group Exhibitions and Projects
European Media Art Festival, Osnabrück, Germany, 1995, 1996, 1998, 2000, 2001
Zwischen Gardenien und Grünlilien, Kunstverein Gehrden, Gehrden, Germany, 1999
The One Minutes, Sandberg Instituut, Amsterdam, The Netherlands, 2000
Marking the Territory, Irish Museum of Modern Art, Dublin, Ireland, 2001
A Little Bit of History Repeated, Kunst Werke, Berlin, Germany, 2001
Filmfestival Bangkok, Bangkok, Thailand, 2001
Video Art Price Marl, Glaskasten Marl; Neues Museum Weimar; Kunstsammlung zu Weimar; Kunsteverein Wiesbaden; Heildelberger Kunstverein; Städtische

Galerie im Lenbachhaus München; Kunstverein
Huert; Neues Museum Weserburg, Bremen, Germany,
2000-2002
Perspektiven, Kunstverein Hannover, Hanover,
Germany, 2002
Reality Slides, Kunstverein Nürnberg Adlershof,
Nuremberg, Germany, 2003
RSVP, Robert Sandelson Gallery, London, United
Kingdom, 2003

Bibliography (selection)
Mara Mattuschka, *Zwischen Gardenien und Grünlilien,*
Kunstverein Gehrden, Gehrden, 1999, p. 3, 7, 8
Uwe Rüth, *9. Marler Video-Kunst-Preis,*
Skulpturenmuseum, Marl, 2000, p. 37
Ambrose Clancy, "Artful Dublin", *Washington Post,*
20/01/2002, p. EO1

Hanna Linn Wiegel
Born 1978 in Goslar, Germany

Education
Hochschule für Bildende Künste, Braunschweig,
Germany, 1997-1998
Institut für Theater und Filmwissenschaft, Freie
Universität, Berlin, Germany, 1998-2000
Institut für Angewandte Theaterwissenschaft, Justus
Liebig Universität, Gießen, since 2000

Selected Solo Exhibitions and Projects
*Ich bin hier – Anlehungsversuche, Urban Dialogues /
Nachbeben* (performance), Rathauspassage am
Alexanderplatz, Berlin, Germany, 1999
Weihnachtsbürger, Institut für Angewandte
Theaterwissenschaft (cooking performance), Gießen,
Germany, 2000
Fish (performance), Institut für Angewandte
Theaterwissenschaft, Gießen, Germany, 2001
Shopping and fxxxing in Gießen (city guide), Gießen,
Germany, 2001
Sommerbürger (cooking performance), Gießen,
Germany, 2001
Auf dem klopapier steht: Happy End (experimental
film), Institut für Angewandte Theaterwissenschaft,
Gießen, Germany 2002
Klangwasser (sound installation), next.wav / Brugges
Capital City of Europe, Bruges, Belgium, 2002
Osterbürger (cooking performance), Diskurswohnung,
Gießen, Germany, 2003

Selected Group Exhibitions and Projects
Sprechraum – Das Jahr 2000 (performance),
Podewil, Berlin, Germany, 1999
Rausch (video installation), Institut für Theater und
Filmwissenschaft, Berlin, Germany, 1999
Die Winterreise (performance), Podewil, Berlin,
Germany, 2000
Loveless (video), Institut für Theater und
Filmwissenschaft, Berlin, Germany, 2000
Alle Wege führen nach Rom (group performance with
Keyfa), Die Kuhle, Berlin, Germany, 2000
Bürgersteig – Sidewalk (group performance /guided
tour, with the group julesetjim), Theater neben dem
Turm, Marburg, 2001
Gerne zuschauen, Hessische Theatertage, Kassel,
Germany, 2002

Plateaux, Künstlerhaus Mousonturm, Frankfurt am
Main, Germany, 2002
Transeuropa, Hildesheim, Germany, 2003 (interactive
audio-play, together with Anne Bösenberg)

Bibliography (selection)
Ive Stevenheydens, "Bescheiden geluidsgolven",
Financieel – Economische Tijd, 19/06/2002
Koen de Meester, "Lawaai is de stilte van deze tijd",
De Morgen, 20/06/2002
Michael Rüsenberg, "Wellenkräuseln", *Frankfurter
Rundschau,* Frankfurt am Main, 26/06/2002
Guy Duplat, "Bruges au son de sculptures sonores",
La Libre Belgique, 16/07/2002, p. 38
Jutta Baier, "Blaukraut bleibt überall Blaukraut",
Frankfurter Rundschau, Frankfurt am Main,
25/11/2002, p. 24
Jürgen Berger, "Kopffüßler", *Süddeutsche Zeitung,*
Munich, 28/11/2002

e-mail: Igonja@gmx.net

Susanne Winterling
Born 1970 in Rehau, Germany

Education
Akademie Isotrop, Bremen, Germany, 1996-2000
Hochschule für Bildende Künste, Braunschweig and
Hochschule für Bildende Künste, Hamburg, Germany,
1996-2001

Prizes and / or Awards
Prize of the Jury, Filmfest Tübingen, Tubingen,
Germany, 1996
Video Prize, Buxtehude, Germany, 1998
Grant of Kunstkommission, 2001

Selected Solo Exhibitions and Projects
Werkschau Filmbüro Baden-Württenberg, Baden-
Wurttemberg, Germany, 1997
Stadtmuseum Buxtehude Videopreis, Buxtehude,
Germany, 1998
Nomadenoase, Hamburg, Germany, 1999

Selected Solo Exhibitions and Projects
Akademie Isotrop, Galerie Daniel Buchholz, Cologne,
Germany, 1999
Akademie Isotrop, Galerie Hoffmann und Senn,
Vienna, Austria, 1999
Akademie Isotrop, Gesellschaft für aktuelle Kunst
Bremen, Bremen, Germany, 2000
Videonale Bonn, Bonn, Germany, 2001
Alien – Inside the Outside, Rome / Swiss Institute,
New York, USA, 2002
Prêt-à-Perform, Viafarini, Milan, Italy, 2002
Rituale, Akademie der Bildende Künste, Berlin,
Germany, 2003

Herma Wittstock
Born 1977 in Peine, Germany

Education
Hochschule für Bildende Künste, Braunschweig,

Germany, since 1999
Class of Marina Abramović, Hochschule für Bildende Künste, Braunschweig, Germany, since 2000

Selected Solo Exhibitions and Projects
Performance Forever, Gallery of Body Art, London, United Kingdom, 1998
I'm German, National Gallery of Contempory Art, Johannesburg, South Africa, 2000
I'm German, Art Gallery Smith, London, United Kingdom, 2001
It Is Raining, Förderung junger Künstler, Bonn / Cologne, Germany, 2002
Dance and Feel, Kunstforum, Kiel, Germany, 2002
Nothing, Small House Group, Prague, Czech Republic, 2002

Selected Group Exhibitions and Projects
Performance Abend 2, Kulturverein, Peine, Germany, 1998
Language or Sandwich, Collecting Art Gallery, London, United Kingdom, 1999
Art and or Basic, National Gallery of Contemporary Art, Johannesburg, South Africa, 2000
Real Presence – Generation 2001, The Balkans Trans / Border – Open Art Project, Belgrade, Serbia and Montenegro, 2001
Marking the Territory, Irish Museum of Modern Art, Dublin, Ireland, 2001
A Little Bit of History Repeated, Kunst Werke, Berlin, Germany, 2001
Cleaning the House workshop, Centro Galego de Arte Contemporánea, Santiago de Compostela, Spain, 2002
Prêt-à-Perform, Viafarini, Milan, Italy, 2002
As Soon as Possible, PAC, Padiglione d'Arte Contemporanea, Milan, Italy, 2003
Recycling the Future, 50. Esposizione Internazionale d'Arte La Biennale di Venezia, Venice, Italy, 2003

e-mail: hermaaguste@hotmail.com

Viola Yesiltać
Born 1975 in Hanover, Germany

Education
Hochschule für Bildende Künste, Braunschweig, Germany, 1999
Class of Marina Abramović and Mara Mattuschka, Hochschule für Bildende Künste, Braunschweig, Germany, 2000

Scholarships
Stipendium der Studienstiftung des Deutschen Volkes, 2003 and 2005

Selected Group Exhibitions
Alliance 01 Ausstellungsraum, Klingenthal, Germany, 2001
Real Presence – Generation 2001, The Balkans Trans / Border – Open Art Project, Belgrade, Serbia and Montenegro, 2001
Marking the Territory, Irish Museum of Modern Art, Dublin, Ireland, 2001
A Little Bit of History Repeated, Kunst Werke, Berlin, Germany, 2001
Intermedia 2002, Triskel Art Center, Cork, Ireland, 2002

Prêt-à-Perform, Viafarini, Milan, Italy, 2002
Body Power / Body Play, Württembergischer Kunstverein, Stuttgart, Germany, 2002
Recycling the Future, 50. Esposizione Internazionale d'Arte La Biennale di Venezia, Venice, Italy, 2003
Performance in der Kunsthalle, Kunsthalle Fridericianum, Kassel, Germany, 2003

Bibliography (selection)
Filmklasse, Salon Verlag, Cologne, 2000, p. 159
"Arti performative, Una nuova avanguardia?", *Flash Art,* Milan, no. 232, February / March 2002, p. 56
404 Team, 404 Yellow Pages, Écart Verlag and JRP Edition Genf, Geneva, 2003

www.viola-yesiltac.com

Marina Abramović's Biography

Born 30 November 1946 in Belgrade, Yugoslavia

1960-68
Paintings and drawings.

1965-70
Academy of Fine Arts, Belgrade, Yugoslavia.

1968-70
Projects, texts and drawings.

1970-72
Graduate studies, Radionica Krsta Hegedusica,
Academy of Fine Arts, Zagreb, Croatia.

1970-73
Sound Environments, exhibitions at the Studenski
Kulturni Centar, Belgrade, Yugoslavia, with Rasa
Todosijević, Zoran Popović, Gergelj Urkom, Slobodan
Milivojevic and Nesa Paripovic.

1973-75
Teaches at the Academy of Fine Arts, Novi Sad,
Yugoslavia.

1973-76
Performances, video, films.

1975
Meets Ulay in Amsterdam.

1976
Starts relation works with Ulay. Decides to make
permanent movements and detours.

1980-83
Travels in Central Australian Sahara, Thar and Gobi
Deserts.

1988
The Great Wall Walk (30 April / 27 June). Afterwards
begins to work and exhibit individually.

1990-91
Visiting professor at the Hochschule der Künste,
Berlin.
Visiting professor at the Académie des Beaux-Arts,
Paris.

1992-96
Professor at the Hochschule für Bildende Künste,
Hamburg. Completes two major theatre performances:
Biography and *Delusional*.

1997
Winner of the Golden Lion Award for Best Artist,
XLVII Biennale di Venezia, Venice.

Since 1997
Professor at the Hochschule für Bildende Künste,
Braunschweig, Germany.

1998
Board member of the Contemporary Art Center,
Kitakyushu, Japan.

2001
Artist in residence at the Atelier Calder, Saché,
France.

2003
Winner of the Niedersächsicher Kunstpreis 2003.
Winner of the New York Dance and Performance
Award (The Bessies).

Lives in Amsterdam and New York.

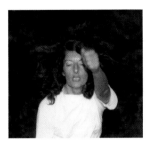

Selected *Cleaning the House* Workshops

THE CLASS OF ABRAMOVIĆ at the Hochschule für Bildende Künste, Braunschweig, Germany. Exhibitions and Events:

Behaviour Workshop Festival, Arnhem, The Netherlands, 1978
College of Fine Arts, University of New South Wales, Sydney, Australia, 1979
Dance Academy, Amsterdam, The Netherlands, 1980
Kunstakademie Berlin, Berlin, Germany, 1982
Kill My Pillow, The Royal Danish Academy of Fine Arts, Denmark, 1984
Sörup, Denmark, 1985
Jan Van Eyck Academy, Maastricht, The Netherlands, 1989
Académie des Beaux-Arts, Paris, France, 1990
Kunsthochschule, Hamburg, Falster, Denmark, 1990
École des Beaux-Arts, Grenoble, France, 1991
Jan Van Eyck Academy, Maastricht, The Netherlands, 1991
Hochschule der Künste Berlin, Sauen, Germany, 1991
Kunstakademie Wien, Kerguéhennec, France, 1992
Workshop with P. L. Tazzi, Grenoble, France, 1992
Hochschule für Bildende Künste Hamburg, Falster, Denmark, 1992
Academie Beeldende Kunsten, Maastricht, The Netherlands, 1993
Hochschule der Bildende Künste Hamburg, Hamburg, Germany, 1994
Workshop with Hamish Fulton, Japan, 1994
Académie des Beaux-Arts, Paris, France, 1994
Académie des Beaux-Arts, Paris, France, 1995
Workshop with artists and actors, Kerguéhennec, France, 1995
Centre d'Art Contemporain, Bignan, France, 1995
Kunsthojskolen, Holbaek, Denmark, 1996
International Workshop Festival, Newcastle upon Tyne, United Kingdom, 1996
Kunstakademie Wien, Kerguéhennec, France, 1997
Centre d'Art Contemporain, Bignan, France, 1997
Hochschule für Bildende Künste Braunschweig, Kerguéhennec, France, 1997
Bundesakademie für Kulturelle Bildung, Wolfenbuttel, Germany, 1999
Hochschule für Bildende Künste Braunschweig, Kerguéhennec, France, 2000
Gießen, Germany, 2001
Fondazione Antonio Ratti, Como, Italy, 2001
Centro Galego de Arte Contemporánea, Antas de Ulla, Spain, 2002

Cleaning the House workshop, Domaine de Kerguéhennec, France, 1997
My 70's, Hochschule für Bildende Künste, Braunschweig, Germany, 1998
Braunschweiger Kulturnacht, L.O.T. Theater, Braunschweig, Germany, 1998
Zwischenräume – Finally, Kunstverein Hannover, Hanover, Germany, 1998
Performance Abend, Rundgang, Hochschule für Bildende Künste, Braunschweig, Germany, 1999
Braunschweiger Kulturnacht, L.O.T. Theater, Braunschweig, Germany, 1999
Unfinished Business, Gallerie Haus am Lützowplatz, Berlin, Germany, 1999
Fresh Air, Kulturstadt Europa, E-Werk, Weimar, Germany, 1999
Performance Abend, Rundgang, Hochschule für Bildende Künste, Braunschweig, Germany, 2000
Visible Differences, Hebbel Theater, Berlin, Germany, 2000
Cleaning the House workshop, Domaine de Kerguéhennec, France, 2000
Get that Balance, Rundgang, Hochschule für Bildende Künste, Braunschweig, Germany, 2001
Performance Klasse Abramović, Kaskadenkondensator, Basel, Switzerland, 2001
Wer hat Angst vor Roger Whittaker?, Freunde Aktueller Kunst e.V. Sachsen und Türingen, Zwickau, Germany, 2001
Real Presence – Generation 2001, The Balkans Trans / Border – Open Art Project, Belgrade, Serbia and Montenegro, 2001
Marking the Territory, Irish Museum of Modern Art, Dublin, Ireland, 2001
Get that Balance, National Sculpture Factory, Opera House / Half Moon Theatre, Cork, Ireland, 2001
A Little Bit of History Repeated, Kunst Werke, Berlin, 2001
Body Basics I / Body Basics II, Transart 02, Klanspuren Festival, Fortezza, Brixen, Italy, 2002
Body Power / Power Play, Württembergischer Kunstverein, Stuttgart, Germany, 2002
Cleaning the House workshop, Centro Galego de Arte Contemporánea, Santiago de Compostela, Spain, 2002
Common Ground, Landesvertretung Niedersachsen and Schleswig-Holstein, Berlin, Germany, 2002
Prêt-à-Perform, Viafarini, Milan, Italy, 2002
As Soon as Possible, PAC, Padiglione d'Arte Contemporanea, Milan, Italy, 2003
Recycling the Future, 50. Esposizione Internazionale d'Arte La Biennale di Venezia, Venice, Italy, 2003
Performance in der Kunsthalle, Kunsthalle Fridericianum, Kassel, Germany, 2003
4th International Performance Festival, Odense, Denmark, 2003

Publications

Marina Abramović
Marina Abramović
Galerija suvremene umjetnosti, Zagreb, Croatia /
Yugoslavia, 1974

Marina Abramović
Ritam 10, 5, 2, 4, 0 u okviru IV Aprilskog Susreta
Salon Muzeja savremene umetnosti, Belgrade, Serbia,
1975

Marina Abramović / Ulay
Ulay / Marina Abramović
Relation / Works, 3 Performances
Galerie Krinzinger, Innsbruck / Galerie H Humanic,
Graz, Austria, 1978

Marina Abramović / Ulay
30 November / 30 November
Harlekin Art, Wiesbaden, Germany, 1979
ISBN 3-88300-004-3

Ulay / Marina Abramović
Marina Abramović / Ulay
Two Performances & DETOUR
Experimental Art Foundation, Adelaide, Australia,
1979
ISBN 0 95 96729 5 8

Marina Abramović / Ulay
Ulay / Marina Abramović
Relation Work and Detour
Idea Books, Amsterdam, The Netherlands, 1980

Ulay & Marina Abramović
Modus Vivendi, 1980-1985
Stedelijk Van Abbemuseum, Eindhoven, The
Netherlands, 1985

Marina Abramović / Ulay
The Lovers, The Great Wall Walk
Stedelijk Museum, Amsterdam, The Netherlands, 1989
ISBN 90-5006-028-5

Marina Abramović
Sur la Voie
Centre Georges Pompidou, Paris, France, 1990
ISBN 2-85850-572-1

Marina Abramović
Le Guide Chinois
Galerie Charles Cartwright, Paris, France, 1990

Marina Abramović
Departure / Brasil project 1990-91
Galerie Enrico Navarra, Paris, France, 1991

Marina Abramović
Transitory Objects

Galerie Krinzinger, Vienna, Austria, 1992

Marina Abramović
Marina Abramović
École nationale supérieure des Beaux-Arts, Paris,
France, 1992
ISBN 2-903639-90-6

Marina Abramović
Abramović
Cantz Verlag, Stuttgart, Germany, 1993
ISBN 3-89322-537-4

Marina Abramović
Abramović
Padiglione d'Arte Contemporanea, Palazzo dei
Diamanti, Ferrara, Italy, 1993

Marina Abramović
Biography
Cantz Verlag, Ostfildern, Germany, 1994
ISBN 3-89322-264-2

Marina Abramović
Cleaning the House
Academy Editions, London, England, 1995
ISBN 1 85490 399 3

Marina Abramović
Objects Performance Video Sound
Museum of Modern Art, Oxford / Edition Hansjörg
Mayer, Oxford / Stuttgart, Great Britain / Germany,
1995
ISBN 0905836 88 X

Marina Abramović
Double Edge
Kunstmuseum des Kantons Thurgau, Kartause Ittingen /
Verlag Niggli, Warth / Sulgen, Switzerland, 1996
ISBN 3-7212-0112-4

Marina Abramović
Marina Abramović
Museum Villa Stuck, Munich, Germany, 1996
ISBN 3-923244-16-9

Marina Abramović
Spirit House
Caldas da Rainha, Portugal, 1997

Ulay / Abramović
Performances 1976-1988
Stedelijk Van Abbemuseum, Eindhoven, The
Netherlands, 1997
ISBN 90-70149-60-5

Marina Abramović
Artist Body

Edizioni Charta, Milan, Italy, 1998
ISBN 88-8158-175-2

Marina Abramović
The Bridge / El Puente
Generalitat Valenciana, Valencia, Spain, 1998
ISBN 84-482-1857-4

Marina Abramović
Inbetween
Center for Contemporary Art (CCA), Kitakyushu,
Japan, 1998
ISBN 4 7713 3408 0

Marina Abramović
Performing Body
Edizioni Charta, Milan, Italy, 1998
ISBN 88-8158-160-4

Marina Abramović
Unfinished Business
Salon Verlag, Cologne, Germany, 1999
ISBN 3-89770-016-6

Marina Abramović
Fresh Air
Salon Verlag, Cologne, Germany, 1999
ISBN 3-89770-025-5

Ulay / Abramović
Performances 1976-1988
Musée d'Art Contemporain de Lyon, Lyon, France,
1999
ISBN 2-90 64 61-50-4

Marina Abramović
*Talon siivous: Matkakaappi / Cleaning the House:
Travelling Cabinet*
Kiasma Museum of Contemporary Art, Helsinki,
Finland, 2000
ISBN 951-53-2102-6

Marina Abramović
Public Body
Edizioni Charta, Milan, Italy, 2001
ISBN 88-8158-295-3

Marina Abramović
Marina Abramović
Edizioni Charta, Milan / Fondazione Antonio Ratti,
Como, Italy, 2002
ISBN 88-8158-365-8

Marina Abramović
Student Body
Edizioni Charta, Milan, Italy, 2003
ISBN 88-8158-449-2

Photo Credits

Judith Adam, p. 408, 409, 410, 411
Isabelle Arthuis, p. 57, 78, 79
E. Bates, p. 62 (bottom)
Anna Berndtson and Mariangela Bombardieri, p. 192, 193
Luca Bianco, p. 71
Oliver Blomeier, p. 39, 153
Mariangela Bombardieri, p. 186
Vera Bourgeois, p. 157, 158, 159
Matthias Brieckle, p. 156 (bottom)
Peter Buermann, p. 149, 261
Alessia Bulgari, p. 18, 27, 29, 41, 87, 104-105, 175, 184, 185, 228, 255, 265, 370, 371, 372-373, 388-389, 396-397, 407, 434, 435, 436, 437, 439, 448, 449, 464-465
Paolo Canevari, p. 275
Ivan Čivić, p. 172, 174
Zlatko Čivić, p. 170
Amanda Coogan, p. 30-31, 180 (left)
Ariane Cohrt, p. 216, 217
Maria Silvina D'Alessandro and Ilya Rabinovich, p. 278, 279
Yingmei Duan, p. 336, 337
Nezaket Ekici, p. 142-143
Jimmy Fay, p. 33, 180 (right), 458-459
Regina Frank, p. 204-205
Regina Frank and Peter Frank Edwards, p. 206, 206-207
Frau Müller p. 34, 288, 392-393
Silvia García, p. 37, 56, 59, 74, 75, 76-77, 85, 90, 92-93, 97, 101, 107, 138, 139, 188-189, 282-283
Pascale Grau, p. 215
Markus Häberlin, p. 62 (top), 62-63, 72
Daniel Herskowitz, p. 200, 200-201
Stefan Husch, p. 156 (top)
Kaolu Katayama, p. 319
Sabine Klem, p. 358-359
Maurice Korbel, p. 54-55, 68-69, 106, 112, 246, 247
Eustachy Kossakowski, p. 14
Oliver Kochta and Frank Lüsing, p. 241, 243, 244, 244-245
Florian Krautkrämer, p. 90, 406
Matthias Langer, p. 366 (right), 367
Mónica Lavandera, p. 324
Lotte Lindner, p. 256-257, 259, 377, 378, 379, 380-381, 381, 462, 463
Giuseppe Liverani, p. 35
Oded Loebel, p. 328-329
Reinhard Lutz, p. 155, 452-453, 393
Andre Lützern, p. 315
Torsten Maidzik and Viola Yesiltać, p. 386, 386-387
Sunhi Mang, p. 360
Manolo Martínez, p. 268, 269
Ronan McCrea, p. 180-181, 182
Daniel Müller-Friedrichsen, p. 295, 302, 303
Llúcia Mundet Pallí, p. 354-355
Asayo Nakagawa and Yun Seok Koh, p. 190, 191
Kuros Nekuian, p. 230-231
Daniel Nieto, p. 203

Pablo Orza, p. 168, 169
Isaac Piñeiro and Silvia García, p. 320, 321
Barak Reiser, p. 327
Carlota Represa, p. 284, 285
Declan Rooney, p. 333, 334, 335
Roland P. Runge, p. 403
Iris Selke, p. 38, 54, 146, 147, 183, 194, 195, 254, 445
Seng Hui-Kinng, p. 50-51
Christian Sievers, p. 363 (right), 364-365, 365, 366 (left), 368-369
Fergal Shannon, p. 331, 338, 339
Ruedi Schill, p. 344-345
Gundel Scholz, p. 394
Angelika Schönfeld, p. 376
Carola Schmidt, p. 348, 349
Anton Soloveitchik, p. 64, 128
Masha Soloveitchik, p. 144, 145
Nele Stecher, p. 342, 343
Till Steinbrenner, p. 260, 264
Till Steinbrenner and Lotte Lindner, p. 262, 262-263
B. Streicher, p. 274
Melati Suryodarmo, p. 390, 391
TheMahler.com, p. 65, 67, 68, 98-99, 151, 271, 272-273, 352-353
TheMahler.com (M), p. 70
Marina Thies, p. 287
Brian Torvik, p. 140
Ewjenia Tsanana, p. 314
Darshana Vora, p. 281
Sonja Wegener, p. 258 (left)
Susanne Winterling, p. 199, 420, 421, 426, 427, 428, 429
Susanne Winterling and Ivan Čivić, p. 176
Viola Yesiltać, p. 141, 148, 160, 161, 162, 163, 179, 187, 212, 213, 248, 249, 258 (right), 347, 350-351, 374, 375, 382, 383, 384, 385, 395, 422, 423, 424-425, 431, 432, 433, 438, 440, 441, 442, 443, 446, 447, 456, 457, 460-461
Viola Yesiltać and Daniel Müller-Friedrichsen, p. 296, 296-297

Unless stated otherwise, all video stills are taken from videos shot by the artists themselves.

We apologize if, due to reasons wholly beyond our control, some of the photo sources have not been listed.

To find out more about Charta,
and to learn about our most recent
publications, visit

www.chartaartbooks.it

Printed in September 2003
by Leva spa, Sesto San Giovanni
for Edizioni Charta